Jeffrey F. Hamburger, Eva Schlotheuber, Susan Marti, and Margot E. Fassler
Liturgical Life and Latin Learning at Paradies bei Soest, 1300-1425

Volume II

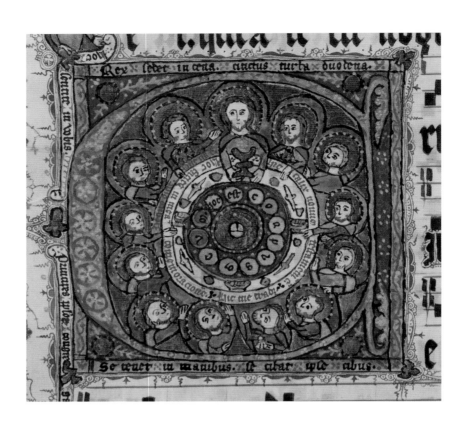

LITURGICAL LIFE AND LATIN LEARNING AT PARADIES BEI SOEST, 1300-1425

INSCRIPTION AND ILLUMINATION IN THE CHOIR BOOKS OF A NORTH GERMAN DOMINICAN CONVENT

VOLUME II

Jeffrey F. Hamburger, Eva Schlotheuber,
Susan Marti, and Margot E. Fassler

Aschendorff
Verlag

Published with the generous support of the Suzanne and James Mellor Prize of the National Museum of Women in the Arts.

NATIONAL MUSEUM
of WOMEN *in the* ARTS

Suzanne and James Mellor Prize

Additional support has been provided by the Alexander von Humboldt-Foundation; the Anne and Jim Rothenberg Fund for Humanities Research, Harvard University; the Department of History of Art and Architecture, Harvard University; the Department of Philosophy (HHU Düsseldorf); and the Institute for Scholarship in the Liberal Arts, College of Arts and Letters, University of Notre Dame.

Cover images and frontispiece:
Düsseldorf, Universitäts- und Landesbibliothek (ULB), Ms-D11 (Graduale), pp. 415, 38, 319

Printed in Germany

ISBN 978-3-402-13072-8

INDEX

VOLUME I

PART VI: THE ART OF INSCRIPTION IN THE GRADUAL D 11

VOLUME II

APPENDICES

FULL-PAGE ILLUSTRATIONS

Bibliography

INDICES

APPENDICES

A: Edition and Translation of the Foundation Legend

De institutione Paradisi et humili ingressu sororum

Münster, Landesarchiv/State Archive NRW Abteilung/
Section Westfalen, Msc. VII, Nr. 6107

T his history of the founding of the convent of Paradies
is taken from the convent cartulary. The following
documents are organized according to property holdings
and cover the years 1242–1339. The year 1339 therefore
provides the terminus post quem for the writing down of
this version of the legend, which may have gone through
several stages of composition. A single leaf from an older
version of the foundation history, with a somewhat differ-
ent text, is preserved in the Stadtarchiv of Soest and was
edited by Norbert Eickermann in 1974.[1] In both the frag-
ment and in the following text of the foundation legend,
the first confessor of the Dominican nuns, Heinrich von
Osthoven, is named as the author.

Parchment, ff. 82, 23 x 18.5 cm; nineteenth-century bind-
ing with a shelfmark taken over from an older binding:
Copiar Kl. Soest-Paradies VII 6107. Later pagination 1–83.
Quires: V 1–20, V 21–40, V 41–60, loss of text of possibly
a double page; VI-1, 61–82, loss of text.
 Mise-en-page 18 x 13 cm, ruled, single column, 27 lines.
Gothic miniscule with elements of diplomatic miniscule,
written in various hands. Headings, the beginning of
sentences, nomina sacra, and initials are for the most
part in red.

Overview on the content and editions:

1–6 Foundation history of the convent of Paradies; 6–82
Copies of 104 documents from the years 1242–1339. The
documents are edited in the Westfälisches Urkundenbuch
V, VII, and XI. The following list includes editions con-
taining the full text. Three documents dating to the years
after 1330 have not yet been edited. In the cartulary the
copies of the documents are organized according to the
authorities that issued the privileges and the estates owned
by the convent. With one exception (p. 8, WUB VII, no.
1017) every document has a rubric which provides some
orientation as to its contents. The rubrics, omitted from
the editions of these documents, are reproduced here.

Papal privileges:
 (pp. 6–7) Hic Clemens papa sorores in Paradiso in
suam protectionem recipit, WUB VII, no. 1271, 572–73
(1267 November 8); (pp. 7–8) Hic recipit [sc. Pope Al-
exander IV.] sorores in suam protectionem et regulam
Augustini confirmat, WUB V, no. 551, 253 (1255 April 22);
(p. 8) without rubric WUB VII, no. 1017, 460–61 (1259 May
25); (8) Alexander papa concedit, ut de usuris et rapinis
centum marcas possimus recipere, WUB VII, no. 1027,
464 (1259 July 7); (pp. 8–9) Hic concedit, ut non possimus
ad iudicium a quocumque evocari, WUB V, no. 550,
352–53 (1255 April 13); (pp. 9–10) Littera Benedicti, WUB
XI, vol. 1, no. 526, 297 (1307 February 20) confirmation of
the bull, WUB XI, vol. 1, no. 305, 161 (1304 February 28);
(pp. 10–12) Littera domini Johannis Tusculani episcopi,
WUB VII, no. 2058, 967–68 (1287 October 31); (p. 12) In
hac dominus Hugo cardinalis suscipit in suam protec-
tionem sorores in Paradiso, WUB VII, no. 789, 349–50
(1253 March 8); (pp. 12–13) Quod sorores in Paradiso
interdicti tempore possunt divina celebrare, WUB VII,
no. 792, 351 (1253 March 17).

Privileges from the archbishops of Cologne:
 (p. 13) Hic Conradus archiepiscopus suscipit sorores
in suam defensionem, WUB VII, no. 813, 361–62 (1253);
(pp. 13–14) Quod familia nostra possit recipere sacra-
mentum in ecclesia nostra, WUB VII, no. 1034, 468
(1259); (p. 14) Hic committit sorores fratribus ordinis
predicti, WUB VII, no. 790, 350 (after 1253 March 8); (p.
14) Hic committit consulibus et proconsulibus, ut curam
ipsarum habeant, WUB VII, no. 1011, 459 (1259 April 19);
(pp. 14–15) Hic confirmat privilegia indulta a predeces-
sore suo, WUB VII, no. 1233, 558 (1266 August 17); (p. 15)
Hic Sifridus archiepiscopus confirmat libertates et iura

[1] Heinrich Osthofen aus Soest, 'Gründungsgeschichte', ed.
Bruns (1974), 9–15.

a predecessoribus suis concessa, *WUB VII, no. 1852, 859 (1282/1283 January 4); (pp. 15–16)* Quod Conradus Coloniensis archiepiscopus donationem comitis de Thekeborg confirmat, *WUB VII, no. 774, 393–94 (1255 June 18); (pp. 16–17)* Hic confirmat collationem domini Ottonis comitis Tekeneborg super curti in Alvoldinchusen, *WUB VII, no. 774, 342 (1252 July 25).*

Estate at Alvoldinchusen:

(p. 17) De proprietate Alvoldinchusen, *WUB VII, no. 764, 338 (1251); (pp. 17–18)* De collatione proprietatis in Alvoldinchusen per Ottonem comitem, *WUB VII, no. 852, 381 (1254 December 27); (p. 18)* Comitis de Thekeneborg resignatio de Alveldinchusen, *WUB VII, no. 983, 446 (1258 April 23); (p. 18)* Item resignatio comitis de Tekeneburg, *WUB VII, no. 853, 381 (c. 1254); (p. 19)* Collatio de Hinrici curtis in Alveldinchusen, *WUB VII, no. 773, 341 (1252 before July 25); (p. 19)* Episcopus Bruno testatus quod audiverit Ottonem comitem fateri, quod Ionathan de Rothenberg nihil iuris habet in Alveldinchusen, *WUB VII, no. 857, 383 (1254/1255 January 3); (pp. 19–20)* De domino Herbordo de Tremonia, *WUB VII, no. 671, 296 (1248 September); (p. 20)* Herbordus resignavit omne ius, quem tenebat in bonis Alvoldinchusen, *WUB VII, no. 843, 377 (1254 October 10); (pp. 20–21)* Littere resignationis domini Herbordi militis, *WUB VII, no. 844, 377–78 (1254 October 10); (p. 21)* De positione Frederici de bonis in Alveldinchusen, *WUB VII, no. 2447, 1173 (1297/1298 February 8); (pp. 21–22)* De compositione Hugonis de Methlere, *WUB XI, vol. 1, no. 84, 42 (1302); (p. 22)* Hic testatus burggravius Werdenis resignationem Herbordi de Tremonia, *WUB VII, no. 842, 337 (1254 October 10); (pp. 22–24)* Littera monachorum de Schede, *WUB VII, no. 2295, 1091–092 (1294 April 23); (pp. 24–25)* Hic confirmat proprietatem de Alveldinchusen, *WUB VII, no. 2314, 1101–102 (1294 January 11/1295, January 10); (pp. 25–27)* De Dithmaro et filiis eius, *WUB VII, no. 1878, 873–74 (1283 August 15); (p. 27)* De transpositione vie, *WUB XI, vol. 1, no. 504 (1306 November 16); (pp. 27–29)* De venditione vrigravie domini Godefridi de Rudenberg, *WUB XI, vol. 1, no. 486, 272–73 (1306 August 19).*

Estates in and near Schwefe (Ridderinghof, Bukele, Wüstehof, unnamed farms):

(pp. 29–30) De curte dicta Ridderinchof, *WUB VII, no. 1126, 510–11 (1263 August 11); (pp. 30–32)* De ecclesia in Sveve, *WUB VII, no. 1825, 845–46 (1282 September 4); (p. 32)* De compositione Ludolfi et Hermanni vrigraviorum, *WUB XI, vol. 1, no. 761, 433–34 (1310/1309, March 16); (pp. 32–34)* De compositione inter conventum et parrochianos ecclesie Svevensis, *WUB VII, no. 2382, 1140–141 (1296 November 5); (p. 34)* De proprietate curtis Bukele, *WUB VII, no. 1692, 775 (1279 November 22); (p. 35)* De bonis sitis in Bukele, *WUB VII, no. 538, 239 (1242/1243 February 28); (pp. 35–36)* Hic dominus Conradus episcopus resignat proprietate[m], quam habet in Bukele, *WUB VII, no. 961, 435–36 (1257 August 24); (pp. 36–37)* De curte dicta Wostehof, *WUB VII, no. 1001, 454–55 (1258); (pp. 37–38)* De bonis apud Sveve, que Cunegundis nobis vendit, *WUB VII, no. 1445, 659 (1272 September 21); (pp. 38–39)* De bonis in Sveve, *WUB VII, no. 1493, 681–82 (1273/1274 March 23); (pp. 39–40)* De Conrado de Medebeke, *WUB VII, no. 2089, 981 (1288 August 9); (p. 40)* De compositione Godfridi dicti Quidele, *WUB XI, vol. 2, no. 931, 530–31 (1312 February 13); (pp. 40–41)* Item de Godefridi dicti Quidele, *WUB XI, vol. 2, no. 919, 525 (before 1312); (pp. 41–42)* De bonis emptis a convento in Bertelincdorp, *WUB VII, no. 1394, 635–36 (1271 June 4); (pp. 42–43)* De Bertelinchdorpe, *WUB VII, no. 1660, 758–59 (1278 December 14); (pp. 43–44)* De bonis emptis a Volchmaro de Ekene, *WUB VII, no. 1910, 888–89 (1284 June 8); (p. 44)* De bonis Volmari dicti de Ekeneberne, *WUB VII, no. 1911, 889 (1284 June 8); (pp. 44–45)* De XX iugeribus apud Sveve a Hermanno Brustenich, *WUB VII, no. 1418, 646–47 (1271/1272 January 20); (pp. 45–47)* De Arturo, *WUB VII, no. 2282, 1084–085 (1293/1294 January 20); (pp. 47–48)* De areis emptis ab Arturo, *WUB VII, no. 2285, 1086 (1293/1294 February 3); (pp. 48–49)* De bonis in Sveve, que Arturus vendidit, *WUB VII, no. 1243, 563 (1266 before December 25); (p. 49)* De Arturo, *WUB VII, no. 1989, 934–35 (1285/1286 February 3); (pp. 49–51)* Hec bona comparavimus Axerano et Arturo, *WUB VII, no. 2286, 1087 (1293/1294 February 14).*

Tithes in Einecke and Eineckerholsen:

(pp. 51–52) De decima quam nobis vendidit Theoderico de Volmesteyne, *WUB VII, no. 2507, 1205–206 (1298 November 8); (p. 53)* De proprietate decime in Endike, *WUB XI, vol. 1, no. 169, 89 (1303); (pp. 53–54)* De permutacione decime, *WUB VII, no. 2505, 1204 (1298 November 1); (pp. 54–55)* De donatione proprietatis decime, *WUB VII, no. 2506, 1205 (1298 November 1); (p. 55)* De resignatione decime, *WUB VII, no. 2526, 1214 (1299 June 5); (pp. 55–57)* De Arnoldo de Specken, *WUB XI, vol. 1, no. 95, 46–47 (1302/1301 February 16); (p. 57)* De resignatione decime a Hinrico, *WUB XI, vol. 1, no. 338, 178–79 (1304 September 14); (pp. 57–58)* De resignatione decime a Wichardo Balken, *WUB XI, vol. 1, no. 339, 179 (1304 September 17); (pp. 58–59)* De renuntiatione decime in Endike a Godfrido de Rudenberg facta, *WUB XI, vol. 1, no. 695, 400–01 (1309 June 9); (p. 59)* De compositione Theoderici de Meschede, *WUB XI, vol. 1, no. 203, 104 (1303/1302 March 17); (pp. 59–60)* De compositione Arnoldi Balke super decima, *WUB XI, vol. 1, no. 344, 182 (1304 September 22); (p. 60)* De compositione Hinrici dicti Berdinch, *WUB VII, no. 2582, 1243 (1300 May 2); (p. 60)* De molendino quod datur a Frucke (*Loss of text means the document is missing*).

Revenues from the town of Werl:

(p. 61) Loss of text means the rubric and part of the document are missing, WUB VII, no. 2361, 1129 (1296 May 10); (p. 61) De Werle, WUB XI, vol. 2, no. 1215, 701–02 (1315 July 29); (p. 61) Item de bonis in Werle, WUB XI, vol. 2, no. 1212, 699–700 (1315 July 10); (p. 62) De VI solidis in Werle de media salina sancti Iohannis, WUB XI, vol. 3, no. 2209, 1310 (1325 July 22); (pp. 62–63) Item de Werle, WUB XI, vol. 1, no. 541, 305 (1307 May 12); (p. 63) De resignatione domus Wenemari, WUB VII, no. 1605, 733 (1277 May 19); (pp. 63–64) De emptione sex solidorum in Werle, WUB VII, no. 2468, 1185 (1298 May 15); (p. 64) De bonis in Werle, WUB XI, vol. 2, no. 1202, 694 (1315 June 15); (p. 65) Item de bonis in Werle, WUB XI, no. 1196, 691 (1315 May 31).

In the following, the principle behind the organzation of the documents according to contents is unclear:

(pp. 65–66) De Gostia, WUB VII, no. 1455, 665 (1272); (pp. 66–67) De compositione Godfridi super quodam fossato et via, WUB XI, vol. 3, no. 1891, 1121 (1322 August 16); (pp. 67–68) De domino Henrico dicto Stikelinc, WUB VII, no. 1434, 654 (1272 May 20); (p. 68) De Vaneholt et manso in Sveve, WUB VII, no. 2586, 1244 (1300 May 22); (p. 68) De Vanenholt, WUB XI, vol. 1, no. 202, 104 (1303/1302 March 17); (pp. 68–69) De bonis in Borgelen emptis a Heydenrico, document remains unedited; (pp. 69–70) De casa cece Elisabet, WUB XI, vol. 3, no. 1880, 1114 (1322 July 18); (pp. 70–71) De malto sororis Sophie, WUB XI, vol. 2, no. 1007, 582 (1313); (p. 71) Item de malto sororis Sophie, WUB XI, vol. 3, no. 1960, 1171 (1323 April 25); (pp. 71–73) De bonis in Iungelinchusen, document remains unedited; (pp. 73–74) Item de bonis in Iungelinchusen, SUB 2, vol. 2 no. 658, 264 (1338 February 5); (pp. 74–75) De compositione Conradi et Hermanni de Reno, WUB VII, no. 2378, 1138–139 (1296 September 25); (p. 75) De compositione Corbike, WUB VII, no. 2609, 1255 (1300 October 24); (pp. 75–76) De compositione fossati cum Balken, WUB XI, vol. 1, no. 32, 16 (1301 May 6); (p. 76) De compositione Borchardi et Conradi de Clotinge, WUB XI, vol. 1, no. 111, 55 (1302 May 8); (pp. 76–77) De compositione Theoderici dicti Rogge, WUB XI, vol. 1, no. 261, 133 (1303 September 18); (p. 77) De compositione Arnoldi de Rollinchusen, WUB XI, vol. 1, no. 401, 208 (1305 May 30); (pp. 77–78) De Henrico de Clotinge, WUB XI, vol. 1, no. 495, 278–79 (1306 September 25); (pp. 78–79) De Theoderico de Meschede, WUB XI, vol. 1, no. 380, 197–98 (1303/1304 January 24); (pp. 79–80) De Frederico de Borgelen, WUB XI, vol. 1, no. 783, 449 (1310 June 30); (p. 80) De Rothlande, WUB XI, vol. 2, no. 1073, 617 (1313 October 7); (pp. 80–81) De Iohanne de Wostehof, WUB XI, vol. 2, no. 1323, 760 (1316 October 23); (p. 81) De Andrea dicto Snap, document remains unedited; (pp. 81–82) De bonis in Egginchus, WUB XI, vol. 1, no. 326, 172–73 (1304 May 26); (p. 82)

De bonis domine Christine de Tremonia, WUB VII, no. 1502, 685–88 (1274 August).

The text of the foundation history was first published in 1857 by Johannes Seibertz in the 'Quellen der West-fälischen Geschichte'.[2] The cartulary shows numerous traces of use and marginal notes from several centuries. The text of the present critical edition has been re-edited from scratch and is based on the manuscript; variants on Seibertz's readings are noted. Wherever possible the text has been left unemended in order to preserve its character. The editor has only intervened in the case of obvious errors or unclear sentence construction; the actual wording of the manuscript is then given in the critical apparatus. The subject apparatus elucidates the historical context, in as far as it can be reconstructed, with particular emphasis on the close links between the documents listed in the cartulary and the information given in the foundation legend. Punctuation and hyphenation in the Latin text follow modern usage. As c and t, and y and i as well as u and v are used without distinction in the manuscript, these letters have, for ease of understanding, been standardized according to their use as either a consonant or a vowel throughout the edition and the entire volume. Proper names are capitalized. Generally common abbreviations are resolved. Roman numerals are capitalized. The editor's insertions are enclosed in square brackets.

[2] *De institutione Paradysi, ed. Seibertz (1857): 4–13 (here-after Seibertz). Thanks to Nadine Hoffmann (Dusseldorf) and Pawel Figurski (Warsaw and Notre Dame, In.) for their preparatory work and collaboration on this edition and the commentary.*

[a]Hic libellus agit per totum de Paradisatio monasterio ordinis Predicatorum. De eius exordio et bonis etc. N. 20[a]
[b]De institutione Paradisi et humili ingressu sororum[b]

[*Decision to found the convent and acquisition of the site*]

Anno[c] domini M°CC°LII° [*1252*] magister Iohannes pater ordinis fratrum Predicatorum[3] veniens in Sosatum cum fratre Hermanno de Havelsberch[4] intellexit, quod fratres in Sosato intenderent, fratres de domo Theutonica promovere, ut in Alveldinchusen reciperent mansionem, de qua omnino cessaverunt propter introitus difficultatem. Tunc dixit magister: "Ex quo fratres in talibus se exponunt et occupant? Quare ordinem proprium in sororibus ordinis, ex quo locus habilis et amenus, et aptus est ad serviendum domino et beate virgini Marie, in eodem loco non promovent? Promoveant auctoritate et licencia nostra in nomine Ihesu Christi". Statim frater Hermannus supradictus[d] ex parte magistri commisit fratri Everhardo Clot,[5] quod opus tam sanctum promoveret. Qui statim parato et libenti animo hilariter obedivit et assumpsit sibi in socium fratrem Hinricum de Osthoven.[6] Qui primo attemptaverat de voluntate domini Hinrici,[7] cuius una

curia fuit. Qui consensit cum uxore sua domina Eveza[8] multum benigne. Soror Aleidis de Rothus[9] cum filia sua a domino Theoderico de Honrode[10] promptissimo animo emit proprietatem cum domo, quam habuit in Aldenieschen. Que valuit ei X malta annuatim, quia feodum fuit domini Hinrici predicti a domino Theoderico supradicto. Sic in hac parte cum domino Theoderico terminatum fuit hoc negotium.

Dominus Otto comes de Thekeneborch[11] cum uxore sua et cum omnibus heredibus suis devote et multum liberaliter dedit domum suam vicinam domui Hinrici, quam dixit se omnino liberam possidere et nullum aliquid iuris preter se in ea habere.[12] Postea frater Hermannus supradictus[e] commisit fratri[f] Conrado de Mulenarken,[13] qui tunc fuit prior fratrum Predicato-

[3] *The Dominican Johannes von Wildeshausen, also known as Johannes Teutonicus (1180–1252), was master of the Dominican Order from 1241 until 1253; see Lohrum, Art, 'Johannes Teutonicus' (1992), col. 595. Contrary to what the foundation legend reports, he arrived in Soest in autumn 1251; see Scheeben, Albert der Große (1931), 37–38, n. 11.*

[4] *The Dominican Hermann von Havelberg was provincial of the province of Teutonia from 1251 until 1254; see Loe & Reichert, Statistisches (1907), 12. In 1253 he acted as witness to the donation to Paradies by Heinrich von Alvoldinchusen of the enfeoffed main farm; WUB VII, no. 805, 356–57 (1253 July 25).*

[5] *Eberhard Clot was a Dominican friar in Soest. In 1253 he also acted as witness to the donation to Paradies by Heinrich von Alvoldinchusen of the enfeoffed main farm, WUB VII, no. 805, 356–77 (1253 July 25); on the Clot family see Michels, Genealogien (1955), 45.*

[6] *Heinrich von Osthoven was a Dominican friar in Soest. He composed an early version of the foundation legend, see Heinrich Osthofen aus Soest, 'Gründungsgeschichte', ed. Bruns (1974), 9–15, and was the first father confessor to the nuns. A Soest Dominican called Heinrich acted as witness to the donation of the allodial property to Paradies by Heinrich von Alvoldinchusen in 1252, WUB VII, no. 773, 341 (1252 before July 25). Heinrich came from the Osthoven family, which belonged to the Soest patriciate, and was probably the son of Albert von Osthoven.*

[7] *Heinrich von Alvoldinchusen was a ministerial of the archbishop of Cologne Heinrich I von Müllenark (1225–1238) (milite [...] Heinrico de Alvelenchusen, ministeriali nostro [Archbishop Heinrich of Cologne]), WUB VII, no. 348, 148 (1230). In 1252 he gave his allodial property in Alvoldinchusen to Paradies, WUB VII no. 773, 341 (1252 before July 25) and in 1253 another farm in Alvoldinchusen, which he held as a fief from Dietrich von Honrode, WUB VII no. 805, 356–57 (1253 July 25).*

[8] *Evesa is documented as the wife of Heinrich von Alvoldinchusen in 1252, WUB VII, no. 773, 341 (1252 before July 25).*

[9] *It has not proved possible to discover anything about Adelheid von Rothus (Rathus) and her daughter. The family obviously remained connected to the convent since a nun by the name of Elisabeth Rathus wrote the gradual D 12, today in the Universitäts- und Landesbibliothek Dusseldorf; see Part II, ch. 8.1, 190–92.*

[10] *The knight Dietrich von Honrode, also known as Dietrich von Soest [Theodericus de Susato dictus Honrode], WUB VII, no. 900, 404 (1256 May 26), was the feudal lord of Heinrich von Alvoldinchusen, who gave the convent of Paradies the enfeoffed farm in Alvoldinchusen, WUB VII, no. 805, 356–57 (1253 July 25). Dietrich inherited the farm from Hoio von Soest; see Wolf, 'Kirchen' (1996), 847. He was married to Kunigunde von Rüdenberg, the daughter of Konrad II von Rüdenberg; see Klocke, Studien (1928), 149. The family maintained its ties to Paradies: the successor, also called Dietrich von Honrode, sold Paradies the tithe in Einecke in 1298; WUB VII, no. 2505, 1204 (1298 November 1); WUB VII, no. 2506, 1205 (1298 November 1); WUB VII, no. 2507, 1205–206 (1298 November 8); WUB VII, no. 2526, 1214 (1299 June 5); WUB XI, vol. 1, no. 169, 89 (1303); WUB XI, vol. 1, no. 338, 178–79 (1304 September 14); WUB XI, vol. 1, no. 339, 179 (1304 September 17); WUB XI, vol. 1, no. 344, 182 (1304 September 22).*

[11] *Count Otto II von Tecklenburg (ca. 1198–1264) and his wife Mechthild von Holstein-Schauenburg gave Paradies the farm in Alvoldinchusen in 1251; WUB VII, no. 764, 338 (1251); WUB VII, no. 853, 381 (ca. 1254); WUB VII, no. 774, 393–94 (1255 June 18) which Herbord von Dortmund had held as a fief, WUB VII, no. 843, 377 (1254 October 10); WUB VII, no. 844, 377–78 (1254 October 10). In 1258 Otto freed the convent from all secular jurisdiction; WUB VII, no. 983, 446 (1258 April 23). Until 1173 the Tecklenburgs had owned the stewardship of the bishopric of Münster and until 1236 the stewardship of the bishopric of Osnabruck; see Zunker, Adel (2003), 216. On the death of Otto II the Tecklenburg family died out since his sons had died without issue before him.*

[12] *Otto von Tecklenburg's renunciation is also documented: WUB VII, no. 983, 446 (1258 April 23).*

[13] *In 1252 Konrad von Müllenark was prior of the Dominicans in Soest [frater Conradus quondam prior Predicatorum in*

rum in Sosato, auctoritatem magistri Iohannis, ut ipsi fratri Hinrico de Osthoven eandem[g] auctoritatem[h] in remissionem peccatorum suorum cum fratre Everhardo Clot et fratre Menrico[14] iniungeret. Quod licet esset eis valde grave suscipere, tandem propter obedientiam susceperunt. Cum autem ista, que iam incepta erant, aliquo modo competenter et prospere dei adiutorio se disponerent et per privilegia et litteras debitas et testimoniis[i] hominum confirmata, de consensu fratris Arnoldi[15] et supradictorum essent omnia ordinata, venit inimicus omnis boni et temptavit omnino iam bonum opus inceptum et subsequens modis diversis inpedire. Quia illusiones per ipsum de nocte sepe ibi vise sunt et alie dissimulationes[j] periculose contra dominum et contra salutem animarum et quia plura mala, que per eum et stultos homines ibi sunt facta, timuit amittere sicut fecit, deo omnipotenti[k] gracias. Isti fratres[l] supra notati, qui humiliter magistro ordinis obediverunt et provinciali fratri Hermanno,[m] tantum sunt tribulati et supra modum vexati a diversis hominibus, quod omnino decreverunt cessare ab incepto[n] *[p. 2]* opere sanctissimo.

Super tali continua tribulacione tandem dederunt se intime orationi coram altari beate Marie virginis, ut, si hoc negotium a beneplacito filii sui esset inchoatum, dignaretur aliquo modo ab ipso obtinere talia promoventibus in tanta tribulacione aliquam salubrem consolationem. Post orationem cessavit tribulacio et venit consolatio, quia per viros sanctos, magistrum et provincialem, fuit ad honorem dei simpliciter et ad salutem hominum inceptum bona intencione. Hoc veraciter compertum est, quod dominus opus inpedientes vel convertit ad bonum vel sustulit de hac vita.

Quidam iuvenis venit in Paradisum contumax et pertinax, qui minas loco et personis intulit dicens: "Ego omnibus modis destruam locum istum". Qui infra paucos dies occisus est. Quidam minabatur dicens: "Nisi recedant cito, ego occidam omnes et omnino delebo locum, quia a domino Herbordo[16] emi, que hic sunt".

Dominus Ionathas,[17] nobilis de Ardeia, dixit curiam suam esse. Prepositus de Sceda[18] similiter, dominus Hildegerus dictus de Foro[19] idem dixit. Pueri[o] de Alveldinchusen idem dixerunt. Ipse dominus Hinricus, qui quasi fundator tantam pensionem loco imposuit, quam non potuissent[p] commode persolvisse,[20] antequam aliquid inde recepisset, mortuus fuit – sicut speratur bona morte, quia se totum claustro cum magna devotione et contricione humiliter commisit. Multi cives Sosacienses, qui coluerunt agros, qui modo sunt Paradisi, valde reclamaverunt. Ista omnia sic a domino Ihesu

Susato]; *WUB VII, no. 846, 378–79 (1254 November 26), see Koske, 'Dominikaner,' vol. 1 (1994), 364.*

14 *Meinrich was a Dominican friar in Soest. In 1252 he acted as witness to the donation to Paradies by Heinrich von Alvoldinchusen of the allodial property; WUB VII, no. 773, 341 (1252 before July 25).*

15 *Arnold von Wiedenbrück was a ministerial of the bishop of Osnabruck. He entered Paradies as a lay brother and later became the first procurator in Paradies. In 1266 he received, as a conversus, a farm in Schwefe (curiam [...] in manus Arnoldi de Paradiso conversi [...] resignavit), WUB VII, no. 1243, 563 (1266 before December 25).*

16 *The knight Herbord von Dortmund [also known as Herrecke] was a vassal of Count Otto von Tecklenburg. In 1248 Herbord transferred the farm in Alvoldinchusen to Gottschalk Torc, who is similarly mentioned in the foundation legend as the one the people laying claim to the farm; WUB VII, no. 671, 296 (1248 September). Herbord and his wife renounced all*

rights to Alvoldinchusen; WUB VII, no. 842, 337 (1254 October 10); WUB VII, no. 843, 377 (1254 October 10); WUB VII, no. 844, 377–78 (1254 October 10); WUB VII, no. 2447, 1173 (1297/1298 February 8). The counts of Dortmund were the heirs of Rabodo von Rüdenberg, to whom Alvoldinchusen had originally belonged; see Hömberg, 'Geschichte' (1950), 55.*

17 *In 1254 Otto von Tecklenburg rejected the claims by Jonathan von Ardey; WUB VII, no. 852, 381 (1254 December 27); no. 857, 383 (1254/1255 January 3). Jonathan was a member of the Volmarstein family, which inherited a large part of the estate of Rathard von Rüdenberg through marriage to one of his daughters. Probably for that reason he named himself after a fortress on this property of Ardey as well as von Rüdenberg; see Hömberg, 'Geschichte' (1950), 55; Wolf, 'Kirchen' (1996), 847.*

18 *Provost Warmund presided over the Premonstratensian monastery of Scheda from 1293 until 1296; see Potthoff, 'Scheda. Prämonstratenser,' vol. 2 (1994), 328. The provost's claims to Paradies arose from the donation of the farm in Alvoldinchusen to the monastery of Scheda by Reiner von Freusberg on the wish of his wife Richenza. In her first marriage Richenza had been married to Rabodo von Rüdenberg, whose father Rathard, together with his wife Wiltrudis, had endowed the monastery of Scheda in 1143–1147. Reiner von Freusberg had given Alvoldinchusen to Hoio von Soest as a fief. Since Hoio von Soest was an ancestor of the Honrodes, Dietrich of Honrode probably inherited the farm and had to settle the debts that had been incurred; see Wolf, 'Kirchen' (1996), 846. Paradies obviously took over these debts. The dispute between the monastery of Scheda and Paradies because of the outstanding debts was resolved in 1294; WUB VII no. 2295, 1091–092 (1294 April 23).*

19 *Hildeger de Foro. The de Foro family belonged to the meliores, the early bourgeois elite in Soest, and for a long time were members of the patriciate; see Klocke, Patriziat (1927), 16–17; Bockhorst, 'Patriziat' (1996), 301–03.*

20 *The convent of Paradies was meant to build Heinrich von Alvoldinchusen a house close to their granary and pay off his debts, estimated at 12 marks. He had also agreed that every year between 11 November and 22 February the convent was to pay him 12 measures of grain, one cart-load of hay, eights cart-loads of firewood, and 20 cart-loads of straw; and the nuns' cowherd was to allow six of his cows to graze alongside the convent cattle; WUB VII, no. 805, 356–57 (1253 July 25); with regard to the levies Koske erroneously gives only one cart-load of firewood; see Koske, 'Paradiese' (1989), 129. See the following footnotes for the people who support Paradies and entered the convent.*

Christo auctore omnium bonorum sunt misericorditer et competenter ordinata et terminata, ut promoveretur[q] in suum obsequium et salutem hominum et precipue illorum ibi commorancium.

[*The "founding convent" of Paradies*]

Tunc misit deus[r] in mentem domini Arnoldi cuiusdam militis, qui morabatur in Widenbrugge, quod vellet se cum uxore et filiabus et cum omnibus rebus suis ad talem locum transferre. Unde fratres cum priore fratre Conrado, hoc audito, vocaverunt eum persuadendo et vitam eternam promittendo. Ipse credidit fratribus et ordini, se et sua de consilio fratrum domino simpliciter et totaliter obtulit et commisit. Secum de eodem oppido vocavit dominam Cunegundim,[21] feminam valde religiosam cum omnibus rebus suis, que statim priorissa fuit, licet laica.

Anno domini M°CC°LII° [*1252*] venerunt in Paradisum. Exemplo[s] sui domini Arnoldi videlicet et suorum multi secuti [sunt] quasi eodem tempore. Dominus Gerhardus miles de Lo[22] et uxor sua domina Agnes locaverunt ibi duas filias suas. Mortuo domino Gerhardo venit domina Agnes et se et pueros suos et omnia, que habuit, devotissime in Paradiso et aliis religiosis pro deo[t] obtulit. Frater Bertuitius[23] cum uxore sua et filia Gerberge totaliter venit,[u] sic frater Arnoldus[24] cum matre sua, sic soror Alheidis de Rothus cum filia sua, taliter dominus Hinricus de Ruden[25] cum uxore et filia

totaliter[v] venit.[w] Dominus Hildegerus de Wlerike[26] filiam unam et alii cives quamplures locaverunt ibidem filias suas. Frater Theodericus de Rykelinchus[x][27] accensus spiritu sancto maximo affectu afficiebatur ad promovendum Paradisum, quod cum effectu optime postea obtinuit. Primo patrem suum induxit, quod in edificiis et in bonis emendis Paradiso multum profuit, secundo dominam Christinam vocavit de Tremonia,[28] [*p. 3*] que ex magno desiderio filiam suam dilectissimam cum gloriosis edificiis et aliis expensis et rebus ibidem locavit, tercio filiam domine Bele[29] et filiam domine Margarete de Tremonia,[30] que[y] multum promoverunt locum Paradisi [et] dominum Hinricum[31] gogravium cum uxore sua. Ipse frater Theodericus fideliter et multum utiliter istos vocavit de Tremonia et alia multa bona idem Theodericus per sollicitudinem continuam et laborem suum magnum in pertinentiis[z] et in temporalibus rebus utiliter[aa] promovit. Fratres quibus a principio a magistro ordinis et provinciali istud sanctum negotium fuerat commissum videntes rem fieri a spiritu sancto retulerunt gratias omnipotenti deo[bb] et beate virgini Marie et beato Dominico et omnibus sanctis, quia per talem devotum fratrem pene omnis sollicitudo et labor eorum cum gaudio dei[cc] finem accepit,[dd] maxime quan-

[21] *Kunigunde, who came to Paradies with the knight Arnold von Wiedenbrück, became the first prioress of Paradies while still a laywoman (see Part I, ch. 1.1, 20).*

[22] *Agnes von Lo, wife of the knight Gerhard, entered Paradies after her husband's death. Before taking vows, she gave half of the Wüstehof to the hospice at Paradies in 1298; WUB VII, no. 2511, 1207–208 (1298/1299 January 13). She also purchased annuities from grain from the farm at Drüggelte which the convent had at its disposal in 1303; WUB XI, vol. 1, no. 219, 113–14 (1303 May 15). Nothing could be found out about her daughters. Members of the von Lo family belonged to the bourgeois ministeriales of the archbishop of Cologne and to the patriciate in Soest. From the mid-thirteenth century onwards further members of the family became burghomasters of Soest; see Klocke, Alt-Soester Bürgermeister (1927), 101.*

[23] *As all those mentioned in this section are burghers, Berthold, his wife and his daughter Gerburgis will also have come from the region around the town. The term* frater *suggests that Berthold later became a laybrother. A Gerburgis is documented in 1300 as abbess of Paradies; WUB VII, no. 2614, 1258 (1300 November 29).*

[24] *Nothing could be found out about brother Arnold and his mother. He, too, was probably a lay brother in Paradies.*

[25] *In 1306 a Heinrich von Rüthen, town councilor in Soest, was twice witness to gifts to Paradies; WUB XI, vol. 1, no. 465, 259–60 (1306 May 23–29); WUB XI, vol. 1, no. 486, 272–73 (1306 August 19).*

[26] *In 1292 the Soest burgher Hildeger von Flerke sold provost Dietrich von Soest a farm in Ampen which was then transferred to Paradies; WUB VII, no. 2230, 1054–55 (1292 April 28). Nothing could be found out about his daughters. Members of the von Flerke family were members of both the ministeriality of the archbishops of Cologne and the patriciate and council in Soest. In the mid-thirteenth century Ludbert von Flerke was burghomaster of Soest; see Klocke, Alt-Soester Bürgermeister (1927), 79.*

[27] *In 1274 Dietrich von Recklinghausen was involved in the payment for the farm of Drüggelte by Christina von Dortmund; WUB VII, no. 1502, 685–88 (1274 August). As he is called* frater *in the foundation history, he probably entered the Dominican order as a lay brother.*

[28] *In 1274 Christina von Dortmund paid the purchase price of a farm in Drüggelte for the newly erected convent of Paradies; WUB VII, no. 1502, 685–87 (1274 April). There is evidence for the von Dortmund family (which came to Soest from elsewhere) in the city from 1225 onwards; see Klocke, Patriziat (1927), 27.*

[29] *Nothing could be found out about Bela von Dortmund and her daughter.*

[30] *The son of a Margarete von Dortmund, in 1271 Johann von Dortmund sold Paradies part of the revenues from two farms in Soelde; WUB VII, no. 1403, 639 (1271 October 24). At the end of the fourteenth century the nun Elisabeth von Lünen copied and illustrated a gradual for the Dortmund Dominicans; see Marti, 'Schwester Elisabeth' (2006), 277 and Part II, ch. 4.1 and 4.2, 93-98.*

[31] *Nothing more could be found out about Gaugraf Heinrich. However, it is probable that he was judge at the district court in Recklinghausen, from which Dietrich von Recklinghausen recruited him for Paradies.*

do[ee] viderent hunc iuvenem constantem et cito in nulla adversitate in honestate multum moveri.

[Albertus Magnus and the entry into the Dominican order of the nuns at Paradies]

Sub domino Alberto,[32] qui tunc fuit prior provincie fratrum Predicatorum, sorores intraverunt Paradisum. Locum, qui ex antiquo vocabatur Alveldinchusen, nunc propter utilitatem et amenitatem vocatus est Paradisus.[33] Et merito, quia sicut primi parentes, si obedientiam[ff] deo[gg] servassent, migrassent sine omni pena ad dei[hh] iussionem et vocacionem in gloriam vite eterne, sic iste sorores et alii ad Paradisum pertinentes, si veram obedientiam humiliter custodiunt et ad quaslibet curiositates et levitates cito moti non fuerint, transferentur per gratiam domini nostri Ihesu Christi de isto lugubri paradiso in illam iocundam et gloriosam[ii] et inenarrabilem letitiam, ubi beata virgo Maria cum dilectissimo filio suo et cum omnibus sanctis sine fine regnabunt. Iste idem dominus Albertus venit ad Paradisum ex instantia et rogatu fratris Arnoldi, qui ad hoc manens in habitu seculari, res et possessiones suas pro utilitate Paradisi distraxerat et vendiderat. Et dominus episcopus, cuius ministerialis fuerat, et uxor et omnes filie eius eodem iure ei pertinebant, volebat impedire, quia invitissime carere voluit ecclesiam suam Osnaburgensem tam honesto viro, sed tandem cessavit.

Dominus Albertus predicavit valde paucis personis, acsi multi fuissent ibidem in Paradiso predicens eis, quomodo secundum regulam beati Augustini et secundum constitutiones ordinis fratrum Predicatorum vivere deberent: propter deum communia diligere, propria contempnere, humiliter, paciener, sine murmure, sine detractione et statim sine mora malivolencie hilariter obedire. Et hoc adiunxit firmiter : "Per sepes et seras et portas et ianuas et fenestras debetis claudi et custodiri et nunquam loqui in loco et tempore prohibito nec per sepem nec ultra sepem nec per parietem sine licentia et socia vel sociabus. In locis honestis et cum personis non suspectis sed matronis utilia semper[jj] tractanda sunt. Prohibita omnino sine vera licencia vel dispensacione non facietis. Pro utilitate et honestate a maioribus discrete ordinata non omittetis. Nihil dare, nihil servare, nihil recipere, nihil de secretis ordinis vel capituli vel etiam intus vel foris alicuius fratris vel sororis revelare debetis vel recitare alicui homini, quantumcumque[kk]

familiaris sit, ne vera pax et caritas tepescat inter vos vel, quod absit, non destruatur. Avertat hoc dominus a vobis, ne sitis ingrate beneficiis suis et ordinis. Beneficia dei sunt, que vobis propter eum ab ordine ministrantur: Verbum optime[ll] predicationis, visitatio sincere vestre correctionis in capitulo, ministracio sacramentorum, videlicet corporis domini et extreme unctionis et confessionis peccatorum *[p. 4]* et diligens custodia vestri, que est salus animarum vestrarum et provisio temporalium. Sed, qui minima negligit,[mm] paulatim defluit." Ad hoc[nn] dominus Albertus episcopus, qui tunc fuit provincialis, ista illis paucis personis inculcando subiunxit dicens: "Ecce humiliter et devote venistis in locum istum, non in curribus, non in equis,[34] non in tumultu hominum, non in aliqua pompa seculari, sed nudis pedibus et habitu humili, quando VI[ta] feria in mane missa celebrata fuit. In hoc imitate sponsum vestrum Christum, statim omnibus vestris relictis post missam sine omni mora huc festinastis, vos et omnia vestra Ihesu Christo devote donantes in hoc loco vos permansuras et de cetero nunquam exituras, deo et magistro ordinis et mihi Alberto provinciali, loco magistri ordinis, vovistis in ecclesia sancte Marie. Quod votum recepi de consilio prioris et omnium amicorum vestrorum et vobis et successoribus vestris confirmo in nomine patris et filii et spiritus sancti et hec observantibus debetur ista benedictio. Felix sit exitus, sancte sorores,[oo] sanctum corpus cum exequiis commendent[pp] terre devote, angeli vero sancti sanctam animam in Paradisum perhennis felicitatis sine omni purgatorio Christo et beate[qq] virgini Marie et omnibus sanctis recommendent in ineffabili gloria et leticia sempiterna. Qui ista fideliter firmiterque crediderit et servaverit, salvus erit."

Ad hoc plura egit dominus Albertus. Ipse dispensacionem domini Hugonis cardinalis[35] confirmavit, que facta fuit per eum circa Gertrudim et Oda[m],[36] filias fratris Arnoldi primi provisoris, et Lisam, ut de regula beati Benedicti ad regulam beati Augustini[rr] transirent in Paradiso de monasterio dicto[ss] Buren. Et hoc diligentissime eisdem et omnibus sororibus commisit et observare eas monuit, ne per nimiam multiplicationem personarum, indiscrete personas recipiendo nec edificia supra posse faciendo destruerent se et locum istum,

32 *The Dominican Albertus Magnus (1200–1280) was provincial of the province of Teutonia from 1254 until 1257 and bishop of Regensburg from 1260 until 1262; see section on the consecration of the altar Part I, ch. 1.2, 21.*

33 *The name Paradies appears for the first time in a document from 1254 [Alvoldighusen iuxta Sosatum, qui locus nunc dicitur Paradisus ad honorem beate Marie ad faciendum claustrum secundum consilium fratrum ordinis Predicatorum]; WUB VII, no. 852, 381 (1254 December 27).*

34 *Bernard of Clairvaux, Opera, eds. Leclercq et al. (1957-1977), vol V, 48: non in curribus et in equis. Thanks to Hartmut Hoffmann, Göttingen, for the reference.*

35 *In 1253 the cardinal legate Hugo bestowed on the convent of Paradies fundamental privileges: papal protection and the permission to hold services of worship in silence in the case of an interdict on the state, WUB VII, no. 789, 349–50 (1253 March 8); WUB VII, no. 792, 351 (1253 March 17); WUB V, no. 551, 253 (1255 April 22).*

36 *Gertrud and Oda, the daughters of Arnold von Wiedenbrück, and Lisa were probably nuns in Cistercian convent of Holthausen near Büren; see Wolf, 'Kirchen' (1996), 851.*

sed expectarent, donec in temporalibus et in beneficiis et in elemosinis fidelium in tantum proficerent, ut sine lesione et impedimento regularis discipline edificia temporalia erigerent.

[Arnold von Wiedenbrück as procurator at Paradies]

Frater Arnoldus difficulter se absolvit a seculo, quia valde secularem vitam duxerat. Acceptus fuerat domino suo episcopo et omnibus tam nobilibus quam ministerialibus. Monachi, religiosi, clerici, laici, sui cognati et universus populus, omnes eum diligebant. Graciosus homo fuit, valde strenuus[tt] cum militibus et omni milicia fortis, corpore magnus, bone et honeste eloquencie, discretus et fidelis in omnibus consiliis, inimicis terribilis, amicis et cognatis suis et domino suo episcopo et ecclesie sue fideliter expositus. Quantum ipse expositus fuerit prelatis ordinis Predicatorum et omnibus fratribus honeste et laute procurando eos, vecturas eis prestando, quandoque[uu] bene sedecim et hoc sepius fecerit, ad diversa loca eos deducendo, hoc fratres recognoverunt ei. Hec et talia similia adhuc existens in seculo hilariter et devote fecit. Et similia fecit postquam habitum et ordinem et procuracionem in Paradiso receperat. Quam humiliter et utiliter fratribus in peticionibus profuit eundo cum eis et saccum eorum portando et expo *[p. 5]* nendo eorum necessitates ad singulas domos et personas bene dignum fuit et est, quod fratres nunquam per ingratitudinem ei et uxori sue et filiabus obliviscantur.

Cum frater Arnoldus primo intravit Paradisum et plene a priore recepisset curam tocius loci et omnium temporalium eius, invenit quasi omnia minus bene ordinata. Sed dominus Herbordus,[37] prepositus quondam sancte Walburgis, et dominus Menricus iudex,[38] dominus Rutbertus Fernere[39] et dominus Albertus de Osthoven[40] cum aliquibus fratribus ad hoc ordinatis, in omnibus consiliis et placitis fideliter assistebant ei. De consilio istorum redemit agros expositos, quorum vix inuenit V[que] iugera absoluta de omnibus agris et de consilio eorundem composuit cum domino Tork[41] de curia sua et cum Thethmaro[vv42] et cum domino Herbordo de Tremonia et cum domino Stephano,[43] qui omnes dicebant curiam esse suam, quam dominus Otto comes de Thekeneborch constanter affirmavit, quod nullus in toto mundo aliquid iuris haberet preter se. Tale litigium taliter oportuit terminari vel omnino iam propositum sanctum adnichilari. Ipse frater Arnoldus innisus[ww] consilio predictorum et confisus plene in domino Ihesu Christo, statim largam elemosinam pauperibus et caritativam receptionem hospitibus et conventui suo intus et foris confratribus suis et familie sue honestam provisionem et in victu et vestitu competentem procuracionem exhibuit. Ipse multum paci et vere humilitati quandoque[xx] propter humilitatem suam et discrecionem plus sequebatur voluntatem aliorum quam propriam, quia speravit sicut infra paucos annos ei occurrit, quod parve res per concordiam bonam crescerent,[44] quod per malam discordiam omnino perirent et si multe essent. Cum bonis et rebus, que secum detulerat de Widenbrugge, in annona, in denariis, in equis et in aliis bonis satis utilibus utensilibus locum extulit. Iste modus vivendi, quem sic arripuit circa principium, tantam a domino accepit graciam, quod mirabiliter cepit habundare.

Tempore cariscie plenas domos in Sosato cum tritico et cum alia annona et victualibus occupaverat et eis, qui hoc percipientes, venerunt ad Paradisum de diversis civitatibus et terris, quasi ad solempne forum, vendidit. Propter hoc tanta fama bona volavit de probitate provisoris et de sanctitate conventus, quod comes et comitissa de Arnesberch[45] festinaverunt ibi

[37] *Herbord was provost of the old Augustinian chapter of canonesses St. Walburgis in Soest. Herbord acted as witness to both the gift of the allodial property by Heinrich von Alvoldinchusen; WUB VII, no. 773, 341 (1252 before July 25) and the gift of the enfeoffed farm to Paradies by Heinrich von Alvoldinchusen; WUB VII, no. 805, 356–57 (1253 July 25).*

[38] *Nothing could be found out about the judge Meinrich.*

[39] *Master Robert Ferner (1252–1268) was a member of the Soest patrician family. He was probably the son of Gottschalk Ferner. From 1251 until 1253 his brother Gottschalk was burghomaster of Soest together with Albert von Osthoven. Other members of the family were also burghomasters and from 1280 onwards some were members of the chapter of St. Patrokli; see Klocke, Alt-Soester Bürgermeister (1927), 80–81. In both 1303 and 1312 a member of the Ferner family, also called Robert, sold Paradies a farm in Schwefe, the titles of which were given to Paradies, WUB XI, vol. 1, no. 221, 114–15 (1303 May 23); WUB XI, vol. 1, no. 993, 572 (1312 November 16).*

[40] *From 1246 until 1248 and from 1250 until 1252 Albert von Osthoven was burghomaster of Soest. In 1252 he was witness to the gift to Paradies of his allodial property by Heinrich von Alvoldinchusen, WUB VII no. 773, 341 (1252 before July 25). Albert's son Heinrich might later have been father confessor to the sisters at Paradies, while his son Gerhard became a canon in St Patrokli. The Osthoven family were a patrician line from Soest, see Klocke, Alt-Soester Bürgermeister (1927), 82–83.*

[41] *In 1248 Herbord von Dortmund transferred Alvoldinchusen as a fief to the knight Gottschalk Torc; WUB VII, no. 671, 296 (1248 September); in 1254 Gottschalk was witness to Herbort von Dortmund's renunciation of Alvoldinchusen; WUB VII no. 843, 377 (1254 October 10).*

[42] *Detmar Riddere is probably meant here; he had sold Paradies the rights of use for the farm given to the convent by Otto von Tecklenburg, see n. 11. In 1283 he came to an agreement with Paradies about the outstanding sum of money; WUB VII, no. 1878, 873–74 (1283 August 15); cf. Wolf, 'Kirchen' (1996), 845–46.*

[43] *No trace of a master Stephan could be found in the sources.*

[44] *Sallust, Bellum Iugurthinum X, 6 (Nam concordia parvae res crescunt). Thanks to Hartmut Hoffmann, Göttingen, for the reference.*

[45] *From 1271 until 1303 Jutta, the daughter of Count Gottfried III*

locare filiam suam. Domina Ida nobilis domicella de Essendia[46] cum magno desiderio et humilitate obtulit se ibidem. Nobilis dominus Conradus de Rudenberch[47]

et uxor sua filias duas dilectas ibidem locaverunt. Frater Arnoldus de Effle,[48] quasi altera manus fratris Arnoldi sicut in vulgari[yy] solet dici, venit cum unica filia sua valde devote et utiliter. Dominus Hinricus,[49] qui fuit quasi filius fundatorum,[zz] ministravit ab inicio in officio sacerdotali sancte et devote. Multi, qui in principio contempserant, quod fiebat in Paradiso, postea, cum vellent habere eorum familiaritatem, consequi non valebant, quia tot et tanti desiderabant eorum familiaritatem, quod ibi non poterat omnibus satisfieri.

[*Address by Heinrich von Osthofen to the sisters at Paradies*]

[aaa]"Sorores de Paradiso, sitis memores cum gratitudine, qualiter prior frater Godefridus, frater Iacobus[50] et frater Albertus et quasi totus conventus fratrum Predicatorum vos promoverint. Prior sacrum *[p. 6]* velamen vobis inposuit, cum essetis numero XII. Episcopus[51] altare vobis consecravit, frater Everhardus Clot multo populo predicavit sub divo, sub tentorio[bbb] pulchro, in aere et tempore pulchro devotissime celebraverunt missas suas fratres. Eodem tempore et die valde devotum festum factum fuit deo[ccc] et vobis. Sorores karissime, introitus vester fuit sanctus, conversatio vestra sit sancta, finis vester sit sanctus per misericordiam Ihesu Christi, cuius sponse estis. Cum quo et cum beata virgine Maria, que[ddd] custos vestra est, et cum omnibus sanctis sit post mortem vita eterne glorie. Amen."

von Arnsberg, was a nun in Paradies and from 1298 probably sub-prioress of the convent; WUB VII no. 1388, 632–33 (1271 April 22); WUB VII, no. 1445, 659 (1272 September 21); WUB VII, no. 2409, 1153 (1296 March 9 / 1297 March 29); WUB VII, no. 2511, 1207–08 (1298/1299 January 13); WUB IX, vol. 1, no. 219, 113–14 (1303 May 15). The Arnsbergs gave Paradies estates in Drüggelte; WUB VII, no. 1388, 632–33 (1271 April 22) which included a mill; WUB VII, no. 2409, 1153 (1296 March 9/ 1297 March 29); estates in Schwefe and the corresponding property rights; WUB VII, no. 1001, 454–55 (1258); WUB VII, no. 1445, 659 (1272 September 21), WUB VII, no. 1493, 681–82 (1273/1274 March 23); a farm in Glashelm; WUB VII, no. 1158, 526 (1264 July 25); and the stewardship of a farm in Nordwalde; WUB VII, no. 1159, 527 (1264 July 25). Paradies gained access to important networks through the Arnsbergs; on the Arnsbergs see, most recently, Leidinger, Grafen von Werl (2009); Gosmann, 'Die Grafen von Arnsberg' (2009): from 1255 until 1300 Jutta's sister Agnes was abbess of the abbey of Meschede. The abbess and convent of Meschede supported the young monastic foundation with presents of property in Steterdorp; WUB VII, no. 1206, 546 (1265), near Ampen; WUB VII, no. 1474, 672–73 (1273 May 17); WUB VII, no. 1646, 751–52 (1278 June 6); WUB VII, no. 1671, 765–66 (1278 March 9) and near Epsingsen; WUB VII, no. 1445, 659 (1272 September 21); WUB XI, vol. 4, no. 1842, 1091–092 (1322 May 1). Jutta's aunt Bertha von Arnsberg († 1292) was abbess of the chapter of canonesses in Essen for about 50 years.

46 *Ida von Essen could not be identified. Thanks to the Arnsberg family there was a connection between Paradies and Essen (see n. 45).*

47 *The daughters of Konrad III von Rüdenberg are mentioned in a document from 1271 [ob dilectionem filiarum nostrarum ibidem]; WUB VII, no. 1418, 646–47 (1271/1272 January 20) in which Konrad III von Rüdenberg approved the sale to Paradies of 20 acres of land in Schwefe. Since this probably provided the sisters' dowries, they entered Paradies at the same time as the daughter of Gottfried III (see n. 45). The Rüdenbergs were a branch line of the Arnsbergs and, especially in the second half of the twelfth century, were amongst the wealthiest, most influential nobility in Westphalia; see, most recently, Pardun, Edelherren von Rüdenberg (1980), 50. They owned the free county of Werl-Soest in which Paradies was situated, on the three different branches, see Pardun, Edelherren von Rüdenberg (1980), 42–62. This made them the most important legal, but also financial, supporters of the convent. In 1263 they gave the convent the Ridderinghof with the advowson of the parish church in Schwefe; WUB VII, no. 1126, 510–11 (1263 August 11); WUB VII, no. 1255, 566–67 (1267 May 11); WUB V, no. 679, 320–21 (1268 April 2); WUB VII, no. 1825, 845–46 (1282 September 4); WUB VII, no. 2036, 959 (1287 May 24); WUB XI, vol. 1, no. 761, 433–34 (1310/1309 March 16); and gave, confirmed, or renounced many more estates: in Schwefe, WUB VII, no. 1394, 635–36 (1271 June 4); WUB VII, no. 1418, 646–47 (1271/1272 January 20); WUB VII, no. 1910, 888–89 (1284 June 8); WUB VII, no. 1911, 889 (1284 June 8); WUB VII, no. 2282, 1084–085 (1293/1294 January 20); WUB VII, no. 2286, 1087 (1293/1294 February 14); WUB XI, vol. 1, no. 221, 114–15 (1303 May 23); WUB XI, vol.*

2, no. 993, 572 (1312 November 16); WUB XI, vol. 2, no. 1007, 582 (1313); and in Einecke, WUB XI, vol. 1, no. 695, 400–01 (1309 June 9). In addition, Konrad III acted as guarantor for and supporter of Paradies, WUB VII no. 1660, 758–59 (1278 December 14); WUB XI, vol. 1, no. 202, 104 (1303/1302 March 17). Finally, in 1306 Gotfried I renounced the rights of their free county in Paradies, WUB XI, vol. 1, no. 486, 272–73 (1306 August 19).

48 *Arnold de Effle was a member of the Soest patrician family of Effeln; see Klocke, Patriziat (1927), 42. In 1266 either he or a relative appears as a witness, WUB VII, no. 1243, 563–64 (1266 December 25). In 1274 members of the Effeln family gave Paradies estates in Effheldehusen, WUB VII, no. 1507, 688 (1274 December 3). As he is here called* frater *he was probably a lay brother in Paradies.*

49 *The father confessor Heinrich von Osthofen is obviously meant here (cf. n. 6).*

50 *In 1280 there is documentary evidence for a Dominican friar called Jakob in Soest, WUB VII, no. 1726.*

51 *On the consecration of the altar, see Part I, ch. 1.2, 21.*

Computatio receptorum et expensarum.

Frater Arnoldus gratia domini nostri Ihesu
Christi[eee] tactus reliquit vitam secularem honestam,
5 submisit se et uxorem suam et filias suas et pulchras
res plena deliberacione prelatis et fratribus ordinis
Predicatorum et ordini eorum. Qui locaverunt[fff] eum
et suos et cum omnibus, que habuit, ut in Paradiso,
ubi vocaverunt eum, inchoaret claustrum sororum
10 ordinis Predicatorum. Cum sic intraret locum Paradisi,
non invenit domos nec horrea, nec agros, sed paucos
vix VII nec sepem circa aream. Ante mortem suam
edificavit domos, pistrinum cum molendino, domum
familie, IIII[or] horrea, caminatam de Sveve, sepem circa
15 omnem aream. Agros expositos solvit, hoc faciendo
ducentas marcas expendit. Has curias emit: Bukele,[52]
Wostenhof[53] pro CCC[a] et L[a] marcis, Ridderinchof[54] pro
CCCC[tis] marcis, Torkonis curiam[55] CCCC[tis] marcis.
Quid ordinaverit cum denariis in Kuddenbeke[56] et in
20 Thodinchusen[57] et plura, que comparavit, et ordinavit
de pluribus rebus emptis et de expensis factis, sepius
ante mortem adhuc sanus computavit, que hic scripta
sunt. Et inventum fuit coram prelatis ordinis et fratribus
et sororibus, quod mille et CCCC[tas] marcas receperat
25 et per istam pecuniam hereditatem, que hic superius
nominata est,[ggg] comparavit, que valuit et valet duo
milia marcarum[hhh] et ducentas marcas. Et in omnibus
cavit omne genus debitorum et sine debitis mortuus est
et reliquit Paradisum cum multa annona et bonis equis
30 et multis pecoribus. Et pius[iii] fuit et misericors circa
conventum suum in victu et vestitu. Et tempore caristie,
trecentos pauperes duobus diebus in septimana in bona
elemosina misericorditer respexit. Et ideo[jjj] Dominus
eum benigne respexit. Anima eius per misericordiam
35 dei requiescat[kkk] in pace. Amen.

[52] In 1257 Archbishop Konrad of Cologne confirmed ownership
of property in Bukele which the Soest burgher Hermann had
previously held as a fief, WUB VII, no. 961, 435–36 (1257
August 24). The chapter of canons at St Patrokli in Soest ob-
viously had rights to the farm as well; it renounced them in
1279; WUB VII, no. 1692, 775 (1279 November 22).

[53] On the Wüstehof, see n. 22.

[54] On the Ridderinghof, see n. 47.

[55] Torc's farm probably refers to the foundation farm in Al-
voldinchusen which Count Otto von Tecklenburg gave to
Paradies (see n. 16).

[56] Nothing could be discovered about Kutmecke.

[57] Todinghausen gave its name to a patrician family in Soest, so
that we may assume members of this family were connected
to Paradies, see Klocke, Alt-Soester Bürgermeister (1927),
89–90. A Ludbert von Thodinghausen is mentioned twice in
lists of witnesses, WUB VII, no. 1910, 888–89 (1284 June 8);
no. 1911, 889 (1284 June 8).

Ista omnia rescripta sunt de manuscripto pie
memorie fratris Hinrici de Osthoven primi patris[lll] et
confessoris sororum de Paradiso fideliter, sicut ab ipso
sunt edita et conscripta.

a	completed in the upper margin by an early eighteenth-century hand
b-b	rubricated, next to it Anno domini M°CC°LII° magister Iohannes
c	two-line rubricated initial
d	ms. supradictos
e	ms. supradictos
f	Seibertz fatri
g	ms. eadem
h	ms. auctoritate
i	unclear, written over an erased section
j	ms. dissolutiones, also Seibertz
k	Seibertz optimo
l	written over an erased section
m	Seibertz Hinrico
n	at the edge in the early eighteenth-century hand In auct est
o	Seibertz parvi
p	scilicet sanctimoniales
q	Seibertz promoueatur
r	Seibertz dominus
s	Seibertz exemplum
t	Seibertz pro dono
u	Seibertz venerunt
v	ms. totus
w	Seibertz venerunt
x	Seibertz Rykelinchusen
y	Seibertz qui
z	Seibertz inprimis
aa	Seibertz multum
bb	Seibertz domino
cc	Seibertz domini
dd	Seibertz acceperat
ee	Seibertz quum
ff	written over an erased section
gg	Seibertz domino
hh	Seibertz domino
ii	et gloriosam is missing in Seibertz.
jj	Seibertz sepius
kk	Seibertz quantumcunque
ll	above it the resolved abbreviation optime in a later hand
mm	ms. neggligit
nn	Seibertz hec
oo	Seibertz sororis
pp	Seibertz commendetur
qq	Seibertz beati
rr	ms. Augustin
ss	ms. dicco
tt	ms. strennuus
uu	Seibertz quanquam
vv	Seibertz thetmaro
ww	Seibertz inuisus
xx	Seibertz confidens
yy	ms. wlgari
zz	Seibertz fundatoris
aaa-aaa	This section of the foundation history matches the text of a fragment from Paradies dating to 1270 and preserved in the Stadtarchiv Soest. However, the next lines from the

fragment were not included or rewritten in the cartulary: in Paradiso, quia ibi comittuntur furta et multa miserie corpora gravantur, et totus homo in deterius mutatur, et iam ista consuetudo pessima in tantum inolevit in aliquibus locis, quod minus faciunt homines claustris quam de iure deberent. Propter hec etiam terrentur aliqui, qui potius locant pueros suos ad seculum quam ad claustrum. Ista laudabilis compromissio servata fuit circa xx personas, et omnes boni et diligentes deum ex toto corde laudabant eam (see *Heinrich Osthofen aus Soest, 'Gründungsgeschichte', ed. Bruns (1974), 9.*

bbb *Seibertz* subtentorio
ccc *Seibertz* domino
ddd *Heinrich Osthofen aus Soest, 'Gründungsgeschichte', ed. Bruns (1974)*, quo
eee *Seibertz* christri
fff *ms.* locacaverunt
ggg *Heinrich Osthofen aus Soest, 'Gründungsgeschichte', ed. Bruns (1974)*, ets
hhh *Heinrich Osthofen aus Soest, 'Gründungsgeschichte', ed. Bruns (1974)*, Mar.
iii *Seibertz* preterea
jjj *Seibertz* idcirco
kkk *Heinrich Osthofen aus Soest, 'Gründungsgeschichte', ed. Bruns (1974)*, requiesat
lll *Seibertz* prioris

Translation

This little volume contains a complete account of the Dominican convent of Paradies, of its origins and of its property, etc.

On the founding of Paradies and the humble entry of the sisters

[*Decision to found the convent and the acquisition of the site*]

When Johannes, the master of the Order, came to Soest with brother Hermann von Havelberg in the year of our Lord 1252, he realized that the friars in Soest intended to induce the brothers of the Teutonic Order to move into a building in Alvoldinchusen. They, however, then completely refrained from doing so because of the difficulties involved in taking possession of it. At that time the master of the Order said: "Why do the friars become so involved in this matter and bother with such affairs? Why do they not support their own Order and their sisters in that Order, since the location, after all, is convenient and delightful and suited to service of the Lord and of the holy Virgin Mary? They should promote them with our authority and permission in the name of Jesus Christ". Soon the friar to whom we have already referred, brother Hermann (von Havelberg), charged brother Eberhard Clot, in the name of the master of the Order, with supporting and promoting this most holy work. The latter immediately obeyed with

a cheerful, willing, and joyful heart and chose brother Heinrich von Osthoven to be his companion. First of all, he enquired after the intentions of lord Heinrich (von Alvoldinchusen), who owned a farm. Heinrich was very happy to agree with his spouse, Lady Evesa. Sister Adelheid von Rothus quickly made up her mind and, together with her daughter, bought the plot of land along with the house owned by lord Dietrich von Honrode in Alvoldinchusen. This brought him revenue of ten measures [of grain] annually because the above-mentioned lord Heinrich held the land as a fief from the above-mentioned lord Dietrich. Thus business with lord Dietrich was concluded on this side.

Lord Otto, count of Tecklenburg, together with his wife and all his heirs, piously and very generously donated the house he owned next door to Heinrich's, saying he owned it without reservation and no one apart from him had any sort of right to it. At a later date, the above-mentioned brother Hermann (von Havelberg) transferred to brother Konrad von Müllenark, at that time prior of the Dominican friars in Soest, the plenipotentiary power of the master of the Order, Johannes. He did so in order that Konrad might transfer this same power to remit their sins to brother Heinrich von Osthoven, together with Eberhard Clot and Meinrich. Although they struggled with accepting this authority, their obedience eventually prompted them to do so. Thus with God's help what had already been started reached a conclusion that was, to some extent, appropriate and felicitous: everything had been confirmed, with privileges, the necessary documents and witness statements by people and had gained the necessary assent from brother Arnold and the people named above. At this very moment, however, the enemy of everything virtuous came to them and attempted to put obstacles in the way of work already begun and to follow, work which on the whole was good. Thus confusing apparitions were frequently seen there at night, all caused by the devil; as well as other dangerous illusions directed against the Lord and the salvation of the soul; and many other evil acts performed there by him and foolish people, because he (the devil) feared losing everything, as then happened, for which be praise to almighty God. The above-mentioned friars, who had humbly obeyed the master of the Order and the provincial, brother Hermann, were sorely importuned and tormented beyond measure, with the result that they decided to desist entirely from the most holy work that had already been begun.

This unceasing affliction finally moved them to give themselves up to profound prayer before the altar of the holy Virgin Mary. They prayed that, if this endeavor had been undertaken with the approval of her son (Christ), she might deign in some way to win from him healing comfort in their ordeal for those who were support-

ing these efforts. After they had prayed their troubles abated and comfort arrived, because the work had been started by the holy men—the master of the Order and the provincial—with the good intention of honoring God and bringing salvation to men. Truly, it was later discovered that the Lord either converted to the path of virtue all those who had obstructed the work, or took them from this life.

A wayward, stubborn youth came to Paradies, uttering threats against both place and people and saying: 'I will destroy this place in every possible way'. After a few days he was killed. Another man said threateningly: 'Unless they vanish rapidly, I will kill them all and completely destroy the place, because I have bought everything here from lord Herbord'. The noble lord Jonathan von Ardey claimed that the farm belonged to him. The provost of Scheda said the same and master Hildeger, called 'de Foro', claimed this as well. The socmen from Alvoldinchusen made the same claim. That same lord Heinrich (von Alvoldinchusen) who, quasi as founder, had imposed such high levies on the place (which they would not easily have been able to pay), died before receiving any of the revenue—we can only hope he died a good death because, with great piety and contrition, he had placed himself entirely in the convent's hands. Many citizens of Soest who tilled the fields which now belonged to Paradies protested vigorously. Thus all these matters were ordered and accomplished mercifully and to the best possible end by the Lord Jesus Christ, from whom flows everything good, so that the plans might be so realized as to serve him and bring salvation to men and above all to those living there.

[*The 'founding convent' of Paradies*]

Then God put into the head of a certain knight, lord Arnold, who lived in Wiedenbrück, the thought that he wished to remove himself to this place together with his wife and his daughters and all his worldly goods. When the friars and prior Konrad heard this, they called him to them in order to persuade him and to promise him eternal life. He believed the brothers and the Order and, on the advice of the friars, gave and put into the Lord's hands himself and all that was his without reservation and absolutely. From the same city he summoned to him, with all her possessions, lady Kunigunde, a very pious woman who—although a lay woman—immediately became prioress.

In the year of the Lord 1252 they came to Paradies. Many people followed the example of their lord, namely Arnold, and his family. Around the same time lord Gerhard, a knight from Lo, and his wife, lady Agnes, found a home for their two daughters there. After lord Gerhard's death lady Agnes came to Paradies and piously delivered herself and her children and everything she possessed to the convent and the other religious

for the sake of the Lord. Brother Bertuitus came with his wife, his daughter Gerburgis and everything he possessed; as did brother Arnold with his mother; and sister Adelheid von Rothus with her daughter. In the same way lord Heinrich von Rüthen came with his wife, daughter, and everything he possessed. Lord Heinrich von Flerke found a home for a daughter there and many other burghers placed their daughters in the convent. Brother Dietrich von Recklinghausen, enflamed by the Holy Ghost, was inspired by immense affection to promote Paradies, something he later demonstrated with the greatest success. The first thing he did was to establish his father in Paradies, an act which later benefitted Paradies considerably in the purchase of estates. The second thing he did was to summon lady Christina von Dortmund, who, moved by deep desire, placed her dearly beloved daughter in the convent and endowed it with magnificent buildings and other revenue and objects. The third thing he did was to summon lady Bela and the daughter of Margareta von Dortmund, both of whom promoted Paradies in many ways. (He) also (summoned) count Heinrich with his wife from Dortmund. This brother Dietrich displayed his loyalty and merit by summoning these people from Dortmund; to the benefit of the convent he took many valuable initiatives, moved by unceasing care, and undertaking considerable toil, for the foundation's possessions and secular affairs. When the friars who had initially been entrusted with this holy task by the master of the Order and the provincial saw that these things were happening through the Holy Ghost, they thanked almighty God and the holy Virgin Mary and Saint Dominic and all the saints because almost all their worries and efforts had been happily resolved and brought to a good conclusion by such a pious brother; and because they saw that this young man had a constant character and did not quickly allow himself to be shaken in his honorable conduct by difficulties of any sort.

[*Albertus Magnus and the entry into the Order of the women at Paradies*]

Under master Albert, who at that time was the provincial prior of the Dominicans, the sisters entered Paradies. The place which for time immemorial had been called Alvoldinchusen is now known as Paradies because of its usefulness and charm—and rightly so, because just as those first ancestors, had they only persisted in obedience to the Lord, would have gone to the glory of eternal life without any punishment and on the command and summons of the Lord, so too will these sisters, and everyone belonging to Paradies, be released by the grace of our Lord Jesus Christ from this mournful Paradise, if they humbly persist in correct obedience and do not allow themselves to thrown off course by any curiosity or frivolity. They will enter

that joyful and splendid and indescribable bliss where the holy Virgin Mary and her dearly beloved Son and all the saints will rule until the end of days. Lord Albert came in response to the pleading and urging of brother Arnold, who was at that time still living in his secular attire and had torn apart and sold his goods and his possessions for the benefit of Paradies. And the bishop [of Osnabruck], whose ministerial he was, and similarly his wife and all his children, who were, by the same law, also subject to the bishop, wished to prevent this because he [the bishop] was reluctant to see his church in Osnabruck be forced to forgo such an honorable man. Eventually, however, he gave in.

Master Albert preached to the few sisters as if there had been many here at that time. He said and prescribed to them how they should live according to the Rule of Saint Augustine and the rules of the Dominican Order: they should love communal property for the sake of God; despise private property; obey humbly, patiently, and uncomplainingly, without carping, promptly, joyfully, and without any surly delay. He added, with great emphasis: "You should be closely confined and guarded by fences and locks, doors and gateways and windows; and never, without permission, talk to a sister or sisters either through the fence or over the fence or through the wall in a forbidden place or at a forbidden time. Practical matters are always to be discussed with the matrons in reputable places and with people who are above suspicion. You should never, on any account, do forbidden things without permission or dispensation".

'You should not ignore matters that have been wisely regulated by your elders for the usefulness and reputation of all: namely, the injunction to give nothing, retain nothing, receive nothing; you should not reveal or tell to anyone, no matter how familiar to you, any of the secrets of the Order or the Chapter, whether they concern internal or external matters, so that true peace and love may not languish amongst you or even—which is unthinkable—be destroyed. May the Lord avert that from you so that you are not ungrateful for his benefaction and that of the Order. This is God's benefaction, given to you by the Order for his sake: the words of the best sermon; the testing in chapter of the proper correction of your errors; the administration of the sacraments, that is, the body of the Lord, and the administration of extreme unction and the confession of sins, because (the Order) loves to protect you, which is the salvation of your souls and the concern for you in secular matters, for he who despises the smallest detail goes astray'. Lord bishop Albert, who at that time was provincial, added to these words for the sake of the few people present, impressing the following upon them: "Behold, you came to this place humbly and piously, not in carriages, not on horseback, not in a great crowd of people, not with any worldly pomp, but with bare feet

and in humble garments, when Mass was celebrated on Friday morning. In this you followed your bridegroom Christ by immediately leaving all your chattels behind and unhesitatingly hurrying here after Mass and, in the church dedicated to holy Mary, swearing a vow to God and the master of the Order and to me, Albert, the provincial representing the master of the Order, that you would remain in this place and would never again leave it in future. I received your vow on the advice of the prior and all your friends; and I confirm, to you and your successors and all those who heed my words, this blessing in the name of the Father, the Son, and the Holy Ghost: Blessed be (your) death, holy sisters. May your holy bodies be given to the earth piously and with the exequies; but in Paradise the holy angels shall entrust your holy souls, without suffering purgatory, to eternal bliss, to Christ and the holy Virgin Mary and all the saints, to your ineffable fame and eternal glory. Whoever believes and keeps this faithfully and constantly shall be saved".

In addition Master Albert accomplished a great deal. He confirmed the dispensation issued by Cardinal Hugo concerning Gertrud and Oda, the daughters of the convent's first provisor, brother Arnold, and Lisa: namely, that they might transfer from the convent called Büren and from the Rule of Saint Benedict to the Rule of Saint Augustine in Paradies. And he particularly commended this to them and all sisters and exhorted them to take care not to destroy themselves or this place, either by admitting too many people through thoughtlessly allowing this to happen; or by erecting buildings for which they lacked the financial means to pay. Rather, they should wait until they had prospered through [gifts of] secular property and through endowments and alms from the faithful, so that they might erect domestic buildings without harm and hindrance of the discipline of the Rule.

[Arnold von Wiedenbrück as procurator for Paradies]

Brother Arnold only took leave of the world with great difficulty as he had led a very worldly life. He was well regarded by his lord the bishop and everyone else, by both the nobles and the ministerials. Monks, religious, clerics, laymen, his relatives, all the people loved him. He was a congenial man, very brave with the knights and strong in every battle, large in stature, good and decent in his oratory, shrewd and sagacious in all counsel, terrible to his enemies; he proved himself true to his friends and his relatives and his lord the bishop and his church. To the prelates of the Dominican Order and all the friars in the Order he proved himself honorable and decent by taking care of them and providing them with transport; and—when he had done this well sixteen times or more—he [also] conveyed them to various other places, services for which the friars

thought very highly of him. He performed these and other services cheerfully and humbly as long as he lived on this earth. And he acted in a similar manner after he had received his robe from the Order and entered the Order and taken over the administration of Paradies. For the way he humbly and usefully served the friars in their begging by accompanying them and carrying their mendicants' sacks and championing their needs at individual houses and with individual people—for this he deserved and still deserves that the friars should never be prompted by ingratitude to forget him and his wife and daughters.

When brother Arnold entered Paradies for the first time and received from the prior the entire duty of care for the whole place and its worldly possessions, he found everything to be, as it were, in a state of chaos. Master Herbord, however, once provost of Saint Walpurgis, and the judge, master Meinrich, as well as master Robert Ferner and lord Albert von Osthoven, together with some other friars who were charged with this task, helped him faithfully in all resolutions and decisions. On their advice he bought back the mortgaged fields—and out of all the fields he discovered barely five unmortgaged acres; and also on their advice he came to an agreement with master Torc about his farm and with Dietmar and with lord Herbord of Dortmund and with master Stephan, all of whom said the farm belonged to them; whereas Otto, count of Tecklenburg, steadfastly asserted that nobody in the whole wide world had any right to the farm but him. Such a dispute had to be resolved in this way or else the holy enterprise would have failed completely. Brother Arnold, supported by the counsel of the above-mentioned men and with full faith in the Lord Jesus Christ, immediately granted the poor generous alms and the guests a friendly welcome; and for those inside his convent and other fellow friars outside it and the convent *familia* he provided honorably; and thus devoted the appropriate care to food and also clothing. Because he [pledged] himself wholly to peace and to true humility, due to his humility and restraint he acted more in accordance with other people's will than his own, because he hoped—as, in fact, came to pass for him within a few years—that little things grow through good concord but perish utterly through evil discord, no matter how numerous they might be. Using the estates and objects he had brought with him from Wiedenbrück, he equipped the place with natural produce, money, horses, and other beneficial and very useful things. The way he had accustomed himself to living from the very beginning earned him great favor with the Lord so that miraculously he began to have a surplus of everything.

In times of need he filled whole store houses in Soest with wheat and other sorts of natural produce and foodstuffs and sold some to those who had heard about this and therefore came to Paradies from other towns and regions, just like at a country market. For this reason the competence of the administrator and the holiness of the convent acquired a good reputation far and wide, so that the count and countess of Arnsberg made haste to find a home there for their daughter. That noble damsel the lady Ida von Essen entered the convent out of a deep inner desire and humility. The noble lord Konrad von Rüdenberg and his wife found a home there for their two beloved daughters. Brother Arnold Effeln, more or less brother Arnold's 'right hand'—as people say in popular speech—arrived in a very pious and meritorious manner with his daughters. From the very beginning the lord Heinrich, who was, as it were, the son of the founder, served in the office of priest with humility and devotion. Many of those who had initially nurtured a poor opinion of what was happening in Paradies were later unsuccessful in their attempts to be admitted into the convent *familia* as so many and such important people wished to be close to it, with the result that not everyone could be satisfied.

[*Address by Heinrich von Osthoven to the sisters of Paradies*]

'Sisters in Paradies, you should remember with gratitude how the prior, brother Gottfried, brother Jacob, brother Albert and, so to speak, the whole convent of the Dominican friars have fostered and supported you. The prior bestowed on you your consecrated veil once there were twelve of you. The bishop consecrated your altar. Brother Eberhard Clot preached to a host of people beneath the canopy of heaven. The brothers celebrated mass most piously in the open air and fine weather. At the same time and on the same day a very solemn feast was celebrated for God and for you. Beloved sisters, your entry was holy, let your way of life be holy; and let your end be holy through the mercy of Jesus Christ, whose brides you are. May you be granted life after death in eternal glory with him and the blessed Virgin Mary, who is your protector, and with all the saints. Amen'.

[*Addendum*]

Statement of revenue and expenditure

Brother Arnold, moved by the grace of our Lord Jesus Christ, abandoned his life in the world and, after mature consideration, placed himself, his wife, and his daughters and his splendid possessions under the authority of the prelates and friars of the Dominican Order and of their Order. The latter allowed him and his family to live [there] with everything he owned, so that he might ensure the convent of the Dominican sisters in Paradies, whither they had summoned him, was established and functioned successfully. When, however, he first set foot in Paradies, he found there neither houses nor granaries nor fields apart from a

few (that is, barely seven) arable fields, nor even a fence around the site. Before his death he built houses, a mill, a house for the convent *familia*, four granaries, a small, heatable room in Schwefe, and a fence around the whole site. He redeemed the fields that had been mortgaged for 200 marks. He purchased the following farms: Bukele, Wüsthof for 350 marks, Ridderinghof for 400 marks, Tork's farm for 400 marks. Before his death, for as long as he was healthy, he frequently rendered due account of what he had done with the monies in Kutmecke and Thodichusen; and with much of what he had purchased; and of the arrangements he had made with regard to the many things he had bought and the money he had spent. It is all recorded here. And (the account) was discovered in the presence of the prelates and the friars and sisters. It stated namely that he had received 1,400 marks and had used this money to buy the legacy which has already frequently been mentioned and which is and was worth 2,200 marks. And in all of this he took great care not to incur any sort of debt and he died without debt and he left Paradies well supplied with food and with good horses and with a large number of cattle. And he was upright and merciful towards his convent when it came to providing the nuns with food and clothing. And in times of need he showed mercy in providing generous alms for 300 poor people on two days a week. And for this the Lord benevolently took care of him. May God's grace grant that his soul rest in peace. Amen.

All these things were carefully copied from the manuscript by brother Heinrich von Osthoven of blessed memory, the first father of and confessor to the nuns in Paradies, just as they were revealed and written down by him.

B: Edition of the Library Catalogue from the Dominican Convent of Lemgo

Landesarchiv Nordrhein-Westfalen, Abt. Ostwestfalen-Lippe (Detmold), L 110 B, Nr. 18 (Former Shelfmark: Tit. 3 Nr. 2)

P archment with a limp binding with sewing holes on the left and upper edges, fabricated from a reused document of the convent, dated July 2, 1386 (the monastery owes Gottschalk von Lynderysse 32 marks, which are to be paid by St. Michael's day). After the debt has been paid, the document will be destroyed (LR 2, no. 1347, 402). A second leaf of parchment, employed as a fly leaf, bears the prayer for Matins, 'Nocte surgentes vigilemus omnes' (Can 008349). Height 10 cm, width 6 cm, bound after 1386. Modern foliation in lead in the upper margin.

On the exterior of the binding a hand, which can be dated to the eighteenth century, has noted: 'Register von allerhand Büchern so bey dem allhiesigen Kloster gewesen außer den Mess- und Chorbüchern'.

A very careful and practiced gothic book hand, ruled in ink; the indications of the respective formats and the initials of the first book title are in red. The first initial 'L', which is over two lines in height, is also in red. The primary hand dates to the second half of the fourteenth century; other, later hands, have made additions. Of these, one entered a list of the equipment of the monastery's own book bindery (f. 10r). As in the edition of the foundation legend (Appendix A), c / t, u / v und y / i have been normalized and the beginnings of sentences, proper names, and book titles capitalized.

App. B: Fig. 1
Catalogue of the library of the Dominican nuns of Lemgo,
Lemgo, after 1386, LAV NRW OWL, L 110 B, Nr. 18, f. 1r.
Photos: Landesarchiv

(f. 3ʳ)

^aModulus maior^a
Liberaria sororum in Lemego libros continet hic conscriptos, hiis exceptis quos chorus habet necessarios pro divino officio peragendo,
videlicet

ᵃ *in the upper margin, possibly added, in red*

[1.] Duas partes Biblie.
 A bible in two volumes

[2.] Scolasticam historiam.
 Petrus Comestor (OSEA, ca 1100–79),
 Historia scholastica
 Edition: PL 198:1053–1722; Petrus Comestor,
 Scholastica historia (2005), ed. Sylwan (2005).
 Literature: Schneyer, Repertorium 4
 (1969–1990), 4, 6543–65; 9, Suppl. 341.

[3.] Omelias temporis estivalis.
 Collection of homilies, summer portion

[4.] Omelias temporis hiemalis.
 Collection of homilies, winter portion

[5.] Parabolas Salomonis cum minoribus prophetis.
 *Proverbs of Salomon (Proverbia) with the
 Minor Prophets*

[6.] Librum unum aliqua ewangelia continentem
 quem habet scola.[1]
 Gospels

[7.] Tres partes Moralium.
 *Gregory the Great († 604), Moralia sive
 Expositio in librum Iob
 Edition: Gregory the Great, Moralia,
 ed. Adriaen (1979–1985).*

(f. 3ᵛ)

ᵇModulus magnusᵇ

[8.] Duas partes Passionalis.
 Passionale sanctorum
 *Possibily Jacobus de Voragine (OP, † 1298),
 Legenda aurea.
 Edition: Iacopo da Varazze, Legenda aurea,
 ed. Maggioni (2007).*

[9.] Collationes patrum.
 *Johannes Cassianus († 435), Collationes patrum
 Edition: John Cassian, Opera, eds. Petschenig &
 Kreuz (2004).*

[10.] Vitas patrum. Vitas fratrum.
 (1) Vitae patrum
 Edition: PL 73; PL 74.

ᵇ *written in red in the upper margin*

App. B: Fig. 3
LAV NRW OWL, L 110 B, Nr. 18, ff. 2v–3r

(2) Gerardus de Fracheto (Gérard de Liège OP, †1271/1281), Vitae fratrum Ordinis Praedicatorum necnon Cronica Ordinis ab anno MCCIII usque ad MCCLIV (written ca. 1260 at the request of Humbert of Romans)
Edition: Gerard of Frachet, Vitae Fratrum, ed. Reichert (1897).
Literature: Boureau, 'Vitae fratrum' (1987); Williams & Hoffmann: 'Vitaspatrum' (1999).

[11.] Expositionem regule secundum magistrum Humbertum.
Humbertus de Romanis (OP, † 1277), Expositio regulae beati Augustini episcopi
Edition: Humbert of Romans, Expositio, ed. Berthier (1889).
Literature: Kaeppeli & Panella, Scriptores (1970–1993), vol. 1, no. 201; Tanneberger, Basistexte (2014), 293–322.

[12.] Expositionem regule secundum Hugonem.[2] Cum tractatu decem preceptorum.
(1) Hugh of Saint-Victor († 1141), Expositio in regulam beati Augustini
Edition: PL 176:881–924.
(2) Possibly Heinrich von Friemar (OSEA, † 1354), Tractatus de decem praeceptis (1324)
Edition: Heinrich de Frimaria, De decim preceptis, ed. Guyot (2005).

[13.] Speculum virginum. Dialogum.
Edition: Speculum virginum (1990).
The title, Dialogus, refers either to the Speculum virginum or to another unidentified text written in the form of a dialogue.

^cModulus minorum^c

[*14.*] Psalterium glosatum.
 Glossed psalter

[*15.*] Librum Richeidis³ De perfectione virtutum.
 Text on the perfection of the virtues

(*f. 4^r*)

[*16.*] Librum Gozte⁴ cuius est principium. Christo confixus sum cruci.
 Possibily Johannes Tauler (OP, † 1363), sermon (Gal 2:19–20).
 Literature: Schneyer, Repertorium (1969–1990), 3, 780, no. 44 (Sermones latini, fortasse in linguam latinam translate, incerti et dubii sunt.
 Incipit: Amabilissima domini salvatoris passio).

[*17.*] Librum qui intitulatur. Flecto genua.
 Possibly Johannes Tauler, sermon (Eph 3:14)
 Incipit: Flecto genua
 Edition: Tauler, Predigten, ed. Vetter (1910), 364–72, no. 67.
 Literature: Schneyer, Repertorium (1969–1990), 3, 785, no. 105.

[*18.*] Librum De laudibus beate Marie virginis.
 Richard von Saint-Laurent (OP, † ca. 1250), De laudibus Beate Marie Virginis (lib. I-XII).
 Incipit: Universis Christi fidelibus inspecturis oculo simplici
 Literature: Stegmüller, Repertorium (1940–1961), 9, no. 7315; Kaeppeli & Panella, Scriptores (1970–1993), 2, no. 2158 (Iacobus de Voragine).

^c adjacent to the title, Psalterium glosatum (added?), in red

App. B: Fig. 5
LAV NRW OWL, L 110 B, Nr. 18, ff. 4v–5r

[*19.*] Librum qui intitulatur. Pigmentum cordis.
 Incipit: Quia vivus est sermo dei
 Berlin, Staatsbibliothek, Cod. Ms. theol.
 fol. 178; 15th c. (provenance: Augustinerkloster
 Lippstadt)
 Explicit: Explicit iste liber cuius titulus […]
 qui intitulatur Pigmentum cordis (*f. 117ra*).
 Literature: V. Rose, Verzeichnis (1901), 276–82,
 cat. no. 426, 27.

[*20.*] Librum sororis Alheidis Letelen[5] qui intitulatur
Breviloquium Boneventure [!].
 Bonaventura, Breviloquium (OFM, † 1257),
 short catechism
 Edition: Bonaventure, Breviloquium,
 ed. Schlosser (2002).

[*21.*] Librum medicinalem in asseribus ligatum.
 Medical miscellany in wooden boards

[*22.*] Item duos parvos libros medicinales cum
operculis.[6]
 Two medical works in a limp binding

[*23.*] Librum sororis Margarete Budde[7] qui intitulatur.
Frater Ambrosius [d]post mortem[d]
 Hieronymus, Frater Ambrosius
 Probably Genesis or the Old Testament
 Literature: Stegmüller, Repertorium
 (1940–1961), 6, no. 9286.

[*24.*] [e]Et librum qui intitulatur. Ludus scacorum[e] [f]post
mortem Hellemburgis Bosen[f8]
 Jacobus de Cessolis (OP, 14. c.), De ludo
 scacorum (ca. 1330)
 Literature: Plessow, Schachzabelbücher (2007).

[d] *entered in the margin by another hand*
[e] *entry in another ink, possibly by the original hand*
[f] *added by another hand (probably the second additional hand)*

App. B: Fig. 6
LAV NRW OWL, L 110 B, Nr. 18, ff. 5v–6r

(f. 4ᵛ)

[25.] ᵍItem librum de virtutibus animalium, arborum, herbarum. et specierumᵍ ʰpost mortem sororum Elizabet de Wirenborne et Goztemʰ9
> *Ps.-Albertus Magnus*, De virtutibus herbarum. De virtutibus lapidum. De virtutibus animalium *(ca. 1290).*
> Edition: Ps.-Albertus Magnus, Liber de virtutibus, ed. Draelants (2007).

[26.] Compendium fratris Winandi de ordine Minorum10 ipost mortem sororum de Nym11
> *Possibly Hugo Ripelin (OP, † 1268),* Compendium theologicae veritatis

ᵍ *entry by the first additional hand*
ʰ *entry by the second additional hand*
ⁱ *entry by another hand in the left margin*

Edition: Albertus Magnus, Opera omnia, eds. Auguste & Emile Borgnet (1890–1899), 34, 1–306; Kaeppeli & Panella, Scriptores (1970–1993), 2, no. 1982.

ʲModulus minimus in asseribus ligatus.ʲ

[27.] Librum Richeidis12 De preparatione cordis.
> *Possibly Gérard de Liège (OCist., 13th c.) or Hugo de S. Caro (OP, † 1263),* De preparatione cordis (De doctrina cordis)
> Edition: Hugo de Sancto Caro, De doctrina cordis, ed. Henrix (1980).
> Literature: Palmer, 'Authorship' (2010), 19–56.

[28.] Item compendium sororis eiusdem.
> *Possibly Hugo Ripelin,* Compendium theologicae veritatis *(see no. 26)*

ʲ *in red*

[29.] Item alium librum de preparatione cordis.
 Possibly Gérard de Liège or Hugo de S. Caro,
 De preparatione cordis *(see no. 27)*

[30.] Librum fratris Iohannis Sapientis[13] De laudibus
 beate Marie virginis.
 Possibly Richard of Saint-Laurent, De laudibus
 Beatae Mariae Virginis (see no. 18)

(f. 5ʳ)

[31.] Librum qui incipit. Deus tibi totum est.
 Possibly Augustinus († 430), In Iohannis
 evangelium tractatus
 Incipit / Titulus: Deus tibi totum est
 Edition: Augustine, In Iohannis, ed. Williams
 (1954).

[32.] Librum eiusdem moduli qui continet duas
 Passiones domini et Expositionem misse. et
 Vitam Christi. qui [!] incipit Ihesu salus.
 (1) Passiones domini
 (2) Possibly Hugo de S. Caro (see no. 27),
 Expositio missae (Tractatus super
 missam)
 Literature: Kaeppeli & Panella, Scriptores
 (1970–1993), 2, no. 1990.
 (3) A life of Christ with the incipit, Ihesu salus,
 cannot be identified. Iesu, salus *is the first*
 verse of various orationes ad Christum,
 see RH 1, nos. 9669–75; RH 3, no. 28605.

[33.] Librum qui continet. Sermones de decem
 preceptis domini.
 Possibly Heinrich von Friemar, Tractatus
 de decem preceptis *(see no. 12, 2).*

(f. 5ᵛ)

ᵏHii sunt libri in operculis ligati.ᵏ

[34.] Librum Remburgis qui ergo incipit Ecce
 descripsi. *(Prov 22:20)*
 Possibly Bonaventura, Contemplatio
 (De triplici via)
 Incipit (Prologue): Ecce descripsi eam
 tripliciter
 Edition: Bonaventure, De triplici via,
 ed. Schlosser (1993).
 Or an anonymous collection, Stegmüller,
 Repertorium 6 (1940–1961), no. 9308 (anony
 mous), AH, vol. 25, 126 (Ecce, descripsi tibi
 eam tripliciter in cogitationibus et scientia).

ᵏ *in red*

[35.] Librum qui incipit Contemplatorum. et continet
 multas narrationes.
 Possibly Ps.-Bonaventura, De septem gradibus
 contemplationis
 Incipit: Contemplatorum aquilinos obtutus
 Edition: Bonaventure, Opera, eds. Borde &
 Arnaud (1668), 7, 96–98.

[36.] Cantica bis glosata.
 Song of Songs with two sets of glosses

[37.] Ritmosˡ fratris Iohannis de Paderborne.[14]

[38.] Librum De terra sancta.
 Possibly Burchard de Monte Sion (OP,
 † nach 1285), Descriptio de terra sancta
 Edition: Burchardus de Monte Sion, Liber,
 ed. Stewart (1896).
 Literature: Kaeppeli & Panella, Scriptores
 (1970–1993), 1, nos. 707, 257–60.

[39.] Librum domini Stephani De animalibus
 Possibly Albertus Magnus († 1280),
 De animalibus
 od. Michael Scotus († um 1235), De animalibus
 Literature: Fauser, Albertus Magnus (1982), 1,
 no. 29, 139–50.

[40.] Librum De expositione horarum beate Marie
 virginis. Expositionem Misse.
 (1) Exegesis of the Hours of the Virgin
 (2) Hugo de S. Caro, Expositio Missae
 (see no. 32, 2).

[41.] Librum sororis Drude de Huckenhusen.[15]
 qui intitulatur Tabula ex-

(f. 6ʳ)

emplorum.
 Collection of exempla in Latin (13th c.): Liber
 de similitudinibus et exemplis (Tabula
 exemplorum)
 Edition: Tabula exemplorum, ed. Welter (1926).

[42.] Librum de statutis domini Petri archiepiscopi
 Magutinensis.
 Peter von Aspelt (Archbishop of Mainz
 1306–1320)
 Edition: Statuten, eds. Schannat & Hartzheim
 (1761), 4, 175–224.

ˡ *ms. rycmos*

App. B: Fig. 7
LAV NRW OWL, L 110 B, Nr. 18, ff. 6v–7r

[43.] Soliloquium beati Augustini.
Ps.- Augustinus, Soliloquium animae ad Deum
Edition: PL 40:863–98.
Literature: Kurz, Überlieferung (1976), 5.1.,
217–20.

[44.] Librum sororis Elizabet Riddering.[16]
De sacramento
Vermutl. De sacramento altaris (treatise on
the eucharist)
Possibly Alger von Lüttich († 1131),
De sacramento corporis et sanguinis Domini
Edition: PL 180:727–854.
Or possibly Hugh of Saint-Victor (1096–1141),
De sacramentis christianae fidei
Edition: Hugh of St. Victor,
De sacramentis, ed. Berndt (2008).

[45.] Compotum ecclesiasticum domini Hildebrandi
de Blomenberghe[17] metrice compositum.
[m]post mortem E.H.C.[m18]
Computus in verse
Literature: Thorndike, Catalogue (1963), 242.

[46.] Compotum sororis Wilburgis de Busche[19]
Lapidarium sororis eiusdem [n]post mortem[n]
(1) Computus
Literature: Thorndike, Catalogue (1963), 242.
(2) Lapidary (see no. 55)

[47.] Legendam sancti Thome.
Saint's life of the apostle Thomas or Thomas
Aquinas
Possibly Bernhardus Guidonis (OP, † 1322),
Legenda sancti Thomae de Aquino
Literature: Kaeppeli & Panella, Scriptores
(1970–1993), 1, no. 611, 209.

[m] added in left margin by another hand

[48.] Legendam sancte Barbare virginis.
Life of St. Barbara

(f. 6ᵛ)

[49.] Legendam sancti Eligii. °cum alio libro°
Life of Eligius of Noyon († 660)
Edition: Vita Eligii Noviomagensis, ed. Krusch
(1902).

[50.] Librum parwum cum cantilenas
Book of songs

[51.] Sequentias aliquas cum notis.
Collection of sequences with notation

[52.] ᵖPost mortemᵖ
Item soror Margareta �q Buddeq dedit ad
librariam. quatuor libros sequentes videlicet.
Ovidium Metamorphoseos;
Ovid, Metamorphoses

[53.] Librum qui continet De terra sancta et
De soliloquio beati Augustini
(1) *Possibly Burchard de Monte Sion,* Descriptio
de terra sancta *(see no. 38)*
(2) *Ps.-Augustinus,* Soliloquium *(see no. 43)*

[54.] Librum qui dicitur Summa Reimundi. et
Sedulium
(1) *Possibly Adam von Aldersbach*
(mid-13th c.), Summula de summa
Raymundi *(Abbreviation of the* Summa
de poenitentia *of Raimundus de*
Penyaforti (OP, † 1275).
Probably not a copy of the full Summa of
Raimundus de Pennaforti, as it would
have been a limp binding among the
smaller formats.
Literature: Worstbrock, 'Magister Adam'
(1978).
(2) *Sedulius,* Carmen Paschale
Edition: Sedulius, Opera omnia,
ed. Huemer (1885).

[55.] ʳItem Lapidarium quod incipit Ewax rex
Arabumʳ.
Marbod of Rennes († 1123), Liber lapidum seu
de Gemmis
Incipit: Evax rex arabum fertur scripsisse
Neroni
Edition: PL 171:1735–70.

[56.] Item Doctrinale glosatum[20]
Glossed copy of Alexander de Villa Dei (OFM,
† ca. 1240), Doctrinale puerorum

(f. 7ʳ)

[57.] Librum theutonicum de trinitate
Treatise on the Trinity, in German

[58.] Librum theutonicum de confessione
Treatise on confession, in German

[59.] Item duos libros theutonicos.
Two additional works in German

[60.] ˢItem notule super cantica qui [!] incipiunt
Sicut in secularibus scriptis.
Anonymous commentary on the Song of Songs
Incipit: Sicut in secularibus scripturis
Literature: Stegmüller, Repertorium
(1940–1961), 6, no. 9224, no. 9977.

[61.] Boecium De consolacione. et Boecium
De doctrina scolarium et etiam continent
Passionem domini glosatam et Enigmata
Symphosii.
(1) *Boethius,* De consolatione philosophiae
Edition: Boethius, Consolatio, ed. Bieler
(1984).
(2) *Ps.-Boethius,* De doctrina scholarium
Edition: Ps.-Boethius, De doctrina
scholarium, ed. Weijers (1976).
(3) *Caelius Firmanus Symphosius,*
Aenigmata Symphosii
(late antique collection of riddles for
teaching Trivium)
Edition: PL 7, 289–98; Anthologia Latina,
ed. Shackleton (1982), 1.1, 202–34
Literature: Baldzuhn, Schulbücher (2009),
878–81.

ᵒ *added by another hand in very faded ink*

ᵖ *The note in the left margin uses a bracket to refer to the*
following four titles.

q *added above the line in another ink*

ʳ *The following entries are written by another hand in very*
faded ink and tied with a bracket, written by the same hand,
to titles 60–62.

ˢ *The following entries are written in very faded ink, but*
possibly by the original hand; grandes materias is added in
the right margin.

[62.] Item epistole Ieronimi[t]. qui [!] incipiunt
Grandes materias[r]
*Hieronymus, collection of letters beginning
with Epistola no. 60 (Ad Heliodorum
patriarcham)*
*Incipit: Grandes materias ingenia parva non
sufferunt*
*Edition: Jerome, Epistolae, ed. Hilberg (1966), 1
(CCSL 55).*

[t]Item aliquos quaternos[u]

[63.] [v]Item Apocalipsim glosatam
Apocalypse with commentary

[u] *entry by the original hand*
[v] *entries by another hand in very faded ink*

[64.] Etyopum terras. glosatum
*Theodolus, Ecloga, glossed (10th–11th centuries,
leoninine hexameters)*
*Incipit: Aethiopum terras iam fervida torruit
aestas*
*Edition: Theodulus, Ecloga, ed. Osternacher
(1902); Theodulus, Ecloga, ed. Casaretto (1997).*
*Literature: Henkel, 'Theodolus' (1995); Henkel,
'Ecloga' (1991), 151–62.*

[65.] Librum sororis Alheidis Lodere[21] qui incipit
Philosophia[v]
*Possibly Albertus de Orlamünde (OP, 13th c.,
Lector in the Province of Teutonia),
Philosophia pauperum*
*Incipit: Philosophia dividitur in tres partes,
scilicet logicam, ethicam et phisicam, sive
rationale, morale et naturalem*
*Literature: Kaeppeli & Panella, Scriptores
(1970–1993), 1, no. 112, 31; Grabmann,
Philosophia (1918).*

App. B: Fig. 9
LAV NRW OWL, L 110 B, Nr. 18, ff. 10v–11r

(fol 7ᵛ–9ᵛ leer)

(f. 10ʳ)

ᵂHe [!] sunt pertinentia ad officium librarie

videlicet IIIIᵒʳ cyste.

tres latule.

Una mensa super quam ligantur libri.

Quatuor cultelli cum quibus libri presciduntur et equantur.

Duo mallei.

Duo forcipes.

Quatuor limas.

Duo incudes.

IIIIᵒʳ penetra.

Una serra.

Quatuor prassen proprie.

Quatuor knipsceren proprie.

Eyn scave proprieᵂ.

ᵂ *addition by another hand*

1. *On teaching in the school of the Dominican convent Lahde/ St. Marien Lemgo, see Part I, ch. 3.2, 76-80. The 'students' of St. Mary in Lemgo ('scolares') are also mentioned in the documents. On August 15, 1323 Simon von der Lippe and his wife Adelheid stipulate that the sick sisters and the puelle scolares of St. Mary's should receive twenty hens and forty-eight eggs eight days prior to the start of Lent; LR, 2, no. 689, 107; see further no. 790, 152 (1337 September 28).*

2. *The Rule of Hugh of Saint Victor was especially important for the convent. It was copied once again for the convent in 1457, translated into Middle Lower German word for word, then glossed. Sister Heilwig von Wierborn indicated that this glossed copy should be used in the convent's school (ad scolares); Halm, Klosterleben (2004), 429. Regarding the books, it is said: 'De codices exigendis / Codices de boke petantur dar scholen werden / ghebeden singulis diebus yn allen daghen / certa hora yn eyner wyssen stunde que / supradictas sorores petierint dar bydden extra horam / buten der rechten stunde non accipiant se / nicht scholen entfanghen supradictos codices de boke'. There follows a long explanation of the importance of study, which as a central obligation of the sisters should take place immediately after the celebration of the Divine Office. Ibid., 399.*

3. *The wife of Widekind III von dem Berge, the aristocratic steward who was one of the driving forces behind the foun-dation of the Dominican convent of Lahde near Minden, was named Richedis or Richeidis. She possibly left the newly founded convent her devotional books, which were then preserved as a legacy of the foundress. See also no. 27; Widekind III died in 1269; it is conceivable that following his death, his widow entered the convent. One of the women who participated in the creation of the embroidery narrating the foundation was also named Richeidis; on the founda-tion, see Part I, ch. 3.2, 76-80 and Deutsche Inschriften Online (DIO): Inschriftenkatalog Stadt Lemgo, No. 1 †, Stift St. Marien. http://www.inschriften.net/lemgo/inschrift/nr/di059-0001.htm (last accessed on January 8, 2016).*

4. *Possibly Goste (Gertrud) von Wierborn, Elisabeth and Goste von Wierborn together donated one additional volume in the library; see no. 25. On the von Wierborn family, see Halm, Klosterleben (2004), 214–16.*

5. *Adelheid von Letelen is documented as having donated a pittance (a benefaction in the form of food) at the Dominican convent of Lemgo in 1366, see Halm, Klosterleben (2004), 322.*

6. *Of the two medical manuscripts listed here, one has possibly survived as LAV NRW OWL, L 110 B, Nr. 19 Liber medici-nalis (Antidotarium, fourteenth and fifteenth centuries), see Gerlach, Klosterbüchereien (1934), 10–17.*

7. *A nun, Margarete Budde and her sister (?) Elisabeth Budde are documented as having died in 1384; see Halm, Klosterleben (2004), 211.*

8 On August 1, 1393, Hellenburg Bose is given a pension of 1 Mark, LR, 2, no. 1414, 432. She was the sister of the knight from Horn, Konrad Bose, who before 1383 donated the altar dedicated to St. Catherine to St. Mary's (dedicated to Sts. Thomas, Mary Magdalen, and Catherine); ibid., no. 1330, 394–95, (1383 December 1). The altar is reproduced in Kloster und Stift (1965), 29, where it is suggested that Konrad Bose is portrayed as the donor. The altar of St. Catherine stood before the choir and played a central role in the investiture of the Dominican nuns; Halm, Klosterleben (2004), 212–14.

9 See above, n. 4.

10 A Franciscan author with the name of Winand cannot be identified. One could suppose that this Compendium was a present of a Franciscan friar to the Dominican convent.

11 Several members of the family von Nieheim (Nym) lived in St. Marien; Mechthild von Nym was the female sacristan and held office as prioress in 1413 and 1415; see Halm, Klosterleben (2004), 216–17. At the end of the fourteenth and the beginning of the fifteenth centuries, a Hermann Nym (Nieheim) lived in the Dominican monastery in Minden. He gave the friars a late twelfth-century copy of Hugh of Saint-Victor's De sacramentis christiane fidei. Libri II, HAB Wolfenbüttel, Helmst. 1044; ownership entry, f. 1r: 'Liber fratrum Hermanni Nym Mynda datus ad librariam sacram ibidem a fratribus Hermanno de Lerbeke et Hermanno Nym'. The chronicler Hermann von Lerbeck (1345– † 1410/1415) was a Dominican in the monastery of St. Paul in Minden, possibly related to him was Gertrud von Lerbeck, who ca. 1350 lived at St. Mary's in Lemgo; LR, 2, no. 945, 217; ibid., 2, no. 1971, 275 (1361 June 9).

12 For Richeidis, see n. 3.

13 On the Dominican prior, Johannes von Busche (named Sapiens) see Part I, ch. 3.2, 78. With the volume given to the library by Johannes Sapiens, the library catalog thus commemorates its own founder.

14 Johannes von Paderborn might be one of the Dominicans from Minden.

15 The respected Lemgo family von Huckenhusen was closely tied to the community of Dominican nuns. Gertrud von Huckenhusen († before 1374) was the daughter of the mayor of the old town, Johann and his wife Oda, LR, 2, no. 728, 126 (1330 February 21–24); Halm, Klosterleben (2004), 206–08.

16 In 1358 Elisabeth (Ilseke) Riddering donated a pittance (1358 March 23); Halm, Klosterleben (2004), 325.

17 Various members of the family von Blomberg are documented as members of the Dominican monastery: Berta, who died in 1377 and Gertrud von Blomberg, who in 1388 received a pension of one Mark, presumably on the occasion of her investiture, for which Adelheid, the widow of Bertram von Blomberg, had given the convent 12 Marks. Halm, Klosterleben (2004), 199–200.

18 The abbreviation E. H. C. cannot be expanded with certainty. C. might not be part of the name, then the letters could refer to the prioress Ermgard von Heidelbeck, under whom the convent moved from Lahde to Lemgo.

19 Wilburg or Walburg von Busche was the daughter of Elisabeth von Batenhorst. She is first mentioned in 1349 on the occasion of her investiture, LR, 2, no. 812, 200–01 (1349 February 4). In 1359 her mother grants her daugther the lifelong right to eight Schillings from her garden in front of the Ostertor, should she later take vows as a member of the community; LR, 2, no. 1050, 264 (1359 October 9): Amelgard, the prioress, and the convent of the monastery in Lemgo received 8 Marks from Elisabeth von Batenhorst and therefore assigned from their garden 'vor dem Ostertor' a rent of 8 shillings to her daughter Wilburg von Busche for the rest of her life, a rent, moreover, which should be paid to Elisabeth's granddaughter (=Wilburg's niece), should she enter the monastery, but which otherwise should be paid to Elisabeth von Batenhorst, but for now should be converted into a pittance for the monastery's refectory. This shows very clearly how carefully families oversaw their options regarding a place within the convent. Wilburg von Busche died before 1387. In 1374 she appears to have the sub-prioress; in 1384, the prioress; see Halm, Klosterleben (2004), 202–03.

20 This manuscript, a glossed Doctrinale of Alexanders de Villa Die, appears to have survived as LAV NRW OWL, L 110 B, Nr. 20 (Doctrinale glossatum); see Gerlach, Klosterbüchereien (1934), 17–19.

21 The family von Loder lived on the market place in the old town. In 1324, Adelheid von Loder had already entered the convent, which over the course of the fourteenth century also housed other members of the family; see Halm, Klosterleben (2004), 194–96.

C: Liturgical Manuscripts from Paradies: Summary Descriptions; Table of Litanies[1]

ULB Dusseldorf, D 7, Antiphonary (Winter Section)

i (modern parchment) + ff. 267 (paginated in pencil, 178 duplicated as 178a, crossed out and replaced, also in pencil, by 179; all subsequent folios bear two numbers, of which the higher one is correct; incomplete at beginning) + i (modern parchment), 420 x 300 (303 x 203) mm, trimmed; 9 staffs, ruled in red, double vertical and single horizontal bounding lines (not full across); prickings trimmed; written in *littera textualis formata* in brown ink; 3-staff illuminated initials; 1-staff initials, red or blue, with blue or red fleuronnée; 1-staff scribal initials in brown, with red; rubrics and cues in red.

Collation: I² (ff. 1–2; two singletons); II⁸⁺¹ (ff. 3–11; singleton=f. 3); III¹⁰ (ff. 12–23); IV¹⁰ (ff. 23–31); V¹⁰ (ff. 33–42); VI¹⁰ (ff. 43–52); VII¹⁰ (ff. 53–62); VIII¹⁰ (ff. 63–72); IX¹⁰ (ff. 73–82); X¹⁰ (ff. 83–92); XI¹⁰ (ff. 93–102); XII¹⁰ (ff. 103–112); XIII¹⁰ (ff. 113–122); XIV¹⁰ (ff. 123–132); XV¹⁰ (ff. 133–142); XVI¹⁰ (ff. 143–152); XVII¹⁰ (ff. 153–162); XVIII¹⁰ (ff. 163–172); XIX¹⁰ (ff. 173–182; f. 173 paper replacement on stub of f. 182); XX¹⁰ (ff. 183–192); XXI¹⁰ (ff. 193–202); XXII¹⁰ (ff. 203–212); XXIII¹⁰ (ff. 213–222); XXIV¹⁰ (ff. 223–332); XXV¹⁰ (ff. 333–342); XXVI¹⁰ (ff. 343–352); XXVII¹⁰ (ff. 353–262); XXVIII⁶ (ff. 263–267 + former rear pastedown, blank, with note in cursive, brown ink, 'ennebe pape fest dyt myt eurer eygen'; holes in corners and center from bosses patched with parchment).

Binding [App. C, fig. 1]: 450 x 325 (1.3–1.5 cm larger than book block along upper, lower, and outer edges), white pigskin over wooden boards, squared off; spine and inner edges of boards restored with white pigskin, tooled in large lozenge pattern, with four lozenge-shaped stamps within each larger lozenge; tooled and stamped front and back: four rectangular frames around rectangular panel at center; stamps: men in profile with hats, facing left or right (center panel); otherwise floral motifs interspersed with figures, bust-length, labeled 'LVCRETIA,' 'PRVDENTIA,' 'MVSICA,' 'FORTITVDO'; severely rubbed, with holes exposing boards; right outer edge with grooves to accommodate straps (modern); nail holes for corner pieces (lost) at upper and lower right; holes for two bosses, top and bottom center (lost); holes for quatreleaf plaques surrounding studs to holds straps (lost; studs replaced); five double straps inserted into horizontal grooves, secured with wooden plugs; painted label, white with a black frame: D.7. No front pastedown (offset from a chant book); rear pastedown (blank) survives as single leaf inserted following f. 267. White leather tabs.

ULB Dusseldorf, D 9, Antiphonary (Summer Section)

ff. 300, 415 x 307 (307 x 204) mm., trimmed; double vertical, single horizontal bounding lines, not full across, ruled in light brown ink, no prickings; 9 staffs, ruled in red; 2-staff illuminated initials, some historiated; 1-staff initials, red or blue with blue or red fleuronnée; rubrics and cues in red; 1-staff scribal initials, brown, with red.

Collation: I¹⁰ (ff. 1–10); II¹⁰ (ff. 11–20); III¹⁰ (ff. 21–30); IV¹⁰ (ff. 31–40); V¹⁰ (ff. 41–50); VI¹⁰ (ff. 51–60); VII¹⁰ (ff. 61–70); VIII¹⁰ (ff. 71–80); IX¹⁰ (ff. 81–90); X¹⁰ (ff. 91–100); XI¹⁰ (ff. 101–110); XII¹⁰ (ff. 111–120); XIII¹⁰ (ff. 121–130); XIV¹⁰⁻¹ (ff. 131–139; stub between ff. 139–140); XV¹⁰ (ff. 141–150); XVI¹⁰ (ff. 151–160); XVII¹⁰ (ff. 161–170); XVIII¹⁰ (ff. 171–180); XIX¹⁰ (ff. 181–190); XX¹⁰ (ff. 191–200); XXI¹⁰ (ff. 201–210); XXII¹⁰ (ff. 211–220); XXIII¹⁰ (ff. 221–230); XXIV¹⁰ (ff. 231–240); XXV⁶ (ff. 241–246: Catherine of Siena, after 1461; + f. 246a: early modern paper, with two watermarks: Doppeladler, 90 x 80 mm.; 4VM monogram, 40 x 20 mm.); XXVI⁴⁺³ (ff. 247–251 [office for John the Evangelist, early XIV]; f. 251=singleton); XXVII¹ (f. 251a [early modern paper] + f. 252 [singleton from gradual with Dedication of Church, ca. 1380]); XXVIII⁴⁺⁵ (ff. f. 252a–260: f. 252a [early modern paper]

[1] More detailed descriptions can now be found in: *Handschriften Düsseldorf* (2015).

App. C: Fig. 1
Front cover, antiphonary (pars hiemalis)
for Paradies. ULB Dusseldorf, D 7

34 | APPENDIX C

App. C: Fig. 2
Front cover, antiphonary (pars hiemalis)
for Paradies. ULB Dusseldorf, D 9

+ ff. 255–257 [singletons inserted between ff. 254–258]; XXIX¹⁰ (ff. 261–270); XXX¹⁰ (ff. 271–280); XXXI¹⁰ (ff. 281–290); XXXII¹⁰ (ff. 291–300); written in *littera formata textualis*, dark brown ink.

Gathering XXV (ff. 241–246): 362 x 225 mm., severely trimmed, no prickings, double vertical bounding lines, ruled in black; double (top) and single (bottom) horizontal bounding lines, ruled in red, full across; 1-staff and 1-line initials, red; some capitals stroked in red; rubrics in red; f. 246r–v with 34 lines; 9 staffs, ruled in red, written in littera formata textualis.

Gathering XXVI (ff. 247–251): 318 x 196 mm., trimmed, no prickings, double vertical bounding lines, ruled in light brown ink; single horizontal bounding lines; 9 staffs, ruled in red, written in *littera formata textualis*; three-staff illuminated initials, all excised; 1-staff red or blue initials with blue or red fleuronnée, one (f. 249v) with extensions running the length of the margin; 1-staff scribal initials, brown with red.

Gathering XXVII (ff. 252): 310 x 202 mm., trimmed, no prickings, double vertical bounding lines, ruled in light brown ink; double horizontal bounding lines, full across, for top and bottom line of chant text; 8 staffs, ruled in red; 1-staff illuminated initial (f. 252v); 1-staff scribal initials, some with inscriptions and figural decoration, stroked in red; interlinear ornamental bands including inscriptions both painted and written; rubrics in red.

Gathering XXVIII (ff. 252a–258): 310 x 203 mm., trimmed, prickings in outer margin, double vertical bounding lines and double horizontal bounding lines for top and bottom lines of chant text, ruled in light brown ink; 8 staffs, ruled in red; 2- and 1-staff illuminated initials, with inhabited vine scroll extensions in margins; 1-staff puzzle initials, red and blue, with red fleuronnée; 1-staff scribal initials, stroked in red; fleuronnée border (f. 253r) and marginal extensions (f. 260v); rubrics in red.

Binding [App. C, fig. 2]: white pigskin over wooden boards, square edges, 435 x 310 mm. (0.5 to 1.3 cm. larger than book block at upper, lower and outer edges); tooled and stamped front and back: four rectangular frames surrounding rectangular panel with large lozenge, the major frame decorated with interlaced ribbons with tassel-like terminals; fly-de-lys in corners of central pattern, otherwise, simple geometric patterns, badly rubbed; spine and innermost portion of boards restored with white leather, crudely trimmed, fastened by iron nails; four simple iron bosses on front cover, on which is written in black ink, "no. 3"; front cover with a single groove at center to accommodate strap (lost); clasp on back cover restored at same time as spine, attached by iron nails. Front and rear pastedowns consist of early modern paper; front inscribed D.9 (pencil); otherwise blank. White leather tabs.

Dortmund, Propsteikirche, Archiv B 6, Gradual

325 parchment leaves, 2 unfoliated paper leaves inserted between leaves 110 and 111, 16th or 17th century. At the end 6 paper leaves added with the 'Dies irae' and early modern addenda. Loss of text: a total of 8 leaves: 3 leaves before f. 1, 3 leaves between ff. 261 and 262, 1 leaf between ff. 273 and 274, and a further leaf between ff. 284 and 285. Original pagination in roman numerals in red, top center of page, breaks off from f. 219 onwards. F. 101 is mistakenly counted twice. From f. 218 modern foliation in pencil (20th century). Size of leaves: 342 x 268 (275 x 195) mm, leaves trimmed on all three sides. Pricking along the inside edge of the leaves. 8 staves in red with 4 lines each; square notation. 24 mm from outside edge of leaf 2 vertical lines 6 mm apart, the same on the inside, height of lines of text 8 mm. Notes and text in *littera textualis formata* in brown ink. Red-blue pen-flourished initials 3 or 4 staves high, those for the most important feasts in the hierarchy with three-sided extensions (for overview see below); red, blue, or red-blue initials 1 staff (including chant text) in height with pen-flourishing in the opposite color; single-line scribal initials with a minor pen-flourishing in brown ink.

Collation: I¹⁴⁻³ (ff. 1–10); II¹² (ff. 11–22); III¹² (ff. 23–34); IV¹² (ff. 35–46); V¹² (ff. 47-58); VI¹² (ff. 59–70); VII¹² (ff. 71–82); VIII¹² (ff. 83–94); IX¹² (ff. 95–106); X¹²⁺²⁽ᵖᵃᵖᵉʳ⁾ (ff. 106–117; f. 101 counted twice); XI¹² (ff. 118–129); XII¹² (ff. 130–141); XIII¹⁴ (ff. 142–155); XIV⁸ (ff. 156–163); XV⁸ (ff. 164–171); XVI¹² (ff. 172–183); XVII¹⁰ (ff. 184–193); XVIII¹² (ff. 194–205); XIX¹² (ff. 206–217); XX¹² (ff. 218–229); XXI¹² (ff. 230–241); XXII¹² (ff. 242–253); XXIII¹⁴⁻³ (ff. 254–264); XXIV¹²⁻¹ (ff. 265–275); XXV¹²⁻¹ (ff. 276–286); XXVI¹² (ff. 287–298); XXVII¹² (ff. 299–310); XXVIII¹⁴ (ff. 311–324); XXIX⁶ (ff. 325–327; paper, 16th/17th century). Quires numbered continuously in Arabic numerals at the bottom left of the first leaf of each quire from beginning to end, probably before binding in the 17th century. No catchwords.

Binding: 380 x 282 mm. Dark brown leather on wooden boards with rounded edges and slightly beveled, scored and stamped on front and back, front and back identically fashioned: cuir ciselée decoration in a fine diamond pattern (distance between lines 2 mm). Parallel to the edges of the covers on all sides two stamped ribbons

with 4 grooves each, in the corners blind stamping with symmetrical leaf motifs running inwards to a point and partly furled. In the center rhombus-shaped blind stamping with the same furled-leaf motifs. On the front two plates secured with three nails each, the bottom one renewed. Two clasps with leather loops, which end in two metal pins. Book spine with 6 cords, probably the original binding from the time of the binding (very late 16th or 17th cent.). Front and back end papers out of paper.

Contents

ff. 1–169v: Gradual, *Proprium de tempore* in the sequence of the church year from 1st Sunday in Advent ('Ad te levavi') until 23rd Sunday after Trinitatis ('Amen dico vobis quicquid orantes petitis').

ff. 169v–171v: Office for Dedication of Church, introit 'Terribilis est locus iste'.

ff. 172r–208v: Proprium de sanctis: 172r Andrew with vigil (30.11.); 172v Nicholas of Myra (6.12.); 172v Lucy (13.12.); 172v Thomas the apostle (21.12.); 173r Stephan (26.12.); 174r John the Evangelist (27.12); 175r Holy Innocents (28.12.); 176r Thomas Becket (29.12.); 176r Silvester I, Pope (31.12.); 176r Felix of Nola (14.1.); 176r Maurus of Subiaco (15.1.); 176r Marcellus, Pope (16.1.); 176r Anthony, Abbot (17.1.); 176r Prisca (18.1.); 176r Fabian and Sebastian (20.1.); 176v Agnes (21.1.); 177r Vincent of Saragossa (22.1.); 177r, Conversion of St Paul (25.1.); 178v Agnes, octave (28.1.); 178v Candlemass (2.2.); 180r Blaise (3.2.); 180r Agatha (5.2.); 180r Valentine (14.2.); 180r Cathedra Petri (22.2.); 181r Matthias the apostle (24.2.); 181v Gregory (12.3.); 181v Annunciation to Mary (25.3.); 182r Ambrose (4.4.); 182r Tiburtius, Valerian, and Maximus (14.4.); 182v George (23.4.); 183v Mark (25.4.); 183v Vitalis (28.4.); 183v Peter Martyr (29.4.); 184r Philip and James (1.5.); 185r Invention of the Cross (3.5.); 185v Crown of Thorns (4.5.); 186v Johannes ante portam latinam (6.5.); 186v Gordianus and Epimachus (10.5.); 186v Nereus, Achilleus, and Pancratius (12.5.); 186v Servatius (13.5.); 187r Translation of Dominic (24.5.); 187r Urban (25.5.); 187r Marcellinus and Peter (2.6.), 187v Primus and Felicianus (9.6.); 187v Barnabas (11.6.); 187v Basilius, Cyrinus, and Narbor (12.6.); 187v Anthony of Padua (13.6.); 187v Martial (30.6.); 187v Mark and Marcellian (18.6.); 187v Gervaise and Protase (19.6.); 188r John the Baptist with vigil (24.6.); 190r John and Paul (26.6.); 191r Peter and Paul with vigil (28.6.); 192v commemoration of Paul the apostle (30.6.); 193r Octave of Peter and Paul (6.7.); 193r Seven Brothers (10.7.); 193v Margaret (13.7.); 193v Praxedes (21.7.); 193v Mary Magdalen (22.7.); 194r Apollinaris (23.7.); 194r James the Greater (25.7.); 194r Martha (29.7.); 194r Nazarius, Celsus, and Pantaleon (28.7.); 194r Felix, Simplicius, and Faustinus (29.7); 194r Abdon and Sennen (30.7.); 194r Germanus (31.7.); 194r Peter ad Vincula (1.8.); 194v

Stephan (2.8.); 194v Invention of Stephan (3.8.); 194v Dominic (5.8.); 195r Lawrence (9.8.); 197r Hippolytus and Companions (13.8.); 197r Assumption of the Virgin Mary with vigil (15.8.); 199r Octave Lawrence (17.8.); 199r Bernard (20.8.); 199r Bartholomew (24.8.); 199r Louis of Toulouse (19.8.); 199r Augustine (28.8.); 199v Decollation of John the Baptist (29.8.); 200r Nativity of the Blessed Virgin Mary (8.9.); 200v Invention of the Cross (14.9.); 201r Eufemia (16.9.); 201r Matthew apostle with vigil (21.9.); 201v Maurice and Companions (22.9.); 201v Cosmas and Damian (27.9.); 201v Archangel Michael (29.9.); 203r/v Jerome (30.9.); 203r/v Remigius (1.10.); 203r/v Francis (4.10.); 203r/v Mark (7.10.); 203r/v Dionysius and companions (9.10.); 203r/v Edward the Confessor (13.10.); 203r/v Eleven Thousand Virgins (21.10.); 203r/v Luke (18.10.); 203r/v Simon and Judas with vigil (28.10.); 203v All Saints with vigil (1.11.); 204r All Souls (2.11.); 207v Four Crowned Martyrs (8.11.); 207v Theodor (9.11.); 207v Martin of Tours (11.11.); 208r Elisabeth of Thuringia (19.11.); 208r Cecilia (22.11.); 208r Clement (23.11.); 208v Catharine (25.11.).

ff. 208v–245r: Commune sanctorum.

ff. 245r–249r: Votive Masses.

ff. 249r–258r: Kyriale.

ff. 258v–302r: Sequentiary: 258v Letabundus exultat (Christmas, *RH* 10012, *AH* 54:2); 259v Victimae paschalis laudes (Easter, *RH* 21505, *AH* 54:7); 260v Omnes gentes plaudite (Ascension, *RH* 14047, *AH* 54:152), f. 261v breaks off after 'Sedet in altis'; [loss of 3 leaves of text with beginning of Sancti spiritus assit nobis, Whitsun, *AH* 54:153], continuation 262r: 'videri supremus genitor possit a nobis'; 263r Veni sancte spiritus et mitte celitus (Whitsun, *RH* 21242, *AH* 54:153); 264r Profitentes unitatem (Trinitatis *RH* 15555, *AH* 54:161); 266r Lauda Sion salvatorem (Corpus Christi, *RH* 10222, *AH* 50:385); 269r Rex Salomon fecit templum (church consecration, *RH* 17511, *AH* 55:31); 271r Ave Maria gratia plena (annunciation to Mary, *RH* 1879, *AH* 54:216); 272r Adest dies celebris quo lumen (Peter Martyr, *RH* 343, *AH* 55:293); 273v In celesti yerarchya (Dominicus, *RH* 8547, *AH* 55:115) breaks off on 273v after 'qui concordet in hac, 1 lost leaf of text, continuation of the sequence 274r from: '<or>bem replet semine'; 275r Precursorem summi regis (nativity of John the Baptist, *RH* 15274, *AH* 42:252); 277r Jubar mundo geminatur (Peter and Paul, *RH* 9786, *AH* 42:312); 278v Monti Syon dat virorem (Mary Magdalen, *RH* 11691, *AH* 8:230); 280r Salve mater salvatoris vas electum (Assumption of the Virgin Mary, *RH* 18051, *AH* 54:245); 281v De profundis tenebrarum (Augustine, *RH* 4245, *AH* 55:75); 283v: Nativitas Marie virginis que nos lavit (Nativity of the Virgin Mary, *RH* 11881, *AH* 54:188); 284v Superne matris gaudia (All Saints, *RH* 19822, *AH* 55:37), breaks off on 284v at 'mundus caro demonia di<versa>', 1 lost leaf of text, continues on 285r at 'dispositi pro dignitate'; 285v Verbum bonum

et suave (1st Saturday of Advent for Virgin Mary, *RH* 21343, *AH* 54:218); 286v Virginis Marie laudes concinnant christiani (Feast of Virgin Mary, *RH* 21651, *AH* 54:21); 287r Hodierne lux diei celebris in matri die (feast of Virgin Mary, *RH* 7945, *AH* 54:219); 288r Ave mundi spes maria (feast of Virgin Mary, *RH* 1974, *AH* 54:217); 289v Jubilemus in hac die (feast of Virgin Mary, *RH* 9813; *AH* 54:284); 291v Tibi cordis in altari (Saturdays for Virgin Mary, *AH* 54:279/422); 293r Stella maris o Maria expers paris parens pia (feast of Virgin Mary, *RH* 19456, *AH* 54:283); 294v Ave virgo virginum (feast of Virgin Mary, *RH* 2261, *AH* 54:285); 295v Mater patris nati nata (feast of Virgin Mary, *RH* 11350, *AH* 54:281); 296v Salve sancta Christi parens (feast of Virgin Mary, *RH* 18203, *AH* 54:282); 298r Ave virgo gratiosa, virgo mater gloriosa (feast of Virgin Mary, *RH* 2217, *AH* 54:278); 299r Ave virgo gloriosa celi iubar (feast of Virgin Mary, *RH* 2205, *AH* 54:277); 301r Salvatoris mater pia (feast of Virgin Mary, *RH* 17821, *AH* 54:280).

ff. 302r–324v: Added sequences 'ex gratia specialis'. 302r Psallat ecclesia mater illibata (Dedication of Church, *RH* 15712, *AH* 53:247); 303r Ave praeclara maris stella (feast of Virgin Mary, *RH* 2045, *AH* 50:241); 305v Verbum dei deo datum (John the Evangelist, *RH* 21353, *AH* 55:212); 308v Celi enarrant gloriam de filii (Dispersion of the Apostles, *RH* 3488, *AH* 50:267); 311v Psallite regi nostro in celis (John the Baptist, *AH* 50:270); 314r Iubilemus in hac die qua baptiste cristi pie (Decollation of John the Baptist, *RH* 28750); 316r Kyrie-Melody for every duplex feast; 319r Quasi stelle matutina in medio (Tract for Thomas Aquinus, not identified); 320r Laus tibi christe qui es creator (Mary Magdalene *AH* 50:268); 322v Versus to 'Salve regina'; 323r Versus to 'Regina coelorum'.

f. 324v: Colophon: 'Hunc librum scripsit, notavit et cum labore complevit soror Elizabet de luenen ordinis fratrum predicatorum in paradyso fratribus eiusdem ordinis in tremonia ob perpetuam sui memoriam'.

App. C, Table 1: Book Decoration. Overview of the highlighted fleuronnée initials and the inscriptions

F.	Initial	Location	Size (N = Notational System, T = line of text)	Inscription	Figurative motif in image
1r	A	Beginning of Temporale, 1st Sunday in Advent (Ad te levavi)	3 N + 3 T		Eagle
8v	B	Hymn, Advent Week (Benedictus es)	1 N + 1 T		
12v	D	Introit Christmas Night (Dominus dixit)	1 N + 1 T	IHESUS	
14r	L	Introit morning Mass on Christmas Day (Lux fulgebit)	1 N + 1 T	MARIA	
15v	P	Christmas Mass (Puer natus est)	3 N + 3 T	AGNOSCE O CRISTIANE DIGNITATEM TUAM	
18v	E	Epiphany (Ecce advenit)	2 N + 2 T		
111v	R	Easter Sunday (Resurrexi)	3 N + 3 T	IESUS	
130v	V	Ascension (Viri Galylei)	2 N + 2 T		
135r	S	Pentecost (Spiritus domini)	3 N + 3 T		Dove with 3 clover leaves
142r	B	Trinity Sunday (Benedicta sit)	2 N + 2 T		
143v	C	Corpus Christi (Cibavit eos)	2 N + 2 T		

169v	T	Dedication of Church (Terribilis est)	2 N + 2 T	ORATE DEUM PRO ME	
172r	D	Beginning of Sanctorale (Dominus secus)	2 N + 2 T		
174r	I	John the Evangelist (In medio ecclesie)	2 N + 2 T		
188v	D	John the Baptist (De ventre matris)	2 N + 2 T	SANCTE JOHANNES TE VENERANTES PROTEGE	Two eagles in stem of letter
192v	S	Paul (Scio cui credidi)	2 N + 2 T		
193v	G	Mary Magdalen (Gaudeamus omnes)	2 N + 2 T	CONGRATULAMINI MICHI OMNES	
199v	I	Decollation of John the Baptist (Iustus ut palma)	5 N + 6 T		
198r	G	Assumption of the Virgin (Gaudeamus omnes)	2 N + 2 T		Dove with clover leaf in mouth
204r	G	All Saints (Gaudeamus omnes)	2 N + 2 T		Dove in stem of letter
278v	M	Sequence Mary Magdalen (Monti Syon)	2 N + 2 T		
302r	P	Sequence Dedication of Church (Psallat ecclesia)	1 N + 1 T		
303r	A	Marian sequence (Ave praeclara)	2 N + 2 T		
311v	P	Sequence John the Baptist (Psallite regi nostro)	1 N + 1 T		
314r	I	Sequence Decollation of John the Baptist (Iubilemus in hac die)	3 N + 4 T		

ULB Dusseldorf, D 11, Gradual

i + 692 pp (parchment, varying in color, thickness and absorbency, which sometimes, e.g., p. 441, caused the brown ink used by the scribe to run; modern pagination, pencil, with some corrections); 440 x 307 mm. (308 x 202) mm. (gathering XXIII: 310 x 205 mm., horizontal ruling full across), ruled in light brown ink, double vertical bounding lines; double horizontal bounding lines (not full across) for upper and lower lines of chant text; prickings in upper, lower and outer margins.

8 staffs (except 9 on all but the last verso of gathering XXIII), written in one hand (including aberrant gathering XXIII, in *littera textualis formata* in dark and light brown ink. To judge from the integration of major and minor scripts in some of the cues, e.g.,

p. 289, the chant and the inscriptions were written by the same hand.

Decoration: 3- to 2-staff historiated initials for major feasts; 2-line puzzle initials in red and blue with red and blue fleuronnée; 2-line initials, blue with red fleuronée; 1-line initials, red with red fleuronnée or vice versa; some initials of all types including burnished gold; scribal initials, 1-line or 1-staff, in brown ink; *nomina sacra* ornamented; most initials historiated, the majority of these incorporating inscriptions; rubrics and cues in red. Numerous additions in margins in an 18th-century hand, brown ink.

App. C: Fig. 3
Front cover, gradual, Paradies.
ULB Dusseldorf, D 11

App. C: Fig. 4
Top Edges, gradual, Paradies.
ULB Dusseldorf, D 11

Collation: I⁸ (pp. 1–15); II¹² (pp. 16–39); III¹² (pp. 40–63); IV¹² (pp. 64–87); V¹² (pp. 88–101); VI¹² (pp. 102–135); VII¹² (pp. 136–159); VIII¹² (pp. 160–183) [viii]; IX¹² (pp. 184–207); X¹² (pp. 208–231); XI¹² (pp. 232–255); XII¹² (pp. 256–279); XIII¹² (pp. 280–303); XIV¹² (pp. 304–329); XV¹² (pp. 330–353); XVI¹⁴ (pp. 354–381); XVII¹² (pp. 382–405) [numbered xvi at beginning, lower left corner, p. 382]; XVIII¹² (pp. 406–429) [xviii]; XIX¹² (pp. 430–453) [xviii<i>]; XX¹² (pp. 454–477); XXI¹² (pp. 478–501); XXII¹² (pp. 502–525); XXIII¹² (pp. 526–558); XXIV¹² (pp. 559–573); XXV¹² (pp. 574–597); XXVI¹² (pp. 598–621); XXVII¹² (pp. 622–645); XXVIII¹² (pp. 646–669); XXIX¹² (pp. 670–692) [outer bifolium reversed]. Some signatures survive, brown ink; no catchwords.

Binding [App. C, figs. 3–4]: brown leather over boards, rounded edges, tooled and stamped (lozenges, defined by intersecting bands, ca. 170 mm., defined by double lines, 2mm. apart, with small acanthus leaves filling intersections, in a rectangular frame, ca. 20 mm. wide, also defined by double lines, filled with helix reinforced at outer edge with additional rectangular stamps in a continuous strip; each 'oval' of helix filled with sun-like blossom; the whole very badly rubbed and pock-marked, with holes revealing wood beneath; spine and 8 cm. of cover rebound in brown leather, 8 pairs of ties; smaller and larger rectangular stamps on rear cover, so badly rubbed as to be illegible; modern endpieces; four brass feet, two each on lower edges of front and back covers, each attached with two nails with round heads; two brass clasps, forked, with curved flanges, on front cover, each attached with three nails with round heads, for leather straps (leather and brass fittings on rear cover restored) with early modern (?) clasps. The volume is ca. 12 cm. thick, with upper, lower, and outer edges painted and gilded with a vine scroll inhabited by lions (comparable to textiles), all in red with black outlines; white leather tabs. On front and back boards, five holes, two smaller ones to each side of each clasp, and, on the front board, one in the middle, testify to a previous pair of clasps.
Front pastedown: modern paper over modern parchment (stub between 15–16); I=original pastedown
Rear pastedown: originally p. 692; now paper over modern parchment. White leather tabs.

ULB Dusseldorf, D 12, Gradual

i (modern parchment) + 326 (pagination, probably XVIII, in same light brown ink as additions in margin) begins with 2 [skips 3] = modern foliation 1, in pencil, through 49, both in upper right-hand corner), 525 x 375 (370 x 245) mm., trimmed, double vertical and double horizontal bounding lines, full across, ruled in light brown ink; prickings in inner and outer margins; rarely in lower margin (f. 1); 9 staffs, ruled in red, notes in brown ink; written in littera textualis formata in brown ink. Tabs, white leather. 3- and 2-staff initials for major feasts, with floral and fleuronnée extensions in margins, many still veiled by their original silk guards or curtains, in diverse colors (green, blue, yellow, red) [App. C, figs. 5–10]; 1-staff and 1-line initials, red or blue, with blue or red fleuronnée, occasionally also red with green fleuronnée or red and blue with green and red fleuronnée; scribal initials in brown ink, with brown fleuronnée and highlighting in red, some including faces and animal motifs; some 1-staff and 1-line initials elaborated in the form of knots or flowers, occasionally with dragons, red, blue, green, and yellow; among the sequences, some initials including elements in burnished gold; *nomina sacra* accentuated with fleuronnée; rubrics and cues in red.

Collation: I¹² (ff. 1–12; 12r–v blank); II¹² (ff. 13–24); III¹² (ff. 25–36); IV¹² (ff. 37–48); V¹² (ff. 49–60); V¹²⁻¹ (ff. 62–71); VI¹² (ff. 72–83); VII¹²⁻¹ (ff. 84–94); VIII¹² (ff. 95–106); IX¹² (ff. 107–118); X¹² (119–130); XI¹² (131–142); XII¹⁰ (ff. 143–152); XIII¹² (ff. 153–164); XIV¹² (ff. 165–176); XV¹² (ff. 177–188); XVI¹²⁻¹ (ff. 189–199); XVII¹² (200–211); XVIII¹² (212–223); XIX¹² (224–235); XX¹⁴⁻¹ (ff. 236–248); XXI¹² (ff. 249–260); XXII¹⁰ (261–270); XXIII¹⁴ (ff. 271–285); XXIV¹⁰ (ff. 286–295); XXV¹² (ff. 296–308); XXVI¹⁰ (ff. 309–318); XXVI⁸ (ff. 319–326) + i (modern parchment). No signatures, no catchwords. Gatherings described as 12–1 could be 10+1; no stubs visible; very tightly bound.

Binding [App. C, fig. 5]: Brown leather over champfered boards with rounded edges, stamped and tooled front and back: a field of lozenges defined by single intersecting lines, each lozenge holding a 5-petal rosette within a circle, with smaller rosettes at intersections, in a rectangular frame with vertical and horizontal bands, also defined by single lines, filled with identical rosettes within circles aligned with those in lozenges, each framed by a pair of small, square stamps containing a Greek cross with arms oriented towards corners; the

squares at the corners of the binding filled with 9 small circles with dots at the center arranged along intersecting diagonals; four holes in each horizontal row to hold metal ornamentation; three holes in all four corners to hold bosses; clasps modern; one cavity in lower center of front board and more in lower edge of rear board to hold feet, lost. Spine restored, brown leather, 7 double straps, with horizontal grooves on inside of board, held by wooden pegs, reinforced by iron nails (later?). No paste down.

App. C, Table 2: Comparison of the Easter litanies in 4 gradual manuscripts

ULB Dusseldorf, D 10a, f. 86v	Dortmund, Archiv der Propsteigemeinde, B 6, f. 105r	ULB Dusseldorf, D 11, p. 241	ULB Dusseldorf, D 12, f. 110v
Dominican gradual of uncertain provenance, ca. 1250-1275	**Dominican gradual for Dortmund, ca. 1360**	**Dominican gradual for Paradies, ca. 1380**	**Dominican gradual for Paradies, ca. 1420**
pater	pater	pater	pater
filius	filius	filius	filius
spiritus	spiritus	spiritus	spiritus
trinitatis	trinitatis	trinitatis	trinitatis
Mary	Mary	Mary	Mary[2]
Michael	Michael	Michael	Michael
Gabriel	Gabriel	Gabriel	Gabriel
Raphael	Raphael	Raphael	Raphael
All archangels/angels	All archangels/angels	All archangels/angels	All archangels/angels
John the Baptist	John the Baptist	John the Baptist	John the Baptist
All patriarchs	All patriarchs	All patriarchs	
Peter	Peter	Peter	Peter
Paul	Paul	Paul	Paul

[2] The name is highlighted by means of pen-flourished decoration.

Andrew	Andrew	Andrew	Andrew
James	James	James	James
John the Evangelist	John the Evangelist	John the Evangelist	John the Evangelist
Thomas	Thomas	Thomas	Thomas
James	James	James	James
Philip	Philip	Philip	Philip
Bartholomew	Bartholomew	Bartholomew	Bartholomew
Matthew	Matthew	Matthew	Matthew
Simon	Simon	Simon	Simon
Jude	Jude	Jude	Jude
Matthew	Matthew	Matthew	Matthew
Mark	Mark	Mark	Mark
Luke	Luke	Luke	Luke
Barnabas	Barnabas	Barnabas	Barnabas
All apostles	All apostles	All apostles	All apostles
Holy Innocents	Holy Innocents	Holy Innocents	Holy Innocents
Stephen	Stephen	Stephen	Stephen
Clement	Clement	Clement	Clement
Cornelius	Cornelius	Cornelius	Cornelius
Cyprian	Cyprian	Cyprian	Cyprian
Laurence	Laurence	Laurence	Laurence
Vincent	Vincent	Vincent	Vincent
Dionysius	Dionysius	Dionysius	Dionysius
Maurice	Maurice	Maurice	Maurice
Sebastian	Sebastian	Sebastian	Sebastian
Thomas	Thomas	Thomas	Thomas
Peter	Peter	Peter	Peter
All martyrs	All martyrs	All martyrs	All martyrs
Silvester	Silvester	Silvester	Silvester
Hilarius	Hilarius	Hilarius	Hilarius
Martin	Martin	Martin	Martin

Augustine	Augustine	Augustine	Augustine
Ambrose	Ambrose	Ambrose	Ambrose
Gregory	Gregory	Gregory	Gregory
Nicholas	Nicholas	Nicholas	Nicholas
	Severin	Severin	Severin
Dominic[3]	Dominic	Dominic	Dominic[4]
Thomas	Thomas	Thomas	Thomas
Francis	Francis	Francis	Francis
Jerome	Jerome	Jerome	Jerome
Benedict	Benedict	Benedict	Benedict
	Bernard	Bernard[5]	Bernard
Antony	Antony	Antony	Antony
All confessors	All confessors	All confessors	All confessors
Mary Magdalen	Mary Magdalen	Mary Magdalen	Mary Magdalen
	Martha	Martha	Martha
Felicity	Felicity	Felicity	Felicity
Perpetua	Perpetua	Perpetua	Perpetua
Agatha	Agatha	Agatha	Agatha
Lucy	Lucy	Lucy	Lucy
Agnes	Agnes	Agnes	Agnes
Cecilia	Cecilia	Cecilia	Cecilia
Katharine	Katharine	Katharine	Katharine
	Margaret	Margaret[6]	Margaret
		Barbara	Barbara
	Ursula	Ursula	Ursula
	Elizabeth	Elizabeth	Elizabeth[7]
All virgins	All virgins	All virgins	All virgins

[3] All manuscripts include the addendum usual for the Order, namely that the name had to be sung twice and in a high voice.

[4] The only name to be written in red letters.

[5] Feast day prescribed for the Order from 1303 onwards.

[6] Inclusion in the litany prescribed for the Order from 1287 onwards.

[7] In this manuscript the name has a background decorated with pen-flourishing, probably because Elisabeth is the patron saint of the scribe.

D: Sequence Tables

App. D, Table 1
Sequences in the repertory of Paradies, with comparison to Humbert, Katharinenthal, Unterlinden, and Dortmund

Orange: in B 6 only
Bold: in D 11 only
Red: in D 11 and D 12 only
Violet: in D 11 and D 12 only, but out of order in D 11
Blue: sequences that are out of liturgical order
Yellow: added in a later hand to Colmar 317;
Green: may have been written at Paradies
Unique: Melody is unique within Soest repertory but may be
found elsewhere

HR: Humbert of Romans
GK: Gradual St. Katharinenthal
Col: Colmar 317 from Unterlinden

Sequences in the Paradies repertory	Feast/Saint and rubric, following D 11	RH; AH no./first page	HR/GK/ D 10a	Status in B 6 from Dortmund	Status in D 11	Status in D 12	Melody in Soest	Earliest witness/ Dominican?	Major art/ D 11; D 12: I= Initial; M=Marginal; V=Individual Verses
Order as in D 11									
Laudes pro mira gratia	St. James the Major, July 25	Not in *AH*			**p. 7**		Unique	14/Paradise?	I/M
Iocundare plebs fidelis	Evangelists	*RH* 9843; *AH* 55:7/11			**p. 10**			13/no	I/M/V
Virgine Iohanne laudes	John the Evangelist at Eastertide	Not in *AH*			**p. 16**		Victime	14/Paradise?	I/V
Letabundus exultet	Christmas, December 25	*RH* 10012; *AH* 54:2/5	1, D 10a; GK:2; Col 167r	258v	p. 546	249r	Letabundus; unique	late 11/no	I/M; I/M
Victime paschali laudes	Easter	*RH* 21505; *AH* 54:7/12	2, D 10a; GK:3; Col 168r	259v	p. 548	250r	Victime	11/no	I; I/M
Omnes gentes plaudite	Ascension	*RH* 14047; *AH* 54:152/232	3, D 10a; GK:4; Col 168v	260v	p. 550	250v	Omnes gentes unique	13/Dom	I/M/V
Sancti spiritus adsit nobis	Pentecost	*RH* 18557, *AH* 53:70/119	4, D 10a; GK:5; Col 169v	yes	p. 553	252v	Unique	9/no	I/M; M

Veni sancte spiritus et emitte celitus	Pentecost	*RH* 21242, *AH* 54:153/234	5, D 10a; GK:6; Col 170v	263r	p. 557	254v	Veni sancte	12/no	I/M; I
Profitentes unitatem	Trinity	*RH* 15555; *AH* 54:161/249	6, D 10a; GK:7; Col 171v	264r	p. 559	255r	Lauda Sion	12/no	I/M
Lauda Sion salvatorem	Corpus Christi	*RH* 10222; *AH* 50:385/584	GK:38; Col 192v	266r	p. 563	256r	Laude Sion/ Laudes crucis	13/Dom	I/M
In celesti ierarchia	Corpus Christi	Not in *AH*			p. 568	260r	In celesti	14/Paradise?	M
Psallat ecclesia mater illibata (Notker Balbulus).	Dedication	*RH* 15712; *AH* 53:247/398		302r	p. 572	262r	Unique	9/no	I/M
Rex Salomon fecit templum	Dedication	*RH* 17511; *AH* 55:31/35	7, 10a; GK:8; Col 172v	269r	p. 573	325r	Unique	12/Victorine	I
Verbum dei deo natum	John the Evangelist, Dec. 27; John before the Latin gate (D 12)	*RH* 21353; *AH* 55:188/211	GK:47	305v	p. 577	269r	Verbum dei deo	12/no	I/M/V; I/M/V
Paule doctor gentium omnium credentium	Paul, Conversion, Jan. 25	Not in *AH*			p. 583	264v	Veni sancte	14/Paradise?	I
Ave Maria gratia plena	Annunciation, March 25	*RH* 1879; *AH* 54:216/337	8; GK:9; Col 173v	271r	p. 584	265v	Unique	11-12/no	I/V
Adest dies celebris quo lumen	Peter Martyr, April 29	*RH* 343; *AH* 55:293/325	9; GK:10; Col. 174v	272r	p. 587	266v	Unique	13/Dom	I/M
Salve salutare lignum	Finding of the Cross, May 3	*AH* 34:14/20			p. 590	268r	Salvatoris mater pia	14/Paradise?	I/V
In celesti ierarchia	Dominic, translation, May 24	*RH* 8547; *AH* 55:115/133	10; GK:11; Col 175v	273v	p. 592	271v	In celesti	13/Dom	I/M
Precursorem summi regis	Birth of John the Baptist, June 24	*RH* 15274; *AH* 42:252/227	GK:42	275r	p. 595	274r	In celesti	14/Dom	I/M
Iubar mundo geminatur	Peter and Paul, June 29	*RH* 9786; *AH* 42:312/282		277r	p. 599	276r	De profundis	14/Dom; see Roma Petro	I/V; I/M

Celi enarrant gloriam de filii	Divisio apostolorum, July 15	RH 3488; AH 50:267/344		308v	p. 602	277v	Unique	11/no Gottschalk	I/V; M
Monti Sion dat virorem	Maria Magdalena, July 22	RH 11691; AH 8:230/175	GK:34	278v	p. 608	280v	Stella maris	13?/Dom	I
Verbum dei incarnatum	Peter's Chains, August 1	AH 44:269/240			p. 611	282r	Verbum dei deo	14/PBS?	I; I
Ave preclara maris stella	Feast of the Assumption, August 15	RH 2045; AH 50:241/313	GK:26; Col 199r add.	303r	p. 616	285r	Unique	12/no	I/V; I/M
Salve mater salvatoris vas electum	Within the Octave of the Assumption	RH 18051; AH 54:245/383	11; GK:12; Col 176v	280r	p. 621	287v	Unique	12/no	I/M; M
Omnis celi ierarchia	On the Octave of the Assumption	AH 9:76/61			p. 624	289r	In celesti	14/PBS?	I/M
De profundis tenebrarum	Augustine, Bishop, August 28	RH 4245; AH 55:75/91	12; GK:14; Col 177v	281v	p. 628	289r	De profundis	12/no	
Nativitas Marie virginis que nos lavit	Nativity of the BVM, September 8	RH 11881; AH 54:188/288	13; GK:15; Col 178v	283v	p. 631	294v	Nativitas Marie	13/Dom	I/V; I
Superne matris gaudia	All Saints, Nov. 1	RH 19822; AH 55:37/45	14; GK:16; Col 179v	284v	p. 634	296r	Unique	12/no	I
Verbum bonum et suave	Mary on Saturdays in Advent	RH 21343; AH 54:218/343	15; Col 180v	285v	p. 637	298r	Unique	12/no	
Letabundus**	For feasts from the Nativity to the Purification	See above					Unique (as above)	as above	
Virgini Marie laudes concinnant Christiani	In Paschal time	RH 21651; AH 54:21/31	16; GK:17; Col 181r	286v	p. 639	299r	Victime	13/Dom	
Hodierne lux diei celebris in matris dei	From Trinity to Advent, when a sequence is sung for Mary	RH 7945; AH 54:219/346	17; GK:18; Col 181v	287r	p. 640	300r	Unique	late 11th/no	

Ave mundi spes maria	Another	*RH* 1974; *AH* 54:217/340	18; GK:19; Col 182v	288r	p. 642	301r	Unique	12/no	
Iubilemus in hac die quam regine celi pie dicavit ecclesie	On Saturdays when the complete office is said for the Virgin Mary	*RH* 9813; *AH* 54:284/430	19; GK:20; Col 183v	289v	p. 645	302v	Unique	13/Dom	
Tibi cordis in altari	Yet another sequence for Saturdays (this rubric from D 12; there is none in D 11)	*AH* 54:279/422	20; GK:36; Col 184v	291v	p. 649	304r	Unique	13/Dom	
Stella maris o Maria expers paris parens pia	Another	*RH* 19456; *AH* 54:283/429	21; GK:25; Col 185r	293v	p. 650	305r	Stella maris	13/Dom	
Ave virgo virginum	Another	*RH* 2261; *AH* 54:285/432	22; GK:21; Col 186r	294v	p. 653	306v	Unique	13/Dom?	
Mater patris nati nata	Another	*RH* 11350; *AH* 54:281/426	23; GK:37; Col. 186v	295v	p. 655	307v	Unique	13/Dom	
Salve sancta Christi parens	Another	*18178*; *AH* 54:282/427	24; GK:27; Col 187r	296v	p. 657	308v	Unique	13/Dom	
Ave virgo gratiosa, virgo mater gloriosa	The same, another	*RH* 2217; *AH* 54:278/419	25; GK:23; Col 188r	298r	p. 660	309v	Unique	13Dom	
Ave virgo gloriosa celi iubar	Another	*RH* 2205; *AH* 54:277/417	26; GK:22; Col 189r	299r	p. 662	310v	In celesti	13/Dom	
Salvatoris mater pia	Another	*RH* 17821; *AH* 54:280/424	27; GK:28; Col 190r	301r	p. 665	312r	Salvatoris	13/Dom	
Exortum lumen lux	John the Evangelist, Dec. 27 (D 12)	*AH* 9:252/189			p. 676	262v	Nativitas Marie	14/Paradise?	I/M/V; I/M
Elisabeth Zacharie magnum virum	John the Baptist	*AH* 9:240/179	Col 190v		**p. 680**		Unique	14/First in Colmar 317	I/M/V

Iubilemus in hac die qua baptiste Christi pie	John the Baptist, August 29 (Beheading)	RH 28750; AH 9:239/ 178		314r	p. 684	292v	In celesti	14/Paradise?	I
Creatoris laude pie	For Apostles	AH 9:377/ 278			**p. 689**		Unique, but compare to Ave virgo gratiosa	14/Paradise?	I/M
Psallite regi nostro psallite	John the Baptist	AH 50:270/ 349		311v				11/no Gottschalk	
Laus tibi Christe qui es creator	Magdalene	AH 50:268/ 346		320r				11/no Gottschalk	
In deserto vox clamantis	Beheading of John the Baptist	AH 37:216/ 190	Col 194v					14/Unterlinden?	
Gratuletur mundus iste	Nativity of John the Baptist	AH 8:195/ 150	Col 195v					14/Unterlinden?	
Clari duces	Peter and Paul	AH 8:268/ 204	GK:31; Col 196r					14/Unterlinden?	
Magdalenam planctu plenam	Magdalene	AH 37:250/ 218	Col 197r					14/Unterlinden?	
Congaudentes	Nicholas		Col 201r add.					11/no	
Lauda sponsa	Conception BVM	AH 54:196/ 305	Col 203r add.				Lauda Sion	14/Dom?	
Astra celi resplendeant	Conception BVM	AH 34:67/ 61	Col 205v add.					14/15 Dom	
Martyris egregii	St. Vincent	AH 55:340/ 379	Col 207r add.					12/no	
Laus erumpat	St. Michael	AH 55: 258/ 288	GK:39; Col 207v add.					12/No	
Lauda Sion increatam	St. Thomas Aquinas	AH 37:312/ 269	Col 210v add.					15 Unterlinden?	
No. of Sequences in D 11 only: 5									
No. of Sequences in D 11 and D 12 only: 6									
No. of Sequences that may have been written at Paradies: 10									

App. D, Table 2
Sequences at Katharinenthal in the early 13th century

Sequences Katharinenthal: numbering, Brenn (Zürich, Schweizerisches Landes-museum, LM 26117)	Folio (of the sequentiary)/Rubrics	In Order ?	Hands	No. In Humbert	AH, if NOT in Table 1
1. Verbum bonum et suave	f. 1 In conmemoratione beate virginis in aduentu domini	Yes	Main	15	
2. Letabundus exsultet fidelis chorus	f. 2	Yes	Main	1	
3. Victime paschali laudes	f. 3 In die pasche sequentibus et duobus. Sequentia.	Yes	Main	2	
4. Omnes gentes plaudite	f. 3v In ascensione domini. Sequentia.	Yes	Main	3	
5. Sancti spiritus adsit	f. 5v In die pentecostes. Sequentia.	Yes	Main	4	
6. Veni sancte spiritus	f. 7 Sequentia in crastino pentecostes et die sequenti.	Yes	Main	5	
7. Profitentes unitatem	f. 8 In festo trinitatis. Sequentia.	Yes	Main	6	
8. Rex Salomon fecit templum	f. 10 In dedicatione ecclesie. Sequentia.	Yes	Main	7	
9. Ave Maria gratia plena	f. 11 In annuntiatione tempore rogationis	Yes	Main	8	
10. Adest dies celebris	f. 13 In festo beati petri martyris fratrum predicatorum	Yes	Main	9	
11. In celesti ierachia	f. 14v In festo beati Dominici confessoris	Yes	Main	10	
12. Salve mater salvatoris	f. 16	Yes	Main	11	
13. Gabrieli vox iocunda	f. 17v (Birth of John the Baptist)	Yes	Main		*AH* 8:198/ 152
14. De profundis tenebrarum	f. 19v Sequentia. De beato Augustino.	Yes	Main	12	
15. Nativitas Marie virginis	f. 21 In nativitate beate virginis. Sequentia.	Yes	Main	13	
16. Superne matris gaudia	f. 22 In festo omnium sanctorum	Yes	Main	14	
17. Virgini Marie laudes […] / o beata.	f. 24 De beata virgine. Tempore paschali.	Votive BVM	Main	16	
18. Hodierne lux diei	f. 25	Votive BVM	Main	17	
19. Ave mundi spes Maria	f. 26	Votive BVM	Main	18	
20. Iubilemus in hac die	f. 27	Votive BVM	Main	19	
21. Ave virgo virginum	f. 29	Votive BVM	Main	22	
22. Ave virgo gloriosa	f. 30	Votive BVM	Main	26	
23. Ave virgo gratiosa	f. 31v In der Christnacht zum früeampt Sequentz.	Votive BVM	Main	25	

24. Gratuletur orbis totus	f. 32v	Votive BVM	Main		*AH* 54:240/ 377
25. Stella maris o Maria	f. 34	Votive BVM	Main	21	
26. Ave preclara maris stella	f. 35v	Votive BVM	Main		*AH* 50:241/ 313
27. Salve sancta Christi parens	f. 37v	Votive BVM	Main	24	
28. Salvatoris mater pia	f. 40	Votive BVM	Main	27	
29. O maiestas deitatis	f. 41 (Trinity)	No	Main		Not in *AH*
30. Laudes crucis attollamus	f. 42v In festo sancte crucis. Sequentia.	No	Main		*AH* 54:120/ 188
31. Clari duces nostre spei	f. 45 In festo sanctorum Petri et Pauli	No	Main		
32. Inviolata intacta et casta es Maria	f. 46	No	Main		Parisian Prosula
33. Nicolaum armonie trine laudant ierarchie	f. 47 (Nicholas)	No	Main		*AH* 44:253/ 226
34. Monte Sion dat virorem	f. 48 (Mary Magdalene)	No	Main		
35. O crux ave fructus celi	f. 49v (Cross)	No	Main		Not in *AH*
36. Tibi cordis in altari	f. 51	Votive BVM	Main	20	
37. Mater patris nati nata	f. 52	Votive BVM	Main	23	
38. Lauda Sion salvatorem	f. 53 (Corpus Christi)	No	Later hands B		
39. Laus erumpat	f. 55 (Michael the Archangel)	No	Later hands B		
40. Iesu Christe dei fili	f. 57 (Corpus Christi)	No	Main		Not in *AH*
41. Gaude mater ecclesia	f. 60 (Vincent Ferrer, Can. 1455)	No	Later hands C		*AH* 55:343/ 383
42. Precursorum summi regis	f. 63 (Birth of John the Baptist)	No	Later D		*AH* 42:252/ 227
43. Salve nobilis regina	f. 63 In festo sancte Katharine	No	Later E		*AH* 55:205/ 232
44. Omni laude conmendanda	f. 66 (John before the Latin Gate)	No	Later E		*AH* 44:179/ 165
45. Lauda Sion cum clangore	f. 67 (Denis)	No	Later E		*AH* 42:210/ 194
46. Psalle Christo laude prece	f. 153v (main body of the Gradual; for Apostles)	Yes	Main hand		*AH* 34:349/ 291
47. Verbum dei deo natum	f. 159 (main body of the Gradual; for John the Evangelist)	Yes	Main hand		

E: Select Sequences from Paradies bei Soest: 1. Melodic Incipits, 2. Transcriptions

Transcribed by Margot Fassler; Engraved by Benjamin A. Stone

Melodic incipits for the sequences in D 11.

Page

4 Lau - des pro _ mi - ra gra - ti - a de - i sa - ba-oth vi-ne-a dat___ iu-bi-lans_ can - ti - co

7 Io-cun-da-re plebs fi-de-lis cu - ius pa-ter_ cum in ce-lis re-co-lens E - ze-chi-e - lis pro-phe-te pre-co-ni-a

13 Vir - gi - ne Io-han-ne lau - des dent Chri-sto Chri-sti - a - ni.

546 Le - ta - bun-dus ex-ul - tet fi-de-lis cho-rus al - le - lu - ia

548 Vi-cti-me pas-cha-li lau - des im-mo-lant Chri-sti - a - ni

550 O-mnes gen-tes plau-di - te, fe-stos cho-ros du-ci - te Chri - sto tri-um-phan - te

553 San - cti spi-ri-tus ad - sit no-bis gra-ti - a

557 Ve - ni san-cte spi - ri-tus et e-mit-te ce - li-tus lu-cis tu - e_____ ra-di-um

559 Pro-fi - ten-tes u - ni - ta-tem ve-ne-re-mur tri-ni-ta - tem pa-ri re-ve-ren-ti - a

563 Lau-da__ Si-on sal-va-to-rem lau-da du-cem et pa-sto - rem in hym-nis et can-ti-cis

568 In ce-le-sti__ ier - ar-chi-a dul-cis so-nat ar - mo - ni-a con-cen-tu an-ge-li - co

572 Psal-lat ec-cle-si - a ma-ter il-li-ba-ta et vir-go si-ne ru-ga ho-no-rem hu-ius ec-cle-si-e

573 Rex Sa-lo-mon__ fe-cit tem - plum quo-rum in - star et ex - em - plum Chri-sti et ec-cle-si-a

577 Ver-bum de - i de-o na-tum quod nec fa-ctum nec cre-a-tum ve-nit__ de ce-le - sti - bus

583 Pau-le doc-tor gen - ti-um om-ni-um cre-den - ti-um tu fi-dem__ ro - bo-ra-sti

584 A - ve Ma-ri - a gra-ti-a ple - na

587 Ad-est__ di-es ce-le-bris quo lu-men de te - ne-bris ex-or-tum e-mi-cu - it

590 Sal-ve__ sa-lu - ta-re lig-num glo-ri-o - se cru-cis__ sig - num tri-um-pha-le sig-ni-fe-rum

592 In ce-le-sti__ ier - ar-chi-a no-va so-net ar - mo - ni-a no-vo du-cta can - ti - co

595 Pre-cur-so - rem__ sum-mi re-gis et pre-co-nem no - ve__ le-gis ce-le-brat ec - cle - si - a

680 E -lis - a- beth_ Za - cha-ri - e ma-gnum vi-rum in hac di - e glo-ri-o - sa___ ge-nu-it

684 Iu -bi - le- mus_ in__ hac di - e qua bap-ti-ste Chri - sti_ pi - e co-li-tur me-mo-ri - a

689 Cre-a - to - ris__ lau-de_ pi - e fe-sta a - gens in__ hac di - e iu -bi-lat__ ec - cle - si - a

'*Omnes gentes plaudite*' for the Ascension (See Chapter 10.2)

1.1 O - mnes gen - tes plau - di - te, fe - stos cho - ros du - ci - te Chri - sto tri - um - phan - te;

1.2 Re - dit cum vi - cto - ri - a ca - pta du - cens spo - li - a tu - ba iu - bi - lan - te.

2.1 Pa - pe quam mag - ni - fi - cum ho - di - e do - mi - ni - cum ger - men glo - ri - a - tur;

2.2 Ter - re fru - ctus ho - di - e su - per thro - nus cu - ri - e ce - li sub - li - ma - tur.

3.1 In - trat ta - ber - na - cu - lum Mo - i - ses et po - pu - lum tra - hit ad spe - cta - cu - lum___ tan - te vir - tus re - i;

3.2 Stant su - spen - sis vul - ti - bus in - ten - den - tes nu - bi - bus Ie - sum sub - du - cen - ti - bus___ vi - ri Ga - li - le - i.

4.1 Dum El - i - as sub - le - va - tur El - i - se - o du - plex da - tur spi - ri - tus___ et pal - li - um;

4.2 Al - ta Chri - stus dum_ con - scen - dit ser - vis su - is mnas ap - pen - dit gra - ti - a - rum o - mni - um.

* 3rd lower in MS

5.1 Tran-sit Ia - cob hunc Ior - da-nem lu-ctam ge-rens non in - a - nem cru-cis u - sus__ ba-cu-lo;

5.2 Re-dit tur - mis cum du - a-bis an-ge-lis et a-ni-ma-bus et the-sau-ri__ sa-cu-lo.

6.1 Hic est__ for-tis__ qui de mor - tis vi-ctor por - tis in-tro-it cum glo-ri - a;

6.2 Rex vir - tu-tum__ cu-ius nu - tum et ob-tu - tum tri-na tre-mit re-gi - a.

7.1 Vo-cat pa - ter fi-li - um ad con-ces - sus so-li - um do-nec

sup-pe-da - ne-os vi-ctos vel spon-ta - ne-os po-nat i-ni-mi - cos;

7.2 Se-det in__ al-tis-si - mis fru-i-tur__ po-tis-si - mus re - dit

in no-vis - si - mus iu-di-cans ex in - ti - mis iu-stos et i-ni - quos.

8.1 Ve - ni de-us ul-ti-o - num ve-ni cum cle - men-ti - a

dum si-ste - mur an-te thro - num in tu-i pre-sen - ti-a;__

8.2 Ma - ne no-bis tunc au-di - tam fac mi-se-ri - cor-di-am

in per-hen - nem trans-fer vi - tam ad fu-tu-ram glo - ri-am.__

A - - - - - men.__

'Creatoris laude pie' for the Common of Apostles (See Chapter 10.3)

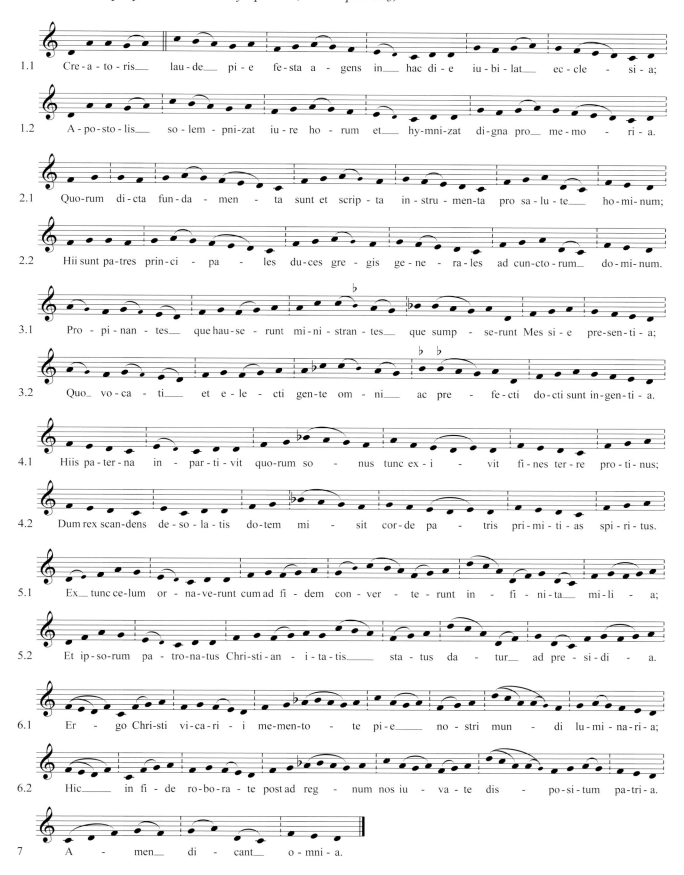

1.1 Cre - a - to - ris__ lau - de__ pi - e fe - sta a - gens in__ hac di - e iu - bi - lat__ ec - cle - si - a;

1.2 A - po - sto - lis__ so - lem - pni - zat iu - re ho - rum et__ hy - mni - zat di - gna pro__ me - mo - ri - a.

2.1 Quo - rum di - cta fun - da - men - ta sunt et scrip - ta in - stru - men - ta pro sa - lu - te__ ho - mi - num;

2.2 Hii sunt pa - tres prin - ci - pa - les du - ces gre - gis ge - ne - ra - les ad cun - cto - rum__ do - mi - num.

3.1 Pro - pi - nan - tes__ que hau - se - runt mi - ni - stran - tes__ que sump - se - runt Mes si - e pre - sen - ti - a;

3.2 Quo__ vo - ca - ti__ et e - le - cti gen - te om - ni__ ac pre - fe - cti do - cti sunt in - gen - ti - a.

4.1 Hiis pa - ter - na in - par - ti - vit quo - rum so - nus tunc ex - i - vit fi - nes ter - re pro - ti - nus;

4.2 Dum rex scan - dens de - so - la - tis do - tem mi - sit cor - de pa - tris pri - mi - ti - as spi - ri - tus.

5.1 Ex__ tunc ce - lum or - na - ve - runt cum ad fi - dem con - ver - te - runt in - fi - ni - ta__ mi - li - a;

5.2 Et ip - so - rum pa - tro - na - tus Chri - sti - an - i - ta - tis__ sta - tus da - tur__ ad pre - si - di - a.

6.1 Er - go Chri - sti vi - ca - ri - i me - men - to - te pi - e__ no - stri mun - di lu - mi - na - ri - a;

6.2 Hic__ in fi - de ro - bo - ra - te post ad reg - num nos iu - va - te dis - po - si - tum pa - tri - a.

7 A - men__ di - cant__ o - mni - a.

'Virgine Iohanne' for John the Evangelist (See Chapter 10.4)

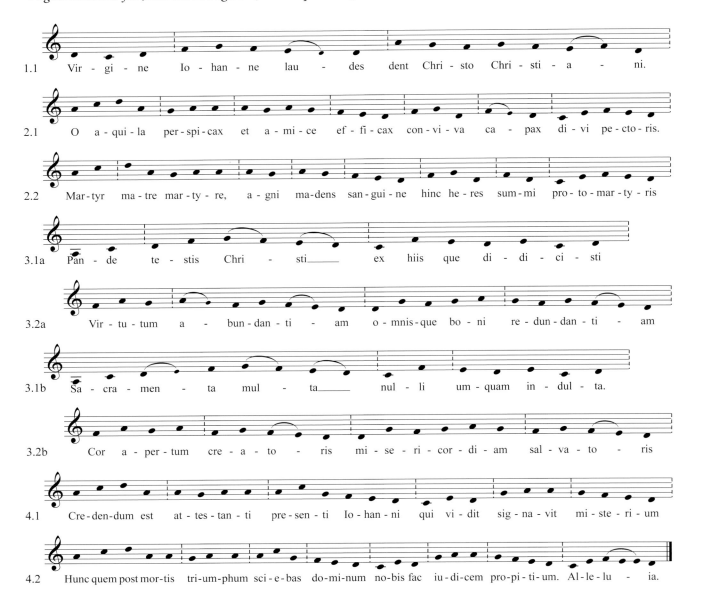

1.1 Vir - gi - ne Io - han - ne lau - des dent Chri - sto Chri - sti - a - ni.

2.1 O a - qui - la per - spi - cax et a - mi - ce ef - fi - cax con - vi - va ca - pax di - vi pe - cto - ris.

2.2 Mar - tyr ma - tre mar - ty - re, a - gni ma - dens san - gui - ne hinc he - res sum - mi pro - to - mar - ty - ris

3.1a Pan - de te - stis Chri - sti___ ex hiis que di - di - ci - sti

3.2a Vir - tu - tum a - bun - dan - ti - am o - mnis - que bo - ni re - dun - dan - ti - am

3.1b Sa - cra - men - ta mul - ta___ nul - li um - quam in - dul - ta.

3.2b Cor a - per - tum cre - a - to - ris mi - se - ri - cor - di - am sal - va - to - ris

4.1 Cre - den - dum est at - tes - tan - ti pre - sen - ti Io - han - ni qui vi - dit sig - na - vit mi - ste - ri - um

4.2 Hunc quem post mor - tis tri - um - phum sci - e - bas do - mi - num no - bis fac iu - di - cem pro - pi - ti - um. Al - le - lu - ia.

'Salve salutare lignum' for the Cross (See Chapter 11.2)

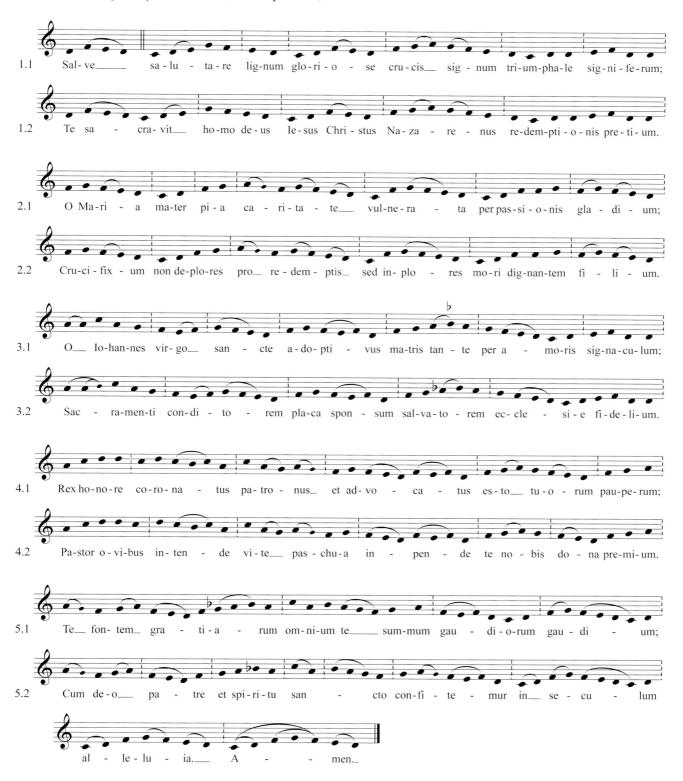

1.1 Sal-ve___ sa-lu-ta-re lig-num glo-ri-o-se cru-cis___ sig-num tri-um-pha-le sig-ni-fe-rum;

1.2 Te sa-cra-vit___ ho-mo de-us Ie-sus Chri-stus Na-za-re-nus re-dem-pti-o-nis pre-ti-um.

2.1 O Ma-ri-a ma-ter pi-a ca-ri-ta-te___ vul-ne-ra-ta per pas-si-o-nis gla-di-um;

2.2 Cru-ci-fix-um non de-plo-res pro___ re-dem-ptis___ sed in-plo-res mo-ri dig-nan-tem fi-li-um.

3.1 O___ Io-han-nes vir-go___ san-cte a-do-pti-vus ma-tris tan-te per a-mo-ris sig-na-cu-lum;

3.2 Sac-ra-men-ti con-di-to-rem pla-ca spon-sum sal-va-to-rem ec-cle-si-e fi-de-li-um.

4.1 Rex ho-no-re co-ro-na-tus pa-tro-nus___ et ad-vo-ca-tus es-to___ tu-o-rum pau-pe-rum;

4.2 Pa-stor o-vi-bus in-ten-de vi-te___ pas-chu-a in-pen-de te no-bis do-na pre-mi-um.

5.1 Te___ fon-tem gra-ti-a-rum om-ni-um te___ sum-mum gau-di-o-rum gau-di-um;

5.2 Cum de-o___ pa-tre et spi-ri-tu san-cto con-fi-te-mur in___ se-cu-lum

al-le-lu-ia.___ A-men._

Three sequences set to 'In celesti ierarchia' for St. Dominic (See Chapter 11.5)
Melody: Dom Ccc

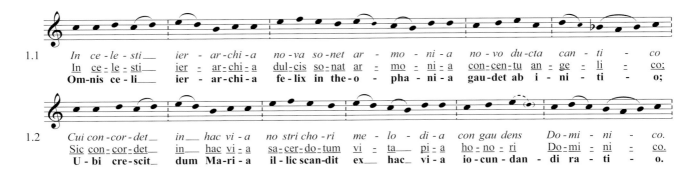

1.1 *In ce-le-sti___ ier-ar-chi-a no-va so-net ar - mo - ni-a no-vo du-cta can - ti - co*
In ce-le-sti___ ier-ar-chi-a dul-cis so-nat ar - mo - ni-a con-cen-tu an - ge - li - co;
Om-nis ce-li___ ier-ar-chi-a fe-lix in the-o - pha-ni-a gau-det ab i - ni - ti - o;

1.2 *Cui con-cor-det___ in hac vi-a no stri cho-ri me - lo - di-a con gau dens Do-mi - ni - co.*
Sic con-cor-det___ in hac vi-a sa-cer-do-tum vi - ta___ pi-a ho-no-ri Do-mi - ni - co.
U - bi cre-scit dum Ma-ri-a il - lic scan-dit ex___ hac vi-a io-cun-dan - di ra-ti - o.

Melody: Dom Bb

2.1 *Ex___ E - gip-to va-sti-ta-tis vi-rum su-e vo-lun - ta-tis vo-cat___ au-ctor___ se-cu-li;*
Quos pre om-ni ho-no-ra-vit na-ti-o-ne quam cre - a-vit ad lau - dem sui no-mi-nis;
E - le-va-ta est ab i-mis ar-ca No-e et sub - li-mis mon-tes___ su - per-gre-di-tur;

2.2 *In - fi cel-la pau per-ta-tis flu-men trans-it va-ni - ta-tis pro sa-lu-te___ po-pu-li.*
Or - tus de ra - di-ce Da-vid cum e-os-dem sub-li - ma-vit di-gni-ta-te___ or-di-nis.
Cu - ius o-dor fra-grat ni-mis hec pro me-ri-tis op - ti-mis pre-mi-is___ per-fru-i-tur.

Melody: Dom Cc

3.1 *In fi - gu-ra___ ca-tu-li pre-di-ca-tor se-cu-li ma-tri pre-mon-stra-tur;*
Pri - mus pa-nem___ con se - cra-vit quem in car-nem per-mu-ta-vit ver-bo - rum___ mi-ste-ri-o;
Af - flu-ens de - li-ci-is col-le-ctis di-vi-ti-is scan-dit___ de - de-ser-to;

3.2 *Por - tans o - re___ fa-cu-lam ad a-mo-ris re-gu-lam po-pu-los___ hor-ta-tur.*
Quam vir - tu tem hiis do - na-vit si-bi quos as - so-ci-a-vit pa-ri mi-ni-ste-ri-o.
Que a - mi cta___ va-ri - is ca-nit tim-pa-ni-stri-is di-le-cto___ re-per-to.

Melody: Dom Dd

4.1 *Hic est___ no vus___ le-gis la-tor hic El-i-as e-mu-la-tor et de-te-stans cri-mi - na;*
Quem in___ ce-lis___ lau-dant thro-ni ex-ul-tan-tes vo-ce so - ni cun-ctis iu-bi-lan-ti - bus;
Tha-la - mum se - cre-ti-o-rem vir-go in-trat ob de-co - rem u - ni-ver-sis pre-di-ta;

4.2 *Vul-pes___ dis-si-pat Sam-so-nis et in tu-ba Ge-de-o - nis ho stis fu-gat ag mi - na.*
De mo - nes quem hor-rent pro-ni quem a-do-rant om-nes bo - ni cum de-vo-tis men-ti - bus.
Vir ga___ que pro - du-xit flo-rem sed na-tu-re pre-ter mo-rem re-fer tur___ in ab-di - ta.

Melody: Dom Ee

5.1
A de-fun ctis re-vo - ca tum ma-tri vi-vum red dit na - tum vi - vens ad huc___ cor po re;
Quam-vis sit is fe-lix___ sa - tis sum-mis si - bi bo-nis da - tis in___ ce - le- sti pa-tri - a;
Re-gem ma-ter dum a - do-rat vi - ce ver - sa rex ho-no - rat ma - trem om-ni___ glo-ri - a;

5.2
Sig -no cru - cis im - ber___ ce-dit tur ba fra trum pa nem e - dit mis sum de-i___ mu-ne - re.
Nu - tu ta - men pi - e - ta-tis es - se vult cum tri-bu-la - tis pre - bens hiis so - la - ti - a.
Sa-crum fla - men quam vir - ro-rat ci - vi-ta-tem hec ex-plo - rat et___ per-trans it___ om-ni - a.

Melody: Dom Ff

6.1
Fe -lix per quem gau - di - a/ to-ta___ iam ec - cle-si - a/___ su mens ex - al - ta-tur;
Hoc stu-pen dum ni - mis mi-rum per to - ti-us___ or-bis gi-rum no-tet om - nis___ na-ti - o;
Ter vo - ca-ta___ ce - li-tus se-mel ve-nit pe - ni - tus___ dig-ne co - ro-nan-da;

6.2
Or bem re plet___ se - mi-ne in ce - lo-rum___ ag-mi - ne___ tan-dem col - lo - ca-tur.
Vi - dit I - si - as___ vi-rum qui ex - cel-lit re gem Ci-rum quem non ca - pit ra - ti - o.
Un-de plus quam pri - mi-tus gau-det___ e-ius___ spi-ri - tus___ o - res pre - di - can-da.

Melody: Dom Gg

7.1
Ia - cet gra-num o - cul-ta tum si - dus la-tet ob um-bra - tum sed plas ma - tor om - ni - um;
Cum sit de - us est u - bi-que cum sit ho-mo u-tro-bi - que ve - ram per___ pre - sen - ti - am;
Ar - che de - i iam trans la - te pa - tet in sub - li-mi-ta - te dig-num ta - ber-na - cu - lum;

7.2
Os -sa Io-seph pul-lu-la-re si - dus iu-bet ra-di-a - re in sa - lu - tem gen - ti - um.
Est in tem-plis hic lo-ca-tis est - in ce-lis e-le-va - tis mi - ram per___ po - ten - ti - am.
Es-ther ab hu - mi-li-ta-te du - ci-tur in ca-ri-ta - te re - gis ad___ cu - bi - cu - lum.

Melody: Dom Hh

8.1
O quam pro-bat___ car nis___ flo rem om nem su-per-ans o - do - rem tu mu-li___ fra gran-ti - a;
Mel le dul - ci - or na - tu-ra su-per om - ne pu - rum pu - ra sic fit ac-ces-si - bi-lis;
O que i - sta___ est__ et___ qua-lis que vir-tu-tum vo - lat a -* lis u - bi est__ se-cu - ri-tas;

8.2
E - gri__ cur runt___ et__ cur-an tur, ce - ci, clau-di re - pa ran - tur vir-tu tum___ fre quen - ti - a.
Dans fi - du - ci - am or - an-di spem-que fir-mam in - pe tran - di pre-ce per su-a-si - bi-lis.
Su per ter - ram___ non est ta-lis cu - i su-per na-tu-ra -* lis in est sin - gu-la - ri-tas.

Melody: Dom Ii

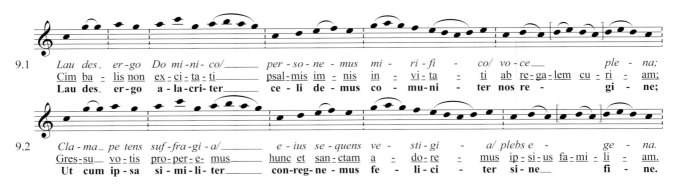

9.1 *Lau des_ er-go Do mi-ni- co/_____ per-so-ne-mus mi - ri -fi - co/ vo-ce___ ple - na;*
Cim ba - lis non ex-ci-ta-ti_____ psal-mis im-nis in - vi-ta - ti ab re-ga-lem cu-ri - am;
Lau des_ er-go a-la-cri-ter_____ ce-li de-mus co - mu-ni - ter nos re - gi - ne;

9.2 *Cla-ma_ pe tens suf-fra-gi-a/_____ e-ius se-quens ve - sti-gi - a/ plebs e - ge - na.*
Gres-su_ vo-tis pro-per-e- mus_____ hunc et san-ctam a - do-re - mus ip-si-us fa-mi-li - am.
Ut cum ip-sa si-mi-li-ter_____ con-reg-ne-mus fe - li-ci - ter si-ne_ fi - ne.

Melody: Dom Jj

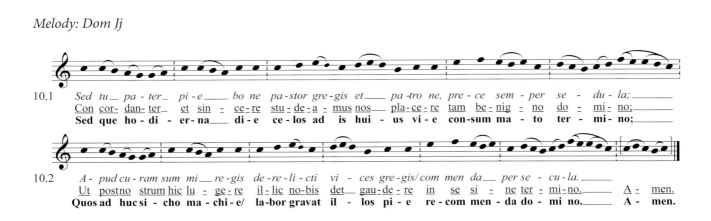

10.1 *Sed tu_ pa-ter_ pi-e_____ bo ne pa-stor gre-gis et___ pa-tro ne, pre-ce sem-per se - du-la;_____*
Con cor-dan-ter_ et sin - ce-re stu-de-a-mus nos pla-ce-re tam be-nig-no do-mi-no;
Sed que ho-di - er-na___ di-e ce-los ad is hui-us vi-e con-sum ma-to ter-mi-no;

10.2 *A - pud cu-ram sum mi_ re-gis de-re-li-cti vi-ces gre-gis/com men da_ per se-cu-la._____*
Ut postno strum hic lu - ge-re il-lic no-bis det_ gau-de-re in se si-ne ter-mi-no._____ A - men.
Quos ad huc si-cho ma-chi-e/ la-bor gravat il - los pi-e re-com men-da do-mi-no._____ A - men.

F: The Fragmentary Office for John the Baptist (Nativity) from D 9 and the Cult of the Baptist in Liturgical Sources from Paradies

Part 1: The Fragmentary Office for John the Baptist (Nativity) from D 9; music for select chants is found in Part V, chapter 24

Modally ordered; accentual rhyming poetry
Fragment, early fifteenth century (on basis of style of illumination and decoration)
Tipped into Dusseldorf, D 9, early fourteenth-century Summer Antiphoner, ff. 253r–260v
(modern folio numbers)
Texts are previously unknown; some melodies are borrowed from other offices; the office and its accompanying illuminations are assumed to be the original work of the nuns of Paradies bei Soest.

Ant. = antiphon; Res. = responsory; V= verse

Genre/Mode	Incipit (chants with a large initial: in bold and underlined)
Top of page:	End of an unidentified responsory with a repetendum beginning with 'flos' and the Gloria
Invitatory: Mode 1	'In honore precursoris'
Ps.: Venite exultemus (Ps 94)	

First Nocturn

Ant: Mode 1	'Iohannes de celis nuntiatur'
Ps.: Beatus vir (Ps 1)	
Ant: Mode 2	'Dei plenus numine'
Ps.: Quare [Fremuerunt] (Ps 2)	

Ant: Mode 3	'O cursus pulchritudinem'
Ps.: Domine quid. (Ps 3)	
Reading 1	
Res.: Mode 1	**'Letabundus mundus congaudeat'**
Reading 2	
Res.: Mode 2	**'Priusquam nascatur'**
Reading 3	
Res.: Mode 3	**'Gaudia totius mundi'**

Second Nocturn

Ant: Mode 4	'A Iudeis ausit Christus'
Ps.: Cum invo<carem> (Ps 4).	
Ant: Mode 5	'O quam gratiose'
Ps.: Verba [mea auribus] (Ps 5).	
Ant: Mode 6	'Ipse iuxta Christi'
Ps: Domine [Dominus noster]. (Ps 8)	
Reading 4	
Res.: Mode 4	**'Zacharias dum proles'**
Reading 5	
Res.: Mode 5	**'Secreta deserti vasta'**
Reading 6	
Res.: Mode 6	**'Euge nimis felix'**

Third Nocturn

Ant.: Mode 7	'Primus penitentiam mundo'
Ps.: In domino [confido] (Ps 10). Mode 7	

Ant.: Mode 8 'Propheta fuit viam' (incomplete, missing page)

Ant.: Mode 9 Missing
Reading 7
Res.: Mode 7 (assumed) Missing
Reading 8
Res.: Mode 8 Ending only (R. is a contrafact of a chant for Dominic)

Reading 9
Res.: Mode 9 'In medio carceris' (first choice, from the feast of the Beheading) or 'Iohannes maior homine' with the verse 'Ora pro nobis beata Iohannes'

Antiphons for Lauds, with psalms

Mode 1 **'O virum ineffabilem'**

Ps.: 'Dominus regnavit' (Ps 92 and the rest of the psalms for Lauds on Sunday or a major feast)

Mode 2 **'Baptista Christi previus'**

Mode 3 **'Iesu dulce refugium'**
Mode 4 **'Iohannes decrevit'**
Mode 5 **'Christum precurrens'**

The Benedictus Antiphon **'Perpetuis nos domine'** (Mode 2) (a widespread chant)

The Magnificat Antiphon **'Gaude celum terra plaude'** (Mode 5) (contrafactum of a Magnificat antiphon from *Letare Germania*, an office for Elizabeth of Hungary)

Troped Benedicamus Domino

Part 2: The Cult of John the Baptist in Liturgical Sources from Paradies

A. Other Materials for John the Baptist in D 9

Vigil of the Birth of John the Baptist	ff. 110v–111r
Birth of John the Baptist	ff. 111r–116r
For ferias within the Octave	f. 116r
For the Octave (initial: Circumcision of John the Baptist)	f. 116v
Feast of the Beheading of John the Baptist (Res.: 'In medio carceris', ff. 170v–171r)	ff. 170r–172r
Masses for John the Baptist	

B. Materials for John the Baptist in D 11

Vigil of John the Baptist	pp. 407–408
Feast (Birth)	pp. 408–409
Beheading	pp. 431–432
Sequence for John the Baptist: 'Precursorem summi regis' (Birth)	pp. 595–599
Sequence for John the Baptist 'Elisabeth Zacharie'	pp. 680–684
Sequence for John the Baptist 'Iubilemus in hac die' (Beheading)	pp. 684–688

C. Dusseldorf D 12, an early fourteenth-century Gradual from Paradies, materials for John the Baptist

Birth of John the Baptist, with historiated initial	ff. 189v–190r
Beheading of John, with historiated initial	ff. 203r–203v
Sequence for John the Baptist: 'Precursorem summi regis' (Birth)	ff. 274r–275v
Sequence for John the Baptist: 'Iubilemus in hac die' (Beheading)	ff. 292v–294v

D. From Rome, Sancta Sabina, XIV L2 (ed. Urfels-Capot), readings for John the Baptist

In vigilia […] (three readings)
In festo […] (nine readings)
In feria proximiori festo Iohannis si non fuerit dominica (three readings)
In alia feria, si non fuerit dominica (three readings)

Dominica infra octavas (six readings; then three from the Sunday homiliary)
In octava [...] (nine readings)

Part 3: Details of the Liturgical Materials

A. Dusseldorf D 9:
The Frame and the Gospel source:

AMICE SPONSI CHRISTI BAPTISTE IOHANNES PATRONE MAXIME TE
VENERANTES PROTEGE ET CUNCTIS CRISTI SANGUINE REDEMPTIS
AUXILIARE

O Friend of Christ the spouse, John the Baptist, great patron, protect those venerating you
and assist all redeemed by the blood of Christ

Refers to Io 3:29–30: Non sum ego Christus: sed quia missus sum ante illum. Qui habet sponsam, sponsus est: amicus autem sponsi, qui stat, et audit eum, gaudio gaudet propter vocem sponsi. Hoc ergo gaudium meum impletum est.

John answered [...], I am not Christ, but that I am sent before him. He that has the bride, is the bridegroom: but the friend of the bridegroom, who stands and hears him, rejoices with joy because of the bridegroom's voice. This my joy, therefore, is fulfilled.

B. The first responsory and its sources

R.: Letabundus mundus congaudeat
precursoris festo tripudians.
 cuius **ortum** Gabriel prenuntiat.
In hoc **ipsum Christo** consimilans.
V.: Nasciturum magnum presagiat
 vite cursum et nomen indicat. [In.]
R.1: Let the greatly celebrating world dancing rejoice together on the feast of the precursor,
whose coming Gabriel foretold; in this he compares to Christ. V.: Let [the angel] portend
the great one about to be born; let him proclaim his course of life and his name.

Source: Io 1: 8–15: At the time the angel announced to Zachariah, it was his priestly duty to
make the offering of incense. [...] the angel stood at the right side of the altar of incense.

C. The second responsory

R.: Priusquam nascatur
santificatur.
prius plenus deo
quam natus in mundo.
Priusquam traxit
proprium accepit
sanctum spiritum.
V.: Futurus Christi baptista.
testis et evangelista Prius. [...]

R.: Before he might be born he is made holy; first full of God then born into the world;
Before he took his own [substance] he received the Holy Spirit. V.: The about-to-be-born witness
of Christ, baptizer and evangelist.

D. The third responsory

R.: Gaudia totius mundi
pueri preludunt mundi.
Sub visceribus conclusi.
Sensu carnis non dum usi.
V.: Contripudiabant crede pie
Iohannes et filius Marie. [Sub].
Gloria patri et filio et spiritui sancto. [Sensu.]

R.: With the joy of all the world, the two pure boys play hid beneath wombs, not yet making use
of the sense of the flesh; V.: They perform a ritual dance together, with pious belief, John and the
Son of Mary. Sub.: [...] Glory to the Father and to the Son and to the Holy Spirit. Sensu [...]
(Note: the words 'Sub' and 'Sensu' are cues for where to begin the part of the responsory
to be repeated.)

E. Text of the Benedictus Canticle

Benedictus dominus deus Israel; quia visitavit et fecit redemptionem plebi suae
et erexit cornu salutis nobis, in domo David pueri sui,
sicut locutus est per os sanctorum, qui a saeculo sunt, prophetarum eius,
salutem ex inimicis nostris, et de manu omnium, qui oderunt nos;
ad faciendam misericordiam cum patribus nostris, et memorari testamenti sui sancti,
iusiurandum, quod iuravit ad Abraham patrem nostrum, daturum se nobis,

ut sine timore, de manu inimicorum liberati, serviamus illi in sanctitate et iustitia coram ipso omnibus diebus nostris.

Et tu, puer, propheta altissimi vocaberis: praeibis enim ante faciem domini parare vias eius,

ad dandam scientiam salutis plebi eius in remissionem peccatorum eorum,

per viscera misericordiae dei nostri, in quibus visitabit nos oriens ex alto,

illuminare his, qui in tenebris et in umbra mortis sedent, ad dirigendos pedes nostros in viam

pacis.

Blessed be the Lord God of Israel; because he hath visited and wrought the redemption of His

people:

And hath raised up an horn of salvation to us, in the house of David his servant:

As he spoke by the mouth of his holy prophets, who are from the beginning:

Salvation from our enemies, and from the hand of all that hate us:

To perform mercy to our fathers, and to remember his holy testament,

The oath, which he swore to Abraham our father, that he would grant to us,

That being delivered from the hand of our enemies, we may serve him without fear,

In holiness and justice before him, all our days.

And thou, child, shalt be called the prophet of the highest: for thou shalt go before the face of

the Lord to prepare his ways:

To give knowledge of salvation to his people, unto the remission of their sins:

Through the bowels of the mercy of our God, in which the Orient from on high hath visited us:

To enlighten them that sit in darkness, and in the shadow of death: to direct our feet into the way

of peace.

G: Initials and Inscriptions in D 12

N.B. Only initials with inscriptions and/or significant decoration besides fleuronnée ornament are listed.

Prefatory material

1r **Antiphona**: Hec est dies.
(Annunciation: Vespers, Magnificat Antiphon)
Initial 'H' (4-staff): Annunciation.
Ave Maria gratia. (Lc 1:28)

1v **In consecratione cerei paschalis. Canticum**.
Exultet iam angelica turba celorum.
(Holy Saturday: Exultet)
Initial 'E' (2-staff): two angels carrying lit candle
(upper compartment); priest and layman
to either side of baptismal font
(lower compartment).

6r (continuation)
℟: Regnum mundi et omnem ornatum seculi.
Margin: Oculus non vidit nec auris audivit
mercede et gloriam qui deus diligentibus se
preparavit. (1Cor 2:9)

6v **In nocte natalis. Ymnus**.
Te deum laudamus.
Initial 'T' (2-staff): Six angels singing, two from
scroll above Holy Face, four below from scroll
inscribed with chant.
Two angels: Benedicamus te. (Gloria of Mass)
Four angels: Adoramus te. (Gloria of Mass)

10v **De sancta cruce**.
O crux splendidior. (Can 004019: Invention of
the Cross, antiphon)
Initial 'O' (1-staff, fleuronnée).
Margin: Salva nos Christe salvator per virtutem
sancte crucis. (Can 004686: Invention of the
Cross, antiphon)

13r **Dominica prima in adventum domini.
Officium**.
Ad te levavi animam meam. (Ps 24:1)
Initial 'A' (two-staff; rises above top line):
Gideon's fleece.
Man praying: Miserere mei deus secundum.
(Ps 50:3)
Fleece: Vellus gede. (Idc 6:33–40)

14r **Dominica secundum. Officium**.
Populus Sion ecce dominus. (cf. Is 30:30)
Initial 'P' (2-staff): Decorative.
Scroll (right of initial): Veni deus ultionum veni
cum clementia. (*AH* 54:152, p. 233, strophe 15)
Margins (top to bottom):
Nobis sis tunc pius censor / nostre cause
defensor / memor tui operis.
Propter temetipsum nobis presta / ingredi ad
tua festa / tunc cum sanctis omnibus (?)
Beati qui parati sunt occurrere illi. (Can 002543:
second feast of second week of Advent,
antiphon). O rex glorie.

15v **Dominica tertia. Officium**.
Gaudete in domino.
Initial 'G' (1-staff): Paul (half-length) with
sword.
Margins (top to bottom):
Paulus. Iterum dico gaudete. Dominus prope
est. (Phlp 4:4–5)
Iohannes baptista. Amicus sponsi gaudio
gaudet propter vocem sponsi. (Io 3:29)
Veni domine Ihesu nos in pace. Ut letemur
coram te corde perfecto. Nunc et hora
novissima. (Can 005321: Second Sunday
in Advent, antiphon)

17v (continuation):
℣: Laudem Domini. (Ps 144:21)
Initial 'L' (1-staff, scribal): decorative.
Scroll: Semper laus Ihesu in ore meo.
(Can 006236a: first week after Epiphany, verse)

19r **Sabbato. Officium.**
Veni et ostende nobis.
Initial 'V' (1-staff): bust of Christ.
Margins (top to bottom):
Vultum tuum domine requiram. ne avertas
faciem tuam a me. (Ps 26:9; Ps 101:3)
Paulus. In quem desiderant angeli prospicere.
Iohannes. Videbimus gloriam eius quasi
unigeniti a patre. (Io 1:14)

23r **Dominica IIII.**
Memento nostri Domine.
Initial 'M' (1-staff): decorative.
Margins (top to bottom):
Ihesu pie veni / ne me ledant alieni / et crudelis
bestia. (*Psalterium de nomine Jesu*)[1]
Isaia. Ecce veniet dominus et merces eius cum
eo et opus illius coram eo. (Is 40:10)
Paulus. Secundum suam misericordiam salvos
nos fecit. (Tit 3:5)

23v **In vigilia natalis domini. Officium.**
Hodie scietis quia veniet dominus.
Initial 'H' (2-staff): decorative, contains letter
'L' (H.L., i.e., Hadewig de Ludensheyde).
Margins (top to bottom):
Non vocaberis derelicta quia conplacuit
domino in te. (cf. Is 62:4)
Crastina die erit vobis salus. Et regnabit super
nos salvator mundi. (Can 006345: Vigil of
Christmas, antiphon). Deus et homo. Conditor
mundi.

25r **In nocte natalis domini in galli cantu.
Officium.**
Dominus dixit ad me.
Initial 'D' (3-staff): Augustus and Tiburtine
sibyl.
Augustus: Non me adorate sed deum qui natus
est hodie. (cf. Apc 22:9)
Margin (top to bottom): Sedentibus in tenebris
et umbra mortis lux orta est eis. (Mt 4:16);
misericordia domini plena est terra.
(Ps 32:5; 118:64); apparuit benignitas
salvatoris nostri dei. (Tit 3:4)
Lower margin: Verbum caro factum est.
(Io 1:14); gaudeamus et exultemus dantes
gloriam ei
(Apc 19:7) qui pro nobis nasci dignatus est
hodie. (Can 006171: Christmas, responsory)
(Roundels with 'H.L.' and 'E.S.')
25v (continuation):

℣: Quare fremuerunt. (Ps 2:1)
Iudex clemens, sis in agone, Ihesu bone.
(Unidentified hymn)

27v **In aurora. Officium.**
Lux fulgebit.
Initial 'L' (2-staff): magus in initial seeing
golden star: Oritur [sic] stella ex Iacob [in gold].
(Nm 24:17)
Magus above initial: Ecce videmus in oriente
[in gold]. (Mt 2:2)
Magus below initial: Stella ista sicut flamma
coruscat. (Can 005022: Epiphany, antiphon)
Souls emerging from hell mouth: Populus qui
ambulabit [in gold]. (Can 002592: Sunday in
Holy Week, antiphon; Mt 4:16)
Frame of Hell Mouth: Advenisti desiderabilis.
Quem expectabamus. In tenebris ut educeres.
Hac nocte vinculatur de claustris.
(Can 201042: Easter, *Canticum triumphale*)

29r **Ad summam missam. Officium.**
Puer natus est.
Initial 'P' (5-staff): Navitity.
Angels: Adoramus te; benedicimus te.
(Gloria of the Mass)
Unicorn hunt in staff of 'P'.
Dogs labelled: Caritas; spes; fides. (1Cor 13:3)
Angel with spear: Ave Maria plena (Lc 1:28)
Prophets in roundels in lower margin:
Puer natus est (Is 9:6) cognivit bos et asinus
quod (cf. Is 1:3). Ipsa quem genuit adoravit.[2]

31v **In circumcisione domini. Officium.**
Puer natus. **R.** Viderunt omnes. Alleluia.
Margin: In nomine Ihesu omne genuflectatur
(Phlp 2:10); Deus in nomine tuo salvum me fac
(Ps 53:3); O Ihesu salvator / mundi reparator
(cf. *AH* 31:57: Iesu, dulcis mi salvator, / Pius
orbis reparator); propter nomen tuum esto mihi
Ihesus. (cf. Quinquagesima Sunday: officium)

32r **In epiphania domini. Officium.**
Ecce advenit dominator.
Initial 'E' (2-staff): Adoration of Magi (upper
compartment); Herod sending out soldiers to
massacre innocents (lower compartment).
Lower roundel: Marriage at Cana.
Christ: Hodie vinum ex aqua.
(Can 005184: Epiphany, antiphon)
Baptism.
Burning Bush.

[1] *Lateinische Hymnen*, ed. Mone (1853–1855), vol. 1, no. 262,
lines 187–89.

[2] Possibly taken from pseudo-Augustine, Sermo, *PL* 40, col.
1266; cf. Can 001458: Purification of Virgin, antiphon.

32v Tree of Jesse.
(continuation):
℣: Vidimus stellam.
Initial 'V' (1-staff, scribal): star with face.

34v **Dominica prima post octavam epiphaniam. Officium.** [34v]

36r Communion: Dicit dominus implete idrias aqua.
Initial 'D' (1-staff, fleuronnée): eagle (green).

48r **Dominica prima in quadragesima. Officium.**
Invocavit me.
Initial 'I' (4-staff): decorative.
Margin: In hiis diebus exhibeamus nos sicut dei ministros in ieiuniis et cetera. (2Cor 6:4)

74r ℣: Virga tua et baculus tuus.
(Lent, Saturday, 3rd week: Gradual)
Initial 'V' (1-staff, scribal): Crux tua et Maria. (?)

76r **Feria sexta. Officium.**
Deus in nomine tuo.
Initial 'D' (1-staff): decorative, inscribed at center: IESUS in large green letters in fleuronnée.
Margins (top to bottom): [Facing left] Unguentum effusum nomen tuum. Ideo adolescentule dilexi (Ct 1:2); [Facing right] in nomine domine omne genuflectatur; in quo qui est benedictus super terram benedicitur. (Is 65:16)

83r **Dominica in passione domini. Officium.**
Iudica me Deus et discerne. (Ps 42:1)
Initial 'I' (5-staff): decorative.
Margin: Fortitudo et laus mea dominus. Paulus. Omnia possum in ipso qui me confortat. (Phlp 4:13)

97r **Feria quarta. Officium.**
In nomine domini omne genuflecta.
Initial 'I' (5-staff): decorative, with embedded inscription: ADONAY.

98v (continuation):
℣: Ne avertas faciem tuam. (Ps 101:3)
Initial 'N' (1-staff, scribal): Holy Face.

101r **Super Magnificat. Antiphona.**
Cenantibus autem accepit Ihesus.
Initial 'C' (2-staff): decorative.

102v (continuation):
℣: Operuit celos maiestas eius. (Hab 3:3)
Initial 'O' (1-staff, scribal): sun and moon.

116r (continuation):
Tract: Laudate dominum omnes gentes. (Ps 116:1)
Margin: Benedictus deus Israhel quia visitavit et fecit redemptionem plebis sue. (Lc 1:68)

116v **Ad vesperas. Antiphona.**
Alleluia alleluia alleluia. Laudate Domini omnes gentes.
Initial 'A' (5-staff): Three Marys at Tomb.
Angel: Quem queritis. (Io 18:4; Io 18:7)
Outside of letter stem: Laudem dicite deo nostro. (Apc 19:5) quoniam regnavit dominus deus noster omnipotens. Gaudeamus et exultemus et demus gloriam. (Apc 19:6–7)
Inside letter stem: Tulerunt dominum de monumento et nescimus ubi posuerunt eum. (Io 20:2)
Margin (top): Iohannes precucurrit citius Petri et venit ad. (Io 20:4)
Margin (bottom): Congratulamini michi quem querebam apparuit mihi. (cf. Phlp. 2:18; Can 006323: Easter Monday, Matins, first nocturn, third response)

117r **In die sancto** [gold].
Resurrexi et ad huc tecum sum alleluia.
Initial 'R' (4-staff): Resurrection (upper compartment); three Maries (lower compartment).
Christ flanked by angels above Resurrection (outside letter, inside frame):
Christ: Exurge gloria mea exurge. (Ps 56:9)
Angels: Te dominum; te dominum confiteor. (Te deum)

117v (continuation):
℟: Hec dies quam fecit dominus.
Initial 'H' (2-staff): Harrowing of Hell.

121v **Feria IIII. Officium.**
Venite benedicti patris mei.
Initial 'V' (1-staff): decorative.
Margins (top to bottom): Beati qui ad cenam agni sunt vocate (Apc 19:9) O bone Ihesu; propter te metipsum. Pia nobis ingredi ad tua festa tunc cum sanctis omnibus. (?)

127v **Dominica secunda post festum pasche. Officium.**
Misericordia domini plena est terra.
Initial 'M' (1-staff): decorative.
Margins (top to bottom):
Ex misericordia eius a progenie in progenies timentibus eum. (Lc 1:50)
Miserationes domini super omnia opera eius. et in seculum misercordia eius. (Ps 144:9)

134v **In die ascensionis. Officium.**
Viri Galilei.
Initial 'V' (2-staff): Ascension.
Angel: Viri Galilei quid admiramini aspicientes.
2-line inscription at top of initial [gold]: Veni deus ultionum, / <Veni> cum clementia, / dum sistemur ante thronum / in tui presentia. / Mane nobis tunc auditam / fac misericordiam / in perhennem transfer vitam / ad futuram gloriam. (*AH* 54:152, 15–16)
Margins (top to bottom): Hodie deletum cyrographum dampnationis nostre. Natura nostra maledicta hodie in celum ascendit. In nomine deo omne genuflectatur quia dominus Ihesus est in gloria dei patris. (cf. Phlp 2:11)

138v **In die sancto penthecostes. Officium.**
Spiritus domini replevit orbem.
Initial 'S' (3-staff): Pentecost.

145r **Sancta trinitas.**
Benedicta sit.
Initial 'B' (3-staff): Throne of Mercy.

146r **In die sacri corporis Ihesu Christi. Officium.**
Cibavit eos ex adipe.
Initial 'C' (3-staff): Last Supper.
Upper roundel: Jews collecting manna.
Lower roundel: Moses striking the rock.

155v **Dominica XI. Officium.**
Deus in loco sancto suo deus qui inhabita.
Initial 'D' (1-staff): decorative.
Margins (top to bottom): Dominus fortitudo plebis sue et protectio valida sperantium in ipsum; salvam fac populum tuum domine et benedic hereditati tue et rege. (Ps 27:8–9)

158r **Dominica XIIII. Officium.**
Protector noster. (Ps 83:10)
Initial 'P' (2-staff): decorative.
Margin: Respice Ihesu in faciam Christi tui quem pretioso sanguine redemisti. Respice domine in me et miserere mei, da imperium tuum puero tuo et salvum fac filium ancille tue. (Cf. Ps 85:16; Can 004219: processional antiphon).

168v **In anniversaris dedicationis ecclesie. Officium.**
Terribilis est locus. (Gn 28:17)
Initial 'T' (2-line): Dream of Jacob.
Prophet: O domine fraudulenter arripuit benedictionem. (cf. Gn 27:35)

170r **In die sancti Andree apostoli. Officium.**
Dominus secus mare Galieae.
Initial 'D' (2-staff): Christ on the sea of Galilee.
Christ: Venite post me faciam vos fieri piscatores. (Mt 4:19; Mc 1:17)

171r **Sancti Stephani prothomartyris. Officium.**
Etenim sederunt principes. (Ps 118:23)
Initial 'E' (2-staff): Christ in heaven (upper compartment); stoning of Stephen (lower comparment).
Stephen: scroll blank.

173r **In festo sancti Iohannis apostoli et evangelisti. Officium.** [172v]
In medio ecclesie aperuit os eius.
Initial 'I' (5-staff): death of John the Evangelist.
Upper margin: Veni dilecte meus ad me quia ipse est ut epulere in convivio meo. (cf. Can 001458)
Margin: Invitatus ad convivium tuum venio gratias agens quia me dignatus es ad tuas epistolas invitare.

177r **In conversione sancti Pauli apostoli. Officium.**
Letemur omnes in domino.
Initial 'L' (3-staff): Conversion of Saul.
Christ: Saule Saule quid me. (Act 26:14)
Margin: Vas electionis est mihi iste ut portet nomen meum coram gentibus. (Can 005300: Conversion of Paul, antiphon) O gloriosum lumen ecclesiarum sancte paule apostole qui eterni solus. (Can 004030: Conversion of Paul, antiphon)

179r **In die purificationis sancte Marie virginis. Officium.**
Suscepimus deus misericordiam tuam.
Initial 'S' (3-staff): king and prophet to either side of Temple (upper compartment); Presentation in the Temple (lower compartment).

181r **In cathedri sancti Petri apostoli.**
Statuit. (Common of one Confessor,
Mass: Introit 1)
Initial 'S' (2-staff): Quo vadis (upper
compartment: enthroned Peter crowned as
Pope by two angels (lower compartment).
Peter: Domine quo vadis [gold]. (Io 13:36)
Christ: Vado Romam et iterum crucifigi. [gold]
Margin: Super plebem meam principem te
constitui et claves regni. (Can 007674: Peter and
Paul, responsory)

183r **In annunciatione dominica. Officium.**
Rorate celi desuper et nubes.
Initial 'R' (2-line): Annunciation from right.
Isaiah: Ecce virgo concipiet et pariet. (Is 7:14)
Angel: Ave Maria gratia plena. (Lc 1:28)

187r **In inventione sancte crucis. Officium.**
187v: Nos autem gloriari oportet in cruce.
Initial 'N' (1-staff, extending into upper
margin): Brazen Serpent.
Four roundels at corners of initial: symbols of
4 Evangelists holding scrolls (blank).
Three roundels in inner margin attached to
golden *lignum vitae* (from top to bottom):
Christ on Cross; Flagellation; Christ as Man of
Sorrow in tomb with four onlookers, three men
(two with halos), one woman.

189v: **In festo sancti Iohannis apostoli et evangeliste
ante portam latinam. Officium.**
In medio ecclesie.
Initial 'I' (2-staff): John naked in vat of oil with
two executioners ladling oil over his head
protected by God in cloud burst (left); John on
platform holding poisoned chalice protectedby
angel with sword (right).
King and two advisers (left margin): Iohannes
maleo [crossed out or covered by ink blot]
relegatus divine consolatione meruit (?)
relevari. (cf. Can 004397: John the Evangelist,
antiphon)
Margin: Tibi custos virginis nos
Recommendamus. H.L. (Hadewigis
de Ludenscheyde).

191v: **In vigilia nativitatis sancti Iohannis Baptiste**
Ne timeas Zachari
Initial 'N' (2-staff): two dragons

193v: **In vigilia beatorum apostolorum Petri et
Pauli. Officium.**
194r Dicit dominus petro.
Initial 'D' (2-staff): Saints Peter and Paul.

194v: **In die sancto beatorum apostolorum.
Officium.**
Hunc scio vere quia.
Initial 'H' (2-staff): martyrdom of Peter.
Margin (top to bottom):
O pastor bone caritate singulare peccata relaxa
septuagies septies. (?)
Commendo tibi gregem tuum.

195v: **In commemoratione sancti Pauli apostoli.
Officium.**
Scio cui credidi et certus sum.
Initial 'S' (2-staff): Two angels with blank scrolls
(upper compartment); Paul (lower
compartment).

196v: **Sancte Marie Magdalena. Officium.**
Gaudeamus omnes in domino. (Mary
Magdalen, Mass introit)
Initial 'G' (2-staff): Mary Magdalen with
ointment jar; Anne (?) holding Mary holding
Christ on the Cross.

197r: **Ad vincula sancti Petri apostoli. Officium.**
Nunc scio vere.
Initial 'H' (3-staff): angel visiting Peter in
prison (upper compartment); Peter brought
before the emperor (lower compartment).
Prophets:
[top left] Petrus fundamentum ecclesiarum.
[top right] Et gloria sanctorum apostolorum.
Saint [left]: Nunc scio vere quia misit. [gold]
Saint [right]: Tu es Petrus princeps
apostolorum. [gold]
Scrolls (inner margin): O Petre pastor bone.
Cuccurre nobis nunc et in agone. (?)
O princeps apostolorum, supra modum
peccavimus omnes dimitte septua<gies
septies>. (Can 004958: Cathedri St. Petri,
antiphon)
Scroll (lower margin): Sancte Petre clementia
singulare post dominum nostri miserere. (?)

198r: **In festo beati Dominici patris nostri.
Officium.**
Initial 'I' (3-staff): Madonna of Mercy (left);
Dominic kneeling in prayer (right).
In medio ecclesie.
Mary: Filie mee et filii quis dedit in dominus.
Dominic: Ordinem meum videre affecto.
(cf. Dietrich of Apolda, *Acta Ampliora*)[3]

3 AASS, August, vol. I, 583 (August 4th), §115. Kaeppeli &
Panella, *Scriptores* (1970–1993), no. 3677, and vol. 4, 300–01.

201v **In die sancto**. [Assumption of Virgin]
Gaudeamus omnes in Domino.
Initial 'G' (3-staff): Mary as Apocalyptic Woman
standing on moon and in sun crowned by two
angels; two additional angels flanking Christ.
Christ: Veni dilecta mea veni coronaberis.
(cf. Ct 4:8)
Two flanking angels: Hec est virgo et mater
Domini (left); que est ista que ascendit (right).
(Ct 3:6; Ct 8:5: Assumption liturgy)
Grotesque (human torso, lion's body): Iohannes;
in principio erat verbum. (Io 1:1)
Grotesque (human torso, lion's body): Gabriel;
Ave Maria gratia plena. (Lc 1:28)
Prophet in roundel: Dua verba annuntiaverit
mundo quorum comparatione omnia debetur
muta apparere. (?)
Margin (top to bottom):
Obedientia inventrix gratie (Cf. *PL* 102:610:
Smaragdus, *Diadema monachorum*, ch. 13:
Obedientia regni coelorum inventrix est) ad
ethereum pervenisti thalam. (cf. Can 200374:
Assumption of Virgin, antiphon)
Quo pia nostri inmemor necquaquam
existas. (?)

203r **In decollatione Iohannis Baptiste. Officium.**
Initial (3-staff): Feast of Herod with Salome
holding head of John the Baptist on platter
(upper compartment); Martyrdom of John the
Baptist (lower compartment).
Salome (upper compartment): Da mihi in disco
caput Iohannis. (Mt 14:8)
John the Baptist (lower compartment): Domine
deus tibi commendo spiritum meum.
(cf. Lc 23:46)
Hi talis et tantus datur incestui adicitur saltatrici
flos martirum et decorum pudicitie omni
maiorum homine. (Petrus Chrysologus,
Collectio sermonum)[4]

203v **In nativitate sancte Marie. Officium.**
Gaudeamus omnes in domino.
Initial 'G' (3-staff): Birth of the Virgin.
Angels: Nativitas tua dei genetrix virgo.
(Can 007199: Nativity of the Virgin,
responsory)
Four prophets in corners:
Upper left: Ecce ista dedit nobis benedictionem.
(Can 007199: Nativity of the Virgin,
responsory)

4 Cf. Petrus Chrysologus, *Collectio sermonum*, ed. Olivar (1975–
1982), 782, lines 13–14; Urfels-Capot, *Sanctoral* (2007), 115.1: In
festo decollationis beati Johannis Baptiste, lectio prima.

Upper right: Virga de radice Iesse floruit.
(Is 11:1)
Lower left: Donavit nobis vitam sempiternam.
(Can 007199: Nativity of the Virgin,
responsory)
Lower right: Et confundens mortem.
(Can 007199: Nativity of the Virgin,
responsory)
Margin (top to bottom):
[oriented left] Exores pro nobis dominum
Iohannes maxime vatum et tuis nos tuere
persidiis nunc et in extremis periculis.
[oriented right] O Marie gratie nostri miserere.

204v **In exaltatione sancte crucis. Officium.**
Nos autem gloriari oportet in cruce.
(Exaltation of Cross, Lauds: Antiphon 3)
Initial 'N' (3-staff): Crucifixion; John and three
Maries with Longinus on dexter side; centurion
and other witnesses on sinister side.

205v **Sancti Michaeli archangeli. Officium.**
Benedicte domino.
Initial 'B' (2-staff): Michael slaying dragon.
Margin: Michael prepositus paradisi quem
honorificant angelorum cives. Data est potestas
archangelo Michaeli super omnes animas sus
cipiendas ut perducat eas in paradisum. Audita
est vox milia milium dicentium.
(Can 003757: Michael, antiphon)
Lower margin: Salus, honor et virtus deo nostro
alleluia. (Can 006715: Michael, responsory)

208v **In die officium**. [All Saints]
Gaudeamus omnes in domino.
Initial 'G' (3-staff): All saints (apostles and,
behind them, Mary as Madonna of Mercy).
Frame of Initial (left side): O quam gloriosum
est regnum in quo cum Christo gaudent omnes
sancti. (Can 004063: All Saints, Antiphon)
Margin: Adiuvent nos sanctorum merita quos
propria impediunt scelera et excuset intercessio
quos propria accusat actio. (Can: 006305a: All
Saints, verse)

Common of Saints

213v **In communi unius vel plurimorum
apostolorum. Officium.** [213r]
Mihi autem.
Initial 'M' (2-staff): Calling of Matthew.
Christ: O Mathee dimitte eum. (Mt 15:23)
Saints in outer margin (top to bottom):

Peter: Tu es Christus filius dei vivi. (Mt 16:16)
Paul: Tu splendor glorie et figura substantie dei. (Hebrews 1:3)
John the Evangelist: Qui dilexit nos et lavit a peccatis in sanguine suo. (Apc 1:5)
James the Greater: Voca sua suscitabit mortuos. (?)
Apostle: Tu super idem es, et immutabile perseveras. (?)
Apostle: Tu est vere messias qui dicitur Christus. (Io 4:25)

238r **In communi unius virginis. Officium.**
Gaudeamus omnes in domino.
Initial 'G' (2-staff): 3 female saints.
Margin (top to bottom): Pia mater et matrona / Interventrix et patrona / Sis pro nobis omnibus / Sancta Elizabetha (Can 201892: Elisabeth of Hungary)

239r **Item.**
Loquebar.
Initial 'L' (2-staff): Catherine and Barbara.

Marian Chant for Saturdays throughout the year

245r **A purificatione usque ad adventum domini officium quando agitur de beata virgine.**
Salve sancta parens.
Initial 'S' (2-staff): Visitation (upper compartment); Annunciation (lower compartment).
Elisabeth: Salve mater virgo. (Marian hymn)
Gabriel: Salve radix sancta. (Marian epithet)

Sequentiary

249r **In die sancto natalis Domini et festis sequentibus. Sequentia.**
Letabundus exultet fidelis chorus alleluya. (*AH* 54:2; Dominican Prosar)
Initial 'L' (2-staff): decorative.
Frame: [top] O Ihesu dulcis parvule / flos virginee nostris [right] receptos meo sancto sanguine serva [bottom] a peccatis et perduc ad gloriam per- [left] petue claritans. amen. [gold]. (?)
Margin (top to bottom): Puer natus est nobis / et filius datus est nobis. (*AH* 49:69, etc.: Christmas)

Sedentibus in tenebris / lux orta est eis / desiderabilis. (cf. *AH* 25:28: Anne, Matins, third nocturn, antiphon)

250r **In die sancto pasche. Et duobus diebus sequentibus. Sequentia.**
Victime paschali laudes. (*AH* 54:7; Dominican Prosar)
Initial 'V' (2-staff): decorative.
Margin: Hec est dies quam fecit dominus exultemus et letemur in ea (green). (Ps 117:25) Omnem diem fecit dominus (red). Hec dedicavit sanguine suo (red). O mira circa nos summi pietatis (?) dignatio. Ut servum redimeret filium etc. (green). (Exultet)

250v **In die ascensionis domini. Sequentia.**
Omnes gentes plaudite. (*AH* 54:152/232; Dominican Prosar)
Initial 'O' (2-staff): decorative (vine, hearts and lilies in gold).

252v **In die sancto penthecoste. Sequentia.**
Sancti spiritus assit. (*AH* 53:119; unique to Paradies)
Initial 'S' (2-staff): golden dragon.
Margin (top to bottom): Spiritus Domini ornavit celos. (Iob 26:13) Dulcissimum qui in deo spiritus sanctus est.[5] (Bernard of Clairvaux, *Sermones in die pentecostes*) Sine quo preces <omnes> casse creduntur et in digne dei auribus. (*AH* 53:119; cf. f. 254r)

254v **Feria secunda et tertia post penthecostes. Sequentia.**
Veni sanctus spiritus (*AH* 54:153)
Initial 'V' (9-staff): golden dove

257r **In die sacri corporis Christi. Sequentia.**
Lauda Sion salvatorem. (*AH* 50:385)
Initial (2-staff): puzzle initial against framed fleuronnée ground

262v **In festo Sancti Iohanni apostoli et evangeli ad portam latinam. Sequentia.**
Exortum lumen lux in tenebris. (cf. *AH* 9:252, unique to Paradies)
Margin: Iste est Iohnnes cui Christus in cruce matrem virginem virgini commendavit. (Can 001093: John the Evangelist, second nocturn, responsory) Qui privilegeo amoris

[5] Bernard of Clairvaux, *Opera*, eds. Leclercq et al. (1957–1977), vol. 5, 160 (1.1, line 7).

principui ceteris altius a domini meruit
honarari. (Can 006819: John the Evangelist, first
nocturn, responsory)

264v **In utroque festo beati Paulus. Sequentia.**
Paule doctor gentium / omnium credentium.
(Unique to Paradies)
Initial 'P' (3-staff): decorative (two gold hearts).

269r **In festo sancti Iohannis apostoli et evangeliste
ante portam latinam. Sequentie.**
Verbum dei deo natum. (*AH* 55:188/211)
Initial 'V' (2-staff): Eagle, in gold, with scroll.
Eagle: In principio erat verbum [gold].
Margin: Hoc dei consecretalis aspexit
[sic: aspiceret], quo enarrando nec primum nec
similem nec sequentem haberet.
(*Speculum uirginum*)[6]
In multitudine electorum habebit laudem et
inter benedictos benedicetur (Sir 24:4)

270r (continuation):
[…] iste custos virginis.
Initial 'I' (1-staff): gold.

270v (continuation):
[…] Volat avis.
Initial 'V' (1-staff): golden eagle.

271r (continuation):
[…] Aquilam Ezechielis.
Initial 'A' (1-staff): red eagle.

271v **In utroque festo beati Dominici patris nostri.
Sequentia.**
In celesti ierarchia.
(*AH* 55:115; Dominican Prosar)
Initial 'I' (2-staff): decorative (gold vines).
Margin: Imple pater quod dixisti nos tuis iuvans
precibus nec et in extremis periculis. Amen.
(Dominic, Matins, Nocturn 3, Responsory 3)

274r **In nativitatis sancti Iohannis Baptiste et
precursoris. Sequentia.**
Precursorem summi Regis. (*AH* 42:252/227)
Initial 'P' (2-staff): decorative (gold blossoms,
lilies, stars).

276r <Petrus in vincula>
Iubar mundo geminatur. (*AH* 42:312)
Initial 'I' (2-staff): Christ liberating Peter from
prison.
Christ: Quodcumque ligaveris super terram erit
ligatum in celis. (Mt 16:19)
Margin: [oriented left] O piscator animarum
in hoc mari fluctuantes, vos salva periclitantes.

(*AH* 15:212) [oriented right] Isti sunt due
olive et due candelabrum lucentia et cetera.
(Can 003438:
John and Paul: Responsory, Nones

277v **In divisione beatorum apostolorum.
Sequentia.** [277r]
Celi enarrant gloriam dei filii verbi.
(*AH* 50:267/344)
Initial 'C' (2-staff): decorative (twelve golden
stars [apostles], large star at center on blue
ground [Christ]).
Margin (top to bottom): Vos Christi discipuli
vicarii testes et amici. (Can 605050: Division of
Apostles, responsory)
Gloriosi apostoli fundamenta ecclesie et
doctores nostri sitis defensores.[7]
Apud dominum et prolocutatores in omni
periculo et mortis articulo.[8]

282r **In die sancti Petri apostoli ad vincula
Sequentia.**
Verbum dei incarnatum et in mundo
conversatum. (*AH* 44:269; unique to Paradies)
Initial 'V' (2-staff): Christ and Peter as
shepherds. [nuns' work]
Christ: Super plebem meam principem te
constitui et claves et cetera.
(Can 007674: Peter and Paul, responsory)
Christ: Petrus amas me. (cf. Io 21:17)

285r **In die assumptionis sancte Marie. Sequentia.**
[284v]
Ave preclara maris stella. (*AH* 50:241/313)
Initial 'A' (2-staff): decorative (gold star with
gold 'M' on circular green ground at center).
Margin (top to bottom): Ave maris stella /
lucens miseris / deitatis celi / porta principis. /
Paradisi patens fons / tu et cetera. (*AH* 1:4)
286v (continuation):
[…] Ora virgo nos illo pane celi dignos effici.
Initial 'O' (fleuronnée): decorative with silver
star in margin.
287r (continuation):
[…] Audi nos name te filius / nichil negans
honorat.
Initial 'A' (1-staff): decorative (two silver stars
and silver blossom).

[6] *Speculum uirginum*, ed. Seyfarth (1990), ch. 5, line 745.

[7] Cf. *Glossa Ordinaria* on Apc 21–22.

[8] Cf. *AH* 54:184; *Lateinische Sequenzen*, ed. Kehrein (1873),
no. 180: 'Et in mortis articulo / Liberet a periculo'.

287v **Infra octava assumptione. Sequentia.**
Salve mater salvatoris.
(*AH* 54:245; Dominican Prosar)
Initial 'S' (1-staff): decorative (five silver
blossoms and stars).
Margin: O mater dei iube nato / ut nos solvat a
peccatis / et in regno claritatis / quo lux lucet
sedula / collocet per sedula. (cf. *AH* 8:83 and
AH 55:67 [strophe 13])

290r **In octava assumptionis. Sequentia**
Omnis celi ierarchia. (*AH* 9:76)
Initial 'O' (1-staff): decorative (gold).

291r **Sancti Augustini patris nostri. Sequentia.**
De profundis tenebrarum.
(*AH* 55:75; Dominican Prosar)
Initial 'D' (1-staff): decorative, with silver
blossom at center.

292v **In festo decollationis sancti Iohannis
Baptiste. Sequentia.**
Iubilemus in hac die. (*AH* 9:239)
Initial 'I' (9-staff): decorative (gold and silver).

294v **In nativitate sancte Maria virginis. Sequentia.**
Nativitas Marie virginis / que nos lavit a labe
criminis. (*AH* 54:188; Dominican Prosar)
Initial 'N' (2-staff): decorative.
Frame of initial: [Top] Regali ex progenie Marie
[right] exorta refulget cuius precibus [bottom]
nos adiuvari mente et spiritu [left] devotissime
poscimus Ihesus Christus. (gold)
(Can 007519: Nativity of Virgin, responsory)

299r **Tempore paschali de beata virgine. Sequentia.**
Virgine Marie laudes concinant cristiani.
(*AH* 54:21/31)
Initial 'V' (1-staff): decorative (three silver
stars).

H: Sources for the Inscriptions in the Manuscripts from Paradies

Unless indicated otherwise, all inscriptions listed here occur in the gradual D 11. Not all inscriptions in D 11, however, are included. Omitted are those that consist simply of names (*nomina sacra*, etc.) or the many epithets for John the Evangelist discussed in Part V, ch. 23 (unless a given epithet has its origin in a specific text). If more than one inscription on a page draws on the same source (as on p. 402, where Johannes Scotus Eriugena is quoted twice), the page is listed only once; conversely, some inscriptions consist of a cento of different sources. Two citations of the same chapter and verse should not be taken to imply that the inscriptions are identical; each might reproduce a different portion or paraphrase of the passage. Moreover, if a passage points to several sources (e.g., in the Psalms) that cannot be distinguished on the basis of the wording, then all are listed. If a liturgical text employed in an inscription is predicated on a passage in scripture, then both the liturgical and biblical references are listed, as it is not necessarily possible to distinguish between the two. Scriptural sources for chant (e.g., introits, known in the Dominican rite as *officia*), however, are excluded, although they are indicated in the edition to provide context for accompanying inscriptions. If phrases included in the inscriptions occur in several places in scripture, e.g., in all four Gospels, all instances are cited. A small number of inscriptions summarize the content of an entire chapter or book of scripture; in these cases, no verse number is assigned. When the source for an inscription coincides with the Gospel or Epistle pericope for the feast in question in the Dominican liturgy, it is followed in the list by a reference in brackets introduced by the abbreviation GP or EP. Images without inscriptions that refer to pericope readings are not listed here, only in the edition. All references are to the Vulgate bible, which uses a different numbering system for the psalms than modern bibles. In addition to the detailed analysis of the inscriptions for each section in the commentary accompanying the edition, a more general discussion of the inscriptions can be found in vol. I, Part VI. The plates in vol. II, which are arranged sequentially by folio or page number, are keyed to page numbers in vol. I, permitting one to locate the discussion and reproduction of any given inscription in B 6, D 9, D 11 and D 12.

Gn 15:1	p. 2
26:30	p. 26
27:35	f. 168v [D 12]
32:30	p. 3
35	p. 451
Ex 4:13	p. 517
15:27	p. 454
33:20	p. 38
39:14	p. 456
Lv 14:51	p. 20
24:5	p. 457
Nm 1:44	p. 452
7:84	p. 457
24:17	p. 432, f. 27v [D 12]
Dt 8:3	p. 104
32:4	p. 237
Ios 4:3–21	p. 456
Idc 6:33–40	p. 391, f. 13r [D 12]
1Sm 2:2	p. 448
6	p. 391
Idt 9:19	p. 450
16:17	p. 102
1Rg 2:8	p. 18
10:22	p. 26
10:29	p. 7
2Par 4:15	p. 455
Esd 9:46	p. 559
Tob 13:23	p. 450

Iob 26:13	p. 304, f. 252v [D 12]	56:6	p. 19
28:7	Cambridge, f. 1v	56:9	pp. 19, 258, f. 117r [D 12]
37:4	p. 402	56:12	p. 17, 19
37:5	Cambridge, f. 1v	62:3	p. 18
39:27	p. 676, Cambridge, f. 1v	63:10	p. 7
		65:2	p. 19
Ps 2:7	p. 53	65:8	p. 43
2:8	p. 317	66:2	p. 38
3:6	p. 259	67:2	p. 258
4:2	p. 128	67:18	p. 7
4:4	p. 676	67:33	p. 72
6:2	p. 133	67:35	p. 237
16:15	p. 17	68:18	p. 38
17:11	p. 3	70:8	p. 19
18:2	p. 17	72:24	p. 17, Munich (recto)
18:6	pp. 517, 519	73:2	pp. 200, 550
18:7	p. 59	73:19	pp. 295, 441
19:8	p. 213	73:20	p. 397
20:5	p. 460	76:19	p. 402, Munich (recto)
20:14	p. 295	76: 21	p. 237
21:17	p. 182	77:16	p. 21
22:4	p. 415	77:24	p. 319
23:7–10	p. 19	77:25	p. 563
23:8	p. 255	79:2	p. 45
23:9	p. 17	83:2	p. 440
23:10	p. 255	83:5	p. 366
24:2	p. 23	83:6	p. 3
24:14	p. 516	83:8	p. 19
25:3	p. 515	83:10	p. 317
25:8	p. 18	83:12	p. 17
26:8	p. 38	84:10	p. 17
26:9	p. 38, f. 19r [D 12]	84:11	pp. 280, 286
27:8–9	f. 155v [D 12]	84:12	p. 32
27:9	p. 317	85:16	f. 158r [D 12]
28:2	p. 19	88:2	p. 257
32:5	ff. 25r, 25v [D 12]	88:12	p. 256
32:22	p. 256	88:15	pp. 283, 546
33:6	p. 2	88:16	p. 283
37:22	p. 133	88:18	p. 18
40:11	p. 258	88:37–38	p. 23
44:1	p. 2	89:16	pp. 79, 317
44:5	p. 427	89:17	p. 81
44:11	p. 29	90:11–12	p. 102
44:13	p. 38	91:14	p. 83
44:14	p. 17	92:5	p. 375
44:15	pp. 2, 509	95:3	p. 18
46:3	p. 293	95:11	p. 56
46:10	p. 319	96:6	p. 18
48:2	p. 385	101:2	p. 215
50:3	f. 13r [D 12]	101:3	f. 19r [D 12]
50:4	p. 20	101:28	p. 53
50:6	p. 20	102:22	p. 62
53:3	f. 31v [D 12]	103:31	p. 19
53:8	p. 165	107:2	p. 19
55:2	p. 214	107:6	p. 17

| | | | | |
|---|---|---|---|
| Hab 3:13 | p. 255 | 3:35 | p. 317 |
| 3:18 | p. 65 | 6:31–44 | p. 66 |
| | | 10:28 | p. 450 |
| Soph 3:17 | p. 402 [OT: 227] | 10:34 | p. 400 |
| | | 11:10 | p. 23 |
| Mt 1:21 | pp. 65, 317 | 11:24 | p. 290 |
| 2:2 | f. 27v [D 12] | 14:8 | f. 203r [D 12] |
| 3:17 | pp. 66, 317 | 15:17 | p. 400 |
| 4:3 | p. 104 [GP: 4:1–11] | 15:34 | p. 222 |
| 4:4 | p. 104 | 16:6 | p. 259 [GP: 16:1–7] |
| 4:6 | p. 102 | | |
| 4:16 | p. 239, f. 27r [D 12] | Lc 1:5 | p. 408 [GP 1:1–15] |
| 4:17 | p. 29 | 1:15 | p. 408 |
| 4:19 | p. 369, f. 170r [D 12] | 1:28 | pp. 584, 624, ff. 1r, 29r, 183r, 201v [D 12] |
| 5:13–14 | p. 450 | 1:34 | p. 391 |
| 8:16 | p. 315 | 1:35 | p. 391 |
| 12:18 | Munich (recto) | 1:38 | p. 584 |
| 12:47 | p. 416 | 1:44 | p. 680 |
| 13:35 | p. 200 | 1:46–47 | p. 680 |
| 14:8 | p. 431, f. 203r [D 12] | 1:48 | p. 603 |
| 14:13–21 | p. 66 | 1:50 | p. 317, f. 127v [D 12] |
| 14:35 | p. 315 | 1:68 | f. 116r [D 12] |
| 15:23 | p. 128 [GP: 15:21–28], f. 213v [D 12] | 1:76 | pp. 408, 595 |
| 15:28 | p. 128 [GP: 15:21–28] | 1:79 | p. 255 |
| 16:16 | p. 611, f. 213v [D 12] | 2:10 | p. 56, 546 |
| 16:19 | p. 450, f. 276r [D 12] | 2:13 | p. 520 |
| 17:4 | p. 124 [GP: 17:1–9] | 2:15 | p. 56 [GP: 2:15–20] |
| 17:5 | p. 66 | 2:21 | p. 65 [GP: 2:21] |
| 19:27 | p. 450 | 2:32 | pp. 239, 385 |
| 19:28 | p. 450 | 2:38 | p. 448 |
| 20:4 | p. 81 [GP: 20:1–6] | 4:10 | p. 102 |
| 20:7 | p. 81 [GP: 20:1–6] | 5:17 | p. 313 [GP 5:17–26] |
| 20:21 | p. 133 | 5:20 | p. 313 [GP 5:17–26] |
| 20:22 | p. 133 | 8:10 | p. 85 [GP: 8:4–15] |
| 20:23 | p. 133 [GP: 20:17–28]; f. 252r [D 9] | 8:11 | p. 83 [GP: 8:4–15] |
| | | 9:1 | p. 311 [GP: Lc 9:1–6] |
| 21:5 | p. 200 [GP: 21:1–9] | 9:10–17 | p. 66 |
| 21:10 | p. 317 | 11:19 | p. 450 |
| 22:18 | f. 194v [D 12] | 11:27 | p. 142 [GP:11:14–28] |
| 25:34 | p. 26 | 14:15 | p. 568 |
| 25:35–36 | p. 26 | 15:6 | p. 317 |
| 26:9 | p. 215 | 15:9 | p. 317 |
| 26:23 | p. 319 | 16:19 | p. 322 [GP: 16:19–31] |
| 26:39 | p. 218 | 16:24 | p. 322 [GP: 16:19–31] |
| 26:41 | p. 218 | 18:28 | p. 450 |
| 26:42 | p. 218 | 18:41 | p. 87 [GP: 18:31–43] |
| 26:53 | p. 520 | 19:38 | p. 18 |
| 27:46 | pp. 222, 397 | 22:13 | p. 413 |
| 27:54 | p. 222 | 22:19 | pp. 221, 319 |
| 28:18–19 | p. 273 [GP: 28:16–20] | 22:23 | p. 221 |
| | | 22:29 | pp. 450, 603 |
| Mc 1:17 | f. 170r [D 12] | 22:32–33 | p. 413 |
| 3:17 | p. 578 | 23:11 | p. 225 |
| 3:31 | p. 416 | 23:34 | pp. 222, 397 |
| | | 23:43 | pp. 222, 397 |

23:46	pp. 222, 397, 431, f. 203r [D 12]	8:45	p. 32
23:47	p. 397	8:50	p. 17
23:49	p. 222	8:51	p. 434
24:5	p. 457	8:56	p. 182 [GP: 8:46–59]
24:26	p. 262 [GP: 24:13–35] [NT 100]	8:58	p. 87
24:29	p. 553	8:59	p. 182 [GP: 8:46–59]
24:32	p. 261 [GP: 24:13–35]	9:35	p. 170 [GP: 9:1–38]
24:36	p. 264 [GP: 24:36–47]	9:36	p. 170 [GP: 9:1–38]
24:39	p. 278	9:37	p. 170
24:49	p. 295	10:7	p. 309
		10:10	p. 309 [GP: 10:1–10]
Io 1:1	ff. 201v, 269r [D 12]	10:11	p. 283
1:12	p. 2	10:14	p. 283
1:5	p. 239	11:5	p. 418
1:6	p. 595	11:23	p. 176 [GP: 11:1–45]
1:9	pp. 56, 385	11:26	p. 176
1:11	p. 62	11:27	p. 176 [GP: 11:1–45]
1:12	p. 2	11:28	p. 608
1:14	pp. 49, 546 [GP: 1:1–14], f. 19r, 25r [D 12]	11:41–42	p. 317
		12:3	p. 215
1:18	p. 53	12:6	p. 215
1:23	p. 408	12:28	p. 293
1:29	p. 20	12:45	pp. 21, 396
1:41	p. 369 [GP: Io 1:35–51]	13:18	p. 458
1:43	p. 413	13:23	p. 402
1:49	pp. 200, 369	13:24	p. 319
2:3	p. 66	13:36	f. 181r [D 12]
2:5	p. 2, 66	14:6	pp. 2, 283
3:19	p. 307 [GP: 3:16–21]	14:8	p. 396 [GP: 14:1–13]
3:24	p. 431	14:10	p. 396 [GP: 14:1–13]
3:29	pp. 29, 680, f. 15v [D 12]	14:18	p. 450
3:31	p. 32	14:16	p. 550
3:33	p. 32	14:26	p. 304 [GP: 14:23–31]
3:35	p. 317	14:30	p. 104
4:25	f. 213v [D 12]	15:4	p. 72
4:42	p. 157 [GP: 4:5–42]	15:5	pp. 81, 450
5:20	p. 317	15:11	p. 403
5:22	p. 26	15:13	p. 397
5:24	p. 311	15:19	p. 450
5:35	pp. 408, 431	15:27	p. 298 [GP: 15:26–16:4]
6:5–6	p. 161 [GP: 6:1–14]	16:24	p. 288 [GP: 16:23–30]
6:5–15	p. 66	16:27	p. 288 [GP: 16:23–30]
6:10	p. 2	17:1	p. 293 [GP: 17:1–11]
6:35	p. 47	17:17	p. 280
6:48	p. 47	17:24	p. 553
6:51	p. 563	18:4	p. 65, f. 116v [D 12]
6:58	p. 563	18:6	p. 519
6:59	p. 563	18:7	f. 116v [D 12]
6:69	p. 450	18:11	p. 413
6:70	p. 412	19:5	p. 224
6:71	p. 458	19:19	p. 210, 232
7:23	p. 21	19:25–26	p. 222
7:37	p. 21	19:26	p. 579
8:6–8	p. 159	19:26–27	pp. 222, 397
8:11	p. 159 [GP: 8:1–11]	19:27	p. 255, Munich (recto)

3Io 1:4	p. 420
1:11	p. 79
Apc 1:4	p. 572, f. 252v [D 9]
1:5	p. 258, f. 213v [D 12]
1:8	f. 252v [D 9]
1:16	pp. 78, 582
1:17	p. 579
1:18	p. 259
2:1	p. 616
2:3	p. 430
2:7	pp. 256, 617
2:11	p. 459
2:19	pp. 91, 415
3:21	p. 432
2:28	pp. 432, 577
3:2	p. 420
3:5	p. 515
3:7	p. 389
3:8	p. 449
3:11	p. 380
3:12	f. 252r [D 9]
3:19	p. 91
3:21	p. 432
4:8	p. 257
4:11	p. 317
5:2	p. 592
5:5	pp. 259, 677
5:6	p. 20
5:10	p. 487
5:11	pp. 69, 439
5:12	pp. 548, 677
5:13	p. 19
6:2	p. 624
6:4	pp. 383, 583
6:9	p. 587
6:10	p. 376
7:1	p. 435
7:2	p. 603
7:3	p. 157
7:5–8	p. 237
7:9	p. 440
7:10	p. 471
7:12	pp. 43, 373, 440
7:14	p. 599
7:15	p. 439
8:3	p. 406
10:8	pp. 579, 677
10:11	p. 578
11:1	p. 366
11:4	p. 410
11:17	p. 559
11:17–18	p. 460
11:19	p. 83

12:1	pp. 458, 519
12:2	p. 584
12:10	p. 471
13:10	p. 403
13:12	Cambridge, f. 1v
14:1	pp. 377 [GP: 14:1–5], 432
14:4	p. 373
14:4–5	p. 503
15:4	pp. 72, 91, 213
16:5	p. 559
16:18	p. 382
17:17	p. 405
18:20	p. 551
19:1	pp. 4, 440
19:4	p. 76
19:5	f. 116v [D 12]
19:6–7	f. 116v [D 12]
19:7	pp. 47, 373, f. 25r [D 12]
19:9	p. 568, f. 121v [D 12]
19:10	p. 373
20:4	pp. 450, 395, 587
20:6	p. 486
21:2	p. 366, f. 252v [D 9]
21:4	p. 469
21:5	p. 366
21:12	p. 455
21:13	f. 252v [D 9]
21:14	pp. 454, 689, f. 252v [D 9]
21:22	p. 573
22:1	pp. 428, 620
22:9	f. 25r [D 12]
22:12	p. 501
22:16	pp. 577, 616, 631
22:17	p. 21

Liturgical Texts

Analecta Hymnica Medii Aevi (AH)

1:4 (Virgin Mary)	f. 285r [D 12]
5:22 (Division of Apostles)	f. 277v [D 12]
8:83 (Dedication of Church)	f. 287v [D 12]
15:212 (John and Paul)	f. 276r [D 12]
24:14 (Virgin Mary)	p. 519
25:28 (Anne)	f. 249r [D 12]
25:90 (Elisabeth of Hungary)	f. 238r [D 12]
31:57 (Passion)	f. 33v [D 12]
32:173 (Virgin Mary)	p. 427
42:312 (Common of Apostles)	p. 599
46:167 (Mary)	p. 519
49:69	f. 245r [D 12]
50:385 (Corpus Christi)	p. 563
53:119	f. 252v [D 12]

53:119 (Pentecost) — pp. 304, 553, f. 252v [D 12]

54:152 (Ascension) — ff. 14r, 134v [D 12]

54:184 (Conception of Virgin) — f. 277v [D12]

55:67 (Anne) — f. 287v [D12]

CANTUS Database (http://cantusdatabase.org/)

001093 (Office of John the Evangelist) — f. 262v [D 12]

001167 (Vincula Petri) — f. 197r [D 12]

001293 (Purification of Virgin) — f. 29r [D12]

001458 (John the Evangelist) — f. 173r [D 12]

002232 (John the Evangelist) — f. 252r [D 9]

002543 (Advent: Monday of 4th week) — f. 14r [D 12]

002592 (Sunday in Holy Week) — f. 27v [D 12]

002643 (Eve of Pentecost) — p. 553

002762 (Assumption of Virgin) — p. 427

002941 (Octave of Nativity of Virgin) — p. 432

002948 (Trinity Sunday) — p. 19

003002 (Nativity of Virgin) — pp. 427, 631

003105 (Assumption of Virgin) — p. 427

003414 (Assumption of Virgin) — p. 427

003438 (Common of Several Martyrs) — p. 410, f. 276r [D 12]

003567 (Christmas) — p. 56

003757 (Michael) — f. 205v [D 12]

003790 (Decollation of John the Baptist) — p. 431

004019 (Invention of Cross) — f. 10v [D 12]

004030 (Paul) — f. 177r [D 12]

004063 (All Saints) — f. 208v [D 12]

004219 (Processional antiphon) — f. 158r [D 12]

004397 (John the Evangelist) — f. 189v [D 12]

004425 (Assumption of the Virgin) — p. 621

004597 (Regina caeli) — p. 290

004654 (Epiphany) — p. 66

004686 (Invention of the Cross) — f. 10v [D 12]

004958 (Cathedri S. Petri) — f. 197r [D 12]

005022 (Epiphany) — f. 27v [D 12]

005184 (Epiphany) — f. 32r [D 12]

005300 (Paul) — f. 177r [D 12]

005321 (Advent, 2nd Sunday) — f. 15v [D12]

005453 (Assumption of the Virgin) — p. 427

005454 (Assumption of Virgin) — p. 427

006084 (Agnes) — p. 380

006171 (Christmas) — f. 25r [D 12]

006236a (Epiphany) — f. 17v [D 12]

006305a (All Saints: Vespers) — f. 208v [D 12]

006322 (Christmas: Octave) — f. 193v [B 6]

006323 (Easter Monday) — f. 116v [D 12]

006345 (Christmas) — f. 23v [D 12]

006715 (Michael the Archangel) — p. 317, f. 205v [D 12]

006819 (John the Evangelist) — f. 262v [D 12]

007014 (Common of Apostles) — p. 410

007091 (Office of the Dead) — p. 441

007199 (Nativity of Virgin) — f. 203r [D 12]

007519 (Nativity of Virgin) — f. 294v [D 12]

007523 (Circumcision of Christ) — p. 19

007674 (Peter and Paul) — f. 181r [D 12], f. 282r [D 12]

007757 (Michael) — p. 317

007877 (Dedication of Church) — f. 252v [D 9]

007921 (John at the Latin Gate) — f. 252r [D 9]

007921a (John at the Latin Gate) — f. 252r [D 9]

200374 (Assumption of Virgin) — f. 201v [D 12]

201042 (Easter) — f. 27v [D 12]

201892 (Elisabeth of Thuringia) — f. 238r [D 12]

203987 (Catherine of Alexandria) — pp. 427, 517 [3]

204367 (Assumption of Virgin) — p. 621

605050 (Division of Apostles) — f. 277v [D 12]

909010 (Te deum) — pp. 23, 26, 435, f. 117r [D 12]

Creed — p. 450

Gloria — f. 29r [D 12]

Hymn (miscellaneous) — f. 245r [D 12]

Psalterium de nomine Jesu — f. 23r [D 12]

Little Office of the Virgin Mary: Magnificat — pp. 427, 257, 427, 451

Prayer to Holy Name — f. 33v [D 12]

Processional Antiphon (Easter) — f. 29v [D 12]

Quinquagesima officium — f. 31v [D 12]

Responsory (Dominic) — f. 271v [D 12]

Suffrage (Trinity) — p. 450

Vere Dignum — f. 250r [D 12]

Albertus Magnus — See Richard of S. Laurent

Alcuin, *Commentaria in sancti Iohannis Evangelium* — p. 402

Augustine, *Enarrationes in Psalmos* — pp. 458, 689

Bede, Homilia VIII (In die natali sancti Johannis baptistae) — f. 2r (Cambridge)

Bernard of Clairvaux, *In festo Pentecostes* — p. 304, f. 252v [D 12]

Sermo in dom. inf. octavam assumptionis beatae Mariae — p. 517

Sermones in die pentecostes — f. 252v [D 12]

Sermones super Cantica Canticorum — Munich (recto)

Bernard of Clairvaux (pseudo), *Vitis mystica* — p. 516

Bernard Gui, *Legenda S. Thomae de Aquino* (Kaeppli no. 611) — p. 515

Cassiodorus, *Expositio sancti Pauli Epistulae ad Romanos*	f. 213v [D 12]
Dietrich of Apolda, *Acta ampliora* (Kaeppli no. 3677)	p. 420, f. 198r [D 12]
Dominican Lectionary (Sanctorale)	ff. 194v, 197r, 203r [D 12]
Gregory the Great, *Homiliae in evangelis*	p. 450
Humbert of Romans, *Legenda maior* (Kaeppeli no. 2017)	pp. 2, 592
Isidore, *De ortu et obitu patrum*	p. 516
Jacobus de Voragine, *Legenda aurea* (Kaeppeli no. 2154)	pp. 59, 307
Johannes Scotus Eriugena, *Vox spiritualis aquilae*	p. 402, Munich (verso), Cambridge 2r
Leo the Great, *Tractatus septem et nonaginta*	15 v [B 6]
Peter Chrysologus, *Collectio sermonum*	f. 203r [D 12] (Dominican Office Lectionary)
Peter Damian, *Sermones*	Munich (recto), Cambridge f. 1v (in Dominican Office Lectionary)
Pseudo-Abdias, *Virtutes Iohannis*	pp. 261, 290, 373, 422, 611, f. 173r [D 12]
Ps.-Dionysius, Epistle X	Munich (recto)
Richard of Saint *Laurent, De laudibus sanctae Mariae virginis*	p. 427, f. 201v [D 12]
Rupert of Deutz, *Commentaria in evangelium sancti Iohannis*	Cambridge f. 1r
Commentarium in Apocalypsim	p. 373
De Trinitate et operibus eius libri XLII	p. 373
Speculum humanae salvationis	pp. 385, 391, 427
Speculum virginum	p. 375, f. 269r [D 12], Munich (verso)
Smaragdus, *Diadema monachorum*	f. 201v [D 12]
Thomas Aquinas, *Summae theologiae*	p. 319
William of Tocco, *Ystoria sancti Thome de Aquini* (Kaeppli no. 1664)	p. 515

Unidentified or Original Inscriptions

Munich, Staatliche Graphische Sammlung, Inv. no. 18703
Recto: Ie\<re\>mias. Deo in virtute mea in ore tibi.
Verso: Innocentius papa. Maius non poterat deus facere createm quia que adoptaret sibi in filium. Per plurima privilegia fecit Iohannem toti mundo venerabilem et specialem.

Cambridge, Harvard University, Houghton Library, Typ 1095, f. 2r
Episcopus Anselmus. Johannes columpna omnia qui in toto orbe sicut ecclesiarum. Post necem sanctorum apostolorum. Velud alter Ioseph est salvator mundi relictus.
Johannes Crisostomos: Cum prophetiam audieris; vere scies. Quare per ipsum ad naturam humanam loquitur deus.

D 9

f. 252r: Iohannes. Virgo a sola mater virgine procedi\<t\>

D 11

p. 12: O Ihesus sol iusticie splendorem pro te vicarium […]
p. 29: Cum nullo te occupaberis, tunc ex eo non turbaberis; in oratione sepe sis, et dabo tibi gratiam meam; stude solus esse, et habebis gaudium; ama me, et procurabo te; sis humilis et tacens, nunc quid facis fac propter me; non turberis de re terrena, sufficiat tibi in eo quod tibi dedero; nulli si comminus nisi michi soli, et ego te consolabor.
p. 373: Potentia patris miraculis eum mirifice exaltavit.
p. 373: Sapientia filii eum plus omni creatura honoravit.
p. 373: Trinitas sancta fecit eum consortium omnium sanctorum.
p. 402: Beda. Quis umquam sanctorum tantum lumen intelligentie accepit.
p. 516: Innocentius papa: Non poterat deus maius facere creature quam adoptare in fratrem (cf. Io 9:33)
p. 516: Quos precunctis dilexisti hos in morte coniunxisti.
p. 519: Nichil equalit Marie.
p. 519: Friar: Numquam inveniet gratiam qui non amat Mariam.
p. 676: Sol verus maris stella aquila circumvolans ista.

f. 14r: Propter temetipsum / nobis prima ingredi ad tua festa / tunc cum sanctis omnibus.
Nobis sis tunc pius censor / nostre cause defensor / memor tui operis.

f. 25v: Iudex clemens sis in agone Ihesu bone.
(Cf. *AH* 29:46/4: Vale, iuste tu patrone, assis nobis in agone, et da, Ihesu, pastor bone, eius prece spem corone).

f. 121v: O bone Ihesu; propter te metipsum. Pia nobis ingredi ad tua festa tunc cum sanctis omnibus.

f. 194v: O pastor bone caritate singulare peccata relaxa septuagies septies.

f. 197r: O Petre pastor bone. Cuccurre nobis nunc et in agone.

f. 197r: Sancte Petre clementia singulare post dominum nostri miserere.

f. 201v: Dua verba annuntiaverit mundo quorum comparatione omnia debetur muta apparere.
Quo pia nostri inmemor necquaquam existas.

f. 203v: Exores pro nobis dominum Iohannes maxime vatum et tuis nos tuere persidiis nunc et in extremis periculis. (Cf. *AH* 48:10/39: Iohannes, vatum maxime, / Prae cuneus verba excipe / Et prophetarum numerum / Ad hoc ascito socium).

f. 203v: Exores pro nobis dominum Iohannes maxime vatum et tuis nos tuere persidiis nunc et in extremis periculis.
O Marie gratie nostri miserere.

f. 213v: Voca sua suscitabit mortuos.
Tu semper idem es, et immutabile perseveras.

f. 249r: O Ihesu dulcis parvule, flos virginee nostris, redemptos meo sancto sanguine, serva a peccatis, et perduc ad gloriam per perpetue claritatis. Amen.

FULL-PAGE ILLUSTRATIONS

Gradual
ULB Dusseldorf, D 11

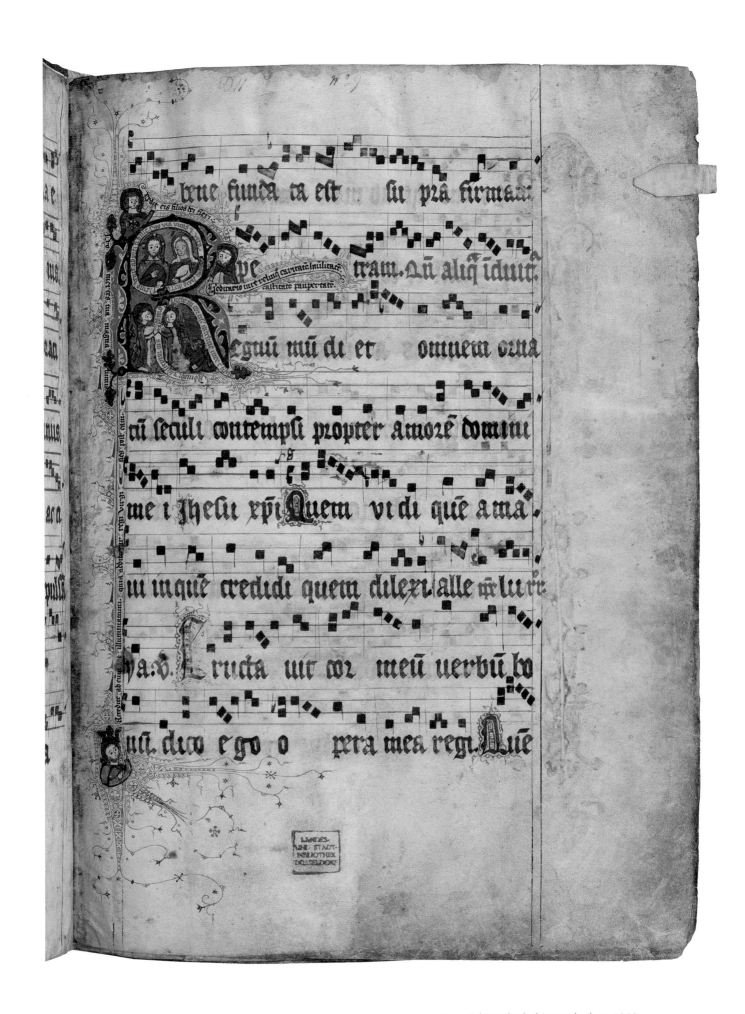

1. Taking the habit, gradual, ca. 1380.
ULB Dusseldorf, D 11, p. 2 [vol. I, pp. 62, 299–304]

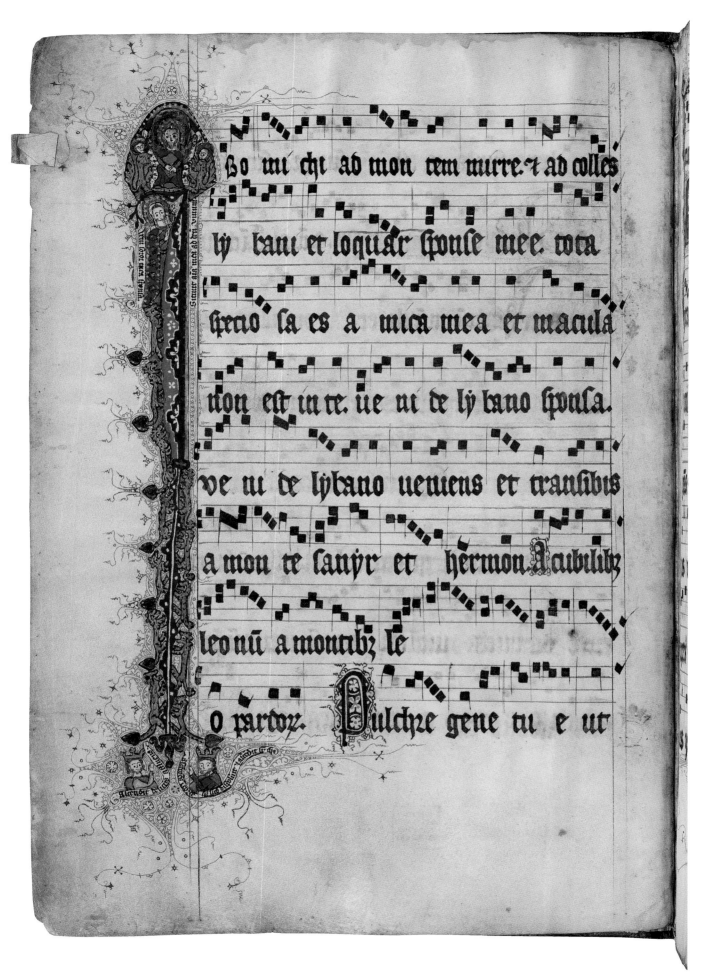

2. Processional antiphon, gradual, ca. 1380, Assumption of
Virgin. ULB Dusseldorf, D 11, p. 3 [vol. I, pp. 276, 304–305]

GRADUAL, ULB DUSSELDORF, D 11 | 97

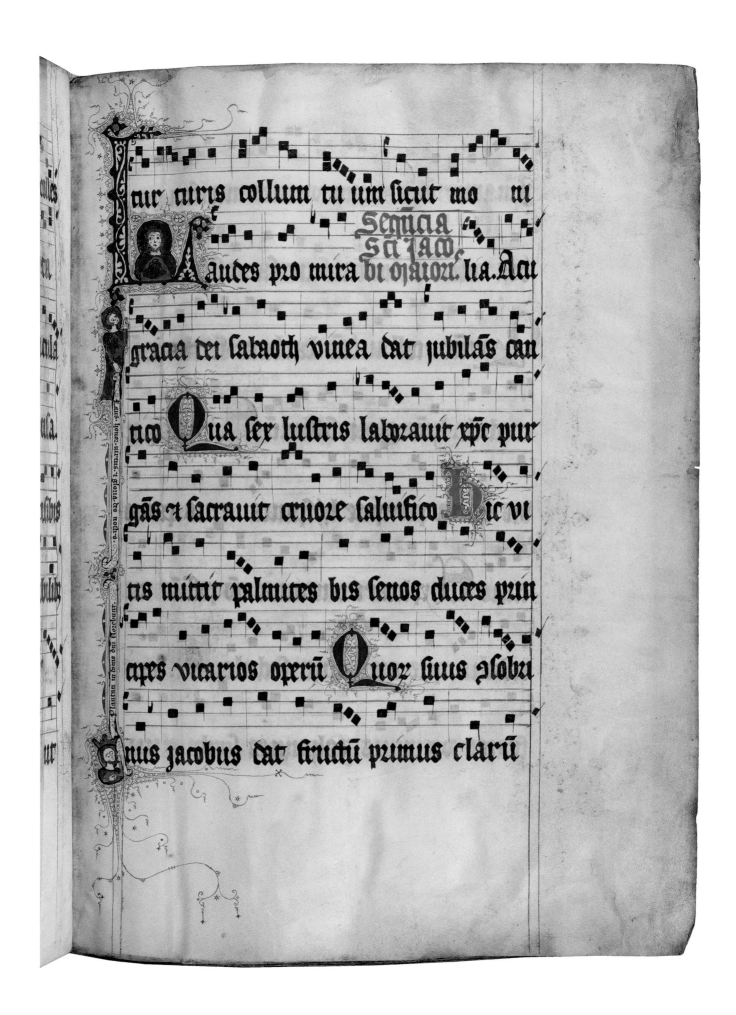

3. James the Greater: sequence, gradual, ca. 1380.
ULB Dusseldorf, D 11, p. 4 [vol. I, pp. 305–306]

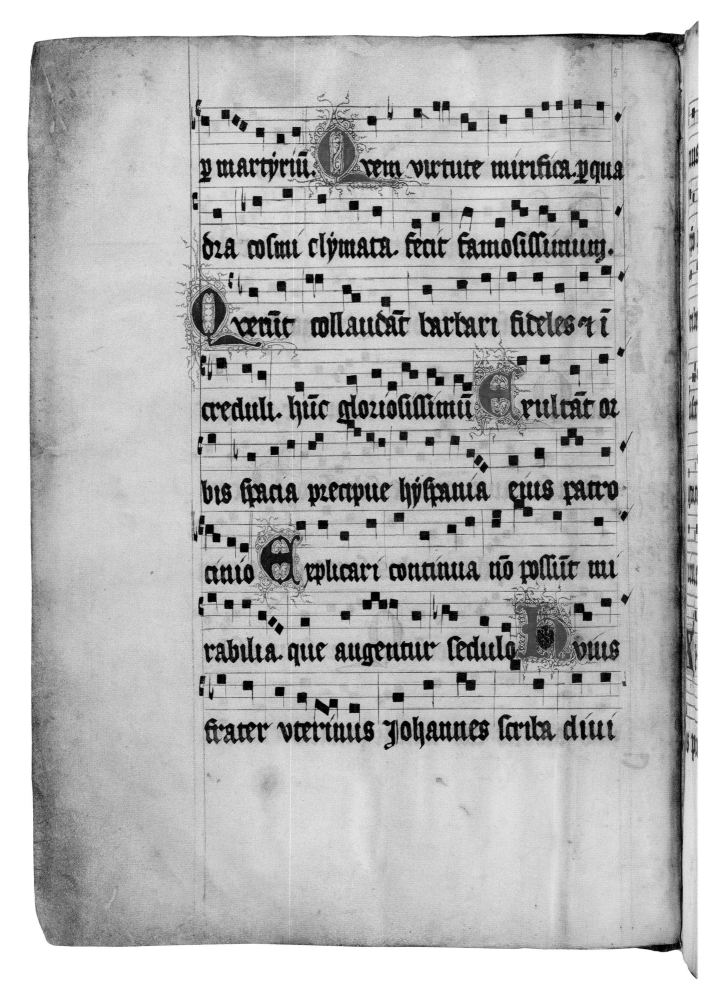

y martyriū. Qrem virtute mirifica. pqua

dra cosmi clymata. fecit famosissimum.

Qrenit collaudāt barbari fideles ⁊ ī

creduli. hūc gloriosissimū Exultāt or

bis spacia precipue hyspania eius patro

canio Explicari continua nō possūt mi

rabilia. que augentur sedulo Huius

frater vterinus Johannes scriba diui

4. James the Greater: sequence, gradual, ca. 1380.
ULB Dusseldorf, D 11, p. 5 [vol. I, p. 306]

GRADUAL, ULB DUSSELDORF, D 11 | 99

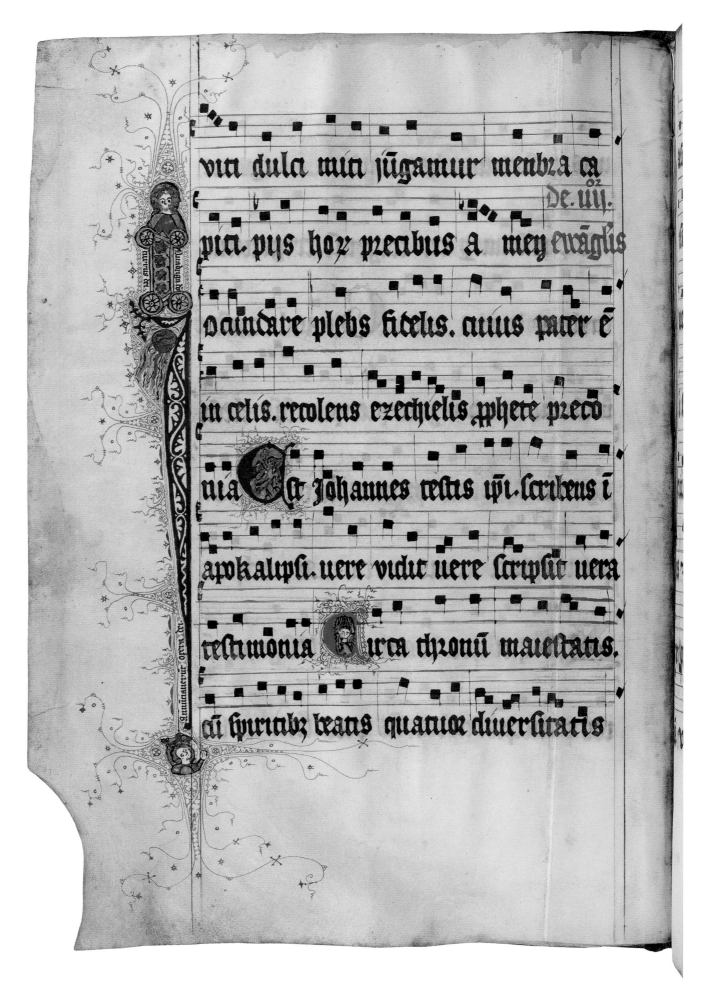

5. James the Greater, four Evangelists: sequences, gradual, ca. 1380. ULB Dusseldorf, D 11, p. 7 [vol. I, p. 307]

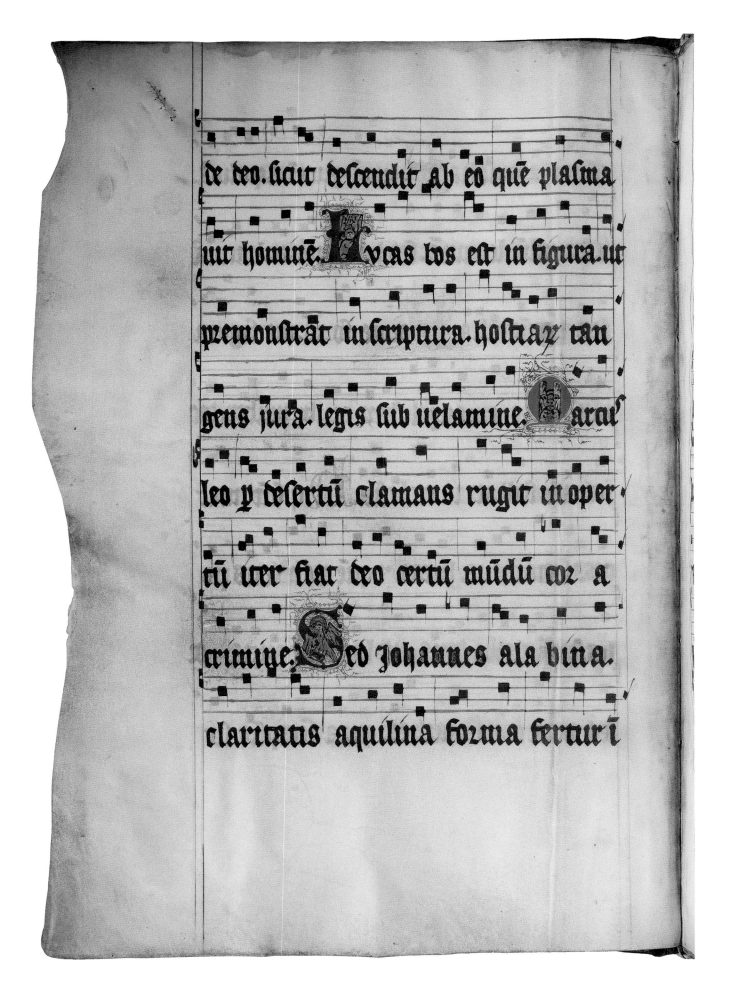

de deo. sicut descendit ab eo que plasma
uit homine. Lucas bos est in figura. ut
premonstrat in scriptura. hostiax tan
gens iura. legis sub uelamine. Marcus
leo p desertu clamans rugit in oper
tu iter fiat deo certu mundu cor a
crimine. Sed Johannes ala bina
claritatis aquilina forma fertur i

6. Four Evangelists: sequence, gradual, ca. 1380.
ULB Dusseldorf, D 11, p. 9 [vol. I, p. 307]

GRADUAL, ULB DUSSELDORF, D 11 | 101

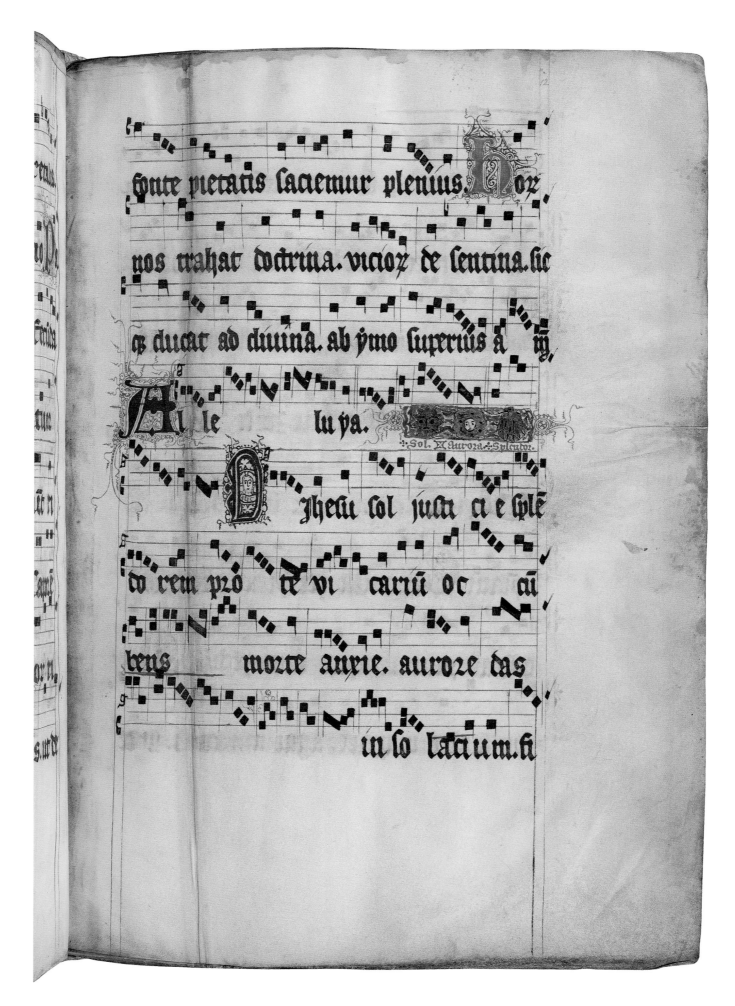

7. John the Evangelist: Alleluia, gradual, ca. 1380.
ULB Dusseldorf, D 11, p. 12 [vol. I, pp. 172, 256, 299, 307, 597]

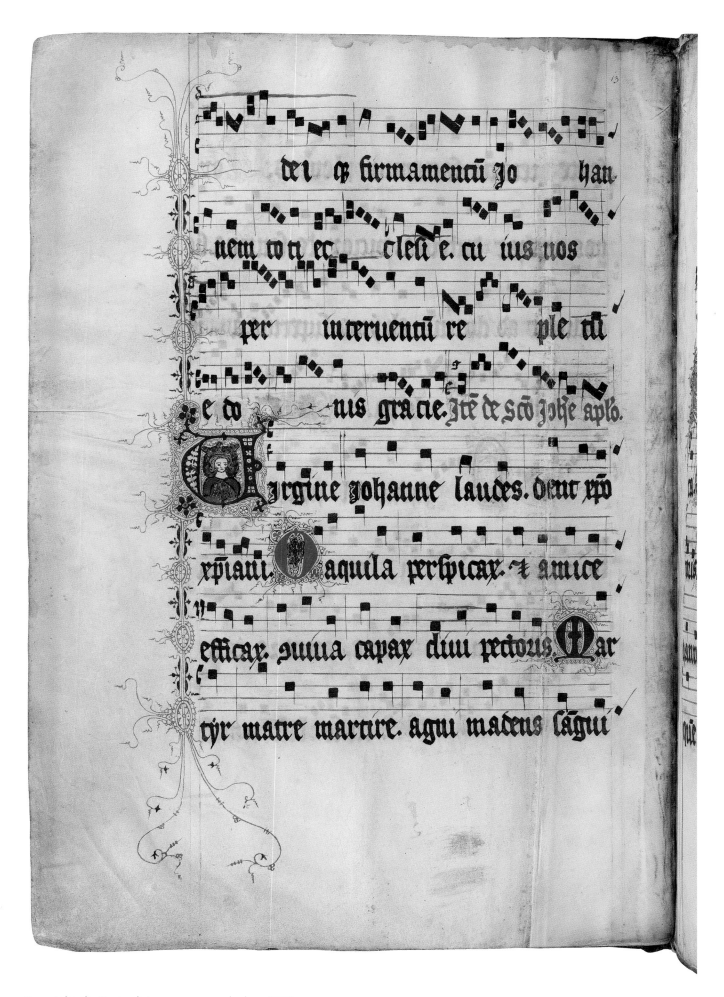

8. John the Evangelist: sequence, gradual, ca. 1380.
ULB Dusseldorf, D 11, p. 13 [vol. I, pp. 254, 309]

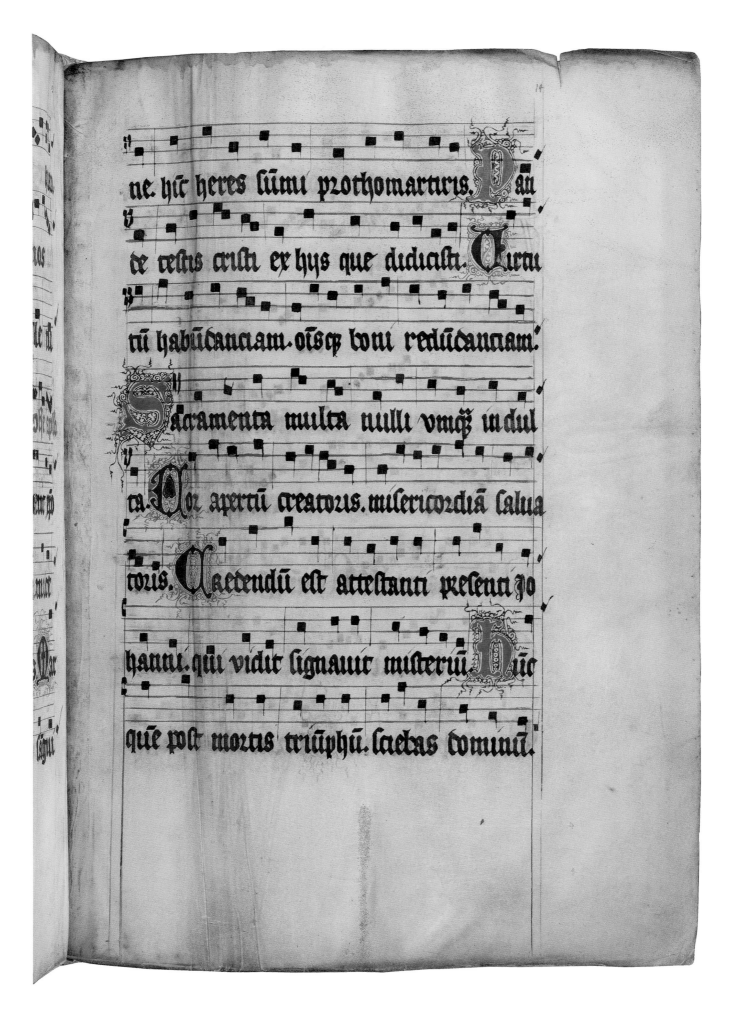

9. John the Evangelist: sequence, gradual, ca. 1380.
ULB Dusseldorf, D 11, p. 14 [vol. I, pp. 254, 309]

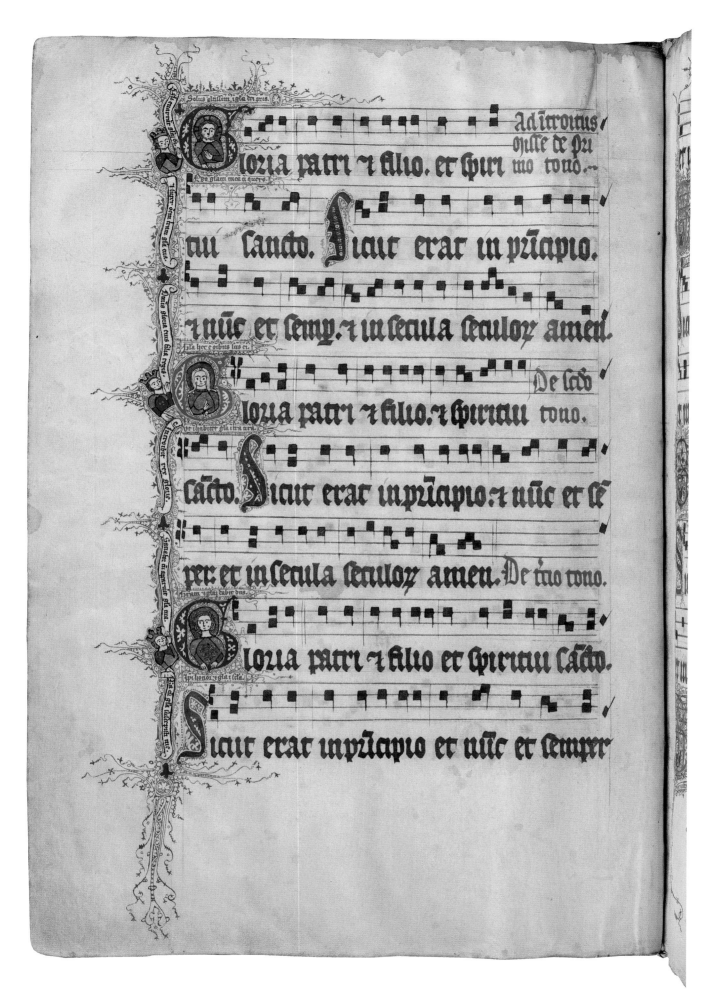

10. Eight tones, gradual, ca. 1380.
ULB Dusseldorf, D 11, p. 17 [vol. I, p. 311]

GRADUAL, ULB DUSSELDORF, D 11 | 105

11. Eight tones, gradual, ca. 1380.
ULB Dusseldorf, D 11, p. 18 [vol. I, pp. 311–12, 741]

12. Eight tones, gradual, ca. 1380.
ULB Dusseldorf, D 11, p. 19 [vol. I, pp. 184, 312–14]

GRADUAL, ULB DUSSELDORF, D 11 | 107

13. Aspersion antiphon, gradual, ca. 1380.
ULB Dusseldorf, D 11, p. 20 [vol. I, p. 315]

14. Aspersion antiphon, gradual, ca. 1380.
ULB Dusseldorf, D 11, p. 21 [vol. I, p. 316]

15. Pentecost: verse, gradual, ca. 1380.
ULB Dusseldorf, D 11, p. 22 [vol. I, p. 315]

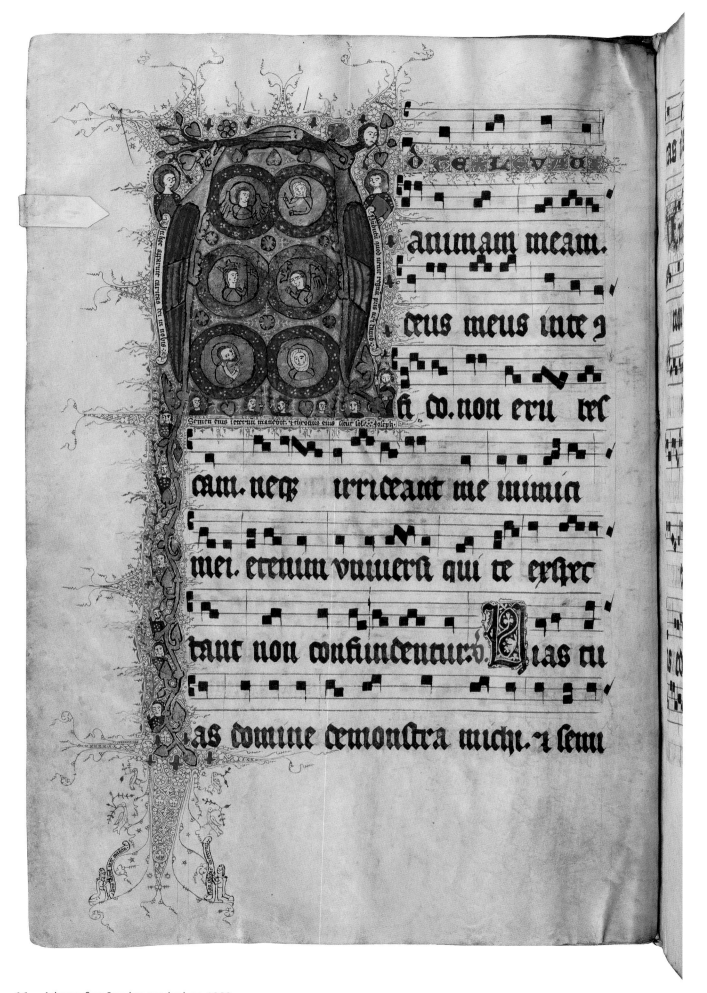

16. Advent: first Sunday, gradual, ca. 1380.
ULB Dusseldorf, D 11, p. 23 [vol. I, pp. 318–25, 743]

GRADUAL, ULB DUSSELDORF, D 11 | 111

17. Advent: second Sunday, gradual, ca. 1380.
ULB Dusseldorf, D 11, p. 26 [vol. I, pp. 326–28, 741]

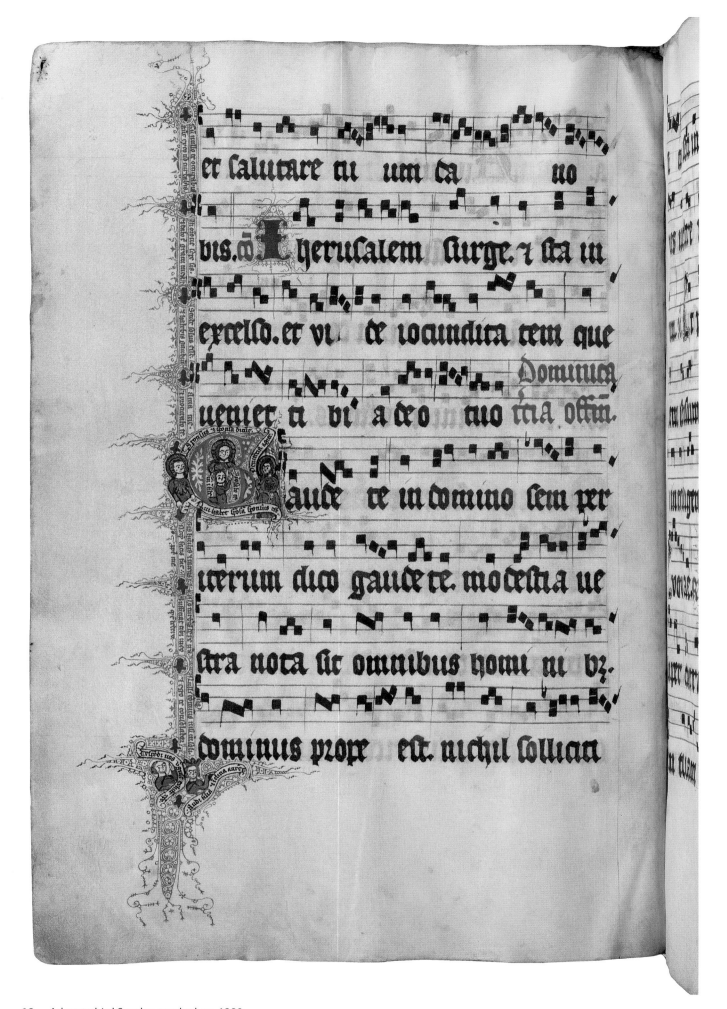

18. Advent: third Sunday, gradual, ca. 1380.
ULB Dusseldorf, D 11, p. 29 [vol. I, pp. 169, 328–31]

GRADUAL, ULB DUSSELDORF, D 11 | 113

19. Advent: fourth Sunday, gradual, ca. 1380.
ULB Dusseldorf, D 11, p. 32 [vol. I, p. 333]

20. Advent: fourth Sunday, gradual, ca. 1380.
ULB Dusseldorf, D 11, p. 35 [vol. I, p. 175]

21. Ember Saturday, gradual, ca. 1380. ULB Dusseldorf, D 11, p. 38 [vol. I, pp. 177, 184, 335–36, 743]

22. Ember Saturday, gradual, ca. 1380.
ULB Dusseldorf, D 11, p. 43 [vol. I, pp. 336–37]

GRADUAL, ULB DUSSELDORF, D 11 | 117

23. Ember Saturday, gradual, ca. 1380.
ULB Dusseldorf, D 11, p. 45 [vol. I, pp. 337–38]

24. Advent: fourth Sunday, gradual, ca. 1380.
ULB Dusseldorf, D 11, p. 47 [vol. I, p. 338]

GRADUAL, ULB DUSSELDORF, D 11 | 119

25. Christmas: vigil, gradual, ca. 1380.
ULB Dusseldorf, D 11, p. 49 [vol. I, pp. 343–45]

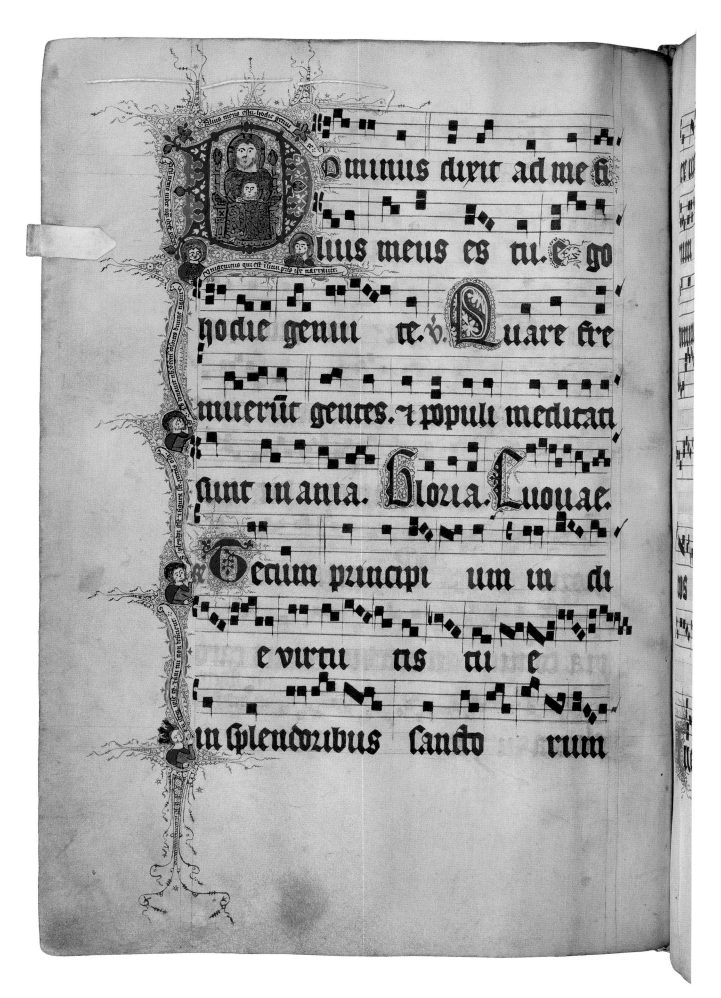

26. Christmas Day: Midnight Mass, gradual, ca. 1380.
ULB Dusseldorf, D 11, p. 53 [vol. I, pp. 345–49]

GRADUAL, ULB DUSSELDORF, D 11 | 121

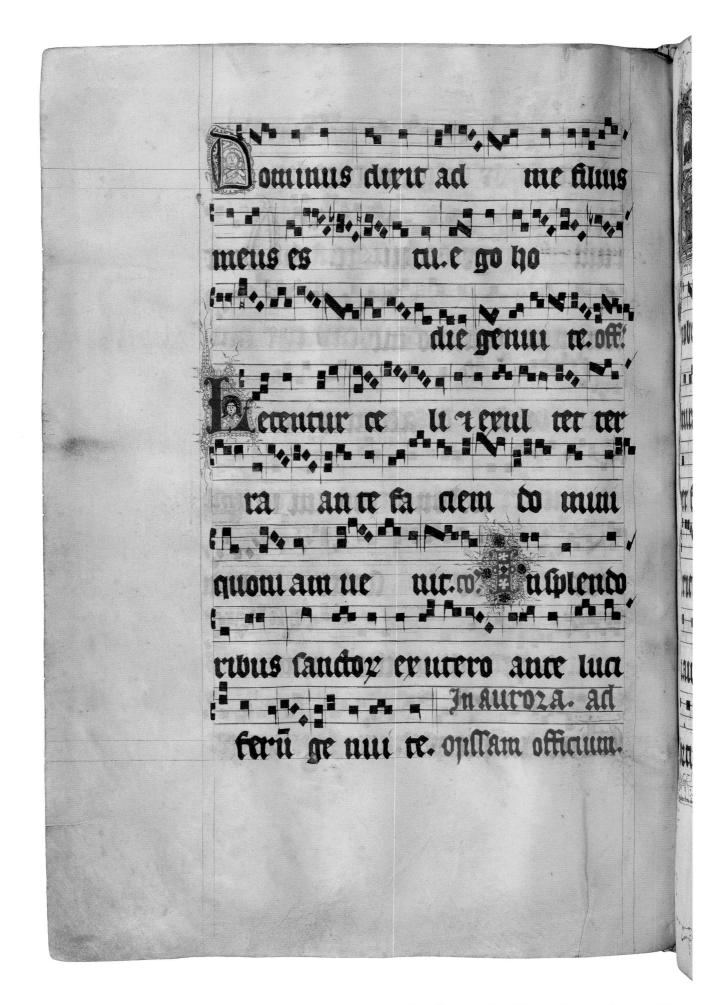

27. Christmas Day: Midnight Mass, gradual, ca. 1380.
ULB Dusseldorf, D 11, p. 55 [vol. I, pp. 175–76, 349]

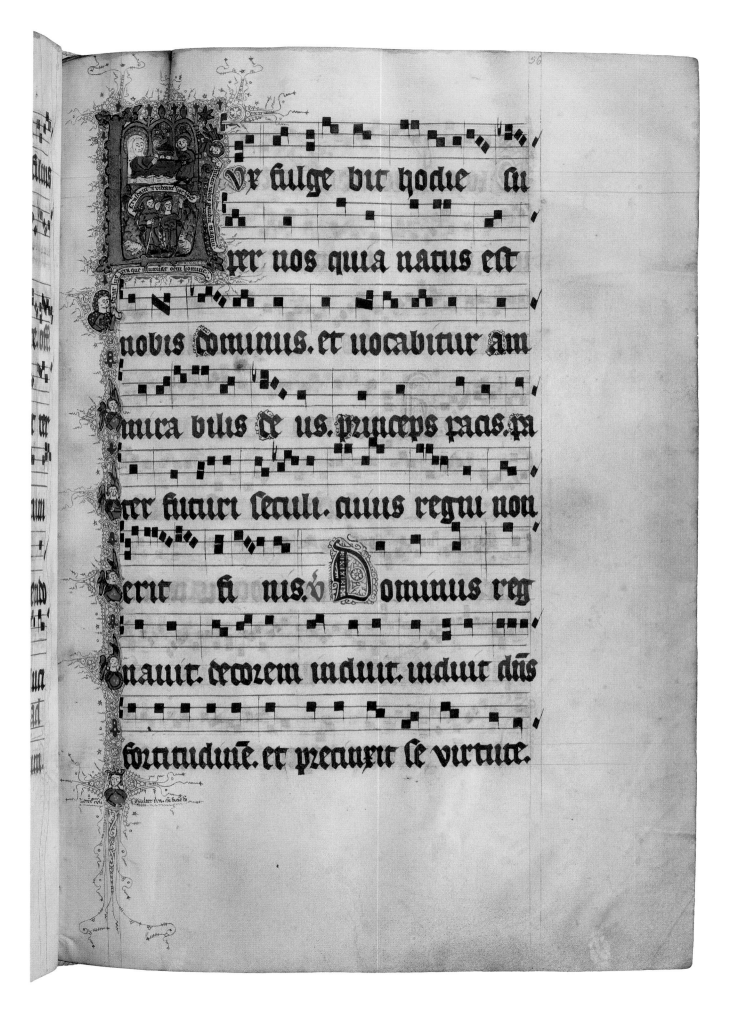

56

Lux fulge bit hodie su per nos quia natus est nobis dominus. et uocabitur am mira bilis de us. princeps paas. pa ter futuri seculi. cuius regni non erit fi nis. Dominus reg nauit. decorem induit. induit dūs fortitudinē. et precinxit se virtute.

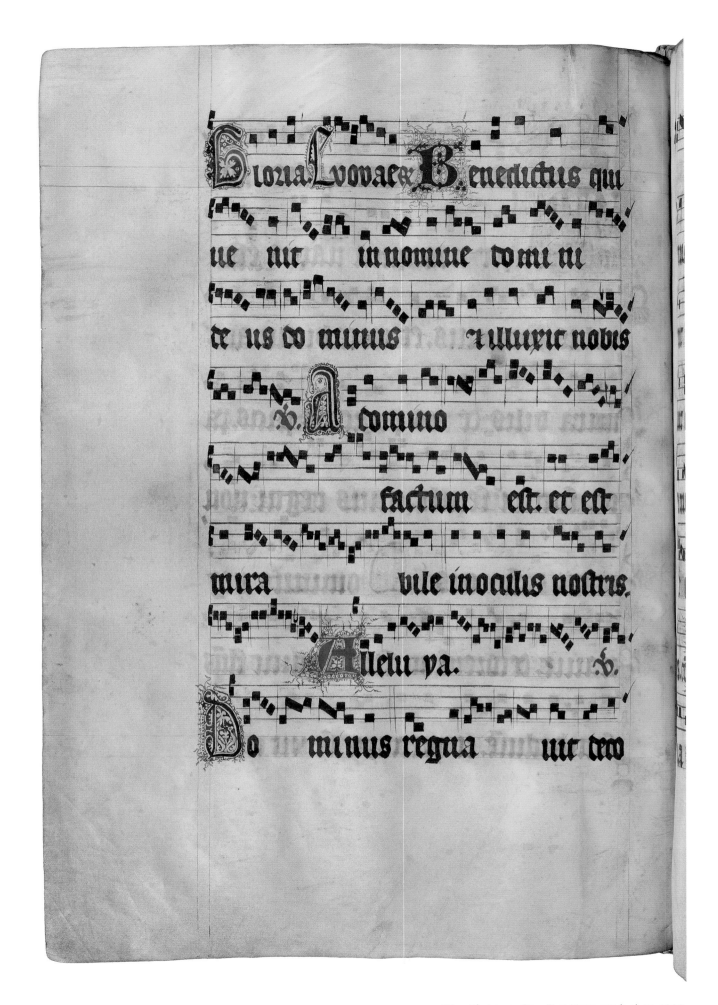

29. Christmas Day: First Mass, gradual, ca. 1380.
ULB Dusseldorf, D 11, p. 57 [vol. I, p. 350]

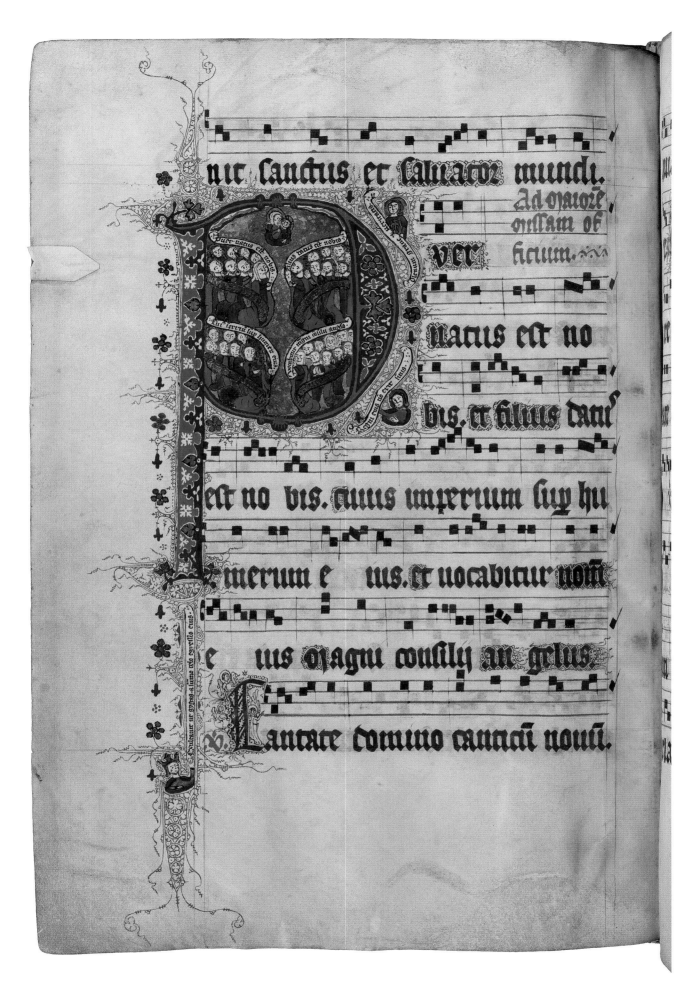

30. Christmas Day: Second Mass, gradual, ca. 1380.
ULB Dusseldorf, D 11, p. 59 [vol. I, pp. 178, 351–57]

GRADUAL, ULB DUSSELDORF, D 11 | 125

31. Christmas Day: Second Mass, gradual, ca. 1380.
ULB Dusseldorf, D 11, p. 60 [vol. I, p. 358]

32. Christmas Day: Second Mass, gradual, ca. 1380.
ULB Dusseldorf, D 11, p. 61 [vol. I, p. 352]

GRADUAL, ULB DUSSELDORF, D 11 | 127

33. Christmas: Sunday within octave, gradual, ca. 1380.
ULB Dusseldorf, D 11, p. 62 [vol. I, p. 361]

34. Christmas: Sunday within octave, gradual, ca. 1380.
ULB Dusseldorf, D 11, p. 64 [vol. I, p. 361]

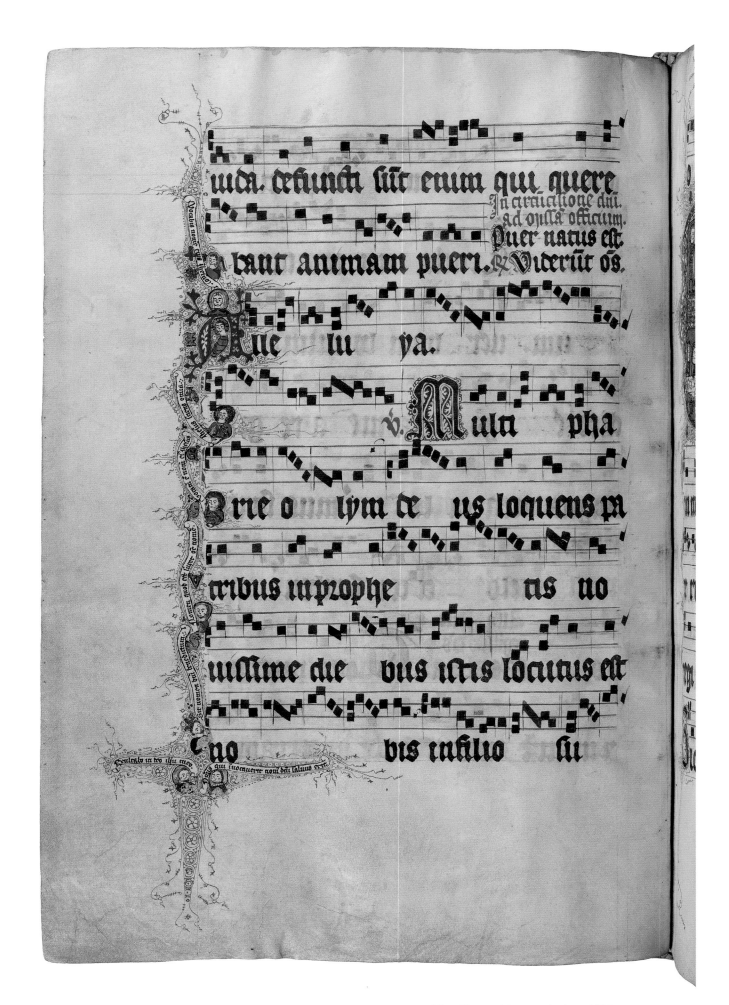

35. Circumcision, gradual, ca. 1380.
ULB Dusseldorf, D 11, p. 65 [vol. I, pp. 362–66]

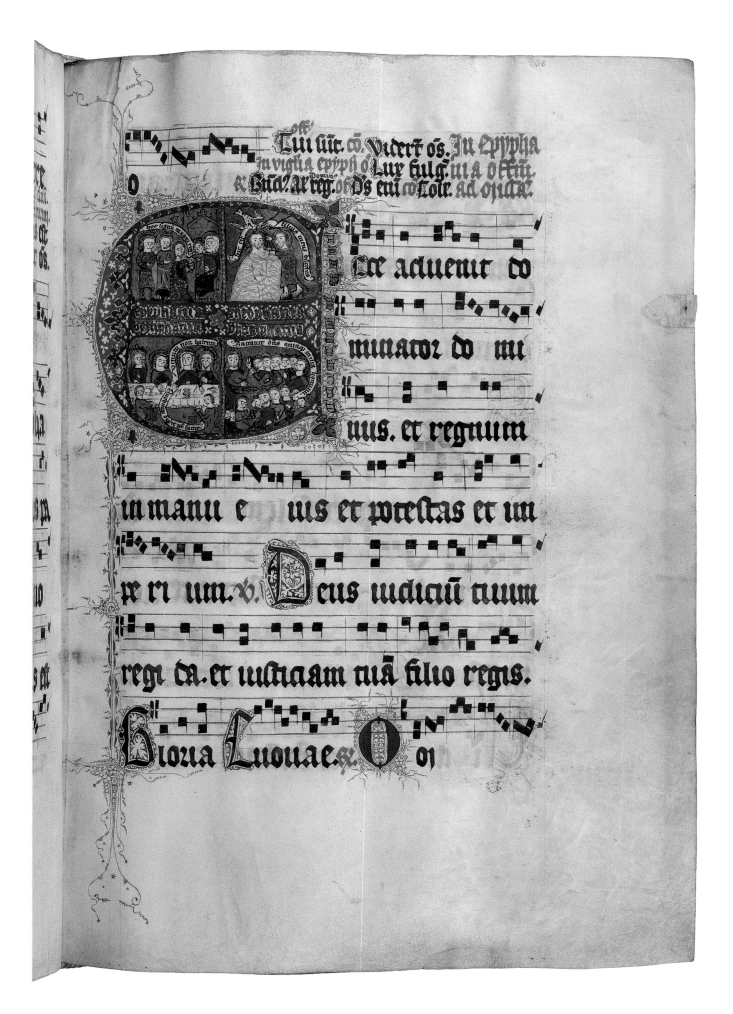

36. Epiphany, gradual, ca. 1380.
ULB Dusseldorf, D 11, p. 66 [vol. I, pp. 366–69]

GRADUAL, ULB DUSSELDORF, D 11 | 131

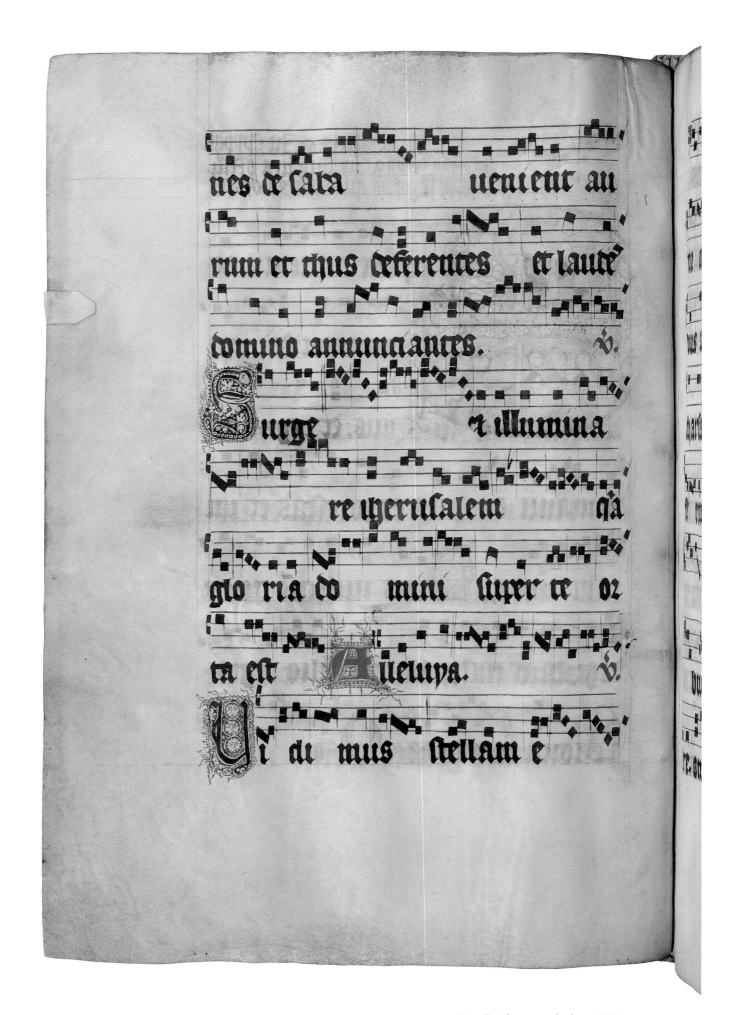

37. Epiphany, gradual, ca. 1380.
ULB Dusseldorf, D 11, p. 67 [vol. I, p. 366]

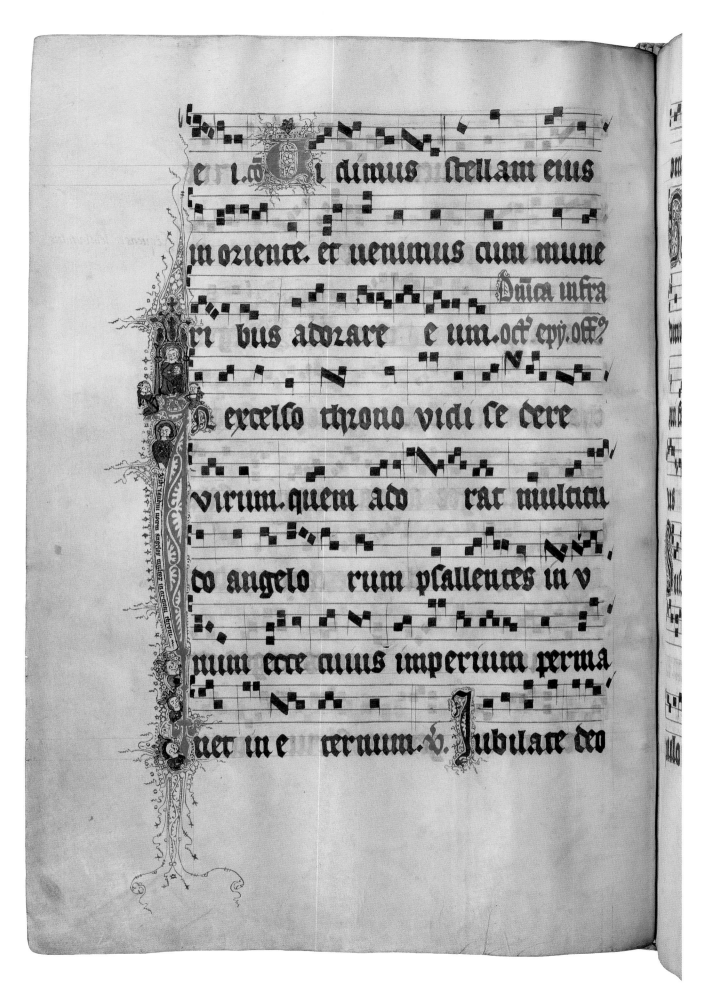

38. Epiphany: Sunday within octave, gradual, ca. 1380.
ULB Dusseldorf, D 11, p. 69 [vol. I, pp. 369–71]

GRADUAL, ULB DUSSELDORF, D 11 | 133

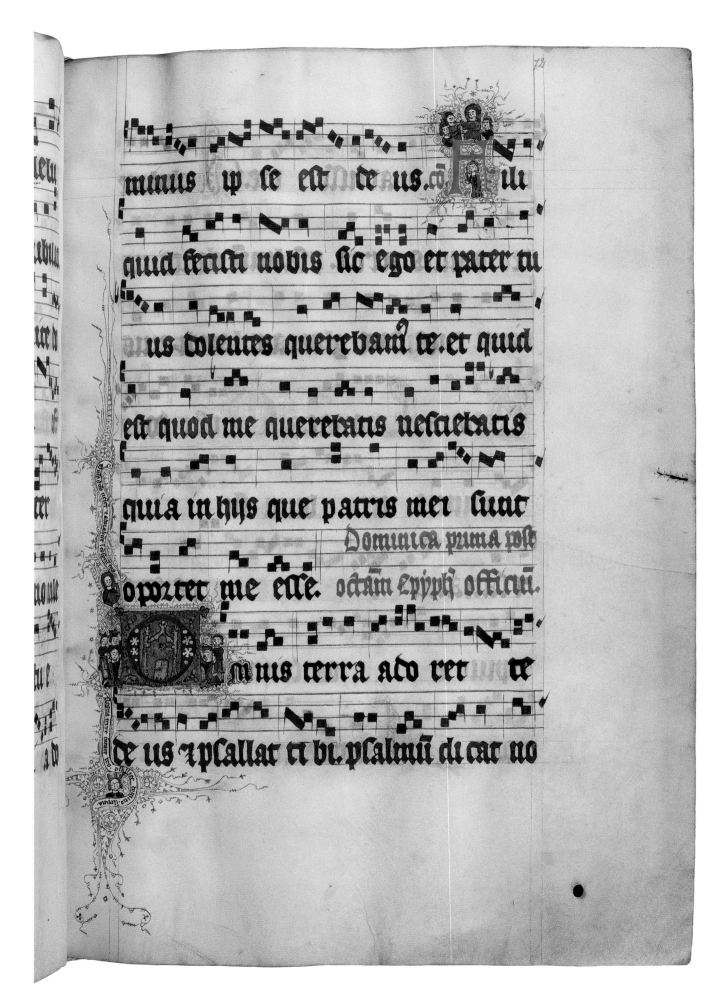

39. Epiphany: first Sunday, gradual, ca. 1380.
ULB Dusseldorf, D 11, p. 72 [vol. I, pp. 371–73, 374]

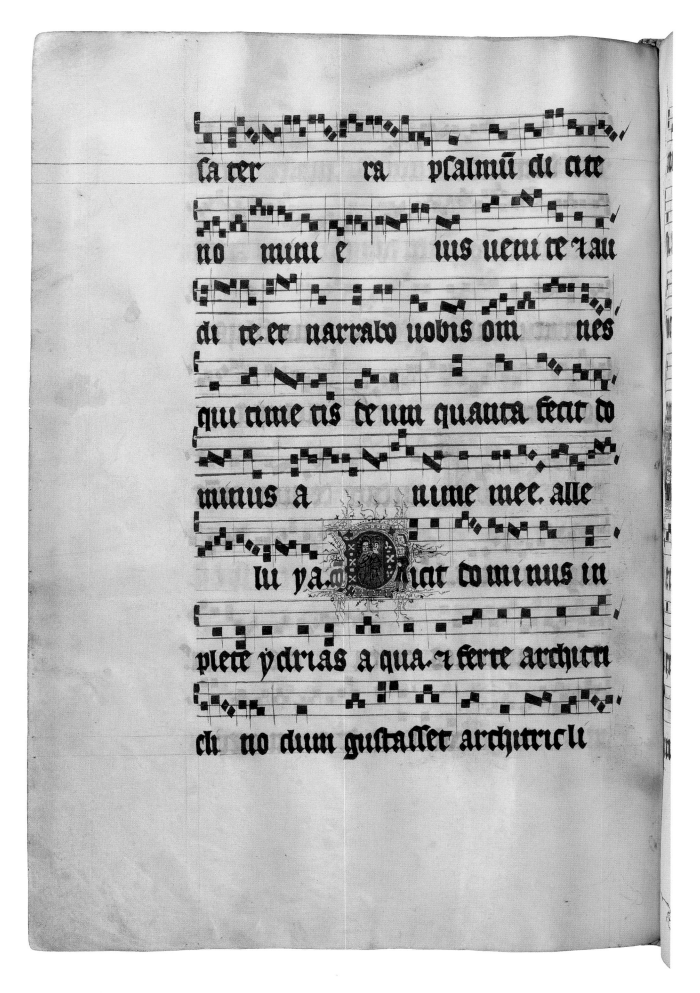

40. Epiphany: first Sunday, gradual, ca. 1380.
ULB Dusseldorf, D 11, p. 75 [vol. I, pp. 372–73]

GRADUAL, ULB DUSSELDORF, D 11 | 135

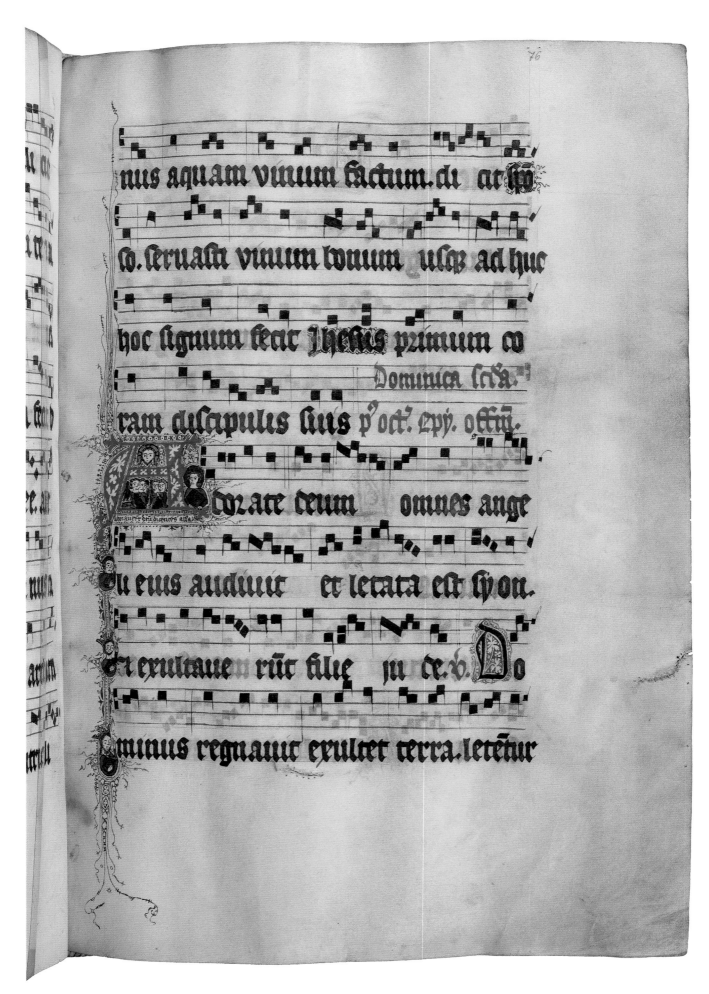

41. Epiphany: second Sunday, gradual, ca. 1380.
ULB Dusseldorf, D 11, p. 76 [vol. I, pp. 373–375]

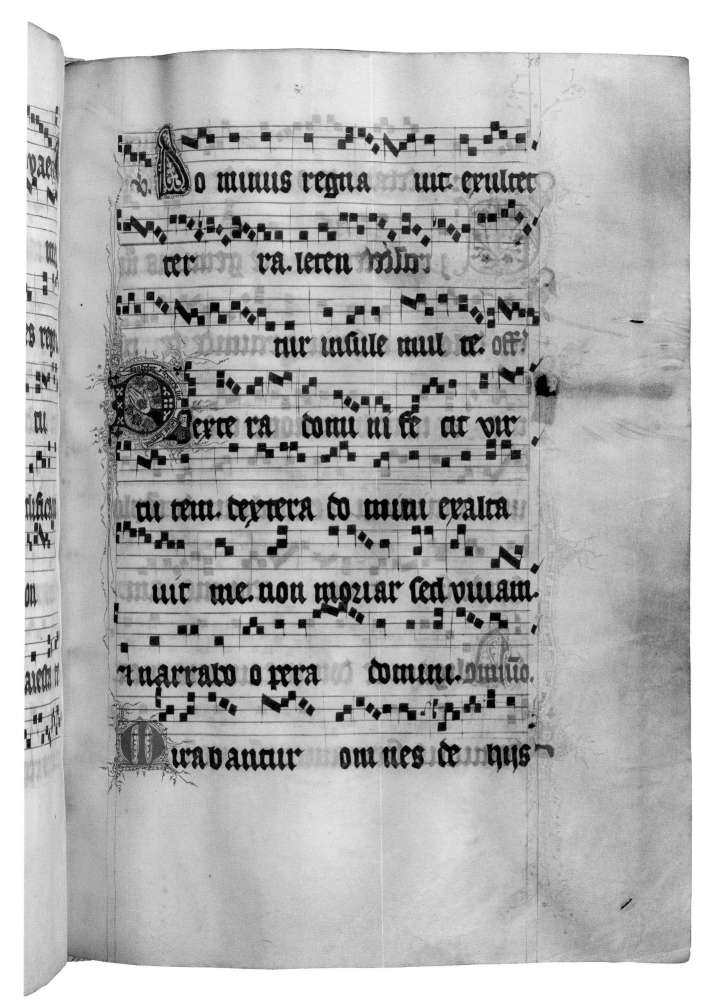

42. Epiphany: second Sunday, gradual, ca. 1380.
ULB Dusseldorf, D 11, p. 78 [vol. I, pp. 374–375]

GRADUAL, ULB DUSSELDORF, D 11 | 137

43. Septuagesima Sunday, gradual, ca. 1380.
ULB Dusseldorf, D 11, p. 79 [vol. I, p. 378]

cia pau perum non peribit in eter
um. exurge domine non preua
leat ho mo. tractus
De profundis clamaui ad te do
mine domine exaudi
uo cem me am. v. Fiant
aures tu e intenden tes
in ora ci onem ser

44. Septuagesima Sunday, gradual, ca. 1380.
ULB Dusseldorf, D 11, p. 81 [vol. I, pp. 381–82]

GRADUAL, ULB DUSSELDORF, D 11 | 139

45. Sunday in Sexagesima, gradual, ca. 1380, gradual,
ca. 1380. ULB Dusseldorf, D 11, p. 83 [vol. I, pp. 382–84]

46. Sunday in Sexagesima, gradual, ca. 1380.
ULB Dusseldorf, D 11, p. 85 [vol. I, p. 384]

GRADUAL, ULB DUSSELDORF, D 11 | 141

47. Sunday in Quinqagesima, gradual, ca. 1380.
ULB Dusseldorf, D 11, p. 87 [vol. I, pp. 385–86]

48. Ash Wednesday, gradual, ca. 1380.
ULB Dusseldorf, D 11, p. 91 [vol. I, pp. 386–87]

49. Ash Wednesday, gradual, ca. 1380.
ULB Dusseldorf, D 11, p. 93 [vol. I, p. 387]

50. Ash Wednesday, gradual, ca. 1380.
ULB Dusseldorf, D 11, p. 95 [vol. I, p. 387]

GRADUAL, ULB DUSSELDORF, D 11 | 145

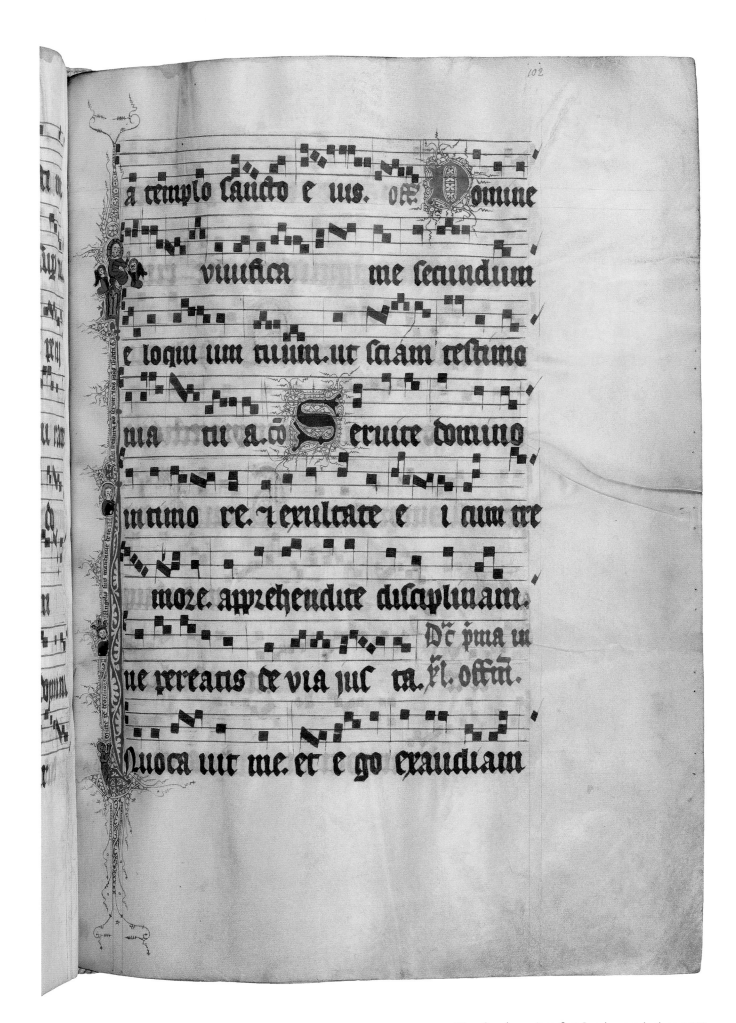

51. Quadragesima: first Sunday, gradual, ca. 1380.
ULB Dusseldorf, D 11, p. 102 [vol. I, pp. 388–89]

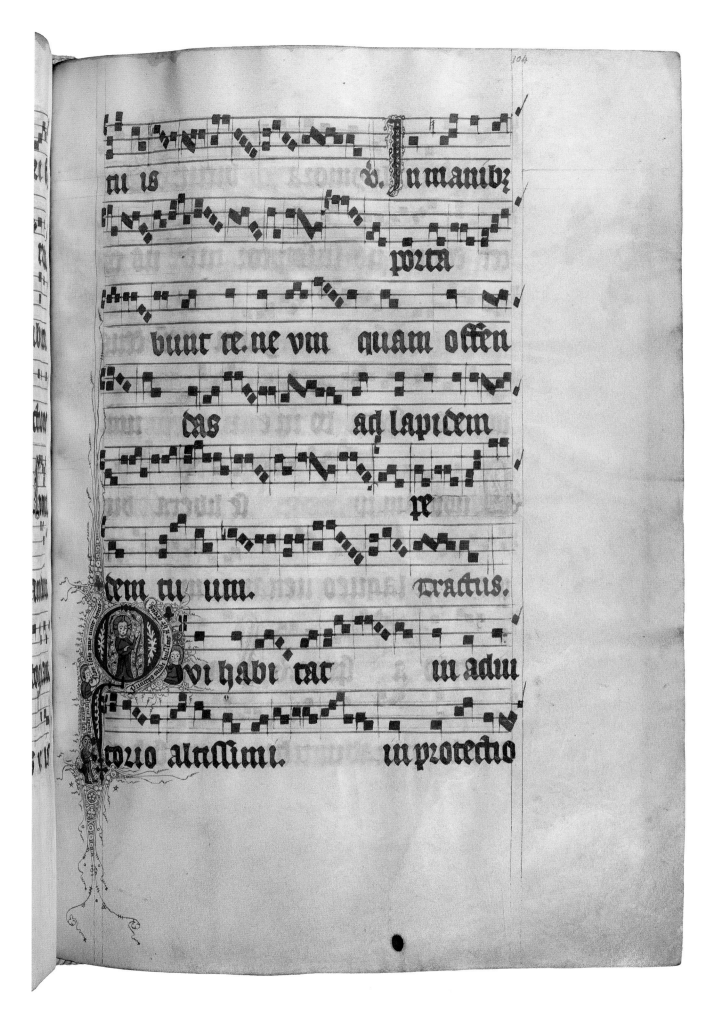

52. Quadragesima: first Sunday, gradual, ca. 1380.
ULB Dusseldorf, D 11, p. 104 [vol. I, p. 389]

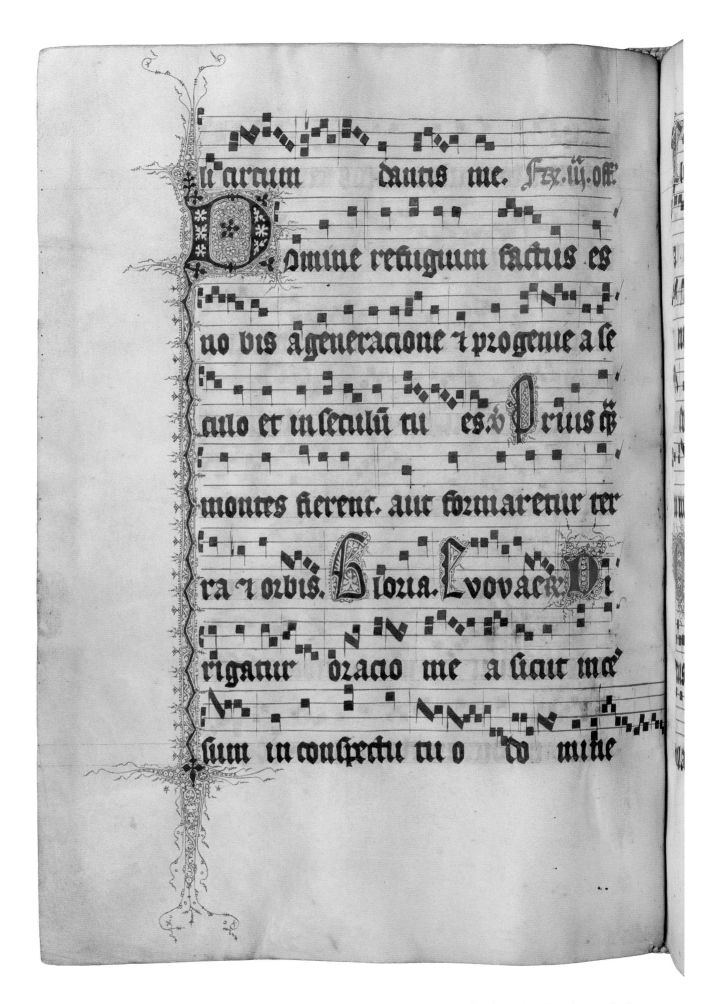

53. Quadragesima: Tuesday, gradual, ca. 1380.
ULB Dusseldorf, D 11, p. 113 [vol. I, p. 390]

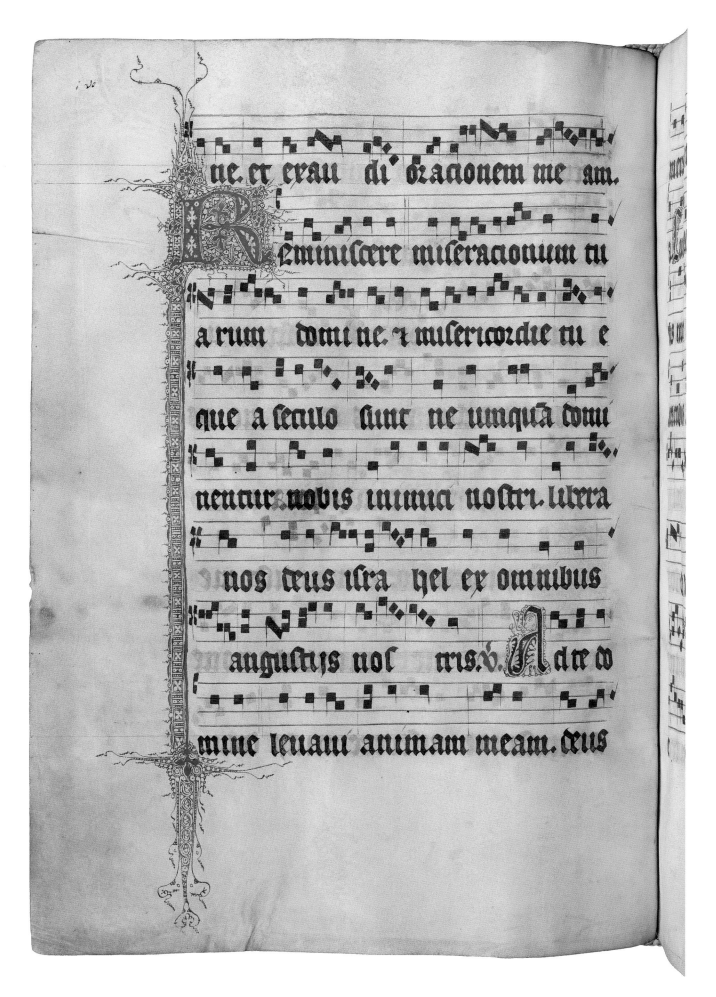

ne. et exau di̅ oracionem me am.

Reminiscere miseracionum tu

arum domi ne. ⁊ misericordie tu e

que a seculo sunt ne unquam domi

nentur nobis inimicia nostra. libera

nos deus israͤ hel ex omnibus

angustijs nos tris. ꝟ. Ad te do

mine leuaui animam meam. deus

54. Quadragesima: Wednesday, gradual, ca. 1380.
ULB Dusseldorf, D 11, p. 115 [vol. I, p. 390]

GRADUAL, ULB DUSSELDORF, D 11 | 149

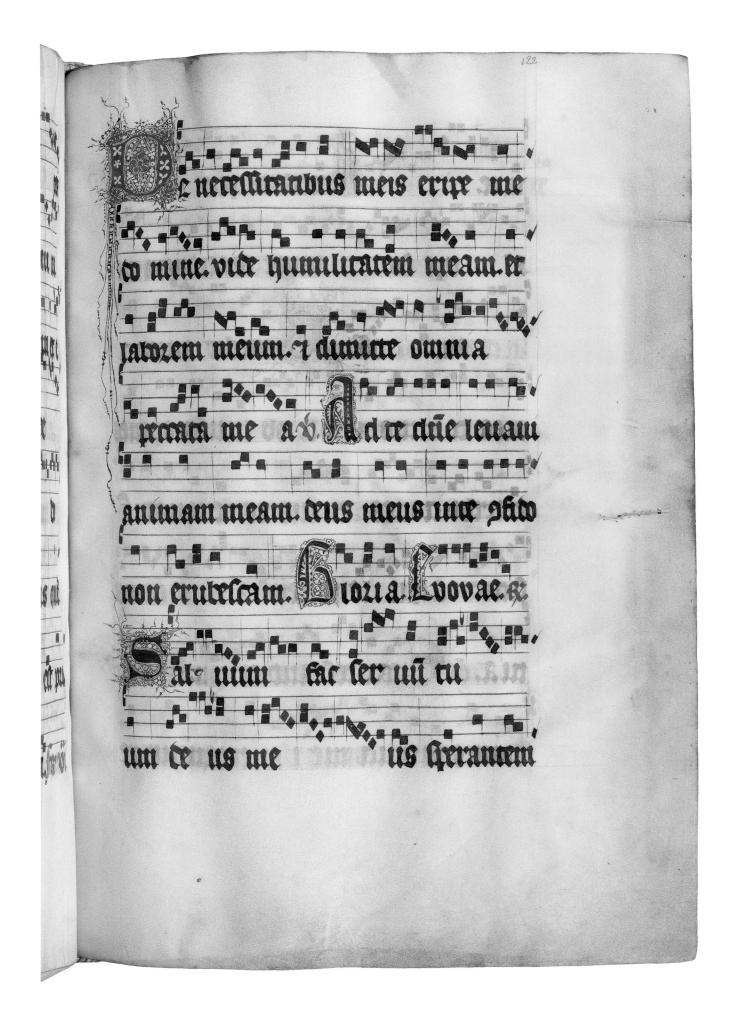

55. Quadragesima: Friday, gradual, ca. 1380.
ULB Dusseldorf, D 11, p. 122 [vol. I, p. 391]

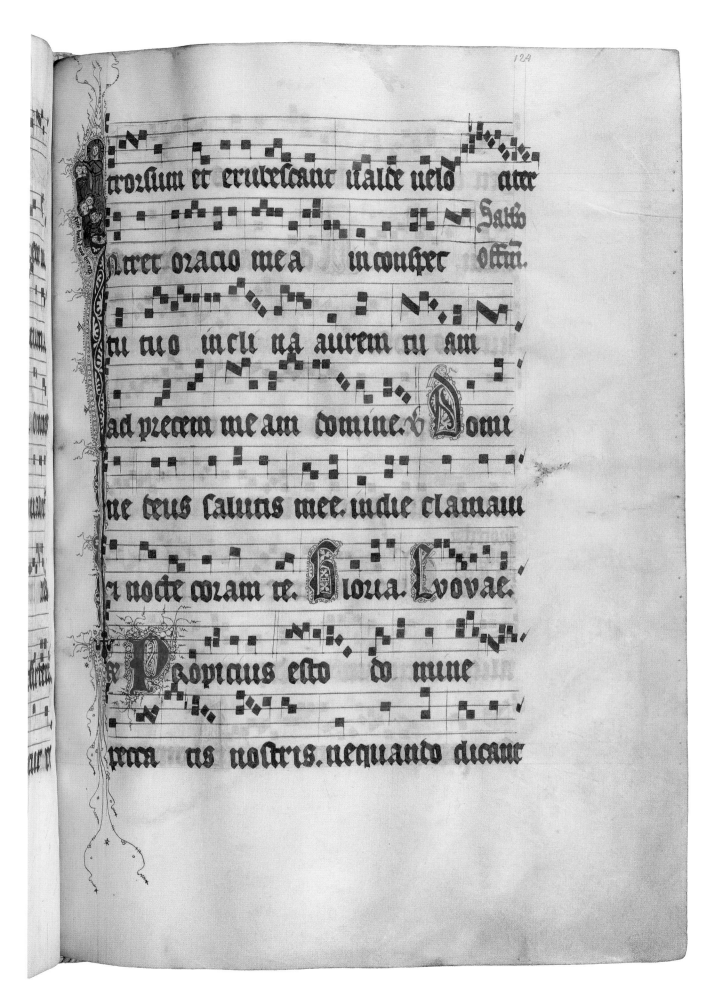

56. Quadragesima: first Sunday, gradual, ca. 1380.
ULB Dusseldorf, D 11, p. 124 [vol. I, p. 391]

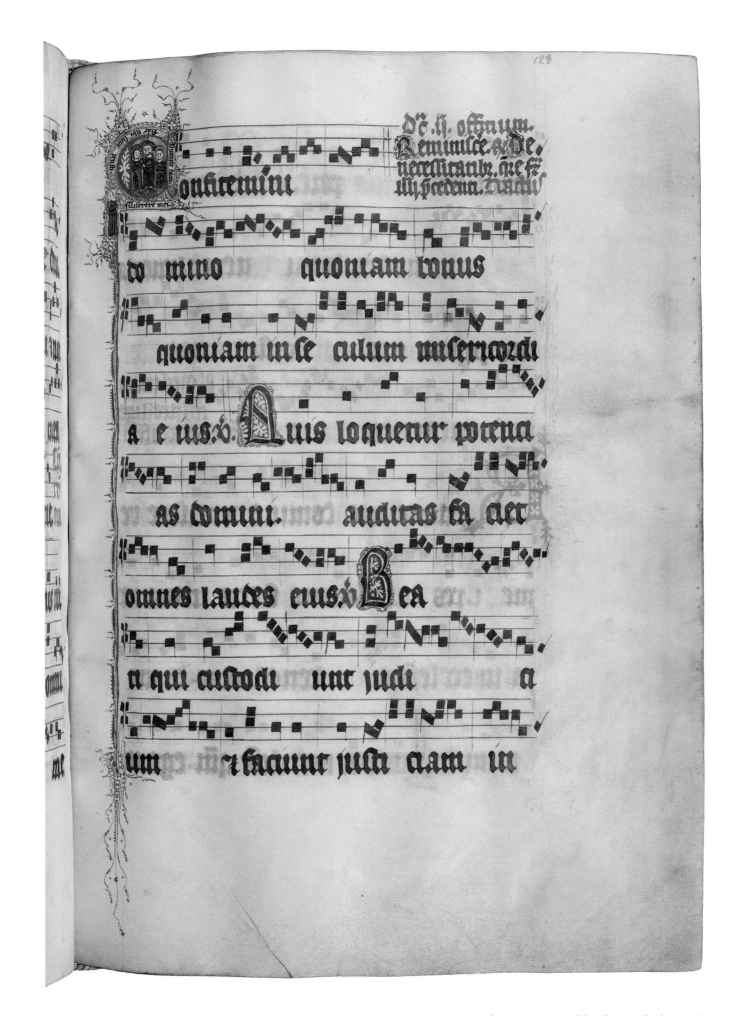

57. Quadragesima: second Sunday, gradual, ca. 1380.
ULB Dusseldorf, D 11, p. 128 [vol. I, p. 392]

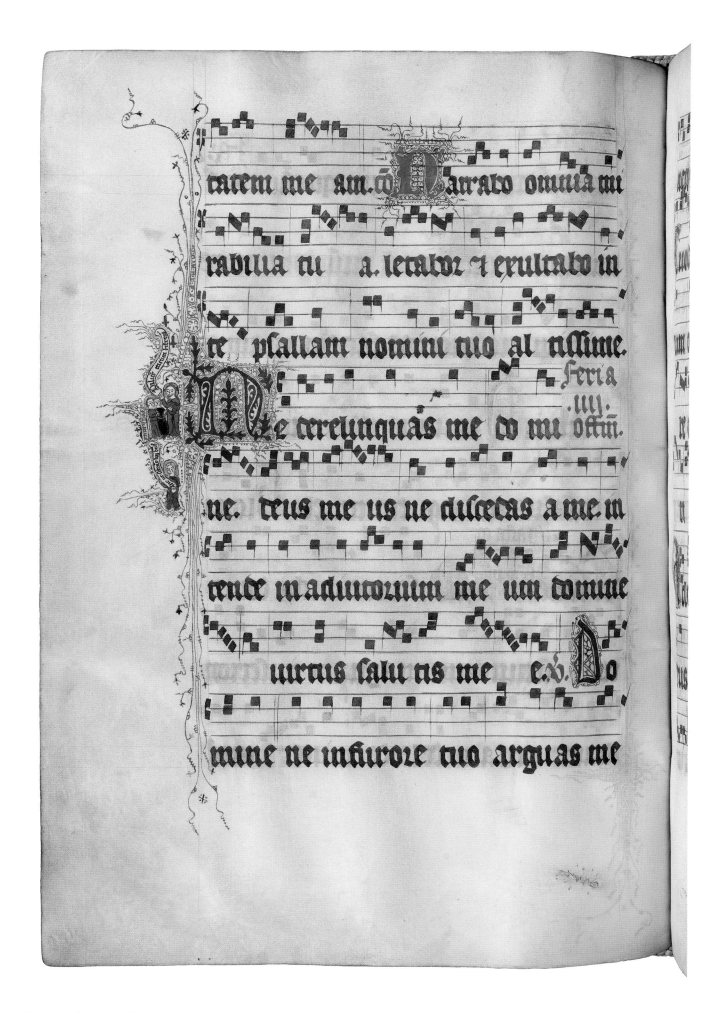

58. Quadragesima: Wednesday of the second week, gradual,
ca. 1380. ULB Dusseldorf, D 11, p. 133 [vol. I, pp. 393]

GRADUAL, ULB DUSSELDORF, D 11 | 153

59. Quadragesima: third Sunday, gradual, ca. 1380.
ULB Dusseldorf, D 11, p. 142 [vol. I, p. 394]

60. Quadragesima: Friday of the third week, gradual,
ca. 1380. ULB Dusseldorf, D 11, p. 157 [vol. I, pp. 395–96]

GRADUAL, ULB DUSSELDORF, D 11 | 155

61. Quadragesima: Saturday of the third week, gradual, ca. 1380. ULB Dusseldorf, D 11, p. 159 [vol. I, p. 396]

62. Quadragesima: Fourth Sunday, gradual, ca. 1380.
ULB Dusseldorf, D 11, p. 161 [vol. I, pp. 397–98]

63. Quadragesima: Monday of the fourth week, gradual, ca. 1380. ULB Dusseldorf, D 11, p. 165 [vol. I, pp. 398–99]

64. Quadragesima: Wednesday of the fourth week, gradual,
ca. 1380. ULB Dusseldorf, D 11, p. 170 [vol. I, p. 400]

GRADUAL, ULB DUSSELDORF, D 11 | 159

65. Quadragesima: Friday of the fourth week, gradual, ca. 1380. ULB Dusseldorf, D 11, p. 176 [vol. I, p. 400]

66. Passiontide: Sunday, gradual, ca. 1380.
ULB Dusseldorf, D 11, p. 182 [vol. I, p. 405]

GRADUAL, ULB DUSSELDORF, D 11 | 161

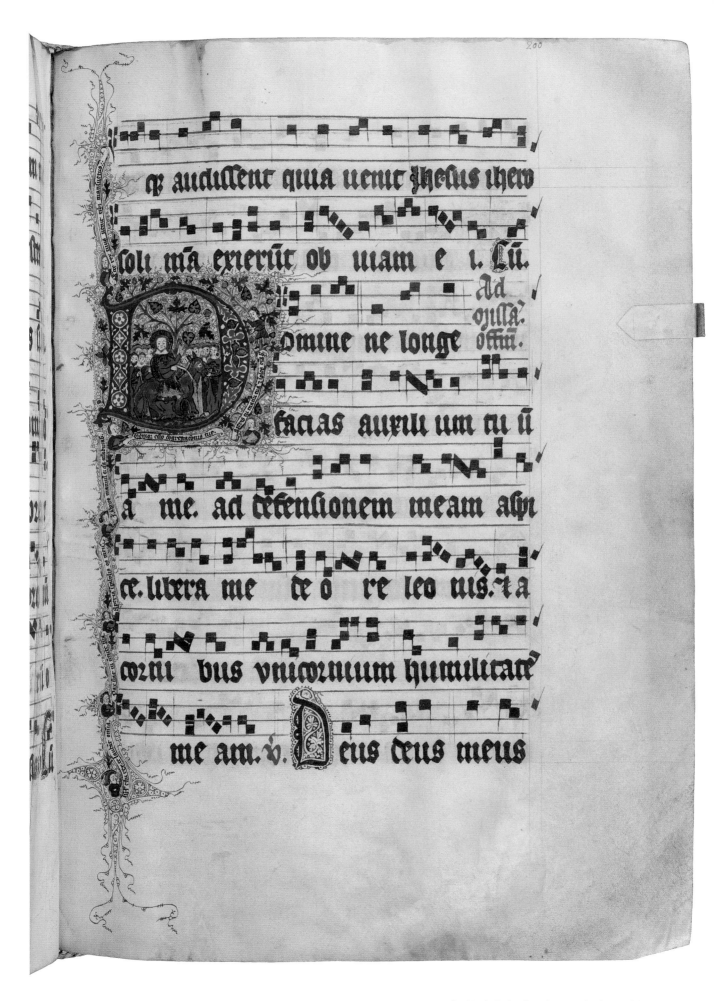

67. Holy Week: Palm Sunday, gradual, ca. 1380.
ULB Dusseldorf, D 11, p. 200 [vol. I, pp. 407–408, 629]

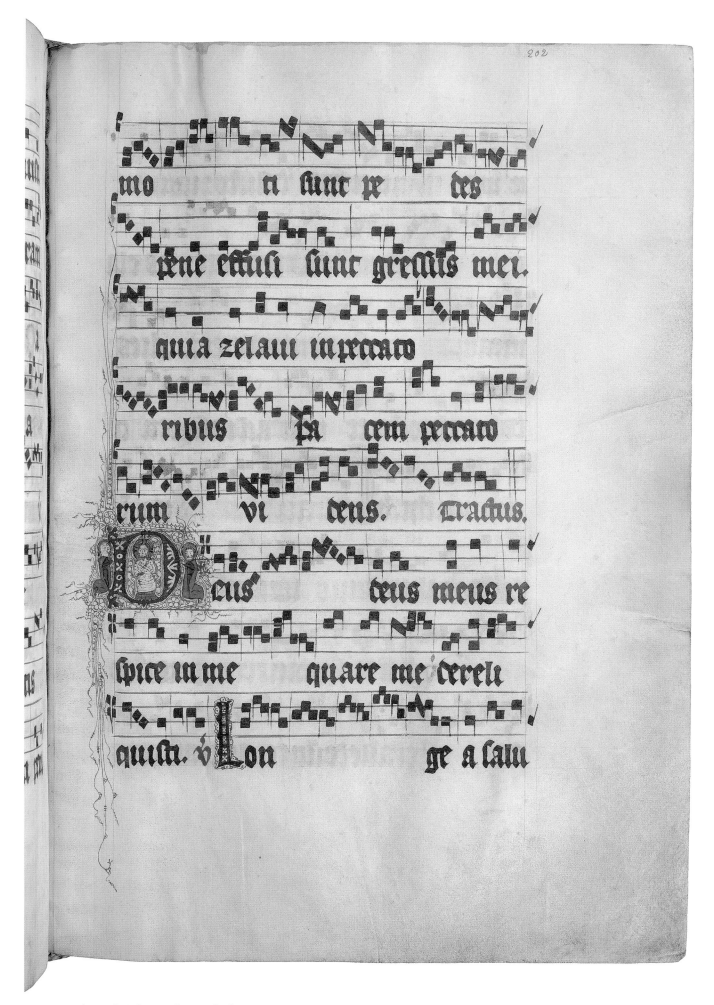

68. Holy Week: Palm Sunday, gradual, ca. 1380.
ULB Dusseldorf, D 11, p. 202 [vol. I, pp. 409, 590]

GRADUAL, ULB DUSSELDORF, D 11 | 163

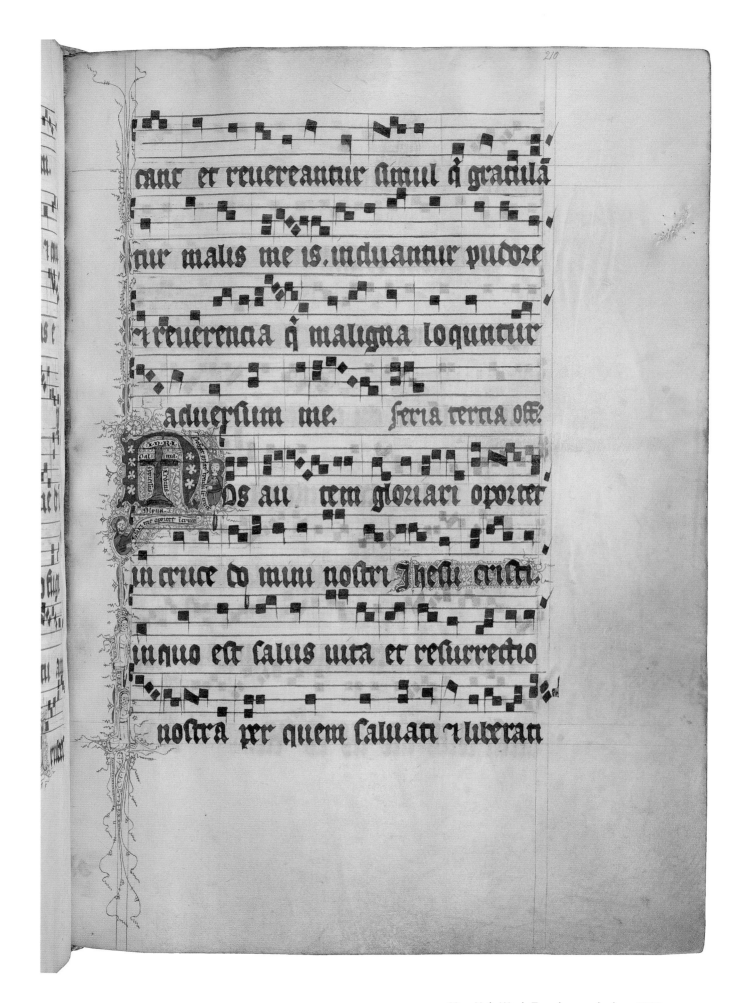

69. Holy Week: Tuesday, gradual, ca. 1380.
ULB Dusseldorf, D 11, p. 210 [vol. I, pp. 410–411]

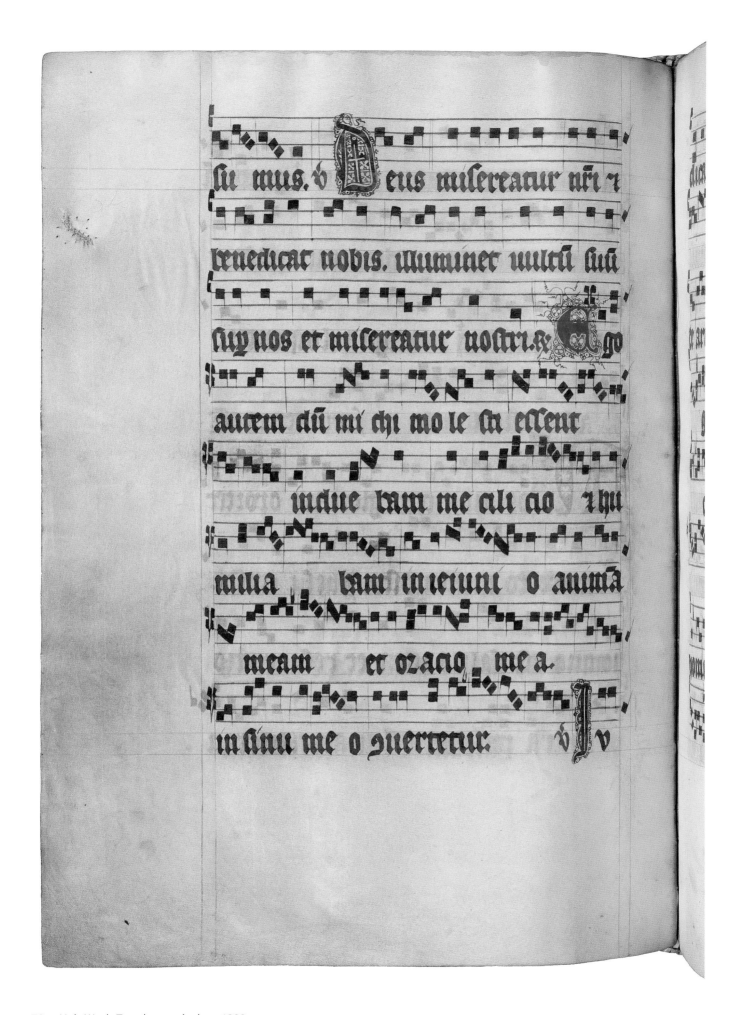

70. Holy Week: Tuesday, gradual, ca. 1380.
ULB Dusseldorf, D 11, p. 211 [vol. I, p. 412]

GRADUAL, ULB DUSSELDORF, D 11 | 165

71. Holy Week: Wednesday, gradual, ca. 1380.
ULB Dusseldorf, D 11, p. 213 [vol. I, pp. 165, 412–13]

72. Holy Week: Wednesday, gradual, ca. 1380.
ULB Dusseldorf, D 11, p. 214 [vol. I, p. 412]

GRADUAL, ULB DUSSELDORF, D 11 | 167

73. Holy Week: Wednesday, gradual, ca. 1380.
ULB Dusseldorf, D 11, p. 215 [vol. I, pp. 413–15]

74. Holy Week: Maundy Thursday, gradual, ca. 1380.
ULB Dusseldorf, D 11, p. 218 [vol. I, p. 417]

GRADUAL, ULB DUSSELDORF, D 11 | 169

75. Holy Week: Maundy Thursday, gradual, ca. 1380.
ULB Dusseldorf, D 11, p. 219 [vol. I, pp. 417–18]

76. Holy Week: Maundy Thursday, gradual, ca. 1380.
ULB Dusseldorf, D 11, p. 221 [vol. I, p. 418]

GRADUAL, ULB DUSSELDORF, D 11 | 171

77. Holy Week: Good Friday, gradual, ca. 1380.
ULB Dusseldorf, D 11, p. 222 [vol. I, pp. 418–19, 591–92]

78. Holy Week: Good Friday, gradual, ca. 1380.
ULB Dusseldorf, D 11, p. 223 [vol. I, p. 420]

GRADUAL, ULB DUSSELDORF, D 11 | 173

79. Holy Week: Good Friday, gradual, ca. 1380.
ULB Dusseldorf, D 11, p. 224 [vol. I, pp. 420–23]

80. Holy Week: Good Friday, gradual, ca. 1380.
ULB Dusseldorf, D 11, p. 225 [vol. I, p. 423]

GRADUAL, ULB DUSSELDORF, D 11 | 175

81. Holy Week: Good Friday, gradual, ca. 1380.
ULB Dusseldorf, D 11, p. 226 [vol. I, p. 423]

82. Holy Week: Good Friday, gradual, ca. 1380.
ULB Dusseldorf, D 11, p. 227 [vol. I, p. 423]

GRADUAL, ULB DUSSELDORF, D 11 | 177

83. Holy Week: Good Friday, gradual, ca. 1380.
ULB Dusseldorf, D 11, p. 230 [vol. I, pp. 423–24]

sam recolimus passionem. miserere
nostri qui passus es pro nobis. a Cru-
cem adoramus domine. et sanctam resur-
rectionem tuam laudamus et glorifica-
mus. ecce enim propter crucem venit
gaudium in universo mundo. a Ad-
oremus crucis signaculum per quod
salutis sumpsimus sacramentum. ps.

84. Holy Week: Good Friday, gradual, ca. 1380.
 ULB Dusseldorf, D 11, p. 231 [vol. I, pp. 423–24]

GRADUAL, ULB DUSSELDORF, D 11 | 179

85. Holy Week: Good Friday, gradual, ca. 1380.
ULB Dusseldorf, D 11, p. 232 [vol. I, pp. 424–25]

86. Holy Week: Holy Saturday, gradual, ca. 1380.
ULB Dusseldorf, D 11, p. 237 [vol. I, pp. 427–28]

GRADUAL, ULB DUSSELDORF, D 11 | 181

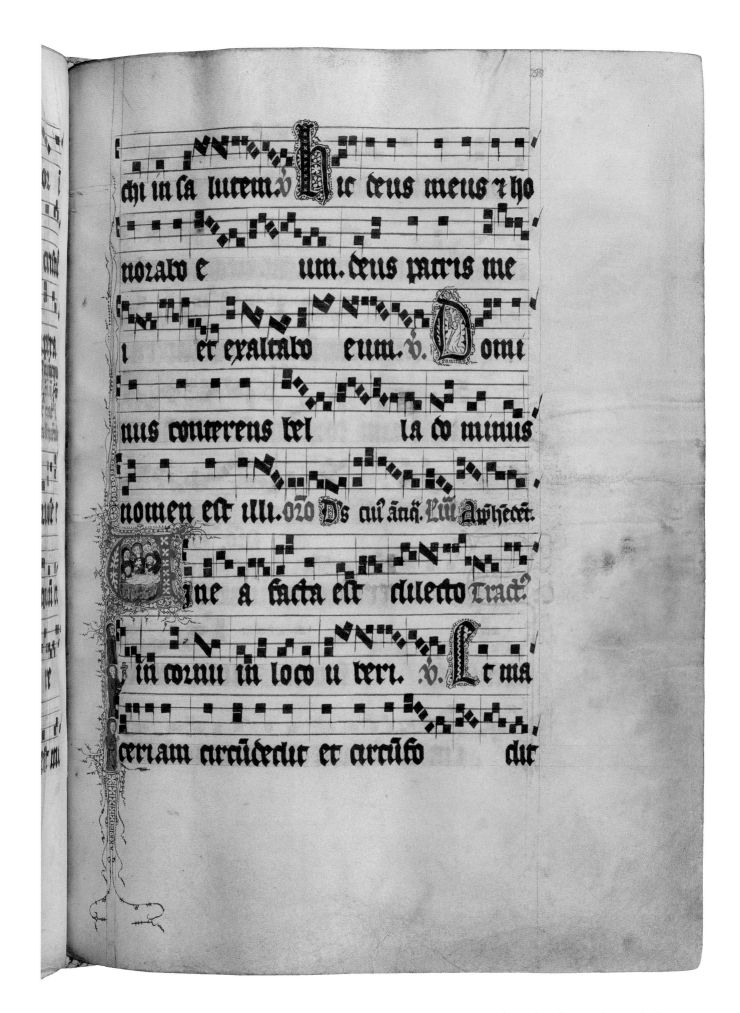

87. Holy Week: Holy Saturday, gradual, ca. 1380.
ULB Dusseldorf, D 11, p. 238 [vol. I, p. 428]

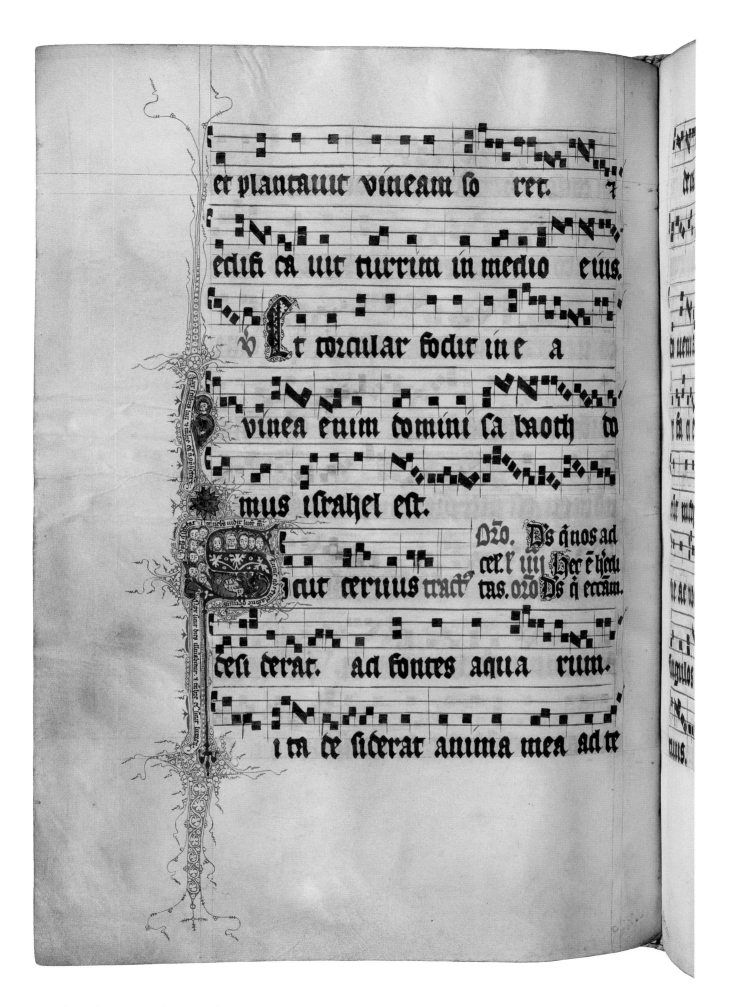

88. Holy Week: Holy Saturday, gradual, ca. 1380.
ULB Dusseldorf, D 11, p. 239 [vol. I, p. 428]

GRADUAL, ULB DUSSELDORF, D 11 | 183

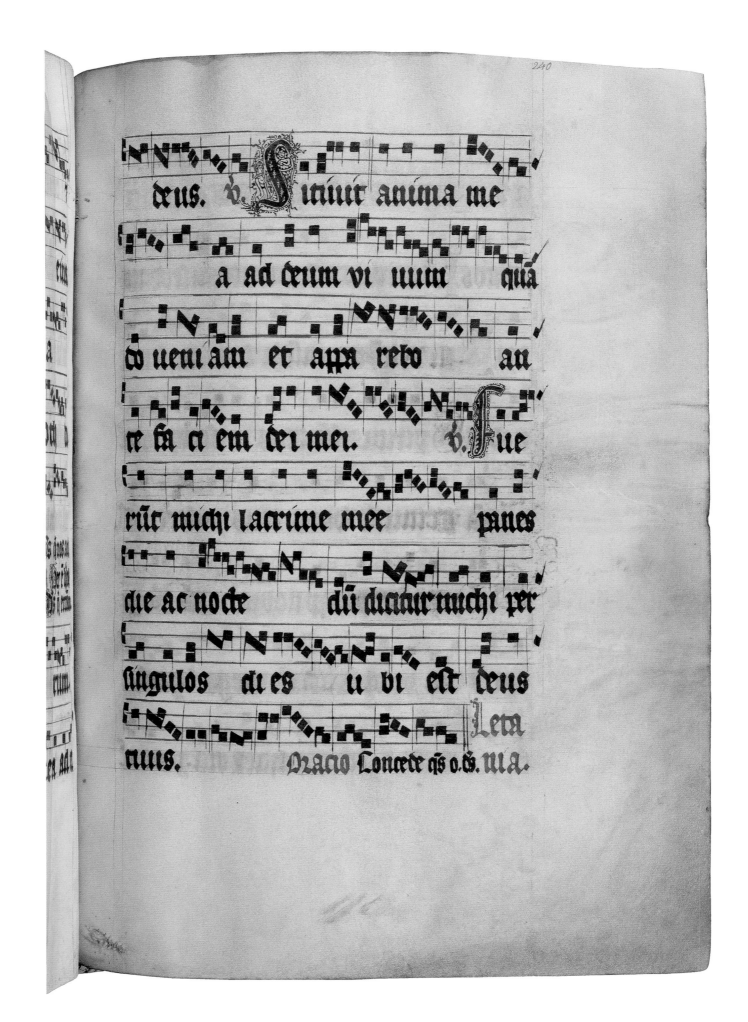

89. Holy Week: Holy Saturday, gradual, ca. 1380.
ULB Dusseldorf, D 11, p. 240 [vol. I, p. 428]

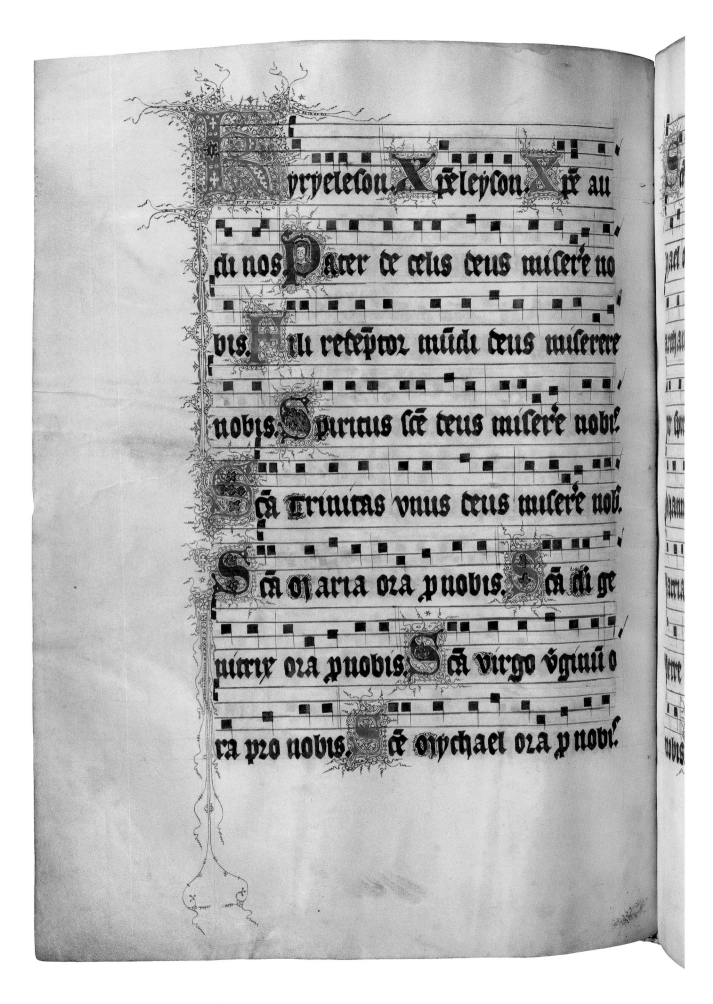

90. Holy Week: Holy Saturday, gradual, ca. 1380.
ULB Dusseldorf, D 11, p. 241 [vol. I, p. 428]

GRADUAL, ULB DUSSELDORF, D 11 | 185

91. Holy Week: Holy Saturday, gradual, ca. 1380.
ULB Dusseldorf, D 11, p. 243 [vol. I, p. 428]

92. Holy Week: Holy Saturday, gradual, ca. 1380.
ULB Dusseldorf, D 11, p. 255 [vol. I, pp. 428–29]

93. Holy Week: Holy Saturday, gradual, ca. 1380.
ULB Dusseldorf, D 11, p. 256 [vol. I, pp. 431, 590]

94. Holy Week: Holy Saturday, gradual, ca. 1380.
ULB Dusseldorf, D 11, p. 257 [vol. I, pp. 431–33]

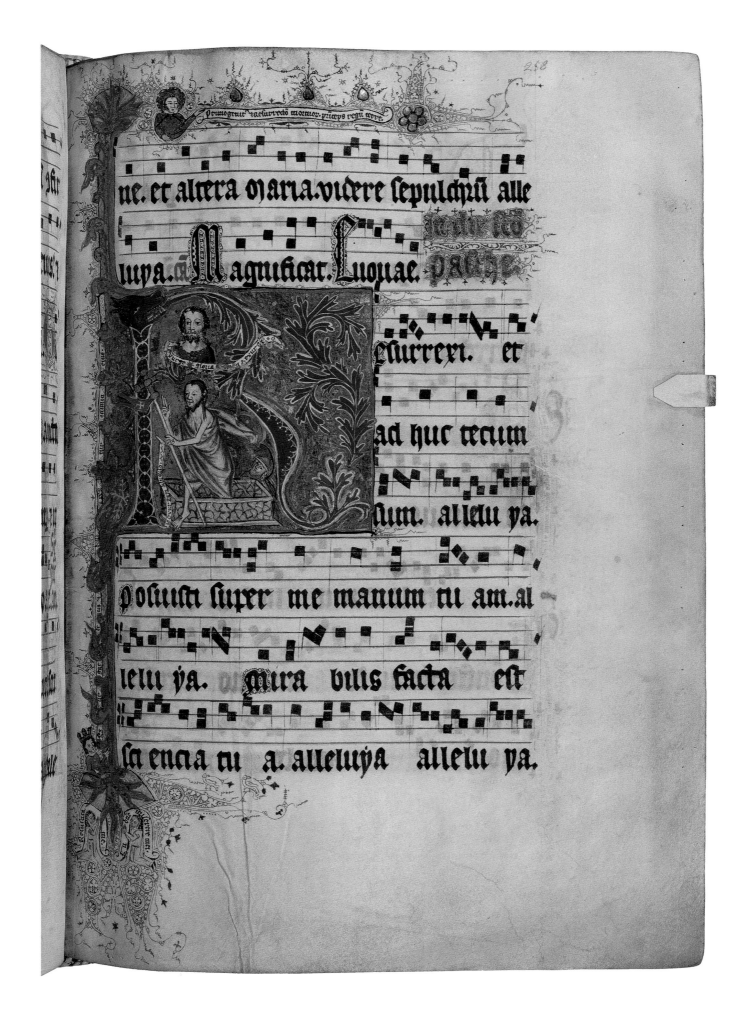

95. Easter Sunday, gradual, ca. 1380. ULB Dusseldorf, D 11, p. 258 [vol. I, pp. 178, 181–84, 235–36, 436–37]

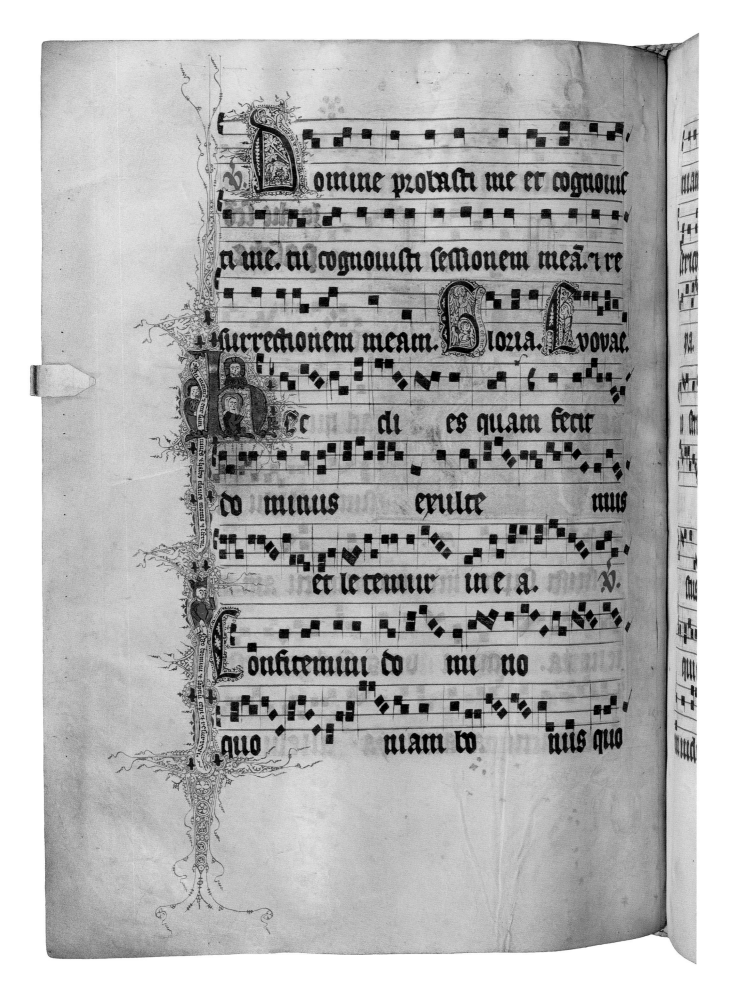

96. Easter Sunday, gradual, ca. 1380.
ULB Dusseldorf, D 11, p. 259 [vol. I, pp. 437–38]

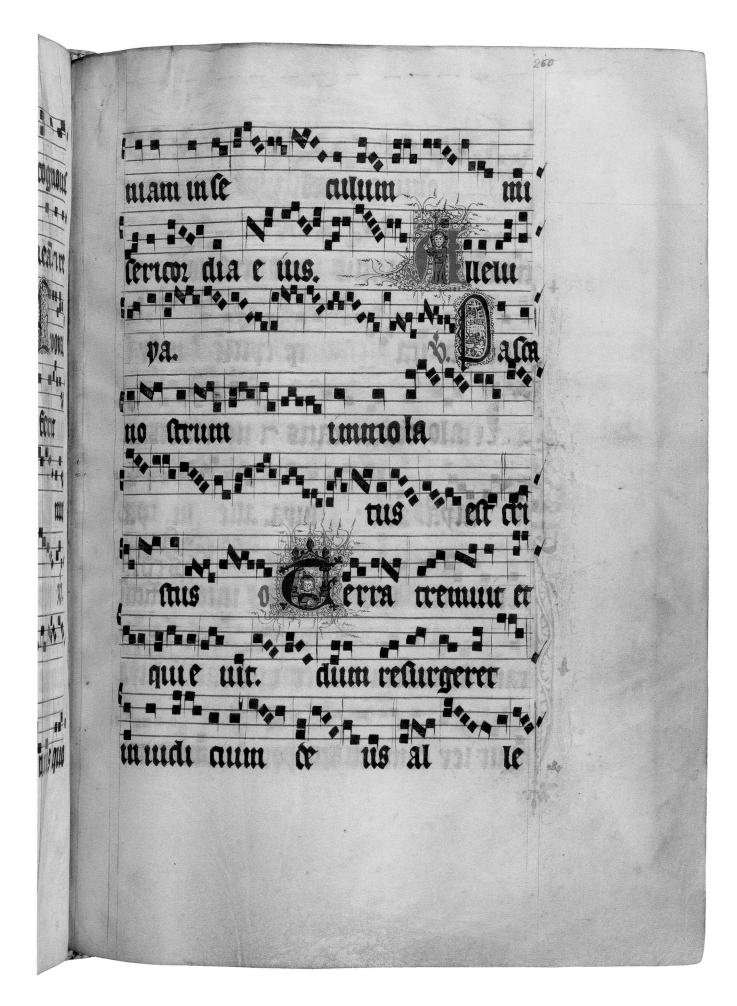

97. Easter Sunday, gradual, ca. 1380.
ULB Dusseldorf, D 11, p. 260 [vol. I, pp. 438–39]

98. Easter Sunday; Easter Monday, gradual, ca. 1380.
ULB Dusseldorf, D 11, p. 261 [vol. I, pp. 439, 441–42]

GRADUAL, ULB DUSSELDORF, D 11 | 193

99. Easter Monday, gradual, ca. 1380.
ULB Dusseldorf, D 11, p. 262 [vol. I, p. 441]

100. Easter Monday, gradual, ca. 1380.
ULB Dusseldorf, D 11, p. 263 [vol. I, pp. 442–443]

101. Easter Monday; Easter Tuesday, gradual, ca. 1380.
ULB Dusseldorf, D 11, p. 264 [vol. I, p. 443]

102. Easter Tuesday, gradual, ca. 1380, gradual, ca. 1380.
ULB Dusseldorf, D 11, p. 265 [vol. I, p. 444]

GRADUAL, ULB DUSSELDORF, D 11 | 197

103. Easter Wednesday, gradual, ca. 1380.
ULB Dusseldorf, D 11, p. 267 [vol. I, pp. 444-45]

104. Easter Wednesday, gradual, ca. 1380.
ULB Dusseldorf, D 11, p. 268 [vol. I, p. 445]

GRADUAL, ULB DUSSELDORF, D 11 | 199

105. Easter Thursday, gradual, ca. 1380.
ULB Dusseldorf, D 11, p. 270 [vol. I, pp. 445–46]

106. Easter Thursday, gradual, ca. 1380.
ULB Dusseldorf, D 11, p. 271 [vol. I, p. 446]

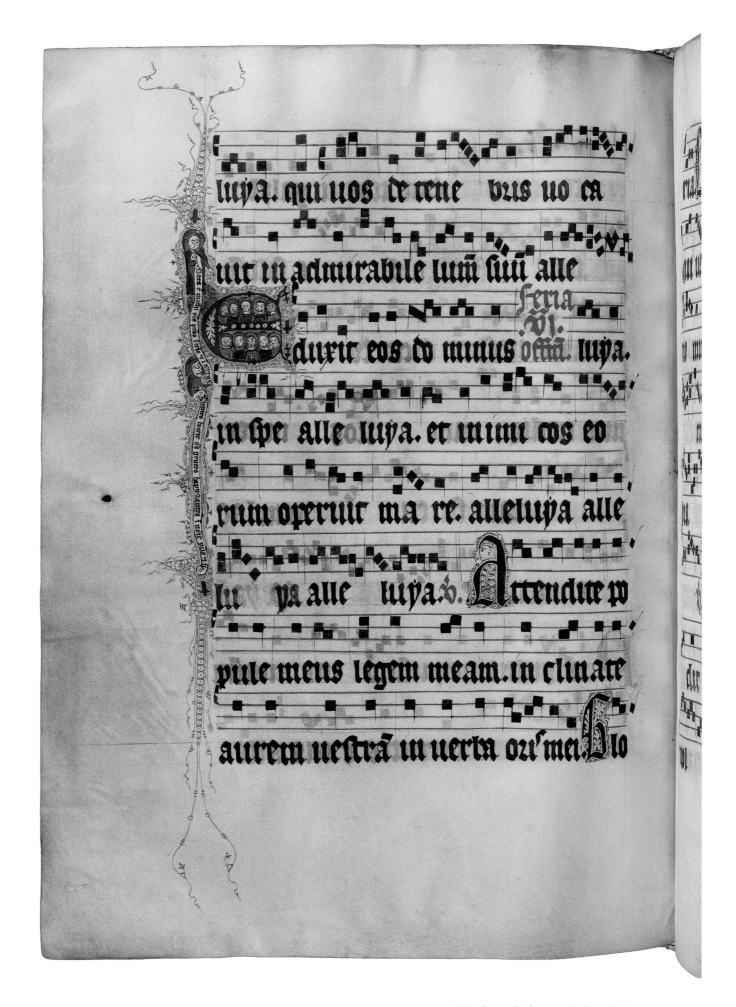

107. Easter Friday, gradual, ca. 1380.
ULB Dusseldorf, D 11, p. 273 [vol. I, p. 447]

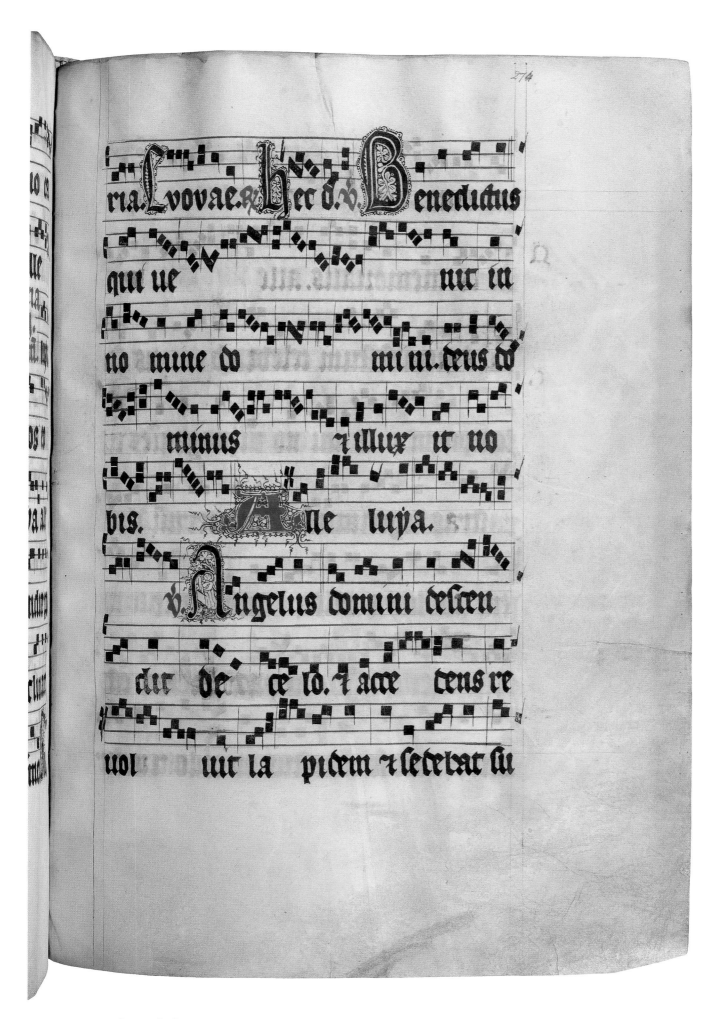

108. Easter Friday, gradual, ca. 1380.
ULB Dusseldorf, D 11, p. 274 [vol. I, p. 447]

GRADUAL, ULB DUSSELDORF, D 11 | 203

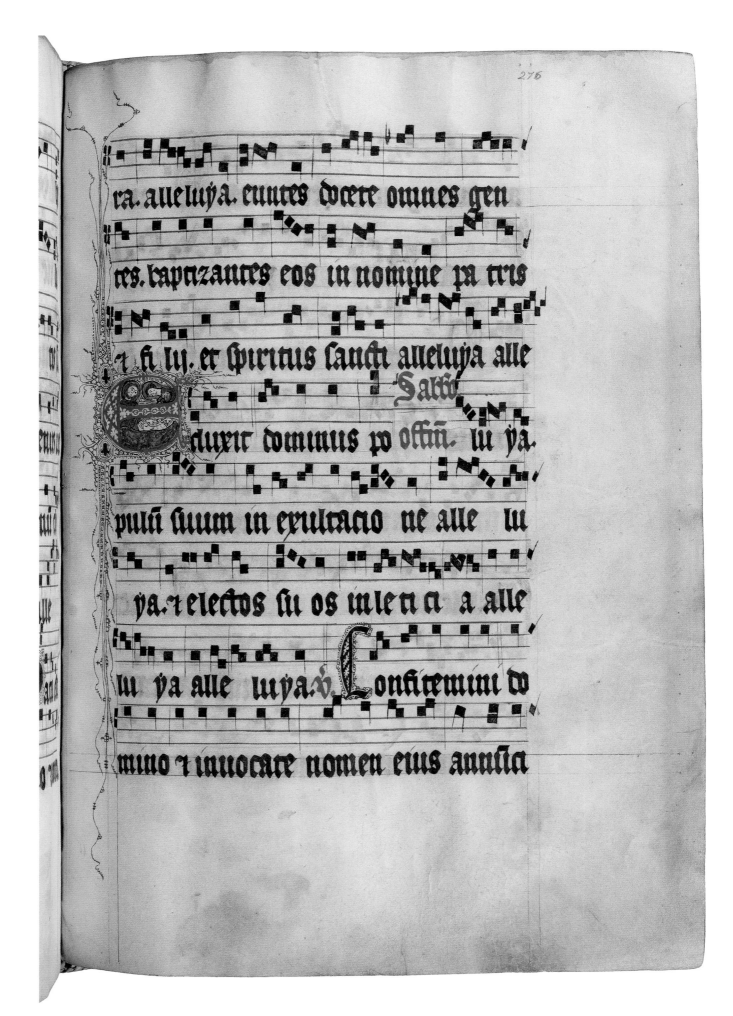

109. Easter Saturday, gradual, ca. 1380.
ULB Dusseldorf, D 11, p. 276 [vol. I, pp. 447–48]

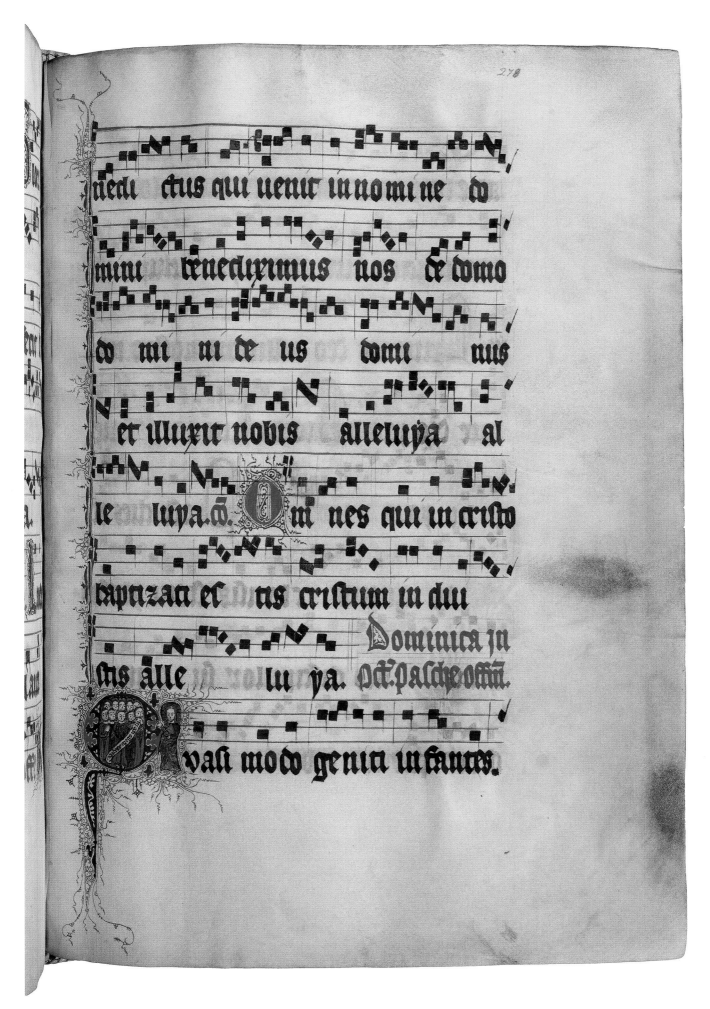

nedi ctus qui uenit in nomine do

mini benediximus nos de domo

do mi ni de us domi nus

et illuxit nobis alleluya al

le luya. ꝟ. Omi nes qui in cristo

baptizati es tis cristum in dui

Dominica in

tis alle lu ya. Oct. pasche offm.

Quasi modo geniti infantes.

110. Octave of Easter, gradual, ca. 1380.
ULB Dusseldorf, D 11, p. 278 [vol. I, p. 449]

GRADUAL, ULB DUSSELDORF, D 11 | 205

111. Octave of Easter, gradual, ca. 1380.
ULB Dusseldorf, D 11, p. 279 [vol. I, p. 449]

112. Second Sunday after Easter, gradual, ca. 1380.
ULB Dusseldorf, D 11, p. 280 [vol. I, p. 450]

GRADUAL, ULB DUSSELDORF, D 11 | 207

113. Second Sunday after Easter, gradual, ca. 1380.
ULB Dusseldorf, D 11, p. 281 [vol. I, p. 450]

114. Second Sunday following octave of Easter, gradual, ca. 1380. ULB Dusseldorf, D 11, p. 283 [vol. I, pp. 451–52]

GRADUAL, ULB DUSSELDORF, D 11 | 209

115. Second Sunday following octave of Easter, gradual, ca. 1380. ULB Dusseldorf, D 11, p. 284 [vol. I, p. 452]

bitis me alleluya. Iterū modi cū et

videbitis me qui a vado ad patrem

Dūica tercia. p̄

alleluya alle luya. oct pasche offm.

Cantate domino canticū novum

allelu ya. quia mirabi lia fecit do

minus alleluya ante conspectum

gencium revela vit iusticiam su

am alleluya allelu ya. Saluauit si

116. Third Sunday following octave of Easter, gradual,
ca. 1380. ULB Dusseldorf, D 11, p. 286 [vol. I, p. 453]

GRADUAL, ULB DUSSELDORF, D 11 | 211

117. Third Sunday following octave of Easter, gradual, ca. 1380. ULB Dusseldorf, D 11, p. 287 [vol. I, p. 453]

118. Fourth Sunday following octave of Easter, gradual, ca. 1380. ULB Dusseldorf, D 11, p. 288 [vol. I, pp. 453–54]

GRADUAL, ULB DUSSELDORF, D 11 | 213

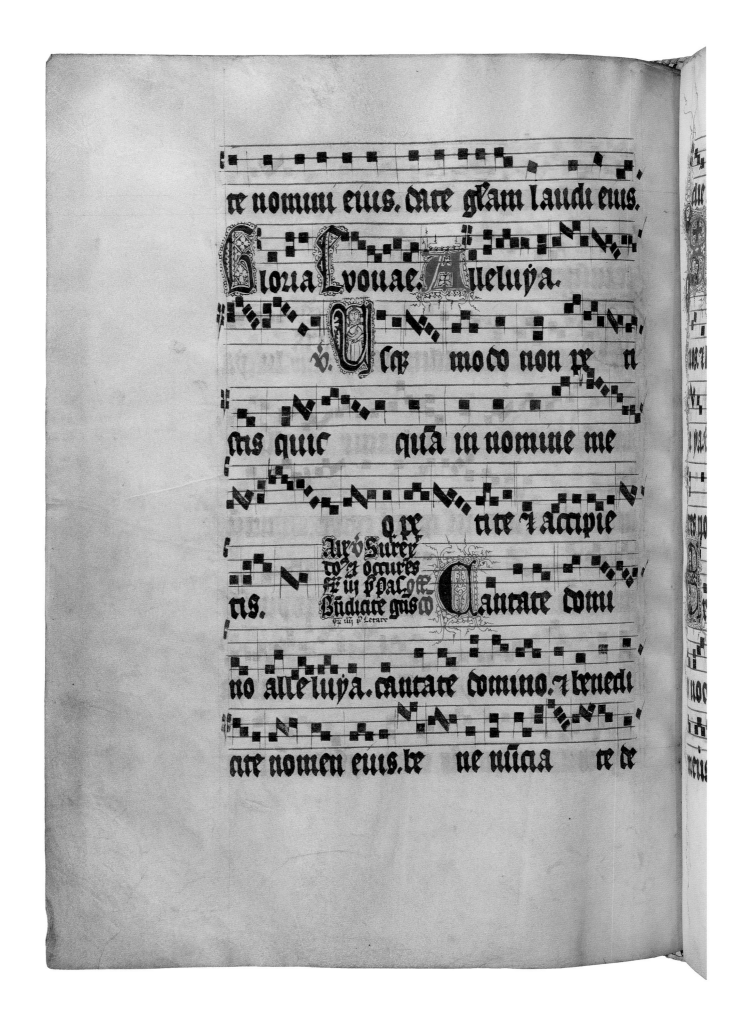

119. Fourth Sunday following octave of Easter, gradual, ca. 1380. ULB Dusseldorf, D 11, p. 289 [vol. I, p. 454]

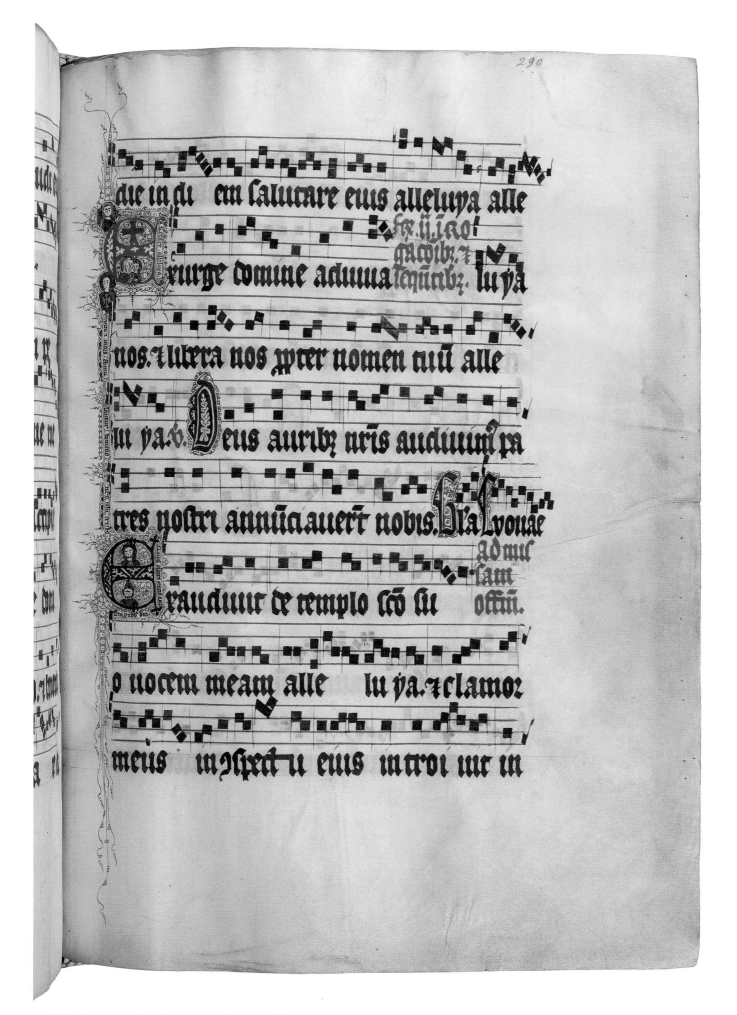

120. Minor rogations: Monday, gradual, ca. 1380.
ULB Dusseldorf, D 11, p. 290 [vol. I, p. 455]

GRADUAL, ULB DUSSELDORF, D 11 | 215

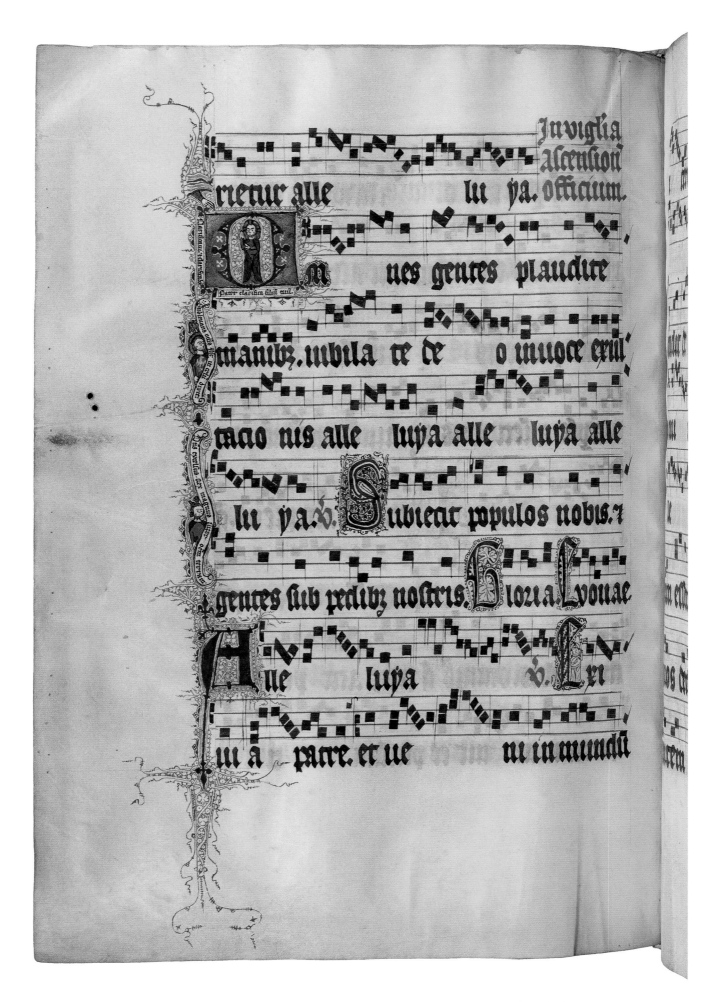

121. Ascension: vigil, gradual, ca. 1380.
ULB Dusseldorf, D 11, p. 293 [vol. I, pp. 455–56]

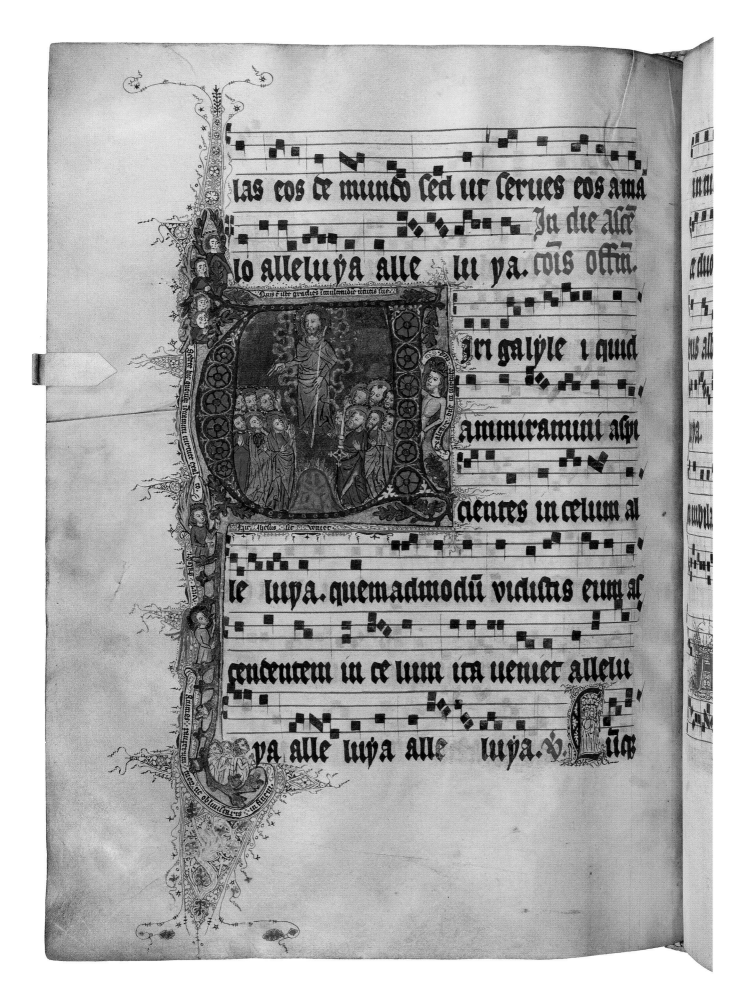

las eos de mundo sed ut serues eos ama

In die Asc̄

lo alleluya alle lu ya. cōis offm.

Iri galyle i quid

ammiramini aspi

cientes in celum al

le luya. quemadmodū vidistis eum as

cendentem in celum ita ueniet allelu

ya alle luya alle luya. V. Lu̅

122. Ascension, gradual, ca. 1380. ULB Dusseldorf,
D 11, p. 295 [vol. I, pp. 178, 181, 456–59]

GRADUAL, ULB DUSSELDORF, D 11 | 217

123. Ascension, gradual, ca. 1380.
ULB Dusseldorf, D 11, p. 296 [vol. I, p. 459]

124. Ascension, gradual, ca. 1380.
ULB Dusseldorf, D 11, p. 297 [vol. I, p. 463]

125. Sunday within octave of Ascension, gradual, ca. 1380.
ULB Dusseldorf, D 11, p. 298 [vol. I, pp. 465–66]

to afcendens in al tu. cap

ctuam dur it

of afcendit cls in ju.
cp ater cu eetm cuea
vtruiqz juigl alceu.

captiuuta rem. In vigilia penthetostes.
Lectio prima. lic i vigl pal Temptauit cls. finita loe. i medi
ate dicat oro. Ds qi in abraham co sca. Scripsit ozoyse.
Post scam loem. cautetur Tractus sequies imediate. et o
sus ta in isto. qua induob; alys cautentur alternatim.

Attende ce lum et loquar

et audiat terra uerba er

oze meo v. Erpectetur siar plu

uia eloquiu me u z desce

126. Pentecost: vigil, gradual, ca. 1380.
ULB Dusseldorf, D 11, p. 300 [vol. I, pp. 467–68]

GRADUAL, ULB DUSSELDORF, D 11 | 221

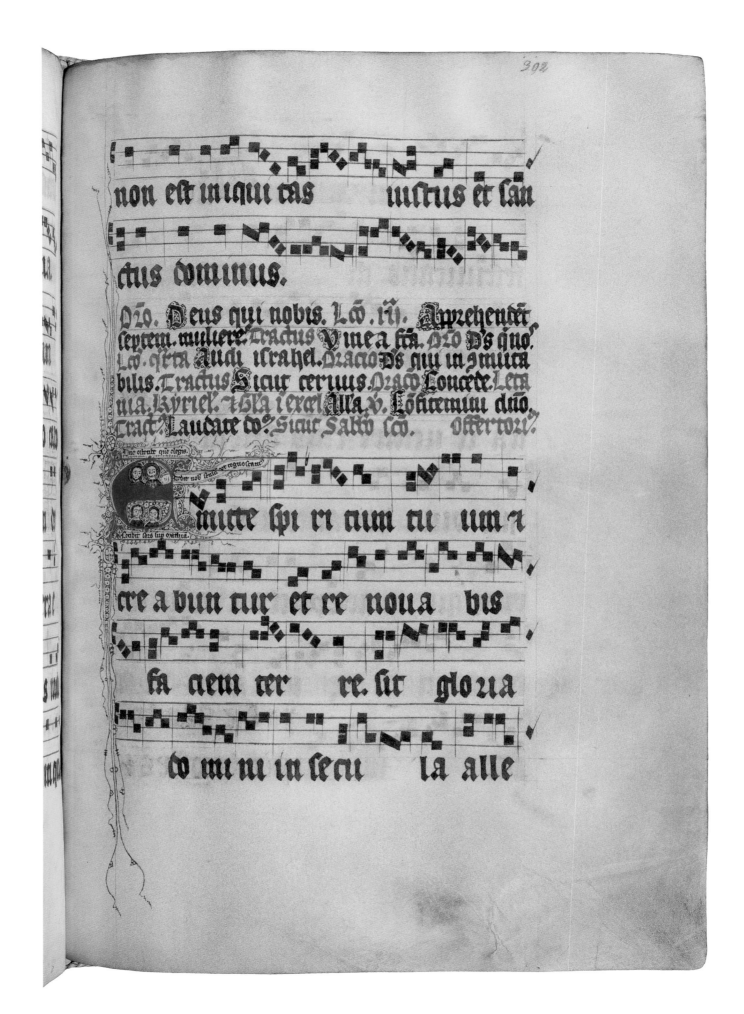

127. Pentecost: vigil, gradual, ca. 1380.
ULB Dusseldorf, D 11, p. 302 [vol. I, pp. 468, 470]

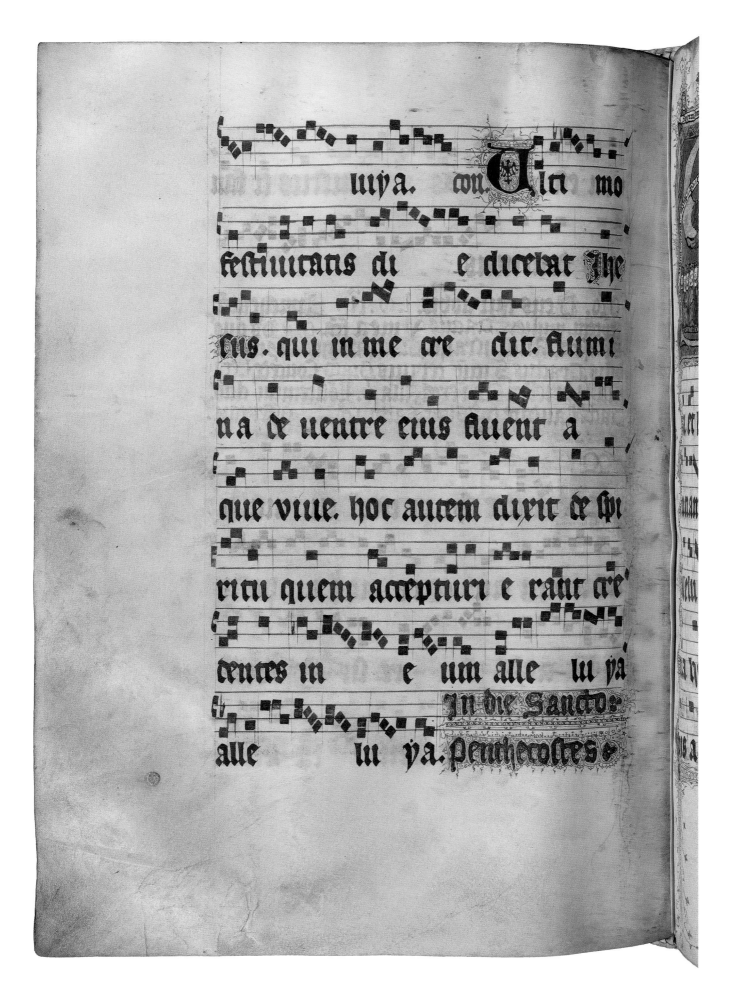

luya. con. T ci mo

festiuitatis di e dicebat The

sus. qui in me cre dit. flumi

na de ventre eius fluent a

que viue. hoc autem dixit de spi

ritu quem accepturi e rant cre

dentes in e um alle lu ya

alle lu ya. penthecostes.
In die Sancto

128. Pentecost, gradual, ca. 1380.
ULB Dusseldorf, D 11, p. 303 [vol. I, p. 468]

GRADUAL, ULB DUSSELDORF, D 11 | 223

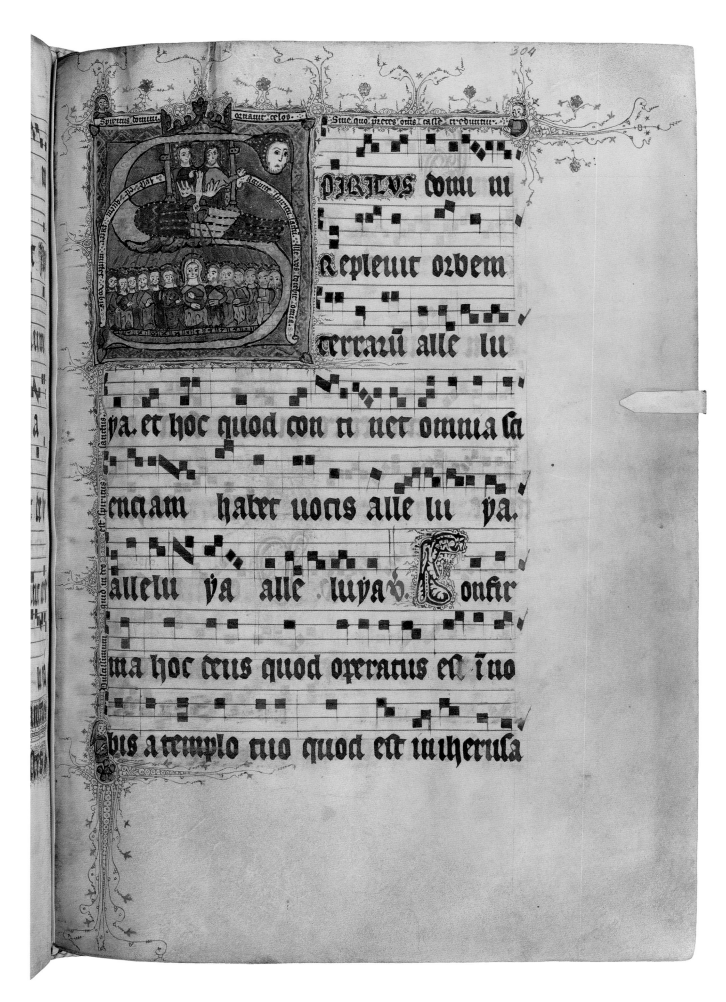

129. Pentecost, gradual, ca. 1380.
ULB Dusseldorf, D 11, p. 304 [vol. I, pp. 468–70]

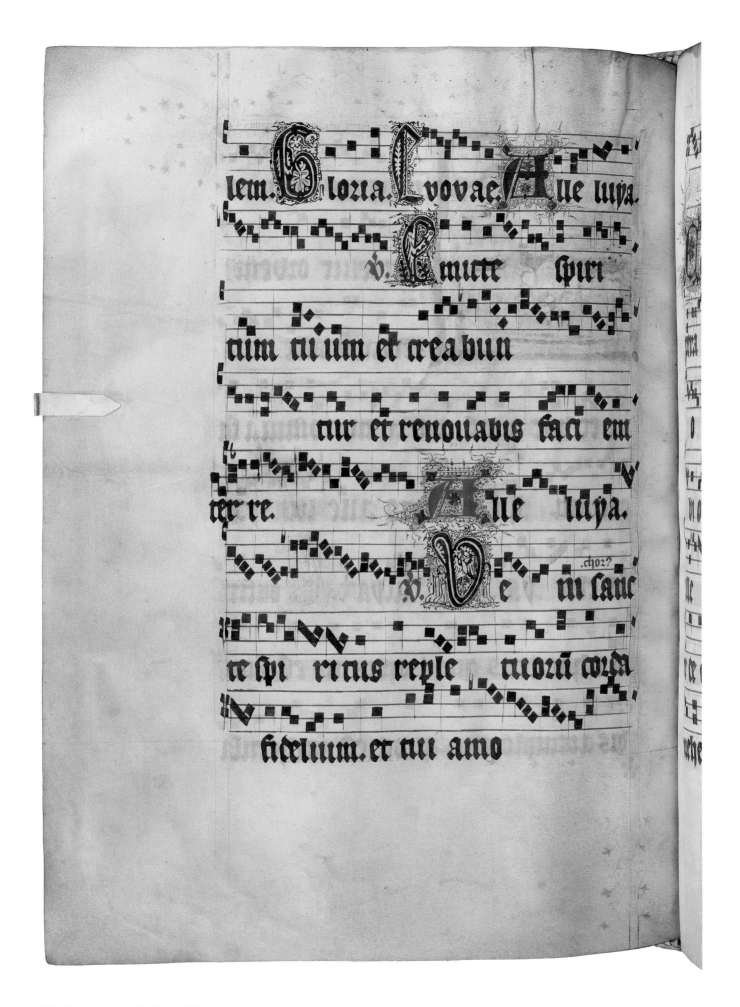

130. Pentecost, gradual, ca. 1380.
ULB Dusseldorf, D 11, p. 305 [vol. I, p. 471]

GRADUAL, ULB DUSSELDORF, D 11 | 225

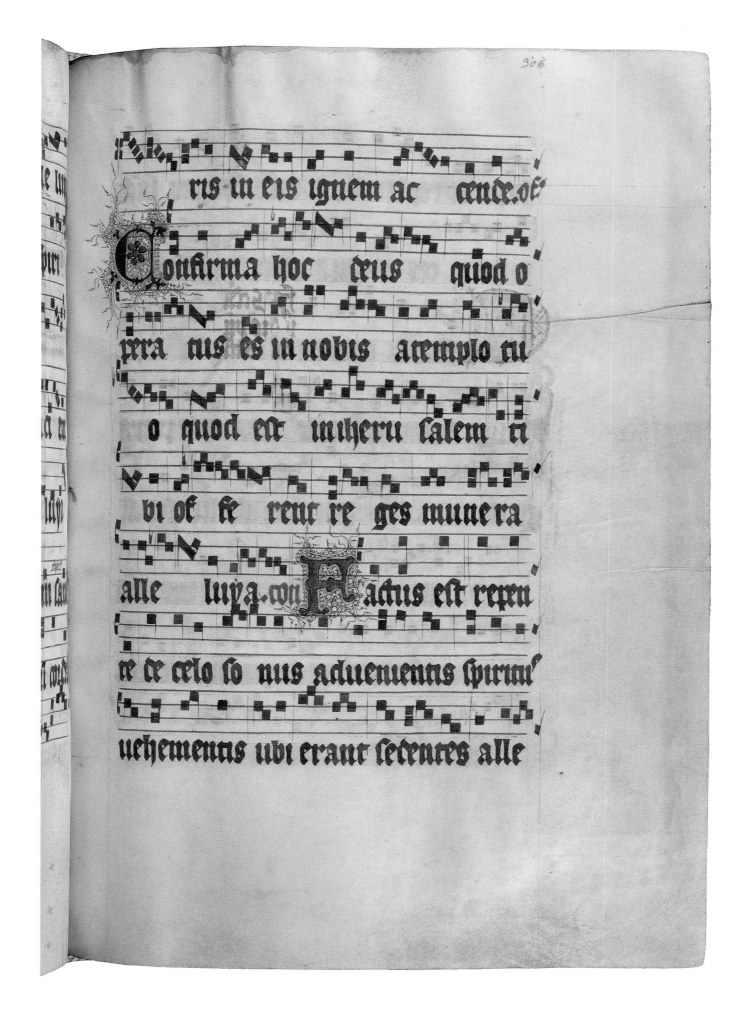

131. Pentecost, gradual, ca. 1380.
ULB Dusseldorf, D 11, p. 306 [vol. I, p. 469]

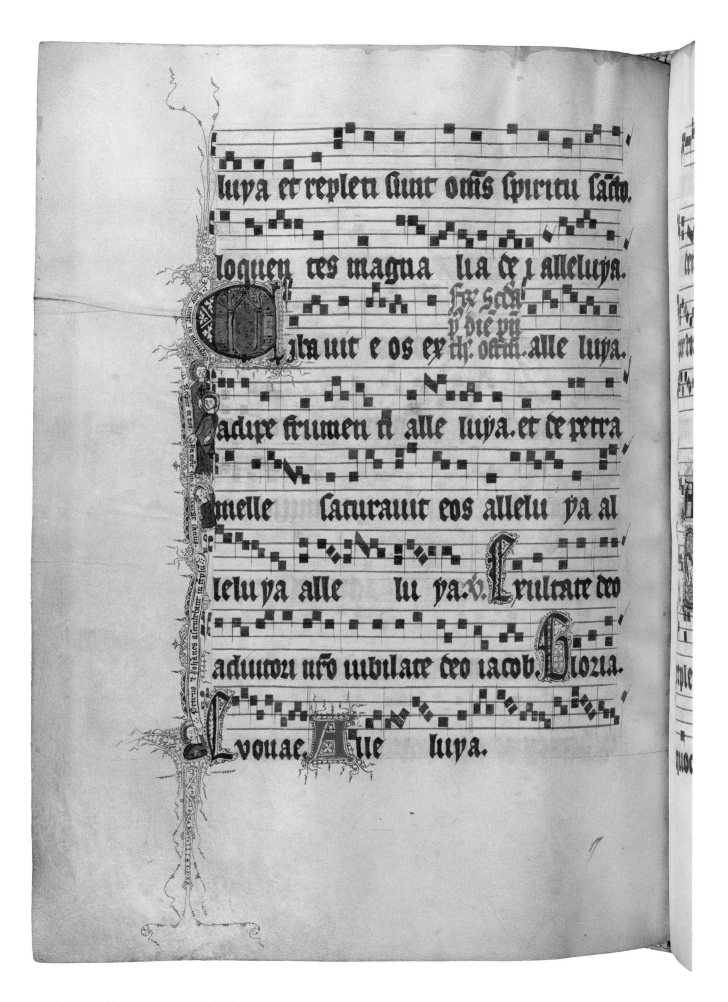

132. Pentecost: Monday, gradual, ca. 1380.
ULB Dusseldorf, D 11, p. 307 [vol. I, pp. 473–74]

GRADUAL, ULB DUSSELDORF, D 11 | 227

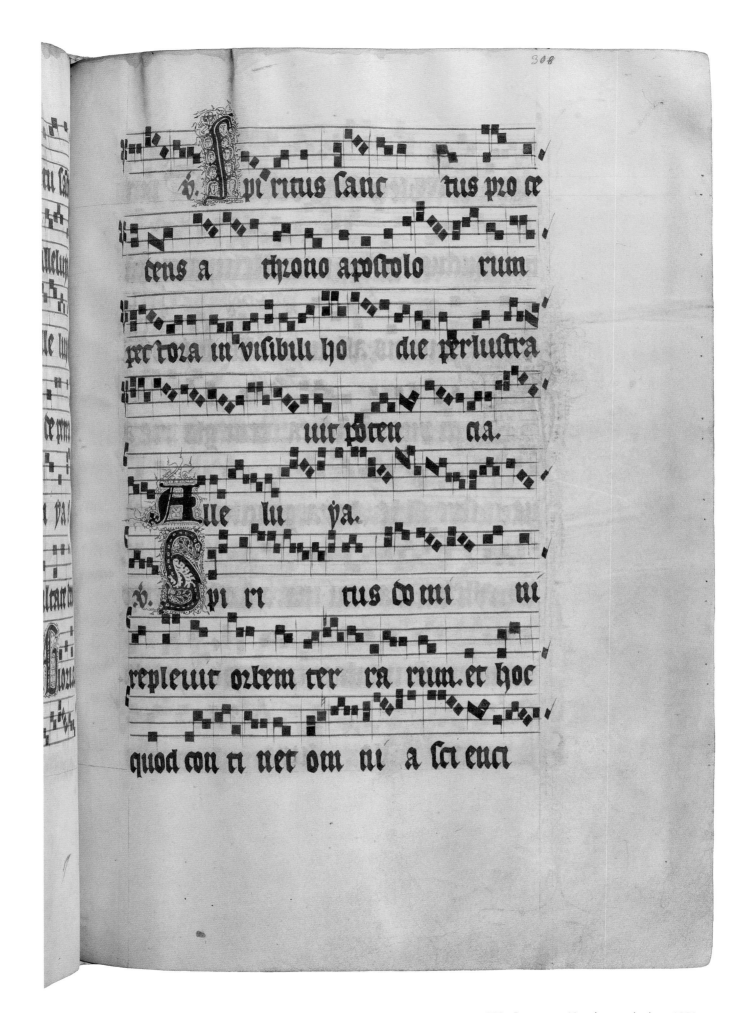

133. Pentecost: Monday, gradual, ca. 1380.
ULB Dusseldorf, D 11, p. 308 [vol. I, p. 474]

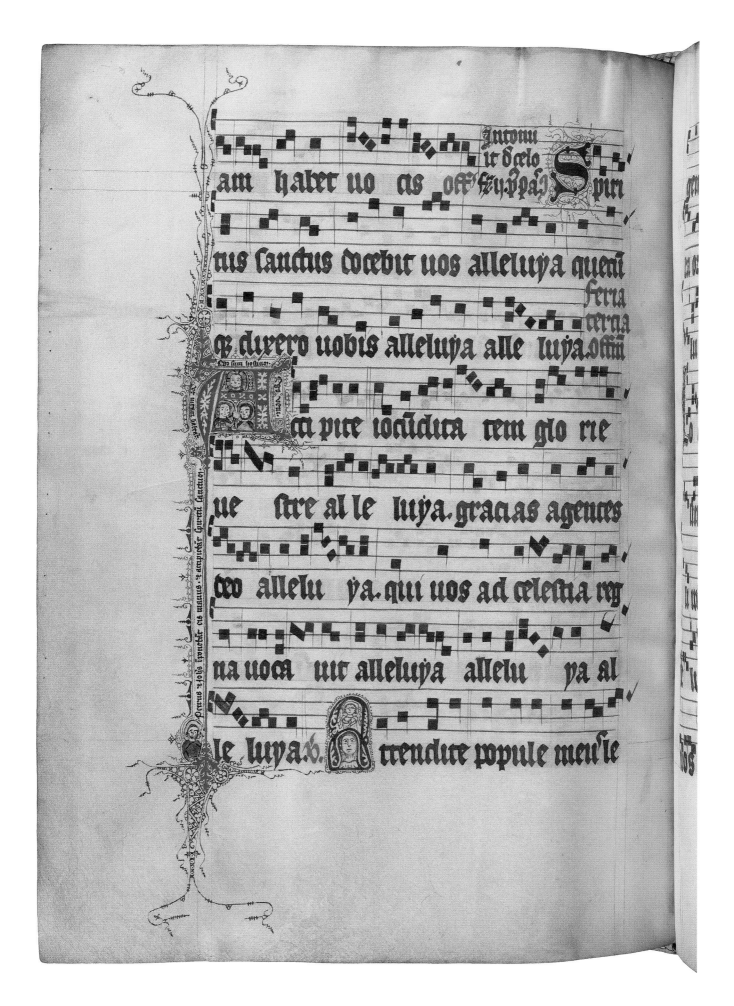

134. Pentecost: Tuesday (Whit Tuesday), gradual, ca. 1380.
ULB Dusseldorf, D 11, p. 309 [vol. I, p. 475]

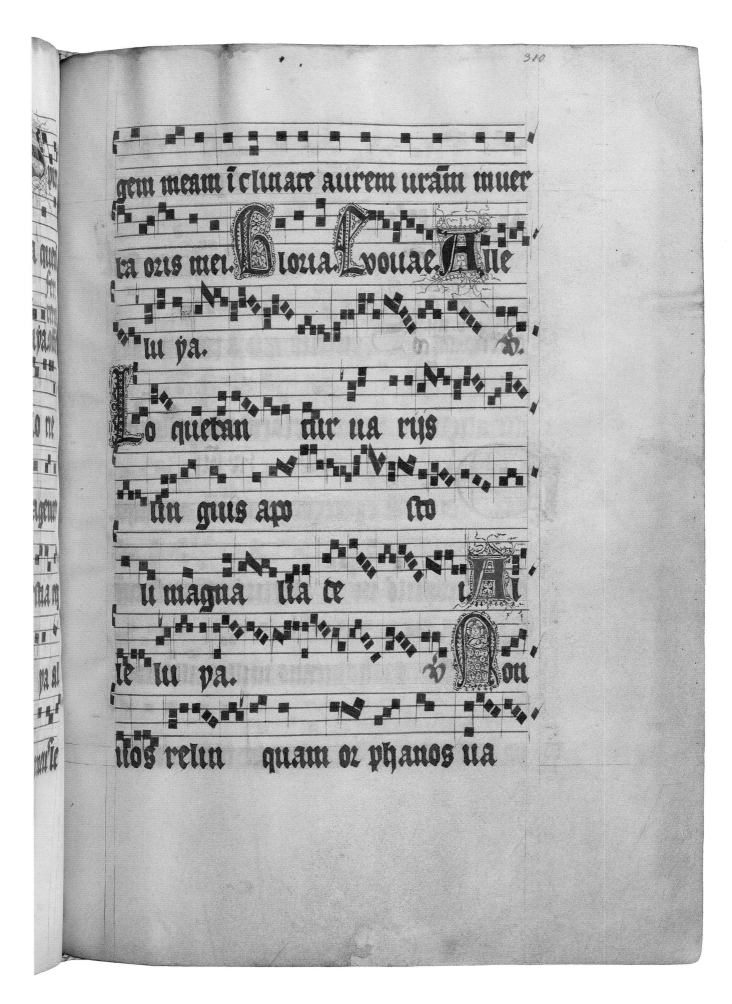

135. Pentecost: Tuesday (Whit Tuesday), gradual, ca. 1380.
ULB Dusseldorf, D 11, p. 310 [vol. I, p. 475]

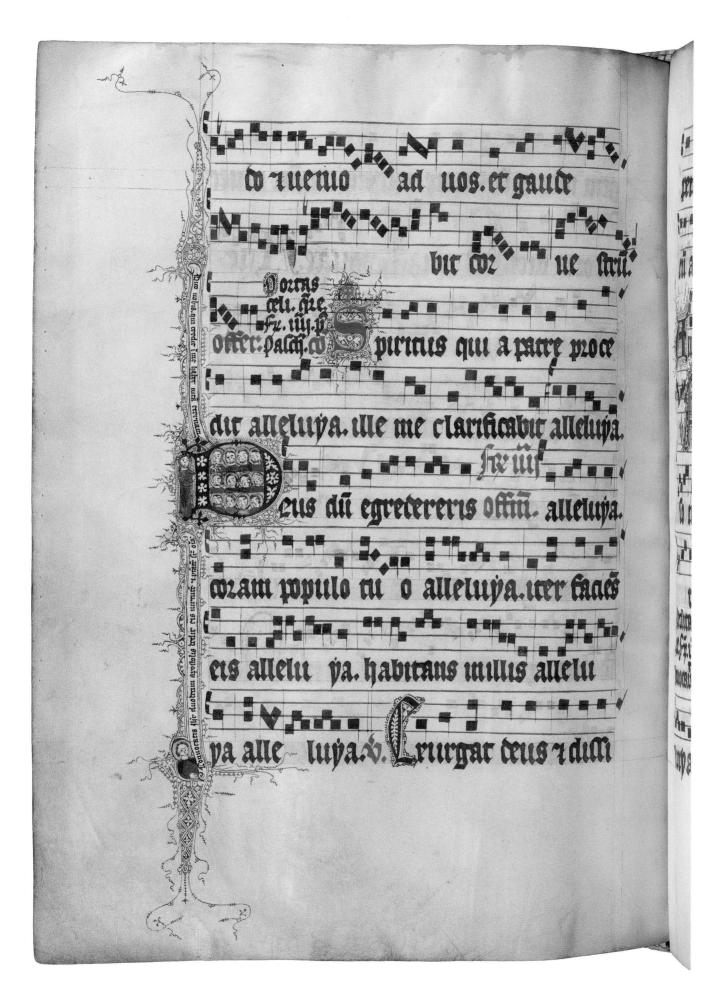

136. Pentecost: Wednesday (Whit Wednesday), gradual, ca. 1380. ULB Dusseldorf, D 11, p. 311 [vol. I, p. 475]

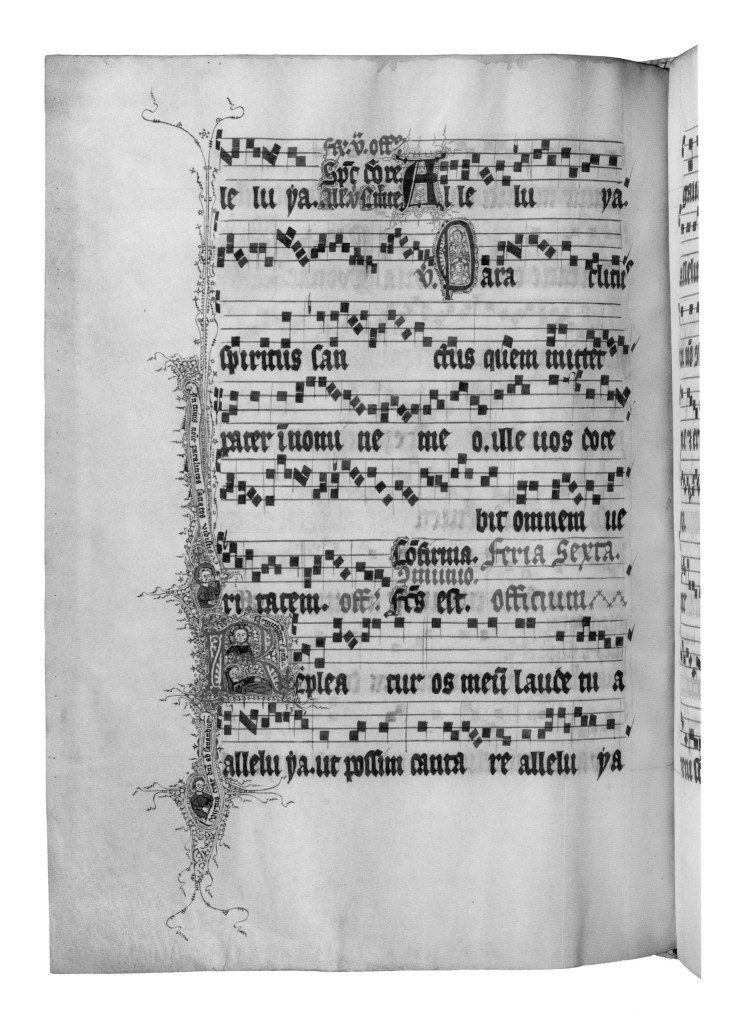

137. Pentecost: Friday (Whit Friday), gradual, ca. 1380.
ULB Dusseldorf, D 11, p. 313 [vol. I, p. 475]

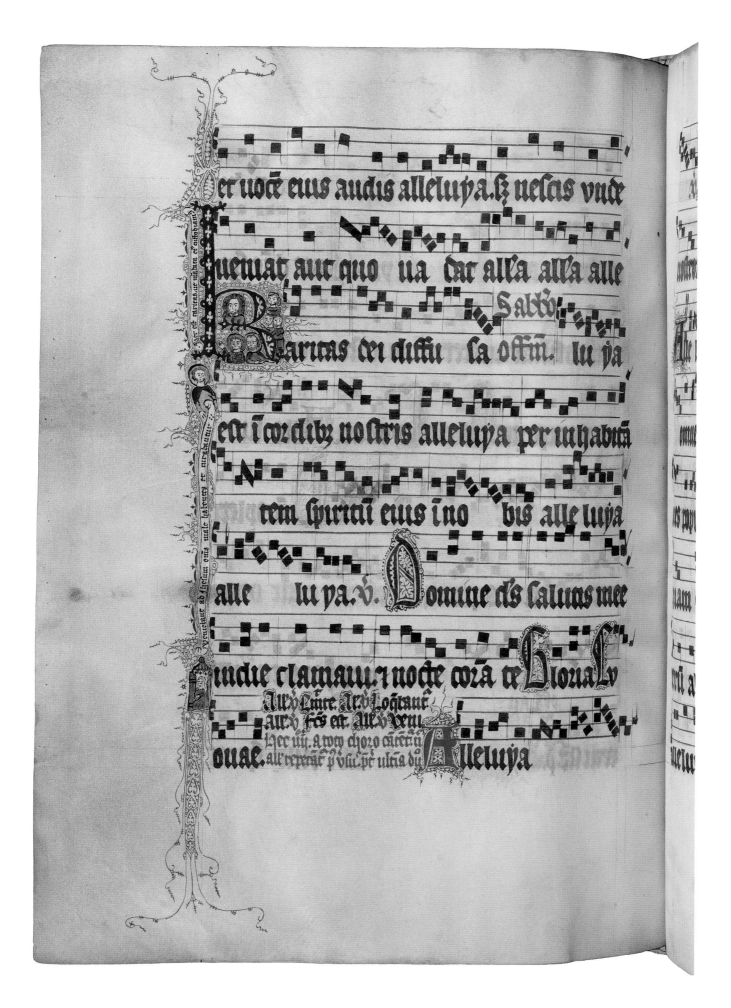

138. Pentecost: Saturday (Whit Saturday), gradual, ca. 1380.
ULB Dusseldorf, D 11, p. 315 [vol. I, p. 477]

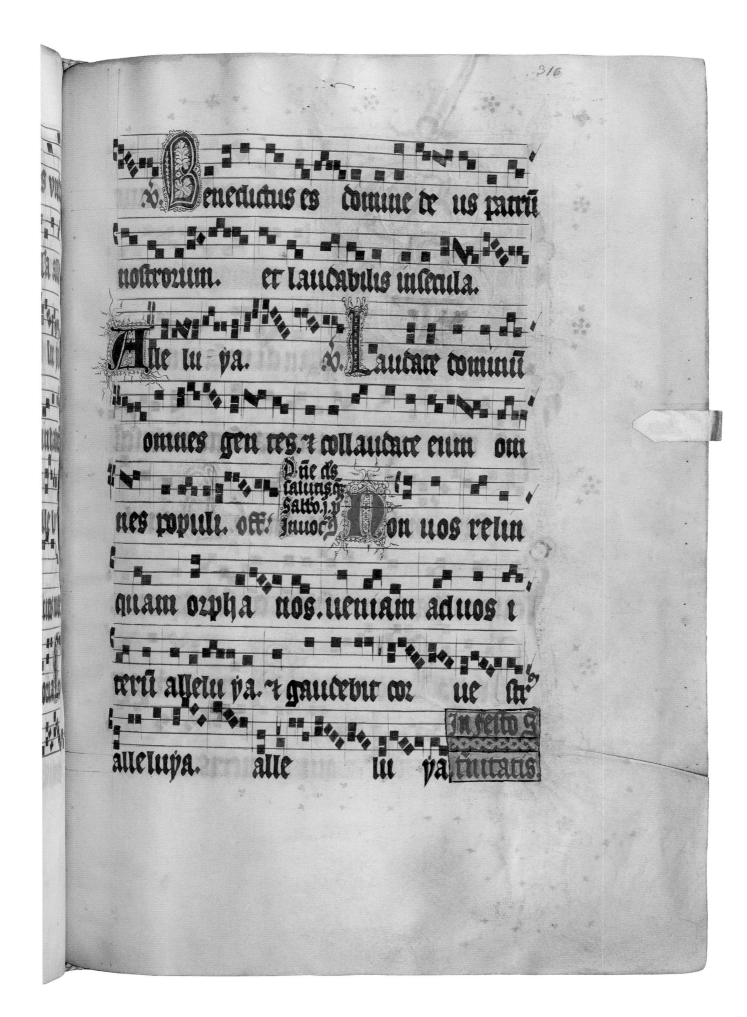

139. Trinity Sunday, gradual, ca. 1380.
ULB Dusseldorf, D 11, p. 316 [vol. I, pp. 479–83]

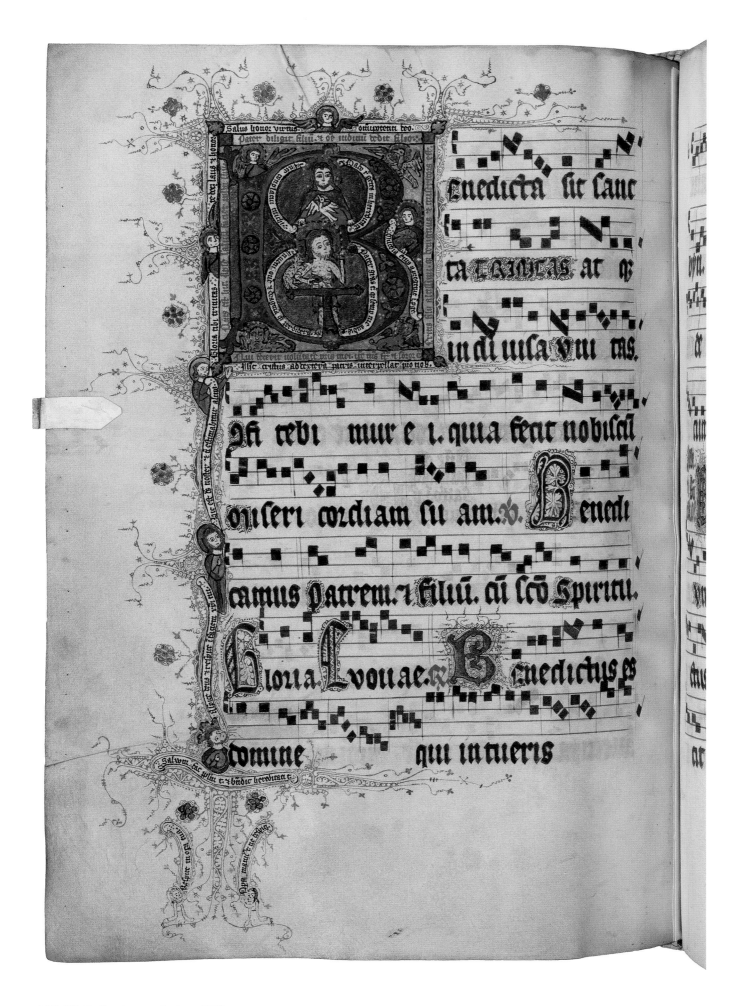

140. Trinity Sunday, gradual, ca. 1380.
ULB Dusseldorf, D 11, p. 317 [vol. I, pp. 483, 590]

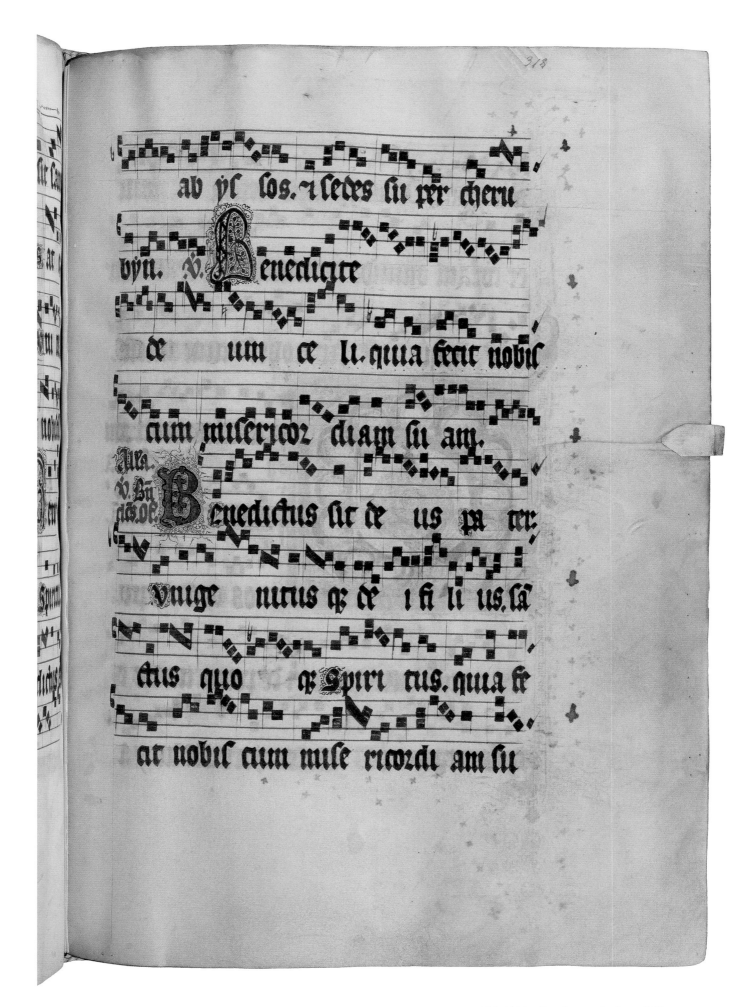

141. Trinity Sunday, gradual, ca. 1380.
ULB Dusseldorf, D 11, p. 318 [vol. I, p. 483]

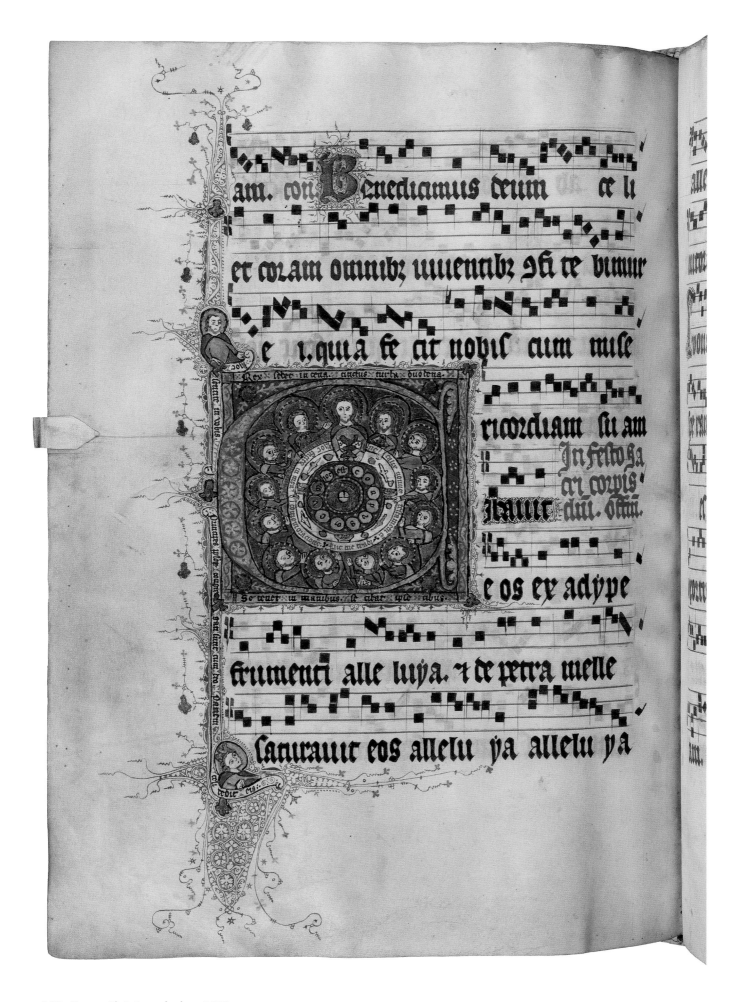

142. Corpus Christi, gradual, ca. 1380.
ULB Dusseldorf, D 11, p. 319 [vol. I, pp. 483–91]

GRADUAL, ULB DUSSELDORF, D 11 | 237

143. Corpus Christi, gradual, ca. 1380.
ULB Dusseldorf, D 11, p. 320 [vol. I, p. 492]

144. Corpus Christi, gradual, ca. 1380.
ULB Dusseldorf, D 11, p. 321 [vol. I, p. 484]

145. Trinity Sunday: octave, gradual, ca. 1380.
ULB Dusseldorf, D 11, p. 322 [vol. I, pp. 488–91]

146. Third Sunday after Trinity, gradual, ca. 1380.
ULB Dusseldorf, D 11, p. 326 [vol. I, p. 495]

GRADUAL, ULB DUSSELDORF, D 11 | 241

147. Ninth Sunday after Trinity, gradual, ca. 1380.
ULB Dusseldorf, D 11, p. 337 [vol. I, p. 496]

148. Ninth Sunday after Trinity, gradual, ca. 1380.
ULB Dusseldorf, D 11, p. 339 [vol. I, p. 496]

149. Eleventh Sunday after Trinity, gradual, ca. 1380.
ULB Dusseldorf, D 11, p. 340 [vol. I, p. 496]

150. Fourteenth Sunday after Trinity, gradual, ca. 1380.
ULB Dusseldorf, D 11, p. 345 [vol. I, p. 496]

GRADUAL, ULB DUSSELDORF, D 11 | 245

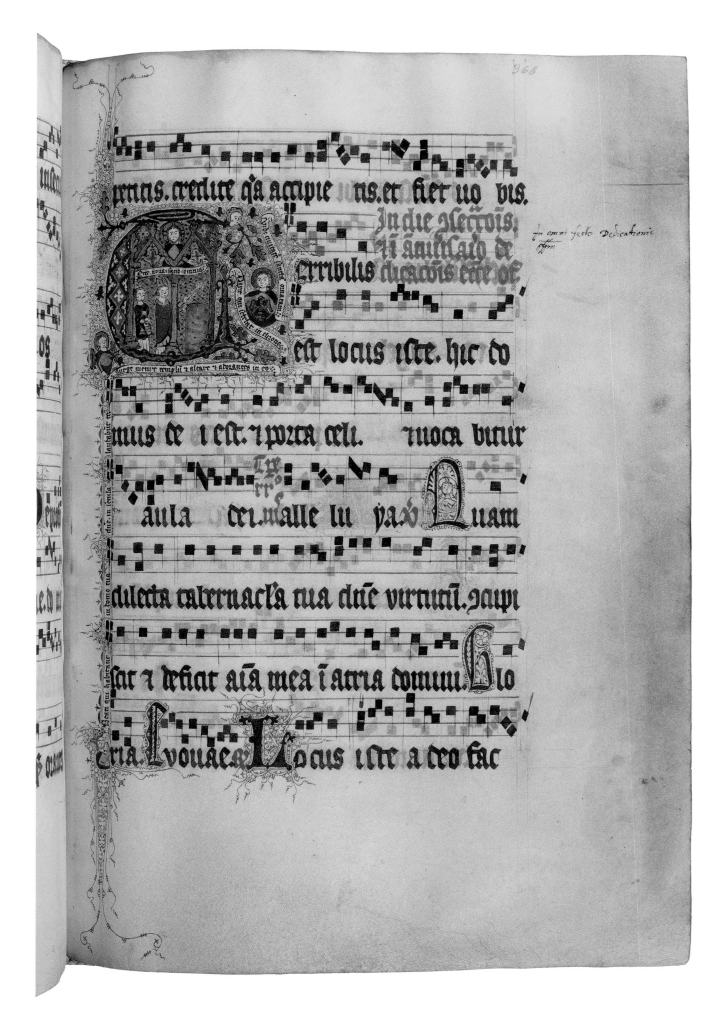

151. Dedication of a Church, gradual, ca. 1380.
ULB Dusseldorf, D 11, p. 366 [vol. I, pp. 726–29]

152. Dedication of a Church, gradual, ca. 1380.
ULB Dusseldorf, D 11, p. 367 [vol. I, p. 729]

GRADUAL, ULB DUSSELDORF, D 11 | 247

153. Dedication of a Church, gradual, ca. 1380.
ULB Dusseldorf, D 11, p. 368 [vol. I, p. 729]

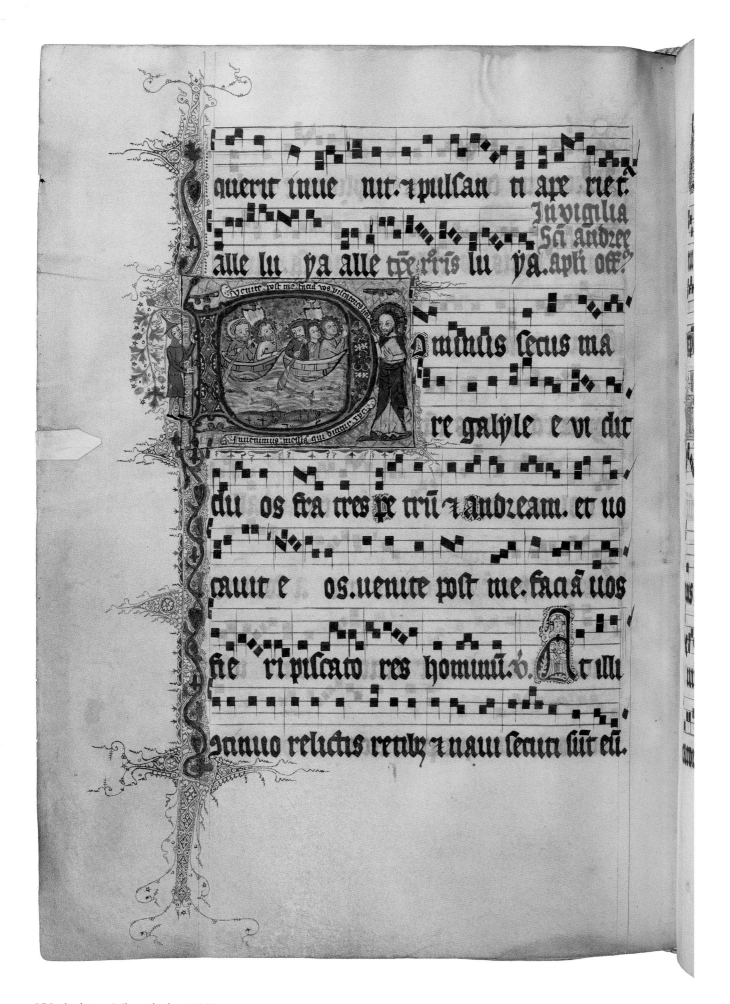

querit inuenuit. ↄ pulſan ti ape riet.

In vigilia Scī andree aplī offᵒ

alle lu ya alle tᵗᵉ rᶜᶠᶜ lu ya. aplī offᵒ

Dnīcus ſecus ma

re galyle e vi dit

du os fra tres pe trū ↄ andream. et uo

cauit e os. uenite poſt me. fracā uos

fie ri piſcato res hominū. ꝟ. Et illi

ꝫ mō relictis renb⁊ ↄ naui ſecuti ſūt eū.

154. Andrew: vigil, gradual, ca. 1380.
ULB Dusseldorf, D 11, p. 369 [vol. I, pp. 178, 639–41]

GRADUAL, ULB DUSSELDORF, D 11 | 249

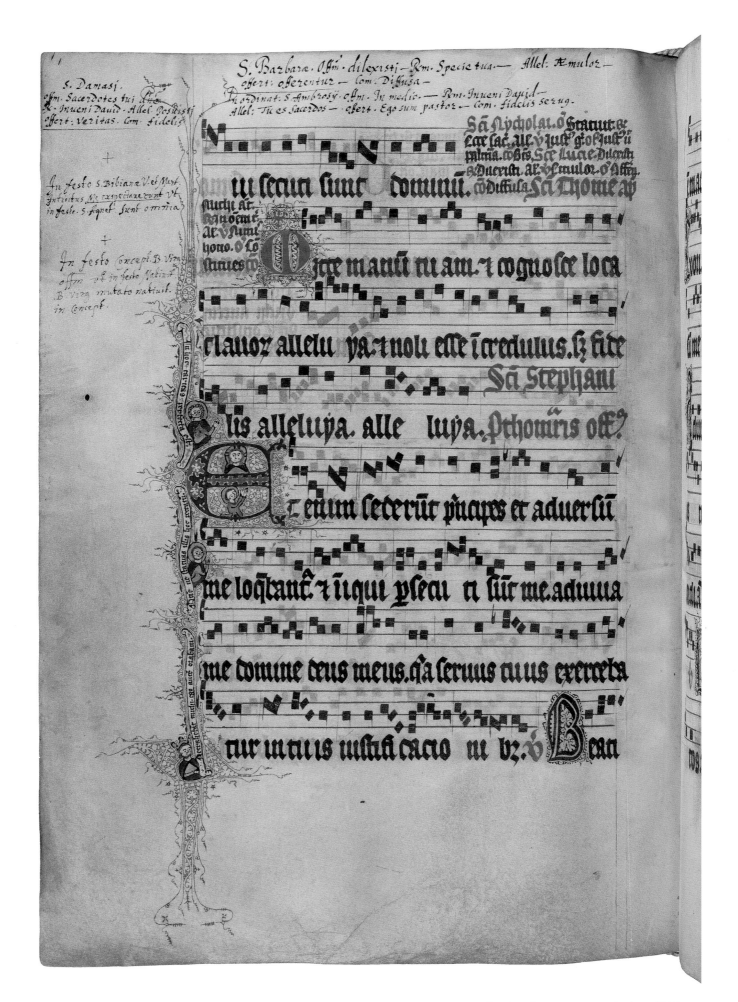

155. Stephen Protomartyr, gradual, ca. 1380.
ULB Dusseldorf, p. 371 [vol. I, pp. 641–42]

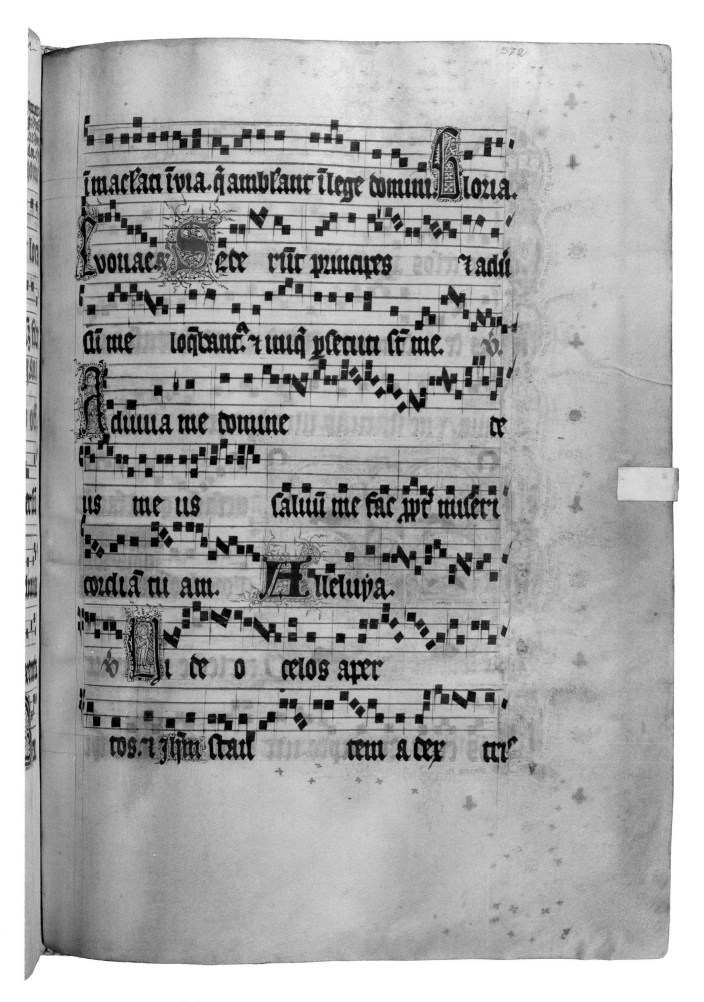

156. Stephen Protomartyr, gradual, ca. 1380.
ULB Dusseldorf, D 11, p. 372 [vol. I, pp. 641–42]

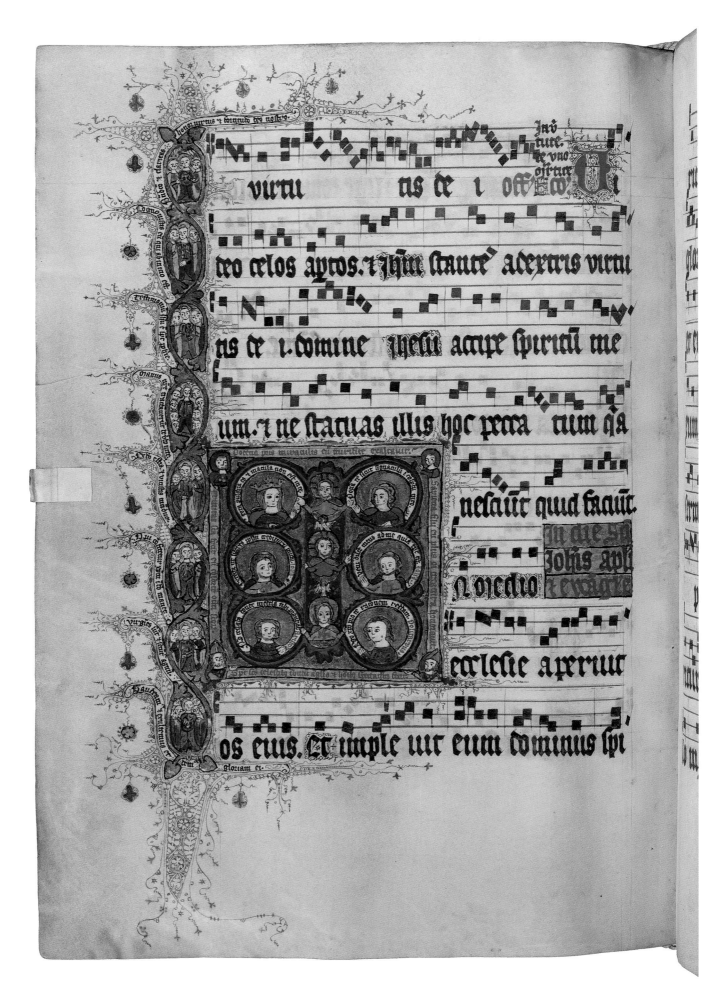

157. John the Evangelist, gradual, ca. 1380. ULB Dusseldorf,
D 11, p. 373 [vol. I, pp. 595–96, 611–12]

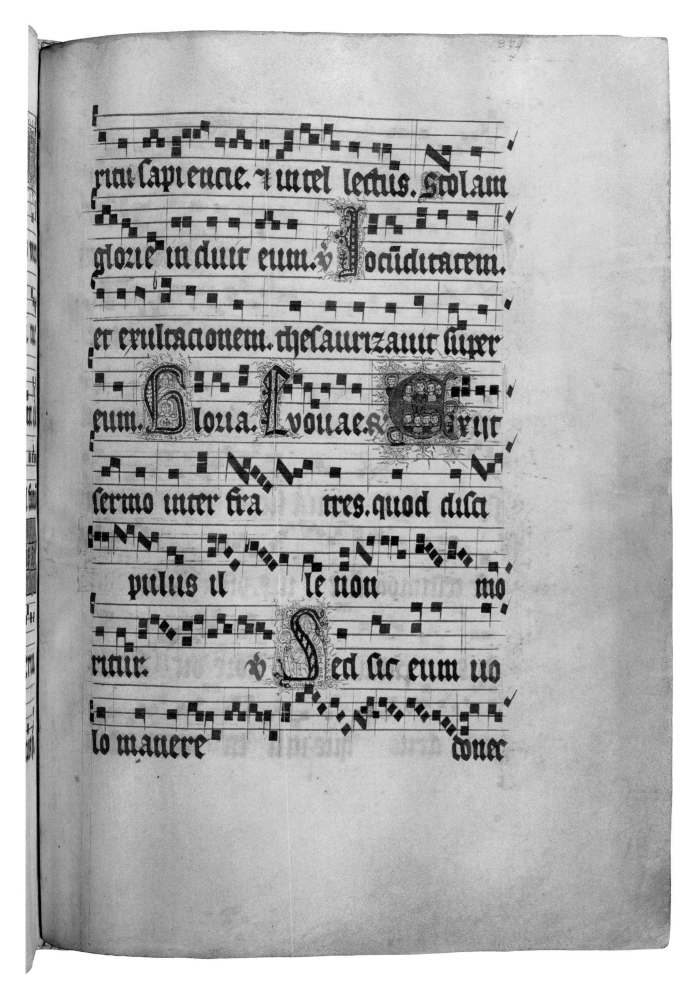

rint sapiencie. ⁊ intellectuis. Stolam

glorie induit eum. ℣ Jocundiratem.

et exultacionem. thesaurizauit super

eum. Gloria. Fuoae ẋ Exit

sermo inter fra tres. quod disci

pulus il le non mo

ritur. ℣ Sed sic eum uo

lo manere donec

158. John the Evangelist, gradual, ca. 1380.
ULB Dusseldorf, D 11, p. 374 [vol. I, p. 612]

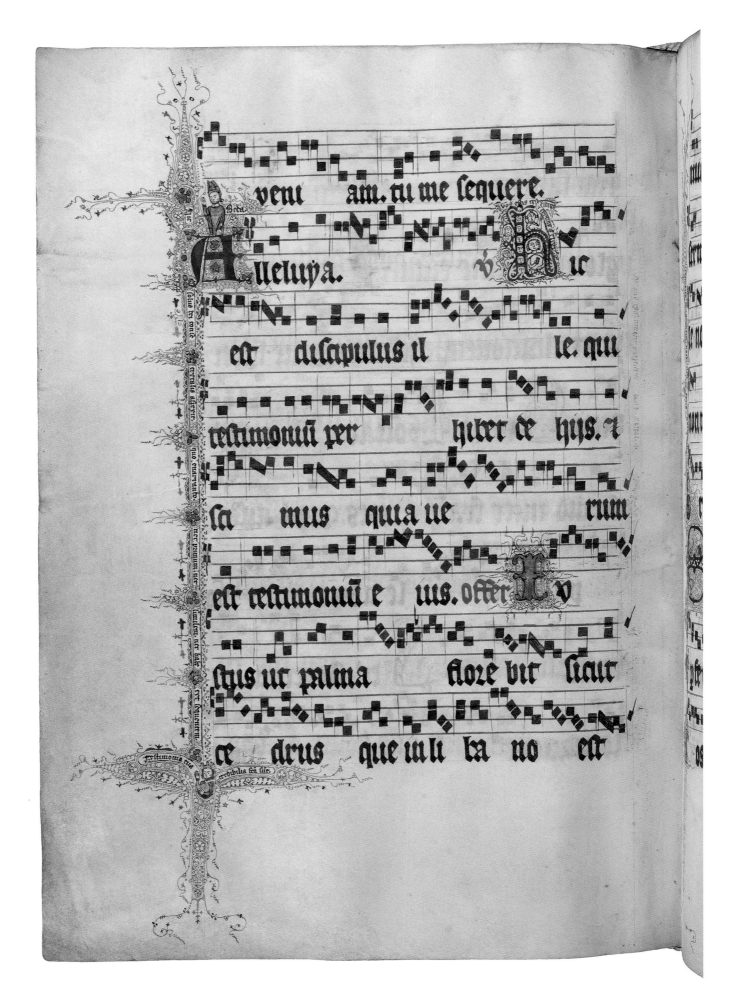

159. John the Evangelist, gradual, ca. 1380.
ULB Dusseldorf, D 11, p. 375 [vol. I, pp. 612, 614]

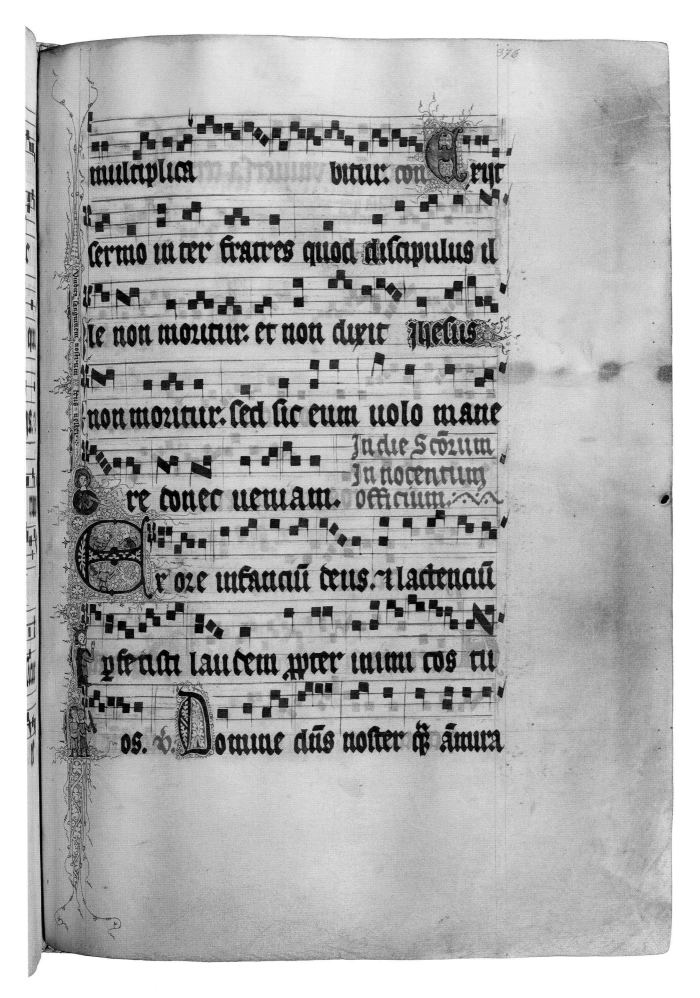

160. John the Evangelist; Holy Innocents, gradual, ca. 1380.
ULB Dusseldorf, D 11, p. 376 [vol. I, p. 614]

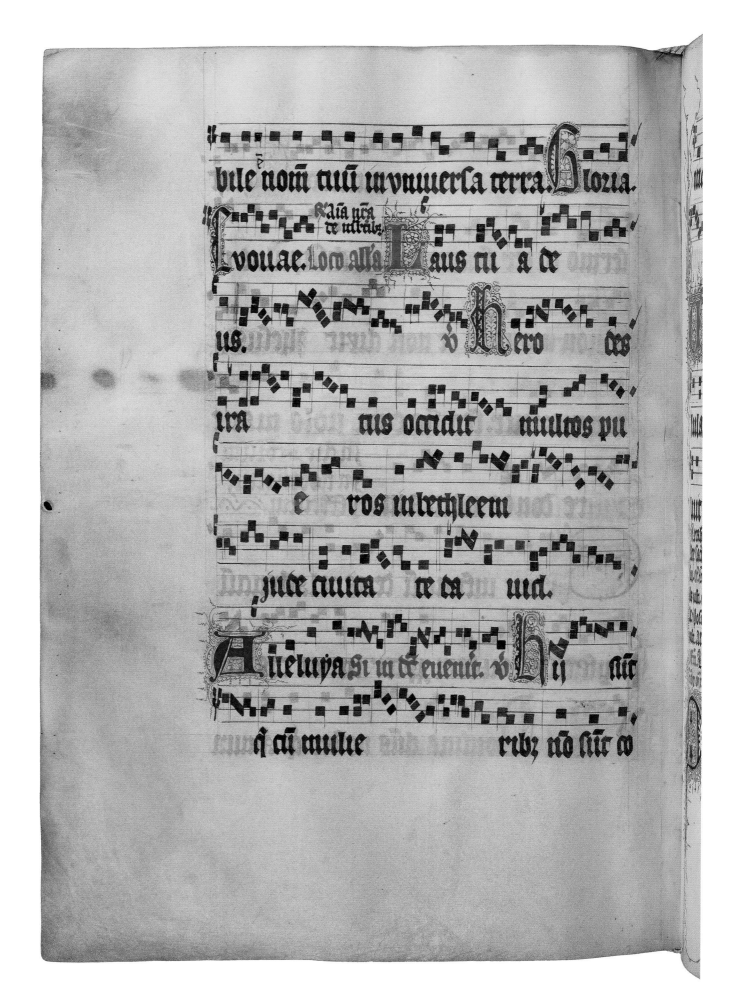

161. Holy Innocents, gradual, ca. 1380.
ULB Dusseldorf, D 11, p. 377 [vol. I, pp. 642–43]

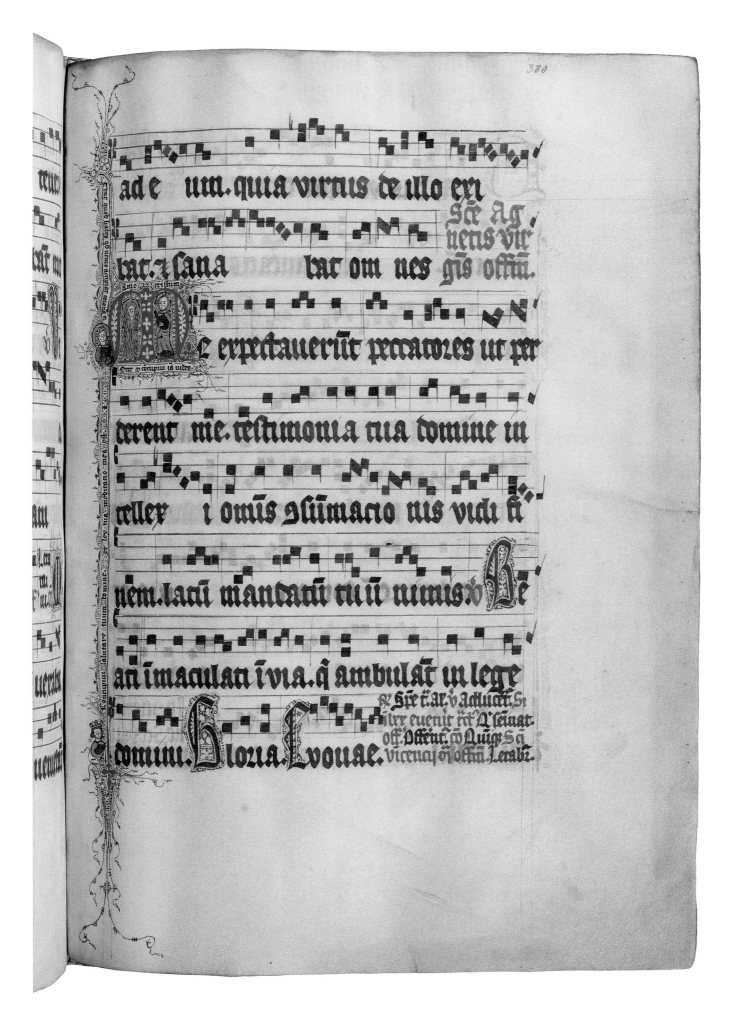

162. Agnes, gradual, ca. 1380. ULB Dusseldorf,
D 11, p. 380 [vol. I, pp. 644–48]

GRADUAL, ULB DUSSELDORF, D 11 | 257

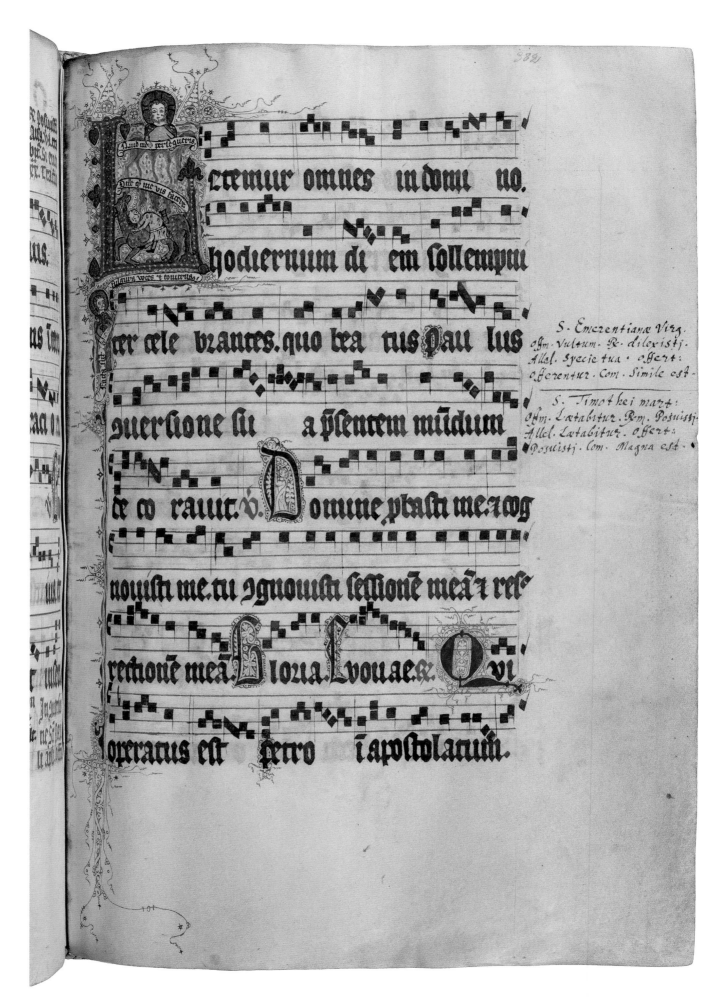

163. Paul: Conversion, gradual, ca. 1380.
ULB Dusseldorf, D 11, p. 382 [vol. I, pp. 649–50]

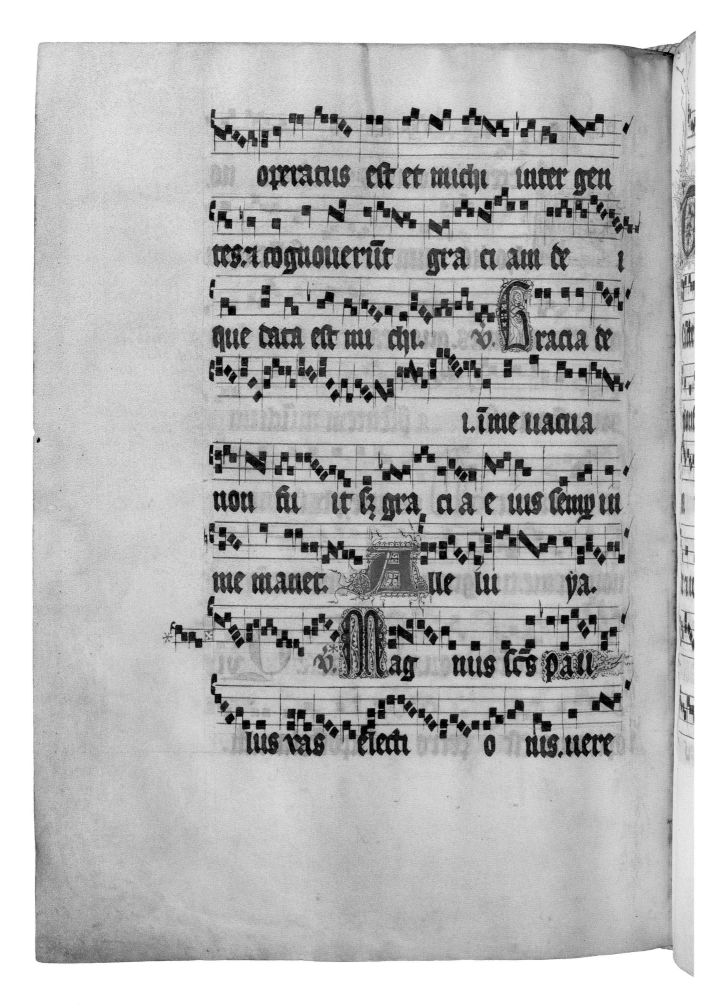

164. Paul: Conversion, gradual, ca. 1380.
ULB Dusseldorf, D 11, p. 383 [vol. I, pp. 649–50]

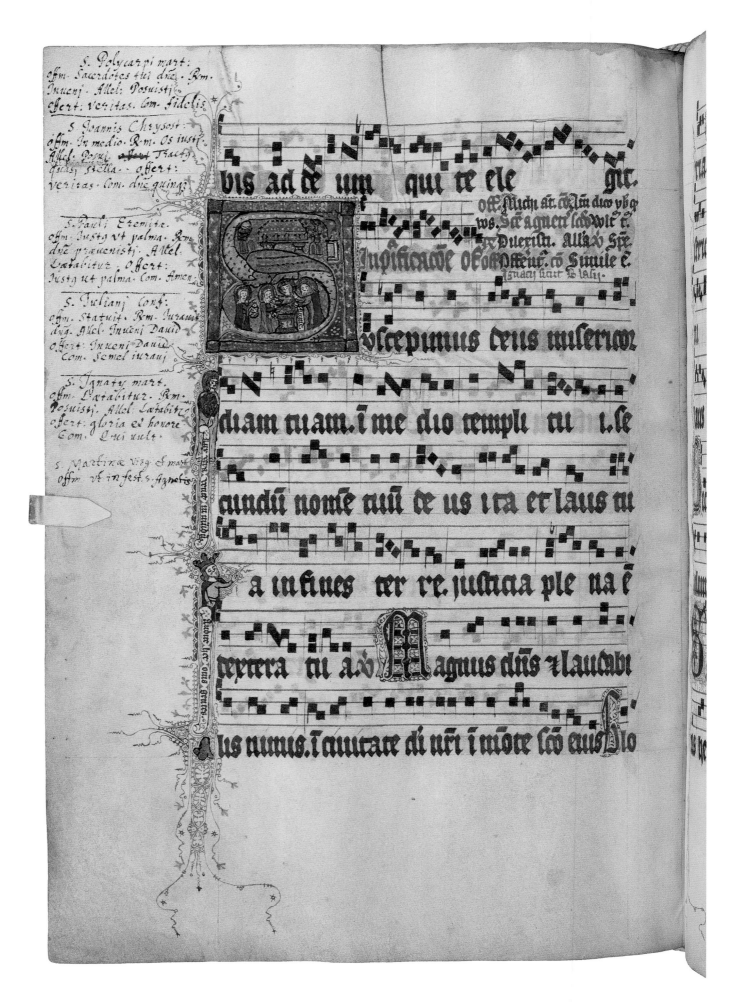

165. Presentation of Virgin, gradual, ca. 1380.
ULB Dusseldorf, D 11, p. 385 [vol. I, pp. 520–23]

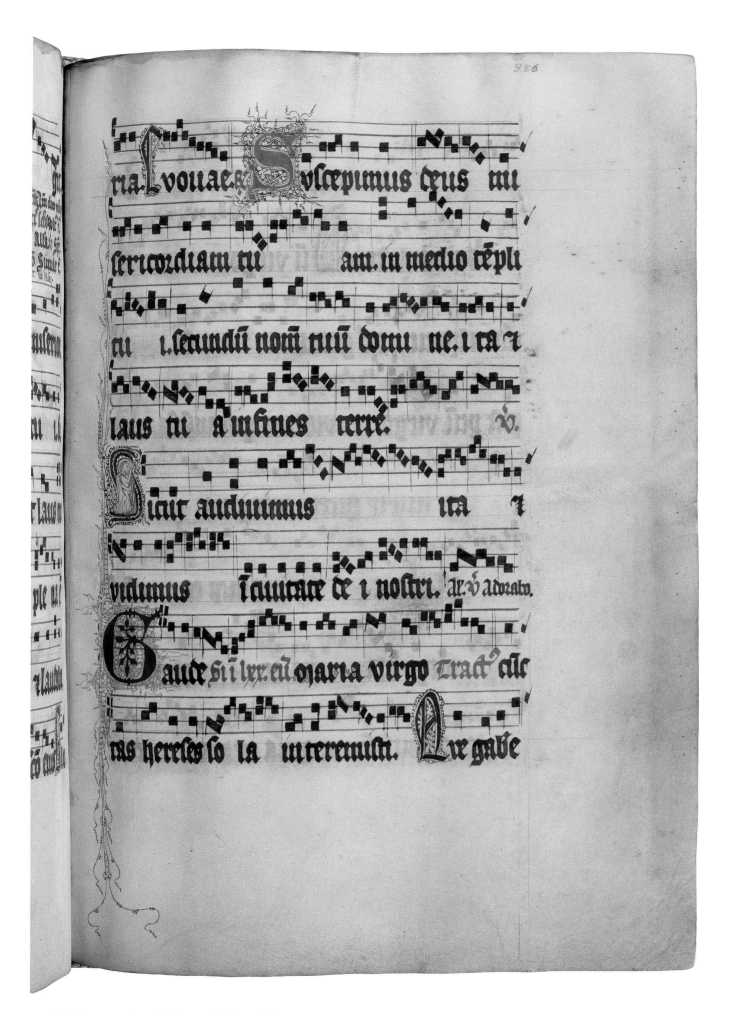

166. Presentation of Virgin, gradual, ca. 1380.
ULB Dusseldorf, D 11, p. 386 [vol. I, p. 520]

167. Peter: cathedra, gradual, ca. 1380, gradual, ca. 1380.
ULB Dusseldorf, D 11, p. 389 [vol. I, pp. 651–52]

168. Matthias: cathedra, gradual, ca. 1380.
ULB Dusseldorf, D 11, p. 390 [vol. I, pp. 651–52]

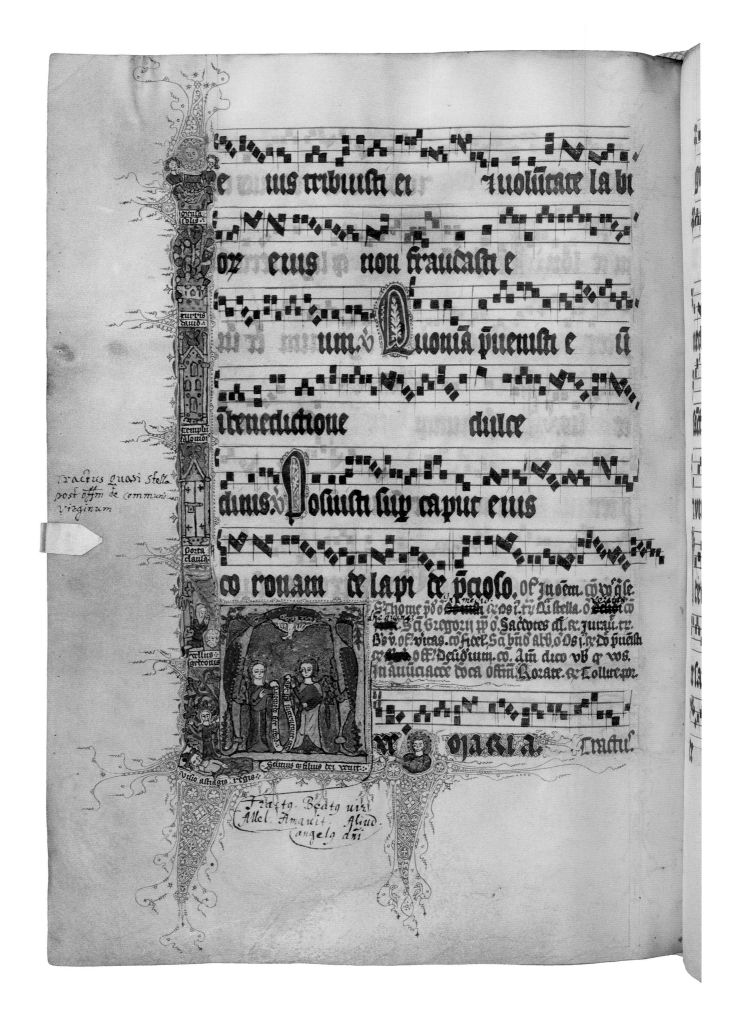

169. Annunciation, gradual, ca. 1380.
ULB Dusseldorf, D 11, p. 391 [vol. I, pp. 524–29]

170. Annunciation, gradual, ca. 1380.
ULB Dusseldorf, D 11, p. 392 [vol. I, p. 528]

GRADUAL, ULB DUSSELDORF, D 11 | 265

171. Tibertius and Valerianius; George, gradual, ca. 1380.
ULB Dusseldorf, D 11, p. 393 [vol. I, pp. 653–54]

172. Peter Martyr, gradual, ca. 1380.
ULB Dusseldorf, D 11, p. 395 [vol. I, pp. 507, 654]

GRADUAL, ULB DUSSELDORF, D 11 | 267

173. Philip and James, gradual, ca. 1380.
ULB Dusseldorf, D 11, p. 396 [vol. I, p. 655]

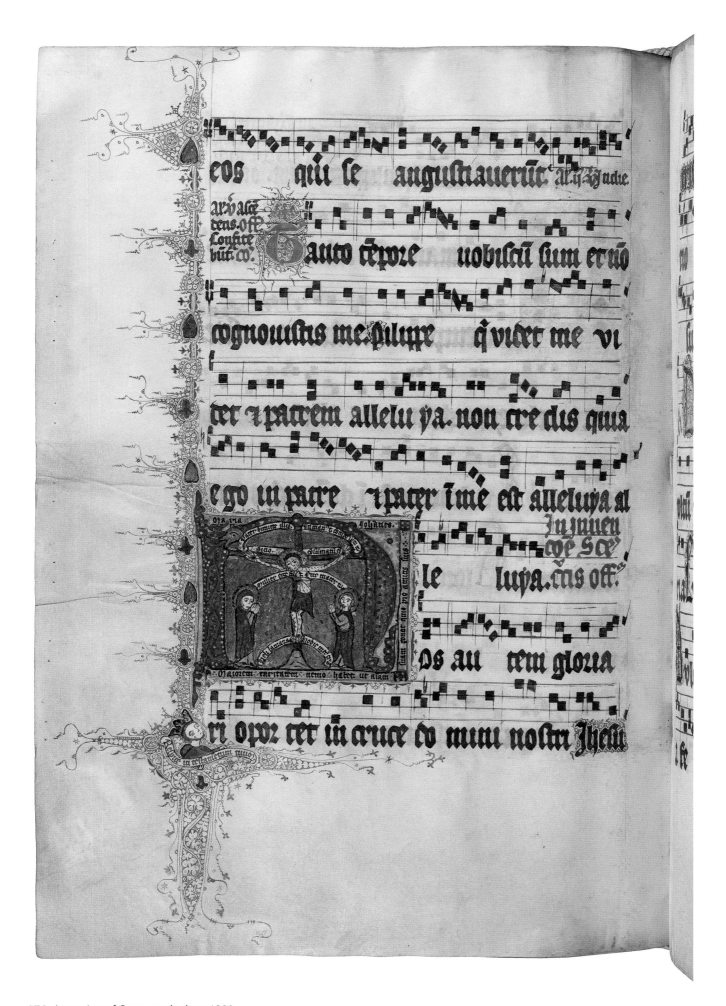

174. Invention of Cross, gradual, ca. 1380.
ULB Dusseldorf, D 11, p. 397 [vol. I, pp. 265–66, 655]

175. Invention of Cross, gradual, ca. 1380.
ULB Dusseldorf, D 11, p. 398 [vol. I, pp. 656–60]

Per lignū serui facti sumus. ꞇ y sat tam crucem liberati su mus. fructus ar boris sedu rit nos. Filius dei redemit nos alle tē rī luya. ne offi. In die Spi nee Coro Gaudeamus omis in dō mī no. diem festum celebrantes sub hono re corone comūi. de cuius solēpnita te gaudent ange li. ꞇ collaudant filium

176. Crown of Thorns, gradual, ca. 1380.
ULB Dusseldorf, D 11, p. 400 [vol. I, pp. 661–63]

177. Crown of Thorns, gradual, ca. 1380.
ULB Dusseldorf, D 11, p. 401 [vol. I, pp. 661–63]

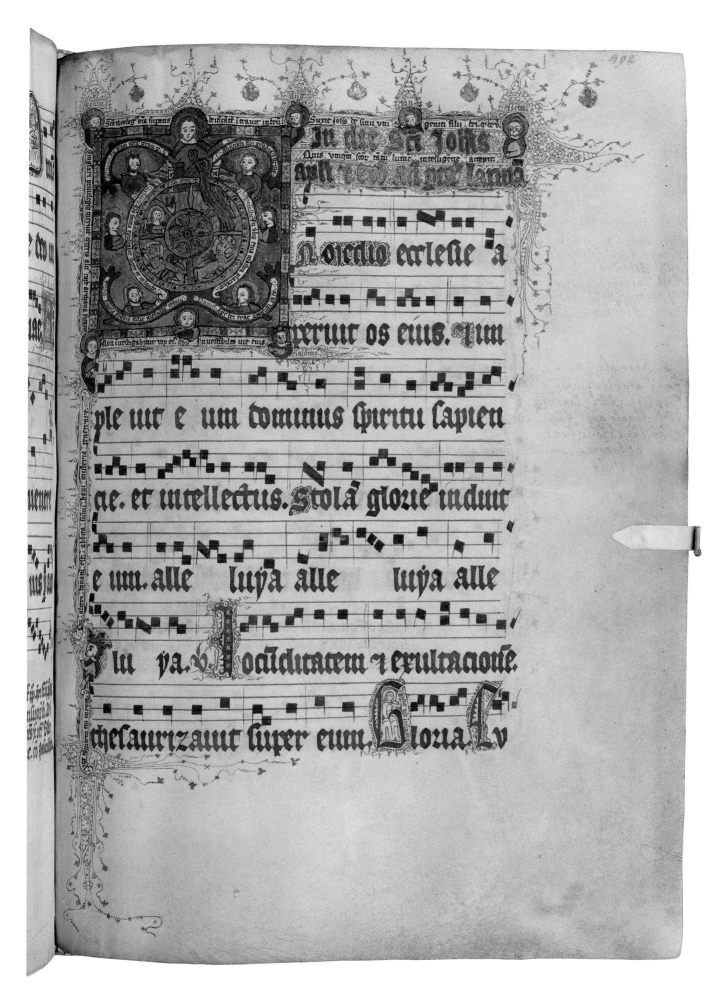

178. John the Evangelist before the Latin Gate, gradual, ca. 1380.
ULB Dusseldorf, D 11, p. 402 [vol. I, pp. 601–02, 6145–15]

GRADUAL, ULB DUSSELDORF, D 11 | 273

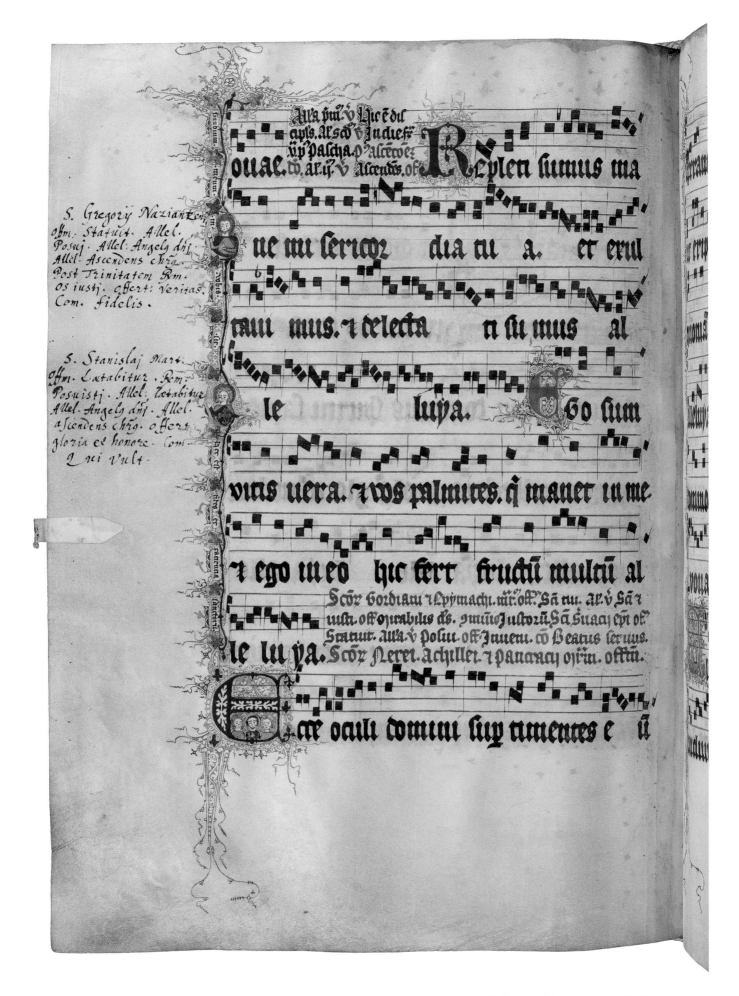

179. Nereus, Achilleus, and Pancratius, gradual, ca. 1380.
ULB Dusseldorf, D 11, p. 403 [vol. I, pp. 614, 663]

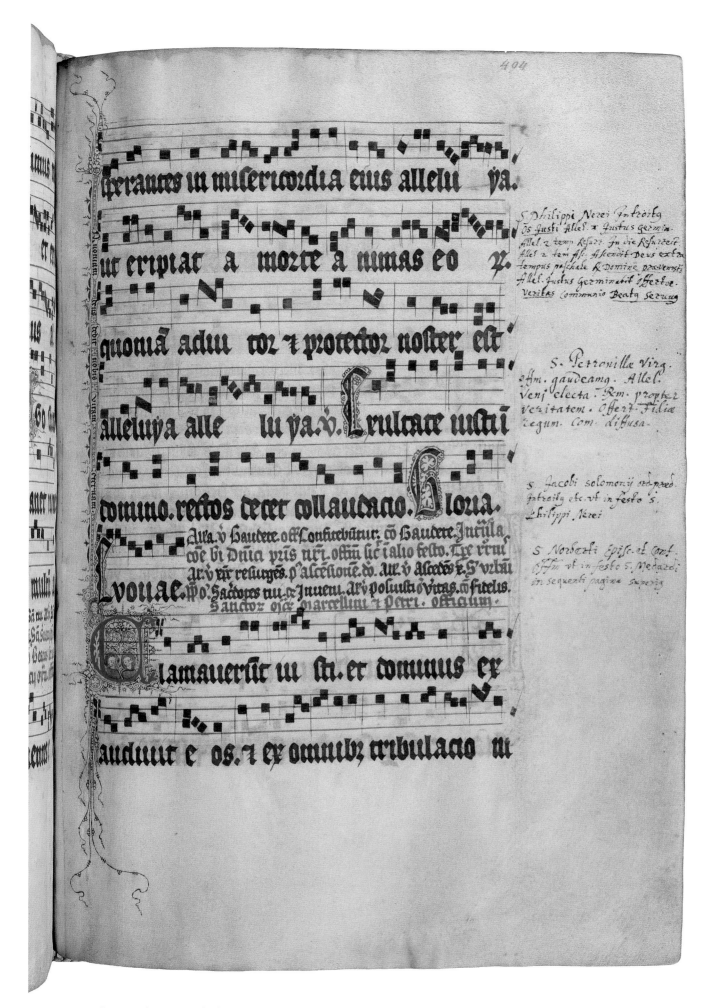

180. Marcellinus and Peter, gradual, ca. 1380.
ULB Dusseldorf, D 11, p. 404 [vol. I, p. 663]

GRADUAL, ULB DUSSELDORF, D 11 | 275

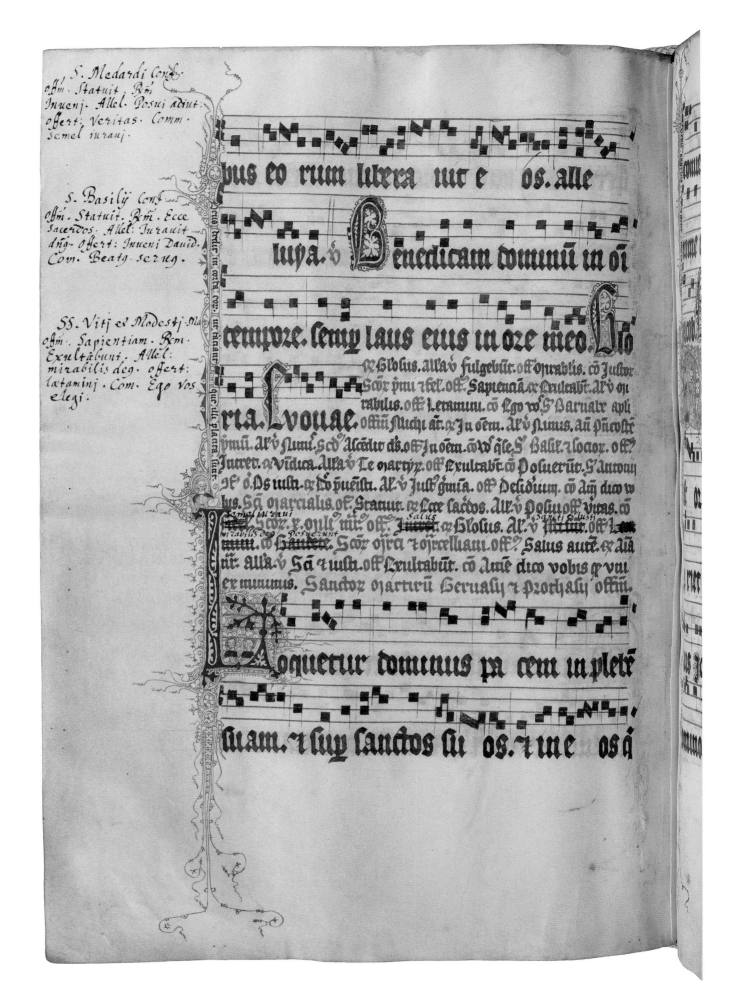

181. Gervasius and Prothasius, gradual, ca. 1380.
ULB Dusseldorf, D 11, p. 405 [vol. I, p. 665]

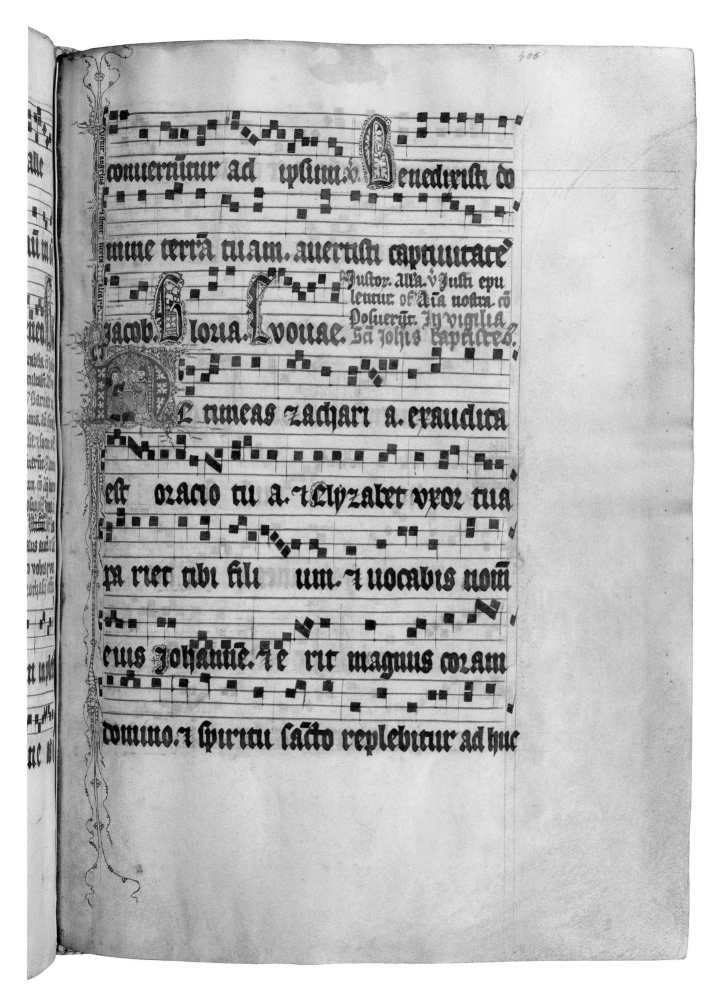

182. John the Baptist: Nativity, vigil, gradual, ca. 1380.
ULB Dusseldorf, D 11, p. 406 [vol. I, pp. 665–66]

183. John the Baptist: Nativity, vigil, gradual, ca. 1380.
ULB Dusseldorf, D 11, p. 407 [vol. I, pp. 665–66]

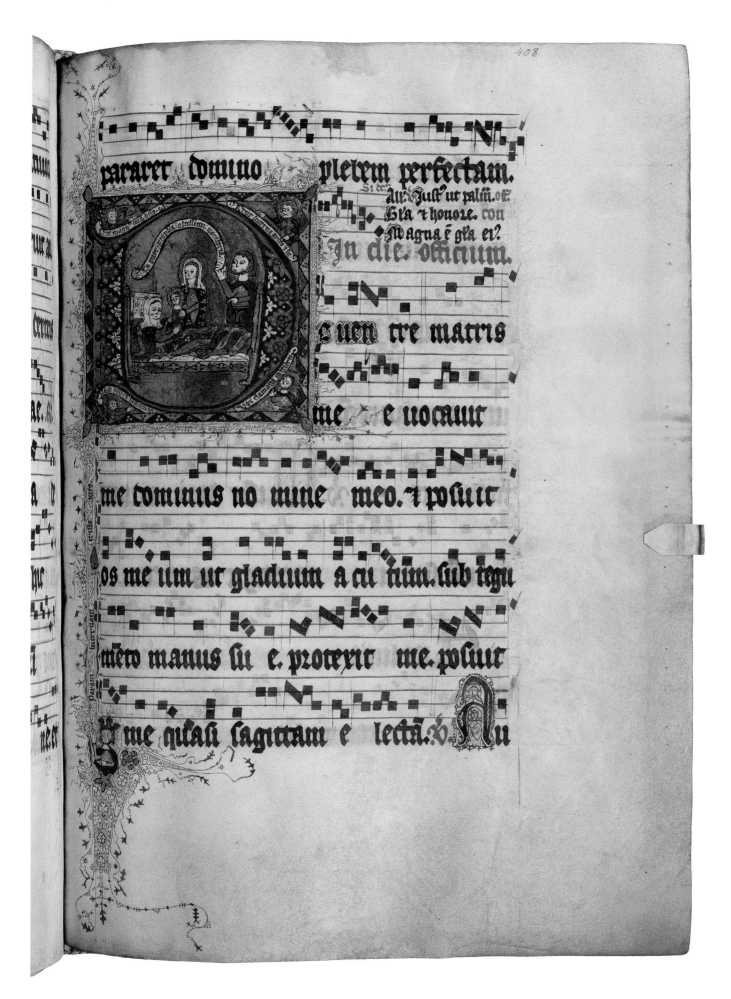

pararet dominio · plebem perfectam.

Si dr̃ · Iust̃ ut palm̃. off·

Gł̃a ꝛ honoꝛe. con

Magna ē gł̃a ei?

Iu die· officium.

S uen ꝛe matris

me e uocauit

me dominus no mine meo. ꝛ posuit

os meum ut gladium a cu tum. sub tegu

mēto manus sue. proterit me. posuit

me qsi sagittam e lectã. ꝺ Nu

184. John the Baptist: Nativity, gradual, ca. 1380.
ULB Dusseldorf, D 11, p. 408 [vol. I, pp. 274, 666–667]

GRADUAL, ULB DUSSELDORF, D 11 | 279

185. John and Paul, gradual, ca. 1380.
ULB Dusseldorf, D 11, p. 410 [vol. I, p. 669]

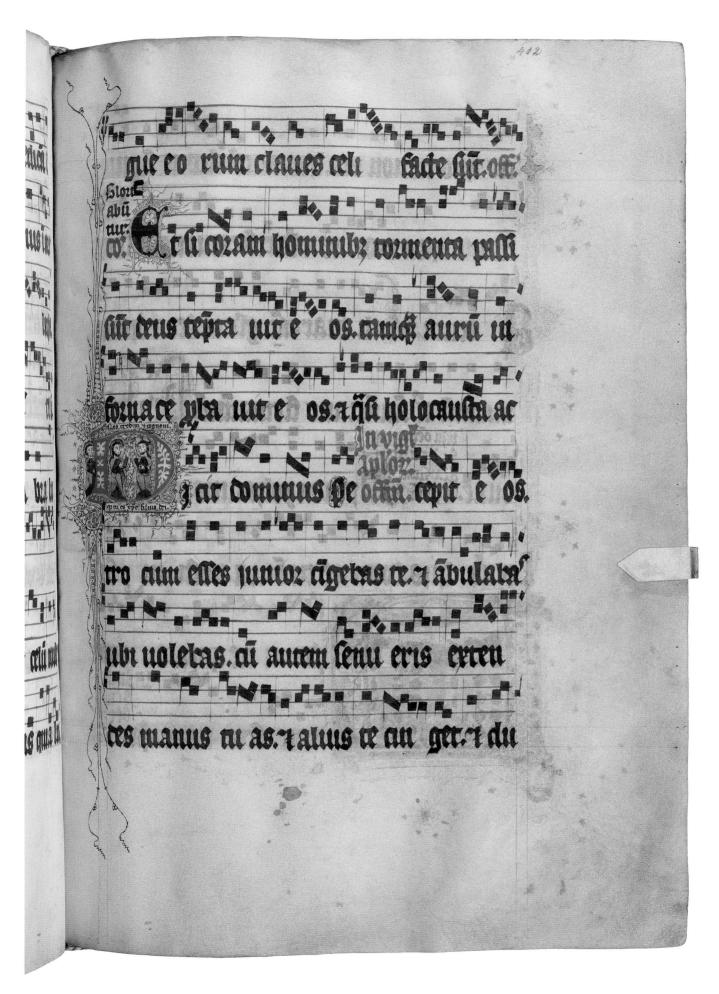

186. Peter and Paul: vigil, gradual, ca. 1380.
ULB Dusseldorf, D 11, p. 412 [vol. I, pp. 669–70]

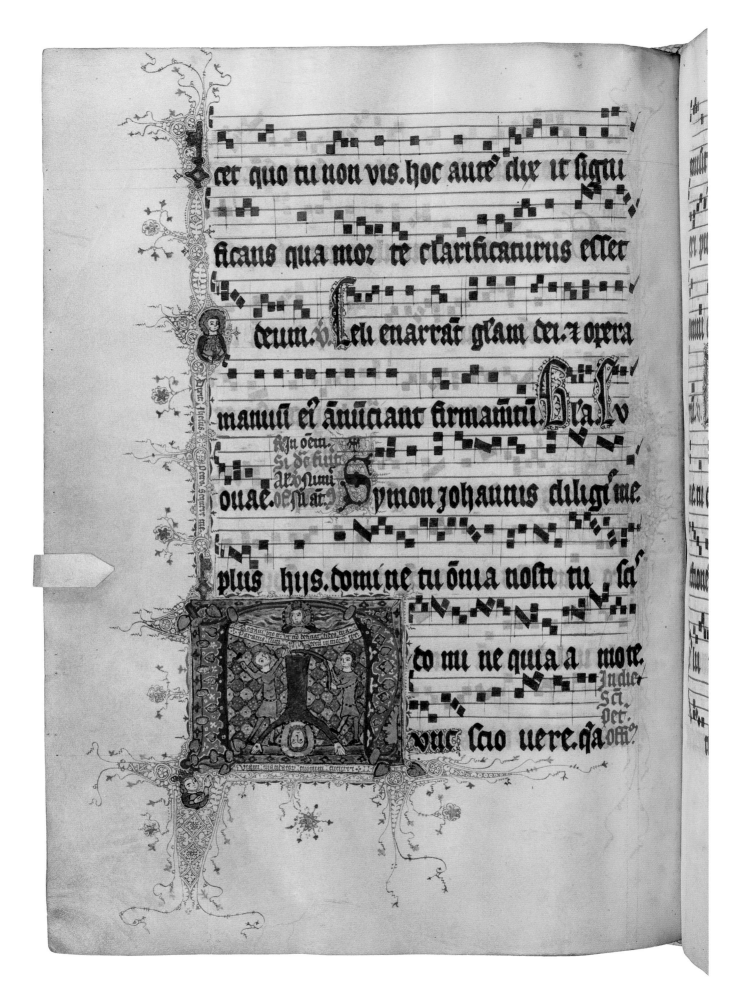

187. Peter and Paul, gradual, ca. 1380.
ULB Dusseldorf, D 11, p. 413 [vol. I, pp. 670–71]

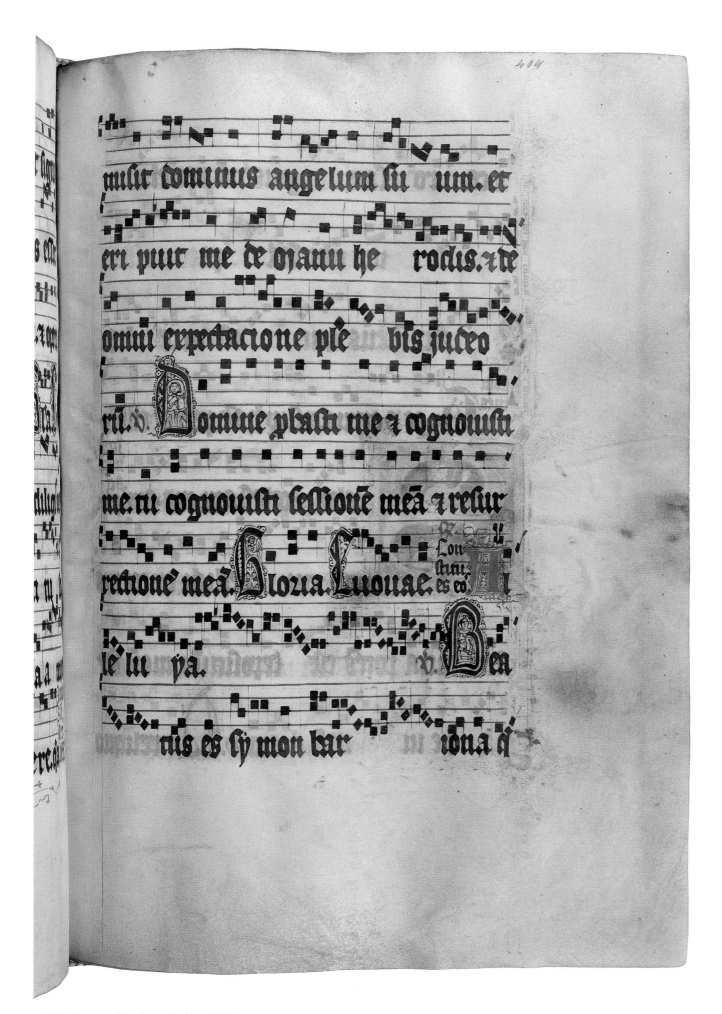

188. Peter and Paul, gradual, ca. 1380.
ULB Dusseldorf, D 11, p. 414 [vol. I, pp. 670–71]

GRADUAL, ULB DUSSELDORF, D 11 | 283

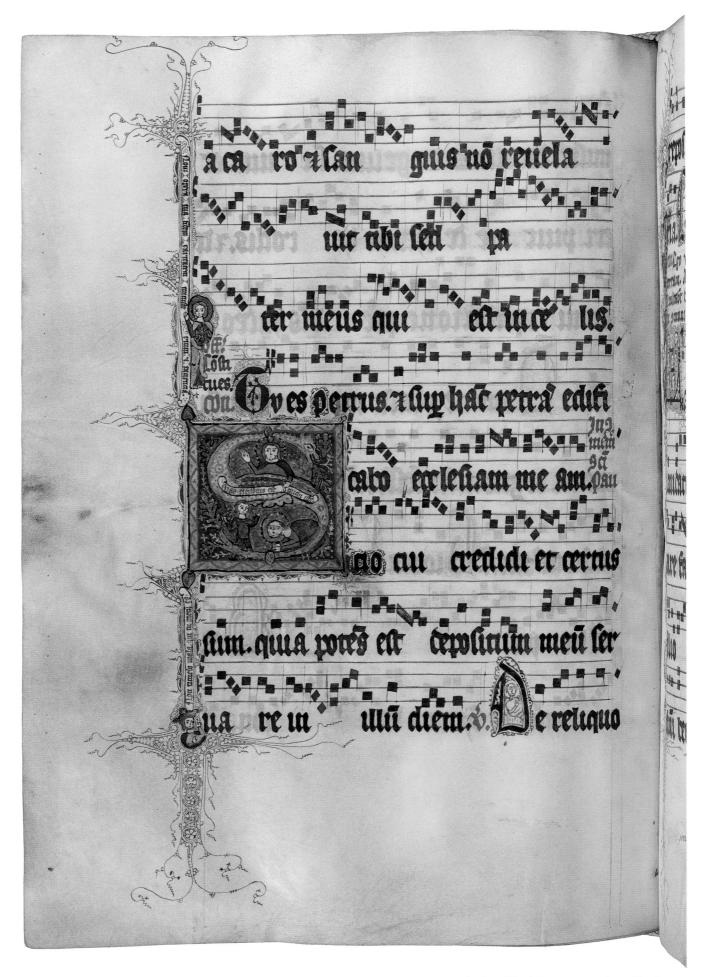

189. Paul and Paul; Commemoration of Paul, gradual, ca. 1380. ULB Dusseldorf, D 11, p. 415 [vol. I, pp. 670–71, 673–74]

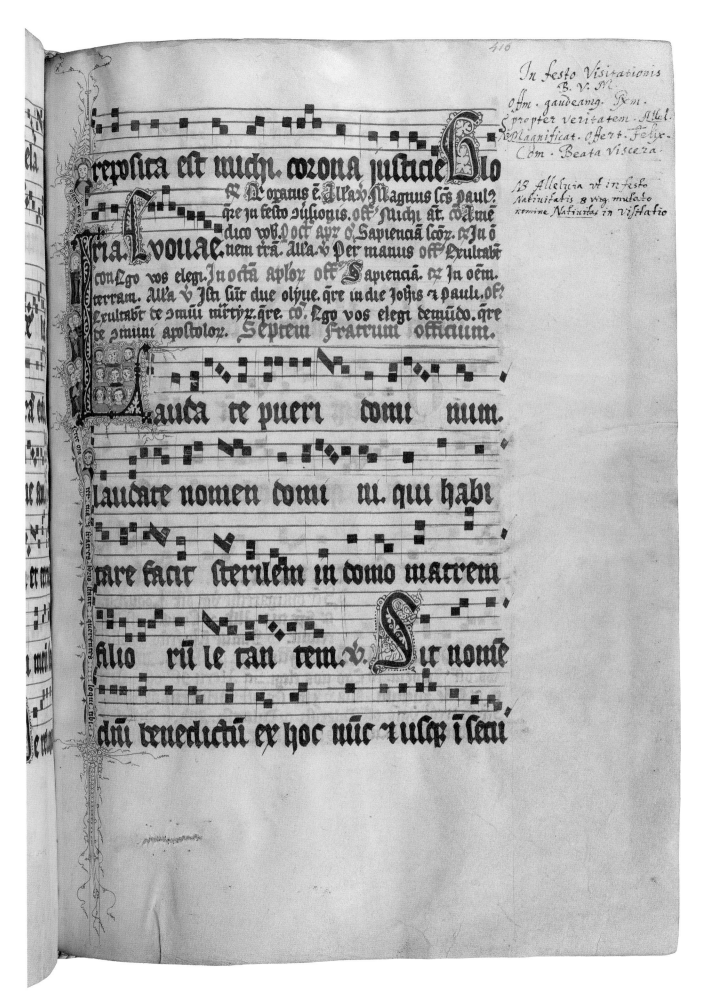

190. Seven Brothers, gradual, ca. 1380.
ULB Dusseldorf, D 11, p. 416 [vol. I, pp. 674–75]

GRADUAL, ULB DUSSELDORF, D 11 | 285

191. Mary Magdalen, gradual, ca. 1380.
ULB Dusseldorf, D 11, p. 418 [vol. I, pp. 681–82]

tres eius. or Sacdotes. Alr v Dilpolui. off Letamini. cō Iustoz. Icō ozate
Alōr Senes oz. Intret. or Glolus. Alr Te ozittyz. off Ozirabil. cō Poluerūt.
Sā ſmal epi. off Statuit. oz Inuēi tū. Alr v Polui. off Vitas. cō Semel iu.
In felto ſā Pet ad vīcla. offiū. Nō ſcio ſicut i alio felto. v Conſtitues

Alle lu ya.

v Sol iie iubente deo terrā

rum Pe tre cathe nas.

qui fa as ut pateaut ce

lefti a reg na bea tis.

Off. Conſtitues eos. Smu Tu es petrus. Quere in alio felto.
Sā Stephāi pp ꝫmūris. offiū Sacerdotes eius. oz Os iusti. Alr.
v Amauit.eū off z Inueni dī. cō Dūe quīꝗ talenta. In
muencōe Sā Stephāi pthomūris off Et enī federunt. ꝟ
Federūt pūcipes. Alla. v Video tot licut i alio felto. off In uute.
cō video celos. In felto billimi dominica Almu gſl. officū.

193. Dominic, gradual, ca. 1380.
ULB Dusseldorf, D 11, p. 420 [vol. I, pp. 508–12]

194. Dominic, gradual, ca. 1380.
ULB Dusseldorf, D 11, p. 421 [vol. I, p. 512]

GRADUAL, ULB DUSSELDORF, D 11 | 289

195. Lawrence: vigil, gradual, ca. 1380.
ULB Dusseldorf, D 11, p. 422 [vol. I, pp. 685–86]

196. Lawrence, gradual, ca. 1380.
ULB Dusseldorf, D 11, p. 424 [vol. I, pp. 686–87]

197. Assumption of Virgin, gradual, ca. 1380.
ULB Dusseldorf, D 11, p. 426 [vol. I, p. 530]

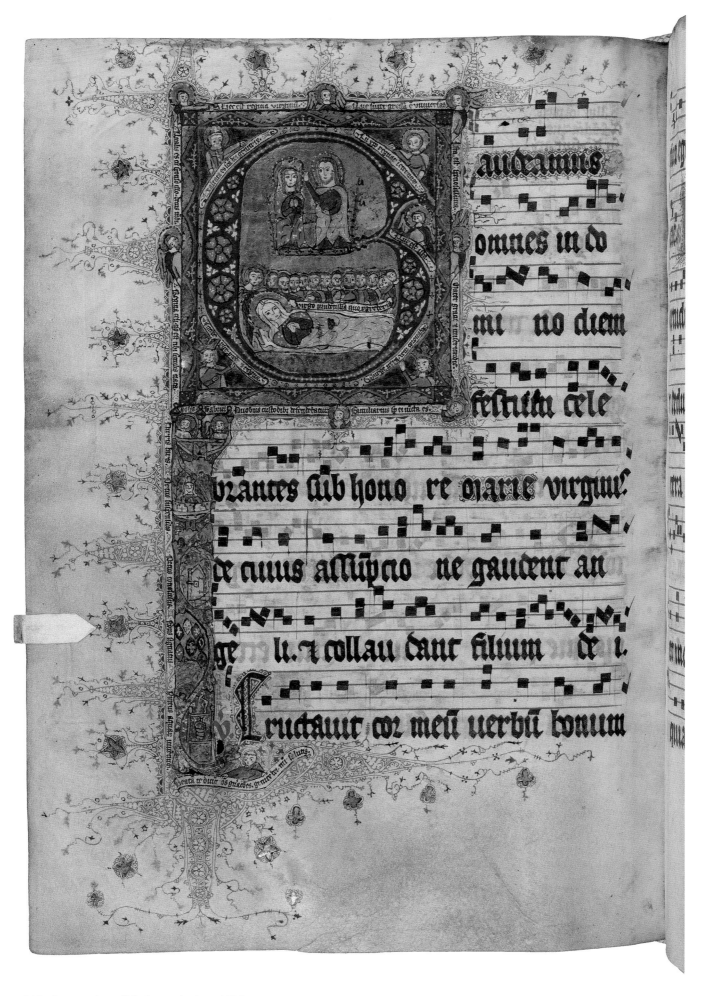

198. Assumption of Virgin, gradual, ca. 1380.
ULB Dusseldorf, D 11, p. 427 [vol. I, pp. 62, 531–40, 747]

199. Assumption of Virgin, gradual, ca. 1380.
ULB Dusseldorf, D 11, p. 428 [vol. I, p. 540]

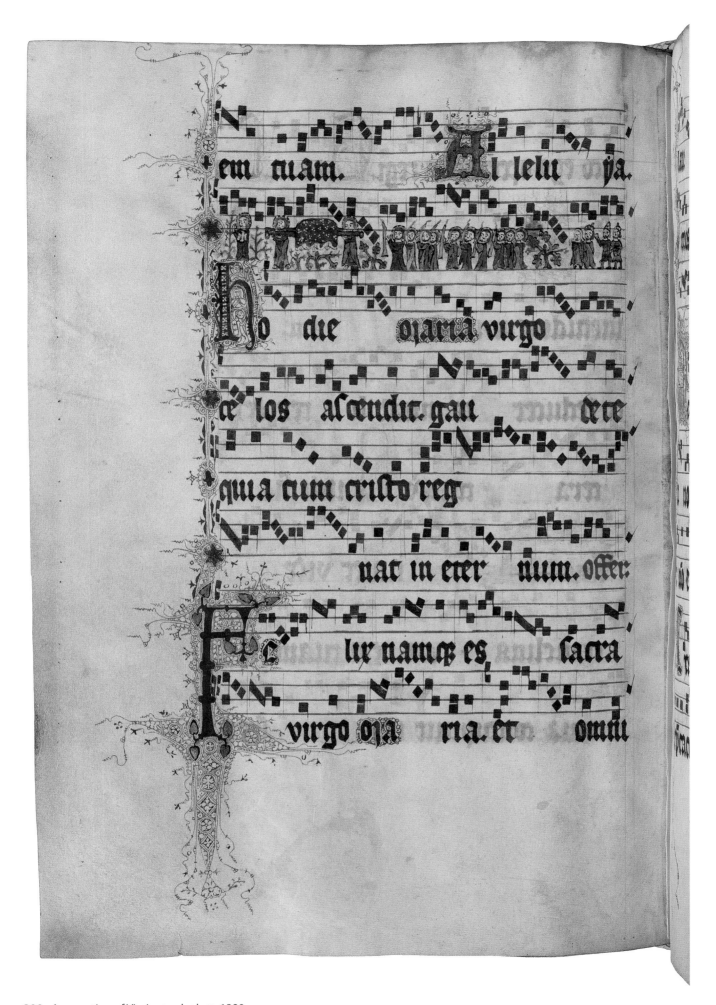

200. Assumption of Virgin, gradual, ca. 1380.
ULB Dusseldorf, D 11, p. 429 [vol. I, p. 541]

GRADUAL, ULB DUSSELDORF, D 11 | 295

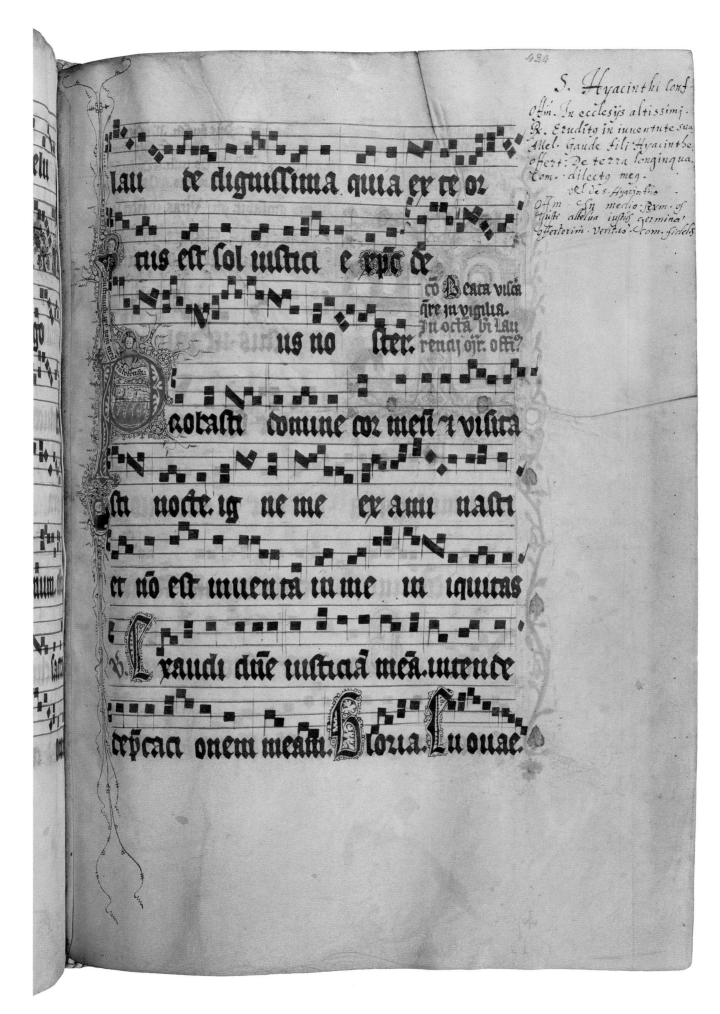

201. Lawrence: octave, gradual, ca. 1380.
ULB Dusseldorf, D 11, p. 430 [vol. I, p. 687]

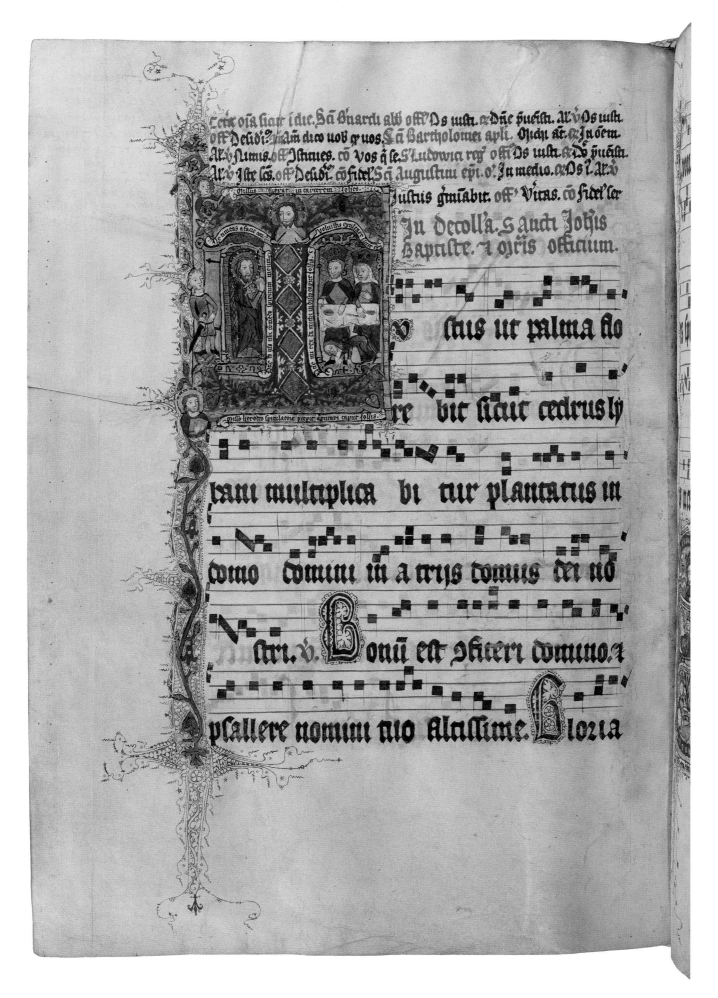

ceta oia fiat i die. Sa Bnardi alb off' Os iusti. cz Due fuesti. Ar'b Os iusti. off Desidi. nam dico uob gz uos. Sa Bartholomei apli. Osidi fit. cz In oem. Ar'b Nimis. off Ihanes. cõ Vos q se. S' Ludouici reg' off Os iusti. cz Do fuesti. Ar'b Iste scs. off Desidi. cõ fidel'. Sa Augustini epi. o'. In medio. cz Os l. Ar'b Iustus gmiabit. off' Vitas. cõ fidel' ser

In decolla. Sancti Iohis Baptiste. z oris officium.

Nctus ut palma flo

re bit sicut cedrus ly

bani multiplica bi tur plantatus in

domo domini in a triis domus dei nõ

stri. V. Bonum est sfiteri domino. z

psallere nomini tio Altissime. Gloria

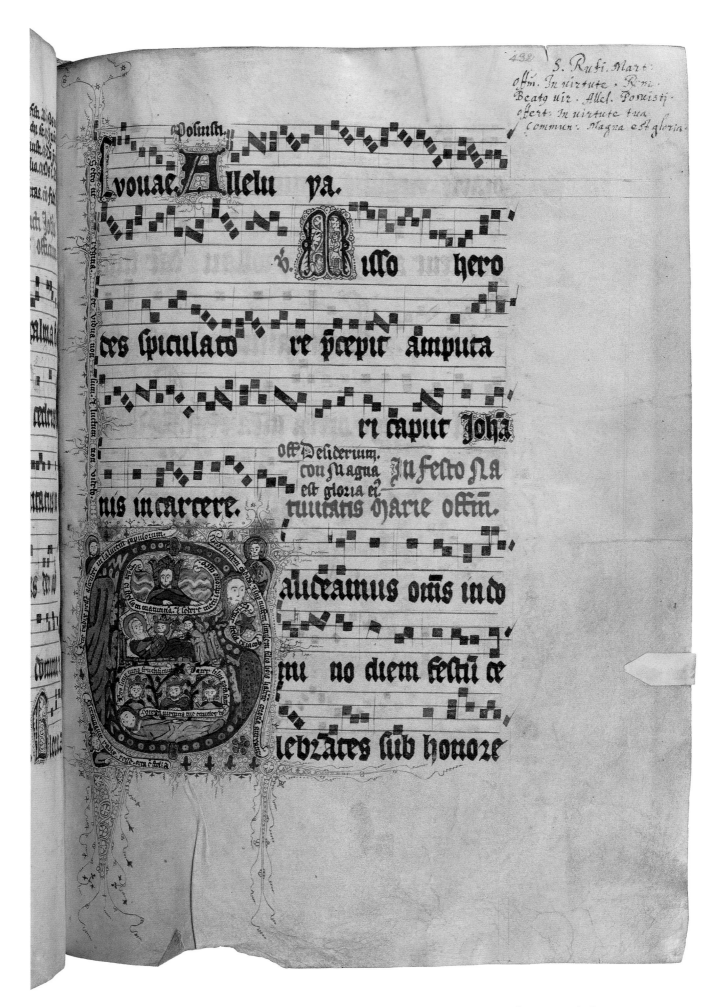

203. Nativity of Virgin, gradual, ca. 1380.
ULB Dusseldorf, D 11, p. 432 [vol. I, pp. 547–48]

204. Nativity of Virgin, gradual, ca. 1380.
ULB Dusseldorf, D 11, p. 433 [vol. I, p. 548]

205. Invention of Cross, gradual, ca. 1380.
ULB Dusseldorf, D 11, p. 434 [vol. I, p. 692]

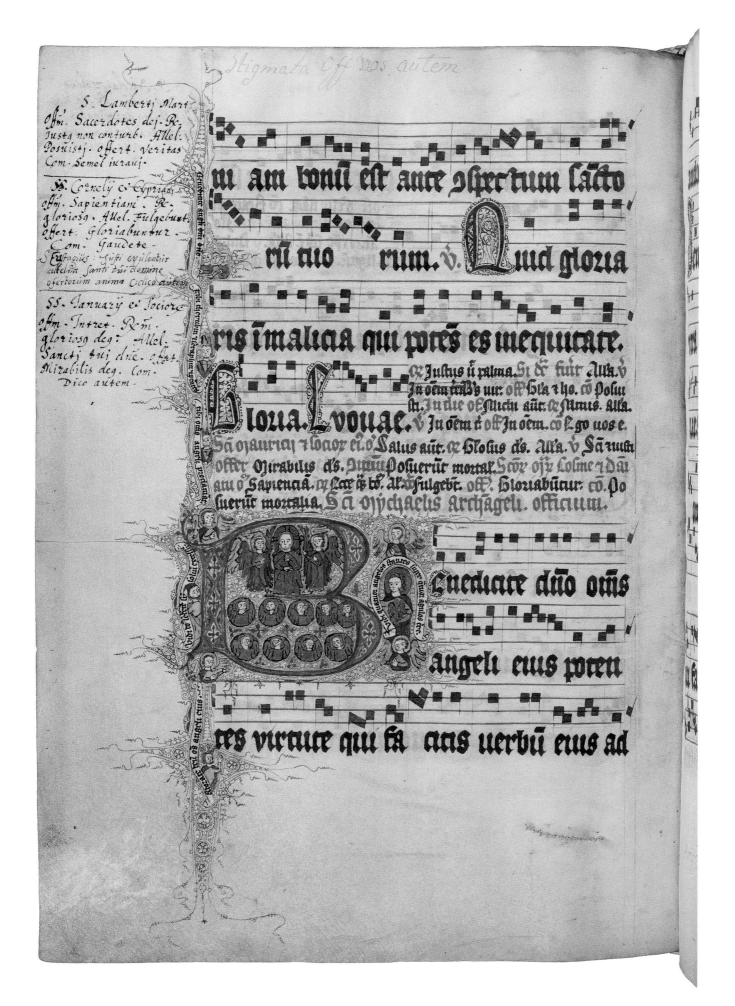

206. Matthew; archangel Michael, gradual, ca. 1380.
ULB Dusseldorf, D 11, p. 435 [vol. I, pp. 692–93]

GRADUAL, ULB DUSSELDORF, D 11 | 301

207. Archangel Michael, gradual, ca. 1380.
ULB Dusseldorf, D 11, p. 436 [vol. I, p. 693]

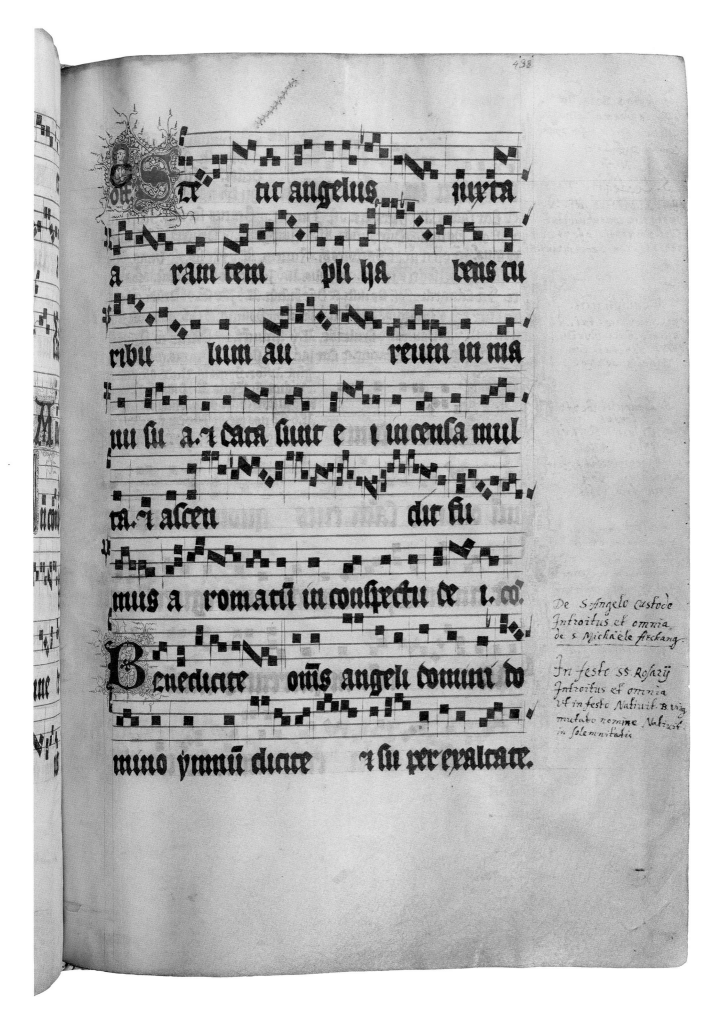

208. Archangel Michael, gradual, ca. 1380.
ULB Dusseldorf, D 11, p. 438 [vol. I, p. 693]

GRADUAL, ULB DUSSELDORF, D 11 | 303

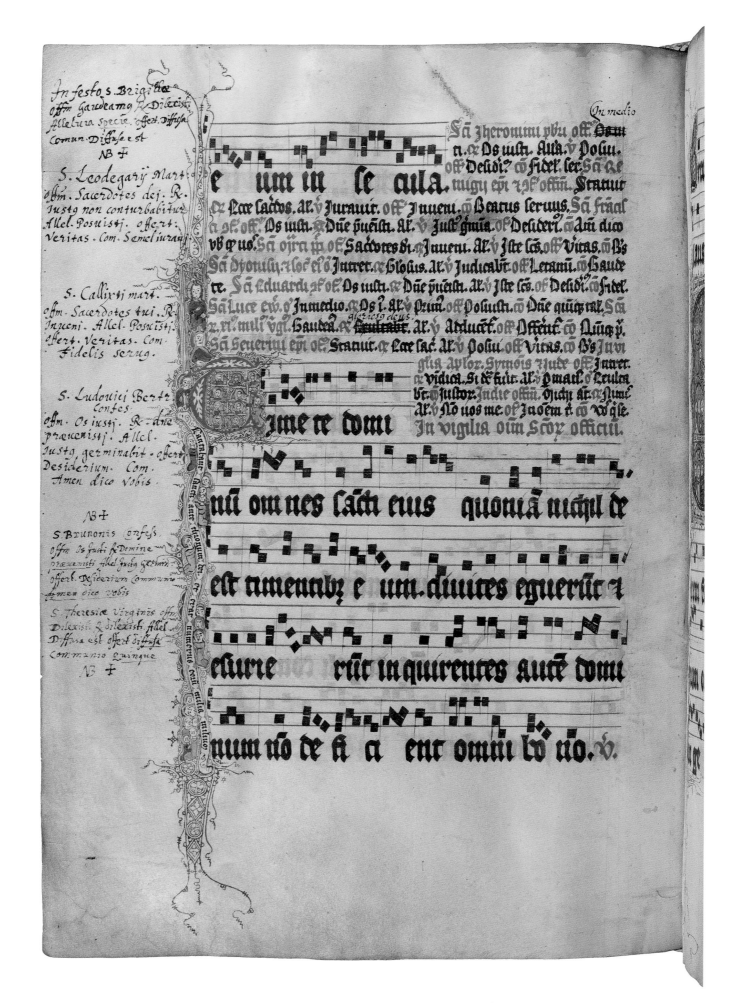

209. All Saints: vigil, gradual, ca. 1380.
ULB Dusseldorf, D 11, p. 439 [vol. I, p. 696]

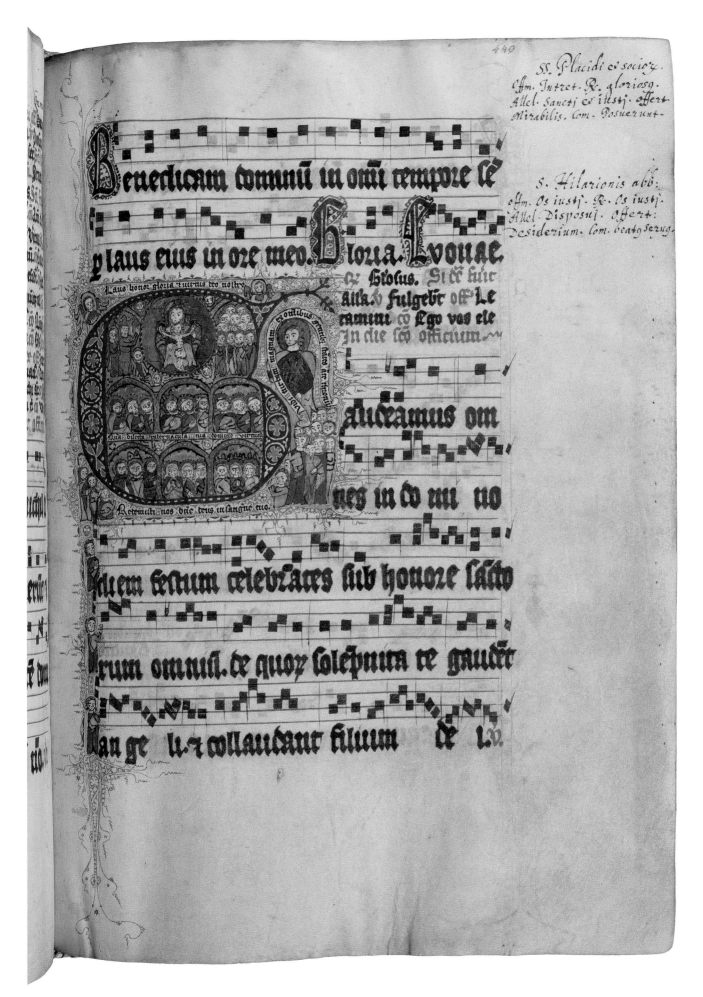

210. All Saints, gradual, ca. 1380.
ULB Dusseldorf, D 11, p. 440 [vol. I, pp. 696–97]

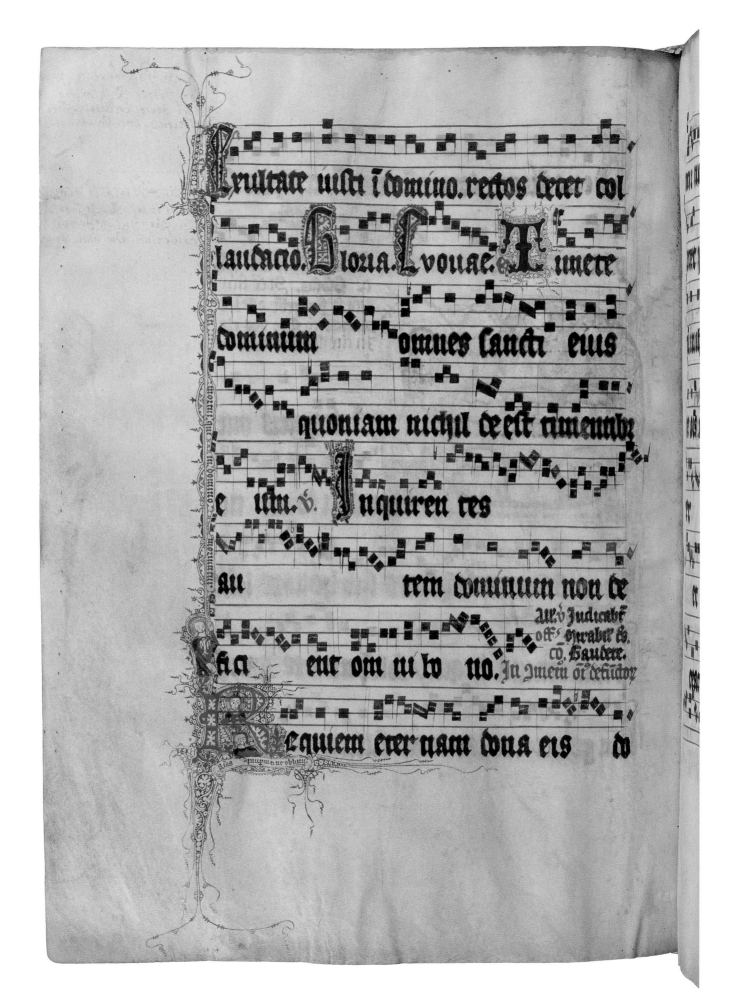

211. All Souls, gradual, ca. 1380.
ULB Dusseldorf, D 11, p. 441 [vol. I, pp. 698–99]

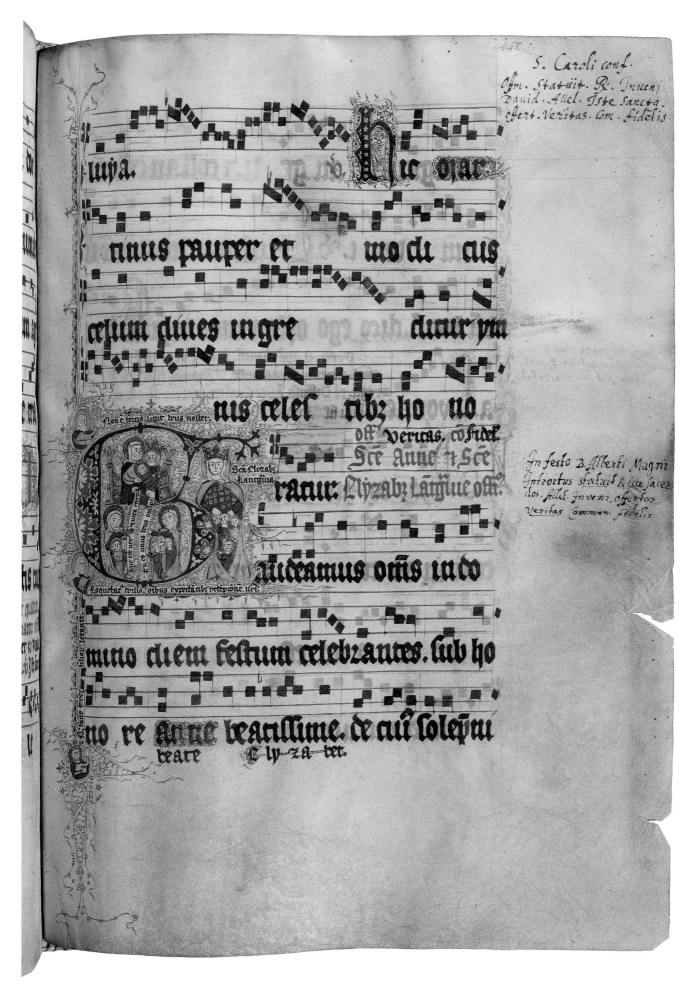

luya.

Nic orat

rinus pauper et modicus

celum ciuies ingre ditur pri

nis celes tibz ho no

Off. Veritas. cofidel.
Sce Anne 7 Sce

ratur. Elyzabz Latgsiue off.

audeamus oms in co

mino diem festum celebrantes. sub ho

no re Anne beatissime. de cui solepni
beate Elyzabet

212. Martin; Anne; Elisabeth of Thuringia, gradual, ca. 1380.
ULB Dusseldorf, D 11, p. 448 [vol. I, pp. 699–701]

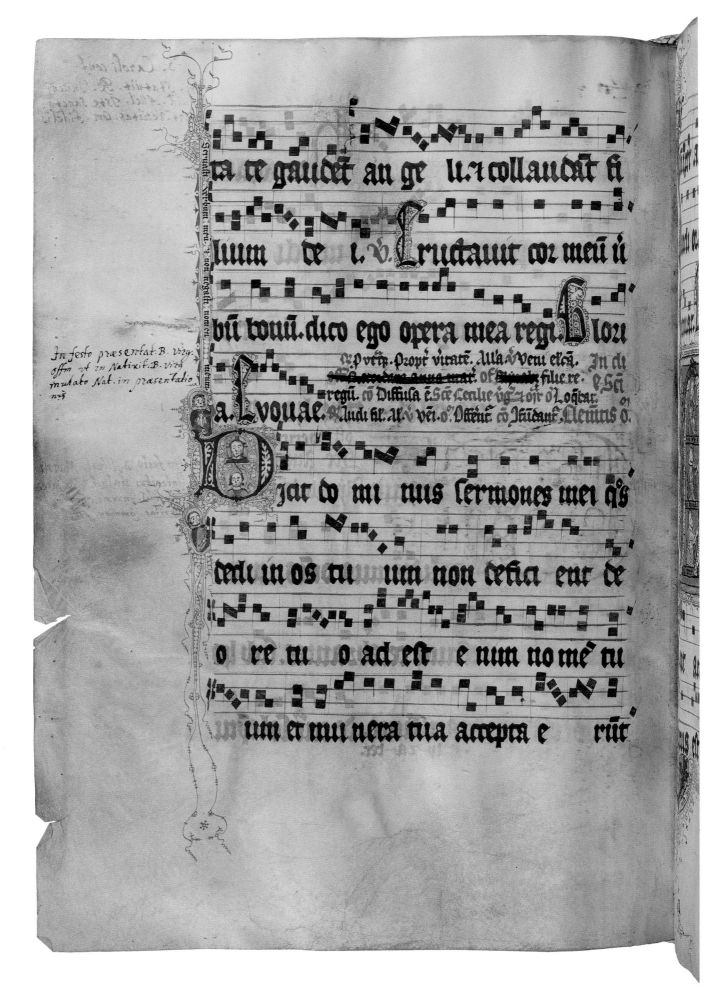

213. Clement, gradual, ca. 1380.
ULB Dusseldorf, D 11, p. 449 [vol. I, p. 701]

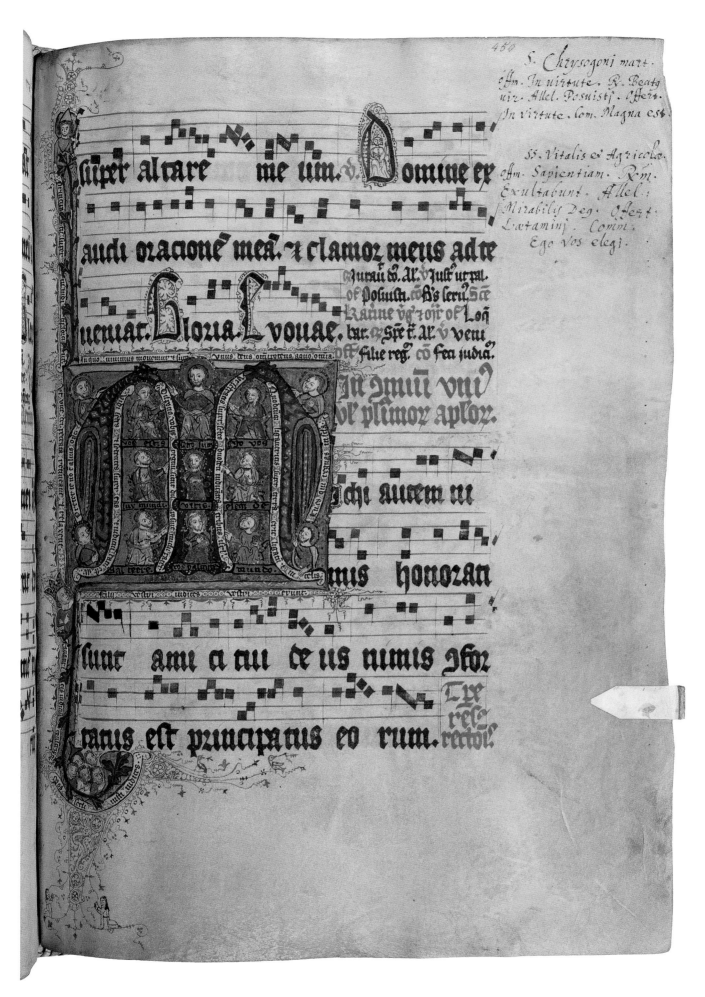

214. Common of one or more apostles, gradual, ca. 1380.
ULB Dusseldorf, D 11, p. 450 [vol. I, pp. 247–48, 701, 703–704, 753]

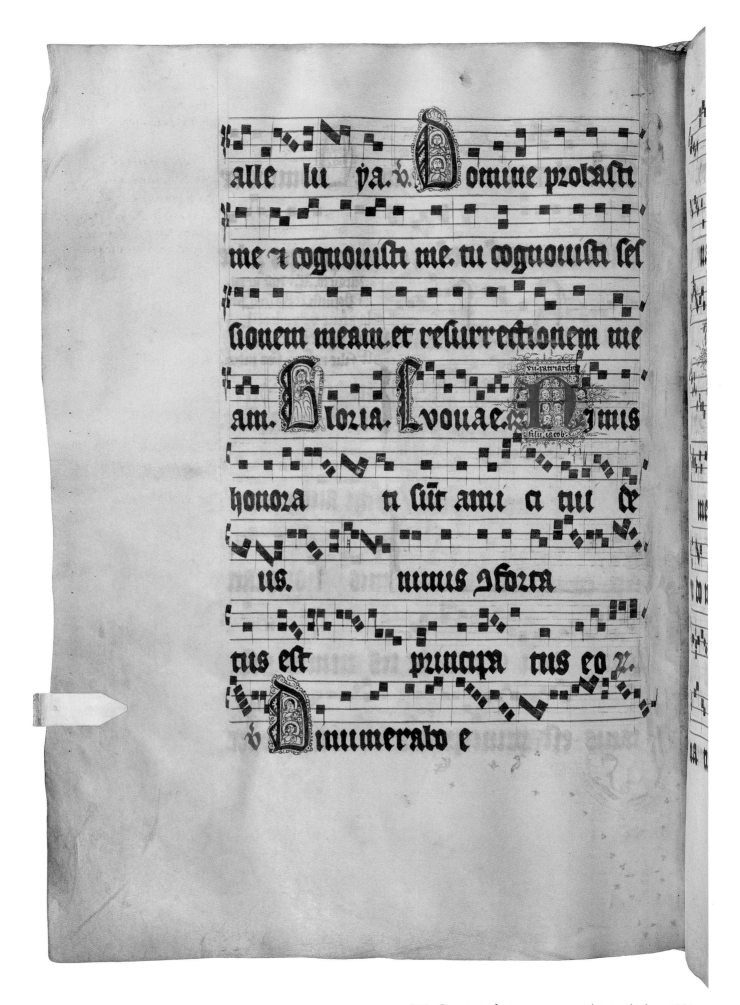

215. Common of one or more apostles, gradual, ca. 1380.
ULB Dusseldorf, D 11, p. 451 [vol. I, pp. 703, 707]

os. ꝛ ſu y are

ram multa plicabuii tur:

Cõſtitu es eos principes

ſuper omnem terram.

me mo res e runt no mini

tu do mine. ꝛo pa

na ꞇ ꞇ ſũt ꞇ ꝟt fi lij. ꝓopter

216. Common of one or more apostles, gradual, ca. 1380.
ULB Dusseldorf, D 11, p. 452 [vol. I, pp. 703, 707]

217. Common of one or more apostles, gradual, ca. 1380.
ULB Dusseldorf, D 11, p. 453 [vol. I, pp. 704, 707]

218. Common of one or more apostles, gradual, ca. 1380.
ULB Dusseldorf, D 11, p. 454 [vol. I, pp. 704, 707]

219. Common of one or more apostles, gradual, ca. 1380.
ULB Dusseldorf, D 11, p. 455 [vol. I, pp. 704, 707]

221. Common of one or more apostles, gradual, ca. 1380.
ULB Dusseldorf, D 11, p. 457 [vol. I, pp. 704–707]

222. Common of one or more apostles, gradual, ca. 1380.
ULB Dusseldorf, D 11, p. 458 [vol. I, pp. 248, 704–707]

GRADUAL, ULB DUSSELDORF, D 11 | 317

223. Common of martyr, gradual, ca. 1380.
ULB Dusseldorf, D 11, p. 459 [vol. I, pp. 714–15]

In virtute tua a domine letabi tur iu

ctus. et sur per salutare tuum um exul

tabit vehementer desiderium anime

e ius tribui sti ei. V. Quoniam

preuenisti eu in benedictionibz dulcedi

nis. posuisti in capite eius coronam de la

pide precioso. Sta. Luouae. V Posuisti
co mine su per ca put e

224. Common of martyr, gradual, ca. 1380.
ULB Dusseldorf, D 11, p. 460 [vol. I, p. 715]

GRADUAL, ULB DUSSELDORF, D 11 | 319

225. Common of martyr, gradual, ca. 1380.
ULB Dusseldorf, D 11, p. 462 [vol. I, p. 715]

deto 2em inpones super e̅ · eum do̅i
ne. *alle te̅ e̅ lu ya. e̅. Posuisti domine
in capite eius coro nam de lapi de
pcei oso. t. e̅ alle luya. e̅. Qui vult ue
nire post me ab neget semetipsu̅. et
tollat cruce̅ sua̅ et sequatur me.
In co̅r plimo̅z o̅ia. o̅m
Intret in conspectu tu o domine ge
mitus conpedito rium. redde uicinis

226. Common of several martyrs, gradual, ca. 1380.
ULB Dusseldorf, D 11, p. 469 [vol. I, pp. 715–716]

227. Common of several saints, gradual, ca. 1380.
ULB Dusseldorf, D 11, p. 470 [vol. I, p. 717]

ecclesi a nomina autem eo r vi

nuit in seculum seculi: alle

lu ya. ☦. Exultate iusti in domino.

rectos decet collaudacio Gloria. Evovae.

Salus autem iusto r a do offer.

mino. et protector eo r est in tempore

tribulac o nis. ☦. Noli emulari

in malignantibz. neq zelaueris faciētes

228. Common of several saints, gradual, ca. 1380.
ULB Dusseldorf, D 11, p. 471 [vol. I, p. 717]

GRADUAL, ULB DUSSELDORF, D 11 | 323

229. Common of several saints, gradual, ca. 1380.
ULB Dusseldorf, D 11, p. 472 [vol. I, p. 717]

230. Common of several saints, gradual, ca. 1380.
ULB Dusseldorf, D 11, p. 473 [vol. I, p. 717]

231. Common of confessor, gradual, ca. 1380.
ULB Dusseldorf, D 11, p. 486 [vol. I, pp. 717, 719]

232. Common of confessor, gradual, ca. 1380.
ULB Dusseldorf, D 11, p. 487 [vol. I, p. 719]

233. Common of confessor, gradual, ca. 1380.
ULB Dusseldorf, D 11, p. 488 [vol. I, p. 719]

234. Common of virgin, gradual, ca. 1380.
ULB Dusseldorf, D 11, p. 501 [vol. I, p. 721]

235. Common of virgin, gradual, ca. 1380.
ULB Dusseldorf, D 11, p. 502 [vol. I, p. 721]

236. Common of virgin, gradual, ca. 1380.
ULB Dusseldorf, D 11, p. 503 [vol. I, pp. 721–22]

237. Thomas Aquinas, gradual, ca. 1380.
ULB Dusseldorf, D 11, p. 515 [vol. I, pp. 515–17]

238. Thomas Aquinas; John the Evangelist: Alleluias, gradual,
ca. 1380. ULB Dusseldorf, D 11, p. 516 [vol. I, pp. 517, 591, 615]

239. Annunciation: sequence, gradual, ca. 1380.
ULB Dusseldorf, D 11, p. 517 [vol. I, pp. 529, 615]

240. Annunciation: sequence, gradual, ca. 1380.
ULB Dusseldorf, D 11, p. 518 [vol. I, pp. 529, 742]

GRADUAL, ULB DUSSELDORF, D 11 | 335

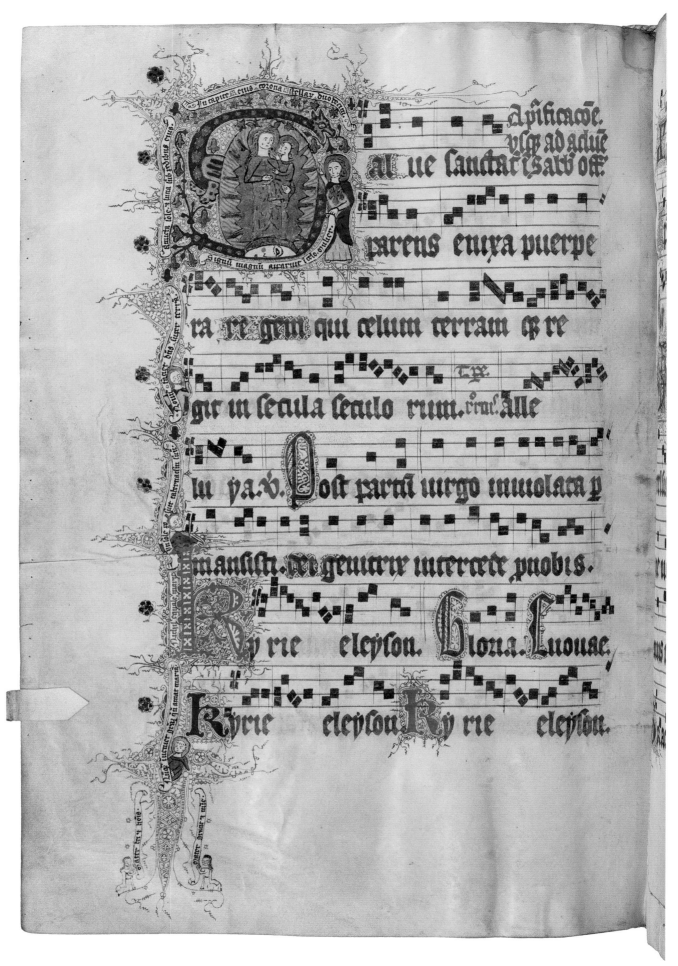

241. Virgin Mary: Saturdays from Presentation to Advent, gradual, ca. 1380. ULB Dusseldorf, D 11, p. 519 [vol. I, p. 551]

242. Virgin Mary: Saturdays from Presentation
to Advent, gradual, ca. 1380. ULB Dusseldorf,
D 11, p. 520 [vol. I, p. 553]

243. Virgin Mary: Saturdays from Presentation
to Advent, gradual, ca. 1380. ULB Dusseldorf,
D 11, p. 522 [vol. I, p. 553]

244. Virgin Mary: Saturdays from Presentation
to Advent, gradual, ca. 1380. ULB Dusseldorf,
D 11, p. 523 [vol. I, p. 553]

245. Christmas: sequence, gradual, ca. 1380.
ULB Dusseldorf, D 11, p. 546 [vol. I, pp. 359, 742]

libz sibilinis uersibz hec predicta. Infelix propera crede uel uetera cur dampnaberis gens misera Quem docet litera natū cō litera ipsum genuit puerpera alleluya scō.

In die

Solempnis Pasche. 7 duobz sequētibz Seq̄n.

Victime paschali laudes. sequētibz Seq̄n.

imolant cristiani. Agnus redemit oues

xp̄c in noceps patri reconsiliauit peccatores.

Mors 7 uita duello conflixere mirando

dux uite mortuus regnat uiuus. Di

246. Easter Sunday: sequence, gradual, ca. 1380.
ULB Dusseldorf, D 11, p. 548 [vol. I, pp. 253, 257]

GRADUAL, ULB DUSSELDORF, D 11 | 341

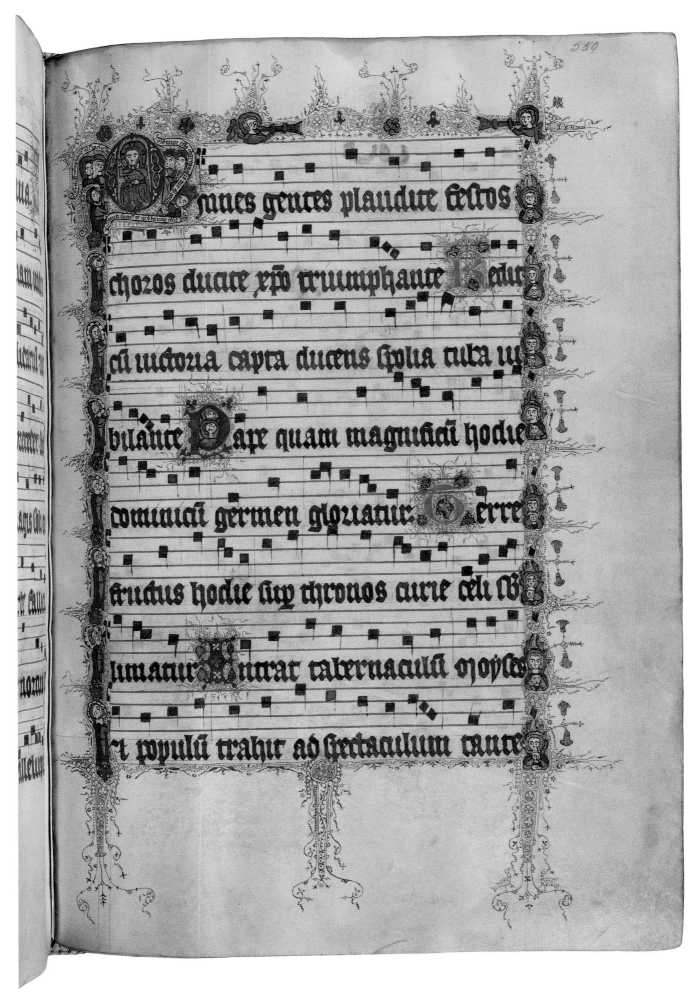

247. Ascension: sequence, gradual, ca. 1380.
ULB Dusseldorf, D 11, p. 550 [vol. I, pp. 237–38, 460–61]

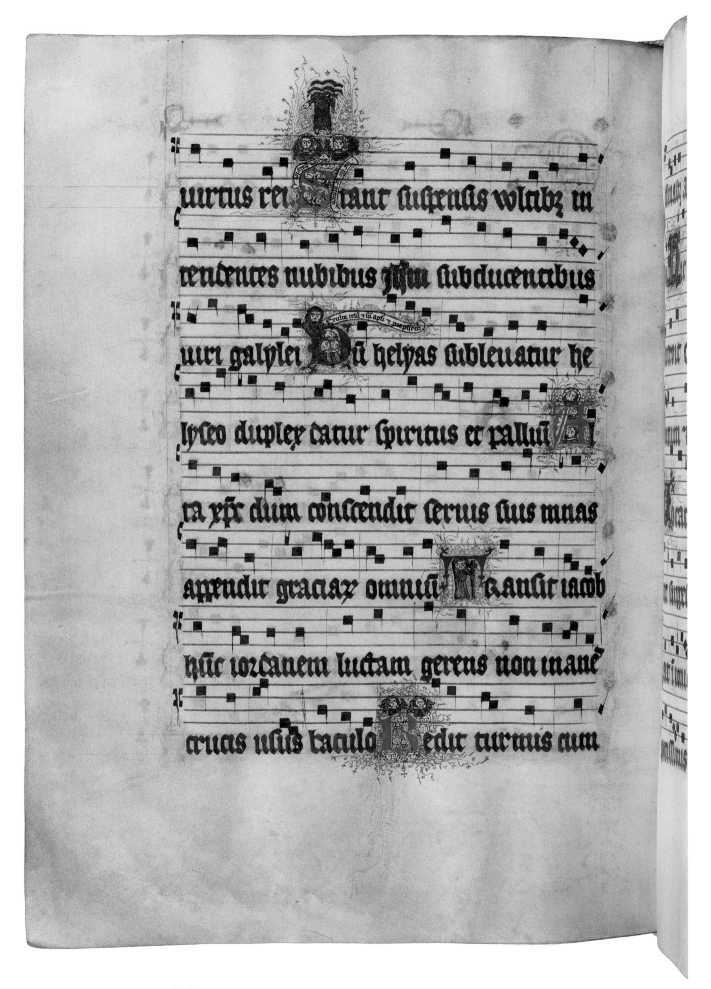

248. Ascension: sequence, gradual, ca. 1380.
ULB Dusseldorf, D 11, p. 551 [vol. I, pp. 238–40, 461–62]

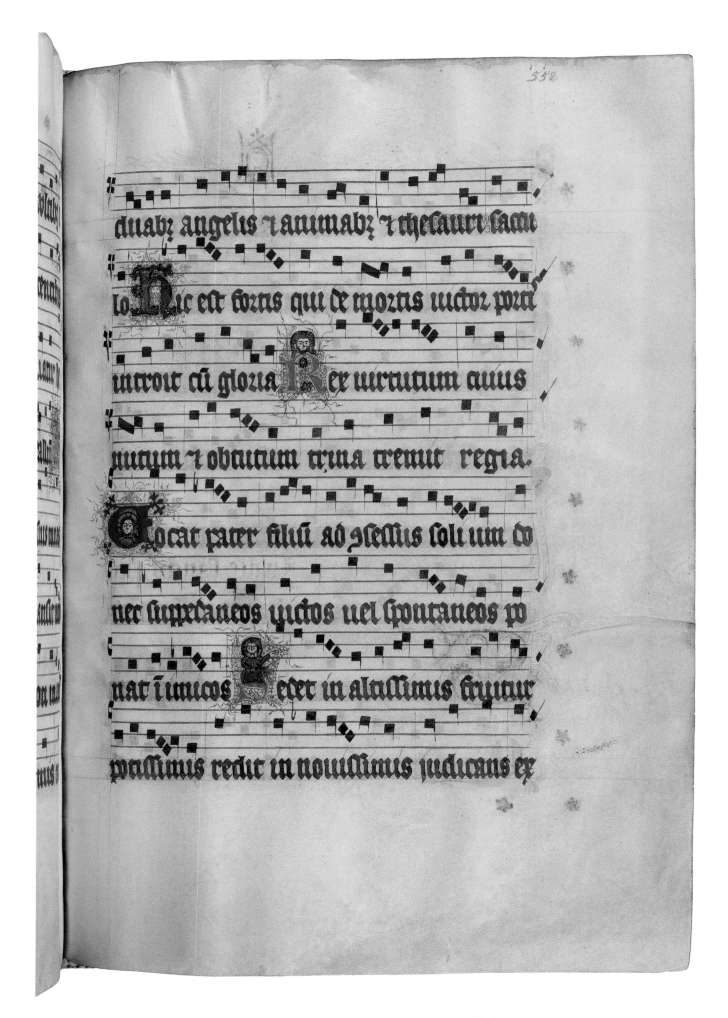

249. Ascension: sequence, gradual, ca. 1380.
ULB Dusseldorf, D 11, p. 552 [vol. I, p. 463]

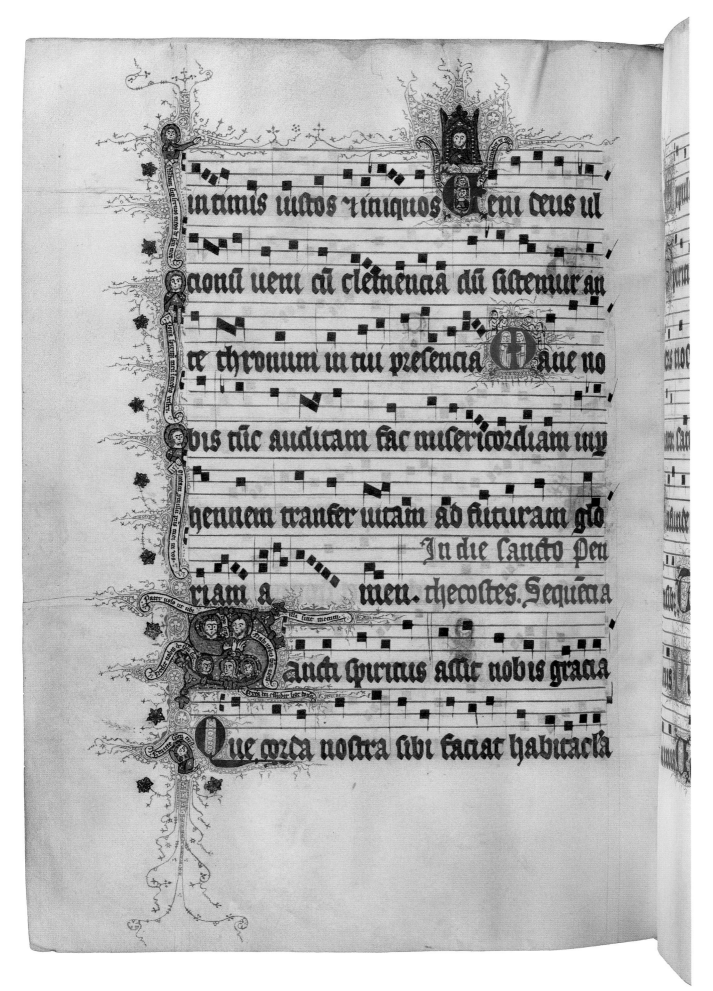

in tannis iustos z iniquos. Cerni deus ul

raonis ueni cu clemenciaa dum sistemur an

te thronum in tui presencia Mane no

bis tunc auditam fac misericordiam my

gennem transfer uitam ad futuram glo

riam a men. thecostes. Sequencia

In die sancto Pen

Sancta spiritus assit nobis gracia

Que corda nostra sibi faciat habitacla

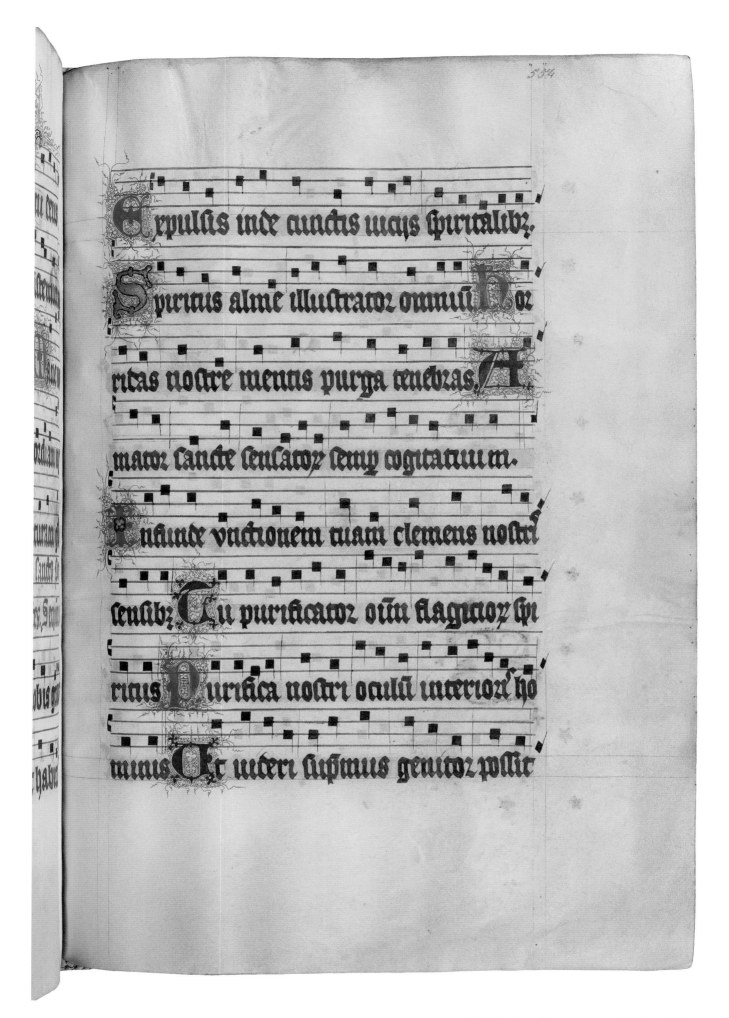

251. Pentecost: sequence, gradual, ca. 1380.
ULB Dusseldorf, D 11, p. 554 [vol. I, p. 469]

252. Pentecost: sequence, gradual, ca. 1380.
ULB Dusseldorf, D 11, p. 557 [vol. I, p. 469]

253. Trinity Sunday, gradual, ca. 1380.
ULB Dusseldorf, D 11, p. 559 [vol. I, p. 483]

uel tri a simplex tam est usya non triplex

essenaa Simplex esse. simplex uolle. simpl

uelle. simplex nolle. cuncta sint simplicia Pa

ter proles sacrn flamen deus unus ihi ta.

men habent quedam propria Non unus

quia duaz. siue trui psonaz minor efficia

a Una virtus. unui numen. unus splédor.

unui lumen. hoc una quod alia Patri pro

254. Trinity Sunday, gradual, ca. 1380.
ULB Dusseldorf, D 11, p. 560 [vol. I, p. 480]

GRADUAL, ULB DUSSELDORF, D 11 | 349

255. Corpus Christi: sequence, gradual, ca. 1380.
ULB Dusseldorf, D 11, p. 563 [vol. I, p. 492]

256. Corpus Christi: sequence, gradual, ca. 1380. ULB Dusseldorf,
D 11, p. 568 [vol. I, pp. 277–78, 492–93, 741]

GRADUAL, ULB DUSSELDORF, D 11 | 351

257. Dedication of a Church: sequence, gradual, ca. 1380.
ULB Dusseldorf, D 11, p. 572 [vol. I, pp. 260, 729–30, 752]

258. Dedication of a Church: sequence, gradual, ca. 1380.
ULB Dusseldorf, D 11, p. 573 [vol. I, p. 731]

GRADUAL, ULB DUSSELDORF, D 11 | 353

259. John the Evangelist: sequence, gradual, ca. 1380.
ULB Dusseldorf, D 11, p. 577 [vol. I, pp. 592, 599–600, 612]

260. John the Evangelist: sequence, gradual, ca. 1380.
ULB Dusseldorf, D 11, p. 578 [vol. I, pp. 599–600, 612–13]

261. John the Evangelist: sequence, gradual, ca. 1380.
ULB Dusseldorf, D 11, p. 579 [vol. I, pp. 589, 613]

262. John the Evangelist: sequence, gradual, ca. 1380.
ULB Dusseldorf, D 11, p. 580 [vol. I, p. 613]

263. John the Evangelist: sequence, gradual, ca. 1380.
ULB Dusseldorf, D 11, p. 581 [vol. I, pp. 590, 613]

264. John the Evangelist: sequence, gradual, ca. 1380.
ULB Dusseldorf, D 11, p. 582 [vol. I, pp. 184, 281, 588, 613–14]

265. Paul: sequence, gradual, ca. 1380.
ULB Dusseldorf, D 11, p. 583 [vol. I, pp. 649–50]

266. Annunciation: sequence, gradual, ca. 1380.
ULB Dusseldorf, D 11, p. 584 [vol. I, p. 529]

GRADUAL, ULB DUSSELDORF, D 11 | 361

267. Peter Martyr: sequence, gradual, ca. 1380.
ULB Dusseldorf, D 11, p. 587 [vol. I, pp. 507–508]

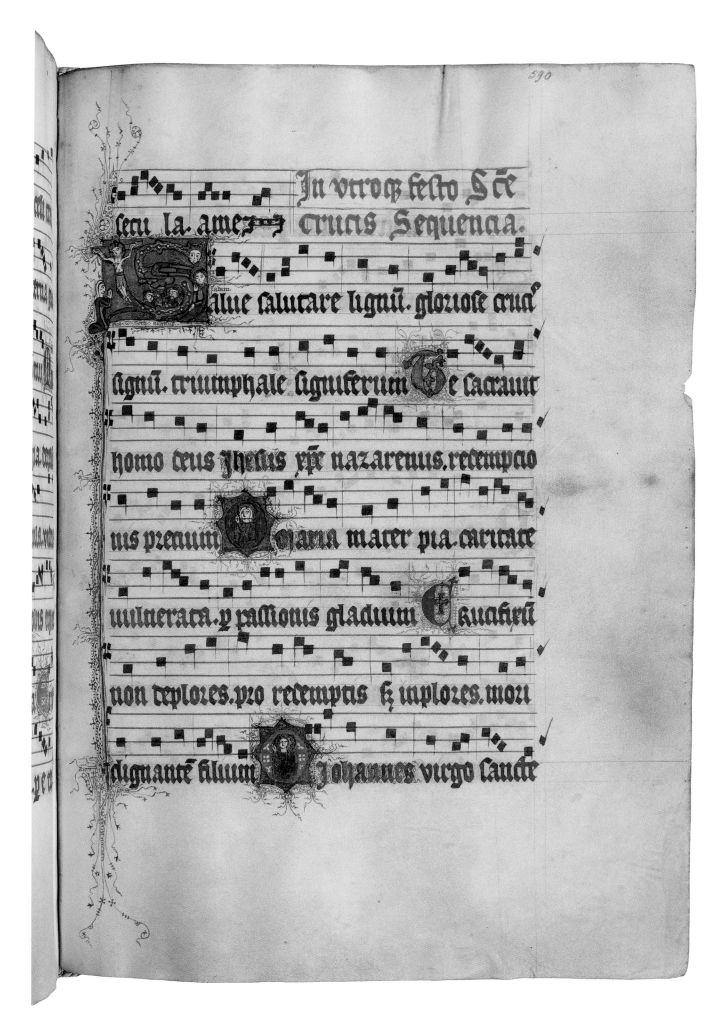

268. Invention of Cross, gradual, ca. 1380. ULB Dusseldorf,
D 11, p. 590 [vol. I, pp. 265–66, 379–81, 660–61]

GRADUAL, ULB DUSSELDORF, D 11 | 363

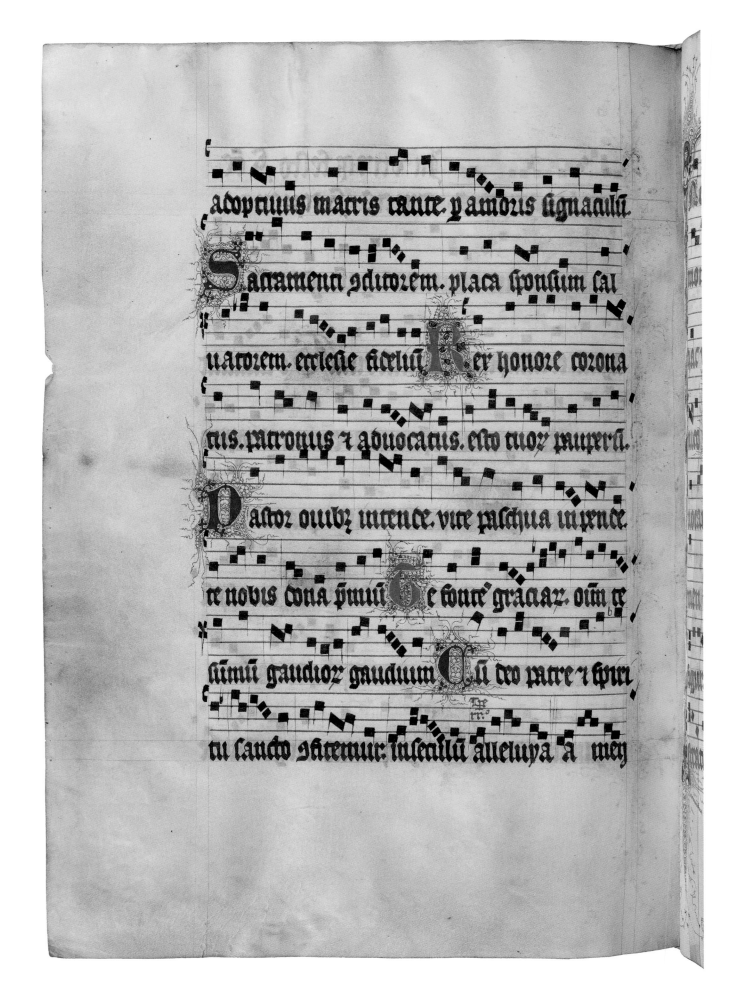

269. Invention of Cross, gradual, ca. 1380.
ULB Dusseldorf, D 11, p. 591 [vol. I, p. 656]

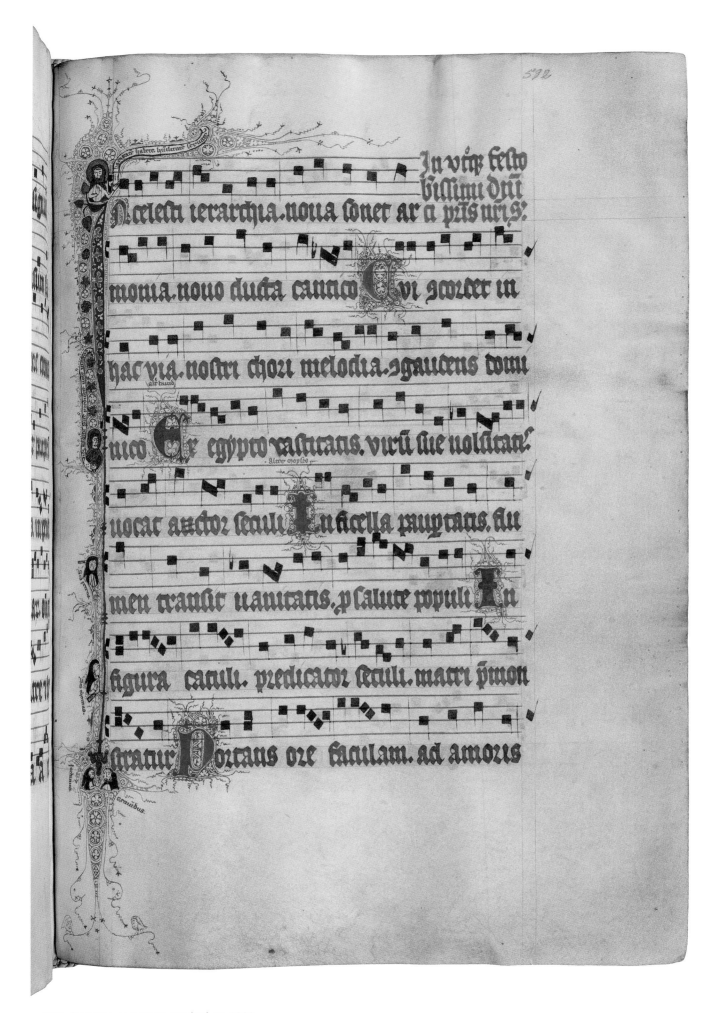

270. Dominic: sequence, gradual, ca. 1380.
ULB Dusseldorf, D 11, p. 592 [vol. I, pp. 512–513]

GRADUAL, ULB DUSSELDORF, D 11 | 365

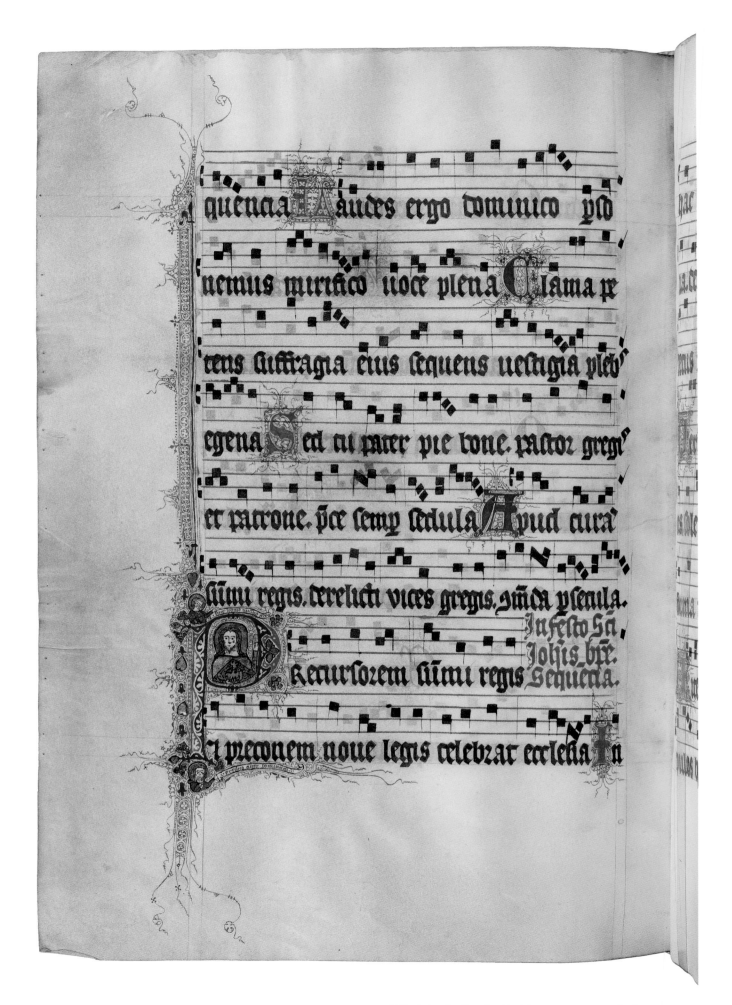

271. John the Baptist: Nativity, sequence, gradual, ca. 1380.
ULB Dusseldorf, D 11, p. 595 [vol. I, pp. 275, 667–69]

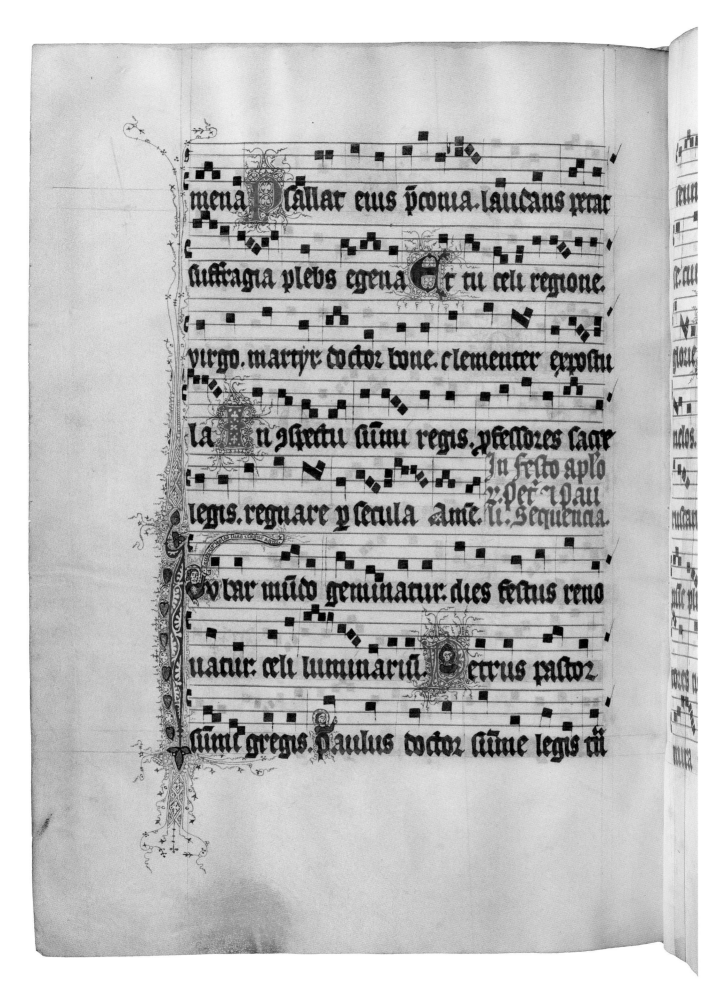

272. Peter and Paul: sequence, gradual, ca. 1380.
ULB Dusseldorf, D 11, p. 599 [vol. I, pp. 671–72]

GRADUAL, ULB DUSSELDORF, D 11 | 367

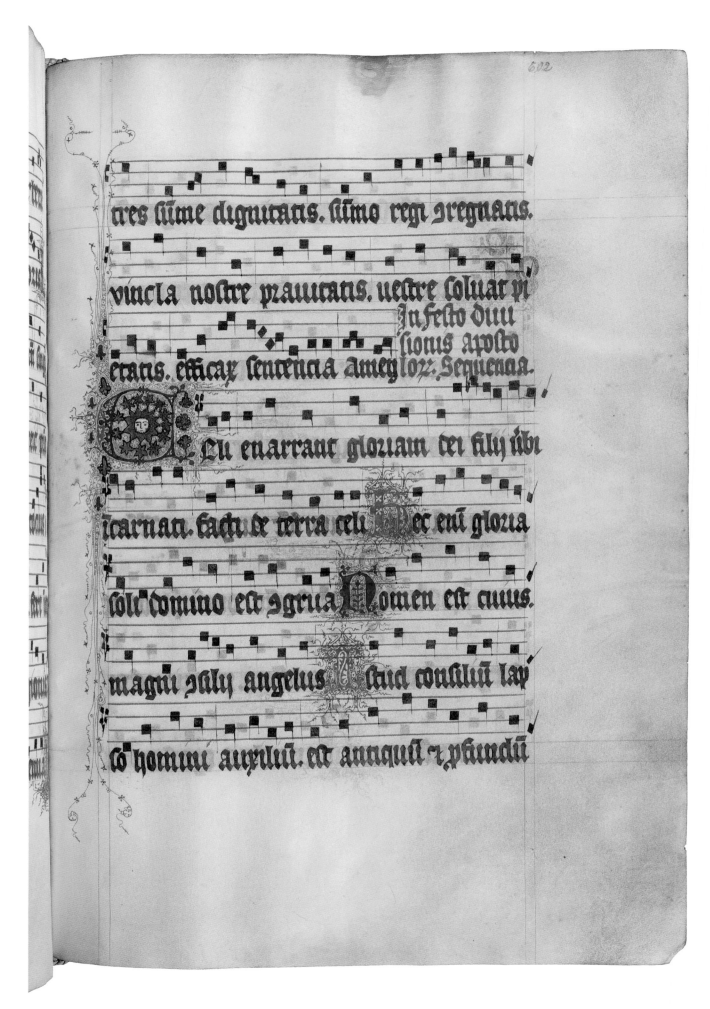

273. Apostles: division, sequence, gradual, ca. 1380.
ULB Dusseldorf, D 11, p. 602 [vol. I, pp. 252, 676–679]

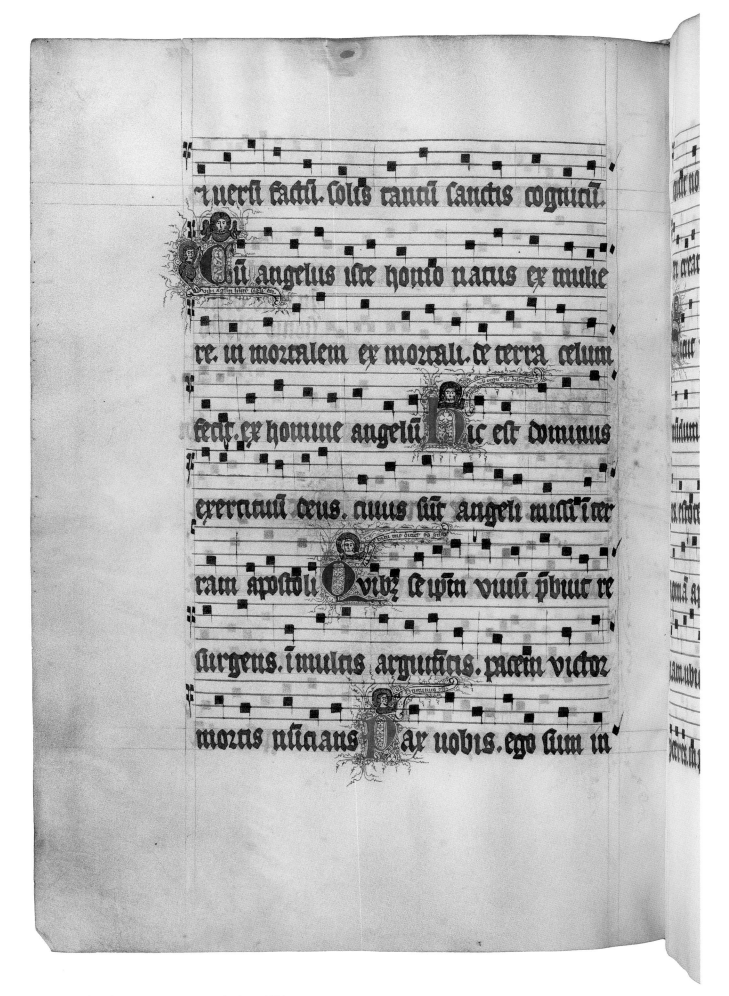

274. Apostles: division, sequence, gradual, ca. 1380.
ULB Dusseldorf, D 11, p. 603 [vol. I, p. 680]

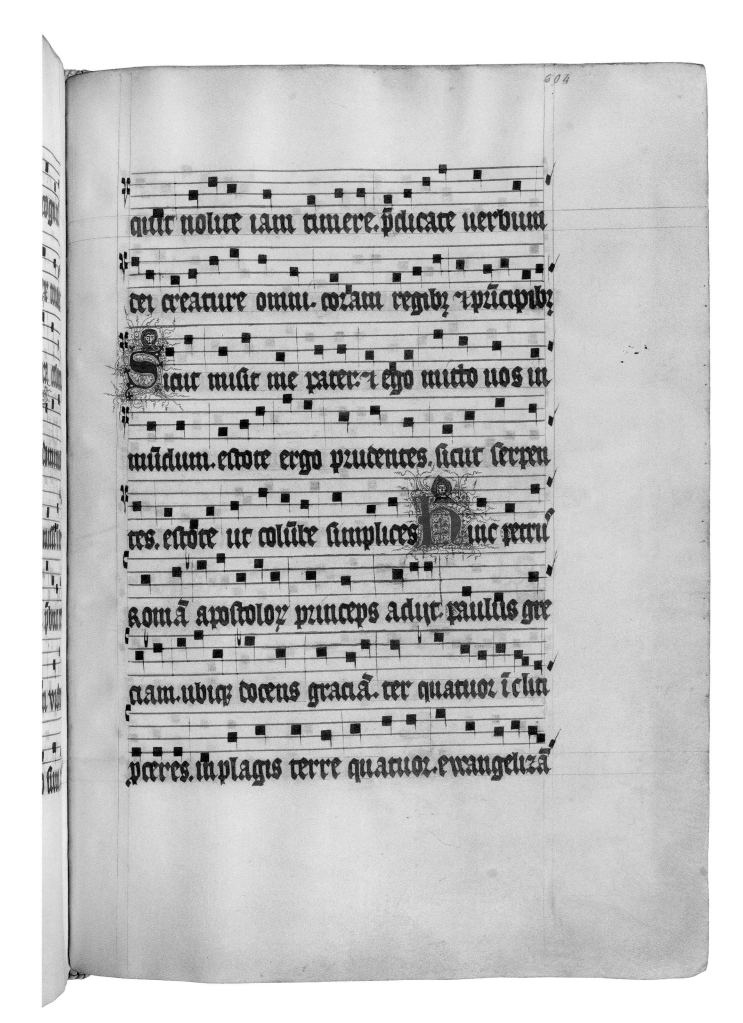

275. Apostles: division, sequence, gradual, ca. 1380.
ULB Dusseldorf, D 11, p. 604 [vol. I, p. 680]

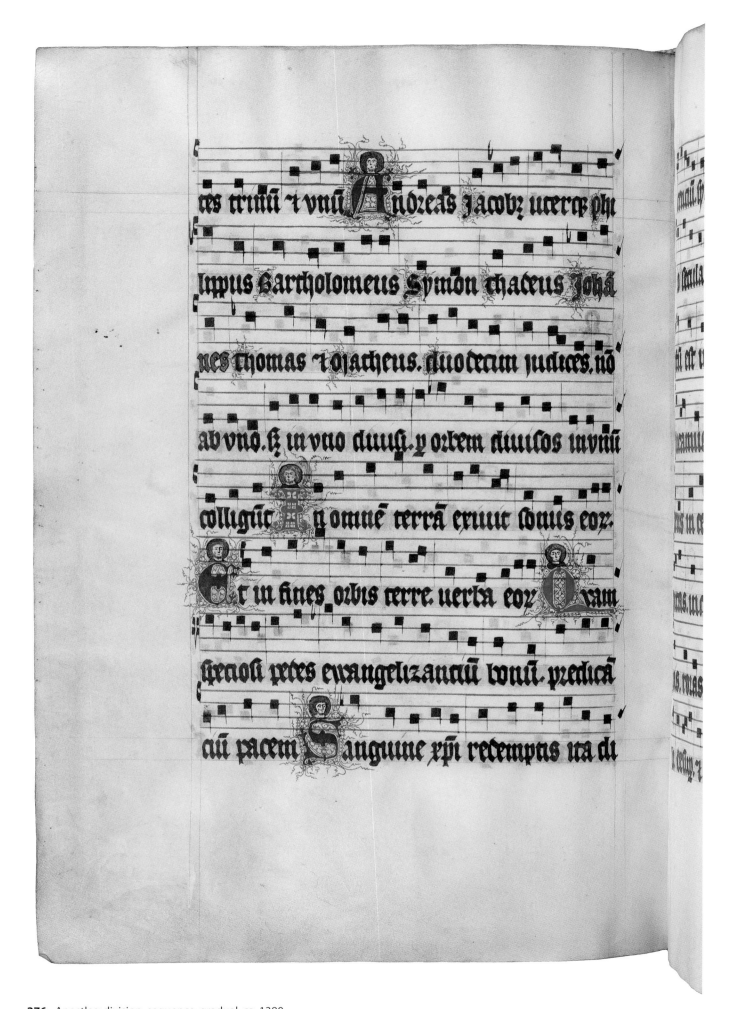

...tes tristis τ vnus Andreas Jacobz ureris phi

lippus Bartholomeus Symon thadeus Johan

nes Thomas τ oratheus. duodecim iudices. non

ab vno. set in vno diuisi. τ p ordem diuisos inuni

colligis. τ p omnē terrā exiuit sonus eoz.

Et in fines orbis terre. uerba eoz. Quam

speciosi pedes euangelizantiū bonū. predicā

cū pacem Sanguine xpi redemptis ita di...

276. Apostles: division, sequence, gradual, ca. 1380.
ULB Dusseldorf, D 11, p. 605 [vol. I, p. 680]

GRADUAL, ULB DUSSELDORF, D 11 | 371

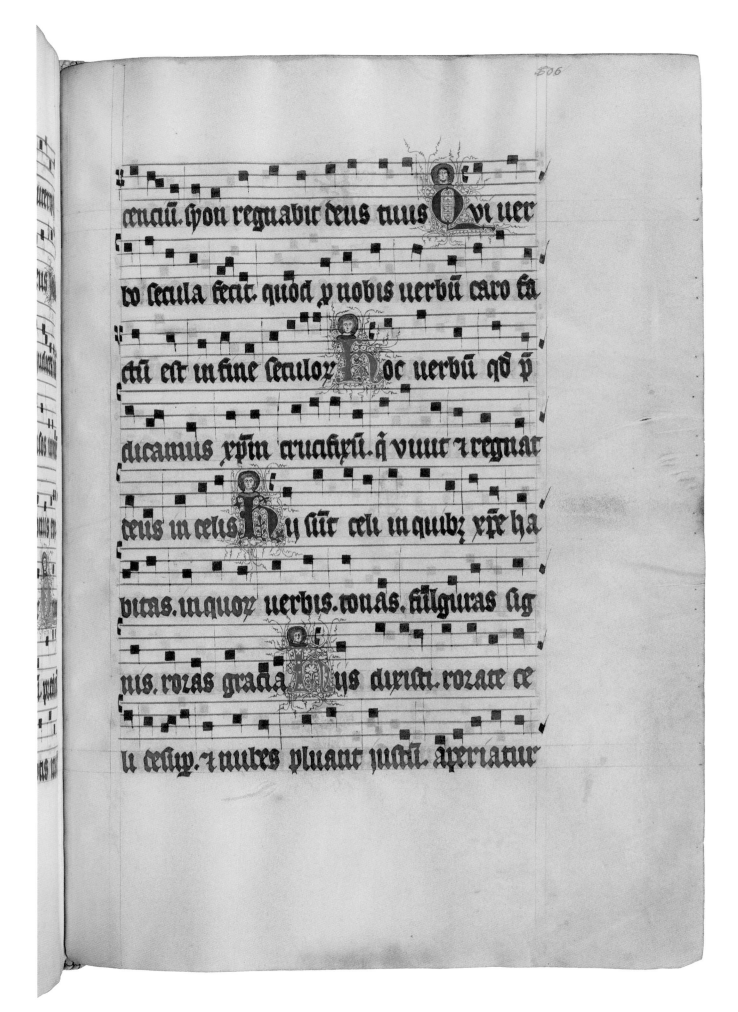

277. Apostles: division, sequence, gradual, ca. 1380.
ULB Dusseldorf, D 11, p. 606 [vol. I, pp. 680]

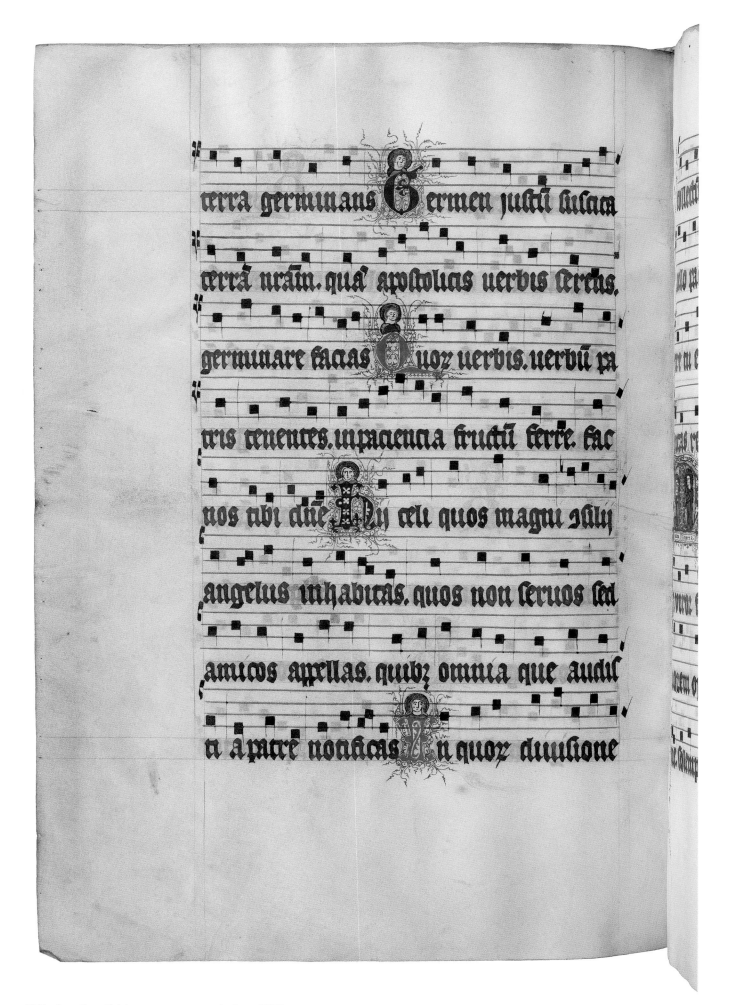

terra germinans Germen iustii susata

terrã nrãm. quã apostolias uerbis terris.

germinare facias Quoz uerbis. uerbũ pa

tris tenentes. in patientia fructũ terre. fac

nos tibi dñe In celi quos magni insili

angelus inhabitas. quos non seruos sed

amicos appellas. quibz omnia que audis

ti a patre notificas In quoz diuisione

278. Apostles: division, sequence, gradual, ca. 1380.
ULB Dusseldorf, D 11, p. 607 [vol. I, p. 680]

GRADUAL, ULB DUSSELDORF, D 11 | 373

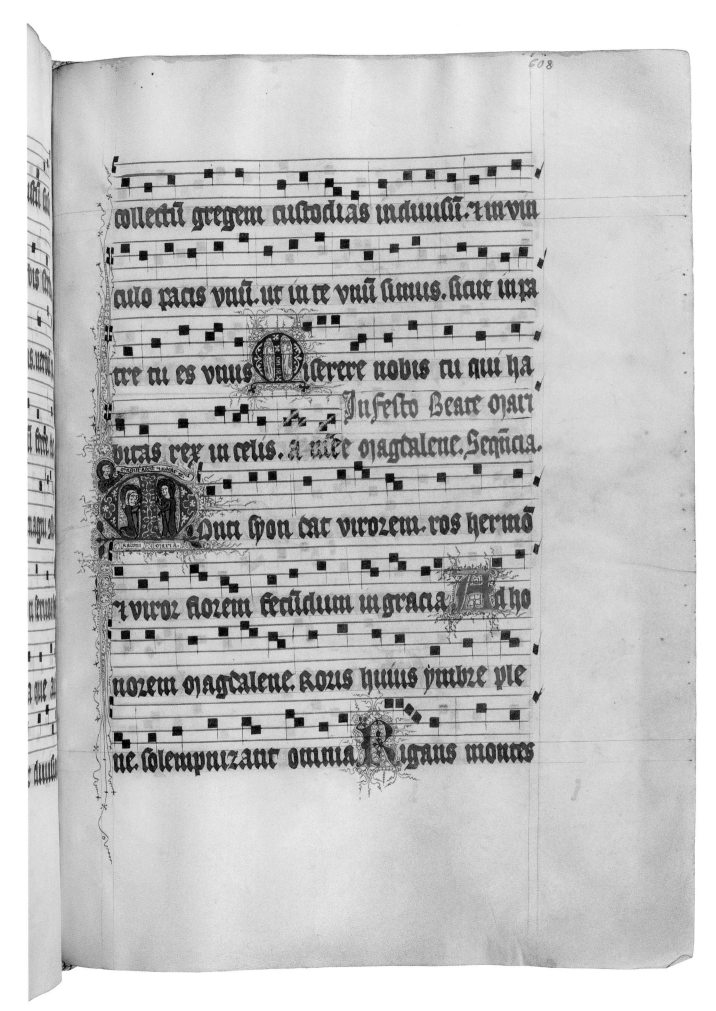

279. Apostles: division, sequence; Mary Magdalen, sequences, gradual, ca. 1380. ULB Dusseldorf, D 11, p. 608 [vol. I, pp. 680, 743]

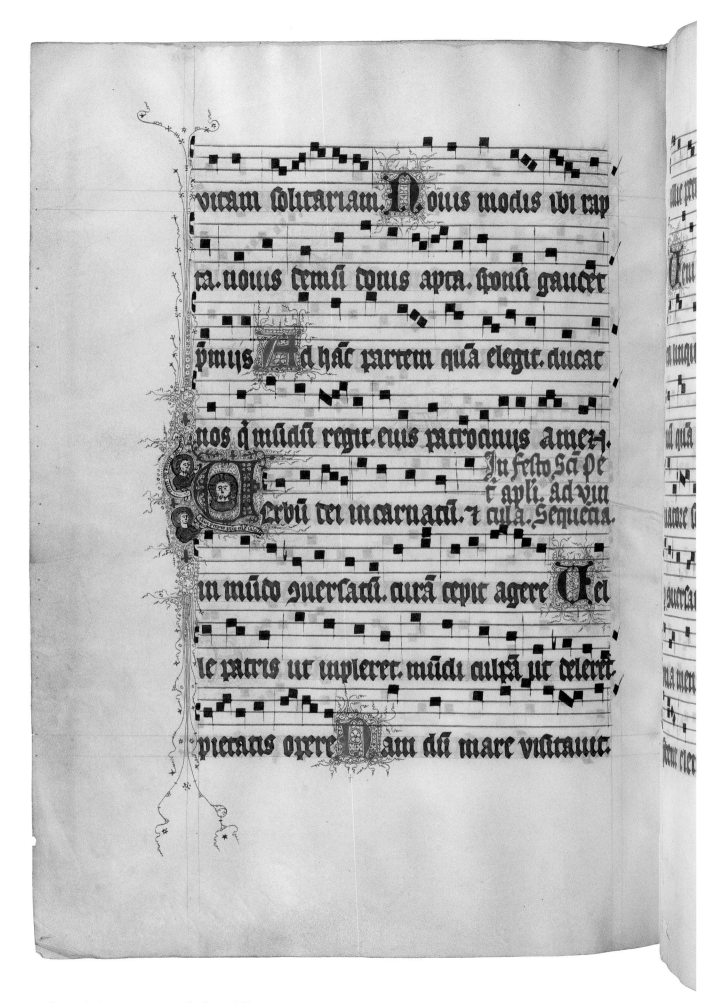

280. Peter: chains, sequence, gradual, ca. 1380.
ULB Dusseldorf, D 11, p. 611 [vol. I, pp. 684–85]

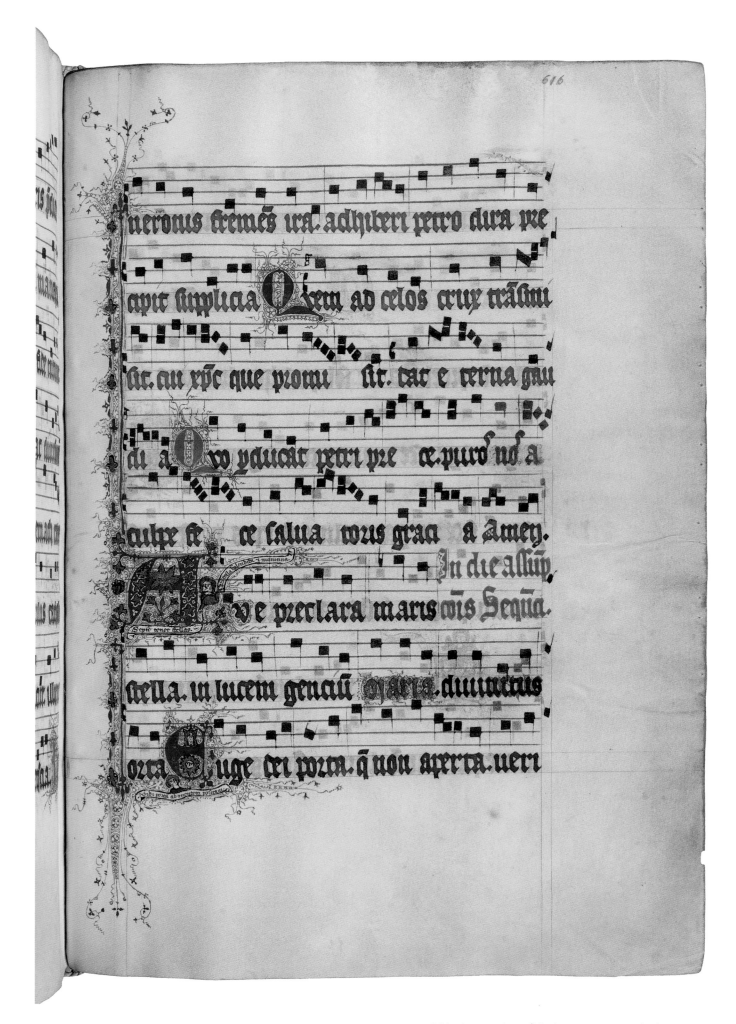

281. Assumption of Virgin: sequence, gradual, ca. 1380.
ULB Dusseldorf, D 11, p. 616 [vol. I, pp. 260, 541–42]

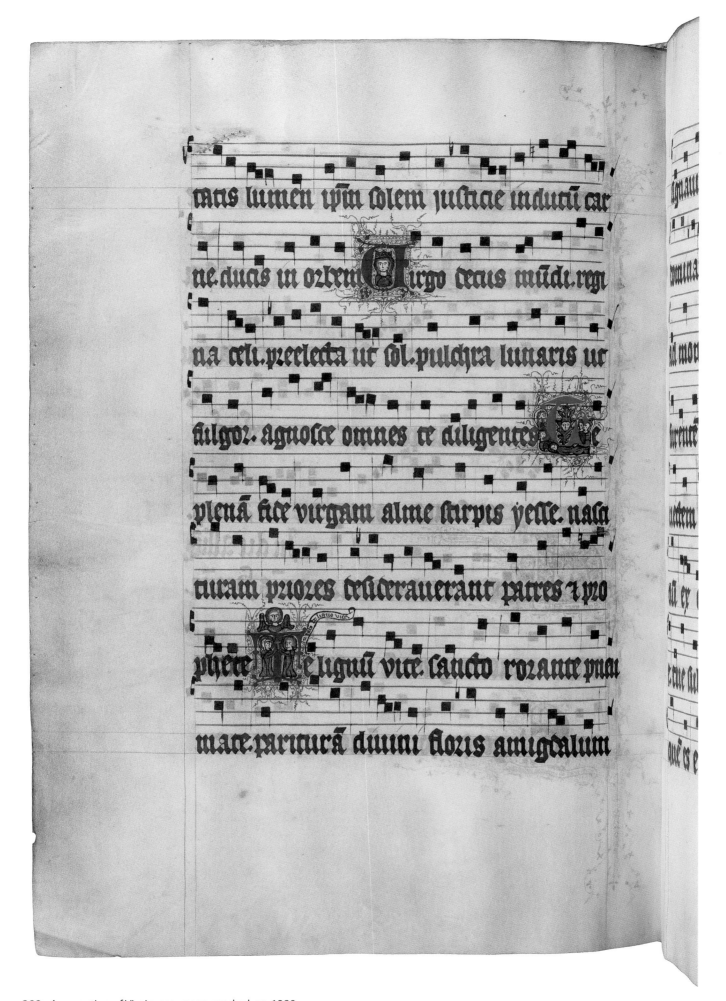

282. Assumption of Virgin: sequence, gradual, ca. 1380.
ULB Dusseldorf, D 11, p. 617 [vol. I, pp. 542–43]

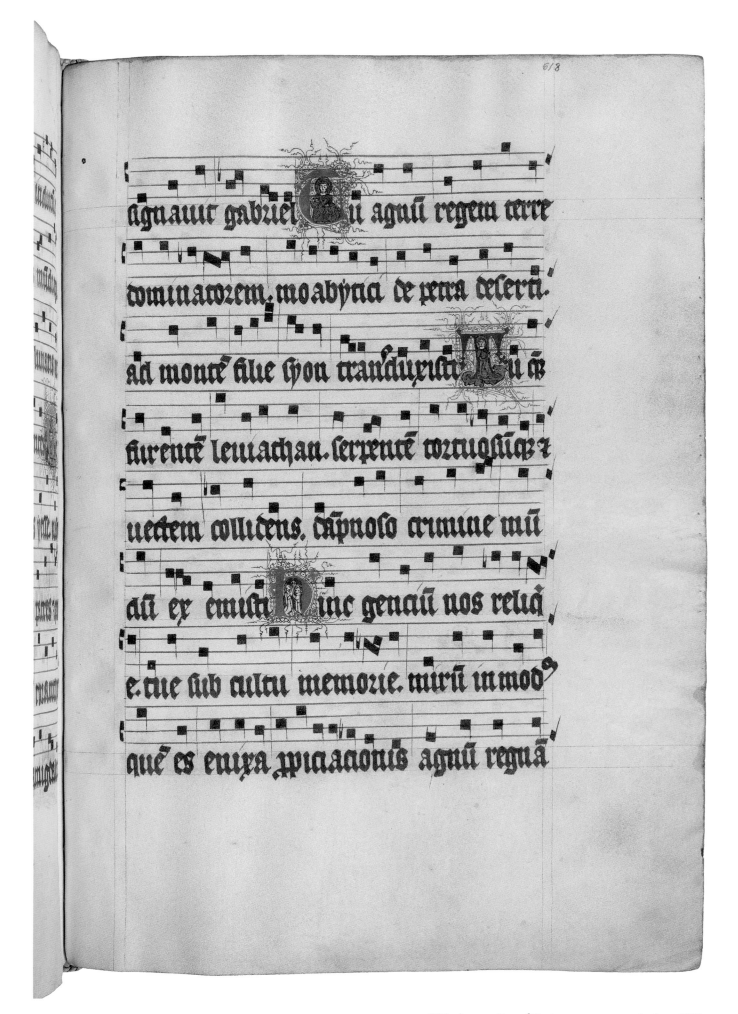

283. Assumption of Virgin: sequence, gradual, ca. 1380.
ULB Dusseldorf, D 11, p. 618 [vol. I, p. 543]

tem celo eternaliter. euocamus ad aram.

mactandum misterialiter. Hinc manna ue

rū. israhelitis ueris. ueri abrahe filijs am

mirantibz. quoniam oriofi ad typus figu

rabat. iam nūc abducto uelo. datur yspia.

Jora virgo. nos illo pane celi. dignos effig.

Hac fonte dulcē. quē in deferto petra

pmonstrauit. deguftare cū sincera fide. re

284. Assumption of Virgin: sequence, gradual, ca. 1380.
ULB Dusseldorf, D 11, p. 619 [vol. I, p. 544]

GRADUAL, ULB DUSSELDORF, D 11 | 379

285. Assumption of Virgin: sequence, gradual, ca. 1380.
ULB Dusseldorf, D 11, p. 620 [vol. I, pp. 544–45]

286. Assumption of Virgin: sequence within octave, gradual, ca. 1380. ULB Dusseldorf, D 11, p. 621 [vol. I, p. 545]

287. Assumption of Virgin: sequence for octave, gradual,
ca. 1380. ULB Dusseldorf, D 11, p. 624 [vol. I, pp. 276, 546]

288. Augustine: sequence, gradual, ca. 1380.
ULB Dusseldorf, D 11, p. 628 [vol. I, pp. ▪▪▪]

289. Nativity of Virgin: sequence, gradual, ca. 1380.
ULB Dusseldorf, D 11, p. 631 [vol. I, pp. 549, 742]

reftauratur in ozaria. Et auroza furgens p

greditur: uelud luna pulchza deferibitur: fu

per cuncta ut fol eligitur: virgo pia Virgo

clemens z virgo vinca. virga fumi sz aroma

tica. iure celi mundz fabzica glozatur. Te

fignarut oza pphetica. tibi canit falomon

cantica canticor te uox angelica ptestatur.

Verbu patris pcessu temporis. intrat tui

290. Nativity of Virgin: sequence, gradual, ca. 1380.
ULB Dusseldorf, D 11, p. 632 [vol. I, pp. 549–50]

GRADUAL, ULB DUSSELDORF, D 11 | 385

291. All Saints: sequence, gradual, ca. 1380.
ULB Dusseldorf, D 11, p. 634 [vol. I, p. 697]

292. Advent: Commemoration of Virgin, gradual,
ca. 1380. ULB Dusseldorf, D 11, p. 637 [vol. I, pp. 557–641]

293. Virgin Mary: Saturdays, sequence, gradual, ca. 1380.
ULB Dusseldorf, D 11, p. 649 [vol. I, pp. 166, 169, 184, 557, 743]

295. John the Evangelist: sequence, gradual, ca. 1380.
ULB Dusseldorf, D 11, p. 677 [vol. I, pp. 598, 615–16]

vis alta uolatu nesciens metã se-

tam predam recipiens aptam raptã diuidit

nutriens xpo gratos randis alis

perlustrat asyam. querit serit pacem et

graciam. tegit regit penuis ecclesiam + re-

natos lagellatur corpus virgineum

cruce duce sert seruens oleum inquina-

tum latum ueneneum potũ vi cit.

296. John the Evangelist: sequence, gradual, ca. 1380.
ULB Dusseldorf, D 11, p. 678 [vol. I, pp. 598, 616]

GRADUAL, ULB DUSSELDORF, D 11 | 391

297. John the Evangelist: sequence, gradual, ca. 1380.
ULB Dusseldorf, D 11, p. 679 [vol. I, p. 616]

298. John the Baptist: nativity, sequence, gradual, ca. 1380.
ULB Dusseldorf, D 11, p. 680 [vol. I, p. 275]

299. John the Baptist: Nativity, sequence, gradual, ca. 1380.
ULB Dusseldorf, D 11, p. 682 [vol. I, p. 669]

...te natalicia colentes ꝛ exaudi nos gemetes in hac solitudine Post arentem ꝛ australe teram anime dotalem petimus irriguam Te manipulos portantes ueniamus exultantes pacem ad perpetuam amen. Hanc ꝓa De sco Jo Jubilemus in hac die qua baptiste xpi pie colitur memoria Qua uox uerbi syncopatur mundi splendor obumbratur morte

300. John the Baptist: sequence, gradual, ca. 1380.
ULB Dusseldorf, D 11, p. 684 [vol. I, pp. 668–69]

GRADUAL, ULB DUSSELDORF, D 11 | **395**

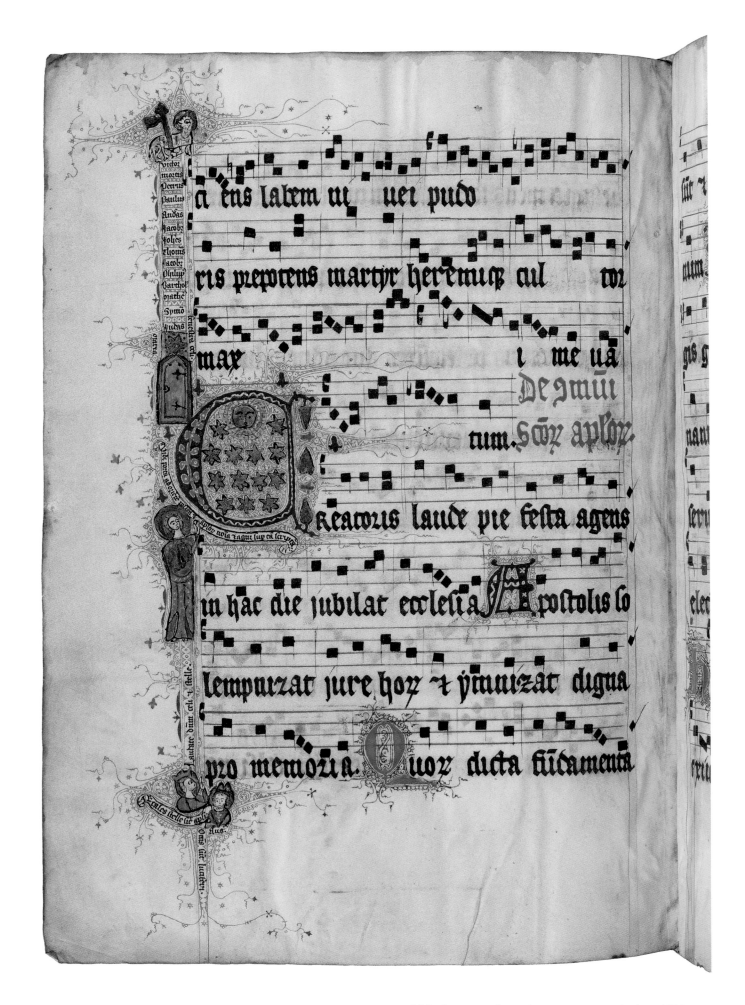

301. Common of apostles: sequence, gradual, ca. 1380.
ULB Dusseldorf, D 11, p. 689 [vol. I, p. 249]

Antiphonary
ULB Dusseldorf, D 7 and D 9

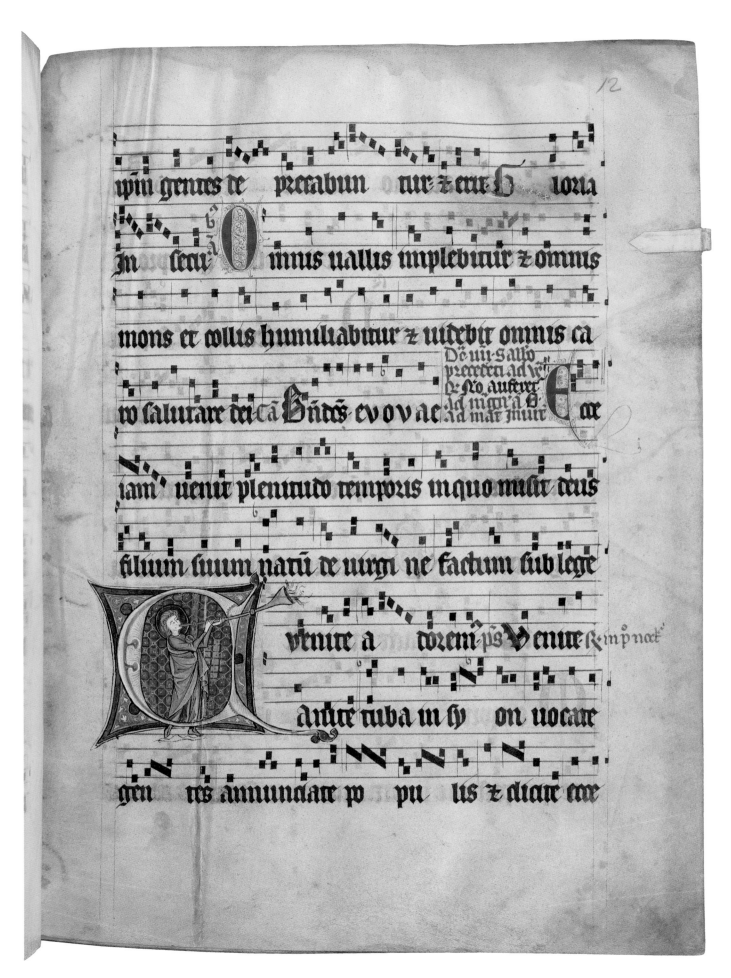

302. Advent: fourth Sunday, antiphonary (pars hiemalis) for Paradies, before 1323. ULB Dusseldorf, D 7, f. 12r [vol. I, p. 137]

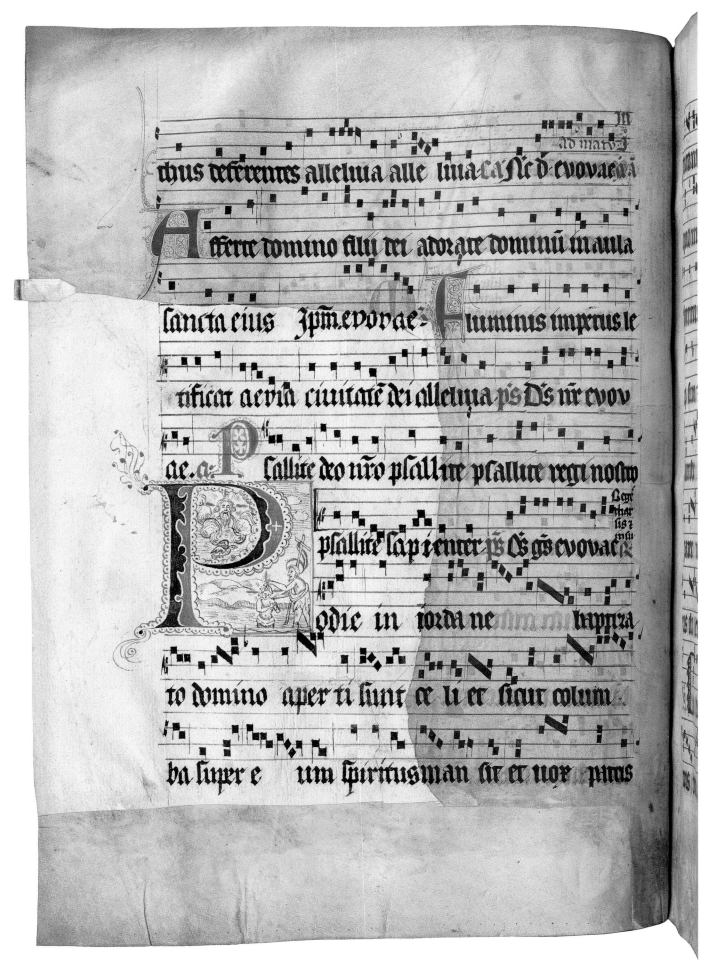

303. Baptism, antiphonary (pars hiemalis) for Paradies, before 1323. ULB Dusseldorf, D 7, f. 36v [vol. I, p. 121]

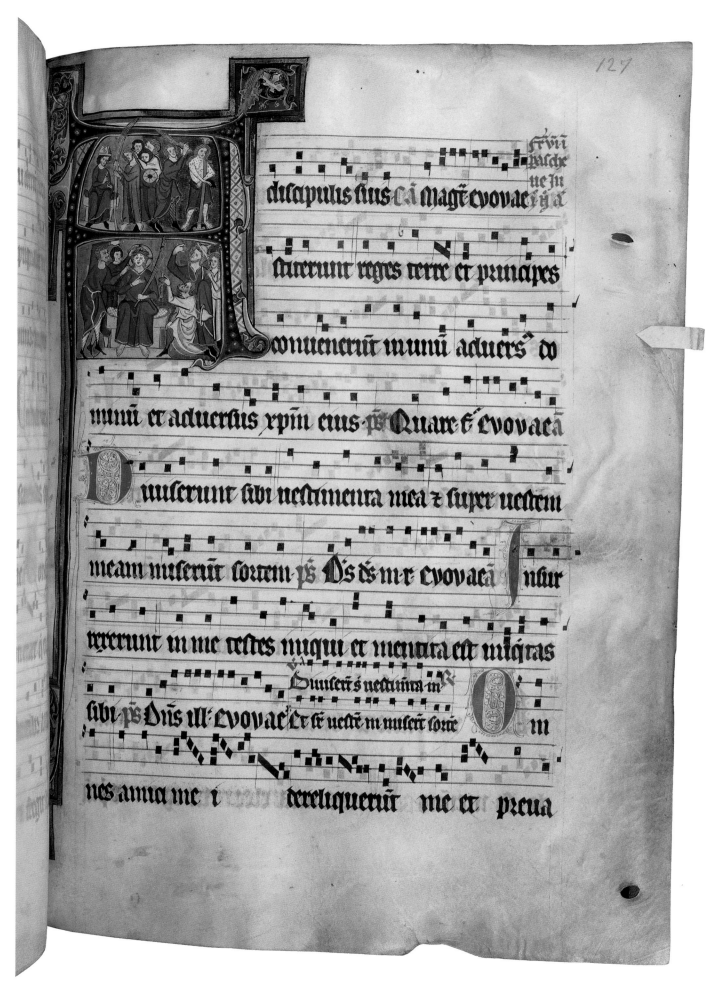

304. Good Friday, antiphonary (pars hiemalis) for Paradies, before 1323. ULB Dusseldorf, D 7, f. 127r [vol. I, p. 129]

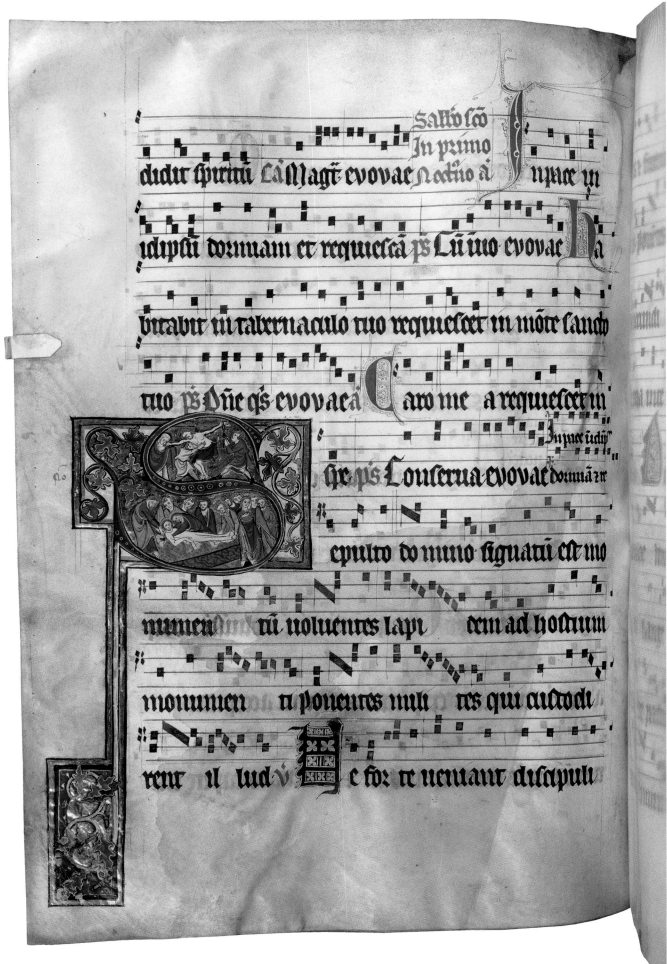

Salvo seo
In primo
dicitur spiritui Laa Magn euouae Nocturno a Invitatorii in

idipsum dormiam et requiescaps Cum iuo euouae Ha

bitabit iii tabernaculo tuo requiescet in monte sancto

tuo ps Dñe qs euouae Caro mea requiescet in

spe ps Couserua euouae domina ꝛc

epulto domino siguatum est mo

numen tu uoluentes lapi dem ad hostium

monumen ti ponentes muli eres qui custodi

rent il lud ve ne for te ueniant discipuli

305. Easter Saturday, antiphonary (pars hiemalis) for
Paradies, before 1323. ULB Dusseldorf,
D 7, f. 131v [vol. I, p. 129]

ANTIPHONARY, D 7 AND D 9 | 401

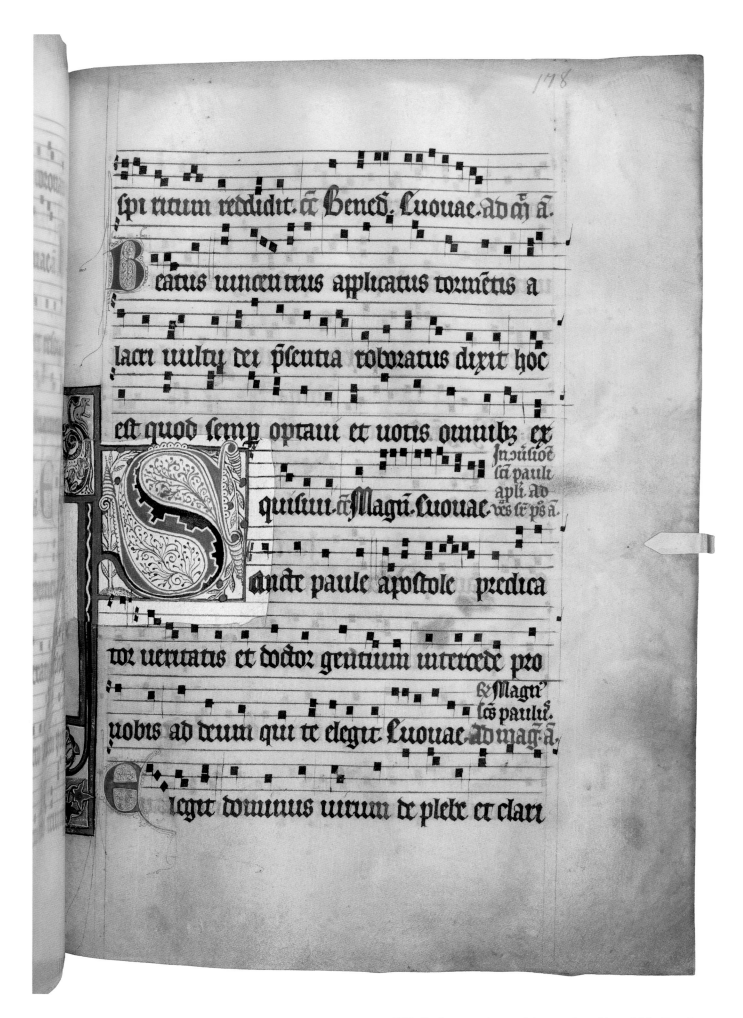

306. Paul: conversion, antiphonary (pars hiemalis) for Paradies, before 1323. ULB Dusseldorf, D 7, f. 178r [vol. I, p. 120]

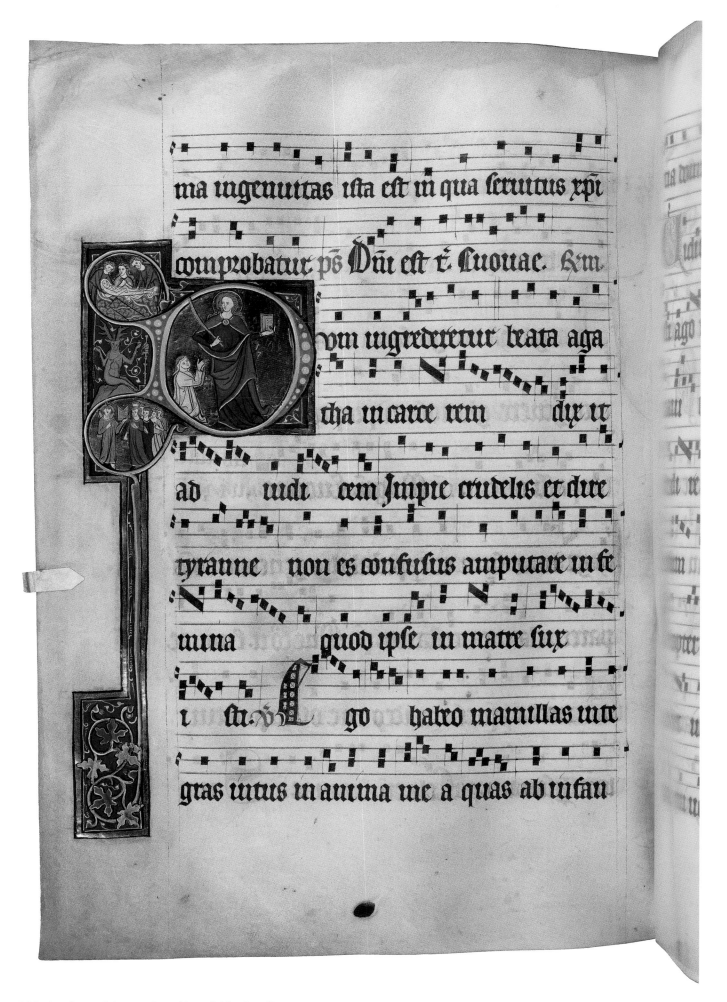

ma ingenuitas ista est in qua seruitus xpi

comprobatur ps Dūs est & Cuouae. Eum

om ingrederetur beata aga

tha in carce rem dix it

ad iudi cem Impie crudelis et dire

tyranne non es confusus amputare in fe

mina quod ipse in matre sua

i sti. V. Ego habeo mamillas inte

gras intus in anima me a quas ab infan

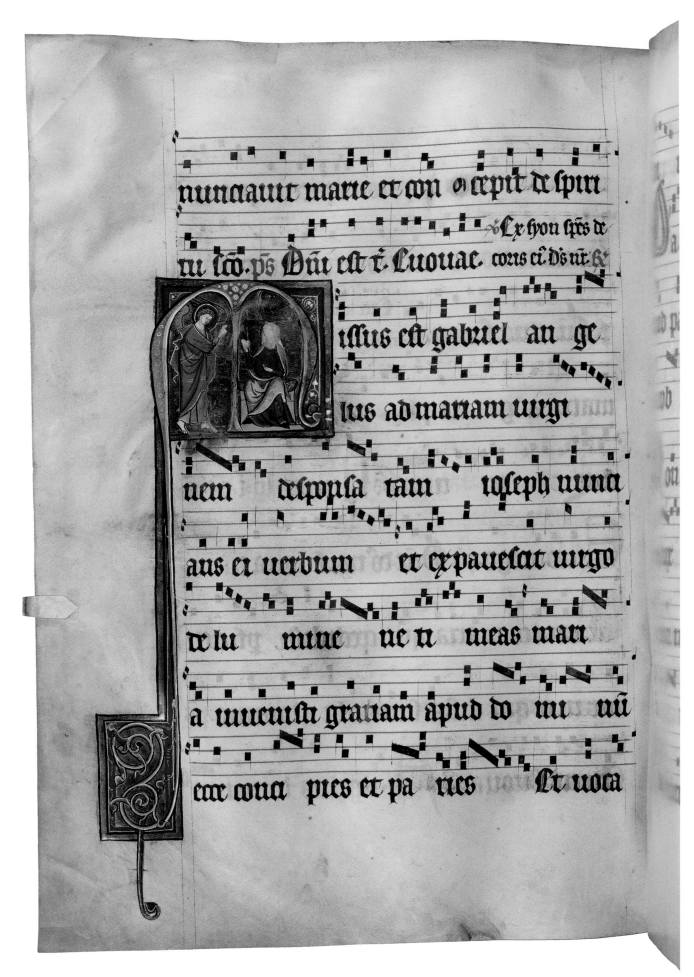

308. Annunciation, antiphonary (pars hiemalis) for
Paradies, before 1323. ULB Dusseldorf,
D 7, f. 202v [vol. I, pp. 117, 23]

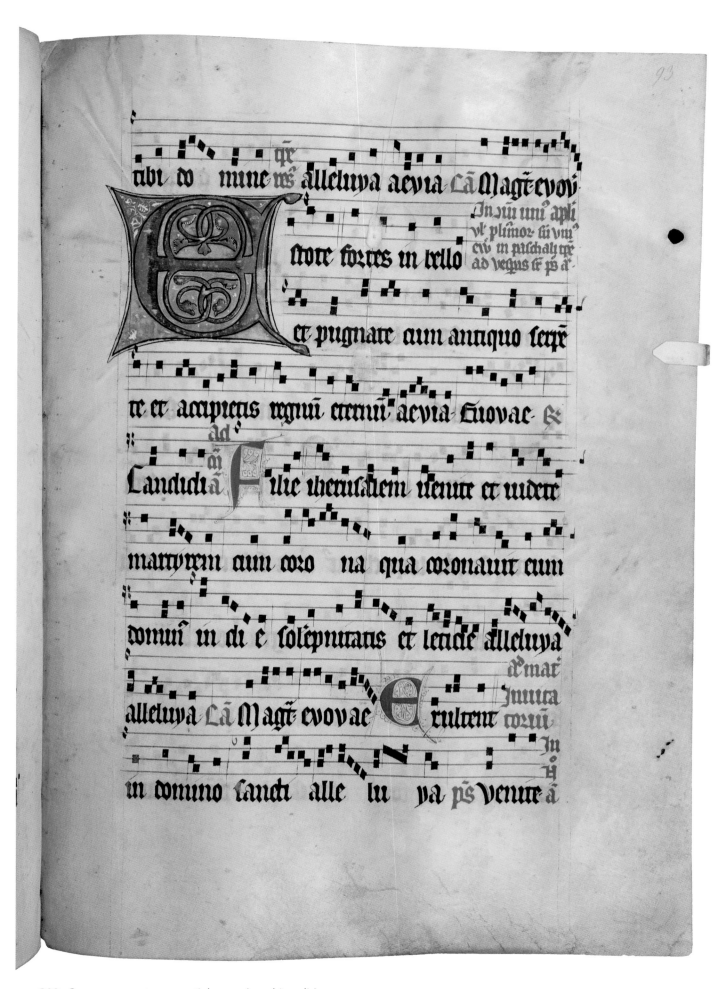

93

...tibi domine... alleluya aevia Cã Magt evov

In .xiii. uni apli vl plimor tii vni eiv in pischali tpe ad vegns tp ps aª

...stote fortes in bello

et pugnare cum antiquo serpẽ

...te et accipietis regnũ eternũ aevia Euovae Et

ad cõ Filie iherusalem isenire et videte

...candidi ã martyrem cum coro na qua coronauit eum

...dominuʒ in di e solépnitatis et leticie alleluya

...alleluya Cã Magt evovae Exultent corũ

...in domino sancti alle lu ya ps Venite ã

309. Commune sanctorum, antiphonary (pars hiemalis)
for Paradies, before 1323. ULB Dusseldorf,
D 9, f. 93r [vol. I, p. 139]

ANTIPHONARY, D 7 AND D 9 | 405

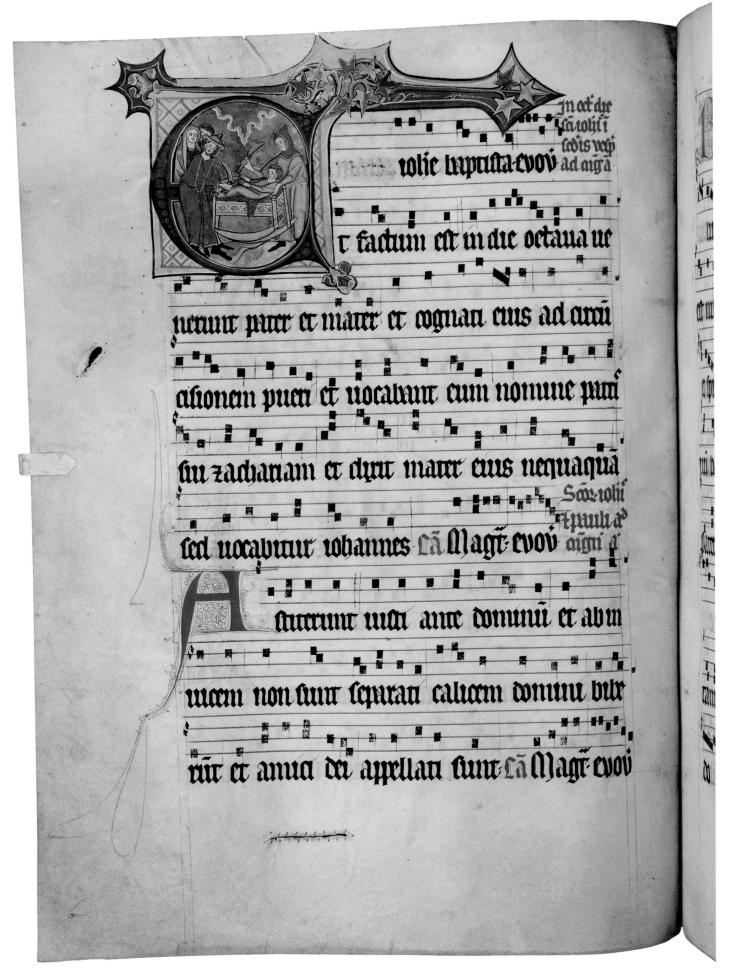

310. Office for Nativity of John the Baptist, antiphonary
(pars estivalis) for Paradies, before 1323.
ULB Dusseldorf, D 9, f. 116v [vol. I, p. 629]

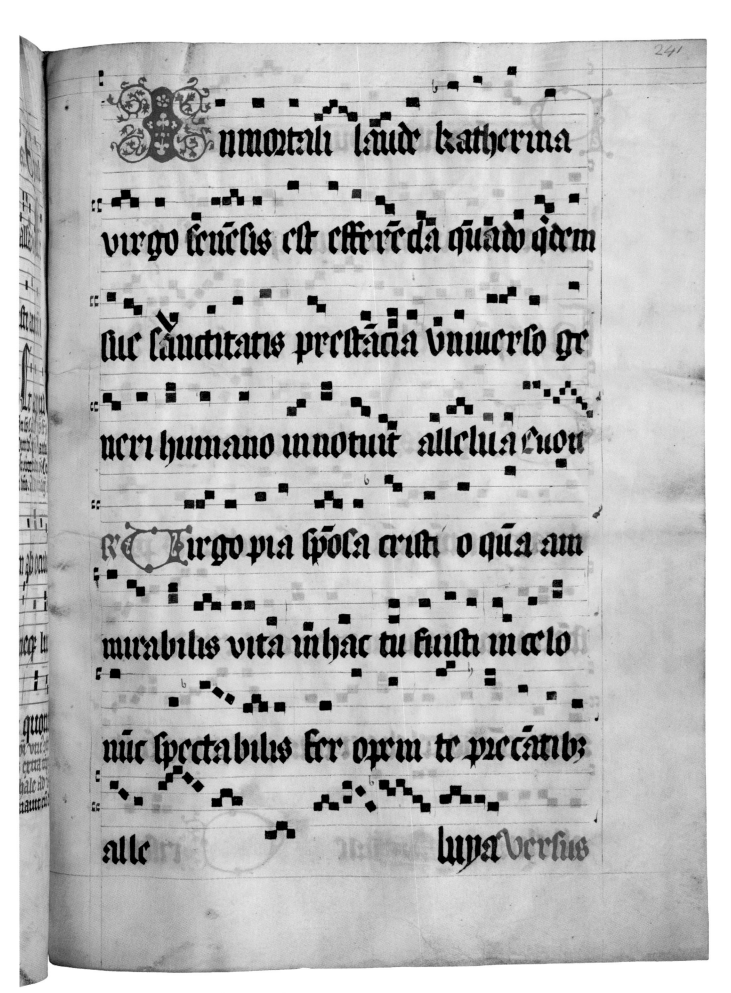

nmortali laude katherina

virgo ſenenſis eſt efferenda quando quem

ſue ſanctitatis preſtancia vniuerſo ge

neri humano innotuit alleluia euon

Virgo pia ſpoſa criſti o qua am

mirabilis vita inhac tu fuiſti in celo

nuc ſpectabilis fer opem te precantib;

alle luya verſus

311. Office for Catherine of Siena (fragment), after 1461,
added to antiphonary (pars estivalis) for Paradies,
before 1323. ULB Dusseldorf, D 9, f. 241r [vol. I, p. 617]　　　　ANTIPHONARY, D 7 AND D 9 | 407

312. Office for John the Evangelist (fragment), early 14th century, added to antiphonary (pars estivalis) for Paradies, before 1323. ULB Dusseldorf, D 9, f. 247r [vol. I, pp. 617, 619]

313. Libellus for John the Evangelist (fragment), added to antiphonary (pars estivalis) for Paradies, before 1323. ULB Dusseldorf, D 9, f. 252r [vol. I, pp. 197, 562–73, 616]

314. Libellus for John the Evangelist (fragment), ca. 1380, added to antiphonary (pars estivalis) for Paradies, before 1323. ULB Dusseldorf, D 9, f. 252v [vol. I, pp. 562–73, 616]

315. Libellus for John the Evangelist (fragment), ca. 1380, added to antiphonary (pars estivalis) for Paradies, before 1323. ULB Dusseldorf, D 9, f. 253r [vol. I, pp. 166, 618].

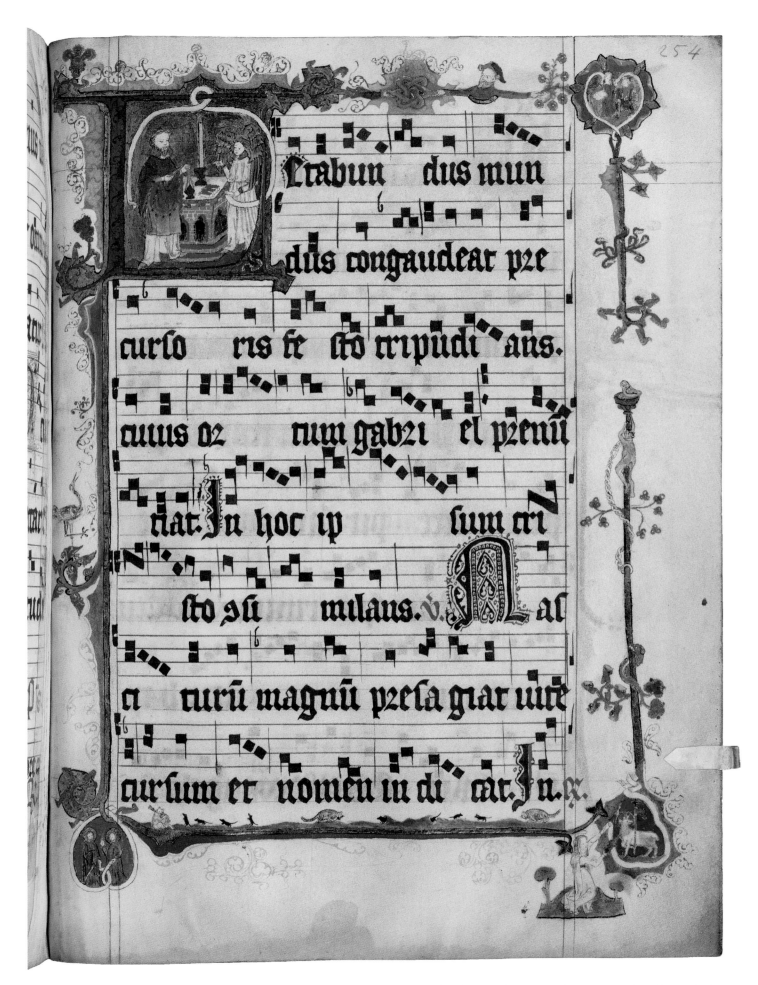

316. Office for John the Baptist (fragment), early 15th c., added to antiphonary (pars estivalis) for Paradies, before 1323. ULB Dusseldorf, D 9, f. 254r [vol. I, pp. 622–624]

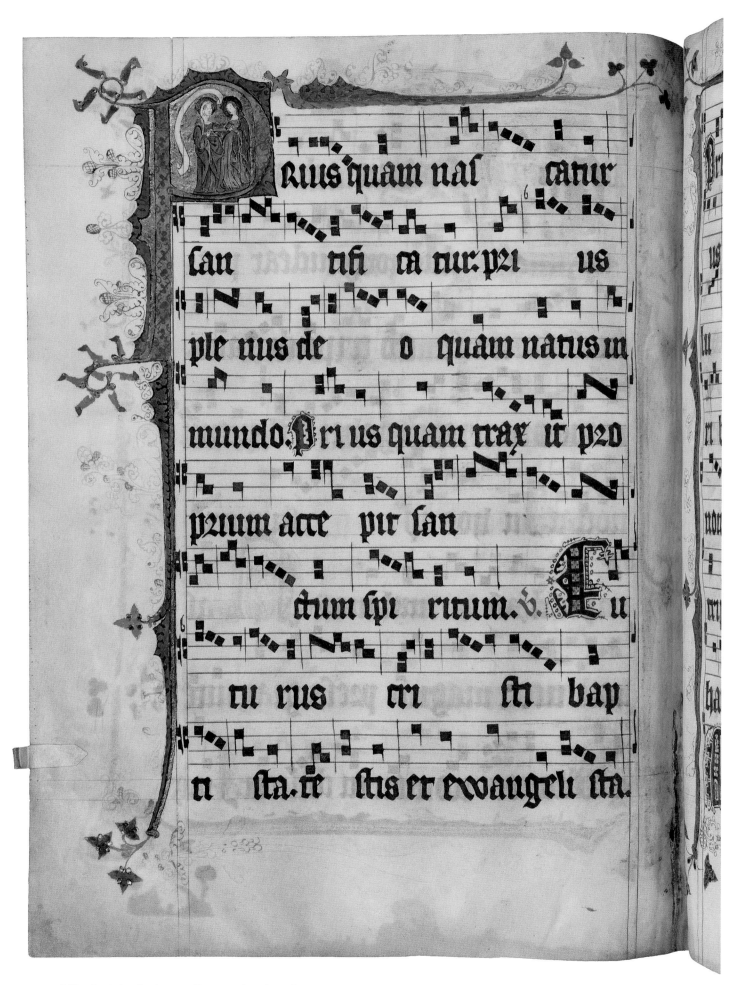

Prius quam nas catur san tifi ca tur. pri us ple nus de o quam natus in mundo. Prius quam trax it pro prium acce pir san ctum spi ritum. V. Eu

ti rus cri sti bap ti sta. te stis er evangeli sta.

317. Office for John the Baptist, (fragment) early 15th century,
added to antiphonary (pars estivalis) for Paradies,
before 1323. ULB Dusseldorf, D 9, f. 254v [vol. I, pp. 624–28]

ANTIPHONARY, D 7 AND D 9 | **413**

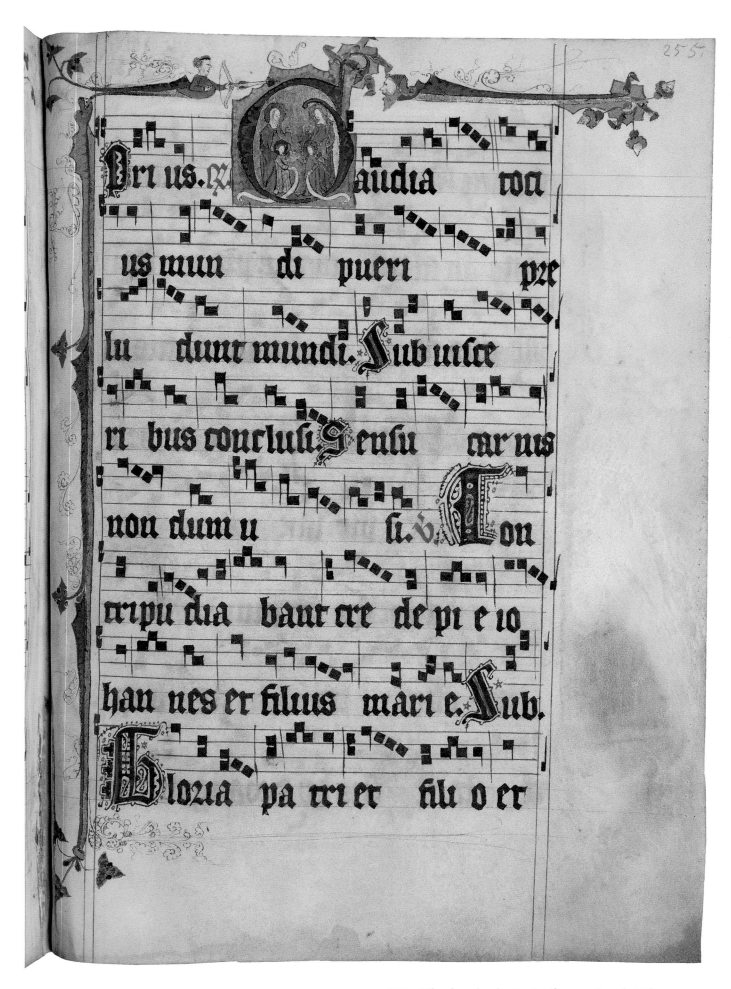

318. Office for John the Baptist (fragment), early 15th century, added to antiphonary (pars estivalis) for Paradies, before 1323. ULB Dusseldorf, D 9, f. 255r [vol. I, p. 628]

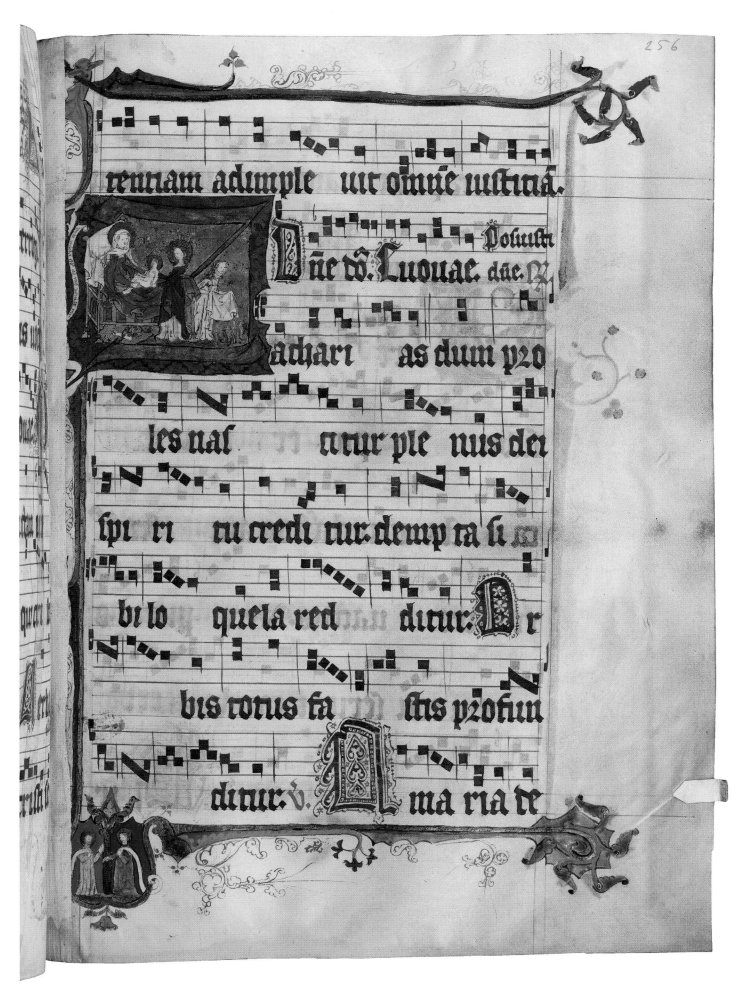

319. Office for John the Baptist (fragment), early 15th century,
added to antiphonary (pars estivalis) for Paradies, before
1323. ULB Dusseldorf, D 9, f. 256r [vol. I, p. 628]

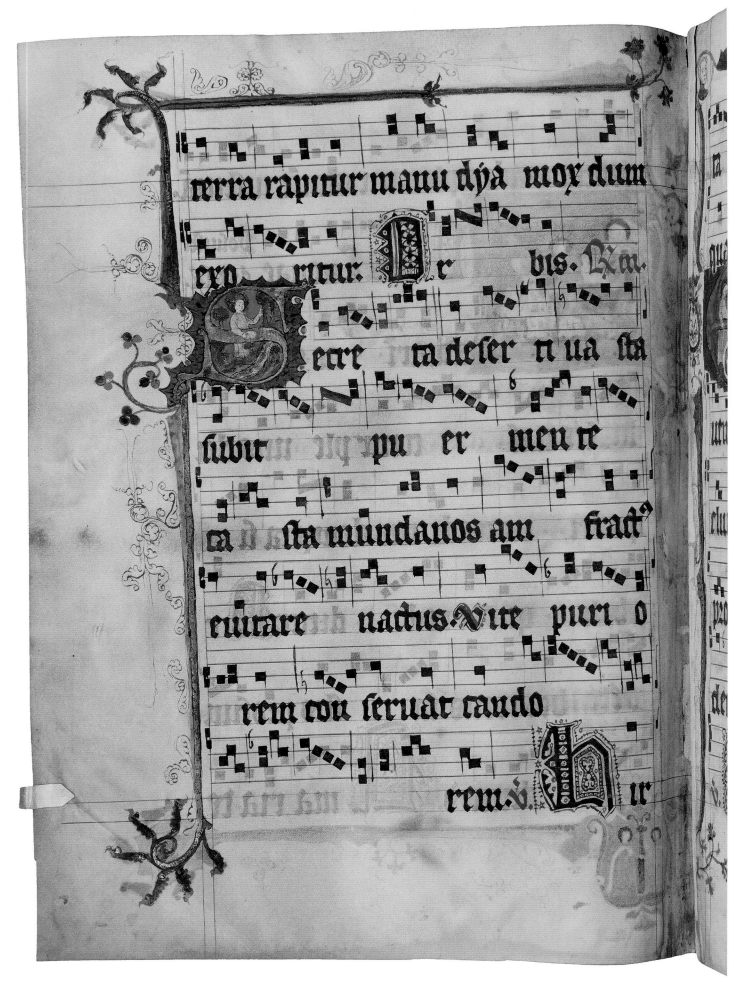

320. Office for John the Baptist (fragment), early 15th century, added to antiphonary (pars estivalis) for Paradies, before 1323. ULB Dusseldorf, D 9, f. 256v [vol. I, p. 630]

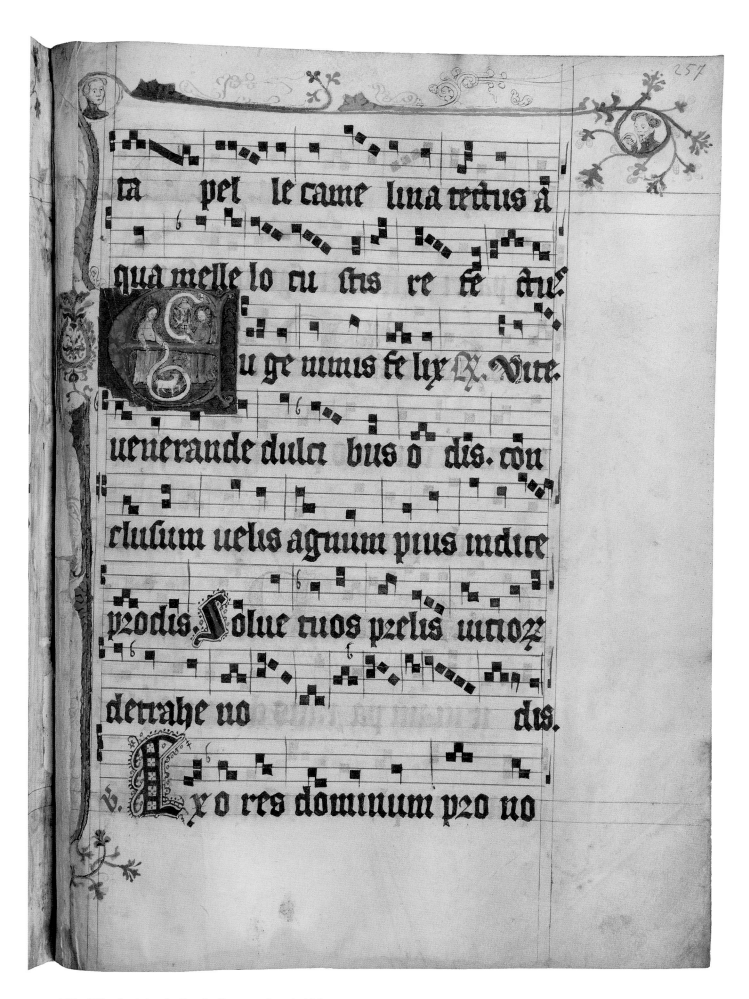

321. Office for John the Baptist (fragment), early 15th century,
added to antiphonary (pars estivalis) for Paradies, before
1323. ULB Dusseldorf, D 9, f. 257r [vol. I, pp. 630–31]

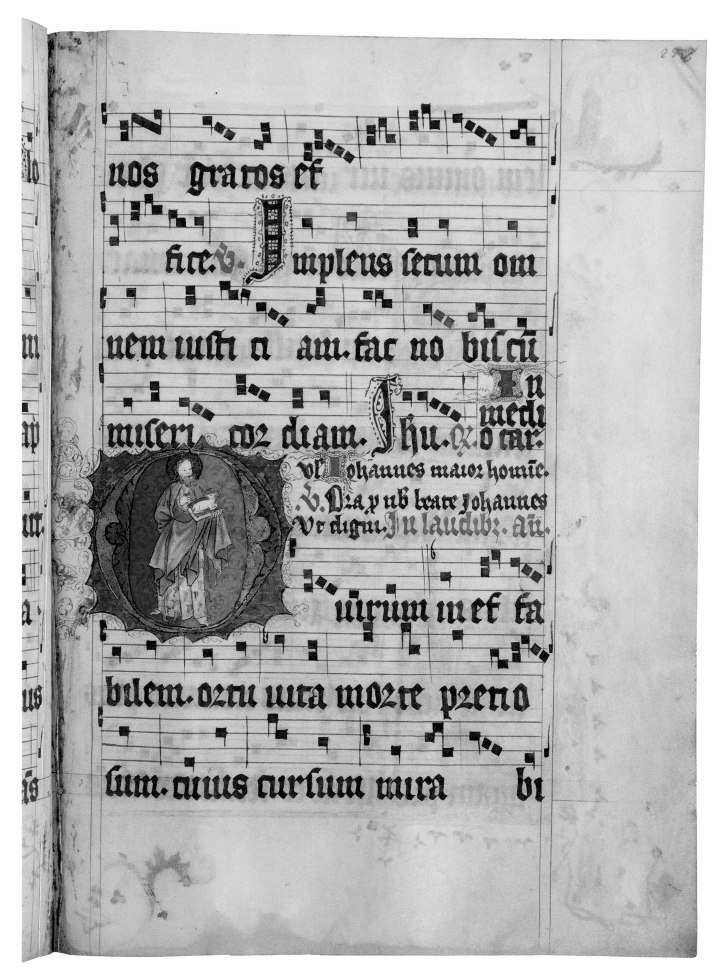

322. Office for John the Baptist (fragment), early 15th century, added to antiphonary (pars estivalis) for Paradies, before 1323. ULB Dusseldorf, D 9, f. 258r [vol. I, pp. 200, 634]

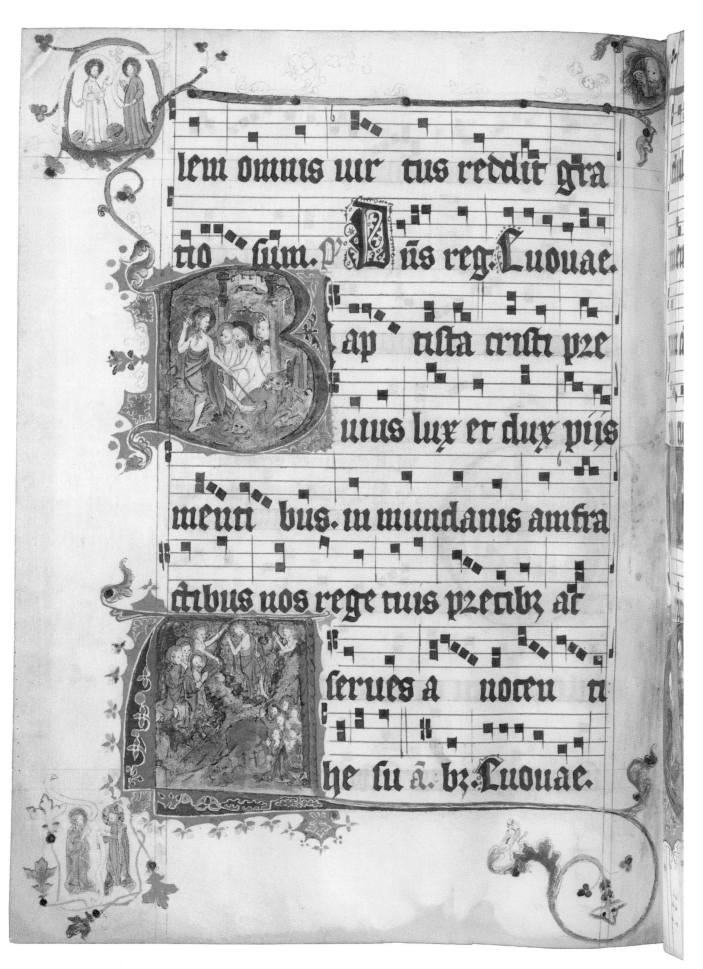

323. Office for John the Baptist (fragment), early 15th century, added to antiphonary (pars estivalis) for Paradies, before 1323. ULB Dusseldorf, D 9, f. 258v [vol. I, pp. 200, 634]

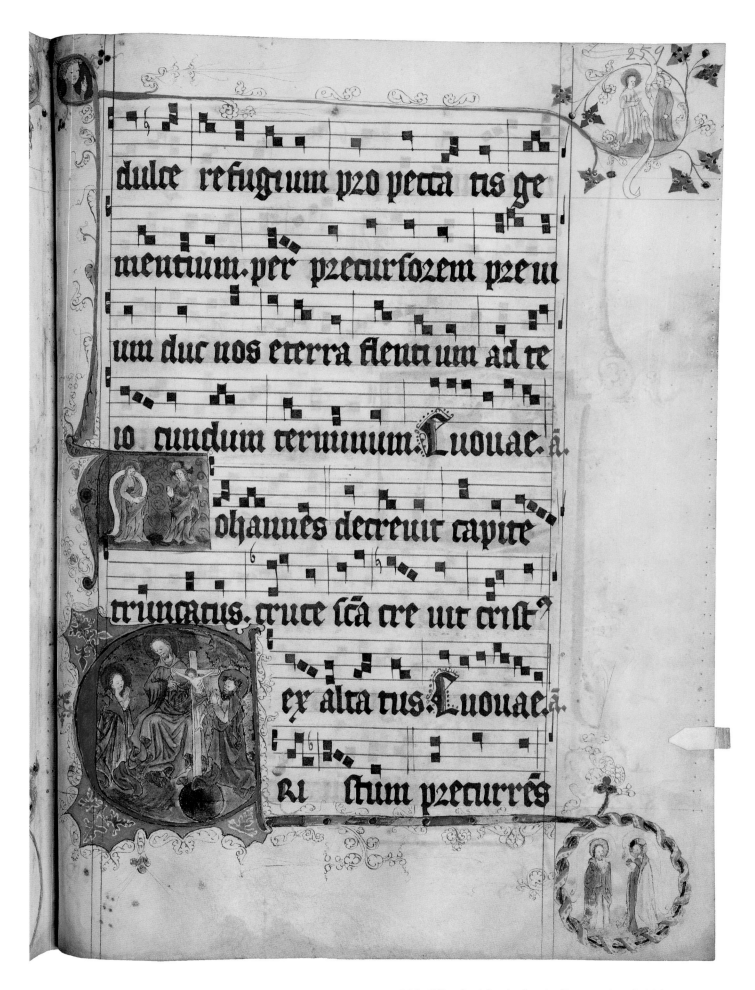

324. Office for John the Baptist (fragment), early 15th century, added to ntiphonary (pars estivalis) for Paradies, before 1323. ULB Dusseldorf, D 9, f. 259r [vol. I, pp. 634–35]

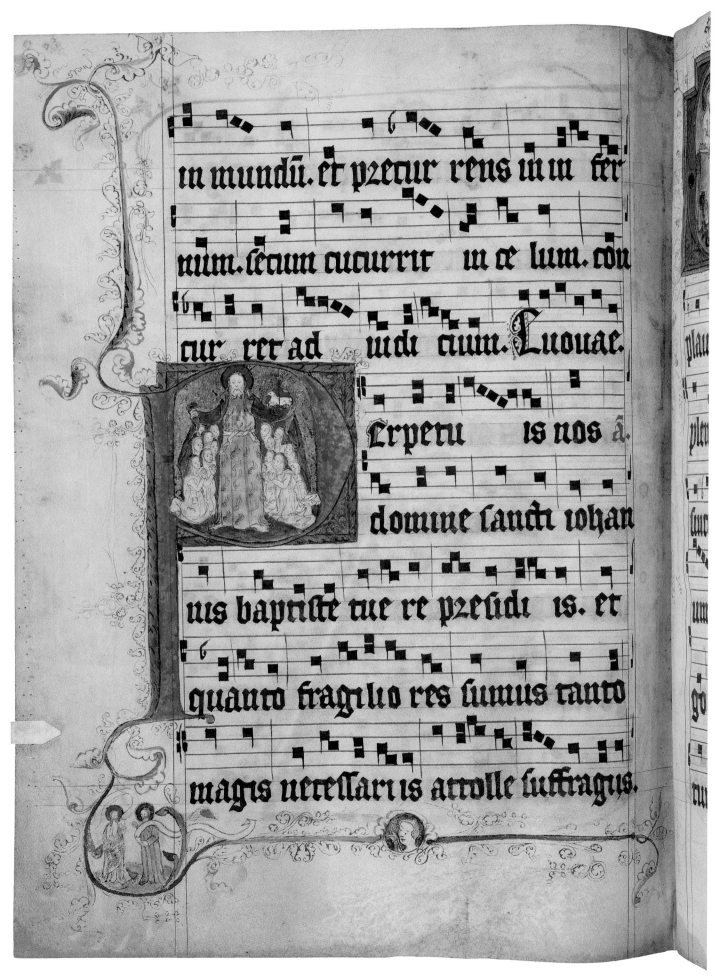

in mundū. et przetur rens in in ter

nium. sęcum cucurrit in ce lum. con

cur rer ad iudi cium. Euouae.

Erpetu is nos ã.

domine sancti iohan

nis baptiste tue re przesidi is. et

quanto fragilio res sumus tanto

magis necessari is attolle suffragiis.

325. Office for John the Baptist (fragment), early 15th century,
added to antiphonary (pars estivalis) for Paradies, before
1323. ULB Dusseldorf, D 9, f. 259v [vol. I, pp. 512, 635]

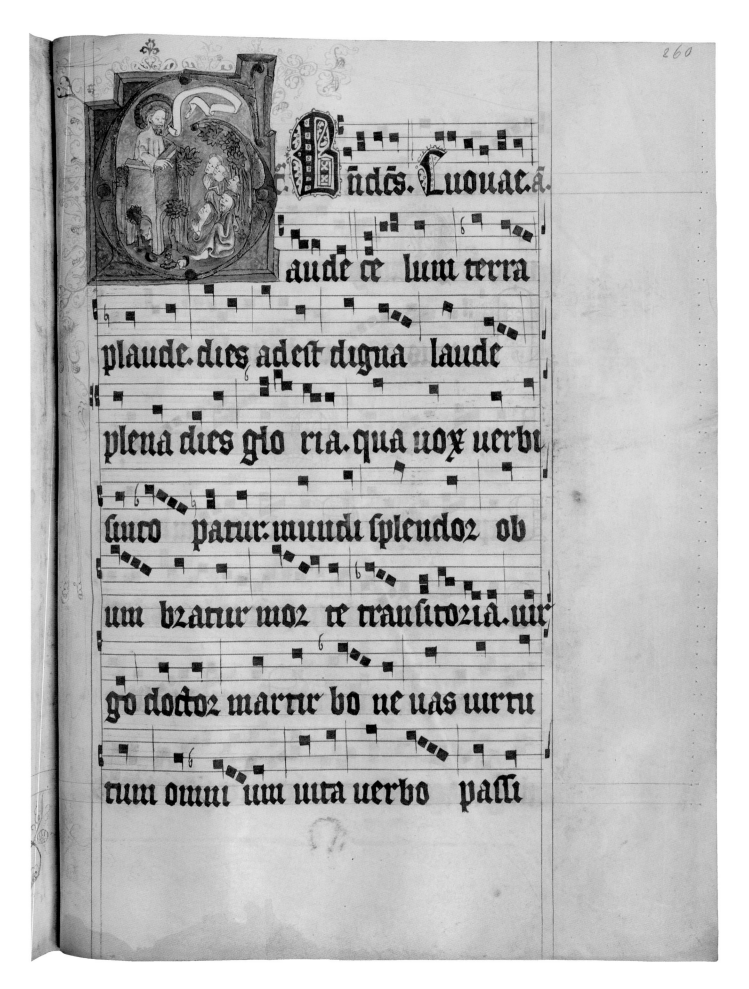

326. Office for John the Baptist (fragment), early 15th century, added to antiphonary (pars estivalis) for Paradies, before 1323. ULB Dusseldorf, D 9, f. 260r [vol. I, pp. 635–636]

Gradual
Dortmund, Propsteikirche
Archiv der Propsteigemeinde, B6

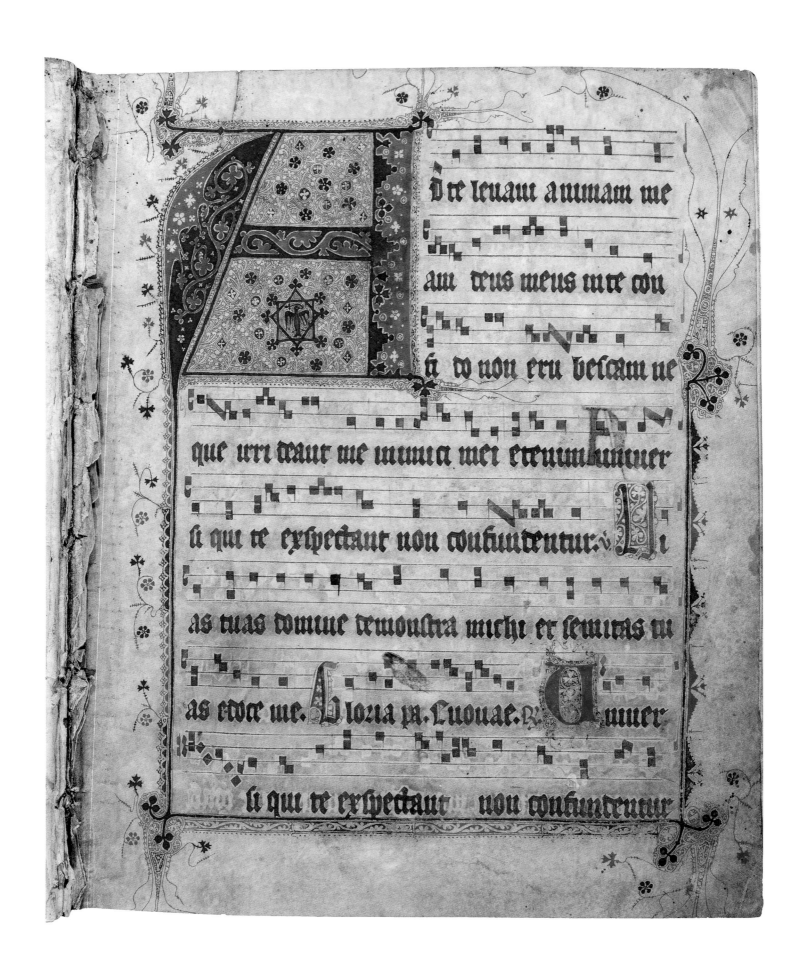

327. Proprium de tempore, gradual, ca. 1360. Dortmund, Propsteikirche, Archiv der Propsteigemeinde, B 6, f. 1r. (Foto R. Glahs, Dortmund) [vol. I, pp. 151–52]

328. Christmas: Midnight Mass, gradual, ca. 1360. Dortmund,
Propsteikirche, Archiv der Propsteigemeinde, B 6, f. 12v.
(Foto R. Glahs, Dortmund) [vol. I, p. 152]

GRADUAL, B 6 | 425

329. Christmas Day: First Mass, gradual, ca. 1360. Dortmund, Propsteikirche, Archiv der Propsteigemeinde, B 6, f. 14r. (Foto R. Glahs, Dortmund) [vol. I, p. 152]

330. Christmas Day: Second Mass, gradual, ca. 1360.
Dortmund, Propsteikirche, Archiv der Propsteigemeinde,
B 6, f. 15v. (Foto R. Glahs, Dortmund) [vol. I, p. 152]

331. Easter, gradual, ca. 1360. Dortmund, Propsteikirche, Archiv der Propsteigemeinde, B 6, f. 111v. (Foto R. Glahs, Dortmund) [vol. I, p. 152]

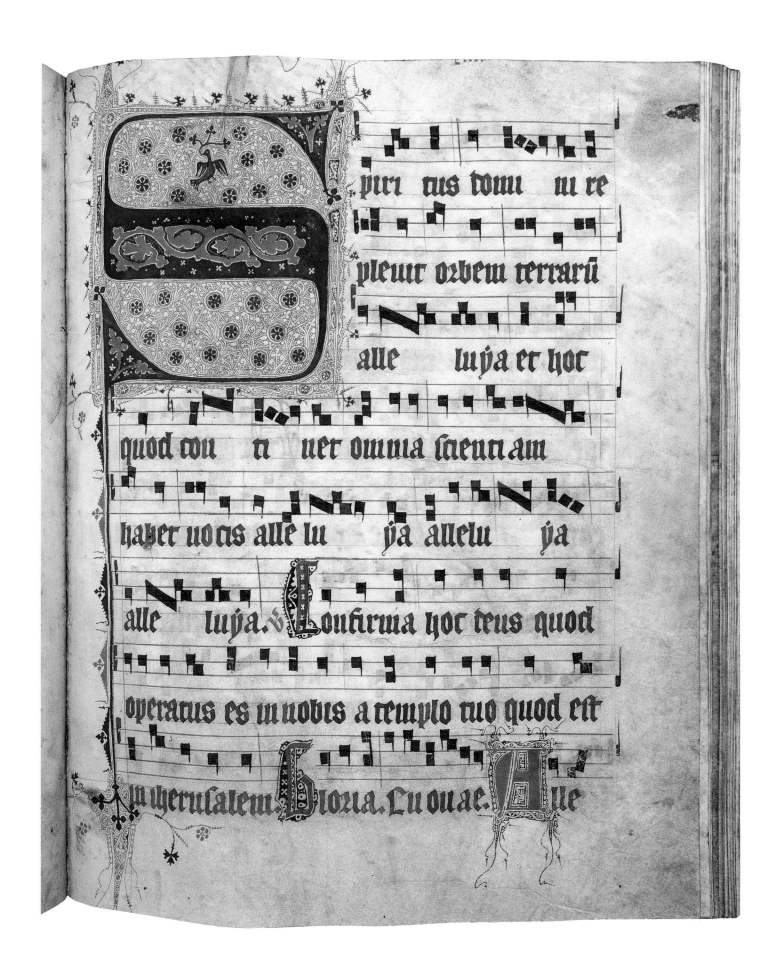

332. Pentecost, gradual, ca. 1360. Dortmund, Propsteikirche,
Archiv der Propsteigemeinde, B 6, f. 135r.
(Foto R. Glahs, Dortmund) [vol. II, p. 6]

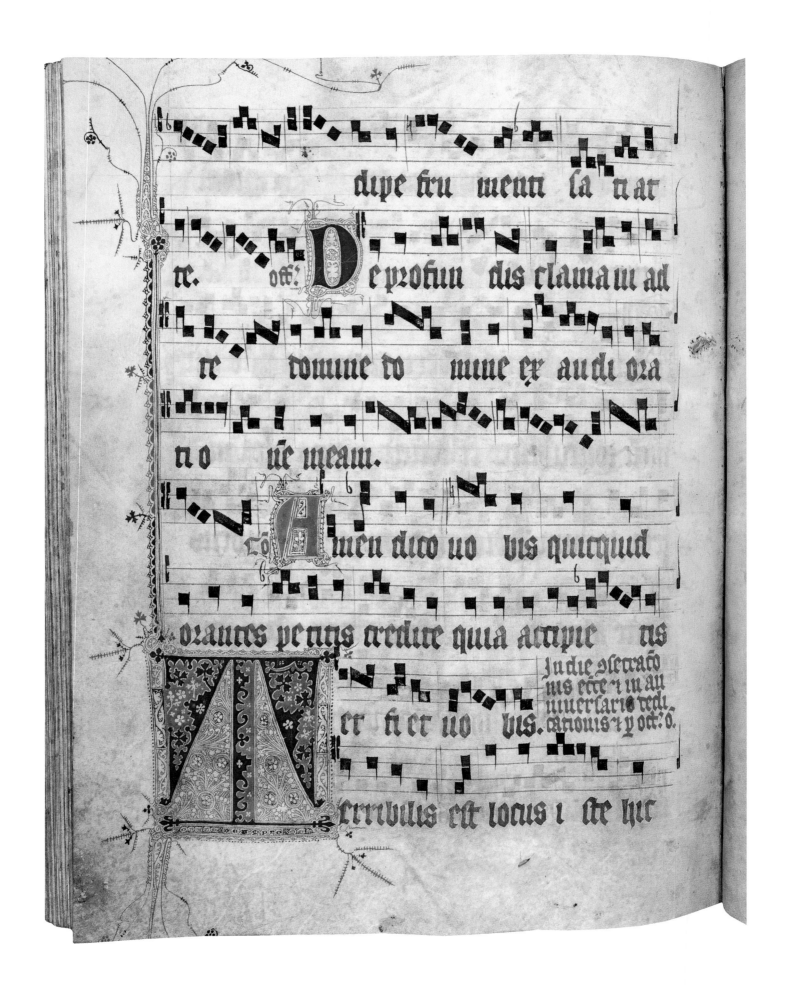

333. Dedication of Church, gradual, ca. 1360. Dortmund, Propsteikirche, Archiv der Propsteigemeinde, B 6, f. 169v. (Foto R. Glahs, Dortmund) [vol. I, pp. 723–24]

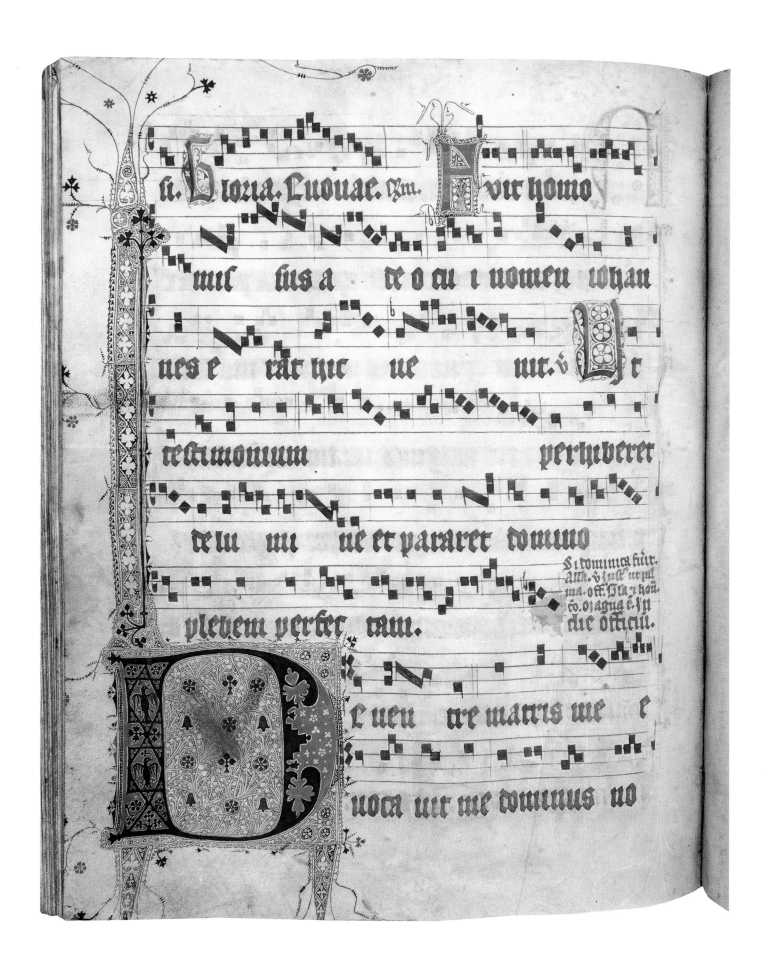

334. John the Baptist, gradual, ca. 1360. Dortmund,
Propsteikirche, Archiv der Propsteigemeinde, B 6, f. 188v.
(Foto R. Glahs, Dortmund) [vol. I, pp. 152–53]

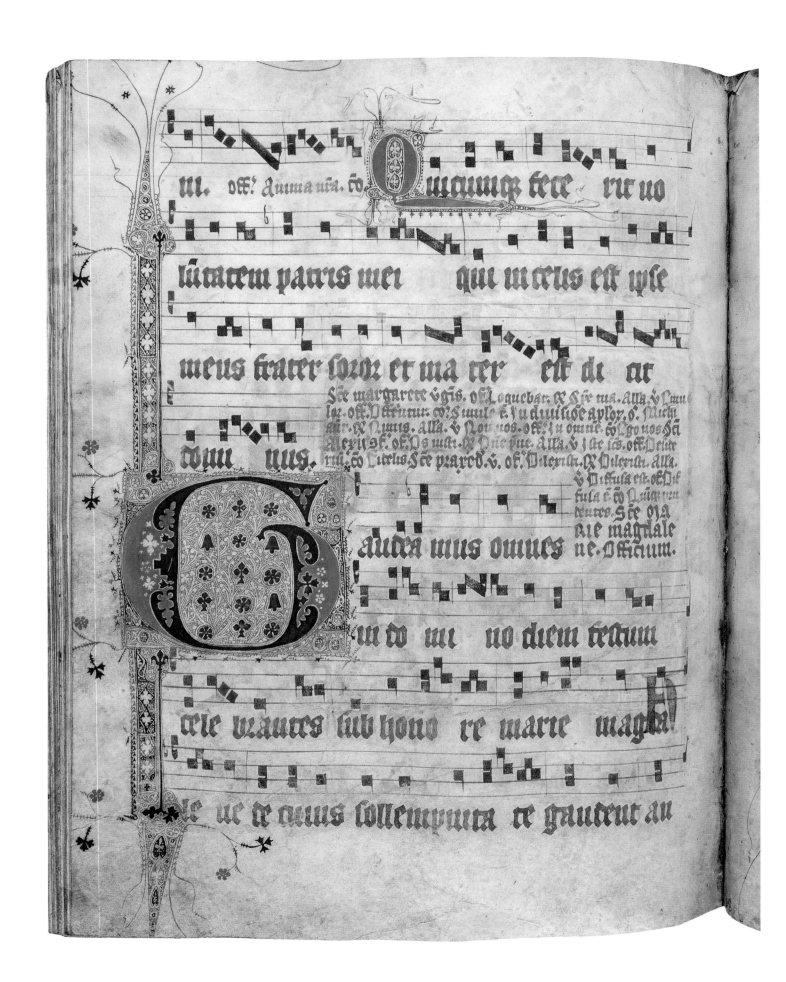

335. Mary Magdalen, gradual, ca. 1360. Dortmund, Propsteikirche, Archiv der Propsteigemeinde, B 6, f. 193v. (Foto R. Glahs, Dortmund) [vol. I, pp. 153, 168]

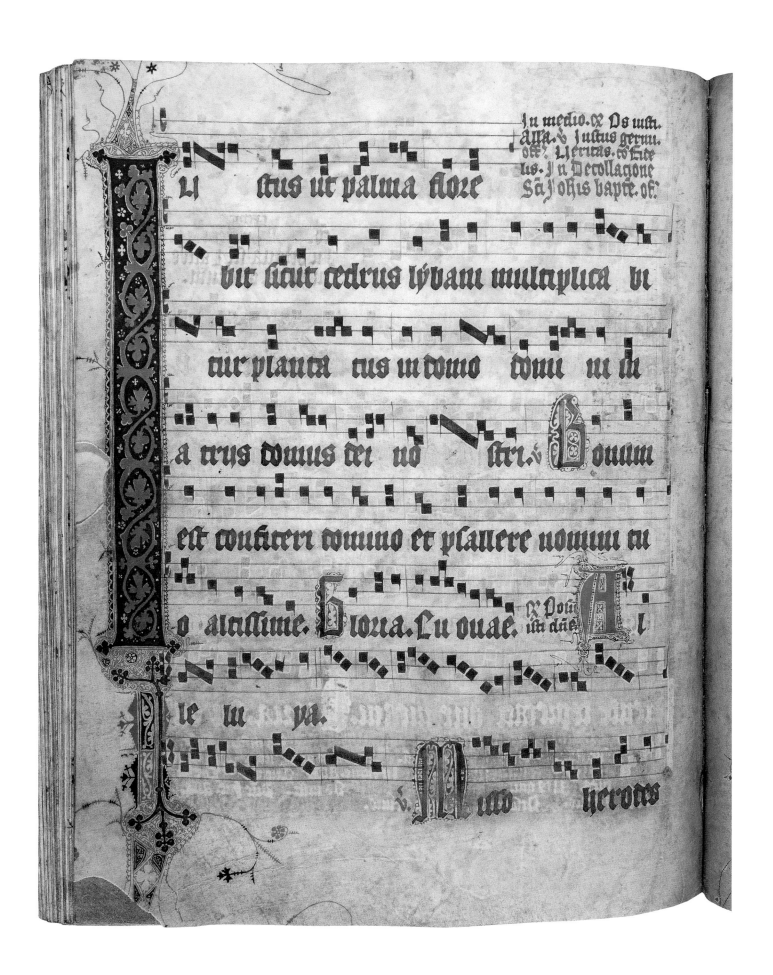

336. John the Baptist: decollation, gradual, ca. 1360.
Dortmund, Propsteikirche, Archiv der Propsteigemeinde,
B 6, f. 199v. (Foto R. Glahs, Dortmund) [vol. II, p. 7]

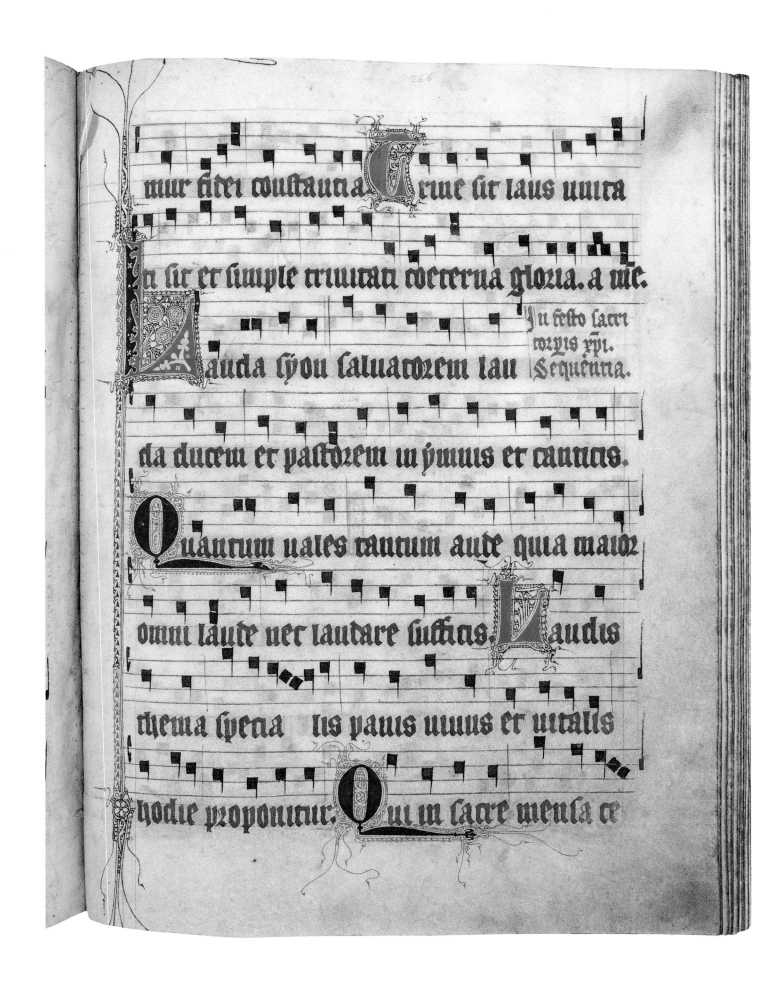

337. Corpus Christi: sequence, gradual, ca. 1360. Dortmund, Propsteikirche, Archiv der Propsteigemeinde, B 6, f. 266r. (Foto R. Glahs, Dortmund) [vol. II, p. 5]

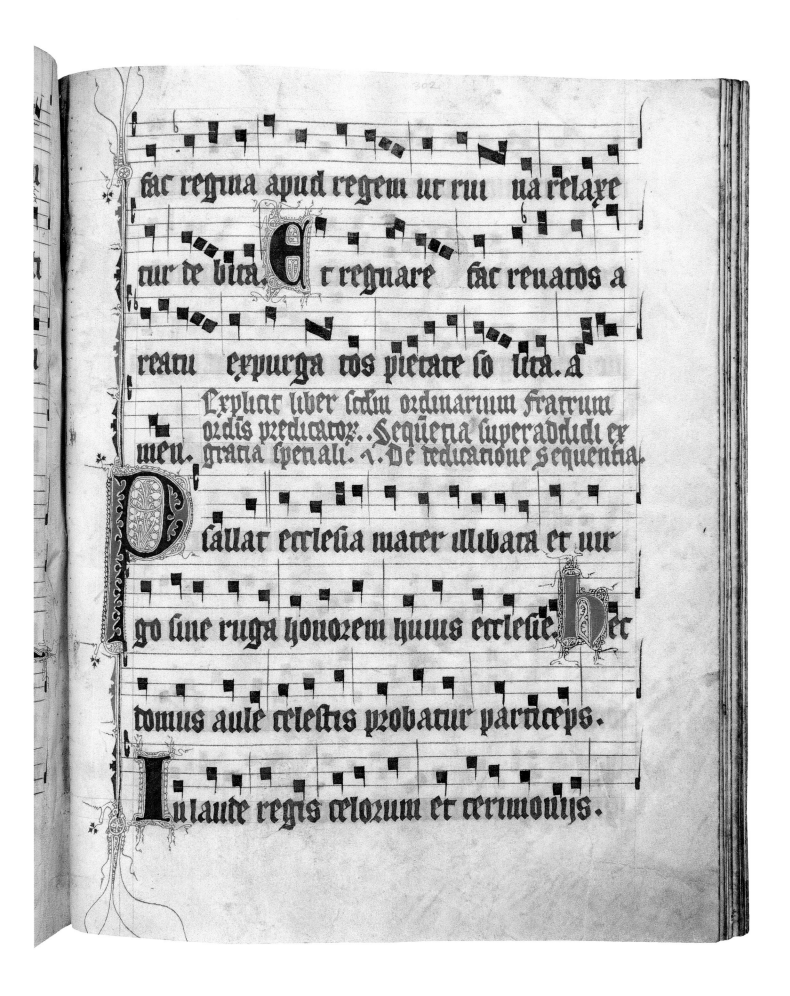

fac regina apud regem ut ruina relaxe

tur de bita. Et regnare fac renatos a

reatu expurga tos pietate so lita. a

Explicit liber scdm ordinarium fratrum
ordis predicatorum. Sequencia superaddidi ex
men. gracia speciali. ↗. De dedicatione sequencia.

Psallat ecclesia mater illibata et vir

go sine ruga honorem huius ecclesie. Hec

domus aule celestis probatur particeps.

In laude regis celorum et cerimoniis.

338. Dedication of Church: sequence, gradual, ca. 1360.
Dortmund, Propsteikirche, Archiv der Propsteigemeinde,
B 6, f. 302r. (Foto R. Glahs, Dortmund) [vol. I, p. 153]

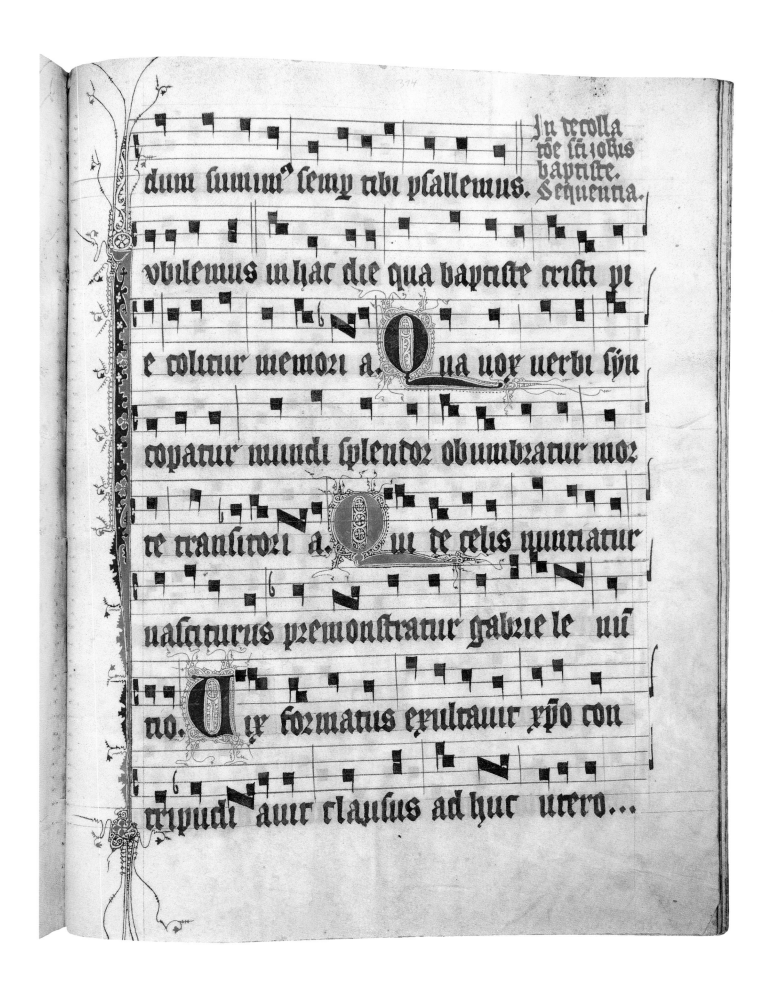

339. John the Baptist: decollation, gradual, ca. 1360.
Dortmund, Propsteikirche, Archiv der Propsteigemeinde,
B 6, f. 314r. (Foto R. Glahs, Dortmund) [vol. II, p. 7]

340. Colophon, gradual, ca. 1360. Dortmund, Propsteikirche,
Archiv der Propsteigemeinde, B 6, f. 324v.
(Foto R. Glahs, Dortmund) [vol. I, p. 148]

Libellus in Honor of John the Evangelist
Munich, Staatliche Graphische Sammlung
Inv. No. 18703
and Cambridge, Houghton Library
Harvard University, MS Typ 1095

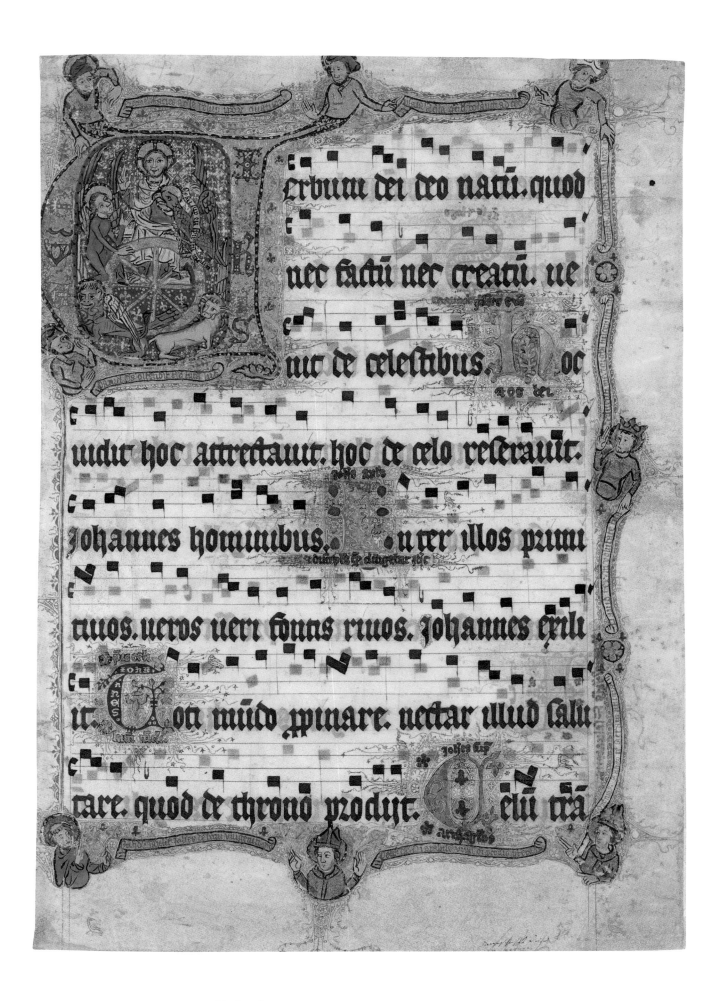

341. John the Evangelist: sequence, libellus (fragment), ca. 1380. Munich, Staatliche Graphische Sammlung, inv. no. 18703, recto [vol. I, pp. 568–73, 581–85, 590–91, 601–02, 608]

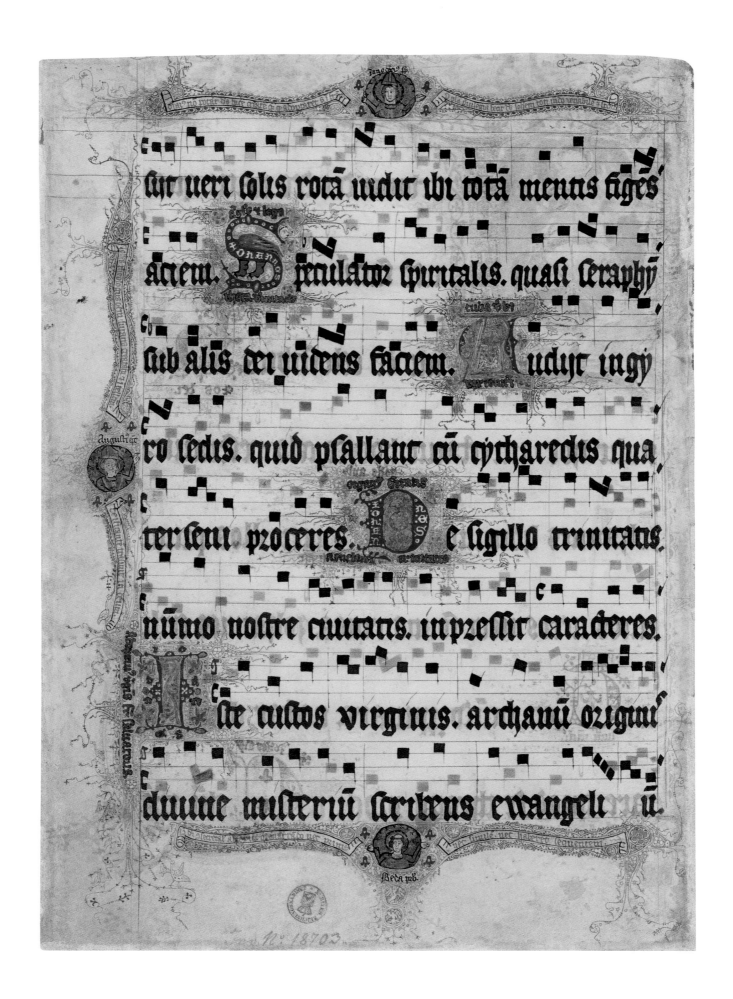

342. John the Evangelist: sequence, libellus (fragment), ca. 1380. Munich, Staatliche Graphische Sammlung, inv. no. 18703, verso [vol. I, pp. 533, 568–73, 581–585, 592–93, 600–02, 607–608]

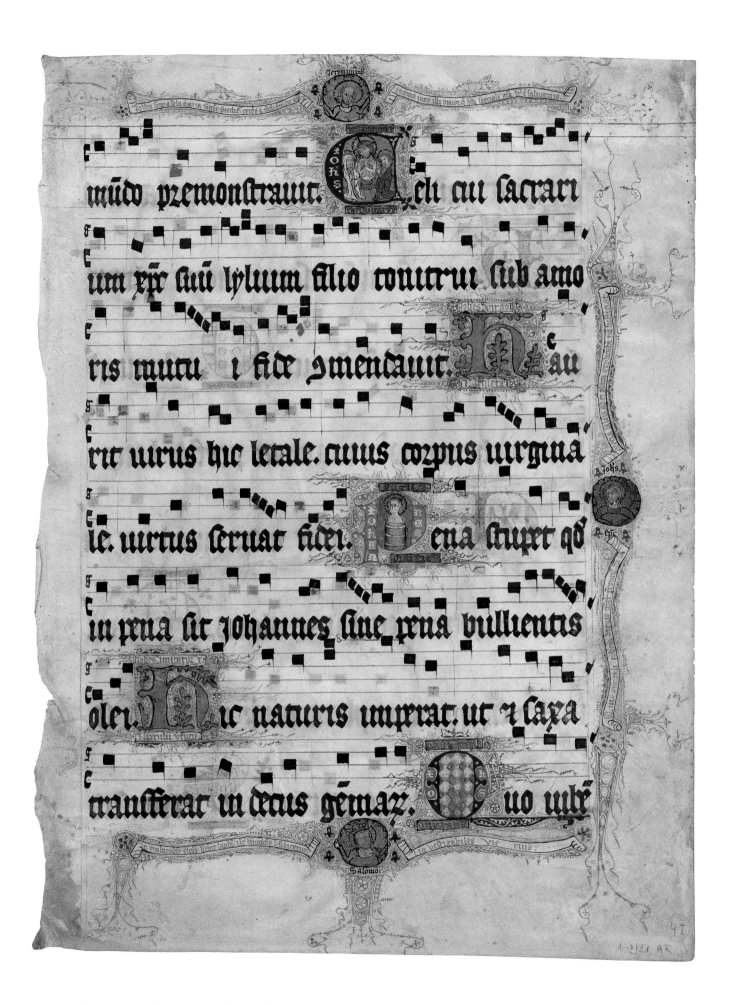

343. John the Evangelist: sequence, libellus (fragment), ca. 1380.
Cambridge, Houghton Library, Harvard University,
MS Typ 1095, f. 1r [vol. I, pp. 568–73, 581–85, 589–90, 609]

344. John the Evangelist: sequence, libellus (fragment, ca. 1380. Cambridge, Houghton Library, Harvard University, MS Typ 1095, f. 1v [vol. I, pp. 568–73, 581–585, 609–10]

345. John the Evangelist: sequence, libellus (fragment), ca. 1380.
Cambridge, Houghton Library, Harvard University,
MS Typ 1095, f. 2r [vol. I, pp. 568–73, 581–85, 610–11]

346. John the Evangelist: sequence, libellus (fragment), ca. 1380.
Cambridge, Houghton Library, Harvard University,
MS Typ 1095, f. 2v [vol. I, pp. 568–73, 581–85, 611]

Gradual
ULB Dusseldorf, D 12

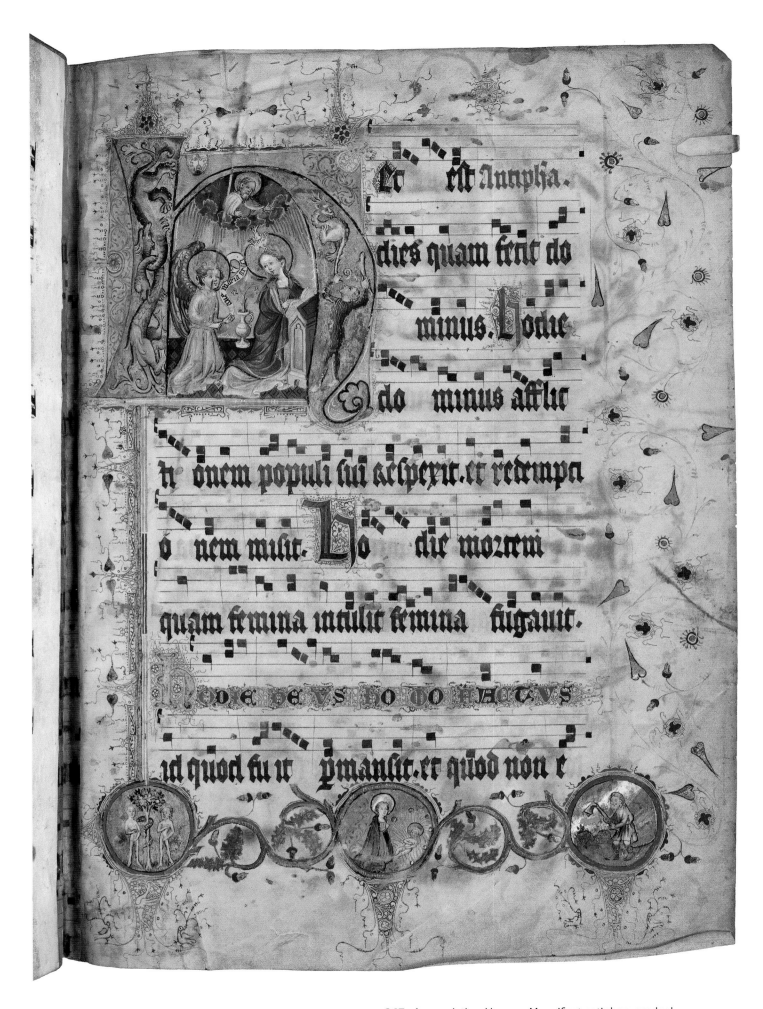

347. Annunciation: Vespers, Magnificat antiphon, gradual, ca. 1420. ULB Dusseldorf, D 12, f. 1r [vol. I, pp. 192, 195–96, 200]

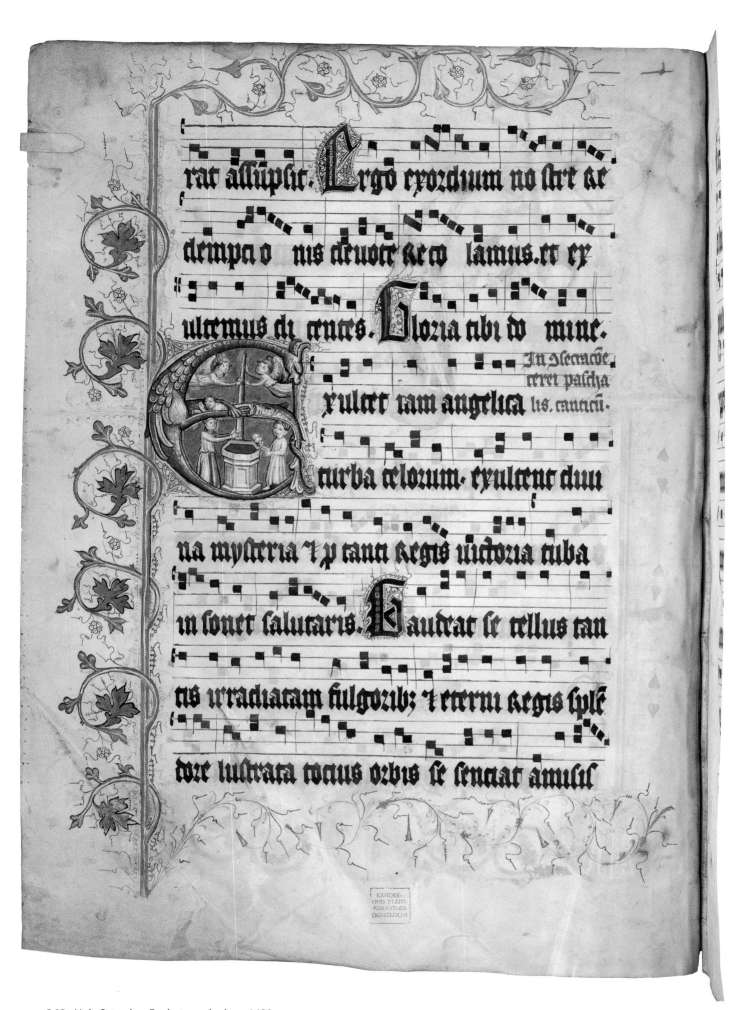

rat assumpsit. Ergo exordium no sirt re

dempra o nis deuote se eq lamus. et ex

ultemus di cenres. Gloria tibi do mine.

In descendeteret pascha
lis. canticu.

rultet iam angelica

turba celorum. exultent diui

na mysteria 7 p tanti regis uictoria tuba

in sonet salutaris. Gaudeat se tellus tan

tis irradiatam fulgozib; 7 eterni regis sple

doze lustrata totius ozbis se senciat amisisse

348. Holy Saturday: Exultet, gradual, ca. 1420.
ULB Dusseldorf, D 12, f. 1v [vol. I, pp. 300–301]

GRADUAL, D 12 | 449

349. Holy Saturday: Exultet. ULB Dusseldorf, D 12, f. 6r [vol. I, pp. 192, 195, 349]

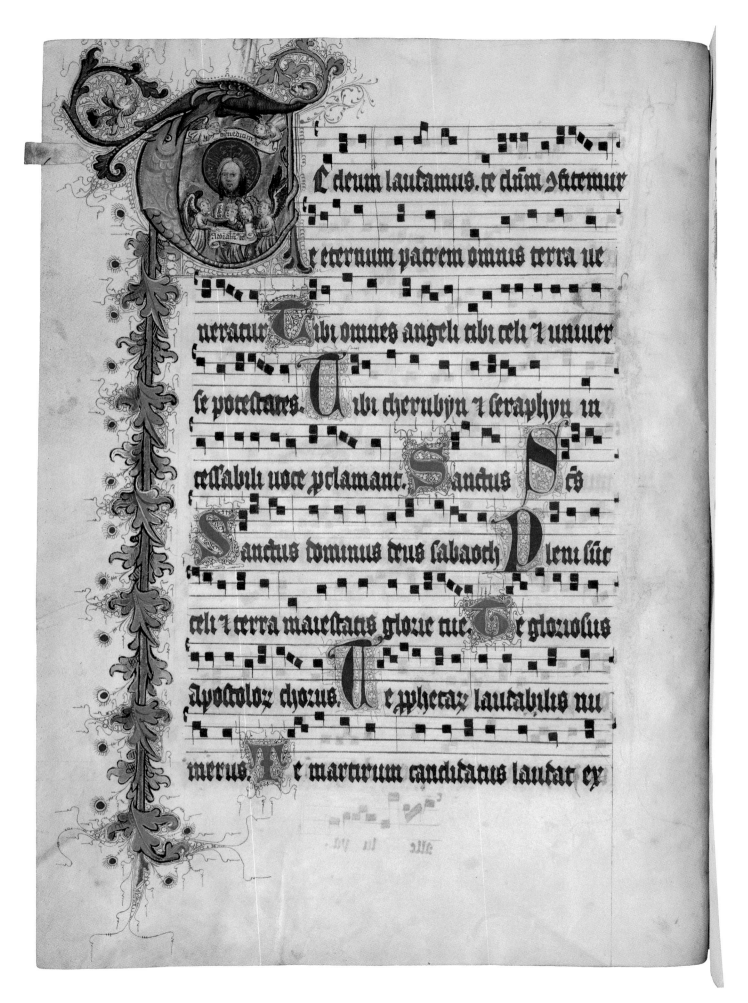

Te deum laudamus. te dominum confitemur

Te eternum patrem omnis terra ve

neratur Tibi omnes angeli tibi celi et univer

se potestates. Tibi cherubyn et seraphyn in

cessabili voce pclamant. Sanctus Sanctus

Sanctus dominus deus sabaoch Pleni sunt

celi et terra maiestatis glorie tue. Te gloriosus

Apostoloz chozus. Te pphetarz laudabilis nu

merus. Te martyrum candidatus laudat ex

350. Christmas: Te deum, gradual, ca. 1420.
ULB Dusseldorf, D 12, f. 6v [vol. I, p. 192, 195, 349]

GRADUAL, D 12 | **451**

351. Invention of Cross: antiphon, gradual, ca. 1420.
ULB Dusseldorf, D 12, f. 10v [vol. I, p. 298 and vol. II, p. 74.]

352. Colophon: gradual, ca. 1420.
ULB Dusseldorf, D 12, f. 11v [p. 191]

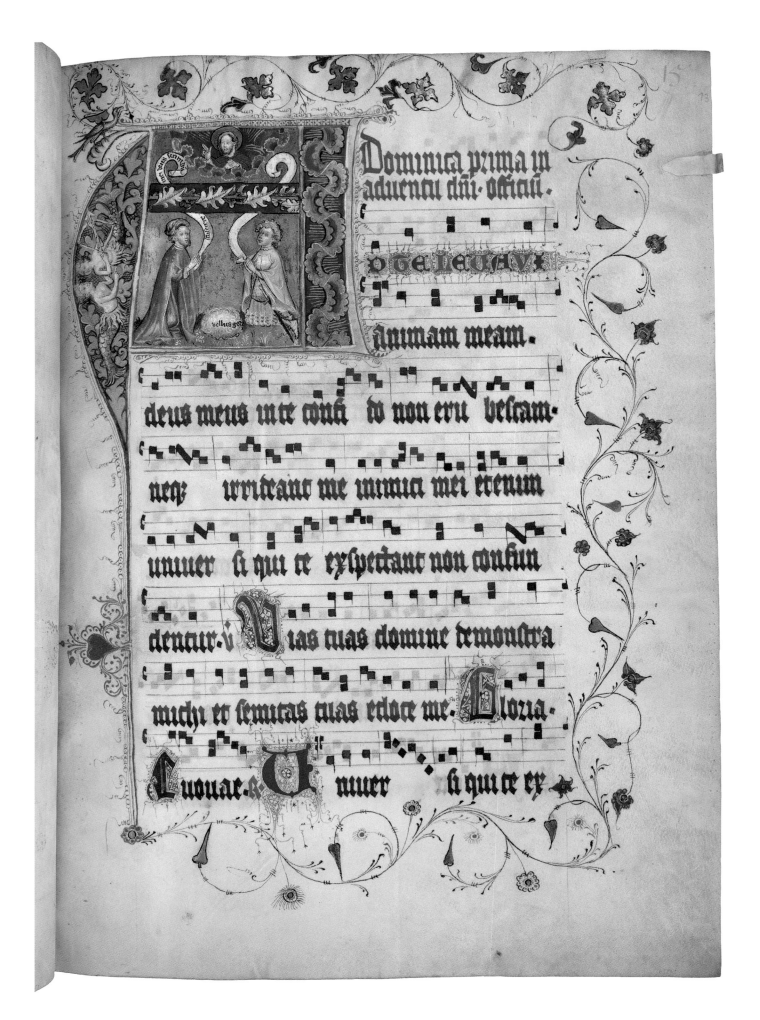

353. Advent: first Sunday, gradual, ca. 1420.
ULB Dusseldorf, D 12, f. 13r [vol. I, p. 192]

354. Advent: second Sunday, gradual, ca. 1420.
ULB Dusseldorf, D 12, f. 14r [vol. I, p. 328]

GRADUAL, D 12 | 455

355. Advent: third Sunday, gradual, ca. 1420.
ULB Dusseldorf, D 12, f. 15v [vol. I, pp. 197, 331–32]

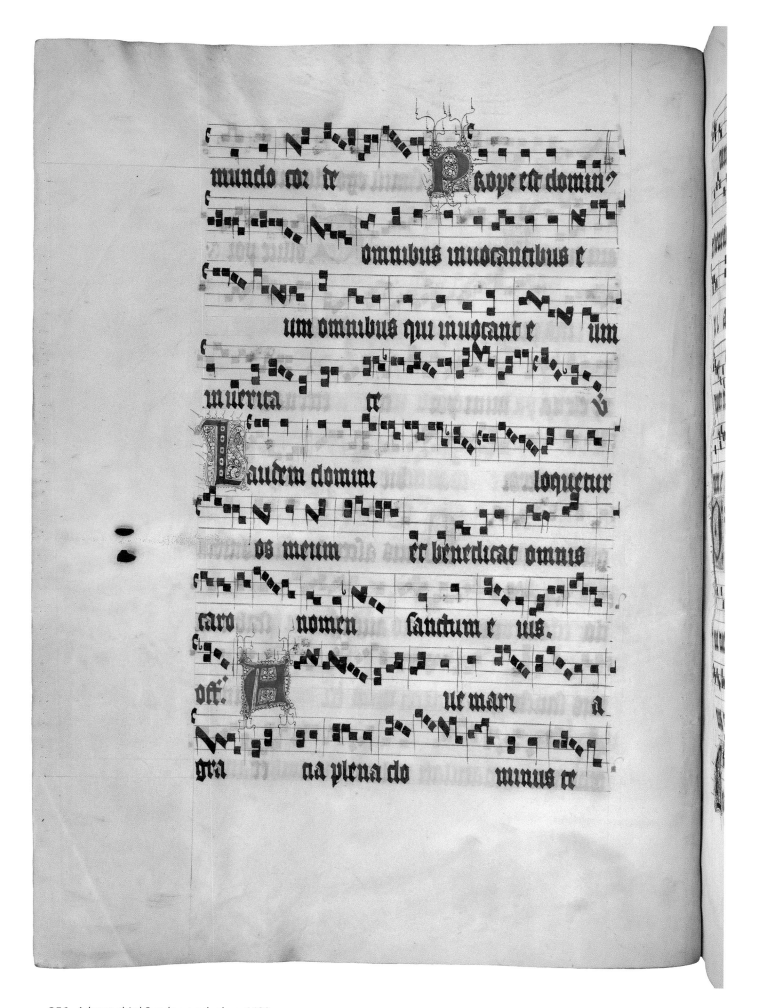

356. Advent: third Sunday, gradual, ca. 1420.
ULB Dusseldorf, D 12, f. 17v [vol. I, pp. 334–35]

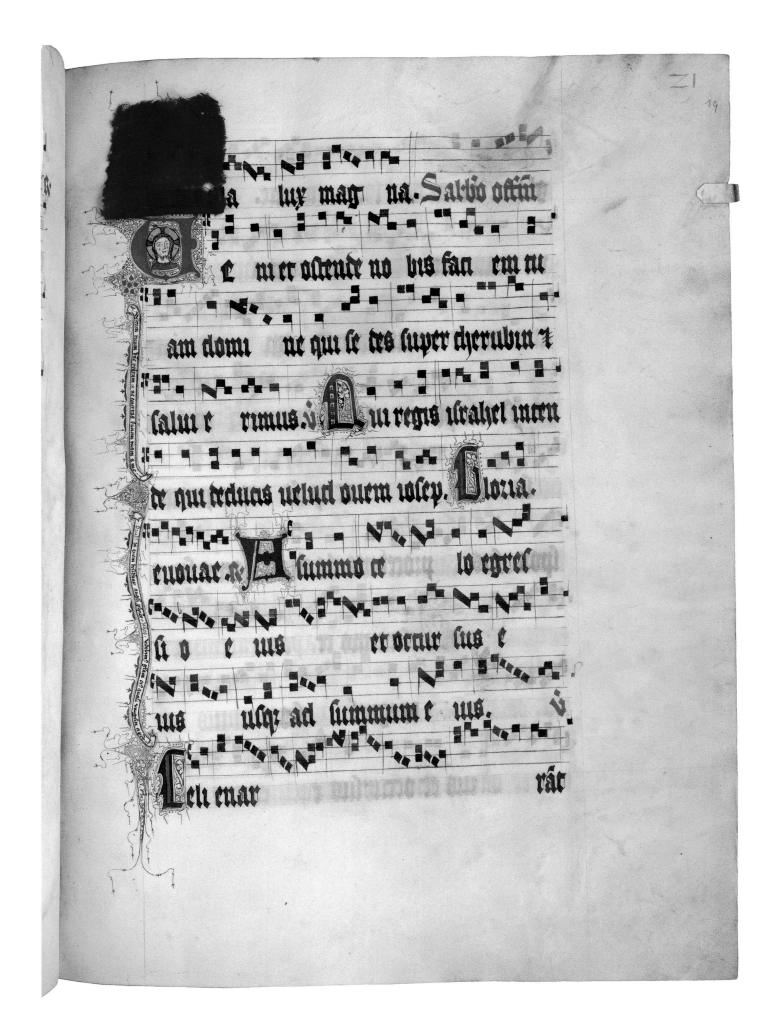

357. Advent: Saturday of third week, gradual, ca. 1420.
ULB Dusseldorf, D 12, f. 19r [vol. II, App. G, p. 2]

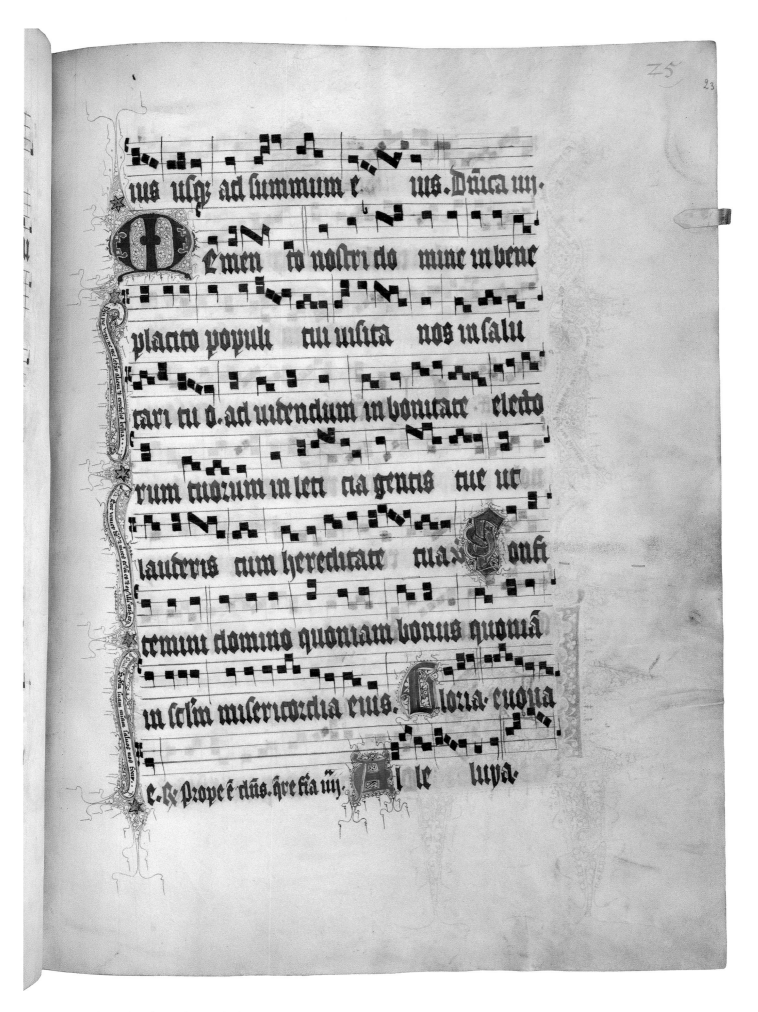

358. Advent: fourth Sunday, gradual, ca. 1420.
ULB Dusseldorf, D 12, f. 23r [vol. I, pp. 339–41]

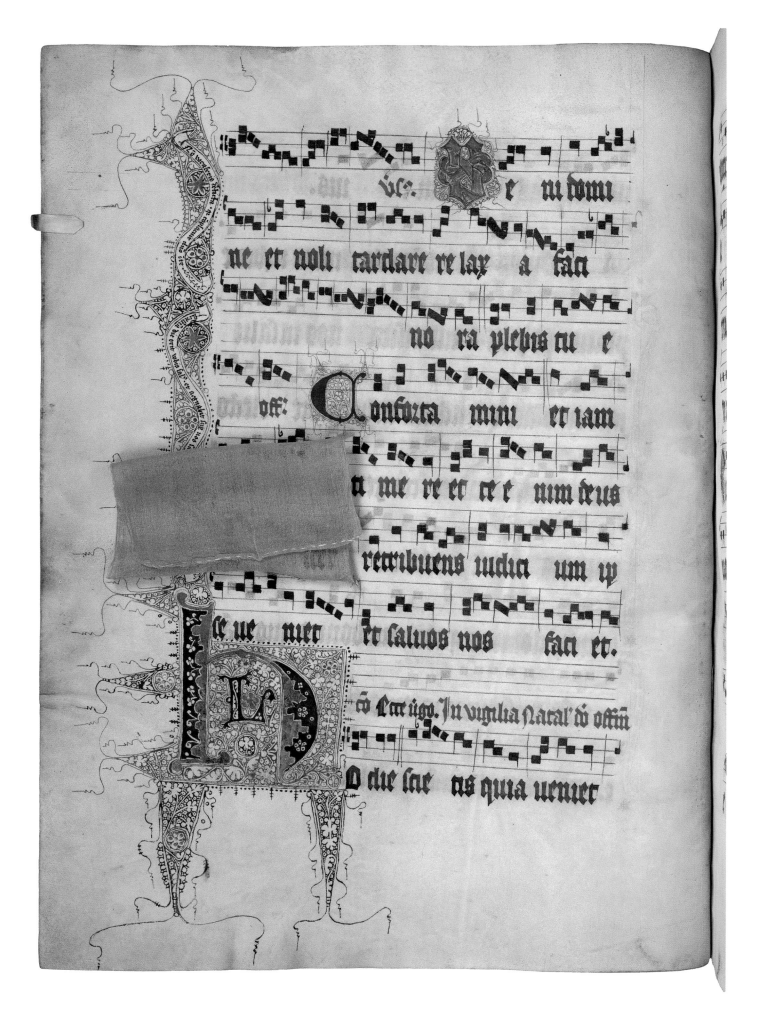

359. Christmas: vigil, gradual, ca. 1420.
ULB Dusseldorf, D 12, f. 23v [vol. I, pp. 191, 345]

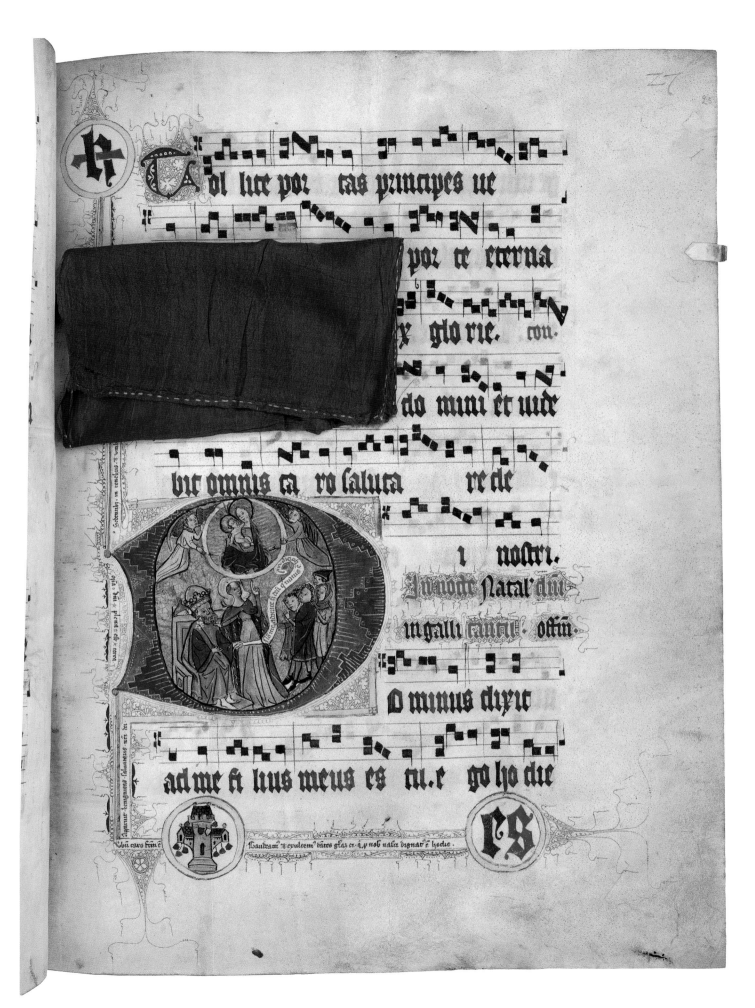

360. Christmas: vigil, gradual, ca. 1420.
ULB Dusseldorf, D 12, f. 25r [vol. I, pp. 192, 357]

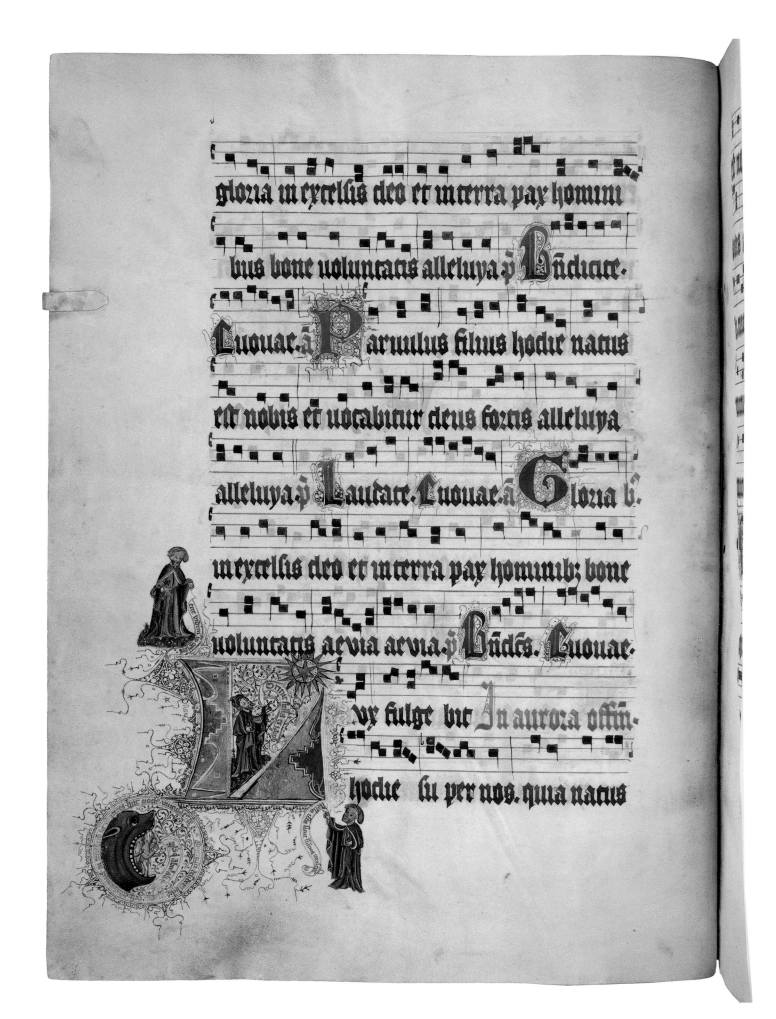

361. Christmas Day: First Mass, gradual, ca. 1420.
ULB Dusseldorf, D 12, f. 27v [vol. I, pp. 350–51]

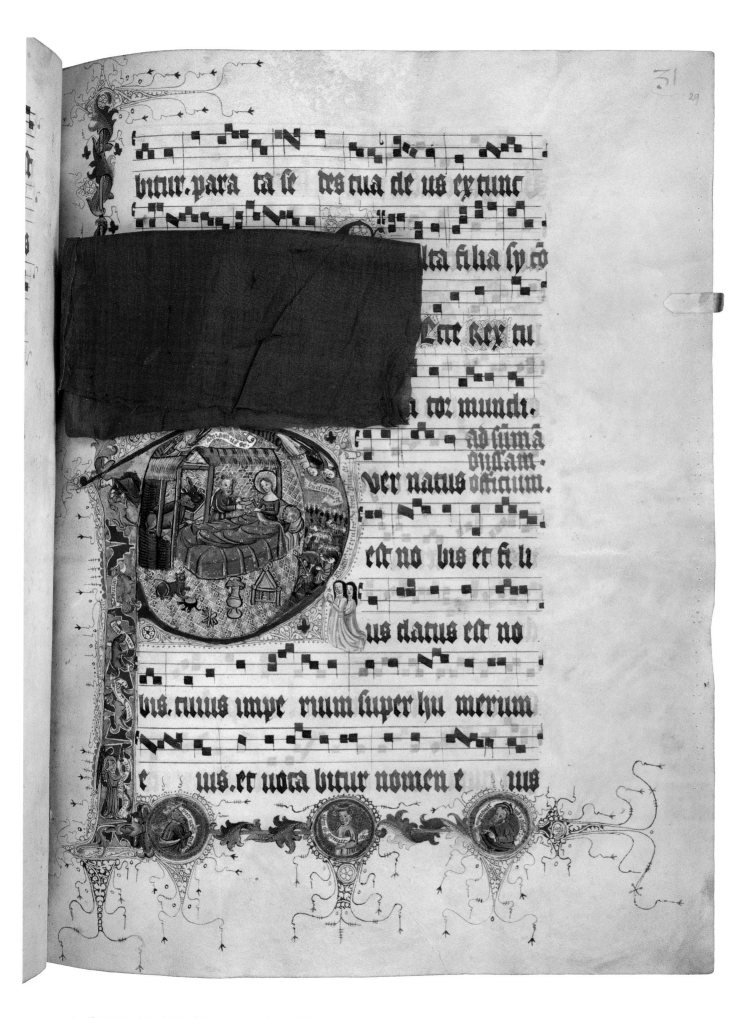

bitur. para ta se des tua de us ex tunc

lta filia sy co

Lce rex tu

tor mundi.

ad sum̃a

villam·

ver natus officium.

est no bis et fi li

us datus est no

bis. cuius impe rium super hu merum

e ius. et uoca bitur nomen e ius

362. Christmas Day: Second Mass, gradual, ca. 1420.
ULB Dusseldorf, D 12, f. 29r [vol. I, pp. 357–58]

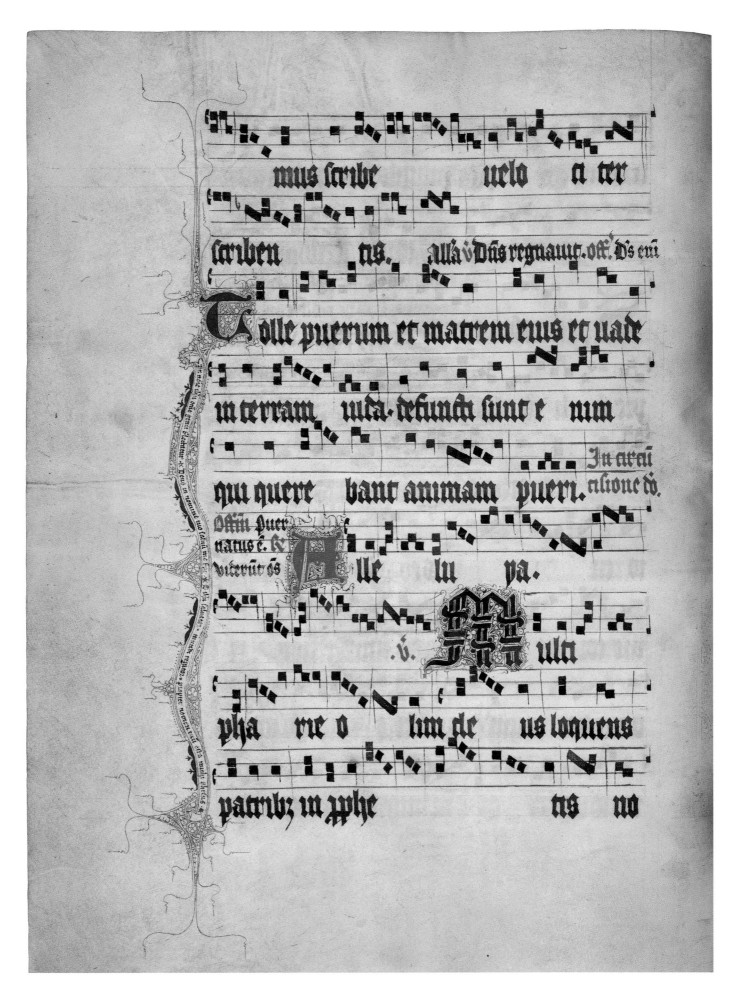

363. Circumcision, gradual, ca. 1420.
ULB Dusseldorf, D 12, f. 31v [vol. I, p. 362]

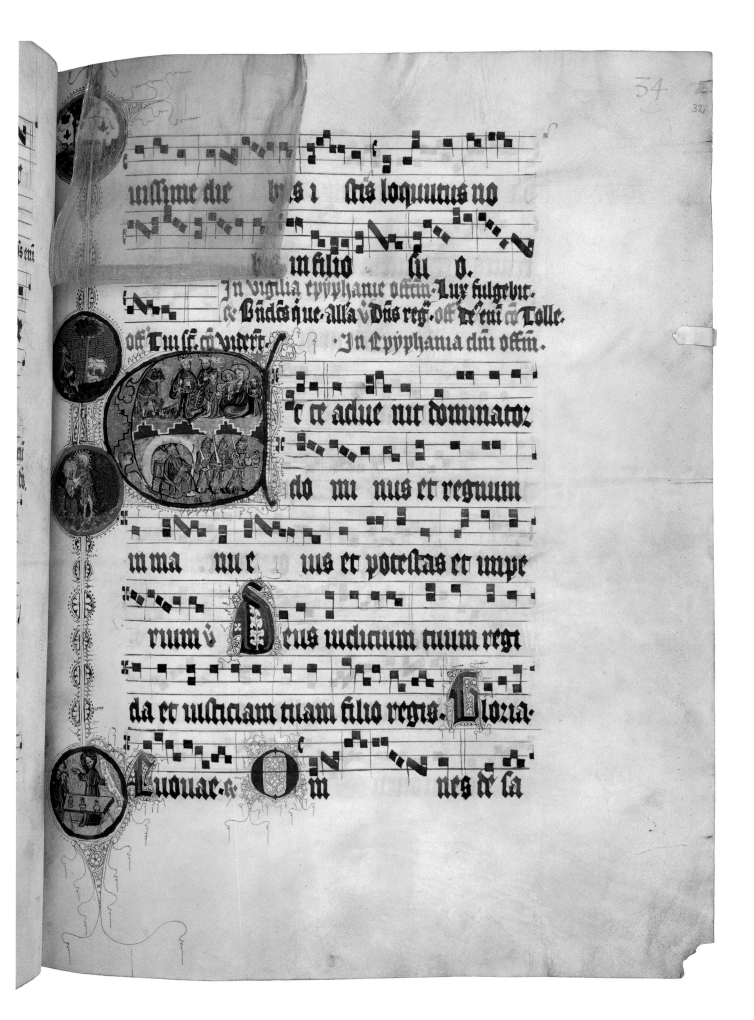

uiſſime dñe · · vꝰ s i · ſtis loquitus no

in filio · · ſu o.

In vigilia epyphanie offm · Lux fulgebit.
te Bndcs q̄ ue · Alla v̄ Dñs reꝯ · off dr̄ eui cō Tolle.
off cui ſc̄ cō viderū · · In epyphania diū offm.

e et aduc nit dominatoz

do mi nus et regnum

in ma nu e us et poteſtas et impe

rium v̄ Deus iudicium tuum regi

da et iuſticiam tuam filio regis · Gloria

Luouae e · O m nes dē ſa

364. Epiphany, gradual, ca. 1420.
ULB Dusseldorf, D 12, f. 32r [vol. I, p. 369]

GRADUAL, D 12 | 465

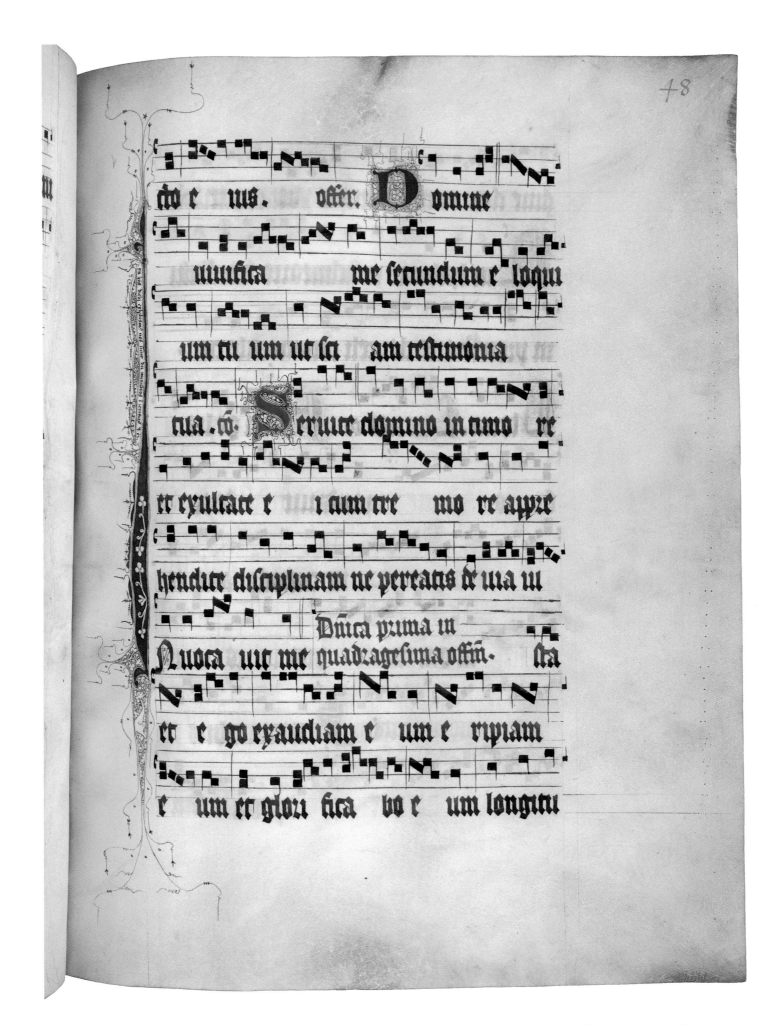

365. Quadragesima: first Sunday, gradual, ca. 1420.
ULB Dusseldorf, D 12, f. 48r [vol. I, p. 399]

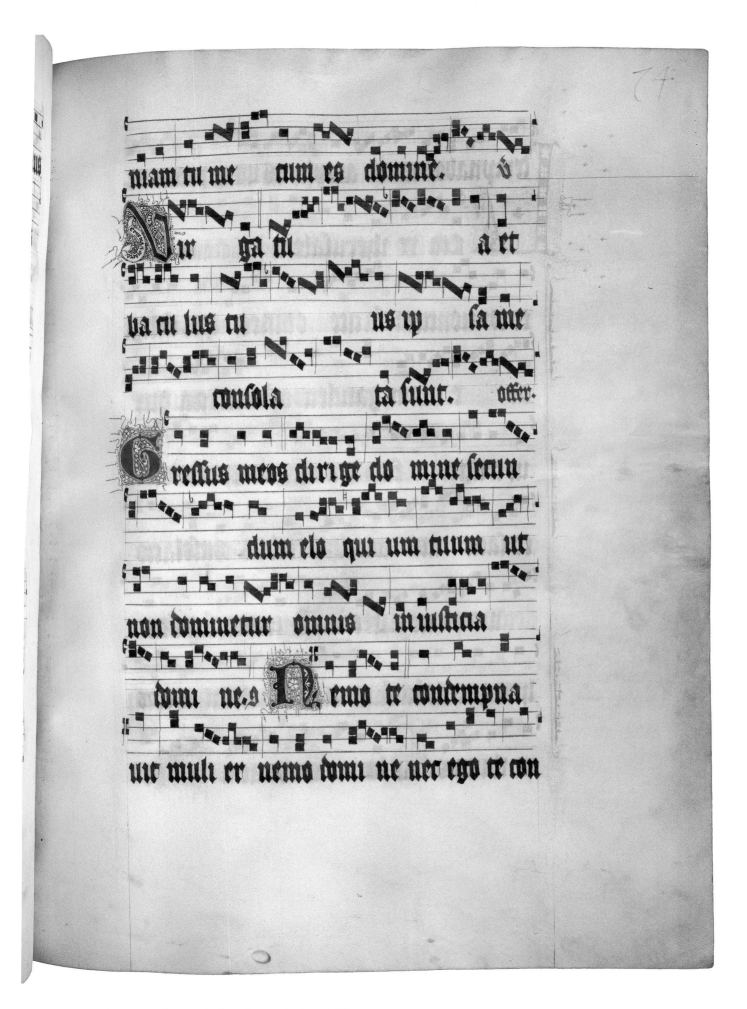

366. Quadragesima: third week, Saturday, gradual, ca. 1420.
ULB Dusseldorf, D 12, f. 74r [vol. I, p. 396]

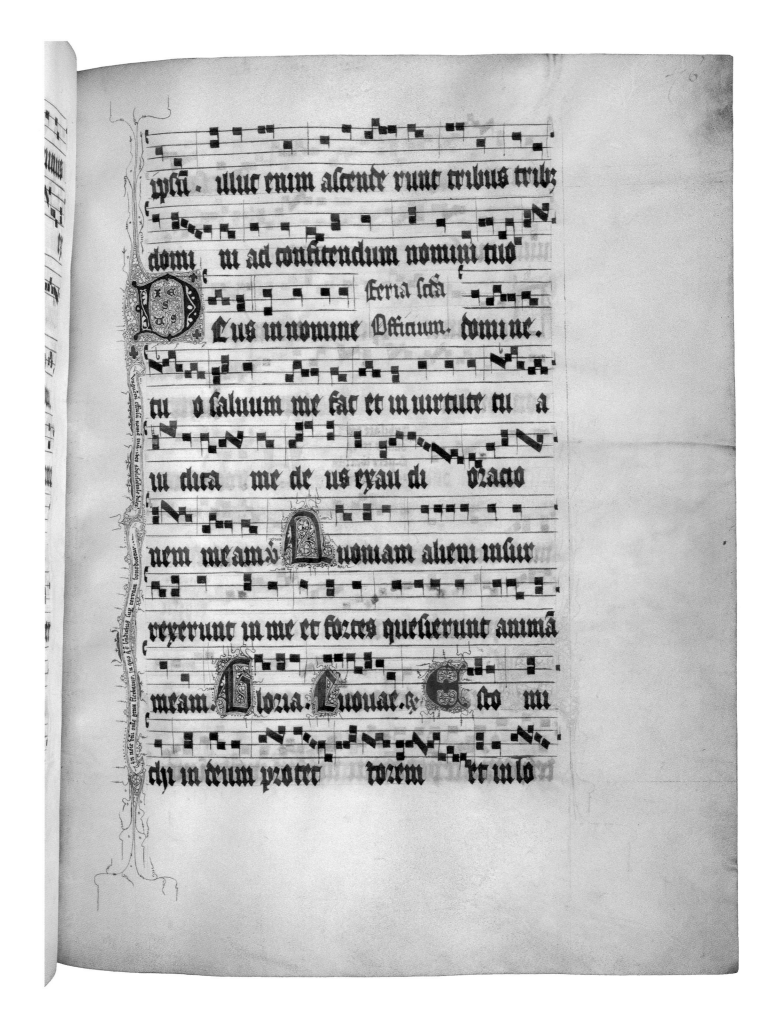

367. Quadragesima: fourth week, Friday, gradual,
ca. 1420. ULB Dusseldorf, D 12, f. 76r [vol. I, p. 399]

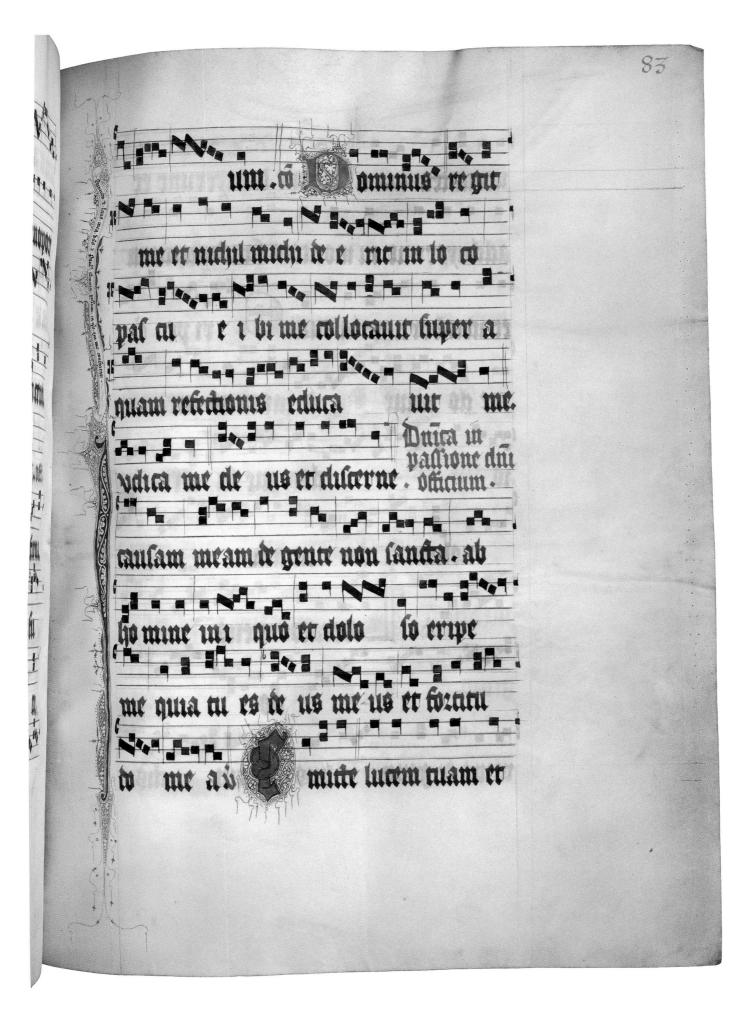

 num. cō **Dominus** re git

me et nichil michi de e rit in to co

pal cu e i bi me collocauit super a

quam refectionis educa uit me.

vdica me de us et discerne. officium.

Dnica in
paſſione dñi

cauſam meam de gente non ſancta. ab

ho mine im quo et dolo ſo eripe

me quia tu es de us me us et fortitu

to me a v mitte lucem tuam et

368. Holy Week: Sunday, gradual, ca. 1420.
ULB Dusseldorf, D 12, f. 83r [vol. I, p. 405]

GRADUAL, D12 | 469

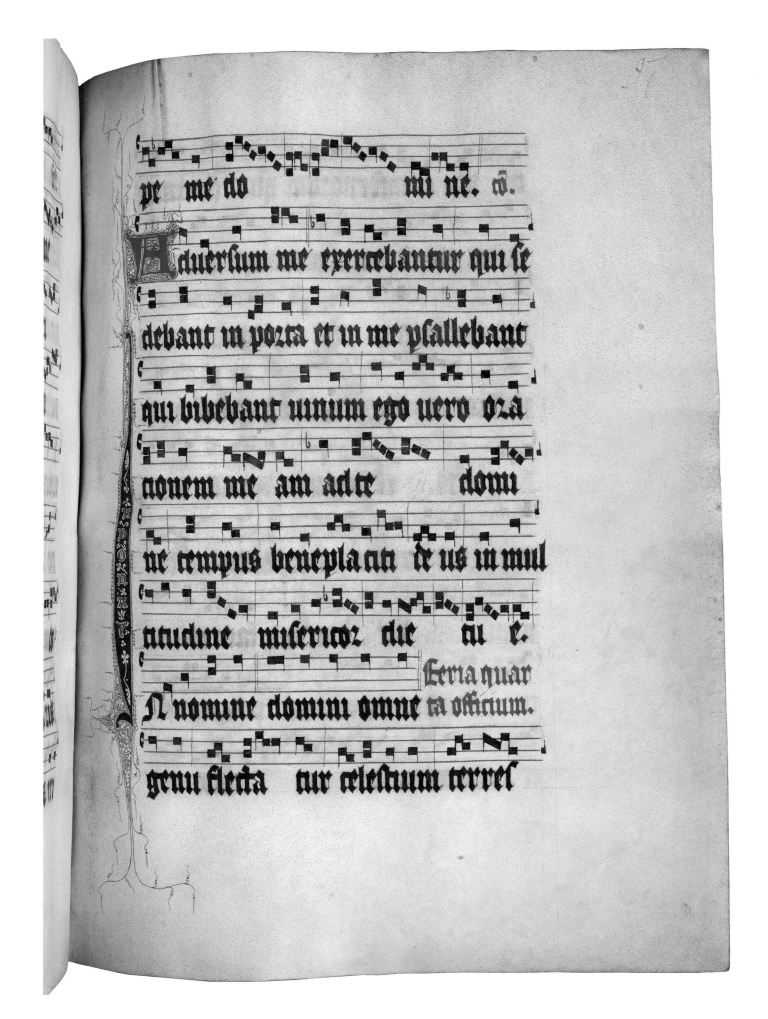

369. Holy Week: Wednesday, gradual, ca. 1420.
ULB Dusseldorf, D 12, f. 97r [vol. I, pp. 165, 194, 412–13]

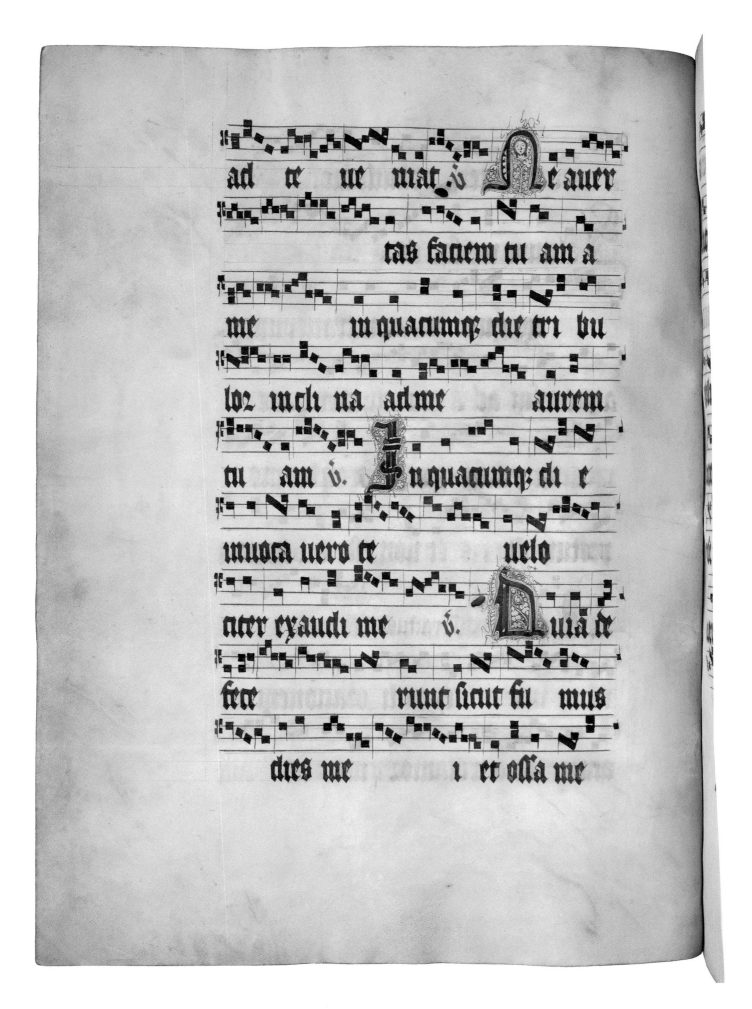

370. Holy Week: Wednesday, gradual, ca. 1420.
ULB Dusseldorf, D 12, f. 98v [vol. I, p. 415]

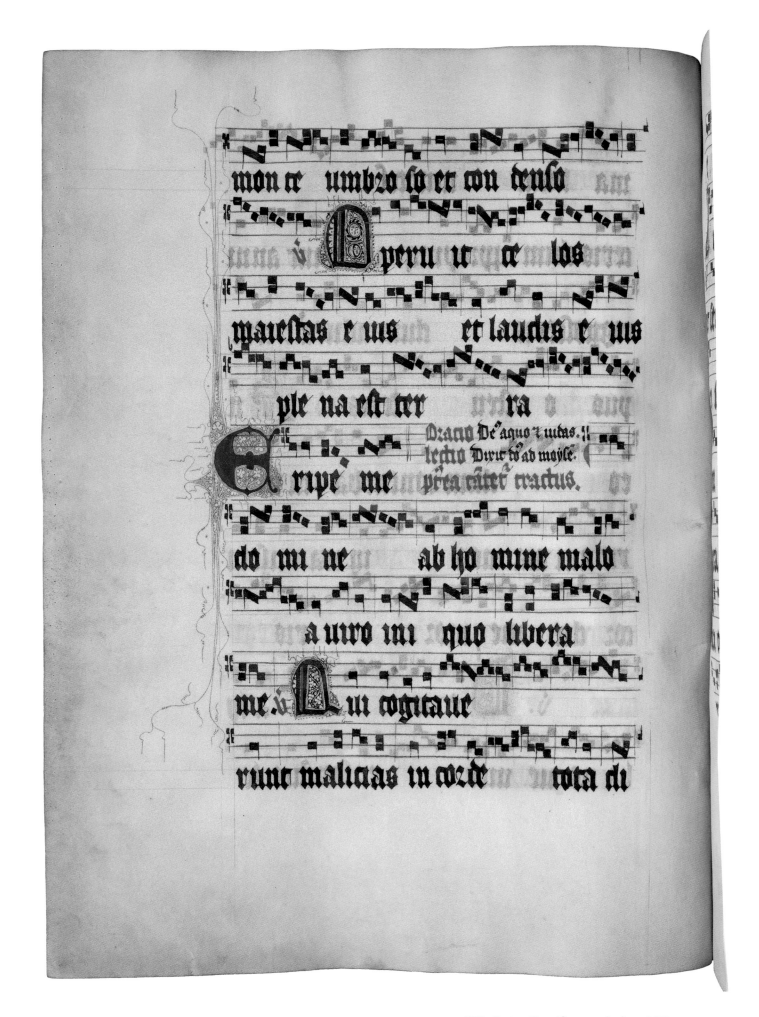

371. Easter: Magnificat, gradual, ca. 1420.
ULB Dusseldorf, D 12, f. 102v [vol. I, p. 420]

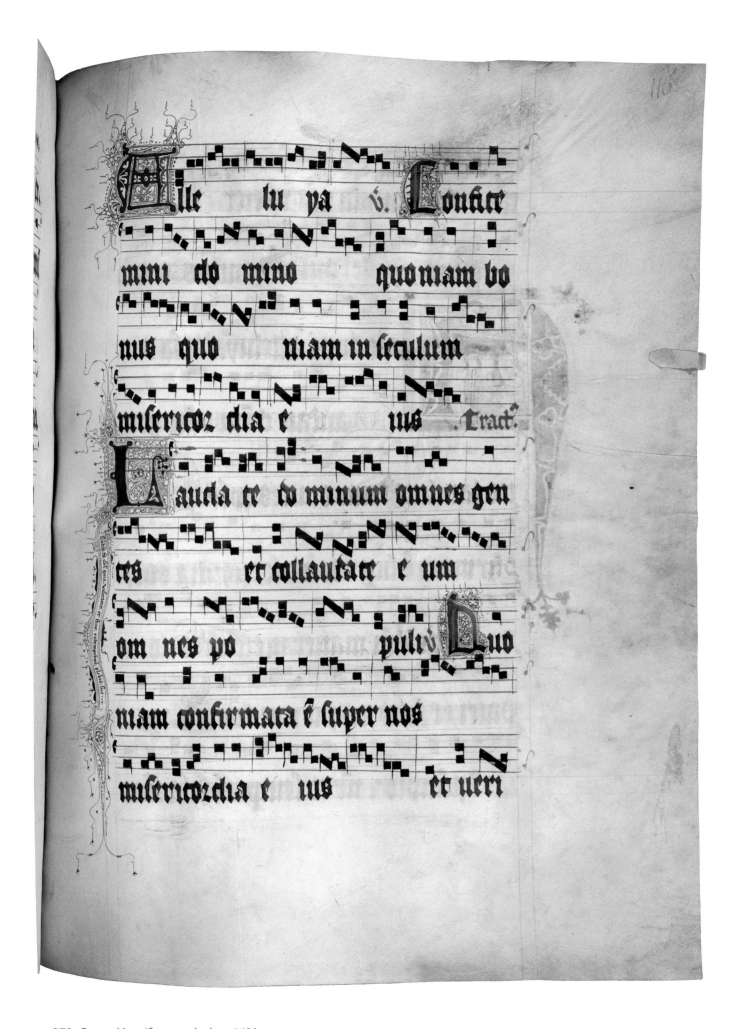

372. Easter: Magnificat, gradual, ca. 1420.
ULB Dusseldorf, D 12, f. 116r [vol. II, App. G, p. 3]

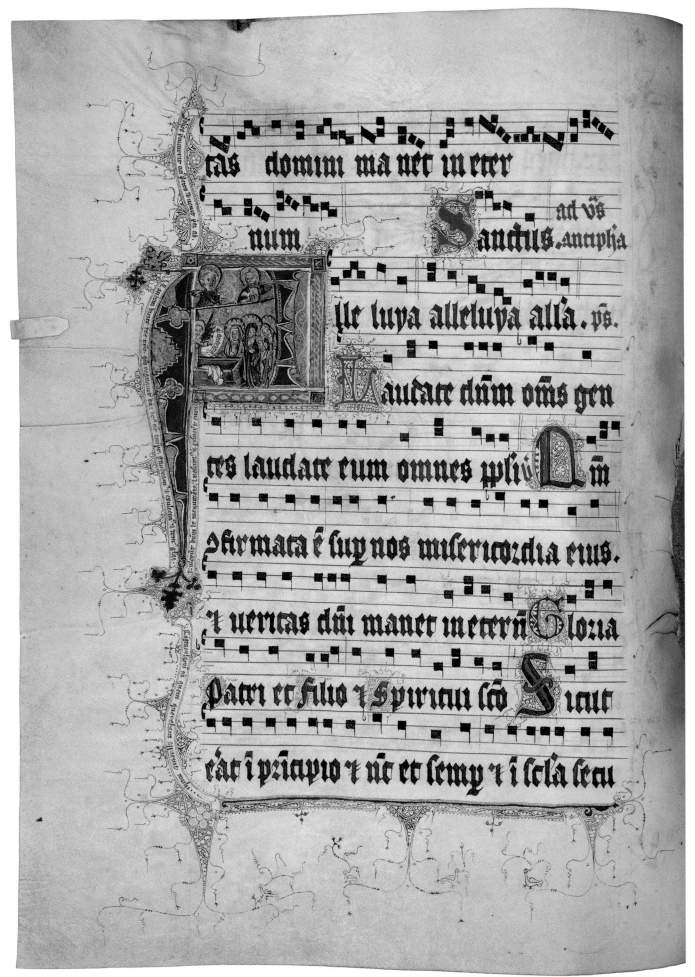

373. Easter: Vespers, gradual, ca. 1420.
ULB Dusseldorf, D 12, f. 116v [vol. I, p. 433]

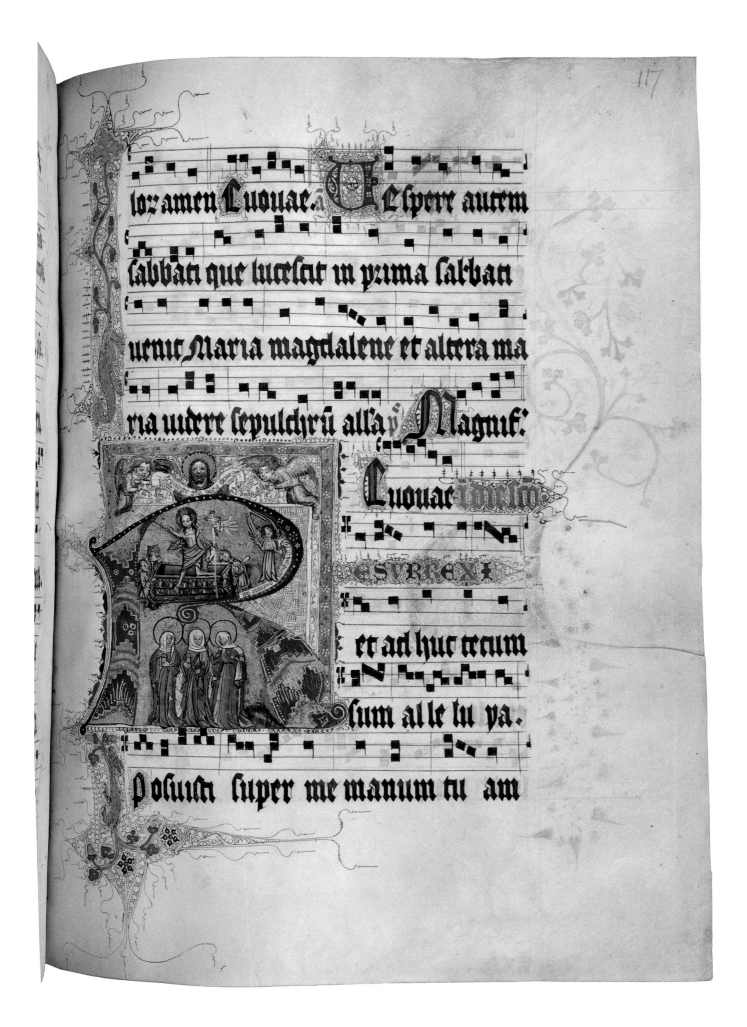

lo2 amen Luouae. Cespere autem

sabbati que lucescit in prima salbati

uenit Maria magdalene et altera ma

ria uidere sepulchru alla. Magnif:

Luouac ibidictn

ESVRREXI

et ad huc tecum

sum alle lu ya.

Posuisti super me manum tu am

374. Easter, gradual, ca. 1420.
ULB Dusseldorf, D 12, f. 117r [vol. I, p. 440]

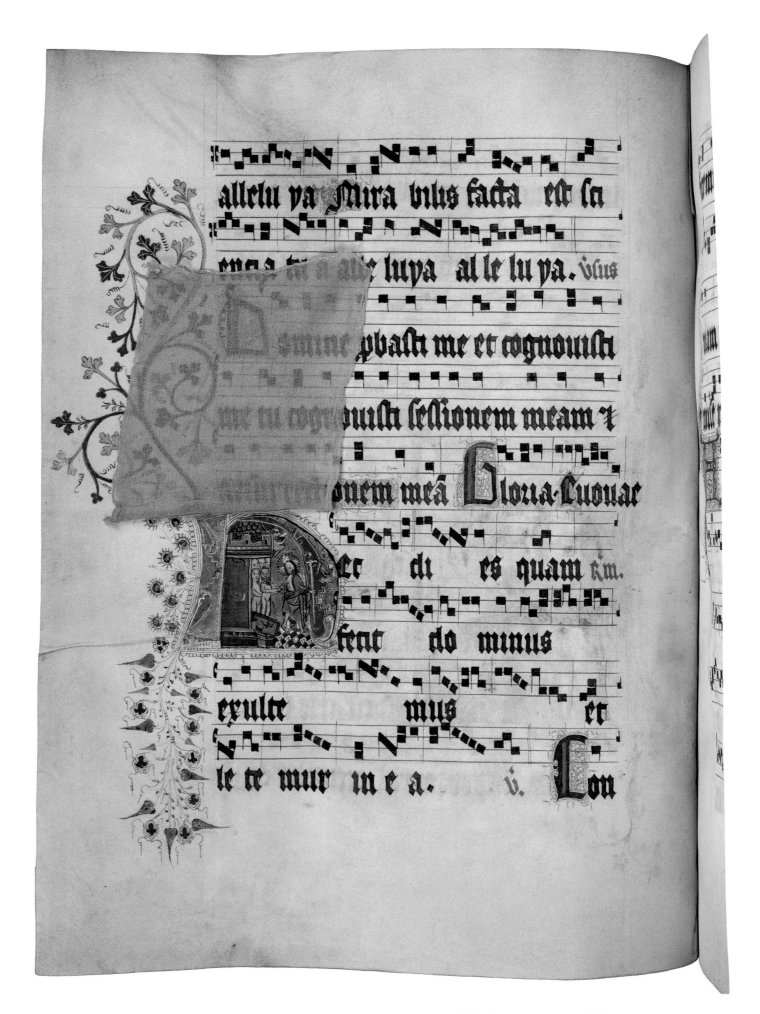

375. Easter, gradual, ca. 1420.
ULB Dusseldorf, D 12, f. 117v [vol. I, p. 440]

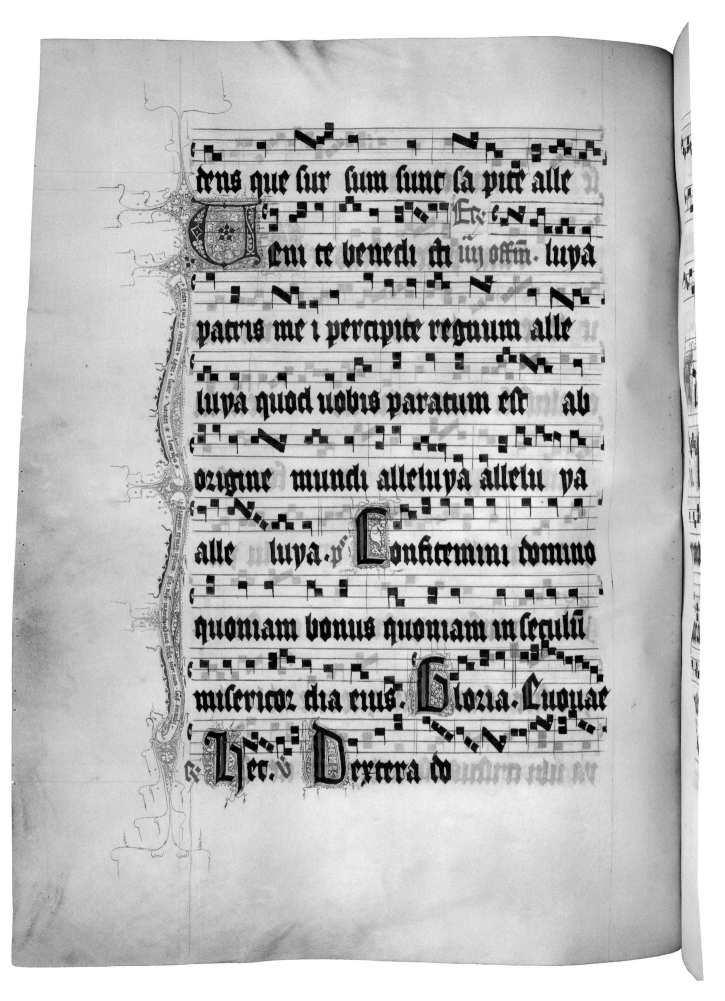

376. Easter: Wednesday, gradual, ca. 1420.
ULB Dusseldorf, D 12, f. 121v [vol. I, p. 445]

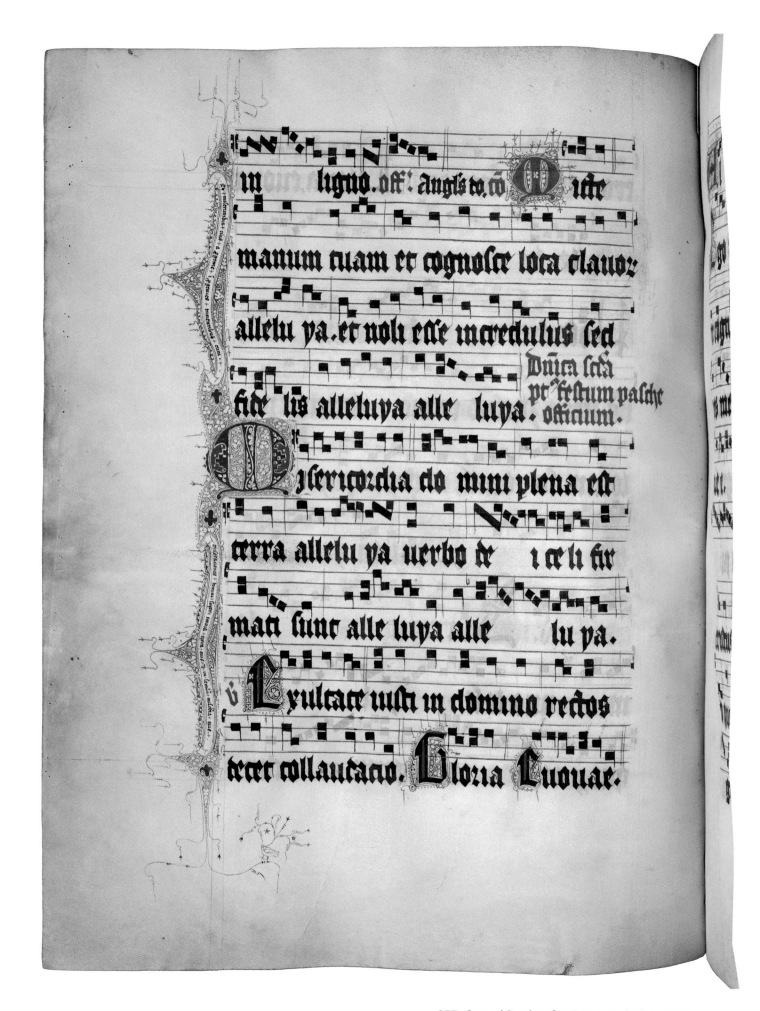

377. Second Sunday after Easter, gradual, ca. 1420.
ULB Dusseldorf, D 12, f. 127v [vol. I, p. 451]

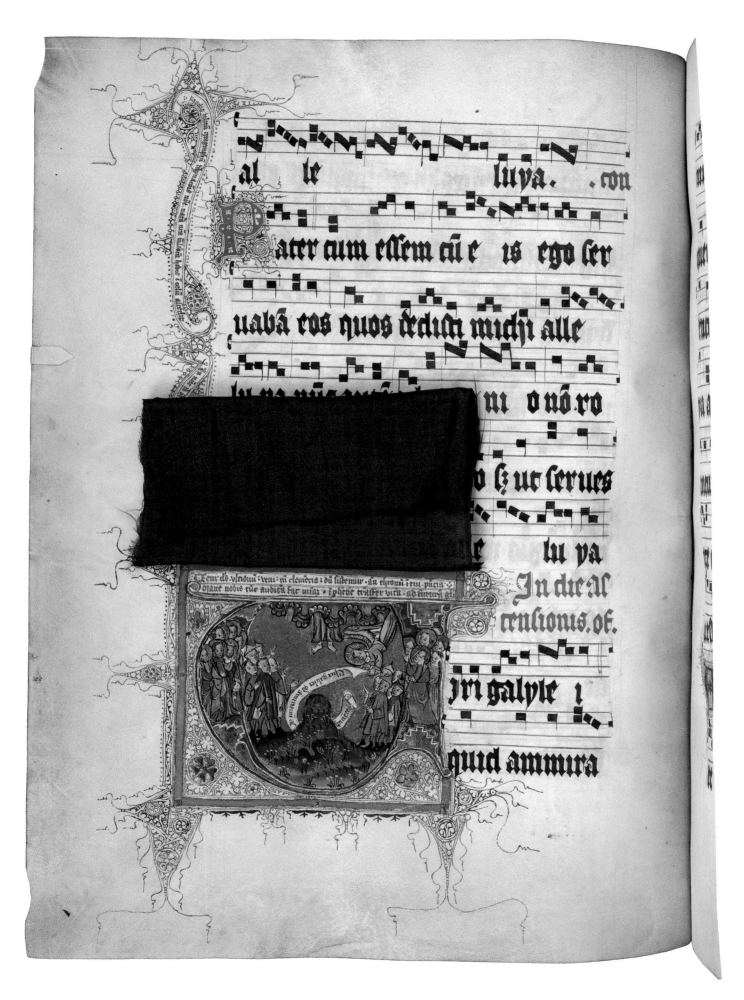

al le luya. con

ater cum essem cu e is ego ser

uabā eos quos dedicti michi alle

ni o nō ro

o sz ur serues

lu ya

In die A

rensionis. of.

in galyle

quid ammira

378. Ascension, gradual, ca. 1420.
ULB Dusseldorf, D 12, f. 134v [vol. I, p. 464]

GRADUAL, D12 | **479**

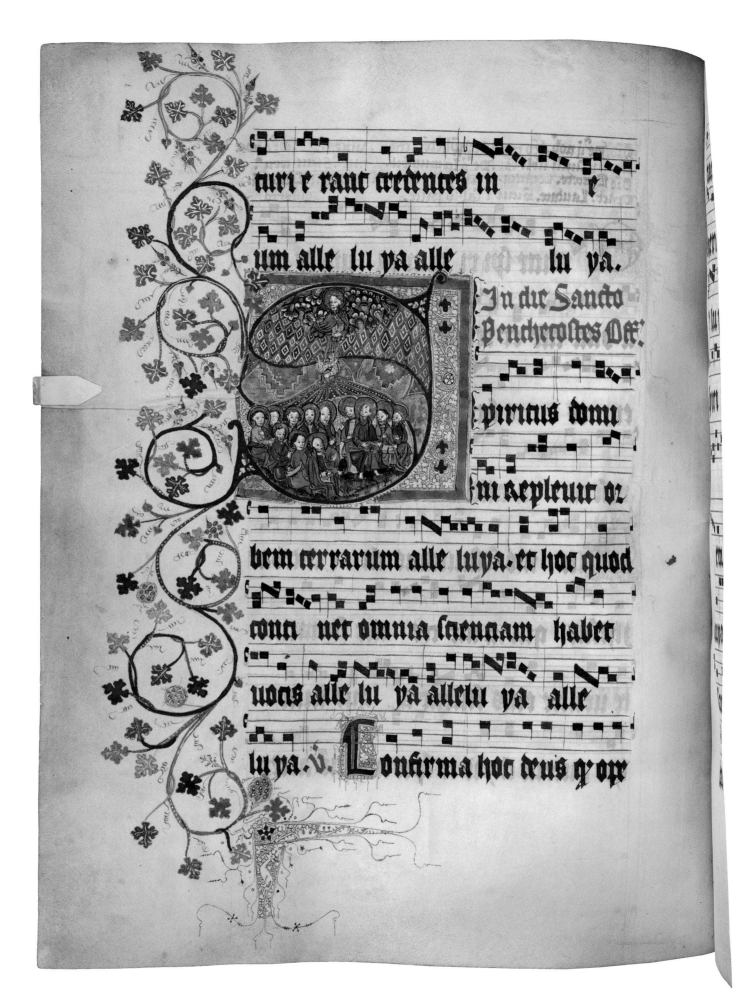

379. Pentecost, gradual, ca. 1420.
ULB Dusseldorf, D 12, f. 138v [vol. I, pp. 195, 469]

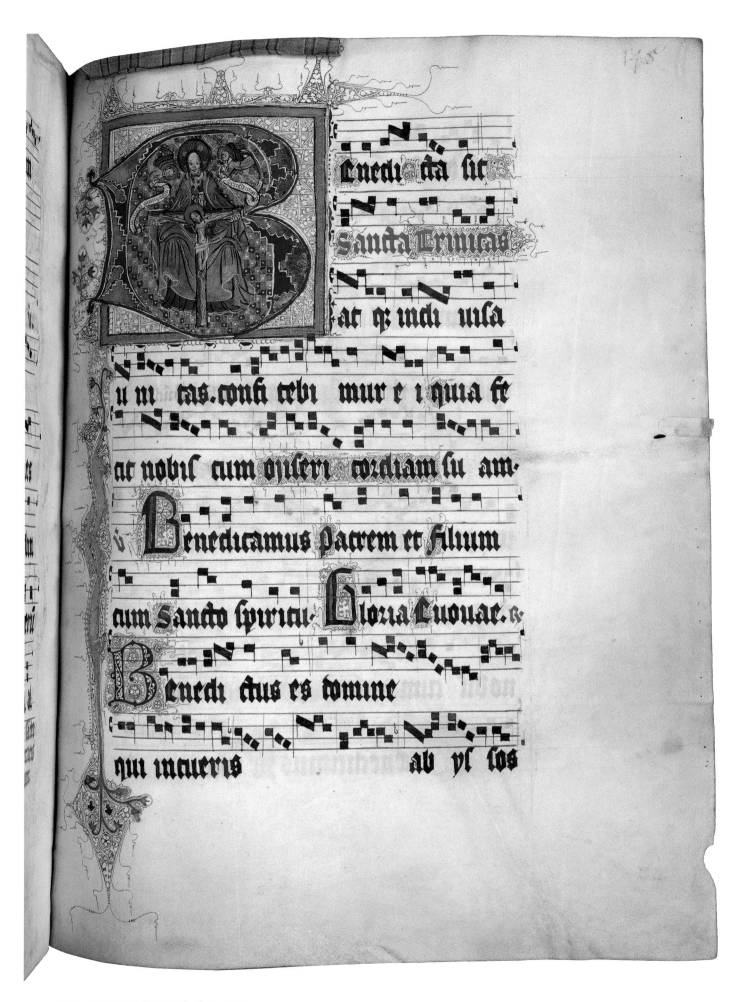

enedi cta sit

Sancta Trinitas

at qz indi uisa

u m tas. confi tebi mur e i quia fe

at nobis cum miseri cordiam su am

Benedicamus patrem et filium

cum sancto spiritu. Gloria tuouae. r

Benedi ctus es domine

qui intueris ab ys sos

380. Trinity Sunday, gradual, ca. 1420.
ULB Dusseldorf, D 12, f. 145r [vol. I, p. 480]

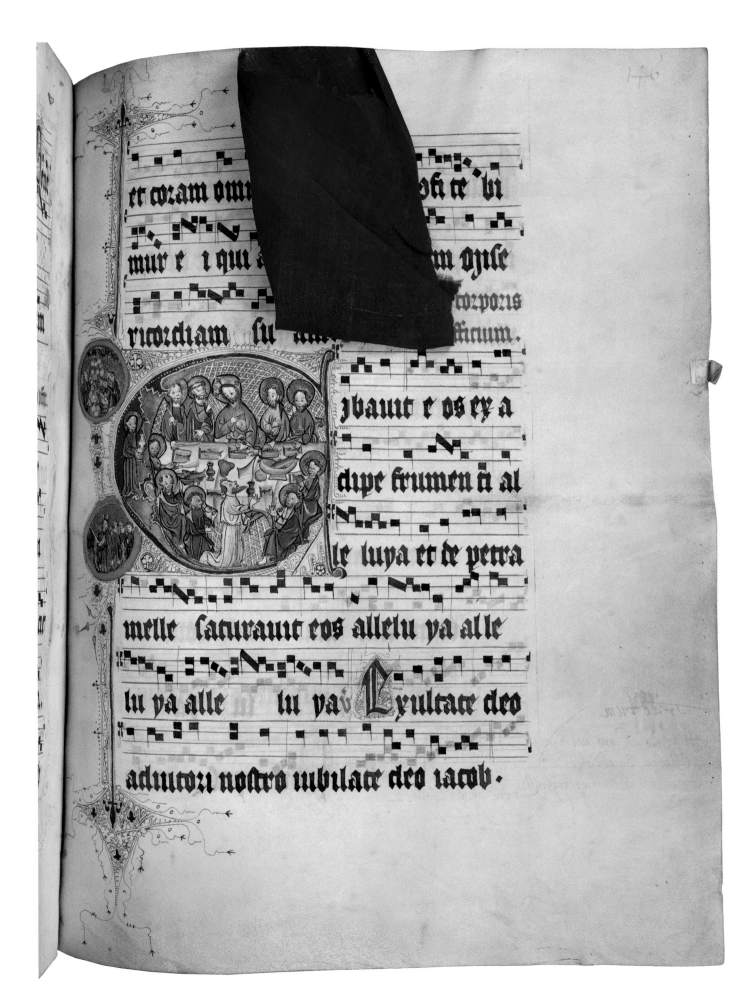

381. Corpus Christi, gradual, ca. 1420.
ULB Dusseldorf, D 12, f. 146r [vol. I, pp. 197, 493]

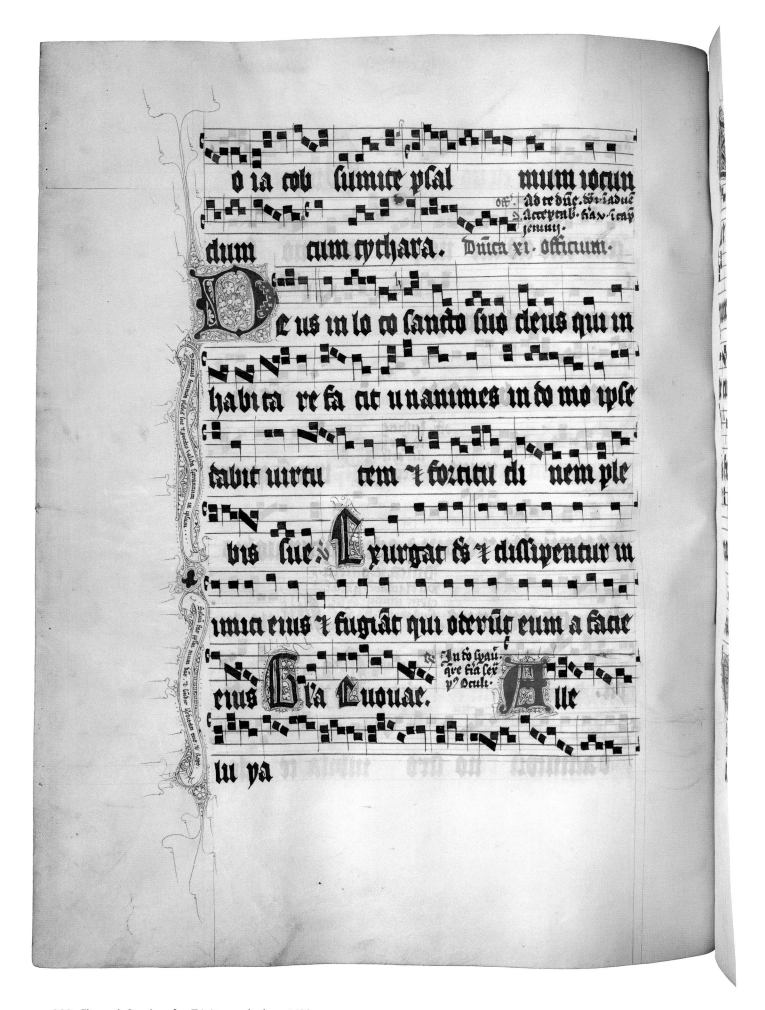

382. Eleventh Sunday after Trinity, gradual, ca. 1420.
ULB Dusseldorf, D 12, f. 155v [vol. I, p. 496]

GRADUAL, D12 | 483

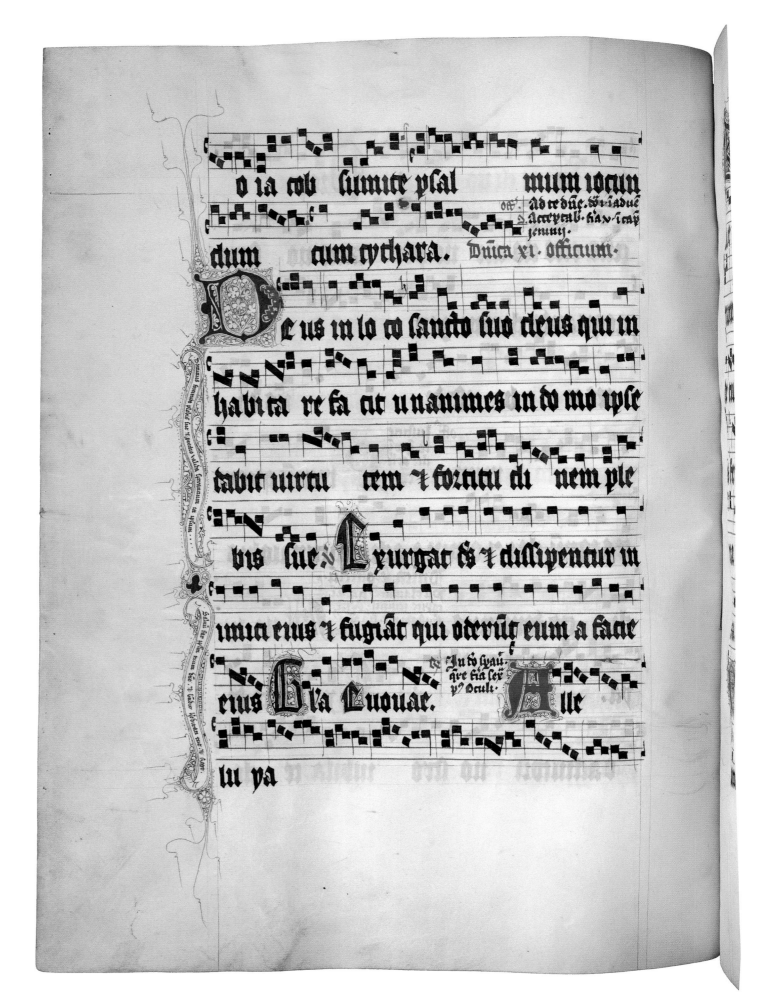

383. Fourteenth Sunday after Trinity, gradual, ca. 1420.
ULB Dusseldorf, D 12, f. 158r [vol. I, p. 496]

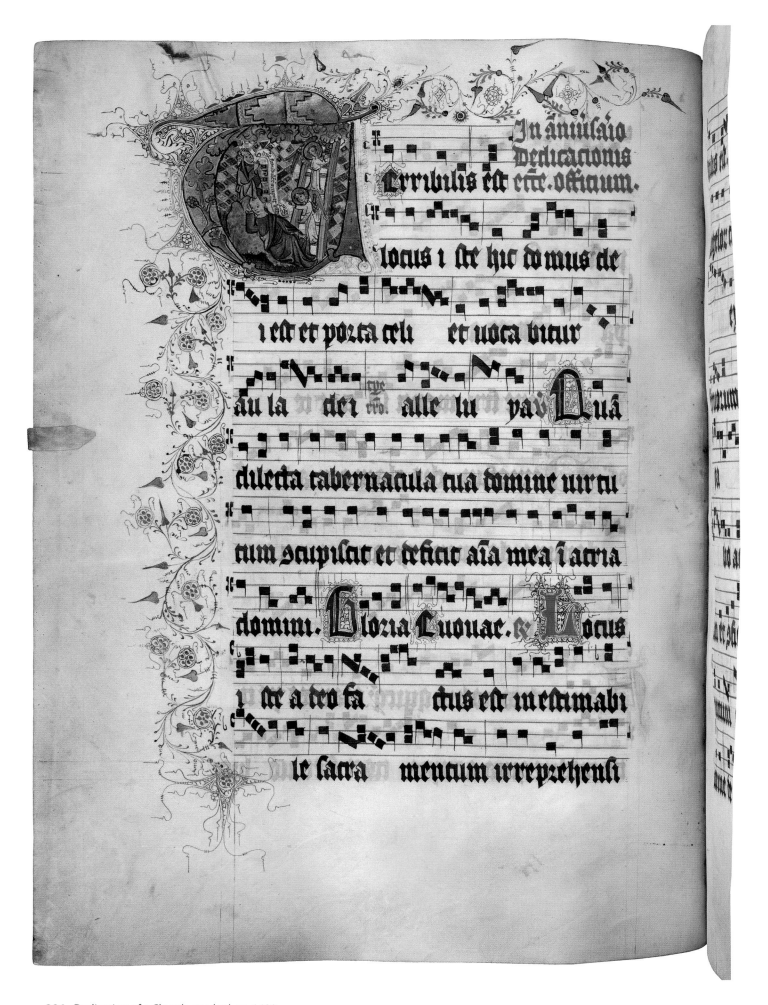

384. Dedication of a Church, gradual, ca. 1420.
ULB Dusseldorf, D 12, f. 168v [vol. I, pp. 727–28]

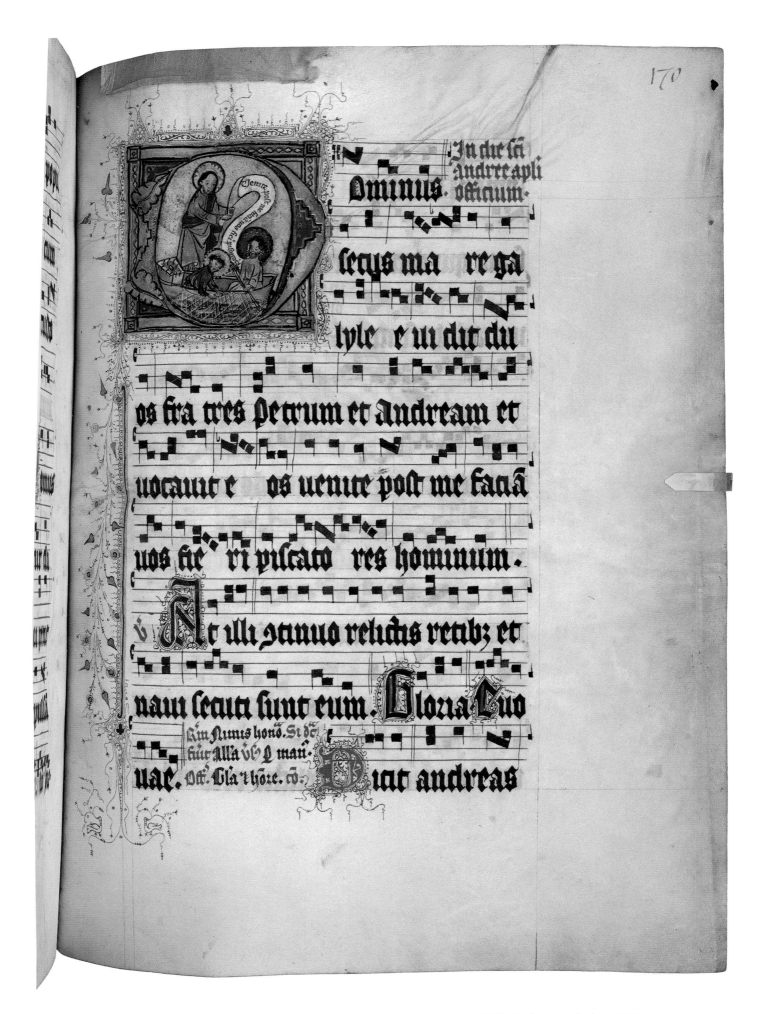

385. Andrew, gradual, ca. 1420.
ULB Dusseldorf, D 12, f. 170r [vol. I, p. 639]

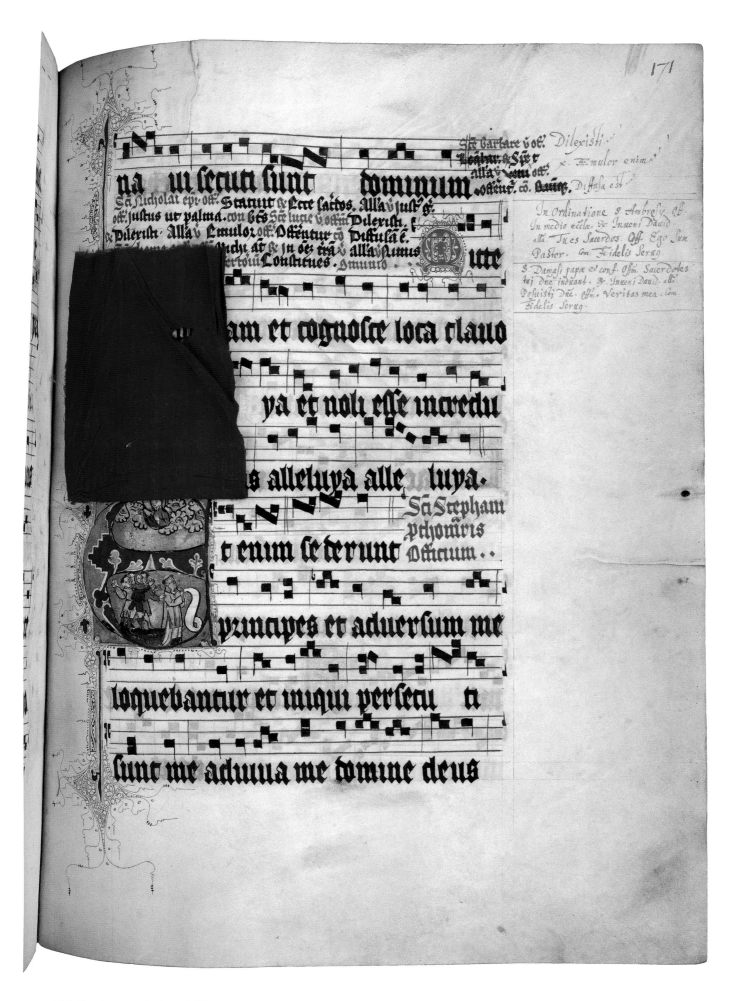

386. Stephen, gradual, ca. 1420.
ULB Dusseldorf, D 12, f. 171r [vol. I, p. 642]

GRADUAL, D12 | **487**

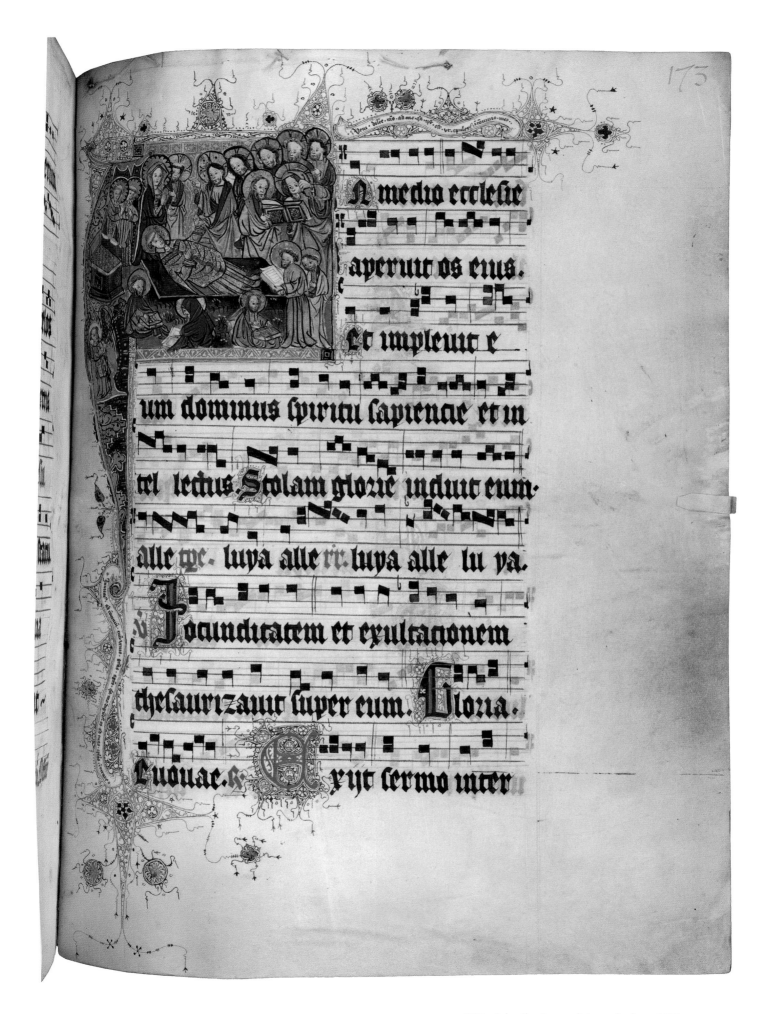

387. John the Evangelist, gradual, ca. 1420.
ULB Dusseldorf, D 12, f. 173r [vol. I, pp. 565–66]

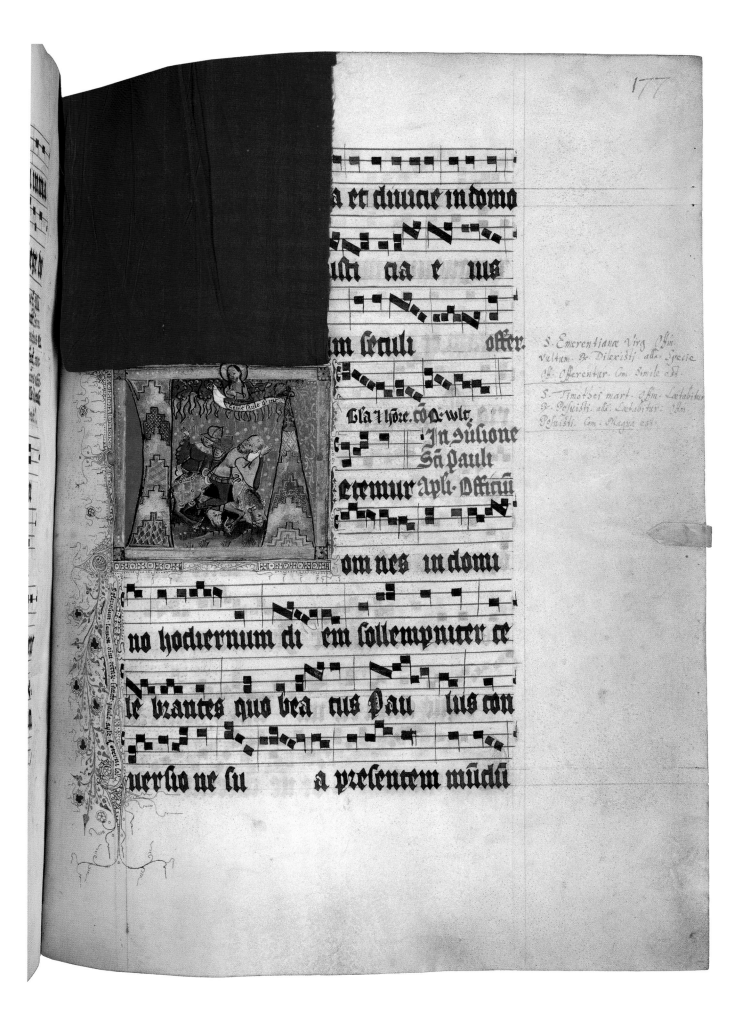

a et diuicie in domo

...uli cia e ius offer.

...um seculi

Gla i hore. con de vlt.

In diuisione
Sa Pauli
e temur Apli. Officiu

om nes in domi

no hodiernum di em sollempniter ce

le brantes quo bea tus Pau lus con

uersio ne su a presentem mundii

S. Emerentiane Virg. Offm
vultum. Br. Dilexisti. alla. Specie
Br. Offerentur. Com. Simile est.

S. Timothei mart. Offm. Letabitur.
Br. Posuisti. alla. Letabitur. Com.
Posuisti. Com. Magna 255.

388. Paul: conversion, gradual, ca. 1420.
ULB Dusseldorf, D 12, f. 177r [vol. I, p. 650]

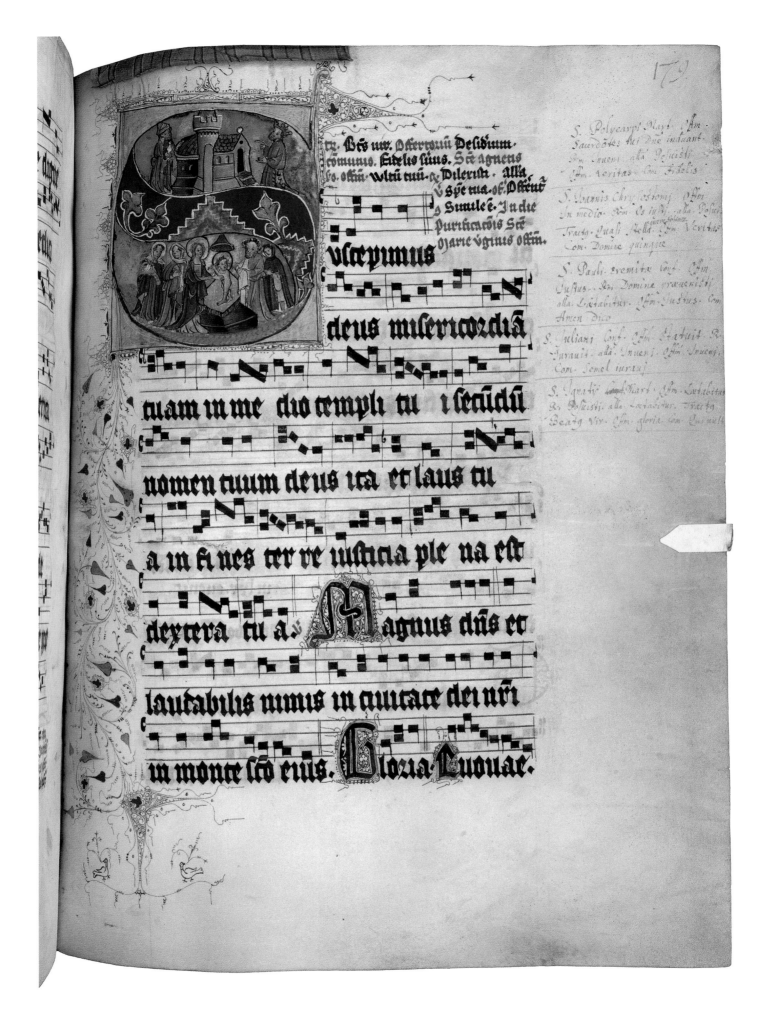

389. Presentation of Virgin, gradual, ca. 1420.
ULB Dusseldorf, D 12, f. 179r [vol. I, pp. 521–22]

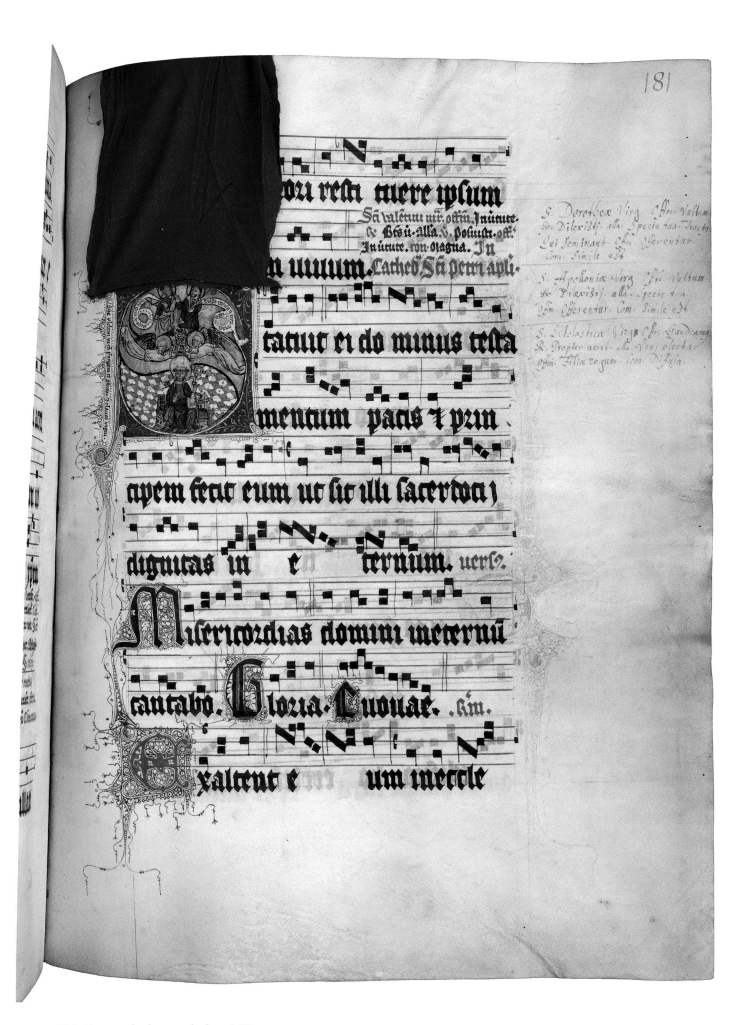

390. Peter: cathedra. , gradual, ca. 1420
ULB Dusseldorf, D 12, f. 181r [vol. I, pp. 651–52]

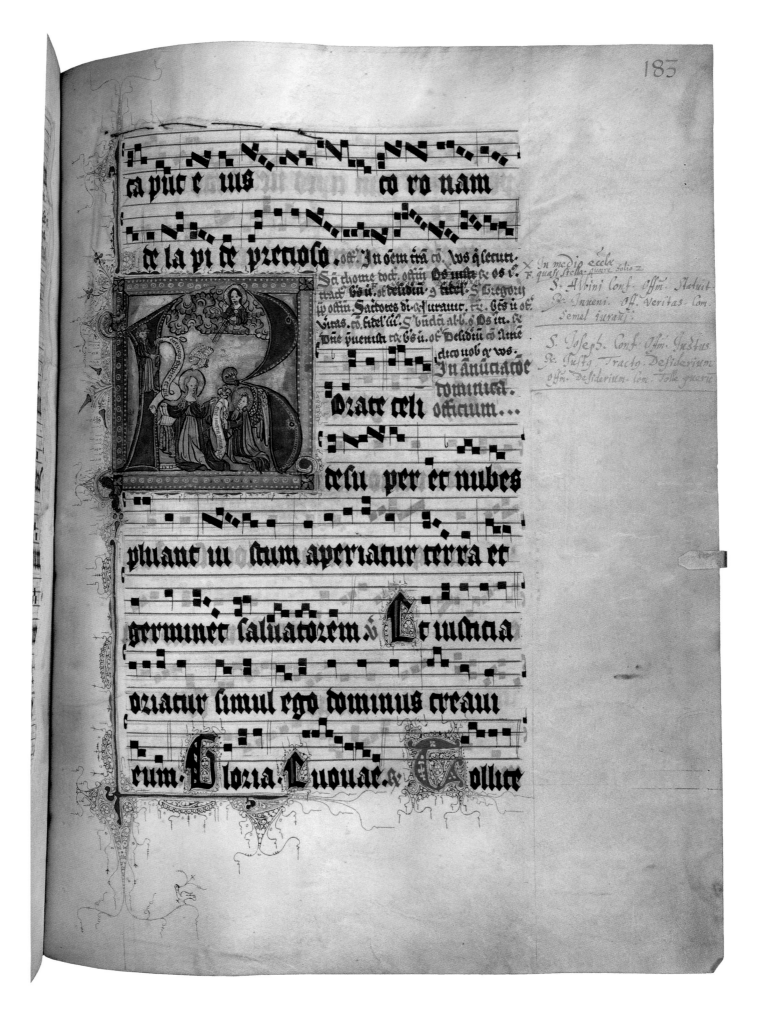

391. Annunciation. ULB Dusseldorf,
D 12, f. 183r [vol. I, p. 525]

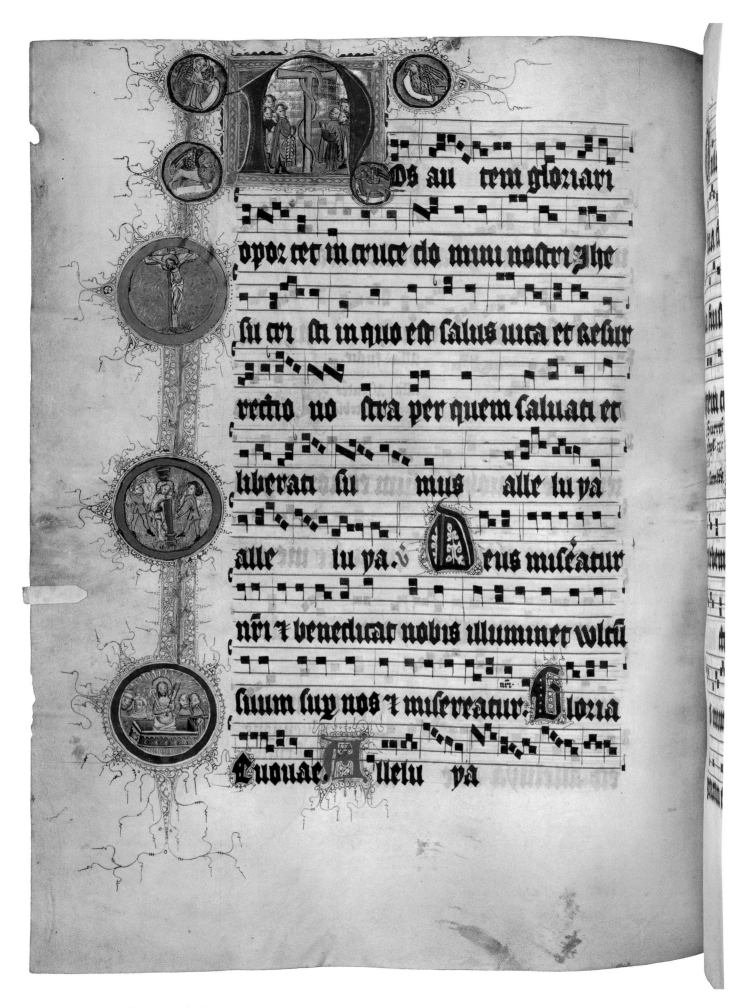

392. Invention of Cross, gradual, ca. 1420.
ULB Dusseldorf, D 12, f. 187v [vol. I, p. 657]

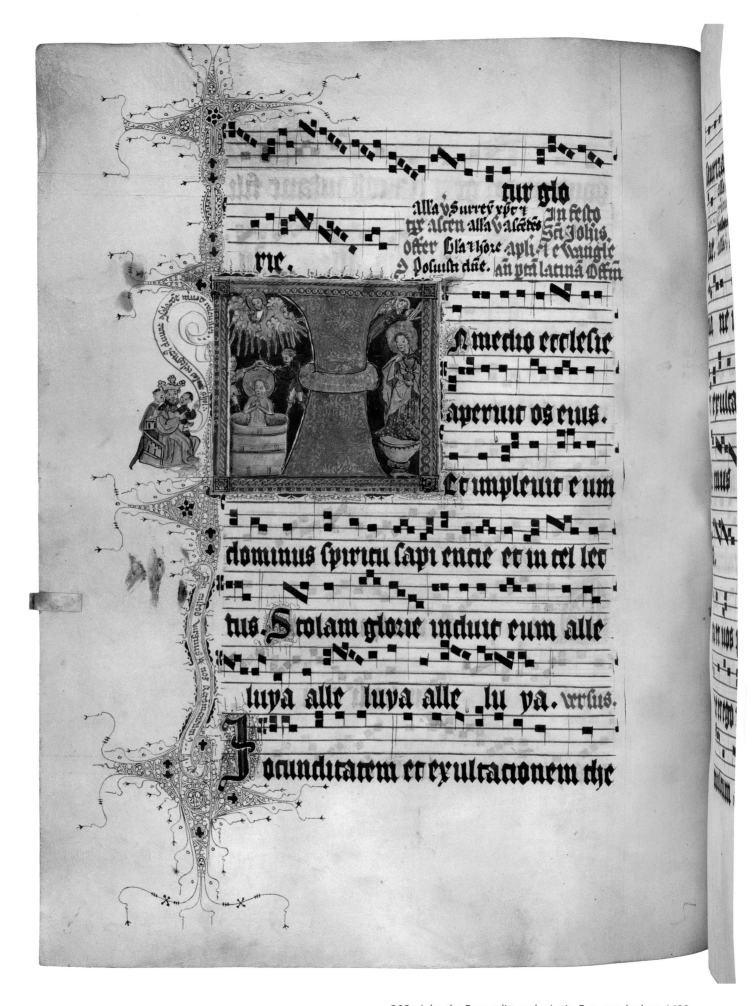

393. John the Evangelist at the Latin Gate, gradual, ca. 1420.
ULB Dusseldorf, D 12, f. 189v [vol. I, pp. 191–92, 596]

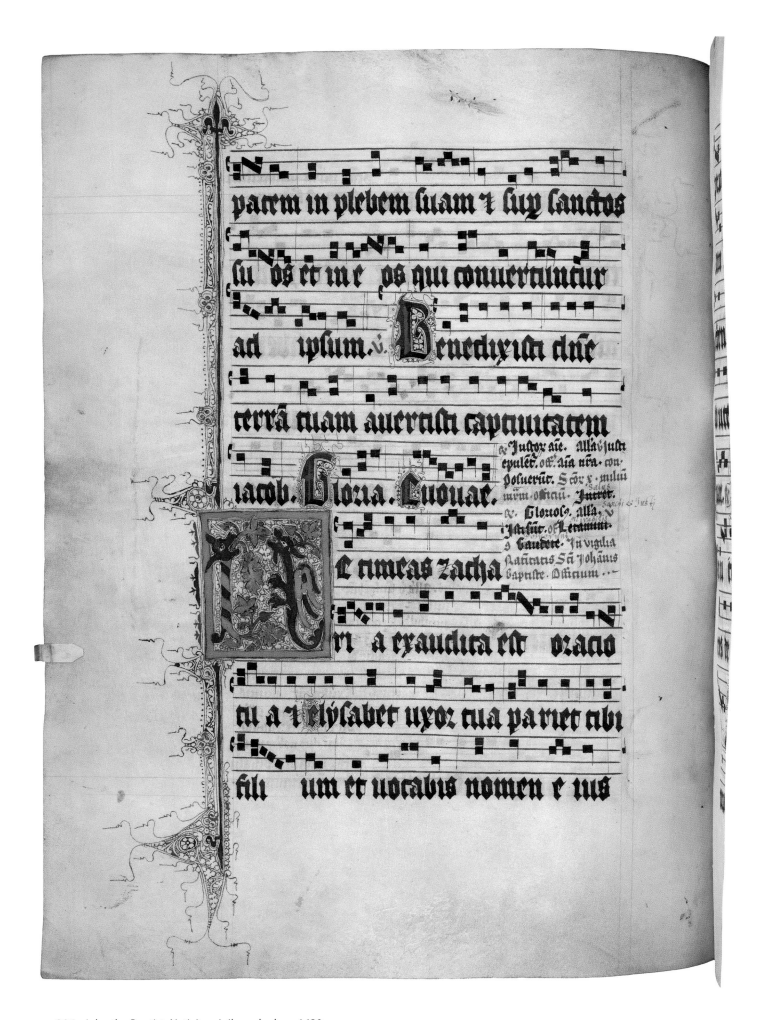

pacem in plebem suam ⁊ sup sanctos

su os et in e os qui convertuntur

ad ipsum. ℣. Benedixisti dñe

terram tuam avertisti captivitatem

iacob. Gloria. Euouae.

℣. Justor̄ aīe. allā ꝯ iusti
epuleñ. oñ. aīa ñra. cōposuerut̄. Scōr̄ x milui
m̄r̄m officiū. Introit.
℣. Glorioꝰ. allā. ℣
istisū. oñ. Letamini
s gaudere. In vigilia
Nativitatis Scī Johānis
baptiste. Officium ···

Ne timeas Zacha

ri a exaudita est oracio

tu a ⁊ elysabet uxor tua pariet tibi

fili um et vocabis nomen e ius

394. John the Baptist: Nativity, vigil, gradual, ca. 1420.
ULB Dusseldorf, D 12, f. 191v [vol. I, p. 669]

GRADUAL, D12 | **495**

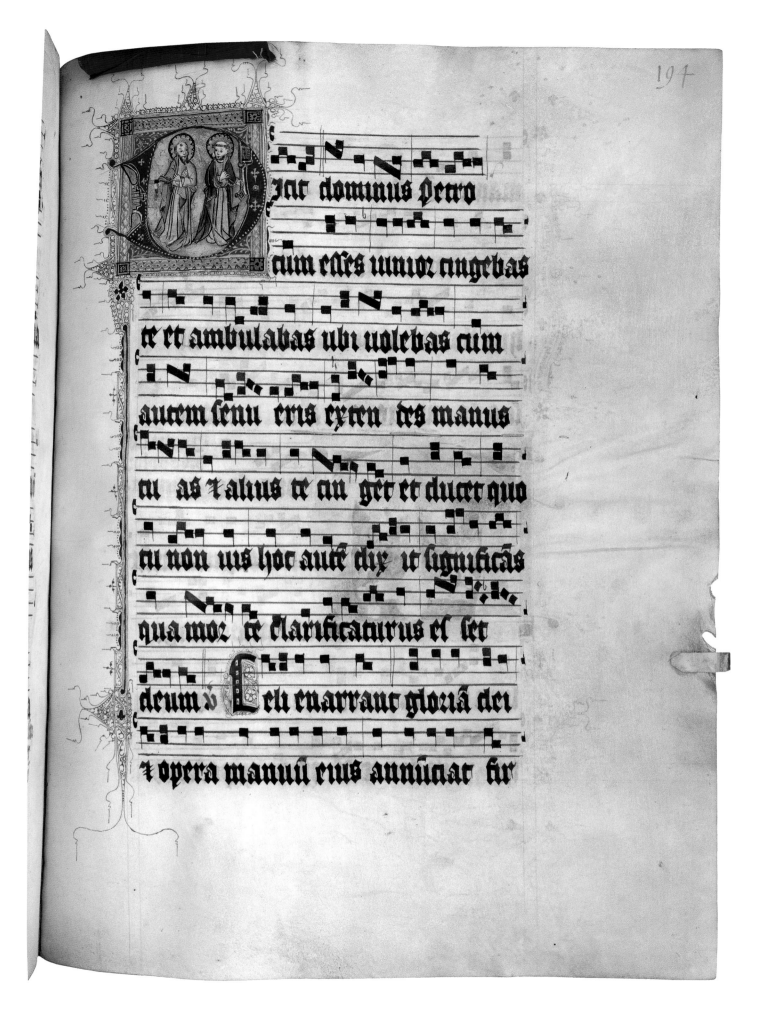

395. Peter and Paul, gradual, ca. 1420.
ULB Dusseldorf, D 12, f. 194r [vol. I, p. 670]

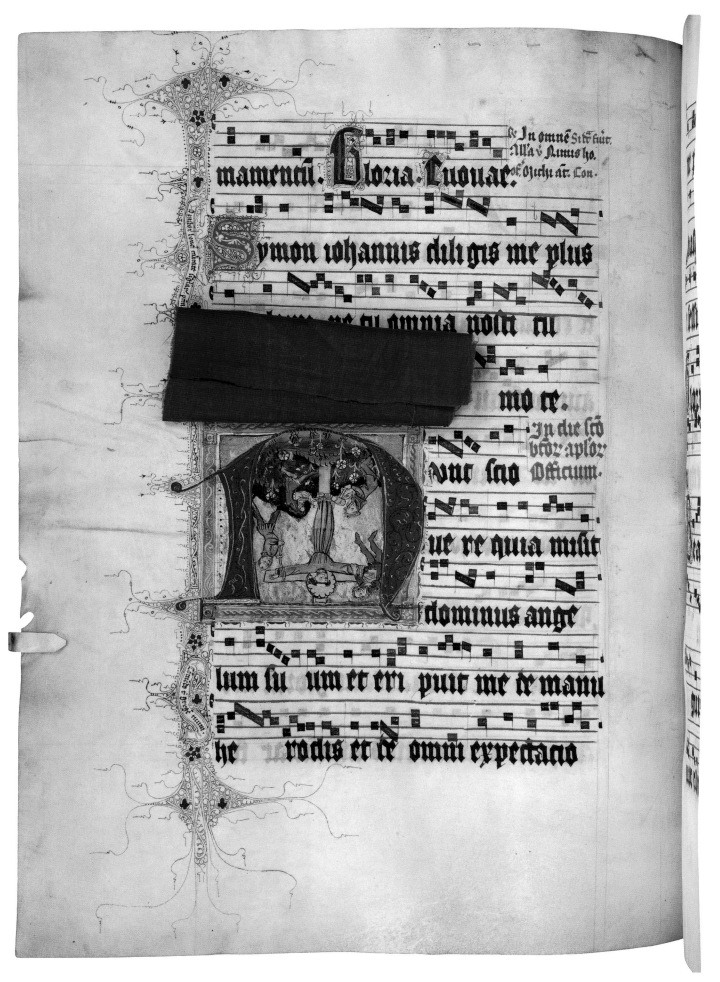

396. Peter and Paul, gradual, ca. 1420.
ULB Dusseldorf, D 12, f. 194v [vol. I, pp. 197, 672]

GRADUAL, D12 | **497**

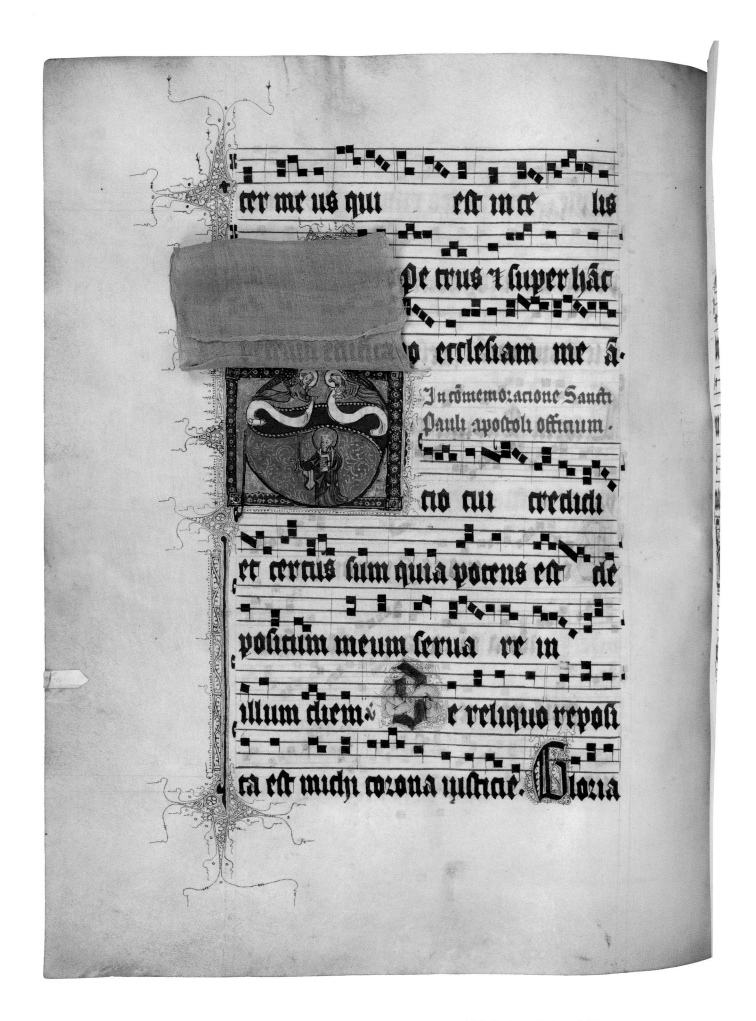

397. Paul, gradual, ca. 1420.
ULB Dusseldorf, D 12, f. 195v [vol. I, p. 674]

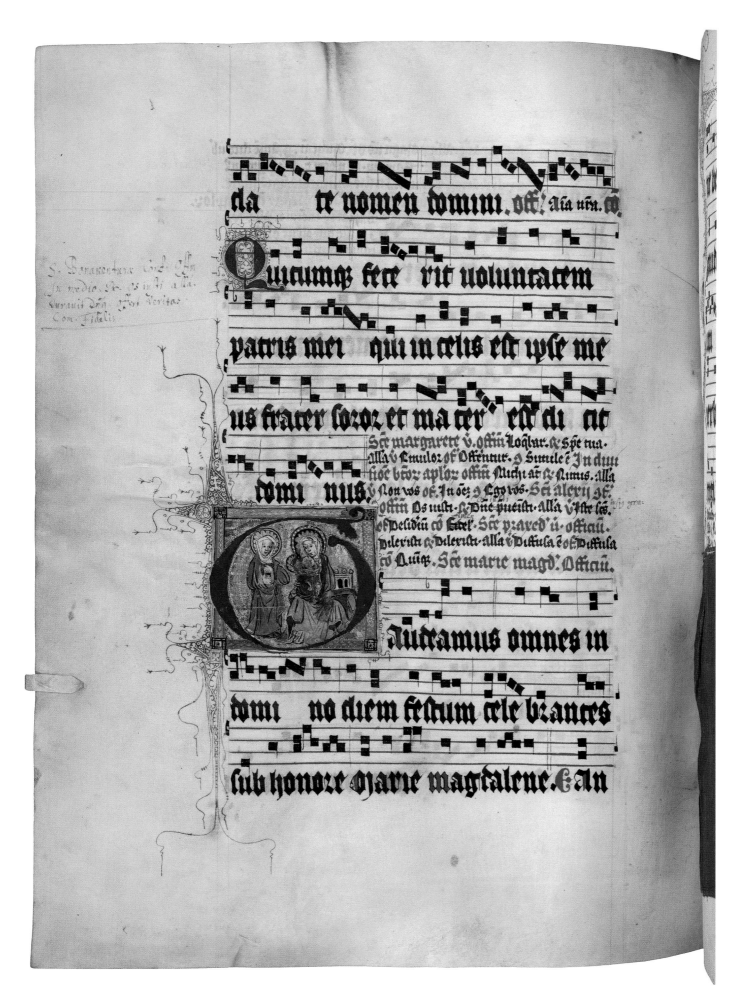

398. Mary Magdalen, gradual, ca. 1420.
ULB Dusseldorf, D 12, f. 196v [vol. I, p. 682]

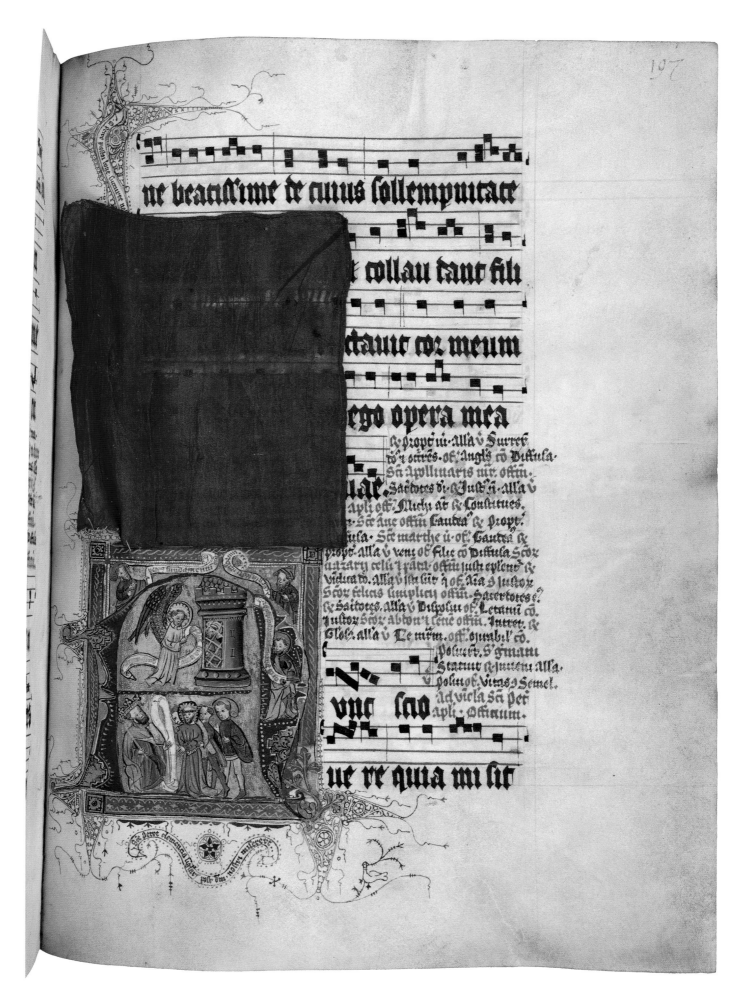

399. Peter: chains, gradual, ca. 1420.
ULB Dusseldorf, D 12, f. 197r [vol. I, pp. 684–85]

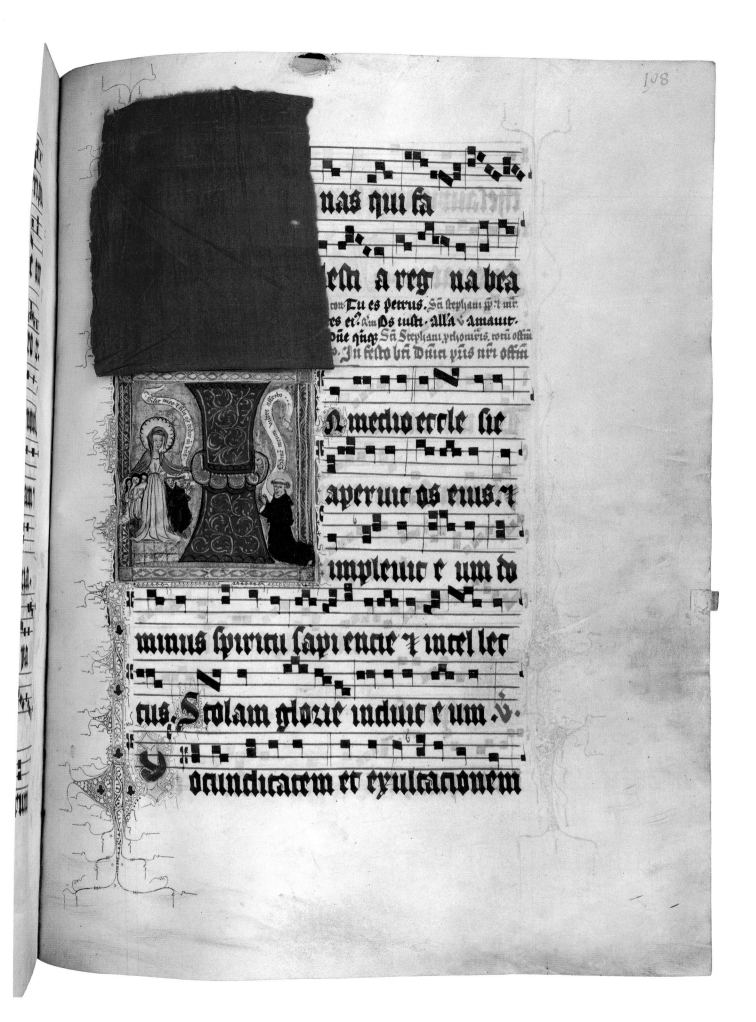

400. Dominic, gradual, ca. 1420.
ULB Dusseldorf, D 12, f. 198r [vol. I, p. 512]

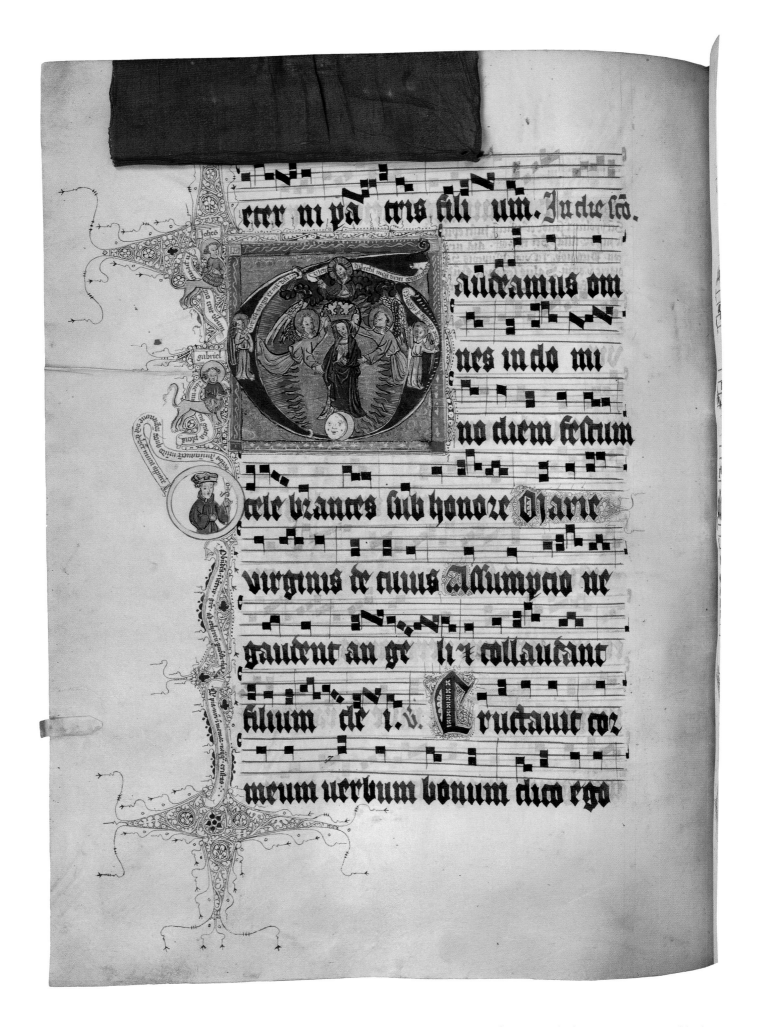

401. Assumption of Virgin, gradual, ca. 1420. ULB Dusseldorf, D 12, f. 201v [vol. I, pp. 198, 534–35, 747]

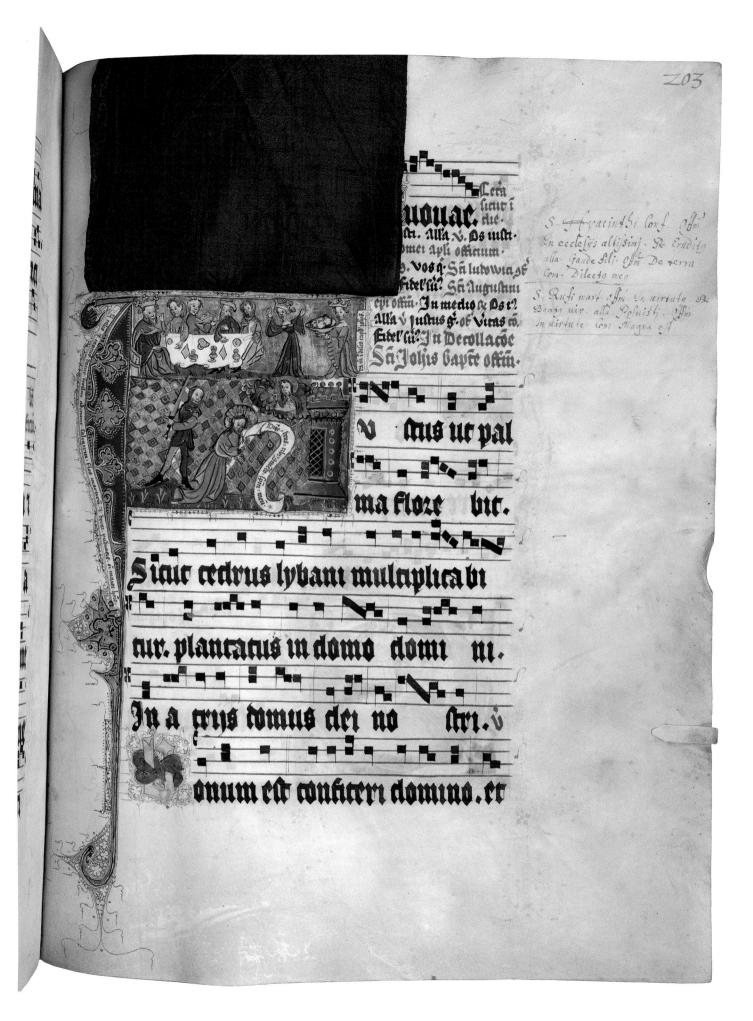

Lcta
licut i
dic.
All'a. V. Os iulti.
omei apli officium.
D. vos q. Sm ludowia ge
fider'su? Sm Augustini
epi officu. In medio te Os r.
All'a V Iustus ge. of Vitas co.
fider'su? I n Decollacoe
Sm Iohis bapte officu.

U scms ur pal
ma floze urc.

Sicut cecrus lybani multiplica bi
tur. plantacius in domo domi ni.
In a crijs domus dei no scri. V
onum ect confiteri domino. et

402. John the Baptist: Decollation, gradual, ca. 1420.
ULB Dusseldorf, D 12, f. 203r [vol. I, p. 689]

GRADUAL, D12 | 503

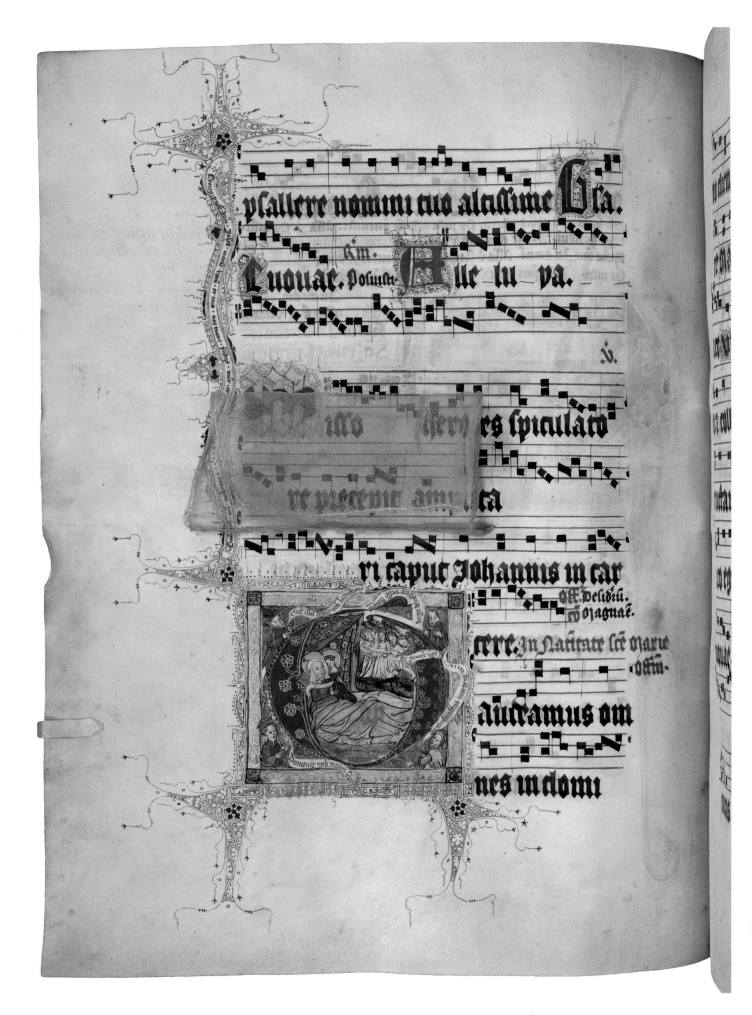

403. Nativity of Virgin, gradual, ca. 1420.
ULB Dusseldorf, D 12, f. 203v [vol. I, p. 549]

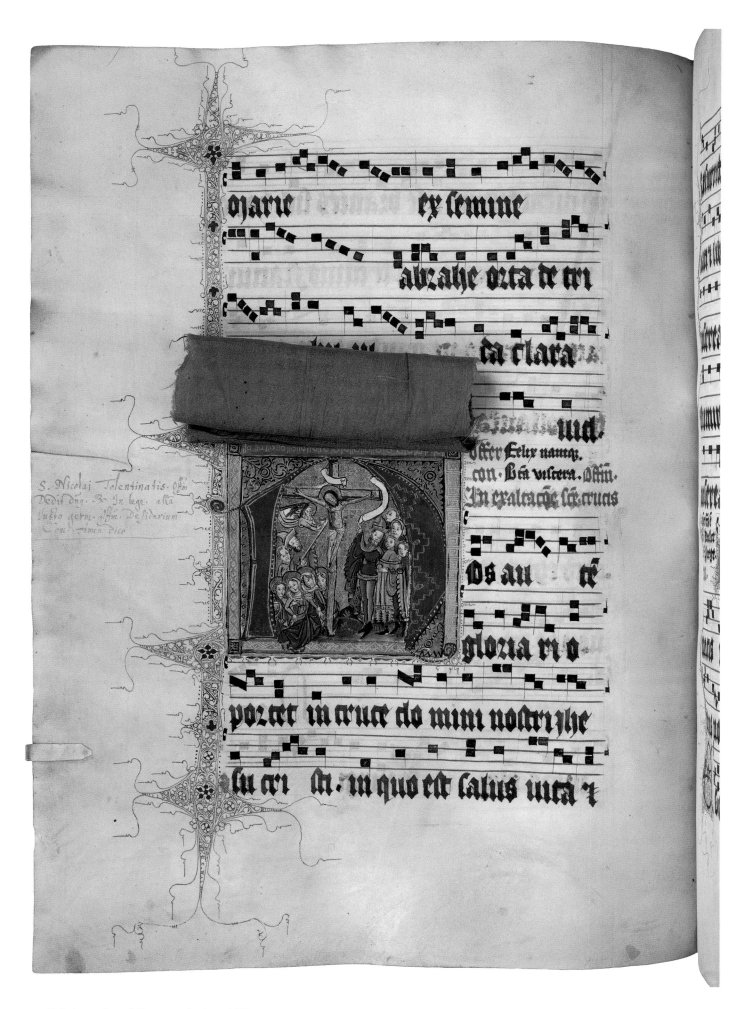

404. Invention of Cross, gradual, ca. 1420.
ULB Dusseldorf, D 12, f. 204v [vol. I, p. 690]

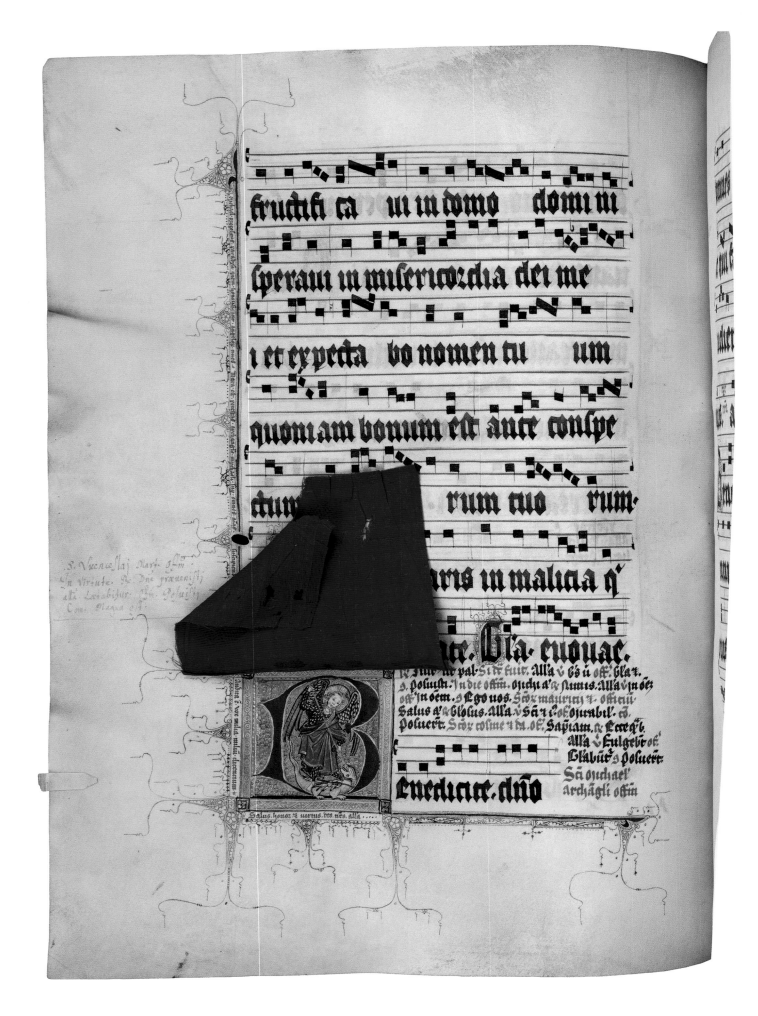

405. Archangel Michael, gradual, ca. 1420.
ULB Dusseldorf, D 12, f. 205v [vol. I, p. 693]

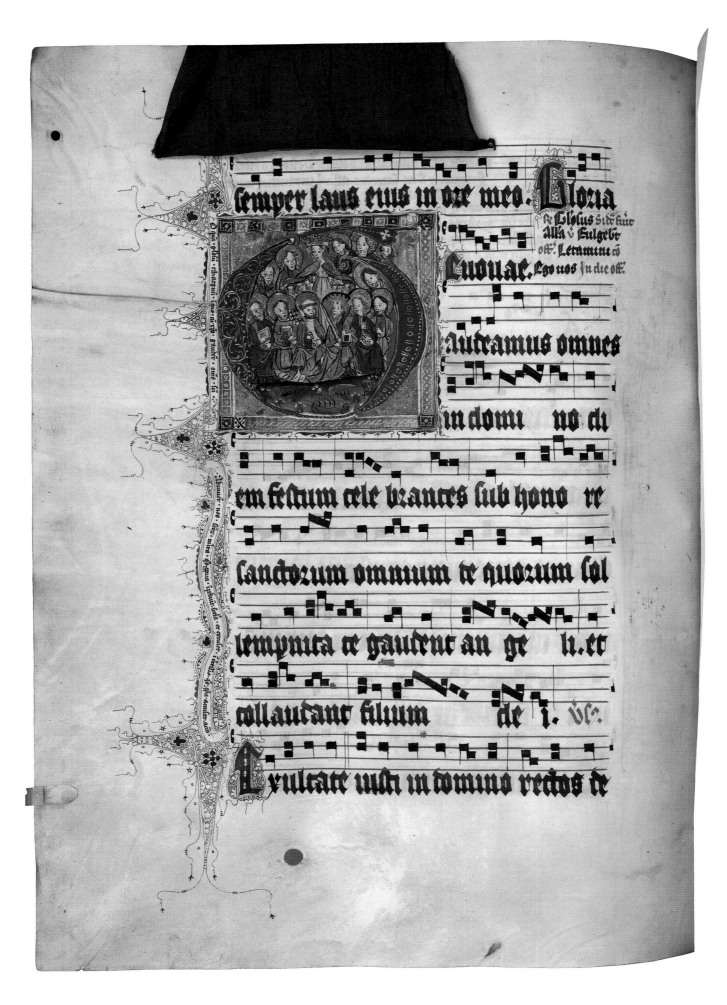

semper laus eius in ore meo. Gloria

Gaudeamus omnes

in domino di

em festum celebrantes sub hono re

sanctorum omnium de quorum sol

lempnita te gaudent an ge li. et

collaudant filium de I. ver.

Exultate iusti in domino rectos de

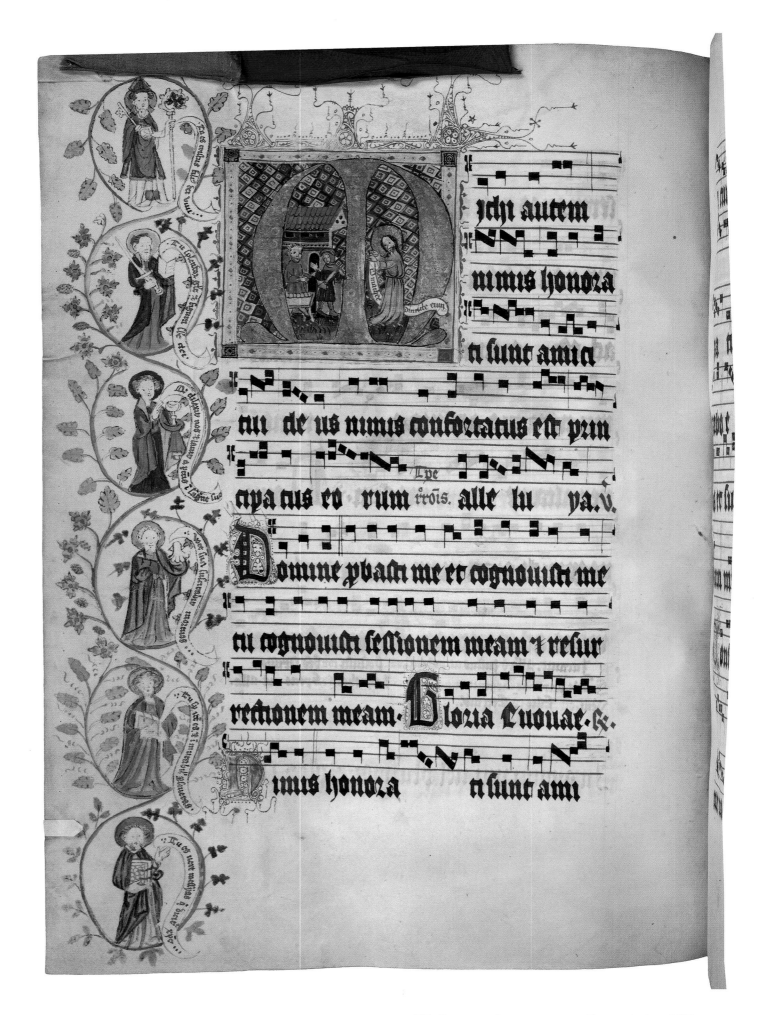

407. Common of one or more apostles, gradual, ca. 1420.
ULB Dusseldorf, D 12, f. 213v [vol. I, p. 199]

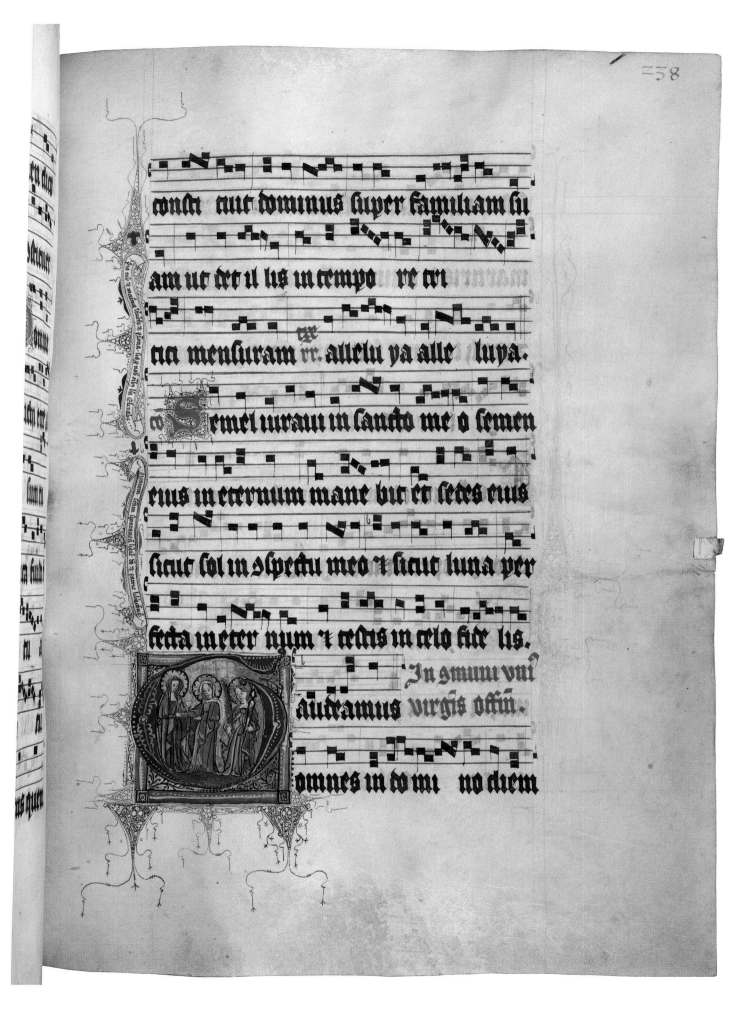

consti tuit dominus super familiam su
am ut det il lis in tempo re tri
tici mensuram rr. allelu ya alle luya.
Semel iuraui in sancto me o semen
eius in eternum mane bit et sedes eius
sicut sol in conspectu meo et sicut luna per
fecta in eter num et testis in celo fide lis.
In omnium vul
audeamus virgis offm.
omnes in do mi no diem

408. Common of virgin, gradual, ca. 1420.
ULB Dusseldorf, D 12, f. 238r [vol. I, p. 721]
GRADUAL, D12 | 509

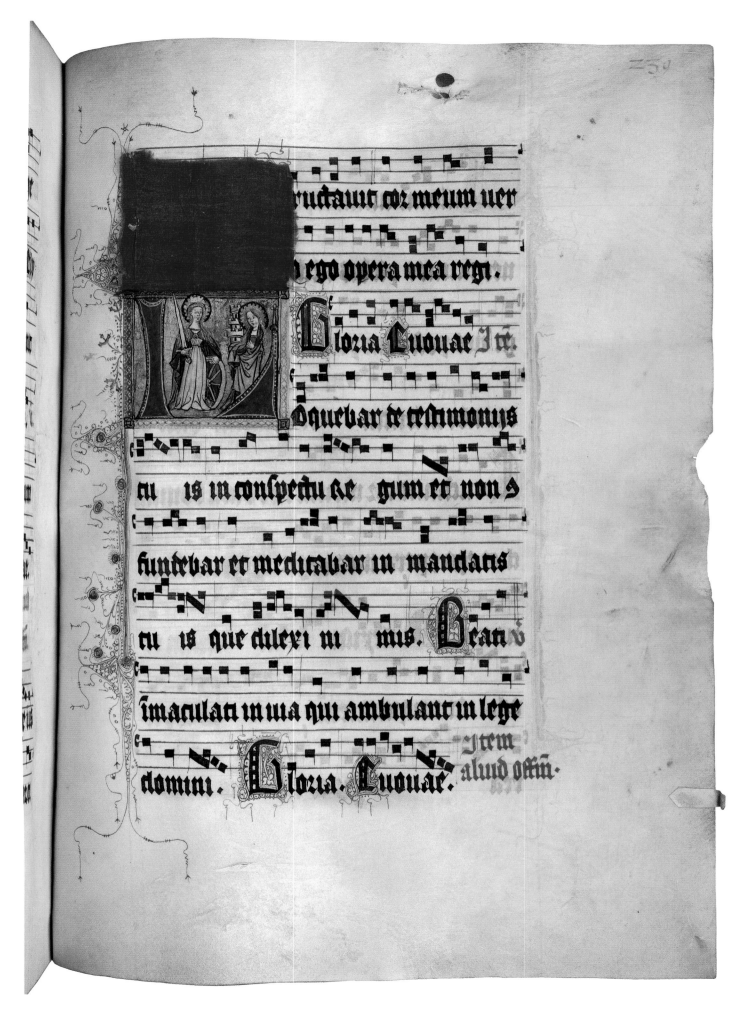

409. Common of virgin, gradual, ca. 1420.
ULB Dusseldorf, D 12, f. 239r [vol. I, p. 721]

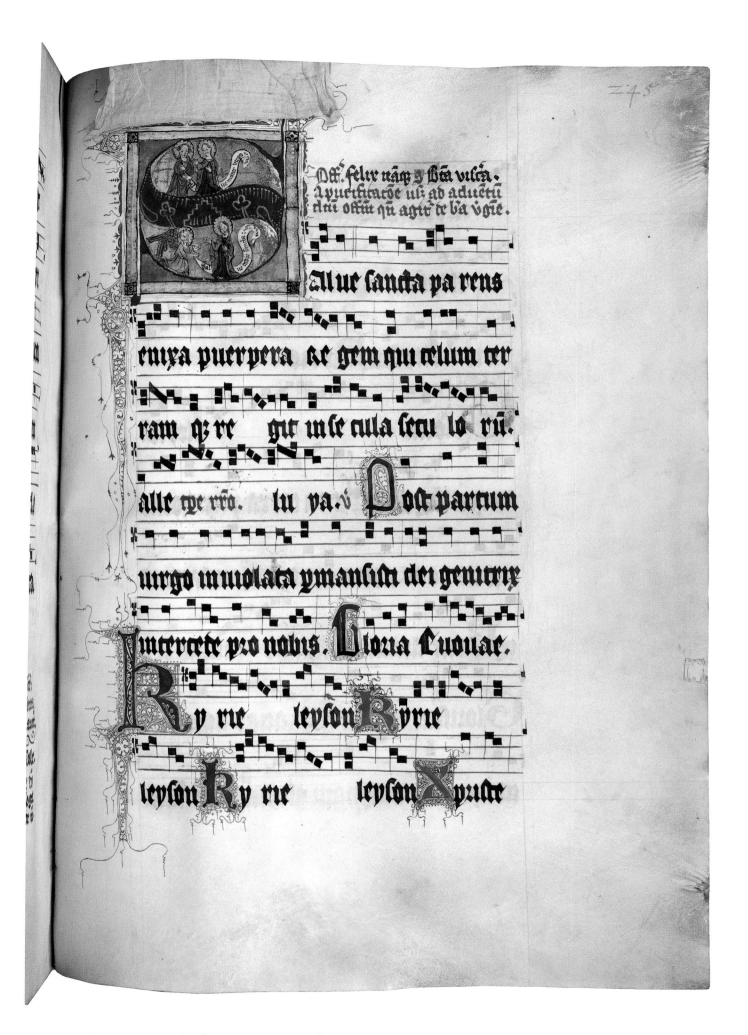

Off. felix naq 9 Bta vlica.
a purificatoe vln ad aduentu
dni offm qn agitr de bta vgie.

Alue sancta pa rens

enixa puerpera te gem qui celum ter

ram qz re git in se cula secu lo ru.

alle tpe reo. lu ya.v Post partum

uirgo inuiolata ymansisti dei genitrix

intercede pro nobis. Gloria Luouae.

Ky rie leyson Kyrie

leyson Ky rie leyson Xpucte

410. Virgin Mary: Saturdays from Presentation to Advent.
ULB Dusseldorf, D 12, f. 245r [vol. I, p. 553]

GRADUAL, D12 | 511

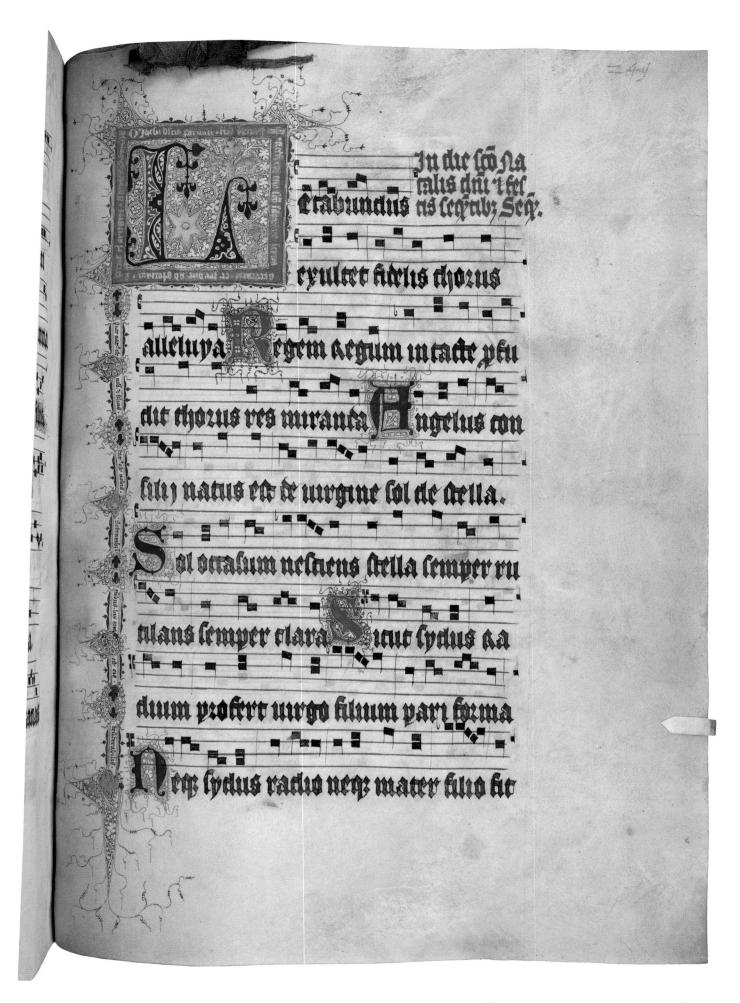

411. Christmas: sequence, gradual, ca. 1420.
ULB Dusseldorf, D 12, f. 249r [vol. I, p. 360]

ipsum genuit pu
rie scd Pasche. et
vz diebz seqntibz. Seq

chime paschali laudes

immolant cristiani.

Agnʼ redemit oues xpc innocens patri

reconsiliauit peccatores Mors ꞇ uita

duello confliyere mirando dux uite mor

tuus regnat uiuus Dic nobis maria

quid uidisti in uia Sepulchrum xpi

412. Easter: sequence, gradual, ca. 1420.
ULB Dusseldorf, D 12, f. 250r [vol. I, p. 440]

GRADUAL, D12 | 513

413. Pentecost: sequence, gradual, ca. 1420.
ULB Dusseldorf, D 12, f. 252v [vol. I, p. 472]

414. Pentecost: sequence, gradual, ca. 1420.
ULB Dusseldorf, D 12, f. 254v [vol. I, p. 471]

415. Corpus Christ: sequence, gradual, ca. 1420.
ULB Dusseldorf, D 12, f. 257r [vol. I, p. 492]

416. John the Evangelist at the Latin Gate: sequence, gradual, ca. 1420. ULB Dusseldorf, D 12, f. 262v [vol. I, p. 596]

417. John the Evangelist at the Latin Gate: sequence, gradual, ca. 1420. ULB Dusseldorf, D 12, f. 269r [vol. I, pp. 582, 586]

seti proceres De sigillo trinitatis nui
mo nostre ciuitatis inpressio caracteres
de custos virginis archanum on
ginis diuine mysterium scribens eua
geli um mundo premonstrauit.
Celi cui sacrarium cristus suum ly
lium filio conitrui sub amoris mutui
i fide conmentauit Maurto virtis
hic letale cui corpus virginale virtus

418. John the Evangelist at the Latin Gate: sequence, gradual,
ca. 1420. ULB Dusseldorf, D 12, f. 270r [vol. I, p. 583]

GRADUAL, D12 | 519

419. John the Evangelist at the Latin Gate: sequence, gradual, ca. 1420. ULB Dusseldorf, D 12, f. 270v [vol. I, p. 583]

sine meta quod nec uates nec propheta

euolauit alcius Nam impleta quam

impleta numquam uidit tot secreta pu

rus homo purius Sponsus aubza

ueste tectus uisus sed non intellectus

redit ad palaci um Aquilam eze

chielis sponse misit que de celis referret

mysteri um Dic dilecte de dilecto

qualis sit ex dilecto sponsus sponse nun

420. John the Evangelist at the Latin Gate: sequence, gradual, ca. 1420. ULB Dusseldorf, D 12, f. 271r [vol. I, p. 583]

421. Dominic: sequence, gradual, ca. 1420.
ULB Dusseldorf, D 12, f. 271v [vol. I, p. 514]

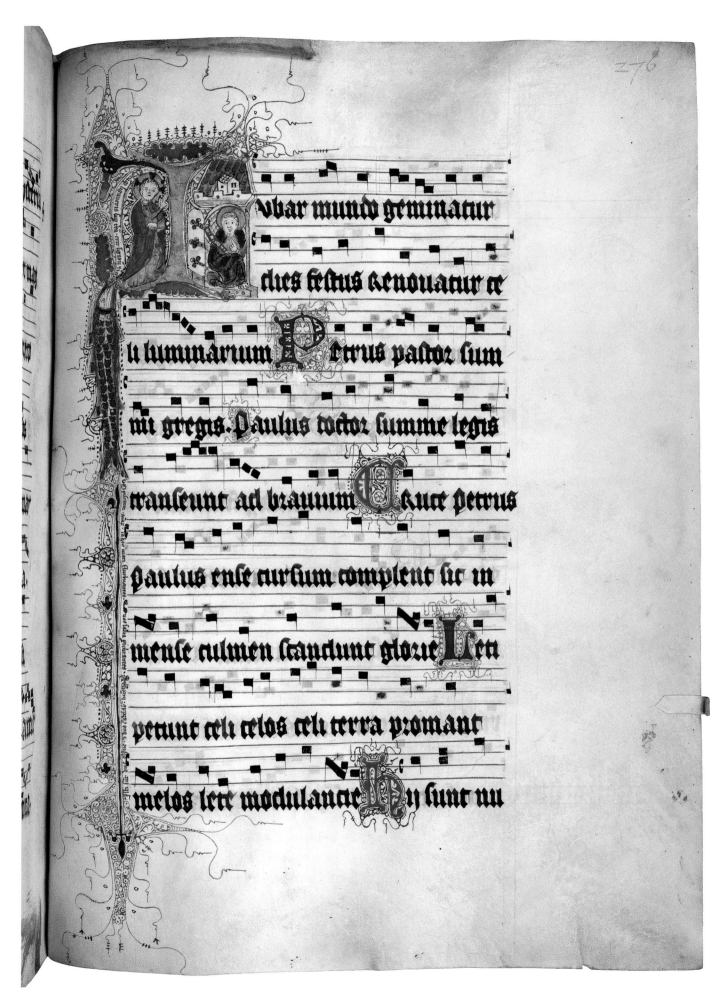

Probar mundo geminatur

dies festus renouatur ce

lu luminarium Petrus pastor sum

mit gregis. Paulus doctor summe legis

transeunt ad brauium Cruce petrus

paulus ense cursum complent sic in

mense culmen scandunt glorie Leti

petunt celi celos celi terra promant

melos lete modulante Hij sunt uu

422. Peter: chains, sequence, gradual, ca. 1420.
ULB Dusseldorf, D 12, f. 276r [vol. I, pp. 671–72]

GRADUAL, D12 | **523**

423. Division of apostles: sequence, gradual, ca. 1420.
ULB Dusseldorf, D 12, f. 277v [vol. I, p. 679]

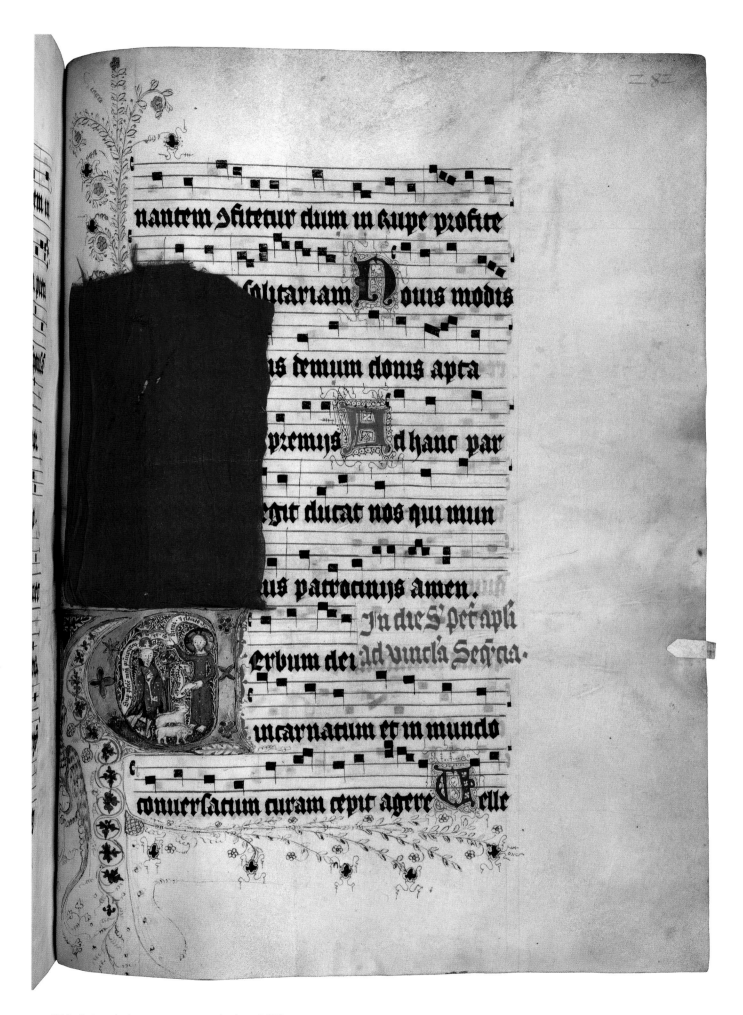

nautem confitetur dum in aupe profite

solitariam Nouis modis

ius demum clonis apta

premiis Ad hanc par

egit ducat nos qui mun

ius patrociniis amen.

In die S pet apli

erbum dei Ad vincla Sequa

incarnatum et in mundo

conuersatum curam cepit agere Telle

424. Peter: chains, sequence, gradual, ca. 1420.
ULB Dusseldorf, D 12, f. 282r [vol. I, p. 202]

GRADUAL, D12 | **525**

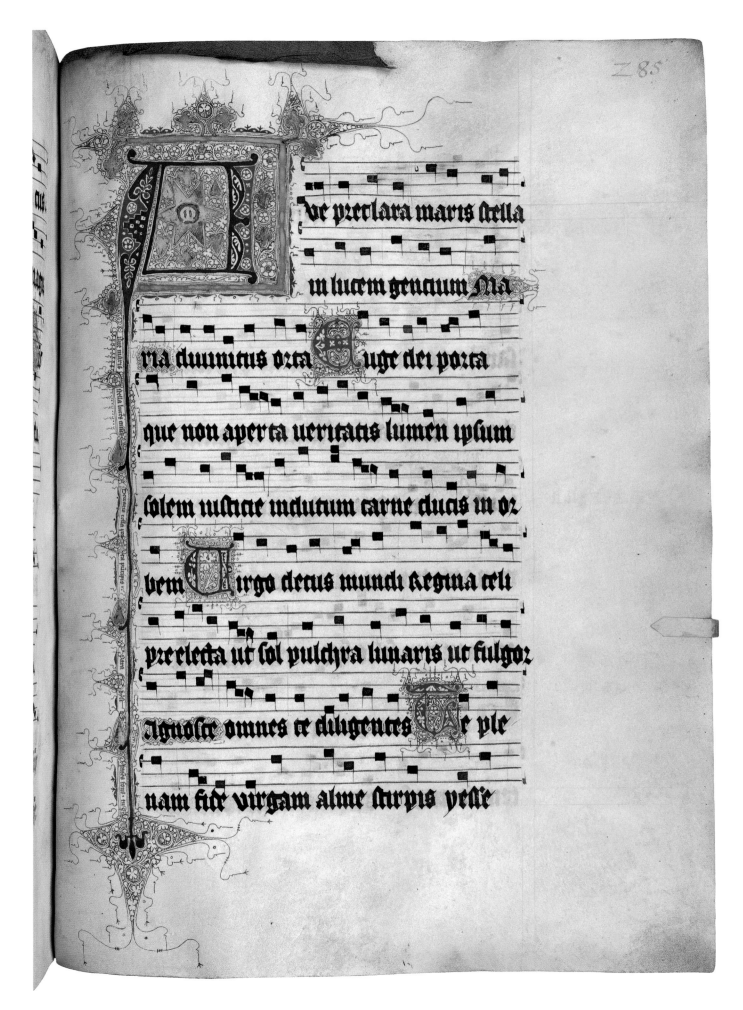

425. Assumption of Virgin: sequence, gradual, ca. 1420.
ULB Dusseldorf, D 12, f. 285r [vol. I, pp. 541–42, 550]

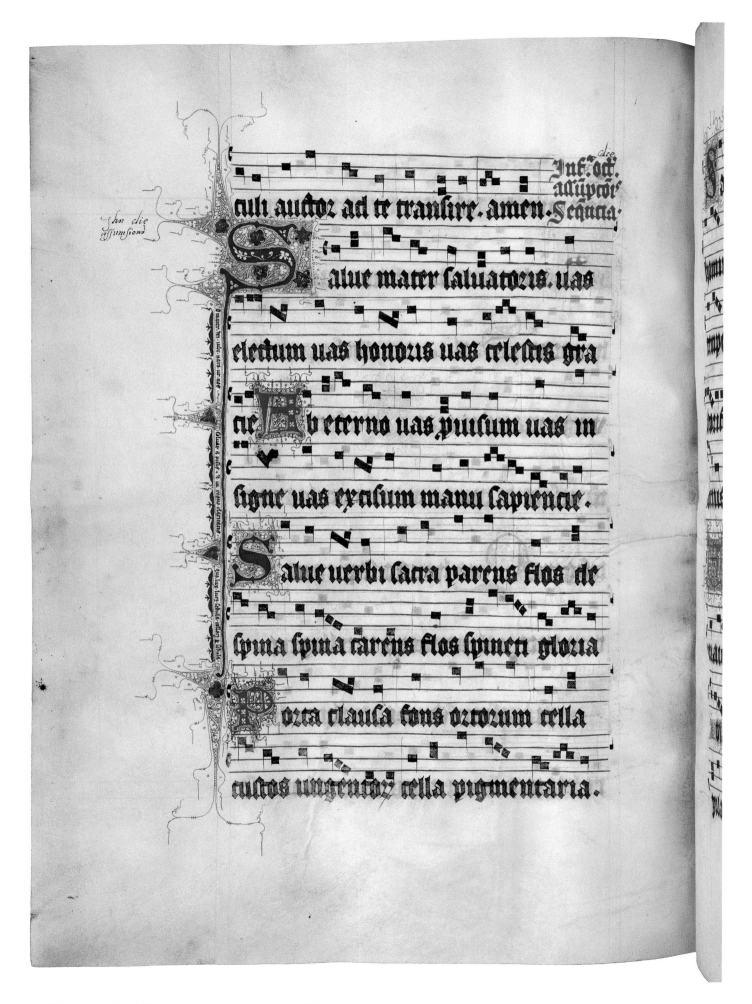

426. Assumption of Virgin: sequence, gradual, ca. 1420.
ULB Dusseldorf, D 12, f. 287v [vol. I, p. 546]

GRADUAL, D12 | 527

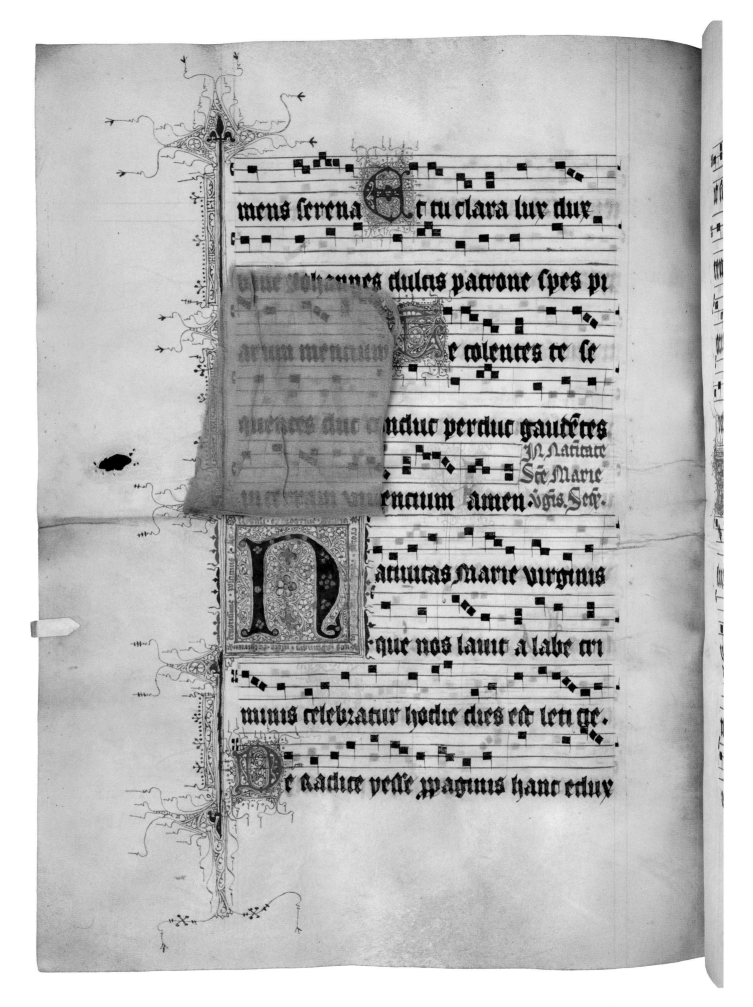

427. Virgin Mary: Nativity, gradual, ca. 1420.
ULB Dusseldorf, D 12, f. 294v [vol. I, p. 546]

Bibliography

Abbreviations for Liturgical Texts

All.: Alleluia
Can: Cantus
Comm.: Communion
EP: Epistle pericope
GP: Gospel pericope
G℟: Gradual responsory
Off.: Officium
Offert.: Offertory
℟: Responsory
℣: Verse

Abbreviations

AASS: *Acta Sanctorum*

Acta: *Acta capitulorum generalium ordinis Praedicatorum*

AH: *Analecta hymnica*

CAO: *Corpus antiphonalium officii*

CCCM: Corpus Christianorum Continuatio Mediaevalis

CCSL: Corpus Christianorum Series Latina

DSAM: *Dictionnaire de spiritualité, ascétique et mystique*

HStA: *Hauptstaatsarchiv*

KdiH: *Katalog der deutschsprachigen illustrierten Handschriften des Mittelalters*

LAV NRW OWL: Landesarchiv Nordrhein–Westfalen, Abteilung Ostwestfalen-Lippe

LcI: *Lexikon der christlichen Ikonographie*

LMA: *Lexikon des Mittelalters*

LR: *Lippische Regesten*

LR NF: *Lippische Regesten. Neue Folge*

MOPH: *Monumenta Ordinis Fratrum Praedicatorum Historica* (Rome, 1896–).

OSB: Ordo Sancti Benedicti

OCist: Ordo Cisterciensis

OESA: Ordo Eremitarum Sancti Augustini

OFM: Ordo Fratrum Minorum

OP: Ordo Praedicatorum

PL: *Patrologia Latina*

PMLA: *Publications of the Modern Language Association*

RDK: *Reallexikon zur deutschen Kunstgeschichte*

RH: *Repertorium hymnologicum*

StA: *Stadtarchiv*

UB: *Urkundenbuch*

ULB: Universitäts- und Landesbibliothek

²VL: *Verfasserlexikon*

WUB: *Westfälisches Urkundenbuch*

Unpublished Sources

Berlin, Staatsbibliothek

Cod. Ms. theol. fol. 178 (Pigmentum Cordis), 15th century

Ms. Germ. fol. 19 (Otto von Passau, Die 24 Alten)

Cambridge, Ma., Houghton Library, Harvard University

Typ 1095 (Libellus, fragment)

Detmold, Landesarchiv NRW, Abt. Ostwestfalen-Lippe

L 110 B, Nr. 18 (Alte Sig.: Tit. 3 Nr. 2), Library Catalogue St. Mary, Lemgo

L 110 B, Nr. 19, *Liber medicinalis* (14th/15th century)

L 110 B, Nr. 20, Alexander of Villedieu, *Doctrinale glosatum*

Dortmund, Archiv der Propsteigemeinde

B 6 (Graduale)

Düsseldorf, Universitäts- und Landesbibliothek (ULB)

Findbuch 1/8, 2. URL: urn:nbn:de:hbz:061:1-448441 'Katalog der von der Großherzoglichen Bibliothek übernommenen Bücher der Bibliothek des Klosters Paradiese zu Soest' (1809/1810)

Findbuch 1/8,6. Theodor Joseph Lacomblet, Katalog der Handschriften der Königlichen Landesbibliothek zu Düsseldorf, Dusseldorf, Königliche Landesbibliothek 1850.

Findbuch 1/8, 8. URL: urn:nbn:de:hbz:061:1-453546 'Acten der Königlichen Landesbibliothek betr. …' [Preparations for the Cataloguing of Manuscripts and the Sale of Parchment] (1846/1850)

Findbuch 1/8, 13. URL: urn:nbn:de:hbz:061:1-448435 'Unterlagen zur Übernahme der Klosterbibliothek Paradiese zu Soest' (1809/1810)

Without shelfmark: 'Restaurierungsbericht D 7': 'Sign. Restaurierungsbericht MS D 7', Werkstatt Claus Schade, Berlin, 2012

Without shelfmark: 'Restaurierungsbericht D 9' (2013): 'Restaurierungsbericht MS D 9', Werkstatt Lars Herzog-Wodtke, Essen, 2013

Ms-B 56 (*De doctrina cordis*)

Ms-D 7 (Antiphonale, pars hiemalis)

Ms-D 9 (Antiphonale, pars estivalis)

Ms-D 10a (Graduale)

Ms-D 11 (Graduale)

Ms-D 12 (Graduale)

Ms-D 37.34 (Antiphonale, fragment)

Freiburg, Stadtarchiv

B 1 (H), no. 108, fol. 21–145, Johannes Meyer, *Amptbuch* (15th c.)

Munich, Bayerisches Hauptstaatsarchiv

Altenhohenau KL Lit. 12 (Hausbuch)

Kloster Altenhohenau, Urk. no. 13 (1246 April 21)

Munich, Staatliche Graphische Sammlung

Inv. nr. 18703 (Libellus, fragment)

Inv. nr. 18703 (Libellus, fragment)

Münster, Landesarchiv NRW, Abteilung Westfalen

Großherzogtum Berg E 10 (Rentei Soest), no. 64, no. 71, no. 92, no. 93.

Kartensammlung Arnsberg no. 1309: Wilhelm Siebigk, plan of Kloster Paradies, copy after W. Vogelsang, 1934

Msc. VII, Nr. 9, Theological-legal miscellany (1267–1428) of the Dominicans of Soest (contains a defense of Kloster Paradies against the charge of simony, including inserted documents, 15th century)

Msc. VII, Nr. 6107, Cartulary and Foundation Legend of Kloster Paradies (c. 1340)

Msc. VII, Nr. 6112, *Sermones* of Jakob von Soest (manuscript of the Dominicans in Soest); contains records of the conflicts over the patronage rights of the Dominican nuns of Paradiese in Sveve

Msc. VII, Nr. 6119, Fragment of a cartulary of Kloster Paradies bei Soest (15th century)

Soest, Urkunden Paradies, nr. 88 (1363)

Soest, Urkunden Paradies, nr. 41 (1287 October 31)

Soest, Stadtarchiv

IX l 4 (*Acta der Municipalitaet Soest wegen des Verkaufs einiger aus dem Closter Paradies vorgefundenen Bücher*).

B X b 1a: W. Vogelsang, four drawings of Kloster Paradies, 1809

Wolfenbüttel, Herzog August Bibliothek

Helmst. 1044, Hugh of Saint Victor's *De sacramentis christiane fidei* (12th c.)

Internet Sources

Cantus Database
http://cantusdatabase.org/

Cantus Gregorianus
http://www.cantusgregorianus.it/vecchiosito/strumentiricerca/Lettere_parlanti_repertorio.pdf

Deutsche Inschriften Online (DIO): Inschriftenkatalog Stadt Lemgo
http://www.inschriften.net/lemgo/inschrift/nr/di059-0001.html

DFG research project 'Schriftlichkeit in süddeutschen Frauenklöstern' [Literacy in Southern German Convents]
https://www.bayerische-landesbibliothek-online.de/sueddeutsche-frauenkloester

M. Hömberg, Wirtschafts(buch)führung (2012–2013):
https://edoc.ub.uni-muenchen.de/19134/1/Hoemberg_Melanie.pdf

The Textmanuscripts site of Les Enluminures
http://www.textmanuscripts.com/manuscript_description

Printed Primary Sources and Translations

Acta capitulorum, ed. Reichert (1898–1900): *Acta capitulorum generalium Ordinis Praedicatorum*, ed. Benedictus Maria Reichert, 3 vols., *MOPH* 3, 4, and 8 (Rome, 1898–1900).

Acta capitulorum provincialium, ed. Douais (1894): *Acta capitulorum provincialium Ordinis Fratrum Praedicatorum. Première province de Provence. Province Romaine. Province d'Espagne (1239–1302)*, ed. Celestin Douais (Toulouse, 1894).

Acta Iohannis, eds. Junod & Kaestli (1983): *Acta Iohannis*, eds. Eric Junod & Jean-Daniel Kaestli, 2 vols., Corpus Christianorum: Series Apocryphorum 1–2 (Turnhout, 1983).

Acta Sanctorum Augusti, ex Latinis & Graecis, aliarumque gentium Monumentis, servata primigenia veterum Scriptorum phrasi, Collecta, Digesta, Commentariisque & Observationibus, ed. Johannes Boland et al., 58 vols. (Antwerp–Brussels, 1643–1867).

Acta capitulorum generalium ordinis Praedicatorum, ed. Benedictus Maria Reichert, 3 vols., MOPH 3, 4, and 8 (Rome, 1898–1900).

Aelred of Rievaulx, *Sermones*, ed. Raciti (1989): Aelred of Rievaulx, *Aelredi Rievallensis sermones*, ed. Gaetano Raciti, CCCM 2A–2B (Turnhout, 1989).

Albertus Magnus, *Opera omnia*, eds. Auguste & Émile Borgnet (1890–1899): Albertus Magnus, *B. Alberti Magni Ratisbonensis episcopi, ordinis Praedicatorum, Opera omnia ex editione lugdune*, eds. Auguste & Émile Borgnet, 38 vols. (Paris, 1890–1899).

Ps.-Albertus Magnus, *Liber de virtutibus*, ed. Draelants (2007): Ps.-Albertus Magnus, *Le Liber de virtutibus herbarum, lapidum et animalium (Liber aggregationis):Un texte à succès attribué à Albert le Grand*, ed. Isabelle Draelants, Micrologus Library 22 (Florence, 2007).

Alleluia-Melodien, ed. Schlager (1987): *Alleluia-Melodien II. Ab 1100*, ed. Karlheinz Schlager, Monumenta monodica medii aevi 8 (Kassel–New York, 1987).

Amalarius, *Opera liturgica omnia*, ed. Hanssens (1948–1950): Amalarius, *Amalarii episcopi opera liturgica omnia*, ed. Johannes Michael Hanssens, 3 vols., Studi e Testi 138–140 (Vatican City, 1948–1950).

Ambrosio, *Monastero femminile domenicano* (2003): Ambrosio, Antonella, *Il monastero femminile domenicano dei SS. Pietro e

Sebastiano di Napoli. Regesti dei documenti dei secoli XIV–XV, La tradizione erudita (Salerno, 2003).

Analecta hymnica medii aevi, ed. Guido Maria Dreves & Clemens Blume, 55 vols. (Leipzig, 1862–1922; repr. New York, 1961).

Anthologia Latina, ed. Shackleton (1982): *Anthologia Latina. Carmina in codicibus scripta*, vol. 1/1, ed. David R. Shackleton Bailey, Bibliotheca scriptorum Graecorum et Latinorum Teubneriana (Stuttgart, 1982).

Apocryphal Gospels, eds. Ehrman & Plese (2011): *The Apocryphal Gospels: Texts and Translations*, eds. Bart Ehrman & Zlatko Plese (Oxford, 2011).

Apocrypha Hiberniæ, eds. McNamara et al. (2001): *Apocrypha Hiberniæ*, eds. Martin McNamara et al., 2 vols., Corpus Christianorum: Series Apocryphorum 13–14, 16 (Turnhout, 2001).

Apocryphal New Testament, ed. James (1924): *The Apocryphal New Testament*, ed. Montague Rhodes James (Oxford, 1924).

Apostolic Fathers, ed. Lightfoot (1885–1890): *The Apostolic Fathers, Part II: S. Ignatius, S. Polycarp*, ed. Joseph Barber Lightfoot, 3 vols. (London, 1885–1890).

Aquinas: *see* Thomas Aquinas

Aristotle, *Works*, ed. McKeon (1941): Aristotle, *The Basic Works of Aristotle*, ed. Richard McKeon (New York, 1941).

Augustine, *De ciuitate Dei*, eds. Dombart & Kalb (1981): *Sancti Aurelii Augustini, De ciuitate Dei libri XXII*, eds. Bernardus Dombart & Alfonsus Kalb (Stuttgart, 1981).

Augustine, *Enarrationes*, eds. Dekkers & Fraipont (1956): *Augustinus Hipponensis, Enarrationes in Psalmos*, eds. Eligius Dekkers & Johannes Fraipont, CCSL 38–40, 3 vols. (Turnhout, 1956).

Augustine, *In Iohannis*, ed. Williams (1954): *Augustinus Hipponensis, In Iohannis euangelium tractatus CXXIV*, ed. Robert Williams, CCSL 36 (Turnhout, 1954).

Bernard of Clairvaux, *Opera*, eds. Leclercq et al. (1957–1977): *Sancti Bernardi opera*, eds. Leclercq et al., 8 vols. (Rome, 1957–1977).

Bernard of Clairvaux, *Sermons*, trans. Edmonds & Leinenweber (2007): Bernard of Clairvaux, *Sermons for Advent and the Christmas Season*, trans. Irene Edmonds & John Leinenweber, Cistercian Fathers Series 51 (Kalamazoo, 2007).

Bernard of Gui, *Scripta*, ed. Tugwell (1998): *Bernardi Guidonis: Scripta de Sancto Dominico*, ed. Simon Tugwell, Corpus Hagiographicum Sancti Dominici 3; MOPH 27 (Rome, 1998).

Biblia sacra (1985): *Biblia sacra iuxta Vulgatam Versionem*, ed. Bonifatius Fischer et al., 3rd rev. edn., 2 vols. (Stuttgart, 1985).

Bibliotheca Rerum Germanicarum, ed. Jaffé (1866): *Bibliotheca Rerum Germanicarum 3: Monumenta Moguntina*, ed. Philipp Jaffé (Berlin, 1866).

'Boccamazza', eds. Maleczek et al. (2013): Werner Maleczek, with Andrea Bottanová et al., 'Die Urkunden des päpstlichen Legaten Johannes Boccamazza, Kardinalbischof von Tusculum, aus den Jahren 1286 und 1287 (Legation ins Reich in der Spätzeit König Rudolfs von Habsburg)', *Archiv für Diplomatik* 59 (2013), 35–132.

Boethius, *Consolatio*, ed. Bieler (1984): Anicius Manlius Severinus Boethius, *Philosophiae Consolatio*, ed. Ludwig Bieler, CCSL 94 (Turnhout, 1984).

Ps.-Boethius, *De doctrina scholarium*, ed. Weijers (1976): *De doctrina scholarium, Édition critique, introduction et notes*, ed. Olga Weijers, Studien und Texte zur Geistesgeschichte des Mittelalters 12 (Leiden–Cologne, 1976).

Bonaventure, *Breviloquium*, ed. Schlosser (2002): Bonaventura, *Breviloquium*, ed. Marianne Schlosser, Christliche Meister 52 (Einsiedeln–Freiburg i. Br., 2002).

Bonaventure, *De triplici via*, ed. Schlosser (1993): Bonaventura, *De triplici via—Über den dreifachen Weg. Lateinisch-Deutsch*, ed. Marianne Schlosser, Fontes Christiani 14 (Freiburg i. Br., 1993).

Bonaventure, *Meditations*, trans. Ragusa & Green (1961): Bonaventure, *Meditations on the Life of Christ: An Illustrated Manuscript of the Fourteenth Century, Paris, Bibliothèque nationale, Ms. Ital. 115*, trans. & eds. Isa Ragusa & Rosalie B. Green (Princeton, 1961).

Bonaventure, *Opera*, eds. Borde & Arnaud (1668): *Sancti Bonaventurae Opera 7*, ed. Petrus Borde & Laurentius Arnaud (Lyon, 1668).

Breviarium (1719): *Breviarium iuxta ritum sacris ordinis predicatorum*, Antoninus Cloche OSB (Rome, 1719).

Burchardus de Monte Sion, *Liber*, ed. Stewart (1896): Burchardus de Monte Sion, *Liber de descriptione terrae sanctae*, ed. Aubrey Stewart (Geneva, 1896).

Büchlein von der Genaden Überlast, ed. Schröder (1871): *Der Nonne von Engelthal Büchlein von der Genaden Überlast*, ed. Karl Schröder, Bibliothek des Litterarischen Vereins Stuttgart 108 (Tübingen, 1871).

Bünger, 'Studienordnungen' (1914): Fritz Bünger, 'Studienordnungen der Dominikanerprovinz Saxonia (ca. 1363–1376)', *Zeitschrift für Kirchengeschichte* 35 (1914), 40–64.

Bürgerbuch, ed. Rothert (1958): *Das älteste Bürgerbuch der Stadt Soest, 1302–1449*, ed. Hermann Rothert (Münster, 1958).

Caritas Pirckheimer, *Denkwürdigkeiten*, ed. Pfanner (1962): *Die 'Denkwürdigkeiten' der Caritas Pirckheimer (aus den Jahren 1524–1528)*, ed. Josef Pfanner, Caritas Pirckheimer – Quellensammlung 2 (Landshut, 1962).

Carmina, ed. Walther (1959–1986): Hans Walther, *Carmina Medii Aevi posterioris Latina*, 10 vols. (Göttingen, 1959–1986).

Cassiodorus (pseudo-), *Commentaria*, ed. Adriaen (1958): *Cassiodori discipulus, Commentaria in epistulas sancti Pauli, Ad Timotheum II*, ed. Marcus Adriaen, CCSL, 97–98 (Turnhout, 1958).

Chronicon Stederburgense, ed. Meibom (1688): *Chronicon Stederburgense*, ed. Heinrich Meibom, in: *Rerum Germanicarum. Historicos Germanicos ab Henrico Meibomio seniore primum editos et illustratos, nunc auctiores* 1, ed. Heinrich Meibom (Helmstedt, 1688), 427–36, 450–55.

Chronik der Anna von Munzingen, ed. König (1880): *Die Chronik der Anna von Munzingen. Nach der ältesten Abschrift mit Einleitung und Beilagen*, ed. Joseph König, *Freiburger Diözesanarchiv* 13 (1880), 129–236.

Codex apocryphus, ed. Fabricus (1719): *Codex apocryphus Novi Testamenti III*, ed. Johannes Albert Fabricius (Hamburg, 1719).

Codex apocryphus, ed. Giles (1852): *Codex apocryphus Novi Testamenti: The Uncanonical Gospels and other Writings referring to the First Ages of Christianity*, ed. John Allen Giles, 2 vols. (London, 1852).

Concilia aevi Karolini, ed. Werminghoff (1808): Monumenta Germaniae Historica, *Concilia aevi Karolini* I, 2/1, ed. Albert Werminghoff (Hannover, 1808).

Corpus antiphonalium officii, ed. Ren.-Jean Hesbert, 6 vols., Rerum ecclesiasticarum documenta: Series maior, fontes 7–12 (Rome, 1963–1979).

Corpus iuris canonici, ed. Friedberg (1879): *Corpus iuris canonici*, ed. Emil Friedberg, 2 vols. (Leipzig, 1879; repr. Graz, 1955–1959).

Creytens, 'Les constitutions primitives' (1947): Raymond Creytens, 'Les Constitutions primitives des soeurs dominicaines de Montargis', *Archivum Fratrum Praedicatorum* 17 (1947), 41–84.

Creytens, '"Testament"' (1973): Raymond Creytens, 'Le 'Testament de S. Dominique dans la littérature dominicaine ancienne et moderne', *Archivum Fratrum Praedicatorum* 43 (1973), 29–72.

Dante, *Epistolae*, ed. Toynbee (1966): *Dantis Allegherii Epistolae: The Letters of Dante*, ed. Paget Toynbee (Oxford, 1966).

De institutione Paradysi, ed. Seibertz (1857): *De institutione Paradysi et humili ingressu sororum per Fr. Henricum de Osthoven*, ed. Johann Suibert Seibertz, in: *Quellen der westfälischen Geschichte* 1 (Arnsberg, 1857), 4–13.

Dionysiaca, ed. Chevallier (1937–1949): *Dionysiaca: recueil donnant l'ensemble des traductions latines des ouvrages attribués au Denys de l'aréopage*, ed. Philippe Chevallier (Paris–Bruges, 1937–1949).

Dominic Missal (1959): *The Saint Dominic Missal: Latin-English* (New York, 1959).

Durandus, *Rationale*, eds. Davril & Thibodeau (1995–2000): *Guillelmi Duranti, Rationale divinorum officiorum*, eds. Anselmus Davril & Timothy M. Thibodeau, CCCM 140, 140A–B (Turnhout, 1995–2000).

Durandus, *Rationale*, trans. Thibodeau (2007): *The Rationale Divinorum Officiorum of William Durand of Mende: A New Translation of the Prologue and Book One*, trans. Timothy M. Thibodeau (New York, 2007).

Elisabeth von Schönau, *Werke*, ed. Dinzelbacher (2006): *Die Werke der heiligen Elisabeth von Schönau*, ed. Peter Dinzelbacher, Katholische Kirchengemeinde St. Florin (Paderborn et al., 2006).

Elisabeth von Schönau, *Visionen*, ed. Roth (1886): *Die Visionen und Briefe der hl. Elisabeth sowie die Schriften der Äbte Ekbert und Emecho von Schönau*, ed. Friedrich Wilhelm Ernst Roth (Brünn, 1886).

Empfänger des Weihesakraments (1999): *Der Empfnäger des Weihesakraments. Quellen zur Lehre und Praxis der Kirche, nur Männern das Weihesakrament zu spenden*, ed. Gerhard Ludwig Müller (Würzburg, 1999).

Epistolae Romanorum pontificum, ed. Thiel (1886): *Epistolae Romanorum pontificum genuinae et quae ad eos scriptae sunt. A S. Hilaro usque ad Pelagium II.*, ed. Andreas Thiel (Brunsberg, 1886).

Eriugena, *Commentaire*, ed. Jeauneau (1999): Jean Scot, *Commentaire sur l'évangile de Jean*, ed. Édouard Jeauneau, Sources chrétiennes 180 (Paris, 1999).

Eriugena, *Vox spiritualis aquilae*, ed. Jeauneau (1969): *Vox spiritualis aquilae: homélie sur le prologue de Jean*, ed. Édouard Jeauneau, Sources chrétiennes 151 (Paris, 1969).

Expositiones sequentiarum, ed. Kihlman (2006): *Expositiones sequentiarum: Medieval Sequence Commentaries and Prologues. Editions with Introductions*, ed. Erika Kihlman, Acta Universitatis Stockholmiensis: Studia Latina Stockholmiensia 53 (Stockholm, 2006).

Feasts, ed. Johansson (1998): *The Feasts of the Blessed Virgin Mary*, Tropes for the Proper of the Mass 4, ed. Ann-Katrin Andrews Johansson, Acta Universitatis Stockholmiensis, Corpus Troporum 9 (Stockholm, 1998).

Fontes, ed. Prümmer (1911): *Fontes Vitae S. Thomae Aquinatis: Notis historicis et criticis illustrati*, ed. Dominicus M. Prümmer (Toulouse, 1911).

Francis of Assisi, *Opera omnia*, ed. de La Haye (1739): *Sancti Francisci Assisiatis, minorum patriarchae nec non S. Antonii Paudani ejusdem ordinis, Opera omnia. Postillis illustrata, expositione mystica in sacram scriptutam, et in eandem concordia morali, locupletata*, ed. Jean de La Haye (Pedeponti [Hof bei Regensburg], 1739).

Gerard of Frachet, *Vitae fratrum*, ed. Reichert (1897): *Fratris Gerardi de Fracheto O.P. vitae fratrum ordinis Praedicatorum necnon cronica Ordinis ab anno 1203 usque ad 1254*, ed. Benedictus Maria Reichert O.P., *MOPH* 1 (Rome, 1897).

Gertrude of Helfta, *Legatus*, eds. Doyère et al. (1968–1986): Gertrude of Helfta, *Œuvres spirituelles*, eds. Jacques Hourlier et al., Vol. 2, *Legatus divinae pietatis*, eds. P. Doyère et al., Sources chrétiennes 139 (Paris, 1968–1986).

Gertrude of Helfta, *Œuvres spirituelles*, eds. Hourlier et al. (1967–1986): Gertrude of Helfta, *Œuvres spirituelles*, eds. Jacques Hourlier et al., 5 vols., Sources chrétiennes 127, 139, 143, 255, 331 (Paris, 1967–1986).

Goldene Bulle, ed. Wolf (1977): *Die goldene Bulle. König Wenzels Handschrift*, ed. Armin Wolf (Graz, 1977).

Graduel de Fontevrault, eds. Amiet et al. (1987): *Le Graduel de Fontevrault*, eds. Robert Amiet et al. (Limoges, 1987).

Gregory the Great, *Gospel Homilies*, trans. Hurst (1990): *Gregory the Great: Forty Gospel Homilies*, trans. Dom David Hurst, Cistercian Studies Series 123 (Kalamazoo, 1990).

Gregory the Great, *Homelia*, ed. Étaix (1999): Gregory the Great: *Homilia in evangelia*, ed. Raymond Étaix, CCSL 141 (Turnhout, 1999).

Gregory the Great, *Moralia*, ed. Adriaen (1979–1985): *S. Gregorii Magni Moralia in Iob*, ed. Marcus Adriaen, 3 vols., CCSL 143–143B (Turnhout, 1979–1985).

Guerrini, *Ordinarium* (1921): Franciscus M. Guerrini, *Ordinarium juxta ritum sacri ordinis fratrum Praedicatorum* (Rome, 1921).

Hadewijch, *Brieven*, ed. van Mierlo (1947): *Hadewijch: Brieven*, ed. Jozef van Mierlo, 2 vols. (Antwerp, 1947).

Hadewijch, *Complete Works*, trans. Hart (1980): *Hadewijch: The Complete Works*, trans. and intro. by Columba Hart (New York, 1980).

Hartung, *Concionis tergeminae rusticae* (1718): Philippus Hartung, *Concionis tergeminae rusticae, civicae, aulicae, in omnes dominicas et festa totius anni, pars II. À Pentecoste ad adventum* (Nuremberg, 1718).

Heilsspiegel (2006): *Heilsspiegel: Speculum humanae salvationis. Handschrift 2505 der Universitäts- und Landesbibliothek Darmstadt*, ed. Margit Krenn (Darmstadt, 2006).

Heinrich de Frimaria, *De decim preceptis* (2005): Heinrich de Frimaria, *De decem preceptis*, ed. Bertrand-Georges Guyot, Centro di Cultura Medievale 14 (Pisa, 2005).

Heinrich von Herford: *Liber de rebus memorabilioribus*, ed. Potthast (1859): Heinrich von Herford, *Liber de rebus memorabilioribus sive chronicon Henrici de Hervordia*, ed. August Potthast (Göttingen, 1859).

Heinrich Meibom, *Rerum Germanicarum*, ed. Meibom (1688): *Rerum Germanicarum. Historicos Germanicos ab Henrico Meibomio seniore primum editos et illustratos, nunc auctiores*, vol. 2: Scriptores Germanicos (Helmstedt, 1688), 526–532.

Heinrich Osthofen aus Soest, 'Gründungsgeschichte', ed. Bruns (1974): Heinrich Osthofen aus Soest: 'Gründungsgeschichte des Dominikanerinnenklosters Paradies (Urfassung)', ed. Norbert Eickermann, in: *Westfälische Quellen im Bild* 9, ed. Alfred Bruns (Münster, 1974), 9-15.

Henry, *Eton Roundels* (1990): Avril Henry, *The Eton Roundels: Eton College, MS 177 ('Figurae bibliorum'): A Colour Facsimile with Transcription, Translation and Commentary* (Aldershot, 1990).

Hermann von Minden, 'Briefe', ed. Löhr (1925): Gabriel Maria Löhr, 'Drei Briefe Hermanns von Minden O.P. über die Seelsorge und die Leitung der deutschen Dominikanerklöster', *Römische Quartalschrift für christliche Altertumskunde und Kirchengeschichte* 33 (1925), 159–67.

Hincmar of Reims, *De cavendis vitiis*, ed. Machtmann (1998): Hincmar of Reims, *De cavendis vitiis et virtutibus exercendis*, ed. Doris Machtmann, Monumenta Germaniae Historica. Quellen zur Geistesgeschichte des Mittelalters 16 (Munich, 1998).

Hugh of St. Victor, *De sacramentis*, ed. Berndt (2008): Hugh of St. Victor, *De sacramentis christianae fidei*, ed. Rainer Berndt, Corpus Victorinum. Textus historici 1 (Münster, 2008).

Hugo de Sancto Caro, *De doctrina cordis*, ed. Hendrix (1980): *Le manuscript Leyde Bibliothèque de l'Université, BPL 2579,*

témoin principal des phases de redaction du traité 'De doctrina cordis' à attribuer au dominicain français Hugues de Saint-Cher (pseudo- Gérard de Liège). Facsimile edition with an introduction by Guido Hendrix, De doctrina sive praeparatione cordis I (Ghent, 1980).

Humbert of Romans, *De dono timoris*, ed. Boyer (2008): *Humberti de Romanis De dono timoris*, ed. Christine Boyer, CCCM 281 (Turnhout, 2008).

Humbert of Romans, *De eruditione* (1677): *Fr. Humberti de Romanis: De eruditione Praedicatorum*, Maxima Bibliotheca Veterum Patrum et Antiquorum Scriptorum Ecclesiasticorum 25 (Lyons, 1677).

Humbert of Romans, *Expositio*, ed. Berthier (1889): Humbertus de Romanis, *Expositio Magistri Humberti super constitutiones fratrum Praedicatorum*, in: Humbert of Romans, *Opera*, ed. Berthier (1889), 1–262.

Humbertus de Romanis, *Instructiones*, ed. Berthier (1889): Humbertus de Romanis, *Instructiones de officiis ordinis, cap. XIII: De officio librarii*, in: Humbert of Romans, *Opera*, ed. Berthier (1889), 263–66.

Humbert of Romans, *Legendae*, ed. Tugwell (2008): Humberti de Romanis, *Legendae Sancti Dominici: necnon materia praedicabilis pro festis Sancti Dominici et testimonia minora de eodem: adiectis miraculis rotomagensibus Sancti Dominici et Gregorii IX bulla canonizationis eiusdem*, ed. Simon Tugwell, Corpus hagiographicum Sancti Dominici, *MOPH* 30 (Rome, 2008).

Humbert of Romans, *Liber constitutionum sororum* (1897): Humbertus de Romanis, *Liber Constitutionum Sororum Ordinis Praedicatorum*, in: *Analecta Sacri Ordinis Fratrum Praedicatorum* (Rome, 1897–1898), 337–48.

Humbert of Romans, *Opera*, ed. Berthier (1889): *B. Humberti de Romanis Opera de Vita regulari 2: Expositio in constitutiones. Instructiones de officiis ordinis. De eruditione praedicatorum. Epistolae encycliae*, ed. Joachim J. Berthier, 2 vols. (Rome, 1889).

Iacopo da Varazze, *Legenda aurea*, ed. Maggioni (2007): *Iacopo da Varazze, Legenda aurea con le miniature dal codice Ambrosiano C 240 inf. Testo critico riveduto e commenta*, ed. Giovanni Paolo Maggioni, 2 vols., Edizione nazionale dei testi mediolatini 20 (Florence–Milan, 2007).

Isidore, *De ortu*, ed. Fraga (1996): Isidore of Seville, *De ortu et obitu patrum*, ed. J. Carracedo Fraga, CCSL 108E, Scriptores Celtigenae 1 (Turnhout, 1996).

James of Voragine, *Golden Legend*, trans. Ryan (1993): *Jacobus de Voragine: The Golden Legend. Readings on the Saints*, trans. William Granger Ryan, 2 vols. (Princeton, 1993).

Jerome, *Commentarii*, ed. Adriaen (1969–1970): Jerome, *Commentarii in prophetas minores*, ed. Mark Adriaen, CCSL 76–76A (Turnhout, 1969–1970).

Jerome, *Commentarii*, ed. Glorie (1964): Jerome, *Commentarii in Ezechielem*, ed. F. Glorie, CCSL 75 (Turnhout, 1964).

Jerome, *Epistolae*, ed. Hilberg (1966): *Sancti Eusebii Hieronymi Epistolae* 1: Epistolae I– LXX, ed. Isidor Hilberg, CCSL 55 (Vienna, 1910–1918, repr. 1966).

Jerome, *Opera homiletica*, ed. Morin (1958): *Hieronymi Presbiteri opera. Pars II, Opera homiletica*, ed. Germain Morin, CCSL 78 (Turnhout, 1958).

Jerome of Moravia, *Tractatus de Musica*, eds. Meyer & Lobrichon (2012): Jerome of Moravia (or Jerome of Moray): *Tractatus de Musica*, eds. Christian Meyer & Guy Lobrichon, CCCM 250 (Turnhout, 2012).

Johannes Beleth, *Summa*, ed. Douteil (1976): *Iohannis Beleth Summa de Ecclesiasticis officiis*, ed. Heribert Douteil, CCCM 41–41A (Turnhout, 1976).

Johannes de Caulibus, *Meditaciones*, ed. Stallings-Taney (1997): *Iohannes de Caulibus, Meditaciones uite Christi*, ed. Mary Stallings-Taney, CCCM 153 (Turnhout, 1997).

Johannes Meyer, *Amptbuch*, ed. DeMaris (2015): *Johannes Meyer. Das Amptbuch*, ed. Sarah Glenn DeMaris, MOPH 31 (Rome, 2015).

Johannes Meyer, *Chronica brevis*, ed. Scheeben (1933): Johannes Meyer, *Chronica brevis Ordinis Praedicatorum*, ed. Heribert Christian Scheeben, Quellen und Forschungen zur Geschichte des Dominikanerordens in Deutschland 29 (Vechta, 1933).

Johannes Nider, *De reformatione religiosorum*, ed. Boucquet (1611): Johannis Nider, *De reformatione religiosorum libri tres*, ed. Jean Boucquet (Antwerp, 1611).

John Cassian, *Collationes*, eds. Petschenig & Kreuz (2004): *Cassiani opera. 2. Collationes XXIIII*, eds. Michael Petschenig & Gottfried Kreuz, CCSL 13, 2nd rev. ed. (Vienna, 2004).

Konstitutionen, ed. Scheeben (1939): *Die Konstitutionen des Predigerordens unter Jordan von Sachsen*, ed. Heribert Christian Scheeben, Quellen und Forschungen zur Geschichte des Dominikanerordens in Deutschland 38 (Vechta, 1939).

Krebs, 'Mystik in Adelhausen' (1904): Engelbert Krebs, 'Die Mystik in Adelhausen. Eine vergleichende Studie über die 'Chronik' der Anna von Munzingen und die thaumatographische Literatur des 13. und 14. Jahrhunderts', in: *Festgabe für Heinrich Finke* (Münster, 1904), 41–105.

Langmann, *Offenbarungen*, ed. Strauch (1878): Adelheid Langmann, *Die Offenbarungen der Adelheid Langmann. Klosterfrau zu Engelthal*, ed. Philipp Strauch, Quellen und Forschungen zur Sprach- und Culturgeschichte der germanischen Völker 26 (Strasbourg, 1878).

Lateinische Hymnen, ed. Mone (1853–1855): *Lateinische Hymnen des Mittelalters*, ed. Franz Joseph Mone, 3 vols. (Freiburg i. Br., 1853–1855; repr. Aalen, 1964).

Lateinische Sequenzen, ed. Kehrein (1873): *Lateinische Sequenzen des Mittelaters. Aus Handschriften und Drucken*, ed. Joseph Kehrein, 3 vols. (Mainz, 1873).

Leo the Great, *Tractatus*, ed. Chavasse (1973): Leo the Great, *Tractatus septem et nonaginta*, ed. Antoine Chavasse, 2 vols., CCSL 138–138A (Turnhout, 2010).

Lippische Regesten, ed. Otto Preuß, with August Falkmann, 4 vols. (Lemgo, 1860–1868).

Lippische Regesten. Neue Folge, ed. Hans-Peter Wehlt, 4 vols., Lippische Geschichtsquellen 17 (Lemgo, 1989–1992).

Litterae Encyclicae, ed. Reichert (1900): *Litterae encyclicae magistrorum generalium ordinis praedicatorum ab anno 1233 usque ad annum 1376*, ed. Benedikt Maria Reichert, *MOPH* 5 (Rome, 1900).

Löhr, 'Briefe' (1925): Gabriel Maria Löhr, 'Drei Briefe Hermanns von Minden O.P. über die Seelsorge und die Leitung der deutschen Dominikanerklöster', *Römische Quartalschrift für christliche Altertumskunde und Kirchengeschichte* 33 (1925), 159–67.

Lutz & Perdrizet, *Speculum* (1907–1909): Jules Lutz & Paul Perdrizet, *Speculum humanae salvationis. Kritische Ausgabe. Übersetzung von Jean Mielot (1448): die Quellen des Speculums und seine Bedeutung in der Ikonographie besonders in der elässischen Kunst des XIV. Jahrhunderts. Mit der Wiedergabe in Lichtdruck (140 Tafeln) der Schlettstadter Handschrift, ferner sämtlicher alten Mülhauser Glasmalereien sowie einiger Scheiben aus Colmar, Weissenburg etc.*, 2 vols. (Leipzig, 1907–1909).

Margaretha Ebner, ed. Strauch (1882): *Margaretha Ebner und Heinrich von Nördlingen. Ein Beitrag zur Geschichte der deutschen Mystik*, ed. Philipp Strauch (Freiburg i. Br., 1882; repr. Amsterdam, 1966).

Der Marner, ed. Willms (2008): *Der Marner. Lieder und Sangsprüche aus dem 13. Jahrhundert und ihr Weiterleben im Meistersang*, ed. and trans. Eva Willms (Berlin, 2008).

Matthew Paris, *Appendix* (1844): Matthew Paris, *Appendix ad Rogeri de Wendover Flores historiarum*, English Historical Society Publications 12 (London, 1844).

Mediaeval Hymns, trans. Neale (1851): *Mediaeval Hymns and Sequences*, trans. John Mason Neale (London, 1851).

Meister Eckhart, *Predigten*, ed. Quint (1958–1976): Meister Eckhart: *Die deutschen Werke. Meister Eckharts Predigten*, ed. Josef Quint, 3 vols. (Stuttgart, 1958–1976).

Meister Eckhart, ed. Largier (1993): *Meister Eckhart. Werke*, ed. Niklaus Largier, 2 vols., Bibliothek des Mittelalters 20–21 (Frankfurt a. M., 1993).

R. Meyer, '*Schwesternbuch*' (1995): Ruth Meyer, *Das 'St. Katharinentaler Schwesternbuch'. Untersuchung, Edition, Kommentar*, Münchener Texte und Untersuchungen 104 (Tübingen, 1995).

Minnesänge, ed. Volckmar (1845): *Bibliothek der gesammten deutschen Nationalliteratur von der ältesten bis auf die neuere Zeit. Bd. 15: Auswahl der Minnesänge*, ed. Karl Volckmar (Quedlinburg–Leipzig, 1845).

'*Miracula*', ed. Walz (1967): Angelus Walz, 'Die *Miracula beati Dominici* der Schwester Cäcilia', *Archivum Fratrum Praedicatorum* 37 (1967), 5–45.

Miracula, ed. Tugwell (1997): *Miracula Sancti Dominici mandato Magistri Berengarii Collecta; Petri Calo, Legendae Sancti Dominici*, ed. Simon Tugwell, Corpus Hagiographicum Sancti Dominici, *MOPH* 26 (Rome, 1997).

Mittelalterliche Bibliothekskataloge 4/2, eds. Glauche & Knaus (1979): *Mittelalterliche Bibliothekskataloge*, vol. 4/2: Bistum Freising, eds. Günter Glauche & Hermann Knaus; Bistum Würzburg, ed. Hermann Knaus (Munich, 1979).

Monumenta diplomatica, ed. Koudelka (1966): *Monumenta diplomatica S. Dominici, Monumenta Ordinis*, ed. Vladimír J. Koudelka, MOPH 25 (Rome, 1966).

'*Necrologium*', ed. Löhr (1927): 'Das *Necrologium des Dominikanerinnenklosters* St. Gertrud in Köln', ed. Gabriel M. Löhr, *Annalen des historischen Vereins für den Niederrhein* 110 (1927), 87–89.

New Testament Apocrypha, ed. Schneemelcher (1991–1992): *New Testament Apocrypha*, ed. Wilhelm Schneemelcher, trans. R. McL. Wilson, 2 vols. (Louisville, 1991–1992).

Offices, ed. Haggh (1995): *Two Offices for St. Elizabeth of Hungary: Gaudeat Hungaria and Letare Germania*, ed. Barbara Haggh (Huglo) (Ottawa, 1995).

Orderic Vitalis, *Ecclesiastical History*, ed. Chibnall (1972–1980): Ordericus Vitalis, *The Ecclesiastical History of Orderic Vitalis*, ed. Majorie Chibnall, 6 vols. (Oxford, 1972–1980).

Origen, *Werke*, ed. Baehrens (1920): *Origenes Werke* 6, ed. Willem Adolf Baehrens, Die griechischen christlichen Schriftsteller 29 (Leipzig, 1920).

Osterfeiern, ed. Lipphardt (1975–1990): *Lateinische Osterfeiern und Osterspiele*, ed. Walther Lipphardt, Ausgaben deutscher Literatur des XV. bis XVIII. Jahrhunderts. Reihe Drama 5 (Berlin, 1975–1990).

Oudste constituties, ed. Thomas (1965): *De oudste constituties van de dominicanen. Voorgeschiedenis, tekst, brounen, ontstaan en ontwikkeling (1215–1237)*, ed. Anthonius Henricus Thomas, Revue d'histoire ecclésiastique: Bibliothèque 42 (Leuven, 1965).

Patrologia Latina, ed. Jacques-Paul Migne, 221 vols. (Paris, 1844–1864).

Peter of Celle, *De disciplina claustrali*, ed. de Martel (1977): *Petri Cellensis, De disciplina claustrali (L'École du cloître)*, ed. Gérard de Martel (Paris, 1977).

Peter Damian, *Sermones*, ed. Lucchesi (1988): *Petrus Damianus sermones*, ed. Johannes Lucchesi, CCCM 57 (Turnhout, 1988).

Peter Ferrand, *Legenda*, ed. Laurent (1935): *Petrus Ferrandi, Legenda Beati Dominici*, ed. M.-Hyacinth Laurent, *MOPH* 16 (Rome, 1935).

Petrus Chrysologus, *Collectio sermonum*, ed. Olivar (1975–1982): *Sancti Petri Chrysologi Collectio Sermonum*, ed. Alexandre Olivar, CCSL 24–24B (Turnhout, 1982).

Petrus Comestor, *Scholastica historia*, ed. Sylwan (2005): Petrus Comestor, *Scolastica historia. Liber genesis*, ed. Agneta Sylwan, CCCM 191 (Turnhout, 2005).

Pontifikalien, ed. Metzger (1914): *Zwei karolingische Pontifikalien vom Oberrhein. Hg. und auf ihre Stellung in der liturgischen Literatur untersucht, mit geschichtlichen Studien über die Entstehung der Pontifikalien, über die Riten der Ordinationen, der Dedicatio ecclesiae und des Ordo baptismi*, ed. Max Josef Metzger (Freiburg i. Br, 1914).

De rebus Alsaticis, ed. Jaffé (1861): *De rebus Alsaticis ineuntis saeculi XIII*, ed. Philipp Jaffé, MGH SS 17 (Hannover, 1861), 232–37.

Reformation, ed. Vosding (2012): *Schreib die Reformation von Munchen gancz daher. Teiledition und historische Einordnung der Nürnberger Klarissenchronik (um 1500)*, ed. Lena Vosding, Quellen und Forschungen zur Geschichte und Kultur der Stadt Nürnberg 37 (Nuremberg, 2012).

Rerum italicarum scriptores, ed. Muratori (1723–1738): Lodovico Antonio Muratori, *Rerum italicarum scriptores ab anno aerae christianae 500 ad annunm 1500*, 25 vols. (Milan, 1723–1738).

Revelationes, ed. Paquelin (1875–1877): *Revelationes Gertrudianae ac Mechtildianae*, ed. Ludwig Paquelin, 2 vols. (Paris, 1875–1877).

Ribnitz, ed. Techen (1909): *Die Chroniken des Klosters Ribnitz*, ed. Friedrich Techen, Mecklenburgische Geschichtsquellen 1 (Schwerin, 1909).

Richard of St. Victor: *L'Édit d'Alexandre*, ed. Châtillon (1951): Richard of St. Victor, *L'Édit d'Alexandre ou les trois processions [Super exiit edictum seu de tribus processionibus]*, ed. Jean Châtillon (Paris, 1951).

Ritzinger & Scheeben, 'Beiträge' (1941): Edmund Ritzinger & Heribert Christian Scheeben, 'Beiträge zur Geschichte der Teutonia in der zweiten Hälfte des 13. Jahrhunderts', *Archiv der deutschen Dominikaner* 3 (1941), 11–95.

Rupert of Deutz, *Commentaria*, ed. Haacke (1969): *Rupertus Tuitensis, Commentaria in euangelium sancti Iohannis*, ed. Rhabanus Haacke, CCCM 9 (Turnhout, 1969).

Rupert of Deutz, *De diuinis officiis*, ed. Haacke (1967): *Rupertus Tuitensis, Liber de diuinis officiis*, ed. Rhabanus Haacke, CCCM 7 (Turnhout, 1967).

Sedulius, *Opera omnia*, ed. Huemer (1885): Sedulius, *Opera omnia*, ed. Johannes Huemer, CCSL 10 (Vienna, 1885; repr. 2007).

Sedulius, *Paschal Song*, trans. Springer (2013): *Sedulius: The Paschal Song and Hymns*, trans. & ed. Carl P. E. Springer, Writings from the Greco-Roman World 35 (Atlanta, 2013).

Seraphin Dietler's Chronik, ed. von Schlumberger (1897): *Seraphin Dietler's Chronik des Klosters Schönensteinbach*, ed. Johann von Schlumberger (Gebweiler, 1897).

Sextuplex, ed. Hesbert (1935): Hesbert, René-Jean, ed., *Antiphonale Missarum sextuplex … d'après le graduel de Monza et les antiphonaires de Rheinau, de Mont-Blandin, de Compiègne, de Corbie et de Senlis* (Brussels, 1935).

Sicardus of Cremona, *Mitralis*, eds. Sarbak & Weinrich (2008): *Sicardi Cremonensis episcopi, Mitralis de officiis*, eds. Gábor Sarbak & Lorenz Weinrich, CCCM 228 (Turnhout, 2008).

Sicardus von Cremona, *Mitralis*, trans. Weinrich (2011): *Sicard von Cremona. Mitralis, der Gottesdienst der Kirche*, trans. Lorenz Weinrich, 2 vols., Corpus Christianorum in Translation 9 (Turnhout, 2011).

Speculum uirginum, ed. Seyfarth (1990): *Speculum uirginum*, ed. Jutta Seyfarth, CCCM 5 (Turnhout, 1990).

Spicilegium, ed. Pitra (1855): *Spicilegium solesmense*, ed. Jean-Baptist Pitra (Paris, 1855).

Statuten, eds. Schannat & Hartzheim (1761): *Die Statuten des Mainzer Provinzialkapitels von 1310*, vol. 4: 1290–1400, eds. Johann Friedrich Schannat & Joseph Hartzheim, Concilia Germaniae 4 (Cologne, 1761; repr. Aalen, 1970), 175–224.

Tabula exemplorum, ed. Welter (1926): *La Tabula exemplorum secundum ordinem alphabeti. Recueil d'exempla compilé en France à la fin du 13e siècle*, ed. Jean-Théobald Welter, Thesaurus Exemplorum, Fasc. 3 (Paris, 1926).

Tauler, *Predigten*, ed. Vetter (1910): *Die Predigten Taulers. Aus der Engelberger und der Freiburger Handschrift sowie aus Schmidts Abschriften der ehemaligen Straßburger Handschriften*, ed. Ferdinand Vetter, Deutsche Texte des Mittelalters 11 (Berlin, 1910).

Theodulus, *Ecloga*, ed. Osternacher (1902): *Theoduli eclogam recensuit et prolegomenis instruxit Johannes Osternacher. Liber separatim typis expressus ex 'programmate' Collegii Petrini* (Ripariae prope Lentiam, 1902).

Theodulus, *Ecloga*, ed. Casaretto (1997): Theodulus, *Ecloga: Il canto della verità e della menzogna*, ed. Francesco Mosetti Casaretto, Per verba. Testi mediolatini con traduzione (Florence, 1997).

Thomas Aquinas, *Opera omnia*, ed. Busa (1980): *S. Thomae Aquinatis Opera omnia ut sunt in Indice Thomistico; additis 61 scriptis ex aliis medii aevi auctoribus*, vol. 7, ed. Robert Busa (Stuttgart–Bad Cannstatt, 1980).

Thomas Aquinas, *Summa theologiae* I (1888–1889): Thomas Aquinas, *Opera omnia iussu impensaque Leonis XIII P.M. edita (Editio Leonina) 4–5: Pars prima Summae theologiae* (Rome, 1888–1889).

Thomas Aquinas, *Summa theologiae* II,1 (1891–1892): Thomas Aquinas, *Opera omnia iussu impensaque Leonis XIII P.M. edita (Editio Leonina) 6–7: Prima secundae Summae theologiae* (Rome, 1891–1892).

Thomas Aquinas, *Summa theologiae* II,2 (1895, 1897–1899): Thomas Aquinas, *Opera omnia iussu impensaque Leonis XIII P.M. edita (Editio Leonina) 8–10: Secunda secundae Summae theologiae* (Rome, 1895, 1897–1899).

Thomas Aquinas, *Tertia pars summae* (1906): Thomas Aquinas, *Opera omnia iussu Leonis XIII P.M. edita (Editio Leonina) 12: Tertia pars summae theologiae supplementum (1903–1906)*.

Thomas Aquinas, *Summa, tertia pars* (1964): Thomas Aquinas, *Summa Theologiae*, vol. 4, *tertia pars*, Biblioteca de autores cristianos (Madrid, 1964).

Tracts, ed. Legg (1904): *Tracts on the Mass*, ed. Leopold George Wickham Legg, Henry Bradshaw Society 27 (London, 1904).

Tropes, ed. Jonsson (1975): *Tropes du propre de la messe 1: Cycle de Noël*, ed. Ritva Jonsson, Corpus Troporum 1; Acta Universitatis Stockholmiensis: Studia Latina Stockholmiensia 21 (Stockholm, 1975).

Ugaccione da Pisa, *Derivationes*, ed. Cecchini (2004): Ugaccione da Pisa, *Derivationes*, ed. Enzo Cecchini, Edizione Nazionale dei Testi Mediolatini 2; Series I, 6 (Florence, 2004).

Ulrich of Lilienfeld, *Concordantiae caritatis*, eds. Douteil et al. (2010): *Die Concordantiae caritatis des Ulrich von Lilienfeld. Edition des Codex Campililiensis 151 (um 1355)*, eds. Herbert Douteil et al. (Münster, 2010).

Ulrich von Zell, *Epistola nuncupatoria* (1884): Ulrich von Zell, *Epistola nuncupatoria*, PL 146 (Paris, 1884), cols. 635–37.

UB der Klöster der Grafschaft Mansfeld, ed. Kühne (1888): *Urkundenbuch der Klöster der Grafschaft Mansfeld*, ed. Max Kühne, Geschichtsquellen der Provinz Sachsen und angrenzender Gebiete 20 (Halle a. d. Saale, 1888).

Urkundenbuch für die Geschichte des Niederrheins, ed. Lacomblet (1840–1857): *Urkundenbuch für die Geschichte des Niederrheins oder des Erzstifts Cöln, der Fürstenthümer Jülich und Berg, Geldern, Meurs, Cleve und Mark, und der Reichsstifte Elten, Essen und Werden*, ed. Theodor Joseph Lacomblet, 4 vols. (Düsseldorf, 1840–1857).

Valerius Maximus, *Deeds*, trans. Walker (2004): Valerius Maximus, *Memorable Deeds and Sayings: One Thousand Tales from Ancient Rome*, trans. with intro. by Henry J. Walker (Indianapolis, 2004).

Virtutes Iohannis: see *Acta Iohannis*.

Vision béatifique, ed. Dykmans (1975): *Pour et contre Jean XXII en 1333: deux traités avignonnais sur la vision béatifique*, ed. Marc Dykmans (Vatican City, 1975).

Vita, ed. Giles (1846): *Vita S. Thomæ Cantuariensis Archiepiscopi et martyris*, ed. John Allen Giles (London, 1846).

Vita Eligii Noviomagensis, ed. Krusch (1902): *Vita Eligii Noviomagensis*, ed. Bruno Krusch, MGH Scriptorum rerum Merovingicarum 4 (Hannover, 1902), 663–742.

'Vitae Sororum' d'Unterlinden, ed. Ancelet-Hustache (1930): *Les 'Vitae Sororum' d'Unterlinden: Édition critique du ms. 508 de la bibliothèque de Colmar*, ed. Jeanne Ancelet-Hustache, *Archives d'histoire doctrinale et littéraire du moyen âge* 5 (1931), 317–513.

'Weiler', ed. Bihlmeyer (1916): 'Mystisches Leben in dem Dominikanerinnenkloster Weiler bei Eßlingen im 13. und 14.

Jahrhundert', ed. Karl Bihlmeyer, *Württembergische Viertel-jahrshefte für Landesgeschichte* N.F. 25 (1916), 61–93.

Westfälisches Urkundenbuch, Verein für Geschichte und Alterthumskunde Westfalens, eds. Heinrich August Erhard et al., 11 vols. (1847–2000).

William of Tocco, *Storia*, ed. Brun-Gouvanic (1996): *Storia sancti Thome de Aquini de Guillaume de Tocco (1323): Édition critique, introduction et notes*, ed. Claire le Brun-Gouanvic, Studies and Texts 127 (Toronto, 1996).

William of Tocco, 'Vita', eds. Prümmer & Laurent (1911): 'Vita S. Thomae Quinatis (Historia beati Thomae) auctore Guillelmo de Tocco, illustrati', in: *Fontes vitae S. Thomae Aquinastis notis historicis et criticis illustrati*, eds. Dominicus M. Prümmer & Marie-Hyacinthe Laurent (Toulouse, n.d. [1911]), 65–145.

Willibald Pirckheimers Briefwechsel, ed. Scheible (2004): *Willibald Pirckheimers Briefwechsel*, vol. 6, ed. Helga Scheible (Munich, 2004).

Willing, ,Konventsbuch' (2016): Antje Willing, *Das ,Konvents-buch' und das ,Schwesternbuch' aus St. Katharina in St. Gallen, kritische Edition und Kommentar*, Texte des späten Mittelalters und der frühen Neuzeit 54 (Berlin, 2016).

Wilms, *Verzeichnis* (1928): *Das älteste Verzeichnis der deutschen Dominikanerinnenklöster*, ed. Hieronymus Wilms, Quellen und Forschungen zur Geschichte des Dominikanerordens in Deutschland 24 (Leipzig, 1928).

Vita Yolandae, ed. Wiltheim (1674): *Vita venerabilis Yolandae Priorissae*, ed. Alexander Wiltheim (Antwerp, 1674).

Secondary Sources

Acklin-Zimmermann, *Gott im Denken* (1993): Béatrice Acklin-Zimmermann, *Gott im Denken berühren. Die theologischen Implikationen der Nonnenviten*, Dokimion 14 (Fribourg, 1993).

Acres, *Invention* (2013): Alfred J. Acres, *Renaissance Invention and the Haunted Infancy*, Studies in Medieval and Early Renaissance Art History (Turnhout, 2013).

Adolf, 'Figure of Wisdom' (1969): Helen Adolf, 'The Figure of Wisdom in the Middle Ages', in: *Arts libéraux et philosophie au moyen âge: Actes du 4e congrès international de philosophie médievale* (Montreal–Paris, 1969), 429–43.

Adventus (2008): *Adventus. Studien zum herrscherlichen Einzug in die Stadt*, eds. Angelika Lampen & Peter Johannek, Städte-forschung 75 (Cologne, 2008).

Ahlers, 'Beziehungen' (1996): Gerd Ahlers, 'Über die Beziehungen der Zisterzienser von Hude zu den Dominikanerinnen in Lemgo während der ersten Hälfte des 14. Jahrhundert', *Oldenburger Jahrbuch* 96 (1996), 33–43.

Alberzoni, 'Ora et labora' (2010): Maria Pia Alberzoni, 'Ora et labora: La concezione del lavoro nella tradizione monastica fino agli inizi del XIII seculo', in: *La grazia del lavoro: Atti del VII convegno storico di Greccio, Greccio, 8–9 maggio 2009*, eds. Alvaro Cacciotti & Maria Melli, Biblioteca di frate Francesco 9 (Milan, 2010), 15–34.

Alexander, *Illuminators* (1992): Jonathan J. G. Alexander, *Medi-eval Illuminators and their Methods of Work* (New Haven, 1992).

Alexandre-Bidon, 'Arbre' (1993): Danièle Alexandre-Bidon, 'Arbre de vie et pâques fleuries: Note sur la symbolique végétale dans la célebration pascale', in: *L'arbre: Histoire naturelle et sym-bolique de l'arbre, du bois et du fruit au Moyen Âge*, ed. Michel Pastoureau, Cahiers du Léopard d'or 2 (Paris, 1993), 83–91.

Alstatt, 'Music' (2011): Alison Noel Alstatt, 'The Music and Lit-urgy of Kloster Preetz: Anna von Buchwald's Buch im Chor in its Fifteenth-century Context', Ph.D. dissertation, University of Oregon (2011) http://gradworks.umi.com/34/66/3466310.html (last accessed on January 15, 2016).

Amiet, '"Mandatum"' (2001): Robert Amiet, 'Le "mandatum" du Jeudi saint', *Études grégoriennes* 29 (2001), 68–87.

Amstutz, *Ludus* (2002): Renate Amstutz, *Ludus de decem viginibus: Recovery of the Sung Liturgical Core of the Thuringian Zehnjungfrauenspiel*, Studies and Texts 140 (Toronto, 2002).

Amsturz, 'Feier' (2004): Renate Amstutz, 'Die liturgisch-drama-tische Feier der Consecratio virginum nach dem Pontifikale des Bischofs Durandus (Ende des 13. Jh.). Eine Studie zur Rezeption der Zehnjungfrauen-Parabel in Liturgie, Ritus und Drama der mittelalterlichen Kirche', in: *Ritual und Inszenierung. Geistliches und weltliches Drama des Mittelalters und der Frühen Neuzeit*, ed. Hans-Joachim Ziegeler (Tübingen, 2004), 71–112.

Andersen, 'Das Kind sehen' (2011): Elizabeth A. Andersen: 'Das Kind sehen. Die Visualisierung der Geburt Christi in Mystik und Meditation', in: *Sehen und Sichtbarkeit in der Literatur des deutschen Mittelalters, XXI. Anglo-German Colloquium London 2009*, eds. Ricarda Bauschke et al. (Berlin, 2011), 290–310.

Anderson, 'One Who Comes After' (2013): Michael Anderson, 'The One Who Comes after Me: John the Baptist, Christian Time, and Symbolic Musical Techniques', *Journal of the American Musicological Society* 66 (2013), 639–708.

Andrä, 'Buchmalerei' (2008): Christina Andrä, 'Buchmalerei für die Regensburger Dominikanerinnen. Das Lektionar von Heilig

Kreuz', in: *Bettelorden in Mitteleuropa. Geschichte, Kunst, Spiritualität. Referate der gleichnamigen Tagung vom 19. bis 22. März 2007 in St. Pölten*, eds. Heidemarie Specht & Ralph Andraschek-Holzer, Beiträge zur Kirchengeschichte Niederösterreichs 15; Geschichtliche Beilagen zum St. Pöltner Diözesanblatt 32 (St. Pölten, 2008), 509–38.

Angenendt, *Geschichte der Religiosität* (1997): Arnold Angenendt, *Geschichte der Religiosität im Mittelalter* (Darmstadt, 1997).

Angenendt, 'Liturgie' (1999): Arnold Angenendt, 'Die Litugie bei Heinrich Seuse', in: *Vita religiosa im Mittelalter. Festschrift für Kaspar Elm zum 70. Geburtstag*, eds. Franz J. Felten & Nikolas Jaspert (Berlin, 1999), 877–97.

Angenendt & Lentes, 'Gezählte Frömmigkeit' (1995): Arnold Angenendt & Thomas Lentes, 'Gezählte Frömmigkeit', *Frühmittelalterliche Studien* 29 (1995), 1–71, summarized in: *Florilegien, Kompilationen, Kollektionen. Literarische Formen des Mittelalters*, ed. Kaspar Elm, Wolfenbüttler Mittelalter-Studien 15 (Wiesbaden, 2000), 107–14.

Arasse, 'Tablette' (1995): Daniel Arasse, 'Entre dévotion et hérésie: la tablette de saint Bernardin ou le secret d'un prédicateur', *Res: Anthropology and Aesthetics* 28 (1995), 118–39.

Arlt, '"Nova Cantica"' (1986): Wulf Arlt, '"Nova Cantica": Grundsätzliches und Spezielles zur Interpretation musikalischer Texte des Mittelalters', *Basler Jahrbuch für historische Musikpraxis* 10 (1986), 13–62.

Arlt, 'Triginta denariis' (1986): Wulf Arlt, 'Triginta denariis—Musik und Text in einer Motette des Roman de Fauvel über dem Tenor "Victimae paschali laudes"', in: *Pax et sapientia*, ed. Ritva Jacobsson, Acta Universitatis Stockholmiensis: Studia Latina Stockholmiensia 29 (Stockholm, 1986), 97–113.

Arlt, 'Sequence' (1992): Wulf Arlt, 'Sequence and "Neues Lied"', in: *La Sequenza medievale: Atti del Convegno Internazionale Milano 7–8 aprile 1984*, ed. Agostino Ziino, Quaderni di San Maurizio 3 (Lucca, 1992), 3–18.

Arlt, 'Komponieren' (1995): Wulf Arlt, 'Komponieren im Galluskloster um 900. Tuotilos Tropen "Hodie cantandus est" zur Weihnacht und "Quoniam dominus Iesus Christus" zum Fest des Iohannes evangelista', *Schweizer Jahrbuch für Musikwissenschaft (Gedenkschrift Stefan Kunze)* N.F. 15 (1995), 41–70.

Arnault, *Philosophisme* (1692): Antoine Arnault: *Le Philosophisme des Jesuites de Marseille* (Avignon, 1692).

Arnold, '"Spiritualis dedicatio"' (2006): Johannes Arnold, '"Spiritualis dedicatio". Zum geistlichen Sinn von Kirchweihfest und Kirchweihritus. Zwei Abschnitte der *Summa de officiis ecclesiasticis* des Wilhelm von Auxerre und ihre Rezeption durch Durandus von Mende', in: '*Das Haus Gottes, das seid ihr Selbst'. Mittelalterliches und barockes Kirchenverständnis im Spiegel der Kirchweihe*, eds. Ralf M. W. Stammberger & Claudia Sticher, with Annekatrin Warnke (Berlin, 2006), 367–438.

Arnulf, *Versus* (1997): Arwed Arnulf, *Versus ad picturas. Studien zur Titulusdichtung als Quellengattung der Kunstgeschichte von der Antike bis zum Hochmittelalter*, Kunstwissenschaftliche Studien 72 (Munich, 1997).

Aschoff, 'Juden in Westfalen' (1980): Diethard Aschoff, 'Die Juden in Westfalen zwischen Schwarzem Tod und Reformation (1350–1530)', *Westfälische Forschungen* 30 (1980), 78–105.

Aschoff, 'Juden' (1993): Diethard Aschoff, 'Die Juden des Jahres 1350 in der älteren westfälischen Geschichtsschreibung', in: *Begegnungen zwischen Christentum und Judentum in Antike und Mittelalter. Festschrift für Heinz Schreckenberg*, eds. Dietrich-Alex Och & Hermann Lichtenberger, Schriften des Institutum Judaicum Delitzschianum 1 (Göttingen, 1993).

Aschoff, 'Judenkennzeichnung' (1993): Diethard Aschoff, 'Judenkennzeichnung und Judendiskriminierung in Westfalen bis zum Ende des Alten Reiches', *Aschkenas* 1 (1993), 15–47.

Auerbach, 'Figura' (1938): Erich Auerbach, 'Figura', *Archivum romanicum* 22 (1938), 436–89.

Auerbach, 'Sermo humilis' (1952): Erich Auerbach, 'Sermo humilis', *Romanische Forschungen* 64 (1952), 304–64.

Auerbach, *Scenes* (1984): Erich Auerbach, *Scenes from the Drama of European Literature*, foreword by Paolo Valesio, Theory and History of Literature (Minneapolis, 1984).

Auf der Maur, *Feiern* (1983): Hansjörg Auf der Maur, *Feiern im Rhythmus der Zeit, I. Herrenfeste in Woche und Jahr*, Gottesdienst der Kirche. Handbuch der Liturgiewissenschaft 5 (Regensburg, 1983).

Augustyn, 'Bildquellen' (2009): Wolfgang Augustyn, 'Liturgische Handschriften als Bildquellen? Eine quellenkundliche Fragestellung, untersucht am Beispiel italienischer Handschriften des 10. bis frühen 13. Jahrhunderts', *Archiv für Liturgiewissenschaft* 51 (2009), 3–42.

Augustyn et al., 'Fleuronné' (1996): Wolfgang Augustyn et al., 'Fleuronné', *RDK* 7 (Munich, 1996), cols. 1113–96.

Aux origines (2004): *Aux origines de la liturgie dominicaine: le manuscrit Santa Sabina XIV L 1*, eds. Leonard Boyle et al., Collection de l'École Française de Rome 327 (Rome–Paris, 2004).

Avril, 'Jacobus Mathey' (1971): François Avril, 'Un enlumineur ornemaniste parisien de la première moitié du XIVe siècle:

Jacobus Mathey (Jacquet Maci ?)', *Bulletin monumentale* 129 (1971), 249–64.

Avril & Rabel, *Manuscrits* (1995): François Avril & Claudia Rabel, *Manuscrits enluminés d'origine germanique: Bibliothèque nationale de France, Département des manuscrits* (Paris, 1995).

Axon, 'Symbolism' (1982): William E. A. Axon, 'The Symbolism of the "Five Wounds of Christ" ', *Transactions of the Lancashire and Cheshire Antiquarian Society* 10 (1892), 67–77.

Backhouse, *Sherborne Missal* (1999): Janet Backhouse, *The Sherborne Missal* (Toronto, 1999).

Bader, 'Gott nennen' (1989): Günter Bader, 'Gott nennen. Von Götternamen zu göttlichen Namen. Zur Vorgeschichte der Lehre von den göttlichen Eigenschaften', *Zeitschrift für Theologie und Kirche* 86 (1989), 306–54.

Bärsch, *Allerseelen* (2004): Jürgen Bärsch, *Allerseelen. Studien zu Liturgie und Brauchtum eines Totengedenktages in der abendländischen Kirche*, Liturgiewissenschaftliche Quellen und Forschungen 90 (Münster, 2004).

Bärsch, 'Quem queritis' (2010): Jürgen Bärsch, 'Quem queritis in sepulchro? Liturgie- und frömmigkeitsgeschichtliche Aspekte der Feier von Ostern im Mittelalter', *Beiträge zur Geschichte des Bistums Regensburg* 44 (2010), 25–45.

Bärsch, 'Allerseelen' (2013): Jürgen Bärsch, 'Die Entstehung des Gedenktages Allerseelen. Liturgie und Eschatologie unter dem reformerischen Anspruch Clunys', in: *Wider das Vergessen und für das Seelenheil. Memoria und Totengedenken im Mittelalter*, ed. Rainer Berndt, Erudiri Sapientia 9 (Münster, 2013), 67–80.

Bärsch, 'Liturgy' (2014): Jürgen Bärsch, 'Liturgy and Reform: Northern German Convents in the Late Middle Ages', in: *Companion to Mysticism and Devotion* (2014), 21–46.

Baert, 'Paradiese' (2001): Barbara Baert, ' "Totten paradiese soe sult ghi gaen": De verbeelding over de herkomst van het kruishout', in: *Aan de vruchten kent men de boom. De boom in tekst en beeld in de middeleeuwse Nederlanden*, eds. Barbara Baert & Veerle Fraeters, Symbolae: Series B/25 (Louvain, 2001), 19–47.

Baert, *Holy Wood* (2004): Barbara Baert, *A Heritage of Holy Wood: The Legend of the True Cross in Text and Image*, Cultures, Beliefs and Traditions. Medieval and Early Modern Peoples 22 (Leiden, 2004).

Baert, 'Adam' (2012): Barbara Baert, 'Adam, Seth and Jerusalem: The Legend of the Wood of the Cross in Medieval Literature and Iconography', in: *Adam, le premier homme*, ed. Agostino Paravicini Bagliani, Micrologus 45 (Florence, 2012), 69–99.

Bäumer, *Histoire* (1905): Suitbert Bäumer, *Histoire du bréviaire*, rev. and trans. Réginald Birgon, 2 vols. (Paris, 1905).

Baldzuhn, *Schulbücher* (2009): Michael Baldzuhn, *Schulbücher im Trivium des Mittelalters und der Frühen Neuzeit. Die Verschriftlichung von Unterricht in der Text- und Überlieferungsgeschichte der 'Fabulae' Avians und der deutschen 'Disticha Catonis'*, Quellen und Forschungen zur Literatur- und Kulturgeschichte 44 (Berlin, 2009).

Balet, 'Liturgie' (1997): Jean-Daniel Balet, 'La liturgie dominicaine au XIIIe siècle', in: *Lector et Compilator: Vincent de Beauvais, frère prêcheur, un intellectuel et son milieu au XIIIe siècle* (Grâne, 1997), 333–41.

Bangemann, *Dominikuslegenden* (1919): Fritz Bangemann, *Mittelhochdeutsche Dominikuslegenden und ihre Quellen*, Inaugural-Dissertation, Vereinigte Friedrichs Universität, Halle-Wittenberg, (1919).

Bangert, 'Metaphor' (2010): Michael Bangert, 'The Metaphor of the Vestment in the Writings of Gertrud of Helfta (1256–1302)', in: *Iconography of Liturgical Textiles in the Middle Ages*, ed. Evelin Wetter, Riggisberger Berichte 18 (Riggisberg, 2010), 129–39.

Barb, 'Mensa sacra' (1956): Alphons Augustinus Barb, 'Mensa sacra: The Round Table and the Holy Grail', *Journal of the Warburg and Courtauld Institutes* 19 (1956), 40–67.

Baroffio, 'Filia Virgo' (2004): Giacomo Baroffio, 'Filia Virgo et Mater: Appunti di mariologia liturgica', in: *Figure poetiche e figure teologiche nella mariologia dei secoli XI e XII: Atti del II Convegno Mariologico della Fondazione Ezio Franceschini con la collaborazione della Biblioteca Palatina di Parma, Parma 19–20 maggio 2000*, eds. Clelia Maria Piastra & Francesco Santi, Millennio Medievale 48 = Atti di Convegni 13 (Florence, 2004), 19–30.

Baroffio, 'Lettere parlante' (2004): Giacomo Baroffio, ' "Lettere parlanti": repertorio alfabetico' http://www.cantusgregorianus.it/vecchiosito/strumentiricerca/Lettere_parlanti_repertorio.pdf (last accessed on December 24, 2015).

Baroffio, '*Vas Electionis*' (2006): Giacomo Baroffio, '*Vas Electionis*: Appunti sul culto di San Paolo nella liturgia latina', in: *The Cult of St Paul in the Christian Churches and in the Maltese Tradition, Acts of the International Symposium, 26–27 June 2006*, ed. John Azzopardi (Malta, 2006), 31–54.

Baroffio, '*Vas Electionis*' (2009): Giacomo Baroffio, '*Vas Electionis*: Appunti sul culto di San Paolo nella liturgia latina', *Rivista liturgica* 96 (2009), 275–81.

Baroffio & Kim, 'Santissima Trinità' (2004): Giacomo Baroffio & Eun Ju Kim, 'La liturgia della Santissima Trinità', *La Cartellina* 28 (2004) 38–70.

Barone, 'Épitomés' (1981): Giulia Barone, 'Les épitomés dominicains de la vie de saint Wenceslas (Biliotheca Hagiographica Latina 8839 et 8840)', in: *Faire croire: modalités de la diffusion et de la réception des messages religieux du XIIe au XVe siècle. Table rond organisée par l'École française de Rome, en collaboration avec l'Institut d'histoire médiévale de l'Université de Padoue (Rome, 22–23 juin 1979)*, Collection de l'École Française de Rome 51 (Rome, 1981), 167–87.

Barth, 'Liebe verwundet' (1983): Hilarius M. Barth, 'Liebe verwundet durch Liebe. Kreuzigungsbild des Regensburger Lektionars als Zeugnis dominikanischer Passionsfrömmigkeit', *Beiträge zur Geschichte des Bistums Regensburg* 17 (1983), 229–68.

Barth, 'Dominikuslegende' (1984): Hilarius M. Barth, 'Die Dominikuslegende im ersten Lektionar Humberts von Romans (1246)', *Archivum Fratrum Praedicatorum* 54 (1984), 82–112.

Barthelmé, *La réforme dominicaine* (1931): Annette Barthelmé, *La réforme dominicaine au XVe siècle en Alsace et dans l'ensemble de la province de Teutonie, etc.* (Strasbourg, 1931).

Bartholemy-Teutsch, 'Elisabeth Kempf' (2000): Claudia Bartholemy-Teusch, 'Elisabeth Kempf, prieure à Unterlinden: une vie entre traduction et tradition (Colmar 1415–1485)', in: *Dominicaines* (2000), vol. 1, 167–70.

Bartlovà, '"Rorate celi"' (1994): Milena Bartlovà, '"Rorate celi desuper et nubes pluant iustum": New Additions to the Iconography of the "Annunciation" from the Altarpiece from Vyssi Brod', *Source: Notes in the History of Art* 12 (1994), 9–14.

Bary, *Rhétorique* (1669): René Bary, *Rhétorique françoise* (Amsterdam, 1669).

Bastiaensen, 'L'histoire d'un vers' (1998): Antoon A. R. Bastiaensen, 'L'histoire d'un vers: le septènaire trochaïque de l'Antiquité au Moyen Âge', *Humanitas* 50 (1998), 173–87.

Bataillon, 'Intermediaires' (1982): Louis-Jacques Bataillon: 'Intermediaires entre les traités de morale pratique et les sermons: les *distinctiones* bibliques alphabétiques', in: *Les Genres littéraires dans les sources théologiques et philosophiques médiévales: Définition critique et exploitation*, Publications de l'Institut d'Études Médiévales, 2e série: Textes, Études, Congrès 5 (Louvain-la-Neuve, 1982), 213–26.

Bath, *Untersuchung* (1919): Marie F. W. Bath, *Untersuchung des Johannesspiels. Der Blindenheilungs- und Maria-Magdalenenscenen in den deutschen mittelalterlichen Passionspielen mit besonderer Berücksichtigung ihrer Beziehungen zu den französischen Mysterien* (Marburg, 1919).

Bau- und Kunstdenkmale in der DDR (1990): *Die Bau- und Kunstdenkmale in der DDR. Mecklenburgische Küstenregion,* mit den Städten Rostock und Wismar, eds. Gerd Baier et al. (Munich, 1990).

Bauerschmidt, *Thomas Aquinas* (2013): Frederick Christian Bauerschmidt, *Thomas Aquinas: Faith, Reason, and Following Christ: Christian Theology in Context* (Oxford, 2013).

Baum, 'Red Hair' (1922): Paull Franklin Baum, 'Judas's Red Hair', *Journal of English and Germanic Philology* 21 (1922), 520–29.

Beach, *Women* (2004): Alison I. Beach, *Women as Scribes: Book Production and Monastic Reform in Twelfth-Century Bavaria* (Cambridge, 2004).

Becker, 'Peregrinus' (1979): Hansjakob Becker, 'Peregrinus Coloniensis, O.P. und die Sequenz *Omnes gentes plaudite*. Ein hymnologischer Beitrag zur literarischen und liturgischen Bedeutung von St. Jacques in Paris im 2. Viertel des 13. Jahrhunderts', *Archivum Fratrum Praedicatorum* 49 (1979), 39–77.

E. Beer, *Buchmalerei* (1959): Ellen J. Beer: *Beiträge zur oberrheinischen Buchmalerei in der ersten Hälfte des 14. Jahrhunderts unter besonderer Berücksichtigung der Initialornamentik*, Schriftenreihe der Stiftung Schnyder von Wartensee 43 (Basel–Stuttgart, 1959).

E. Beer, 'Buchkunst' (1983): Ellen J. Beer, 'Die Buchkunst des Graduale von St. Katharinenthal', in: *Graduale von Sankt Katharinenthal* (1983), 103–224.

M. Beer, *Triumphkreuze* (2005): Manuela Beer, *Triumphkreuze des Mittelalters. Ein Beitrag zu Typus und Genese im 12. und 13. Jahrhundert* (Regensburg, 2005).

M. Beer, 'Orte und Wege' (2010): Manuela Beer, 'Orte und Wege. Überlegungen zur Aufstellung und Verwendung frühmittelalterlicher Marienfiguren', in: *'Luft unter die Flügel …'. Beiträge zur mittelalterlichen Kunst. Festschrift für Hiltrud Westermann-Angerhausen*, eds. Andrea von Hülsen-Esch & Dagmar Täube (Hildesheim, 2010), 99–121.

Behrens, '"Maria am Spinnrocken"' (1938): Ewald Behrens, 'Zur "Maria am Spinnrocken" im Deutschen Museum', *Berliner Museen. Berichte aus den preußischen Kunstsammlungen* 59 (1938), 84–86.

Beier, *Buchmalerei* (2003): Christine Beier, *Buchmalerei für Metz und Trier im 14. Jahrhundert. Die illuminierten Handschriften aus der Falkenstein-Werkstatt* (Langwaden, 2003).

Beierwaltes, 'Negati affirmatio' (1976): Werner Beierwaltes, 'Negati affirmatio. Welt als Metapher. Zur Grundlegung einer mittelalterlichen Ästhetik durch Johannes Scotus Eriugena', *Philosophisches Jahrbuch* 83 (1976), 237–65.

Beinert, *Kirche* (1973): Wolfgang Beinert, *Die Kirche, Gottes Heil in der Welt. Die Lehre von der Kirche nach den Schriften des Rupert von Deutz, Honorius Augustodunensis und Gerhoch von Reichersberg. Ein Beitrag zur Ekklesiologie des 12. Jahrhunderts* (Münster, 1973).

Bell, 'Performance' (1998): Catherine Bell, 'Performance', in: *Critical Terms for Religious Studies*, ed. Mark C. Taylor (Chicago, 1998), 205–24.

Bellot, 'Kunst' (2006): Christoph Bellot, 'Kunst für St. Clara. Altäre—Andachtsbilder—Handschriften', in: *Am Römerturm. Zwei Jahrtausende eines Kölner Stadtviertels*, Publikationen des Kölnischen Stadtmuseums 7 (Cologne, 2006), 61–116.

Belting, *Bild und Kult* (1990): Hans Belting, *Bild und Kult. Eine Geschichte des Bildes vor dem Zeitalter der Kunst* (Munich, 1990), trans. as *Likeness and Presence: A History of the Image before the Era of Art*, trans. Edmund Jephcott (Chicago, 1994).

Belting-Ihm, *'Sub matris tutela'* (1976): Christa Belting-Ihm, *'Sub matris tutela'. Untersuchungen zur Vorgeschichte der Schutzmantelmadonna*, Abhandlungen der Heidelberger Akademie der Wissenschaften: Philosophisch-Historische Klasse 1976/3 (Heidelberg, 1976).

Belting-Ihm, 'Verhältnis' (1994): Christa Belting-Ihm, 'Zum Verhältnis von Bildprogrammen und Tituli in der Apsisdekoration früher westlicher Kirchenbauten', in: *Testi e immagine nell' Alto medioevo, 15–21 aprile 1993*, 2 vols., Settimane di Studio del Centro Italiano di Studi sull' Alto Medioevo 41 (Spoleto, 1994), vol. 2, 839–86.

Benecke, *Randgestaltung* (1995): Sabine Benecke, *Randgestaltung und Religiosität. Die Handschriften aus dem Kölner Kloster St. Klara* (Ammersbek bei Hamburg, 1995).

Bennett, 'Five Wounds' (2006): Adelaide Bennett, 'Christ's Five Wounds in the Aves of the *Vita Christi* in a Book of Hours about 1300', in: *Tributes in Honor of James H. Marrow*, eds. Jeffrey F. Hamburger & Anne S. Korteweg (Turnhout, 2006), 75–84.

Bergmann, *Studien* (1972): Rolf Bergmann, *Studien zu Entstehung und Geschichte der deutschen Passionsspiele des 13. und 14. Jahrhunderts*, Münstersche Mittelalter-Schriften 14 (Munich, 1972).

Beringer, 'Gospels' (2008): Alison Beringer, 'Speaking the Gospels: The Visual Programme in Schaffhausen, Stadtbibliothek, Generalia 8', *Journal of English and Germanic Philology* 107 (2008), 1–24.

Berkenkamp, *Antiphonar* (1966): Birgitte Berkenkamp: *Zwei Bände eines Antiphonars aus dem Kloster Paradies bei Soest. Ein Beitrag zur westfälischen Buchmalerei um 1300* (Munich, 1966).

Berswordt-Meister (2002): *Der Berswordt-Meister und die Dortmunder Malerei um 1400. Stadtkultur im Spätmittelalter*, eds. Andrea Zupancic & Thomas Schilp, Veröffentlichungen des Stadtarchivs Dortmund 18 (Bielefeld, 2002).

Bertelsmeier-Kierst, 'Beten' (2005): Christa Bertelsmeier-Kierst, 'Beten und Betrachen—Schreiben und Malen. Zisterzienserinnen und ihr Beitrag zum Buch im 13. Jahrhundert', in: *Das Skriptorium der Reiner Mönche. Beiträge der Internationalen Tagung im Zisterzienerstift Rein, Mai 2003*, eds. Anton Schwob & Karin Kranich-Hofbauer, Jahrbuch für Internationale Germanistik: Reihe A, Kongressberichte 71 (Bern, 2005), 163–77.

Bertelsmeier-Kierst, 'Handschriften' (2008): Christa Bertelsmeier-Kierst, 'Handschriften für Frauen von Frauen. Buchkultur aus norddeutschen Frauenklöstern im 13. Jahrhundert', in: *Die gelehrten Bräute Christi* (2008), 83–122.

Beste & Fredrich, 'Bischof Sigebert' (1984): Herbert Beste & Michael Fredrich, 'Bischof Sigebert von Minden', *Mitteilungen des Mindener Geschichtsvereins* 56 (1984), 7–25.

Bettels, 'Bemerkungen' (2000): Christian Bettels, 'Bemerkungen zu Handschriften und Drucken mit Gregorianischem Choral in Freckenhorst', in: *Freckenhorst 851–2001. Aspekte einer 1150jährigen Geschichte*, ed. Klaus Gruhn (Warendorf-Freckenhorst, 2000), 73–81.

Betteray, '"Victimae novali zynke ses"' (2008): Dirk van Betteray, 'The Sequence "Victimae novali zynke ses"—A Melodic Restitution in Accordance with the Neumes' in: *Hortus troporum: Florilegivm in honorem Gunillae Iversen: A Festschrift in Honour of Professor Gunilla Iversen on the Occasion of her Retirement as Chair of Latin at Stockholm University*, eds. Alexander Andrée & Erika Kihlman, Acta Universitatis Stockholmiensis: Studia Latina Stockholmiensia 54 (Stockholm, 2008), 12–20.

Beuckers, 'St. Maria im Kapitol' (2009): Klaus Gereon Beuckers, 'Der salische Neubau von St. Maria im Kapitol', in: *Interdisziplinäre Beiträge zu St. Maria im Kapitol zu Köln*, ed. Margit Jüsten-Mertens, Colonia Romanica 24 (Cologne, 2009), 49–70.

Beumer, 'Mariologie' (1959): Johannes Beumer, 'Die Mariologie Richards von Saint Laurent', *Franziskanische Studien* 41 (1959), 19–40.

Beyer, 'Exkurs' (2009): Vera Beyer, 'Exkurs. Goldrahmen—Reservoire des mittelalterlichen Goldgrundes?' in: *Rahmenbestimmungen. Funktionen von Rahmen bei Goya, Velázquez, van Eyck und Degas* (Munich, 2009), 187–201.

Biasiotto, *History* (1943): Peter Regalatus Biasiotto, *History of the Development of Devotion to the Holy Name, with a Supplement* (St. Bonaventure, N.Y., 1943).

Biblioteca Apostolica Vaticana (1992): *Biblioteca Apostolica Vaticana. Liturgie und Andacht im Mittelalter,* exh. cat. Cologne, Erzbischöfliches Diözesanmuseum, eds. Joachim M. Plotzek & Ulrike Surmann (Stuttgart–Zurich, 1992).

Biesheuvel et al., 'Peter Damian' (2007): Ingrid Biesheuvel, Jeffrey F. Hamburger, & Wybren Scheepsma, 'Peter Damian's Sermon 63 on John the Evangelist in Middle Dutch. With an Edition of Ms. Sint-Truiden, Instituut voor Franciscaanse Geschiedenis, a21, f. 53vb–63rb', *Ons geestelijk Erf* 79 (2007), 225–52.

Binnebesel, *Stellung* (1934): Bruno Binnebesel, *Die Stellung der Theologen des Dominikanerordens zur Frage nach der unbefleckten Empfängnis Marias bis zum Konzil von Basel*, Inaugural-Dissertation, Friedrich-Wilhelm-Universität, Breslau (Kallmünz bei Regensburg, 1934).

Binz, *Handschriften* (1907): Gustav Binz, *Die deutschen Handschriften der Oeffentlichen Bibliothek der Universität Basel I. Die Handschriften der Abteiling A.* (Basel, 1907).

Birkmeyer, *Ehetrennung* (1998): Regine Birkmeyer, *Ehetrennung und monastische Konversion im Hochmittelalter in kirchenrechtlichen und historigraphischen Quellen* (Berlin, 1998).

Bischoff, 'Une mémoire noble' (2000): Georges Bischoff, 'Une mémoire noble: les dominicaines d'Unterlinden et leur environnement social du XIIIe au XVIIe siècle', in: *Dominicaines* (2000), vol. 1, 24–41.

Bisogni, 'Visioni' (2006): Fabio Bisogni, 'Le visioni della Donna e del drago nei cicli monumentali dell' Apocalisse nel Trecento in Italia', in: *Maria, l'apocalisse e il Medioevo. Atti del III Convegno Mariologico della Fondazione Ezio Franceschini con la collaborazione della Biblioteca Palatina di Parma, Parma, 10–11 maggio 2002*, eds. Clelia Maria Piastra & Francesco Santi (Florence, 2006), 115–45.

Björkvall & Haug, 'Sequence and Versus', (2002): Gunilla Björkvall & Andreas Haug, 'Sequence and Versus: On the History of Rhythmical Poetry in the Eleventh Century', in: *Latin Culture in the Eleventh Century: Proceedings of the Third International Conference on Medieval Latin Studies Cambridge, September 9–12, 1998*, eds. Michael W. Herren et al., 2 vols., Publications of the Journal of Medieval Latin 5 (Turnhout, 2002), vol. 1, 57–82.

Björkvall & Haug, 'Altes Lied-Neues Lied' (2005): Gunilla Björkvall & Andreas Haug, 'Altes Lied-Neues Lied. Thesen zur Transformation des lateinischen Liedes um 1100', in: *Poesía latina medieval (siglos V–XV)*, eds. Manuel C. Díaz y Díaz & José M. Díaz de Bustamente, Millennio medievale 55 (Florence, 2005), 551–93.

Björkvall & Jacobsson, '*Diadema*' (2008): Gunilla Björkvall & Ritva Jacobsson, '*Diadema salutare* and *Synagoga praeparavit:*

Two Sequences for the *Spinea corona* in Sweden', in: *Hortus troporum: Florilegivm in honorem Gunillae Iversen: A Festschrift in Honour of Professor Gunilla Iversen on the Occasion of her Retirement as Chair of Latin at Stockholm University*, eds. Alexander Andrée & Erika Kihlman, Acta Universitatis Stockholmiensis: Studia Latina Stockholmiensia 54 (Stockholm, 2008), 21–46.

Blaschitz, 'Wort und Bild' (2003): Gertrud Blaschitz, 'Wort und Bild auf Realien. Ein Versuch zur Systematik von Inschriften', in: *Text als Realie. Internationaler Kongress Krems an der Donau 3. bis 6. Oktober*, eds. Karl Brunner et al., Veröffentlichungen des Instituts für Realienkunde des Mittelalters und der Frühen Neuzeit 18; Österreichische Akademie der Wissenschaften, Philosophische-historische Klasse: Sitzungsberichte 704 (Vienna, 2003), 263–96.

Blaschke, *Studien* (1976): Rainer Blaschke, *Studien zur Malerei der Lüneburger 'Goldenen Tafel'* (Bochum, 1976).

Blezzard et al., 'New Perspectives' (1986): Judith Blezzard, Stephen Ryle, & Jonathan J. G. Alexander, 'New Perspectives on the Feast of the Crown of Thorns', *Journal of the Plainsong & Medieval Music Society* 9 (1986), 23–47.

Bloch, 'Leuchter' (1961): Peter Bloch, 'Siebenarmige Leuchter in christlichen Kirchen', *Wallraf-Richartz-Jahrbuch* 23 (1961), 55–190.

Blom, 'Lingua sacrae' (2012): Alderik Blom, 'Lingua sacrae in Ancient and Medieval Sources: An Anthropological Approach to Ritual Language', in: *Multilingualism in the Graeco-Roman World*, eds. Alex Mullen & Patrick James (Cambridge, 2012), 124–40.

Bockhorst, 'Patriziat' (1996): Wolfgang Bockhorst, 'Zum Soester Patriziat', in: *Soest. Geschichte der Stadt* 2 (1996), 299–314.

Bodsch, *Wilhelm von Schadow* (1992): Ingrid Bodsch, *Wilhelm von Schadow und sein Kreis. Materialien und Dokumente zur Düsseldorfer Malerschule* (Bonn, 1992).

Boerresen, *Subordination et équivalence* (1968): Kari Elisabeth Boerresen, *Subordination et équivalence: nature et rôle de la femmes d'après Augustin et Thomas d'Aquin* (Oslo, 1968).

Böse, 'Kunsthandwerkliche Arbeiten' (2003): Kristin Böse: 'Aspekte kunsthandwerklichen Arbeitens in westfälischen Klöstern und Stiften', in: *Westfälisches Klosterbuch* (2003), vol. 3, 545–69.

Bojcov, 'Deutsche Könige' (2007): Michail A. Bojcov, 'Warum pflegten deutsche Könige auf Altären zu sitzen?', in: *Bilder der Macht in Mittelalter und Neuzeit. Byzanz—Okzident—Rußland*, eds. Otto Gerhard Oexle & Michail A. Bojcov (Göttingen, 2007), 243–314.

Bolzoni, *Immagini* (2004): Lina Bolzoni, *La rete delle immagini: Predicazione in volgare dalle origini a Bernardine da Siena* (Turin, 2004), translated as *The Web of Images: Vernacular Preaching from its Origins to Saint Bernardino da Siena*, trans. Carole Preston & Lisa Chien (Aldershot, 2004).

Bonne, *L'art roman* (1984): Jean-Claude Bonne, *L'art roman de face et de profil: le tympan de Conques* (Paris, 1984).

Bonne & Aubert, 'Voire' (2010): Jean-Claude Bonne & Eduardo H. Aubert, 'Quand voire fait chanter: images et neumes dans le tonaire du ms. BNF latin 1118. Entre performance et performativité', in: *La performance des images*, eds. Alain Dierkens et al., Problèmes d'histoire des religions 19 [2009] (Brussels, 2010), 225–40.

Bonniwell, *History* (1944): William R. Bonniwell, *A History of the Dominican Liturgy* (New York, 1944).

Bontekoe, 'Metaphor' (1987): Ron Bontekoe, 'The Function of Metaphor', *Philosophy and Rhetoric* 20 (1987), 209–26.

Borgehammar, 'Admont Sermon Corpus' (1993): Stephan Borgehammar, 'Who Wrote the Admont Sermon Corpus: Gottfried the Abbot, his Brother Irimbert, or the Nuns?', in: *De l'homélie au sermon: Histoire de la prédication médiévale*, eds. Jacqueline Hamesse & Xavier Hermand, Publications de l'Institut d'études médiévales: textes, études, congrès 14 (Louvain-la-Neuve, 1993), 47–51.

Borries, *Schwesternspiegel* (2008): Ekkehard Borries, *Schwesternspiegel im 15. Jahrhundert. Gattungskonstitution – Editionen – Untersuchungen* (Berlin, 2008).

Boskamp, 'Codex Adelhausen 3' (1990): Katrin Boskamp, 'Der Codex Adelhausen 3, Inv. Nr. 11725. Ein dominikanisches Graduale des Freiburger Klosters St. Maria Magdalena zu den Reuerinnen', *Freiburger Diözesan-Archiv* 110 (1990), 79–123.

Botano, *Works of Mercy* (2011): Frederico Botano, *The Works of Mercy in Italian Medieval Art (c. 1050–c. 1400)*, Medieval Church Studies 20 (Turnhout, 2011).

Bouché, 'Spirit' (2000): Anne-Marie Bouché, 'The Spirit in the World: The Virtues of the Floreffe Bible Frontispiece, British Library, Add. Ms. 17738, ff. 3v–4r', in: *Virtue & Vice: The Personifications in the Index of Christian Art*, ed. Colum Hourihane, Resources 1 (Princeton, 2000), 42–65.

Bouché, '*Vox imaginis*' (2005): Anne-Marie Bouché, '*Vox imaginis*: Anomaly and Enigma in Romanesque Art', in: *The Mind's Eye: Art and Theological Argument in the Medieval West*, eds. Jeffrey F. Hamburger & Anne-Marie Bouché (Princeton, 2005), 306–35.

Boureau, 'Vitae fratrum' (1987): Alain Boureau, 'Vitae fratrum, vitae patrum. L'ordre dominicain et le modèle des Pères du désert au XIIIe siècle', *Mélanges de l'École française de Rome. Moyen Âge, temps modernes* 99 (1987), 79–100.

Boureau, 'Patine' (2005): Alain Boureau, 'La patine hagiographique: Saint Pierre Martyr dans la *Légende Dorée*', in: '*Scribere sanctorum gesta*': Recueil d'études d'hagiographie médiévale offert à Guy Philippart, eds. Étienne Renard et al., Hagiologia 3 (Turnhout, 2005), 359–66.

Boutemy, 'Fragments' (1938): André Boutemy, 'Fragments d'une oeuvre perdue de Sigebert de Gembloux (Le Commentaire métrique de l'Ecclésiaste)', *Latomus* 2 (1938), 209–20.

Bowen, 'Tropology' (1941): Lee Bowen, 'The Tropology of Mediaeval Dedication Rites', *Speculum* 16 (1941), 469–79.

Bower, 'Repertoire of Utrecht' (2003): Calvin Bower, 'The Sequence Repertoire of the Diocese of Utrecht', *Tijdscrift* 53 (2003), 49–104.

L. Boyle, 'Date' (1958, 1978): Leonard E. Boyle, 'The Date of the San Sisto Lectionary', *Archivum Fratrum Praedicatorum* 28 (1958), 381–89, repr. in *San Clemente. Miscellany*, eds. Leonard E. Boyle et al., 2 vols. (Rome, 1978), vol. 2, 179–94.

M. Boyle, 'Chaff' (1997): Marjorie O'Rourke Boyle, 'Chaff: Thomas Aquinas's Repudiation of his *Opera omnia*', *New Literary History* 28 (1997), 383–99.

M. Boyle, *Senses of Touch* (1998): Margorie O'Rourke Boyle, *Senses of Touch: Human Dignity and Deformity from Michelangelo to Calvin*, Studies in Medival and Reformation Thought 71 (Leiden–Boston, 1998).

Boynton, 'Rewriting the Early Sequence' (1994): Susan Boynton, 'Rewriting the Early Sequence: "Aureo Flore" and "Aurea Virga"', *Comitatus* 25 (1994), 19–42.

Boynton, 'Training' (2000): Susan Boynton, 'Training for the Liturgy as a Form of Monastic Education', in: *Medieval Monastic Education*, eds. George Ferzoco & Carolyn Muessig (London, 2000), 7–20.

Boynton & Fassler, 'Language, Form, and Performance' (2011): Susan Boynton & Margot Fassler, 'Language, Form, and Performance: The Latin Texts of Monophonic Liturgical Chants', in: *Oxford Handbook of Medieval Latin*, eds. Ralph Hexter & David Townsend (Oxford, 2011), 686–730.

Bräm, '*Imitatio Sanctorum*' (1992): Andreas Bräm, '*Imitatio Sanctorum*. Überlegungen zur Stifterdarstellung im Graduale von St. Katharinenthal', *Zeitschrift für schweizerische Archäologie und Kunstgeschichte* 49 (1992), 103–13.

Bräm, 'Stifterbild' (2005): Andreas Bräm, 'Zum adaptierten Stifterbild in der spätmittelalterlichen Buchmalerei', in: *Manuscripts in Transition: Recycling Manuscripts, Texts and Images. Proceedings of the International Congress held in Brussels, 5–9 November, 2002*, ed. Brigitte Dekeyzer, Corpus of Illuminated Manuscripts 15 (Louvain, 2005), 253–61.

Braulik, 'Ostertypologie' (1993–1994): Georg Braulik, 'Überlegungen zur alttestamentlichen Ostertypologie', *Archiv für Liturgiewissenschaft* 35–36 (1993–1994), 1–18.

Braun, *Handlexikon* (1922): Joseph Braun, *Liturgisches Handlexikon* (Regensburg, 1922).

Braun-Niehr, 'Liturgische Handschriften' (2007): Beate Braun-Niehr, 'Liturgische Handschriften des hohen Mittelalters und ihre Ausstattung', in: *Romanik*, ed. Andreas Fingernagel, Geschichte der Buchkunst 4/1–2 (Graz, 2007), 289–308.

Braun-Niehr, 'Anweisungen' (2012): Beate Braun-Niehr, 'Über verborgene Anweisungen liturgischer Inszenierung', in: *Liturgie in mittelalterlichen Frauenstiften. Forschungen zum "Liber ordinarius"*, ed. Klaus Gereon Beuckers, Essener Forschungen zum Frauenstift 10 (Essen, 2012), 195–214.

Braun-Niehr, 'Der Codex Gisle' (2015): Beate Braun-Niehr, 'Der Codex Gisle als Graduale für das Zisterzienserinnenkloster Rulle bei Osnabrück', in: *Codex Gisle* (2015), 9–21.

Breitenbach, 'Schule des ewigen Königs' (2012): Almut Breitenbach, 'In der Schule des ewigen Königs. Wissen und Bildung in Klarissenklöstern zwischen Norm und Praxis', in: *Gelobte Armut. Armutskonzepte der franziskanischen Ordensfamilie vom Mittelalter bis in die Gegenwart*, eds. Heinz-Dieter Heimann et al. (Paderborn, 2012), 183–216.

Breitenbach, *Finem Pensate* (2015): Almut Breitenbach, *Finem pensate. Formen der Rezeption und Aneignung des Oberdeutschen vierzeiligen Totentanzes*, Spätmittelalter, Humanismus, Reformation 88 (Tübingen 2015).

Bremer, *Juden* (1986): Natascha Bremer, *Das Bild der Juden in den Passionsspielen und in der bildenden Kunst des deutschen Mittelalters* (Frankfurt a. M., 1986).

Brenn, 'Sequenzen' (1960): Franz Brenn, 'Die Sequenzen des Graduale von St. Katharinenthal', in: *Festschrift Alfred Orel zum 70. Geburtstag*, ed. Hellmut Federhofer (Vienna, 1960), 23–42.

Bretscher-Gisiger & Gamper, *Katalog Muri und Hermetschwil* (2005): Charlotte Bretscher-Gisiger & Rudolf Gamper, *Katalog der mittelalterlichen Handschriften der Klöster Muri und Hermetschwil* (Dietikon, 2005).

Bretscher-Gisiger & Gamper, *Katalog Wettingen* (2009): Charlotte Bretscher-Gisiger & Rudolf Gamper: *Katalog der mittelalterlichen Handschriften des Klosters Wettingen. Katalog der mittelalterlichen Handschriften in Aarau, Laufenburg, Lenzburg, Rheinfelden und Zofingen* (Dietikon, 2009).

Brett, 'Dominican Library' (1980): Edward Tracey Brett, 'The Dominican Library in the Thirteenth Century', *Journal of Library History* 15 (1980), 303–08.

Brett, *Humbert of Romans* (1984): Edward Tracy Brett, *Humbert of Romans: His Life and Views of Thirteenth-Century Society*, Studies and Texts 67 (Toronto, 1984).

Brinkmann, 'Verhüllung' (1971): Hennig Brinkmann, 'Verhüllung ('Integumentum') als literarische Darstellungsform im Mittelalter', in: *Der Begriff der Repraesentatio im Mittelalter. Stellvertretung, Symbol, Zeichen*, ed. Albert Zimmerman, Miscellanea Mediaevalia 8 (Berlin, 1971), 314–39.

Brocke, 'Jewish Origin' (1977): Michael Brocke, 'On the Jewish Origin of the "Improperia"', *Immanuel* 7 (1977), 44–51.

Brockett, 'Scenarios' (2008): Clyde W. Brockett, 'Scenarios of the "Descent into Hell" in Two Processional Antiphons', *Comparative Drama* 42 (2008), 301–14.

Brockett, 'Antiphons' (2012): Clyde W. Brockett, 'Antiphons for the Adoration of the Cross Replica', *Plainsong and Medieval Music* 21 (2012), 85–111.

Broekhuijsen, 'Seth's Vision' (2006): Klara H. Broekhuijsen, '"Ende ziet alomme int paradijs": Seth's Vision of Paradise as Part of an Unusual Decoration Program in a Fifteenth-Century Book of Hours from Utrecht', in: *Tributes in Honor of James H. Marrow: Studies in Painting and Manuscript Illumination of the Late Middle Ages and Northern Renaissance*, eds. Jeffrey F. Hamburger & Anne S. Korteweg (London, 2006), 103–16.

Browe, *De frequenti communione* (1932): Peter Browe, *De frequenti communione in ecclesia occidentali usque ad annum c. 1000: Documenta varia*, Textus et documenta in usum exercitationum et praelectionum academicarum: Series theologia 5 (Rome, 1932).

Browe, *Kommunion* (1938): Peter Browe, *Die häufige Kommunion im Mittelalter* (Regensburg, 1938).

Browe, 'Dreifaltigkeitsfest' (1950): Peter Browe, 'Zur Geschichte des Dreifaltigkeitsfestes', *Archiv für Liturgiewissenschaft* 1 (1950), 65–81.

Brown, 'Images' (1999): Peter Brown, 'Images as a Substitute for Writing', in: *East and West: Modes of Communication. Proceedings of the First Plenary Conference at Merida*, eds. Evangelos

Chrysos & Ian Wood, *The Transformation of the Roman World* 3 (Leiden, 1999), 15–34.

Bryson, *Word and Image* (1981): Norman Bryson, *Word and Image: French Painting of the Ancien Régime* (Cambridge, 1981).

Büchsel, 'Cursus' (1983): Martin Büchsel, 'Ecclesiae symbolorum cursus completus', Städel-Jahrbuch N.F. 9 (1983), 69–88.

Bühren, *Barmherzigkeit* (1998): Ralf van Bühren, *Die Werke der Barmherzigkeit in der Kunst des 12.–18. Jahrhunderts. Zum Wandel eines Bildmotivs vor dem Hintergrund neuzeitlicher Rhetorikrezeption*, Studien zur Kunstgeschichte 115 (Hildesheim, 1998).

Bünz, 'Buch' (2014): Enno Bünz, 'Das Buch in den Händen von Geistlichen. Beobachtungen zum kirchlichen und klerikalen Buchbesitz im 12. bis 16. Jahrhundert', in: *Buch und Reformation. Beiträge zur Buch- und Bibliotheksgeschichte Mitteldeutschlands im 16. Jahrhundert*, eds. Enno Bünz et al. (Leipzig, 2014), 39–61.

Bürkle, *Literatur im Kloster* (1999): Susanne Bürkle, *Literatur im Kloster. Historische Funktion und rhetorische Legitimation frauenmystischer Texte des 14. Jahrhunderts* (Tübingen, 1999).

Büttner, 'Bildnisse' (1979): Frank O. Büttner, '*Ad te, domine, levavi animam meam*. Bildnisse in der Wortillustration zu Psalm 24:1', in: *Miscellanea Codicologica F. Masai dicata MCMLXXIX*, eds. Pierre Cockshaw et al., 2 vols. (Ghent, 1979), vol. 2, 331–43.

Bugge, 'Verses' (1975): Ragne Bugge, '*Effigiem Christi, qui transis, semper honora*': Verses Condemning the Cult of Sacred Images in Art and Literature', *Acta ad Archaeologiam et Artium Historiam Pertinentia* 6 (1975), 127–40.

Bugyis, 'Ministers' (2015): Katie Ann-Marie Bugyis, 'Ministers of Christ: Benedictine Women Religious in Central Medieval England', Ph.D. dissertation, University of Notre Dame (2015).

Burbach, 'Legislation' (1942): Maur Burbach, 'Early Dominican and Franciscan Legislation regarding St. Thomas', *Mediaeval Studies* 4 (1942), 139–58.

Burg, 'Palmesel' (2002): Christian von Burg, '"Das bildt vnsers Herren ab dem esel geschlagen". Der Palmesel in den Riten der Zerstörung', in: *Macht und Ohnmacht der Bilder. Reformatorischer Bildersturm im Kontext der europäischen Geschichte*, eds. Peter Blickle et al. (Munich, 2002), 117–42.

Burger, '*Mulier amicta sole*' (1937): Lilli Burger, '*Mulier amicta sole*' in der Kunst des Mittelalters, Inaugural-Dissertation, Ruprecht-Karls-Universität zu Heidelberg (1937).

Burnam, 'Gold and Silver' (1911): John M. Burnam, 'The Early Gold and Silver Manuscripts', *Classical Philology* 6 (1911), 144–55.

Burr, 'Readings' (1992): David Burr, 'Mendicant Readings of the Apocalypse', in: *The Apocalypse in the Middle Ages*, eds. Richard K. Emmerson & Bernard McGinn (Ithaca, 1992), 89–102.

Buzás, *Bibliotheksgeschichte* (1975): Ladislaus Buzás, *Deutsche Bibliotheksgeschichte des Mittelalters*, Elemente des Buch- und Bibliothekswesens 1 (Wiesbaden, 1975).

Bynum, *Jesus as Mother* (1984): Caroline Walker Bynum, *Jesus as Mother: Studies in Spirituality of the High Middle Ages* (Berkeley, 1984).

Bynum, *Holy Feast* (1987): Caroline Walker Bynum, *Holy Feast and Holy Fast. The Religious Significance of Food to Medieval Women* (Berkeley, 1987).

Bynum, 'Religious Women' (1987): Caroline Walker Bynum, 'Religious Women in the Later Middle Ages', in: *Christian Spirituality: High Middle Ages and Reformation*, eds. Jill Raitt et al., World Spirituality 17 (London, 1987), 121–39.

Bynum, *Resurrection* (1995): Caroline Walker Bynum, *The Resurrection of the Body in Western Christianity, 200–1336* (New York, 1995).

Bynum, 'Crowned with Many Crowns' (2015): Caroline Walker Bynum, ' "Crowned with Many Crowns": Nuns and Their Statues in Late-Medieval Wienhausen', *Catholic Historical Review* 101 (2015), 18–40.

Cabassut, 'Dévotion' (1952): André Cabassut, 'La Dévotion au Nom de Jesus dans l'Église d'Occident', *La Vie Spirituelle* 86 (1952), 46–50.

Cabie, 'Pontifical' (1982): Robert Cabie, 'Le pontifical de Guillaume Durand l'ancien et les livres liturgique Languedociens', in: *Liturgie et musique, IXe–XIVe siècles*, Cahiers de Fanjeaux 17 (Toulouse, 1982), 225–37.

Cabrol, 'Culte' (1931): Ferdnand M. Cabrol, 'Le culte de la Trinité dans la liturgie et l'institution de la fête de la Trinité', *Ephemerides Liturgicae* 45 (1931), 270–78.

Cahn, 'Représentations' (1982): Walter Cahn, 'Représentations de la parole', *Connaissance des arts* 369 (1982), 82–89.

Cahn, *Bible Illumination* (1982): Walter Cahn, *Romanesque Bible Illumination* (Ithaca, 1982).

Cahn, *Romanesque Manuscripts* (1996): Walter Cahn, *Romanesque Manuscripts: The Twelfth Century*, 2 vols. (London, 1996).

Cahn, 'Notes' (2009): Walter Cahn, 'Notes on the Illustrations of Ezekiel's Temple Vision in the *Postilla litteralis* of Nicholas of Lyra', in: *Between Judaism and Christianity: Art Historical*

Essays in Honor of Elisheva (Elisabeth) Revel-Neher, ed. Katrin Kogman-Appel, The Medieval Mediterranean 81 (Leiden, 2009), 155–70.

Cain, *Letters* (2009): Andrew Cain, *The Letters of Jerome: Asceticism, Biblical Exegesis, and the Construction of Christian Authority in Late Antiquity* (Oxford, 2009).

Cambridge Illuminations (2005): *The Cambridge Illuminations: Ten Centuries of Book Production in the Medieval West*, eds. Paul Binski & Stella Panayotova (Cambridge, 2005).

Camille, 'Book of Signs' (1985): Michael Camille, 'The Book of Signs: Writing and Visual Difference in Gothic Manuscript Illumination', *Word & Image* 1 (1985), 133–48.

Camille, 'Visualizing' (1988): Michael Camille, 'Visualising in the Vernacular: A New Cycle of Early Fourteenth-Century Bible Illustrations', *Burlington Magazine* 130 (1988), 97–106.

Camille, *Image* (1992): Michael Camille, *Image on the Edge: The Margins of Medieval Art* (Cambridge, Ma., 1992).

Campbell, 'Liturgy' (1981): Thomas P. Campbell, 'Liturgy and Drama: Recent Approaches to Medieval Theatre', *Theatre Journal* 33 (1981), 289–301.

Canal, *Salve regina* (1963): José Maria Canal, *Salve regina misericordiae: Historia y legendas en torno a esta antifona 'Salve Regina'* (Rome, 1963).

Candelaria, review (2008): Lorenzo Candelaria, review, *Singing with Angels: Liturgy, Music, and Art in the Gradual of Gisela von Kerssenbrock* (Turnhout, 2007), in: *Early Music* 36 (2008), 625–26.

Canetti, *L'invenzione* (1996): Luigi Canetti, *L'invenzione della memoria: il culto e l'immagine di Domenico nella storia dei primi frati Predicatori* (Spoleto, 1996).

Cannon, 'Panel' (2011): Joanna Cannon, 'An Enigmatic Italian Panel Painting of the Crucifixion in the Národní galerie, Prague', in: *Studies in Medieval Art, Liber Amicorum Paul Crossley: 1. Architecture, Liturgy and Identity, 2. Image, Memory and Devotion*, eds. Zoë Opačić et al., Studies in Gothic Art (Turnhout, 2011), vol. 2, 157–80.

Cannon, *Religious Poverty* (2013): Joanna Cannon, *Religious Poverty, Visual Riches: Art in the Dominican Churches of Central Italy in the Thirteenth and Fourteenth Centuries* (New Haven–London, 2013).

Canto e colore (2006): *Canto e colore: I corali di San Domenico di Perugia nella Bibliotheca communale Augusta (XIII–XIV sec.)*, ed. Claudia Parmeggiani (Perugia, 2006).

Capelle, 'L'Assomption' (1926): Bernard Capelle, 'La Fête de l'Assomption dans l'histoire liturgique', *Ephemerides theologicae Lovanienses* 3 (1926), 33–45.

Čapská, 'Framing a Young Nun's Initiation' (2014): Veronika Čapská, 'Framing a Young Nun's Initiation: Early Modern Convent Entry Sermons in the Hapsburg Lands. Vestiges of a Lost Oral Culture', *Austrian History Yearbook* 45 (2014), 33–60.

Cariboni, 'Datierung' (2002): Guido Cariboni, 'Zur Datierung der Interpolationen in den Institutiones Sancti Sixti de Urbe. Die normative und institutionelle Entwicklung der sorores penitentes der heiligen Maria Magdalena in Alamannia im 13. Jahrhundert', in: *Regula Sancti Augustini. Normative Grundlage differenter Verbände im Mittelalter*, eds. Gert Melville & Anne Müller (Paring, 2002), 389–418.

Carmina scriptuarum, ed. Marbach (1907): *Carmina scripturarum, scilicet antiphonas et responsoria ex sacro scripturae fonte in libros liturgicos sanctae Ecclesiae Romanae derivata*, ed. Carl Marbach (Strasbourg, 1907).

Carruthers, *Book of Memory* (1990): Mary J. Carruthers, *The Book of Memory: A Study of Memory in Medieval Culture*, Cambridge Studies in Medieval Literature 70 (Cambridge, 1990).

Carruthers, *Craft of Thought* (1998): Mary J. Carruthers, *The Craft of Thought: Meditation, Rhetoric, and the Making of Images, 400–1200* (Cambridge, 1998).

Castelfranco, 'Corali' (1929): Giorgio Castelfranco, 'I Corali di S. Domenico di Gubbio', *Bollettino d'arte del Ministero della Pubblica Istruzione* 8 (1929), 529–55.

Castiglioni, 'Iconologia' (1992): Gino Castiglioni, 'Per un'iconologia del messale: l'*Ad te levavi*', in: *Il Codice miniato: rapporti tra codice, testo e figurazione. Atti del III Congresso di storia della miniatura con una nota sul restauro dei codici della Biblioteca comunale e dell'Accademia etrusca esposti in occasione del Convegna*, eds. Melania Ceccanti & Maria Cristina Castelli, Storia della miniatura 7 (Florence, 1992), 181–93.

Catalogo Vaticana (2014): *Catalogo dei codici miniati della Biblioteca Vaticana, I: I manoscritti Rossiani*, vol. 1, Ross. 2–413, ed. Silvia Maddalo, Studi e Testi 481 (Vatican City, 2014).

Catalogue Fitzwilliam Museum (2009): *A Catalogue of Western Book Illumination in the Fitzwilliam Museum and the Cambridge Colleges: Part I: The Frankish Kingdoms, Northern Netherlands, Germany, Bohemia, Hungary, Austria* 1, eds. Nigel Morgan & Stella Panayotova (Turnhout, 2009).

Caviness, *Stained Glass* (1977): Madeline H. Caviness, *The Early Stained Glass of Canterbury Cathedral, circa 1175–1220* (Princeton, 1977).

Caviness, 'Divine Order' (1984): Madeline H. Caviness, 'Images of Divine Order and the Third Mode of Seeing', *Gesta* 22 (1984), 99–120.

Chabanne, *Saint Dominique* (1994): Sylvie Chabanne, *Saint Dominique et les femmes: Chronique du catharisme ordinaire de Fanjeaux, naissance et développement des moniales de Prouille* (Lyon, 1994).

Chantraine, *Henri de Lubac* (2007–2009): Georges Chantraine, *Henri de Lubac*, Études Lubaciennes 6–7, 2 vols. (Paris, 2007–2009).

Chapeaurouge, 'Historismus' (1965): Donat de Chapeaurouge, 'Zum Historismus des frühen 16. Jahrhundert', *Österreichische Zeitschrift für Kunst und Denkmalpflege* 19 (1965), 15–25.

Châtillon, 'L' héritage' (1946): François Châtillon, 'L' héritage littéraire de Richard de Saint-Laurent', *Revue du moyen âge latin* 2 (1946), 149–66.

Chavannes-Mazel, 'Paradise' (2005): Claudine A. Chavannes-Mazel, 'Paradise and Pentecost', in: *Reading Images and Texts: Medieval Images and Texts as Forms of Communication. Papers from the Third Utrecht Symposium on Medieval Literacy, Utrecht, 7–9 December 2000*, eds. Mariëlle Hageman & Marco Mostert, Utrecht Studies in Medieval Literacy 8 (Turnhout, 2005), 121–60.

Chavasse, 'Carème' (1952): Antoine Chavasse, 'La structure de Carème et les lectures des messes quadragésimales dans la liturgie romaine', *La Maison Dieu* 31 (1952), 76–119.

Christ, 'Mittelalterliche Bibliotheksordnungen' (1942): Karl Christ, 'Mittelalterliche Bibliotheksordnungen für Frauenklöster', *Zentralblatt für Bibliothekswesen* 59 (1942), 1–29.

Christ Child (2012): *The Christ Child in Medieval Culture: Alpha est et O!*, eds. Mary Dzon & Theresa M. Kennedy (Toronto, 2012).

Christe, 'L'émergence' (1987): Yves Christe, 'L'émergence d'une théorie de l'image dans le prolongement de Rm 1,20 du IXe au XIIe siècle en Occident', in: *Nicée II, 787–1987: Douze siècles d'images religieuses: Actes du Colloque International Nicée II, tenu au Collège de France, Paris les 2, 3, 4 Octobre 1986*, eds. François Boespflug & Nicholas Lossky (Paris, 1987), 303–11.

Christe, 'Influences' (1987): Yves Christe, 'Influences et retentissement de l'oeuvre de Jean Scot sur l'art médiéval: Bilan et perspectives', in: *Eriugena redivivus. Zur Wirkungsgeschichte seines Denkens im Mittelalter und im Übergang zur Neuzeit. Vorträge des V. Internationalen Eriugena-Colloquiums Werner-Reimers-Stiftung Bad Homburg, 26.–30. August 1985*, ed. Werner Beierwaltes (Heidelberg, 1987), 142–62.

Christe, 'L'autel' (2000): Yves Christe, 'L'autel des Innocents. Ap. 6, 9–11 en regard de la liturgie de la Toussaint et des Saints Innocents', in: *Kunst und Liturgie im Mittelalter. Akten des Internationalen Kongresses der Bibliotheca Hertizana und des Nederlands Instituut te Rome, Rom, 28.–30. September, 1997*, eds. Julian Kliemann et al. (Munich, 2000), 91–100.

Christe, 'Ap 12' (2006): Yves Christe, 'La femme d'Ap 12 dans l'iconographie des XIe–XIIIe siècles', in: *Maria, l'apocalisse e il Medioevo. Atti del III Convegno Mariologico della Fondazione Ezio Franceshini con la collaborazione della Biblioteca Palatina di Parma, Parma, 10–11 maggio 2002*, eds. Clelia Maria Piastra & Francesco Santi (Florence, 2006), 91–114.

Chronik der Magdalena Kremerin (2016): *Die Chronik der Magdalena Kremerin im interdisziplinären Dialog*, Schriften zur südwestdeutschen Landeskunde 76, eds. Sigrid Hirbodian & Petra Kurz (Tübingen, 2016).

Church at Prayer (1986–1988): *The Church at Prayer: An Introduction to the Liturgy*, ed. Aimé Georges Martimort, with the collaboration of Robert Cabié, trans. Matthew O'Connell (Collegeville, 1986–1988).

Clanchy, 'Learning to Read' (1984): Michael T. Clanchy, 'Learning to Read in the Middle Ages and the Role of Mothers', *Studies in the History of Reading*, eds. Greg Brooks et al. (Reading, 1984), 33–39.

Clark, *Elisabeth von Schönau* (1992): Anne L. Clark, *Elisabeth von Schönau: A Twelfth-Century Visionary* (Philadelphia, 1992).

Clausberg, 'Spruchbandreden' (1993): Karl Clausberg, 'Spruchbandreden als Körpersprache im Berliner Äneïden-Manuskript', in: *Künstlerischer Austausch—Artistic Exchange. Akten des XXVIII. Internationalen Kongresses für Kunstgeschichte Berlin, 15.–20. Juli 1992*, ed. Thomas W. Gaehtgens, 3 vols. (Berlin, 1993), vol. 2, 345–56.

Claussen, 'Goldgrund' (2007): Peter Cornelius Claussen, 'Goldgrund', *Kritische Berichte* 3 (2007), 64–66.

Clemens & Graham, *Introduction* (2007): Raymond Clemens & Timothy Graham: *Introduction to Manuscript Studies* (Ithaca, 2007).

Coatsworth, 'Cloth-Making' (1998): Elizabeth Coatsworth, 'Cloth-Making and the Virgin Mary in Anglo-Saxon Literature and Art', in: *Medieval Art: Recent Perspectives: A Memorial Tribute to C. R. Dodwell*, eds. Gale R. Owen-Crocker & Timothy Graham (Manchester, 1998), 8–25.

Coatsworth, 'Text and Textile' (2007): Elizabeth Coatsworth, 'Text and Textile', in: *Text, Image, Interpretation: Studies in Anglo-Saxon Literature and its Insular Context in Honour of Éamonn Ó*

Carragáin, eds. Alastair Minnis & Jane Roberts, Studies in the Early Middle Ages 18 (Turnhout, 2007), 187–207.

Cockerell & Strange, *Catalogue* (1923): Sidney C. Cockerell & Edward Fairbrother Strange, rev. by Cecil Harcourt Smith, *Catalogue of Miniatures, Leaves, and Cuttings from Illuminated Manuscripts*, rev. ed. (London, 1923).

Der Codex Gisle (2015): *Der Codex Gisle Ma 101 Bistumsarchiv, Osnabrück. Kommentar zur Faksimile-Edition*, with contributions by Beate Braun-Niehr et al. (Lucerne, 2015).

'Codex Henrici' (1998): *Der 'Codex Henrici'. Lateinische Bibelhandschrift Westfalen, 1. Viertel des 14. Jahrhunderts*, ed. Universitäts- und Landesbibliothek Münster, Kulturstiftung der Länder – Patrimonia 144 (Löningen, 1998).

Cohen, *Uta Codex* (2000): Adam Cohen, *The Uta Codex: Art, Philosophy, and Reform in Eleventh-Century Germany* (University Park, 2000).

Coleman, 'Aurality' (1995): Joyce Coleman, 'The Theory and Practice of Medieval English Aurality', *Yearbook of English Studies* 25 (1995), 63–79.

Colledge, 'Legend' (1974): Edmund Colledge, 'The Legend of St. Thomas Aquinas', in: *St. Thomas Aquinas 1274–1974: Commemorative Studies* (Toronto, 1974), 13–28.

Collomb, '*Légende dorée*' (2001): Pascal Collomb, 'Les éléments liturgiques de la *Légende dorée*: Tradition et innovations', in: *Sainteté* (2001), 97–122.

Companion to Mysticism and Devotion in Northern Germany (2014): *A Companion to Mysticism and Devotion in Northern Germany in the Late Middle Ages*, eds. Elizabeth Andersen et al., Brill's Companions to the Christian Tradition 44 (Leiden, 2014).

Connell, 'Easter' (1999): Martin F. Connell, 'From Easter to Pentecost', in: *Passover and Easter, 2: The Symbolic Structuring of Sacred Seasons*, eds. Paul F. Bradshaw & Lawrence A. Hoffman, Two Liturgical Traditions 6 (Notre Dame, 1999), 94–106.

Constable, 'Introduction' (1985): Giles Constable, 'Introduction', in: *Burchardi ut videtur, abbatis Bellevallis, Apologia de barbis*, in: *Apologiae duae*, ed. Robert B. C. Huygens, CCCM 62 (Turnhout, 1985), 47–150.

Constable, 'Ideal' (1995): Giles Constable, 'The Ideal of the Imitation of Christ', in: *Three Studies in Medieval Religious and Social Thought: The Interpretation of Mary and Marty. The Ideal of the Imitation of Christ. The Orders of Society* (Cambridge, 1995), 143–248.

Constable, *Three Studies* (1995): Giles Constable, *Three Studies in Medieval Religious and Social Thought: The Interpretation of Mary and Martha. The Ideal of the Imitation of Christ. The Orders of Society* (Cambridge, 1995), 143–248.

Conzelmann, 'Johannes-Devotion' (2013): Jochen Conzelmann, 'Die Johannes-Devotion im Dominikanerinnenkonvent St. Katharinental bei Dießenhofen. Ein Modellfall für Literaturrezeption und -produktion in oberrheinischen Frauenklöstern zu Beginn des 14 Jahrhunderts?' in: *Predigt im Kontext*, eds. Volker Mertens et al. (Berlin, 2013), 299–332.

Corbin, 'Offices' (1947): Solange Corbin, 'Les Offices de la Sainte Face', *Bulletin des études portugaises* 11 (1947), 1–65.

Corbin, *Déposition* (1960): Solange Corbin, *La déposition liturgique du Christ au Vendredi Saint: sa place dans l'histoire des rites et du théâtre religieux (analyse de documents portugais)* (Paris, 1960).

Corley, *Conrad von Soest* (1996): Brigitte Corley, *Conrad von Soest: Painter among Merchant Princes* (London, 1996).

Cothenet, *Exégèse* (1988): Édouard Cothenet, *Exégèse et Liturgie*, Lectio Divina 133 (Paris, 1988).

Courdraud, 'Décoration' (1980): Philippe Courdraud, 'La décoration du Graduel-Antiphonaire Ms. 2 (17) de la Bibliothèque de Limoges', Mémoire de maîtrise, Université de Paris IV-Sorbonne (1980).

Courtenay, 'Framework' (2010): William J. Courtenay, 'The Educational and Intellectual Framework of German Dominicans in the Late Thirteenth and Early Fourteenth Century', *Freiburger Zeitschrift für Philosophie und Theologie* 57 (2010), 245–59.

Crocker, *Sequence* (1977): Richard Crocker, *The Early Medieval Sequence* (Berkeley, 1977).

Crusius, 'Miniatur' (1950): Eberhard Crusius, 'Eine neue Miniatur aus der Nachfolge des Konrad von Soest', *Westfalen* 28 (1950), 7–13.

Culpepper, *John* (1994): Alan R. Culpepper, *John, the Son of Zebedee: The Life of a Legend* (Columbia, 1994).

Cunnar, 'Typological Time' (1987): Eugene R. Cunnar, 'Typological Time in a Sequence by Adam of St. Victor', *Studies in Philology* 84 (1987), 294–317.

Curschmann, 'Perspectives' (2004): Michael Curschmann, 'Epistemological Perspectives at the Juncture of Word and Image in Medieval Books before 1300', in: *Multi-Media Compositions from the Middle Ages to the Early Modern Period*, ed. Margriet Hoogvliet, Groningen Studies in Cultural Change 9 (Louvain, 2004), 1–14.

Cutler, 'Octavian' (1965): Anthony Cutler, 'Octavian in Christian Hands', *Vergilius* 11 (1965), 22–32.

Cutler, '*Mulier amicta sole*' (1966): Anthony Cutler, 'The *Mulier amicta sole* and her Attendants: An Episode in Late Medieval Finnish Art', *Journal of the Warburg and Courtauld Institutes* 29 (1966), 115–34.

Dahan, 'Genres' (2000): Gilbert Dahan, 'Genres, Forms and Various Methods in Christian Exegesis of the Middle Ages', in: *Hebrew Bible Old Testament: The History of Its Interpretation. I/2: The Middle Ages*, ed. Magne Sæbo (Göttingen, 2000), 196–236.

Damen, '*Callimachus*' (2002): Mark Damen, 'Hrotsvit's *Callimachus* and the Art of Comedy', in: *Women Writing Latin from Roman Antiquity to Early Modern Europe*, 3 vols., vol. 2: Medieval Women Writing Latin, eds. Laurie J. Churchill et al. (New York, 2002), 37–91.

Daniélou, *Bible* (1956): Jean Daniélou, *The Bible and the Liturgy* (Notre Dame, 1956).

Daniélou, 'Typologie' (1963): Jean Daniélou, 'La Typologie biblique traditionelle dans la liturgie du moyen-âge', in: *La Bibbia nell' alto medioevo, 26 aprile – 2 maggio 1962*, 2 vols., Settimane di Studio del Centro Italiano di Studi sull' Alto Medioevo 10 (Spoleto, 1963), vol. 1, 141–61.

Dartmann, 'Geltung' (forthcoming): Christoph Dartmann, 'Geltung als kommunikativer Prozess. Zum Umgang mit Urkunden in spätmittelalterlichen Konflikten in der Zisterzienserabtei Doberan und in Trier', in: *Texte des Mittelalters zwischen zeitgenössischer Performativität und moderner Performanz*, ed. Annika Bostelmann (forthcoming).

Dauven-van Knippenberg, 'Schauspiel' (1998): Carla Dauven-van Knippenberg, 'Ein Schauspiel für das innere Auge? Notiz zur Benutzerfunktion des Wienhäuser Osterspielfragments', in: *Ir sult sprechen willekomen. Grenzenlose Mediävistik. Festschrift für Helmut Birkhan zum 60. Geburtstag*, ed. Christa Tuczay (Bern, 1998), 778–87.

Dauven-van Knippenberg, 'Texte' (2003): Carla Dauven-van Knippenberg, 'Texte auf der Grenze. Zum "Maastrichter (ripuarischen) Passionsspiel"', in: *Schnittpunkte. Deutsch-Niederländische Literaturbeziehungen im späten Mittelalter*, eds. Angelika Lehmann-Benz et al., Studien zur Geschichte und Kultur Nordwesteuropas 5 (Münster, 2003), 95–107.

Dauven-van Knippenberg, '"Das Maastrichter Passionsspiel"' (2008): Carla Dauven-van Knippenberg, '"Das Maastrichter Passionsspiel" (um 1300)', in: *Literarische Performativität. Lektüren vormoderner Texte*, eds. Cornelia Herberichs & Christian Kiening, Medienwandel—Medienwechsel—Medienwissen 3 (Zurich, 2008), 223–40.

Days of the Lord (1991–1994): *Days of the Lord: The Liturgical Year*, eds. Robert Gantoy & Romain Swaeles, 7 vols. (Collegeville, 1991–1994).

De Kegel, 'Doppelkloster Engelberg' (2008): Rolf De Kegel, 'Monasterium, quod duplices (…) habet conventus: Einblicke in das Doppelkloster Engelberg 1120–1615', in: *Nonnen, Kanonissen und Mystikerinnen* (2008), 181–201.

Debiais, *Messages* (2009): Vincent Debiais, *Messages de pierre: La lecture des inscriptions dans la communication médiévale (XIIIe–XIVe siècles)*, Culture et société médiévales 17 (Turnhout, 2009).

Debiais, 'Trahison' (2009): Vincent Debiais, 'Tair ou pointer le traître? Trahison et mémoire dans la communication épigraphique du Moyen Âge', in: *La trahison au moyen âge: De la monstruosité au crime politique, Ve–XVe siècle*, eds. Maïté Billoré & Martin Aurell (Rennes, 2009), 67–88.

Delalande, *Graduel* (1949): Dominique Delalande, *Vers la version authentique du Gradual Grégorien: Le Graduel des Prêcheurs. Recherches sur les sources e la valeur de son texte musical*, Bibliothèque d' histoire dominicaine 2 (Paris, 1949).

C. Delcorno, 'Liturgie' (2008): Carlo Delcorno, 'Liturgie et art de bien prêcher (XIIe–XVe siècle)', in: *Prédication et liturgie au moyen âge*, eds. Nicole Bériou & Franco Morenzoni, Bibliothèque d' histoire culturelle du moyen âge 5 (Turnhout, 2008), 201–21.

P. Delcorno: 'In the Mirror' (2016): Pietro Delcorno, 'In the Mirror of the Prodigal Son: The Catechetical Use of a Biblical Narrative in the Construction of the Lay Identity', Ph.D. dissertation, Radboud Universiteit (Nijmegen, 2016).

DeMaris, 'Anna Muntprat's Legacy' (2015): Sarah Glenn DeMaris, 'Anna Muntprat's Legacy for the Zoffingen Sisters: A Second Copy of the Unterlinden Schwesternbuch', *Zeitschrift für deutsches Altertum und deutsche Literatur* 144 (2015), 359–78.

Denifle, 'Anfänge der Predigtweise' (1886): Heinrich Denifle, 'Über die Anfänge der Predigtweise der deutschen Mystiker', *Archiv für Literatur- und Kirchengeschichte des Mittelalters* 2 (1886), 641–52.

Denny, *Annunciation* (1977): Don Denny, *The Annunciation from the Right: From Early Christian Times to the Sixteenth Century* (New York, 1977).

Derolez, 'Observations' (2003): Albert Derolez, 'Observations on the Aesthetics of the Gothic Manuscript', *Scriptorium* 50 (1996), 3–12; repr. in: Albert Derolez, *The Palaeography of Gothic Manuscript Books: From the Twelfth to the Early Sixteenth Century* (Cambridge, 2003), 28–45.

Deshman, 'Disappearing Christ' (1997): Robert Deshman, 'Another Look at the Disappearing Christ: Corporeal and Spiritual Vision in Early Medieval Images', *Art Bulletin* 79 (1997), 518–46.

Die deutsche Literatur des Mittelalters. Verfasserlexikon, eds. Kurt Ruh et al., 2nd edn., 14 vols. (Berlin, 1978–2008).

Die deutsche Predigt im Mittelalter. Internationales Symposium am Fachbereich Germanistik der Freien Universit.t Berlin vom 3.-6. Oktober 1989, eds. Volker Mertens & Hans-Jochen Schiewer (Tübingen, 1992)

Dictionnaire de spiritualité, ascétique etmystique: doctrine et histoire, eds. Marcel Viller et al., 16 vols. (Paris, 1937–1995).

Didi-Huberman, 'Puissance' (1990): Georges Didi-Huberman: 'Puissance de la figure: Exégèse et visualité dans l'art chrétien', *Encyclopedia Universalis: Symposium* (Paris, 1990), 608–21, translated as *The Power of the Figure: Exegesis and Visuality in Christian Art*, trans. Kristi Burman and Roland Spolander (Umea, 2003).

Diederichs-Gottschalk, *Schriftaltäre* (2005): Dietrich Diederichs-Gottschalk, *Die protestantischen Schriftaltäre des 16. und 17. Jahrhunderts in Nordwestdeutschland. Eine kirchen- und kunstgeschichtliche Untersuchung zu einer Sonderform liturgischer Ausstattung in der Epoche der Konfessionalisierung* (Regensburg, 2005).

Diefenbach, *Glossarium* (1857): Laurentius Diefenbach, *Glossarium Latino-Germanicum mediae et infimae aetatis* (Frankfurt a. M., 1857).

Dijk & Walter, *Origins* (1960): Stephen J. P. van Dijk & Joan Hazelden Walker, *The Origins of the Modern Roman Liturgy: The Liturgy of the Papal Court and the Franciscan Order in the Thirteenth Century* (Westminster, Md., 1960).

Dinkler-von Schubert, 'CATROC' (1995): Erika Dinkler-von Schubert, 'CATROC. Vom "Wort vom Kreuz" (1 Cor. 1,18) zum Kreuz-Symbol', in: *Byzantine East, Latin West: Art-Historical Studies in Honor of Kurt Weitzmann*, eds. Doula Mouriki et al. (Princeton, 1995), 29–39.

Dinzelbacher, review (1982): Peter Dinzelbacher, review of Siegfried Ringler, *Viten- und Offenbarungsliteratur in Frauenklöstern des Mittelalters. Quellen und Studien*, Münchener Texte und Untersuchungen 72 (Zurich, 1980), in: *Zeitschrift für deutsches Altertum und deutsche Philologie* 111 (1982), 63–71.

Dinzelbacher 'Adlersymbolik' (1993): Peter Dinzelbacher, 'Die mittelalterliche Adlersymbolik und Hadewijch', in: Peter Dinzelbacher, *Mittelalterliche Frauenmystik* (Paderborn, 1993), 188–204.

Dirks, 'Liturgia' (1984): Ansgar Dirks, 'De liturgiae dominicanae evolutione', *Archivum Fratrum Praedicatorum* 54 (1984), 39–82.

Dittmar, 'Corps sans fins' (2012): Pierre-Olivier Dittmar, 'Les corps sans fins: extensions animales et végétales dans les marges de la représentation (XIIIe–XIVe siècle)', *Micrologus* 20 (2012), 25–42.

Divina Officia (2004): *Divina Officia. Liturgie und Frömmigkeit im Mittelalter*, ed. Patrizia Carmassi, Ausstellungskataloge der Herzog August Bibliothek 83 (Wolfenbüttel, 2004).

Divine Mirrors (2001): *Divine Mirrors: The Virgin Mary in the Visual Arts*, ed. Melissa R. Katz (Oxford, 2001).

Dobrzeniecki, 'Quinity' (1964): Tadeusz Dobrzeniecki, 'The Torún Quinity in the National Museum in Warsaw', *Art Bulletin* 46 (1964), 380–88.

Dobrzeniecki, '*Debilitatio Christi*' (1967): Tadeusz Dobrzeniecki, '*Debilitatio Christi*: A Contribution to the Iconography of Christ in Distress', *Bulletin du Musée National de Varsovie* 8 (1967), 93–111.

Dobszay, 'Histories' (2006): László Dobszay, 'The Histories of the Pre-Lenten Period', in: *Papers read at the 12th Conference of the IMS Study Group Cantus Planus, Lillefüred (Hungary), 2004*, ed. Laszlo Dobszay (Budapest, 2006), 565–81.

Dockray-Miller, 'Myth' (2008): Mary Dockray-Miller, 'The Myth of the Virgin Nun', in: *Misconceptions about the Middle Ages*, eds. Stephen J. Harris & Bryon L. Grigsby, Routledge Studies in Medieval Religion and Culture 7 (New York, 2008), 260–62.

Doglio, 'Erode' (1984): Mary Federico Doglio, 'Erode furente e i Magi cristiani, dall' *Officium Stellae* alle laude drammatiche perugine', in: *Atti del IV Colloquio della Société internationale pour l'étude du théâtre médiéval, Viterbo, 10–15 luglio 1983*, eds. Maria Chiabò et al. (Viterbo, 1984), 275–95.

Dominicaines (2000): *Les dominicaines d'Unterlinden*, eds. Madeleine Blondel et al., 2 vols. (Colmar–Paris, 2000).

Donadieu-Rigaut, *Ordres religieux* (2005): Dominique Donadieu-Rigaut, *Penser en images les ordres religieux (XIIe–XVe siècles)* (Paris, 2005).

Dondaine, 'Saint Pierre' (1953): Antoine Dondaine, 'Saint Pierre martyr: études', *Archivum Fratrum Praedicatorum* 23 (1953), 66–162.

Die Dortmunder Dominikaner und die Propsteikirche als Erinnerungsort, eds. Thomas Schilp & Barbara Welzel, Dortmunder Mittelalter-Forschungen 8 (Bielefeld, 2006).

Doyle, 'Prayer' (1948): A. Ian Doyle, 'A Prayer Attributed to St. Thomas Aquinas', *Dominican Studies* 1 (1948), 231–32.

Dox, 'Roman Theatre' (2004): Donnalee Dox, 'Roman Theatre and Roman Rite: Twelfth-Century Transformation in Allegory, Ritual, and the Idea of Theatre', in: *The Appearances of Medieval Rituals: The Play of Construction and Modification*, eds. Nils Holger Petersen et al., Disputatio 3 (Turnhout, 2004), 33–48.

Dreves, *Gottschalk* (1897): Guido M. Dreves, *Gottschalk, Mönch von Limburg-an-der-Hardt und Propst von Aachen. Ein Prosator des XI. Jahrhunderts*, Hymnologische Beiträge 1 (Leipzig, 1897).

Drewery, 'Deification' (1975): Ben Drewery, 'Deification', in: *Christian Spirituality: Essays in Honour of Gordon Rupp*, ed. Peter Brooks (London, 1975), 35–62.

Dronke, *Fabula* (1974): Peter Dronke, *Fabula: Explorations into the Uses of Myth in Medieval Platonism*, Mittellateinische Studien und Texte 9 (Leiden, 1974).

Dronke, *Women Writers* (1984): Peter Dronke, *Women Writers of the Middle Ages: A Critical Study of Texts from Perpetua († 203) to Marguerite Porete († 1310)* (Cambridge, 1984).

Drumbl, 'Improperien' (1973): Johann Drumbl, 'Die Improperien in der lateinischen Liturgie', *Archiv für Liturgiewissenschaft* 15 (1973), 68–100.

Dubois, 'Saintes Écritures' (1984): Jacques Dubois, 'Comment les moines du Moyen Âge chantaient et goûtaient les Saintes Écritures', in: *Le Moyen Âge et la Bible*, eds. Pierre Riché & Guy Lobrichon, Bible de tous les temps 4 (Paris, 1984), 261–98.

Dubreil-Arcin, *Vies de saints* (2011): Agnès Dubreil-Arcin, *Vies de saints, légendes de soi: l'écriture hagiographique dominicaine jusqu'au Speculum sanctorale de Bernard Gui (1331)*, Hagiologia 7 (Turnhout, 2011).

Dudley, 'Holy Innocents' (1994): Martin R. Dudley, '*Natalis innocentium*: The Holy Innocents in Liturgy and Drama', *Studies in Church History* 31 (1994), 233–42.

Dumoutet, 'L'iconographie' (1936): Édouard Dumoutet, 'L'iconographie de l'introit du premier dimanche de l'Avent dans les missels à peintures du moyen âge', *La vie et les arts liturgique* 12 (1936), 34–36.

Dunn-Lardeau, 'Sept dormants' (2001): Brenda Dunn-Lardeau, 'La légende des sept dormants ou la traversée du temps', in: *Sainteté* (2001), 227–52.

Dutton & Jeauneau, 'Verses' (1983): Paul Dutton & Édouard Jeauneau: 'The Verses of the Codex Aureus of Saint Emmeram', *Studi medievali*, 3rd series 24 (1983), 75–120.

Duval, *Anges* (2015); Sylvie Duval, *Comme des anges sur terre. Les moniales dominicaines et les débuts de la réforme observante, 1385-1461*, Bibliothèque des Écoles françaises d'Athènes et de Rome 366 (Rome, 2015).

Duys, 'Royal Allegories' (2011): Kathryn A. Duys, 'Reading Royal Allegories in Gautier de Coinci's Miracles de Nostre Dame: The Soissons Manuscript (Paris, BnF n.a. fr. 24541)', in: *Collections in Context: The Organization of Knowledge and Community in Europe*, eds. Karen Fresco & Anne D. Hedeman (Columbus, 2011), 208–36.

Earl, 'Towneley Plays' (1972): James W. Earl, 'The Shape of History in the Towneley Plays', *Studies in Philology* 69 (1972), 434–52.

Eggenberger, 'Psalterium' (2010): Christoph Eggenberger, 'Psalterium eines Cistercienser-Klosters der Baseler Diözese um 1260. Besançon, Bibliothèque municipale, Ms. 54', *Baseler Zeitschrift für Geschichte und Altertumskunde* 110 (2010), 37–53.

Eggers, 'Bordesholmer Marienklage' (1978): Hans Eggers, 'Bordesholmer Marienklage', in: ²*VL* 1 (Berlin, 1978), cols. 958–60.

Ehbrecht, 'Mittelalterliches Soest' (2010): Wilfried Ehbrecht: 'Das mittelalterliche Soest – eine Stadt der Heiligen', in: *Soest. Geschichte der Stadt* 1 (2010), vol. 1, 987–1040.

Ehrenschwendtner, '*Puellae litteratae*' (1997): Marie-Luise Ehrenschwendtner, '*Puellae litteratae*: The Use of the Vernacular in the Dominican Convents of Southern Germany', *Medieval Women in their Communities*, ed. Diane Watt (Toronto, 1997), 49–71.

Ehrenschwendtner, *Bildung* (2004): Marie-Luise Ehrenschwendtner, *Die Bildung der Dominikanerinnen in Süddeutschland vom 14. bis 14. Jahrhundert*, Contubernium. Tübingener Beiträge zur Universitäts- und Wissenschaftsgeschichte 60 (Stuttgart, 2004).

Ehrenschwendtner, 'Sacred Space' (2010): Marie-Luise Ehrenschwendtner, 'Creating the Sacred Space Within: Enclosure as a Defining Feature in the Convent Life of Medieval Dominican Sisters (13th–15th c.)', *Viator: Medieval and Renaissance Studies* 41 (2010), 301–16.

Eichberg, *Choeurs* (1998): Barbara Bruderer Eichberg, *Les neuf choeurs angéliques. Origines et évolutions du thème dans l'art du Moyen Âge*, Civilisation médiévale 6 (Poitiers, 1998).

Eichenlaub, 'Notes sur les livres manuscrits' (1996): Jean-Luc Eichenlaub, 'Notes sur les livres manuscrits des établissements dominicains de Colmar et Guebwiller', in: *Dominicains et dominicaines en Alsace, XIIIe–XXe siècles. Actes du colloque de Guebwiller, 8–9 avril 1994*, ed. Jean-Luc Eichenlaub (Colmar, 1996), 31–36.

Einhorn, 'Fragment' (1971): Jürgen Werinhard Einhorn, 'Ein jüngst aufgefundenes Fragment der Soester Lesepult-Decke im Victoria and Albert Museum London', *Zeitschrift für Kunstgeschichte* 34 (1971), 47–58.

Einhorn, 'Londoner Fragment' (1971): Jürgen Werinhard Einhorn, 'Ein Londoner Fragment zur Ergänzung der Lesepult-Decke in der Wiesenkirche', *Soester Zeitschrift* 83 (1971), 43–47.

Einhorn, *Spiritalis unicornis* (1976): Jürgen Werinhard Einhorn, *Spiritalis unicornis. Das Einhorn als Bedeutungsträger in Literatur und Kunst des Mittelalters*, Münstersche Mittelalter-Schriften 13 (Munich, 1976).

Einhorn, 'Entdeckung' (2009): Jürgen Werinhard Einhorn, 'Die Entdeckung der abgetrennten Stickerei der Soester Lesepultdecke', *Soester Zeitschrift. Zeitschrift des Vereins für Geschichte und Heimatpflege Soest* 121 (2009), 67–75.

Eis, 'Predigt' (1961): Gerhard Eis, 'Johannes Praussers Predigt über die Unaussprechlichkeit Gottes', *Archivum Fratrum Praedicatorum* 31 (1961), 323–25.

Eisenhofer & Lechner, *Liturgy* (1961): Ludwig Eisenhofer & Joseph Lechner, *The Liturgy of the Roman Rite*, trans. A. J. & E. F. Peeler, ed. H. E. Winstone (Freiburg i. Br., 1961).

Eisermann, *Inschriften* (1996): Falk Eisermann, *Die Inschriften auf den Textilien des Augustiner-Chorfrauenstifts Heiningen*, Nachrichten von der Akademie der Wissenschaften in Göttingen, Philologisch-historische Klasse 6 (Göttingen, 1996).

Eisler, 'Athlete' (1961): Colin Eisler, 'The Athlete of Virtue: The Iconography of Asceticism', in: *De artibus opuscula: Essays in Honor of Erwin Panosky*, ed. Millard Meiss, 2 vols. (New York, 1961), 82–97.

El-Akramy, 'Verworrene Geschichte' (2006): Ursula El-Akramy, 'Eine verworrene Geschichte. Die Gründung des Dominikanerklosters in Dortmund', in: *Die Dortmunder Dominikaner* (2006), 99–122.

El Kholi, *Lektüre* (1997): Susann El Kholi, *Lektüre in Frauenkonventen des ostfränkisch-deutschen Reiches vom 10. Jahrhundert bis zum 13. Jahrhundert*, Epistemata. Reihe Literaturwissenschaft 203 (Würzburg, 1997).

El Kholi, *Bücher* (1998): Susann El Kholi, *Bücher in Frauenkonventen des ostfränkisch-deutschen Reiches vom 10. bis zum 13. Jarhhundert: Inauguraldissertation* (Bonn, 1998).

Elfving, *Étude lexicographique* (1962): Lars Elfving, *Étude lexicographique sur les séquences Limousines*, Acta Universitatis Stockholmiensis. Studia Latina Stockholmiensia 7 (Stockholm, 1962).

Elisabeth von Thüringen (2007): *Elisabeth von Thüringen, eine europäische Heilige. Katalog, 3. Thüringer Landesausstellung Wartburg-Eisenach, 7. Juli bis 19. November 2007*, eds. Dieter Blume & Matthias Werner (Petersberg, 2007).

Elisabeth von Thüringen (2008): *Elisabeth von Thüringen und die neue Frömmigkeit in Europa*, ed. Christa Bertelsmeier-Kierst, Kulturgeschichtliche Beiträge zum Mittelalter und der frühen Neuzeit 1 (Frankfurt a. M., 2008).

Ellis, 'Word' (1984): Roger Ellis, 'The Word in Religious Art of the Middle Ages and Renaissance', in: *Word, Picture, and Spectacle*, Early Drama, Art, and Music Monograph Series 5 (Kalamazoo, 1984), 21–38.

Emmerson, '*Figura*' (1992): Richard K. Emmerson, '*Figura* and the Medieval Typological Imagination', in: *Typology and English Medieval Literature*, ed. Hugh T. Keenan, Georgia State Literary Studies 7 (New York, 1992), 7–42.

Engelbert, *Conrad von Soest* (1995): Arthur Engelbert, *Conrad von Soest. Ein Dortmunder Maler um 1400* (Dortmund, 1995), 161–75.

Engen, 'Canons' (2005): John H. van Engen, 'From Canons to Preachers: A Revolution in Medieval Governance', in: *Domenico di Caleruega e la nascita dell' Ordine dei Frati Predicatori: Atti del XLI Convegno storico internazionale, Todi, 10–12 ottobre 2004*, Atti dei convegni del Centro Italiano di Studi sul Basso Medioevo. Accademia Tudertina e del Centro di Studi sulla Spiritualità 18 (Spoleto, 2005), 261–95.

Eorsi, '*Sed venit redemptor*' (1997): Anna Eorsi, '"*Sed venit redemptor, et victus est deceptor*": Egy román kori Angyali üdvözlet. Keresztrefeszítés könyvborító ikonográfiája', *Ars Hungarica: Bulletin of the Institute of Art History of the Hungarian Academy of Sciences* 25 (1997), 27–46.

Épigraphie (1996): *Épigraphie et iconographie: Actes du colloque tenu à Poitiers les 5–8 octobre*, ed. Robert Favreau, Civilisation médiévale 2 (Poitiers, 1996).

A. Ernst, *Martha* (2009): Allie M. Ernst, *Martha from the Margins: The Authority of Martha in Early Christian Tradition*, Supplements to Vigiliae Christianae 98 (Leiden, 2009), 95–117.

U. Ernst, 'Labyrinthe' (1990): Ulrich Ernst, 'Labyrinthe aus Lettern. Visuelle Poesie als Konstante europäischer Literatur', in: *Text und Bild, Bild und Text (DFG-Symposion 1988)*, ed. Wolfgang Harms (Stuttgart, 1990), 197–215.

U. Ernst, *Carmen figuratum* (1991): Ulrich Ernst, *Carmen figuratum. Geschichte des Figurengedichts von den antiken Ursprüngen bis zum Ausgang des Mittelalters*, Pictura et Poesis 1 (Cologne, 1991).

U. Ernst, 'Farbe' (1994): Ulrich Ernst, 'Farbe und Schrift im Mittelalter unter Berücksichtigung antiker Grundlagen und neuzeitlicher Rezeptionsformen', in: *Testo e immagine nell' Alto medioevo, 15–21 aprile 1993*, 2 vols., Settimane di Studio del Centro Italiano di Studi sull' Alto medioevo (Spoleto, 1994), 343–415.

U. Ernst, 'Hieroglyphe' (2000): Ulrich Ernst, 'Von der Hieroglyphe zum Hypertext. Medienumbrüche in der Evolution visueller Texte', in: *Die Verschriftlichung der Welt. Bild, Text und Zahl in der Kultur des Mittelalters und der Frühen Neuzeit*, eds. Horst Wenzel et al., Schriften des Kunsthistorischen Museums Wien 5 (Vienna, 2000), 213–39.

U. Ernst, *Intermedialität* (2002), Ulrich Ernst, *Intermedialität im europäischen Kulturzusammenhang. Beiträge zur Theorie und Geschichte der visuellen Lyrik*, Allgemeine Literaturwissenschaft—Wuppertaler Schriften 4 (Berlin, 2002).

U. Ernst, 'Lüge' (2004): Ulrich Ernst, 'Lüge, Integumentum und Fiktion in der antiken und mittelalterlichen Dichtungstheorie. Umrisse einer Poetik des Mendakischen', in: *Das Mittelalter* 9 (2004), 73–100.

U. Ernst, *Facetten* (2006): Ulrich Ernst, *Facetten mittelalterlicher Schriftkultur. Fiktion und Illustration*, Wissen und Wahrnehmung, Beihheft zum *Euphorion* 51 (Heidelberg, 2006).

U. Ernst, 'Text' (2006): Ulrich Ernst, 'Text und Intext. Textile Metaphorik und Poetik der Intextualität am Beispiel visueller Dichtungen der Spätantike und des Frühmittelalters', in: *'Textus' im Mittelalter. Komponenten und Situationen des Wortgebrauchs im schriftsemantischen Feld*, eds. Ludolf Kuchenbuch & Uta Kleine (Göttingen, 2006), 43–75.

U. Ernst, 'Leuchtschriften' (2008): Ulrich Ernst, 'Leuchtschriften. Vom Himmelsbuch zur Lichtinstallation', in: *Beiträge zu einer Kulturgeschichte des Leuchtenden*, eds. Christina Lechtermann & Haiko Wandhoff, Publikationen zur Zeitschrift für Germanistik 18 (Bern, 2008), 71–89.

Esbroeck, 'Virgin' (2005): Michel van Esbroeck, 'The Virgin as the True Ark of the Covenant', in: *Images of the Mother of God*, ed. Maria Vassilake (Aldershot, 2005), 63–68.

Esmeijer, *Divina Quaternitas* (1978): Anna C. Esmeijer, *Divina Quaternitas: A Preliminary Study in the Method and Application of Visual Exegesis* (Assen, 1978).

Étaix, 'Leçons' (2004): Raymond Étaix, 'Les leçons patristiques de l'office temporal dans le "lectionarium" et le "breviarium" du "Prototype" dominicain', in: *Aux origines* (2004).

Euw, 'Darstellung' (2004): Anton von Euw, 'Die Darstellung zum 90. (91.) Psalm in der frühmittelalterlichen Psalter- und Evangelienillustration mit Ergänzungen aus Kommentaren', in:

The Illuminated Psalter, ed. Frank O. Büttner (Turnhout, 2004), 405–11, 567–70.

Euw & Plotzek, *Handschriften* (1979–1985): Anton von Euw & Joachim M. Plotzek, *Die Handschriften der Sammlung Ludwig*, 4 vols. (Cologne, 1979–1985).

Evans, 'Geometry' (1980): Michael Evans, 'The Geometry of the Mind', *Architectural Association Quarterly* 12 (1980), 31–55.

Falconer, *Tropes* (1993): Keith Falconer, *Some Early Tropes to the Gloria*, Quaderni di Musica/Realtà 30 (Modena, 1993).

Fassler, 'Sermons' (2000): Margot E. Fassler, 'Sermons, Sacramentaries, and Early Sources for the Office in the Latin West: The Example of Advent', in: *The Divine Office in the Latin Middle Ages: Methodology and Source Studies, Regional Developments, Hagiography*, eds. Margot E. Fassler & Rebecca A. Baltzer (Oxford, 2000), 15–47.

Fassler, 'Music' (2004): Margot E. Fassler, 'Music and the Miraculous: Mary in the Mid-Thirteenth-Century Dominican Sequence Repertory', in: *Aux origines* (2004), 229–78.

Fassler, *Gothic Song* (2011): Margot E. Fassler, *Gothic Song: Victorine Sequences and Augustinian Reform in Twelfth-Century Paris*, 2nd edn. (Notre Dame, 2011).

Fassler & Baltzer, *The Divine Office* (2000): Margot E. Fassler & Rebecca A. Baltzer, *The Divine Office in the Latin Middle Ages: Methodology and Source Studies, Regional Developments, Hagiography* (Oxford, 2000).

Fassler & Hamburger, 'Desert' (2015): Margot E. Fassler & Jeffrey F. Hamburger: 'The Desert in Paradise: A Newly-Discovered Office for John the Baptist from Paradies bei Soest and its Place in the Dominican Liturgy', in: *Resounding Images*, eds. Susan Boynton & Diane J. Reilly (Turnhout, 2015), 251–79.

Faupel-Drevs, *Gebrauch* (2000): Kirstin Faupel-Drevs, *Vom rechten Gebrauch der Bilder im liturgischen Raum. Mittelalterliche Funktionsbestimmungen bildender Kunst im 'Rationale divinorum officiorum' des Durandus von Mende (1230/1–1296)*, Studies in the History of Christian Thought 89 (Leiden, 2000).

Fauser, *Albertus Magnus* (1982): Winfried Fauer, *Die Werke des Albertus Magnus in ihrer handschriftlichen Überlieferung* 1: Die echten Werke, Alberti Magni opera omnia. Tomus subsidiarius I (Münster, 1982).

Favreau, 'L'épigraphie' (1992): Robert Favreau, 'L'épigraphie comme source pour la liturgie', in: *Vom Quellenwert der Inschriften. Vorträge und Berichte der Fachtagung Esslingen 1990*, ed. Renate Neumüllers-Klauser, Supplemente zu den Sitzungsberichten der

Heidelberger Akademie der Wissenschaften, Philosophisch-historische Klasse 7 (Heidelberg, 1992), 65–137.

Fechter, 'Meyer, Johannes OP' (1987): Werner Fechter, 'Meyer, Johannes OP', in: ²*VL* 6 (Berlin, 1987), cols. 474–89.

Federer, *Mystische Erfahrhung* (2011): Urban Federer, *Mystische Erfahrung im literarischen Dialog. Die Briefe Heinrichs von Nördlingen an Margaretha Ebner*, Scrinium Friburgense 25 (Berlin, 2011).

Felskau, 'Brabant' (2006): Christian-Frederik Felskau, 'Von Brabant bis Böhmen und darüber hinaus. Zu Einheit und Vielfalt der "religiösen Frauenbewegung" des 12. und des 13. Jahrhunderts', in: *Fromme Frauen — unbequeme Frauen? Weibliches Religiosentum im Mittelalter*, ed. Edeltraud Klueting, Hildesheimer Forschungen 3 (Hildesheim, 2006), 67–103.

Felten, 'Kanonissenstifte' (2001): Franz J. Felten, 'Wie adelig waren Kanonissenstifte (und andere weibliche Konvente) im (frühen und hohen) Mittelalter?' in: *Studien zum Kanonissenstift*, ed. Irene Crusius, Veröffentlichungen des Max-Planck-Instituts für Geschichte 167; Studien zur Germania Sacra 24 (Göttingen, 2001), 39–128.

Felten, *Frauen in der Klosterreform* (2012): Franz J. Felten, *Frauen in der Klosterreform des späten 11. Jahrhunderts. Festvortrag anlässlich der Verleihung des ersten Romanikforschungspreises 2011*, Vorträge im Europäischen Romanik-Zentrum 1 (Halle, 2012).

Ferber, 'Pucelle' (1984): Stanley H. Ferber, 'Jean Pucelle and Giovanni Pisano', *Art Bulletin* 66 (1984), 65–72.

Ferne Welten (2006): *Ferne Welten — freie Stadt. Dortmund im Mittelalter*, exh. cat., Museum für Kunst und Kulturgeschichte Dortmund, eds. Matthias Ohm et al., Dortmunder Mittelalter-Forschungen 7 (Bielefeld, 2006).

Fête-Dieu (1999): *Fête-Dieu (1246–1996)*, eds. André Haquin & Jean-Pierre Delville, 2 vols., Publications de l'Institut d'études médiévales: Textes, études, congrès 19 (Louvain-la-Neuve, 1999).

Figura (2013): *Figura. Dynamiken der Zeiten und Zeichen im Mittelalter*, eds. Christian Kiening & Katharina Mertens Fleury, Philologie der Kultur 8 (Würzburg, 2013).

Finke, 'Biographie' (1890): Heinrich Finke, 'Zur Biographie der Dominikaner Hermann von Minden, Hermann von Lerbeke und Hermann Korner', *Mitteilungen des Instituts für Österreichische Geschichtsforschung* 11 (1890), 447–50.

Fischediek, 'Regula Benedicti' (1993): Teresa Karin Fischediek, *Das Gehorsamsverständnis der 'Regula Benedicti'. Der Gehorsam als Grundlage für ein exemplarisch christliches Gemeinschafts-leben*, Regulae Benedicti studia: Supplementa 13 (Erzabtei St. Ottilien, 1993).

B. Fischer, 'Psalm 90' (1958): Balthasar Fischer, 'Conculabis Leonem et Draconem. Eine deutungsgeschichtliche Studie zur Verwendung von Psalm 90 in der Quadragesima', *Zeitschrift für katholische Theologie* 80 (1958), 421–29, repr. in: B. Fischer, *Die Psalmen als Stimme der Kirche. Gesammelte Studien zur christlichen Psalmenfrömmigkeit herausgegeben von Andreas Heinz anlässlich des 70. Geburtstages von Prof. Dr. Balthasar Fischer am 3. Sept. 1982* (Trier, 1982), 73–83.

B. Fischer, *Psalmen* (1982): Balthasar Fischer, *Die Psalmen als Stimme der Kirche. Gesammelte Studien zur christlichen Psalmenfrömmigkeit*, ed. Andreas Heinz (Trier, 1982).

B. Fischer, 'Hintergrund' (1983): Balthasar Fischer, 'Der patristische Hintergrund der drei grossen johanneischen Tauf-perikopen von der Samariterin, der Heilung des Blindgeborenen und der Aufweckung des Lazarus am dritten, vierten und fünften Sonntag der Quadragesima', in: *I Simboli dell'iniziazione cristiana: Atti del I° Congresso Internazionale di Liturgia, Pontificio Istituto Liturgico 25–28 Maggio 1982*, ed. P. Giustino Farnedi, Studia Anselmiana 87, Analecta Liturgica 7 (Rome, 1983), 61–79.

I. Fischer, *Handschriften* (1972): Irmgard Fischer, *Handschriften der Ratsbücherei Lüneburg, 2. Die theologischen Handschriften: 1. Folioreihe* (Wiesbaden, 1972).

L. Fischer, *Quatember* (1914): Ludwig Fischer, *Die kirchlichen Quatember. Ihr Entstehung, Entwicklung und Bedeutung in liturgischer, rechtlicher und kulturhistorischer Hinsicht*, Universität München. Kirchenhistorisches Seminar, Veröffentlichungen IV/3 (Munich, 1914).

Flaeten, 'New Reading' (2013): Jon Oygarden Flaeten, 'New Reading of Heinrich Suso's Horologium sapientiae', Ph.D. dissertation, University of Oslo, 2013 (forthcoming).

Flanigan, 'Apocalypse' (1992): C. Clifford Flanigan, 'The Apocalypse and the Medieval Liturgy', in: *The Apocalypse in the Middle Ages*, eds. Richard K. Emmerson & Bernard McGinn (Ithaca, 1992), 333–51.

Flasch, *Meister Eckhart* (2010): Kurt Flasch, *Meister Eckhart. Philosoph des Christentums* (Munich, 2010).

Fleith, *Studien* (1991): Barbara Fleith, *Studien zur Überlieferungsgeschichte der lateinischen Legenda Aurea*, Subsidia hagiographica 72 (Brussels, 1991).

Fleming, *Analysis* (1989): Sonia Scott Fleming, *The Analysis of Pen Flourishing in Thirteenth-Century Manuscripts*, Litterae textuales (Leiden, 1989).

Flett, 'Text Scrolls' (1991): Alison R. Flett, 'The Significance of Text Scrolls: Towards a Descriptive Terminology', in: *Medieval Texts and Images: Studies of Manuscripts from the Middle Ages*, eds. Margaret M. Manion & Bernard J. Muir (Chur, 1991), 43–56.

Flora, 'Women' (2012): Holly Flora, 'Women Wielding Knives: The Circumcision of Christ by His Mother in an Illustrated Manuscript of the *Meditationes vitae Christi* (Paris, Bibliothèque nationale de France ital. 115', in: *Christ Child* (2012), 145–66.

Flug, 'Mainz, Altmünster' (1999): Brigitte Flug, 'Mainz, Altmünster', in: *Die Männer- und Frauenklöster der Benediktiner in Rheinland-Pfalz und Saarland*, eds. Friedhelm Jürgenmiester & Regina Elisabeth Schwerdtfeger, Germania Benedictina 9 (St. Ottilien, 1999), 398–425.

Flug, 'Altmünster' (2002): Brigitte Flug, 'Vom Kloster in der Stadt zum städtischen Kloster. Altmünster von seiner Gründung bis zum Ende des 14. Jahrhunderts', in: *Bausteine zur Mainzer Stadtgeschichte. Mainzer Kolloquium 2000*, eds. Michael Matheus & Walter Gerd Rödel (Stuttgart, 2002), 1–11.

Flug, *Altmünsterkloster* (2006): Brigitte Flug, *Äussere Bindung und innere Ordnung. Das Altmünsterkloster in Mainz in seiner Geschichte und Verfassung von den Anfängen bis zum Ende des 14. Jahrhunderts*, Geschichtliche Landeskunde 61 (Stuttgart, 2006).

Flynn, 'Liturgy' (1999): William T. Flynn, 'Liturgy and Scripture Study: Interpreting Scripture within the Liturgy', in: *Medieval Music as Exegesis*, Studies in Liturgical Musicology 8 (Lanham–London, 1999), 107–38.

Föllmi, 'Osterintroitus' (1990): Beat Föllmi, 'Der Osterintroitus "Resurrexi" und seine Tropierungen. Ein Beitrag zur Geschichte des Tropus', *Kirchenmusikalisches Jahrbuch* 74 (1990), 1–6.

Förster, 'Antiphon' (2005): Hans Förster, 'Die ältesten marianische Antiphon—eine Fehldatierung? Überlegungen zum "ältesten Beleg" des Sub tuum praesidium', *Journal of Coptic Studies* 7 (2005), 99–109.

Forsyth, 'Magi' (1968): Ilene H. Forsyth, 'Magi and Majesty: A Study of Romanesque Sculpture and Liturgical Drama', *Art Bulletin* 50 (1968), 215–28.

Forsyth, *Throne of Wisdom* (1972): Ilene H. Forsyth, *The Throne of Wisdom: Wood Sculptures of the Madonna in Romanesque France* (Princeton, 1972).

Fortescue, 'Gospel' (1909): Adrian Fortescue, 'Gospel', *The Catholic Encyclopedia*, eds. Charles G. Herbermann et al., 15 vols. (New York, 1909), vol. 6, 662–63.

Fournier et al., *Catalogue général* (1889): P. Fournier, E. Maignien, & A. Prudhomme, *Catalogue général des manuscrits des Bibliothèques publiques de France: Départements 7. Grenoble* (Paris, 1889).

H. Frank, 'Ecce advenit' (1963): Hieronymus Frank, '*Ecce advenit dominator dominus*. Alter und Wanderung eines römischen Epiphaniemotivs', in: *Perennitas. Beiträge zur christlichen Archäologie und Kunst, zur Geschichte der Literatur, der Liturgie und des Mönchtums sowie zur Philosophie des Rechts und zur politischen Philosophie. P. Thomas Michels OSB, zum 70. Geburtstag*, eds. Hugo Rahner & Emmanuel von Severus (Münster, 1963), 136–54.

I. Frank, 'Dominikanerinnen' (1998): Isnard Wilhelm Frank, 'Wie der Dominikanerorden zu den Dominikanerinnen kam. Zur Gründung der "Dominikanerinnen" im 13. Jahrhundert', in: *Das Dominikanerinnenkloster zu Bad Wörishofen*, ed. Werner Schiedermair (Weißenhorn, 1998), 36–49.

I. Frank, 'Zweiter Orden' (2006): Isnard Wilhelm Frank, 'Die Dominikanerinnen als Zweiter Orden der Dominikaner', in: *Fromme Frauen—unbequeme Frauen? Weibliches Religiosentum im Mittelalter*, ed. Edeltraud Klueting, Hildesheimer Forschungen 3 (Hildesheim, 2006), 105–25.

J. Frank, 'Quadrige' (1999): Jacqueline Frank, 'The Quadrige Aminadab Medallion in the "Anagogical" Window of the Royal Abbey of Saint-Denis', *Gazette des beaux-arts* 133 (1999), 220–34.

J. B. Frank, *Praxis Geometrica* (1705): Johann Bartholomäus Frank, *Praxis Geometrica Universalis oder Allgemeine Lehre Vom Feld-Messen […] Nebenst einer Zugaab einiger Geometrisch Algebraischen Lust- und Kunst-Rechnungen, mit vielen nöthigen Kupffer-Figuren versehen* (Augsburg, 1705).

Franz, *Messe* (1902): Adolf Franz, *Die Messe im Deutschen Mittelalter. Beiträge zur Geschichte der Liturgie und des religiösen Volkslebens* (Freiburg, 1902).

Franz, *Benediktionen* (1909): Adolf Franz, *Die kirchlichen Benediktionen im Mittelalter*, 2 vols. (Freiburg i. Br., 1909).

Frauen im Mittelalter (1984): *Frauen im Mittelalter. Frauenbild und Frauenrechte in Kirche und Gesellschaft. Quellen und Materialien* 2, ed. Annette Kuhn, Studien Materialien 19 (Düsseldorf, 1984).

Freed, *The Friars* (1977): John Beckman Freed, *The Friars and German Society in the Thirteenth Century (1219–1273)* (Cambridge, Ma., 1977).

Freiburger Büchergeschichten (2007): *Freiburger Büchergeschichten. Handschriften und Drucke aus den Beständen der Universitätsbibliothek und die neue Sammlung Leuchte* (Freiburg i. Br., 2007).

Fries, 'Die Trinitätssequenz' (1983): Albert Fries, 'Die Trinitätssequenz "Profitentes" und Albertus Magnus', *Archiv für Liturgiewissenschaft* 25 (1983), 276–96.

E. Fritz, *Glasmalereien* (2003): Eva Fritz, *Die mittelalterlichen Glasmalereien im Halberstädter Dom*, Corpus vitrearum Medii Aevi: Deutschland 17 (Berlin, 2003).

R. Fritz, 'Halbfigurenbild' (1951): Rolf Fritz, 'Das Halbfigurenbild in der westdeutschen Tafelmalerei um 1400', *Zeitschrift für Kunstwissenschaft* 5 (1951), 161–78.

Frizzell & Henderson, 'Jews' (2001): Lawrence E. Frizzel & J. Frank Henderson: 'Jews and Judaism in the Medieval Latin Liturgy', in: *The Liturgy of the Medieval Church*, eds. Thomas J. Heffernan & E. Ann Matter (Kalamazoo, 2001), 187–214.

Frommberger-Weber, 'Buchmalerei' (1973): Ulrike Frommberger-Weber, 'Spätgotische Buchmalerei in den Städten Speyer, Worms und Heidelberg (1440–1510). Ein Beitrag zur Malerei des nördlichen Oberrheingebietes im ausgehenden Mittlelalter', *Zeitschrift für die Geschichte des Oberrheins* 121 (1973), 35–145.

Fuchß, *Altarensemble* (1999): Verena Fuchß, *Das Altarensemble. Eine Analyse des Kompositcharakters früh- und hochmittelalterlicher Altarausstattung* (Weimar, 1999).

Fuente, *Vida liturgica* (1981): Antolin Gonzalez Fuente, *La Vida liturgica en la orden de predicadores: Estudio en su legislacion, 1216–1980* (Rome, 1981).

Fuhrmann, '*Sind eben alles Menschen gewesen*' (1996): Horst Fuhrmann, '*Sind eben alles Menschen gewesen*'. *Gelehrtenleben im 19. und 20. Jahrhundert. Dargestellt am Beispiel der Monumenta Germaniae historica und ihrer Mitarbeiter* (Munich, 1996).

Fulton, '*Quae est ista*' (1998): Rachel Fulton, '*Quae est ista quae ascendit sicut aurora consurgens*? The Song of Songs as the *Historia* for the Office of the Assumption', *Mediaeval Studies* 60 (1998), 55–122.

Fulton, *Judgment to Passion* (2002): Rachel Fulton, *From Judgment to Passion: Devotion to Christ and the Virgin Mary, 800–1200* (New York, 2002).

Future of the Page (2004): *The Future of the Page*, eds. Peter Stoicheff & Andrew Taylor (Toronto, 2004).

Gärtner, *Römische Basiliken* (2002): Magdalena Gärtner, *Römische Basiliken in Augsburg. Nonnenfrömmigkeit und Malerei um 1500*, Schwäbische Geschichtsquellen und Forschungen 23 (Augsburg, 2002).

Gärtner, 'Basilikabilder' (2009): Magdalena Gärtner, 'Die Basilikabilder des Katharinenklosters in Augsburg als frühe Stell-vertreterstätten für die Sieben-Kirchen-Wallfahrt', in: *Augsburger Netzwerke zwischen Mittelalter und Neuzeit*, eds. Klaus Herbers & Peter Rückert, Jakobus-Studien 18 (Tübingen, 2009), 61–94.

Gaffuri, 'Predicazione' (2001): Laura Gaffuri, 'La predicazione domenicana su Maria (il secolo XIII)', in: *Gli studi di mariologia medievale: bilancio storiografico. Atti del 1. convegno mariologico della Fondazione Ezio Franceschini, Parma, 7–8 novembre 1997*, ed. Clelia Maria Piastra (Florence, 2001), 193–215.

Gardill & Wolfson, 'Überlegungen' (1992): Ingrid Gardill & Michael Wolfson, 'Überlegungen zu Stil und Ikonographie des Wennigser "Marientodes"', *Niederdeutsche Beiträge zur Kunstgeschichte* 31 (1992), 37–49.

Gassmann, *Konversen* (2013): Guido Gassmann, *Konversen im Mittelalter. Eine Untersuchung anhand der neun Schweizer Zisterzienserabteien*, Vita Regularis 56 (Münster, 2013).

Gautier de Coinci (2006): *Miracles, Music, and Manuscripts*, eds. Kathy M. Krause & Alison Stones, Medieval Texts and Cultures of Northern Europe 13 (Turnhout, 2006).

Gay-Canton, *Dévotion* (2011): Réjane Gay-Canton, *Entre dévotion et théologie scolastique: réceptions de la controverse médiévale autour de l'Immaculée Conception en pays germaniques*, Bibliothèque d'histoire culturelle du Moyen Âge 11 (Turnhout, 2011).

Gaylord, 'Reflections' (2006): Alan T. Gaylord, 'Reflections on D. W. Robertson, Jr., and "Exegetical Criticism"', *Chaucer Review* 40 (2006), 311–33.

Gaztambide, 'Juan de Monsón' (1980): José Goñi Gaztambide, 'Fray Juan de Monsón, O.P., su vida y sus ombras (c. 1340–c.1412)', *Boletín de la Sociedad Castellonense de Cultura* 56 (1980), 506–23.

Gębarowicz, *Mater Misericordiae* (1986): Mieczysław Gębarowicz, *Mater Misericordiae: Pokrow-Pokrowa w sztuce i legendzie środkowo-wschodniej Europy*, Studia z historii sztuki, 38 (Wrocław, 1986).

Gechter, 'St. Agatha' (1995): Marianne Gechter: 'St. Agatha', in: *Kölner Kirchen und ihre mittelalterliche Ausstattung* 1, Colonia romanica 10 (Cologne, 1995), 31–37.

Geistliche Literatur (2012): *Geistliche Literatur des späten Mittelalters. Kleine Schriften*, eds. Kristina Freienhagen-Baumgardt & Katrin Stegherr, Spätmittelalter, Humanismus, Reformation 64 (Tübingen, 2012).

Geith, 'Priorin und Übersetzerin' (1980–1981): Karl-Ernst Geith, 'Elisabeth Kempf (1415–1485). Priorin und Übersetzerin in Unterlinden in Colmar', *Annuaire de la Société d'Histoire et d'Archéologie de Colmar* 29 (1980–1981), 41–73.

Geith, 'Elisabeth Kempf' (1984): Karl-Ernst Geith, 'Elisabeth Kempfs Übersetzung und Fortsetzung der *Vitae sororum* der Katharina von Gueberschwihr', *Annuaire de la Société d'Histoire et d'Archéologie de Colmar* 32 (1984), 27–42.

Geith, 'Textgeschichte' (1986): Karl-Ernst Geith, 'Zur Textgeschichte der *Vitae sororum* (Unterlindener Schwesternbuch) der Katharina von Gueberschwihr', *Mittellateinisches Jahrbuch* 21 (1986), 230–38.

Geith, 'Kempf, Elisabeth' (2004): Karl-Ernst Geith, 'Kempf, Elisabeth', in: ²*VL* 11 (Berlin, 2004), cols. 836–37.

Die gelehrten Bräute Christi (2008): *Die gelehrten Bräute Christi. Geistesleben und Bücher der Nonnen im Mittelalter. Vorträge,* ed. Helwig Schmidt-Glintzer, Wolfenbütteler Hefte 22 (Wiesbaden, 2008).

Gemmeke & Schiffke, 'Neuenheerse' (1994): Anton Gemmeke & Peter Schiffke: 'Neuenheerse – Damenstift', in: *Westfälisches Klosterbuch* (1994), vol. 2, 137–49.

Gerhardt, *Metamorphosen* (1979): Christoph Gerhardt, *Die Metamorphosen des Pelikans. Exempel und Auslegung in mittelalterlicher Literatur, mit Beispielen aus der bildenden Kunst und einem Bildanhang,* Trierer Studien zur Literatur 1 (Frankfurt a. M., 1979).

Gerhardt, 'Meditationsbilder' (1989): Christoph Gerhardt, 'Meditationsbilder aus dem ehemaligen Klarissenkloster Ribnitz (Bez. Rostock, DDR)', *Trier Theologische Zeitschrift. Pastor Bonus* 98 (1989), 95–112.

Gerhardt, '*Tumba gygantis*' (1992): Christoph Gerhardt, 'Die *tumba gygantis* auf dem Wormelner Tafelbild "Maria als Thron Salomons"', *Westfälische Zeitschrift* 142 (1992), 247–75.

Gerlach, *Klosterbüchereien* (1934): Friedrich Gerlach, *Aus mittelalterlichen Klosterbüchereien und Archiven* (Lemgo, 1934).

Gerwing, 'Weltende, Weltzeitalter' (1999): Manfred Gerwing, 'Weltende, Weltzeitalter', *LMA* 8 (1999), 2168–72.

Gesamtkatalog der Wiegendrucke (1925–): *Gesamtkatalog der Wiegendrucke,* ed. Kommission für den Gesamtkatalog der Wiegendrucke, 2nd edn., 8 vols. (Leipzig, 1925–).

Gignac, *Sanctoral* (1959): Louis-Marie Gignac, *Le Sanctoral dominicain et les origins de la liturgie dominicaine* (Paris, 1959).

Giraud, 'Production and Notation' (2013): Eleanor Giraud, 'The Production and Notation of Dominican Manuscripts in Thirteenth-Century Paris', Ph.D. dissertation, University of Cambridge (2013).

Glass, '"Ordo prophetarum"' (2001): Dorothy Finn Glass, 'Otage de l'historiographie: l'"Ordo prophetarum" en Italie', *Cahiers de civilisation médiévale* 44 (2001) 259–73.

Glaube und Wissen (1998): *Glaube und Wissen im Mittelalter. Die Kölner Dombibliothek. Katalogbuch zur Ausstellung Glaube und Wissen im Mittelalter — die Kölner Dombibliothek,* Erzbischöfliches Diözesanmuseum (Köln), ed. Joachim M. Plotzek (Munich, 1998).

Gleeson, 'Liturgical Manuscripts' (1972): Philip Gleeson, 'Dominican Liturgical Maunscripts from before 1254', *Archivum Fratrum Praedicatorum* 42 (1972), 81–135.

Gössmann, 'Anthropologie' (1979): Elisabeth Gössmann, 'Anthropologie und soziale Stellung der Frau nach den Summen und Sentenzen des 13. Jahrhunderts', in: *Soziale Ordnungen im Selbstverständnis des Mittelalters* 1, ed. Albert Zimmermann, Miscellanea mediaevalia 12/1–2 (Berlin–New York, 1979), 218–97.

Goez, *Schriftlichkeit* (2003): Elke Goez, *Pragmatische Schriftlichkeit und Archivpflege der Zisterzienser. Ordenszentralismus und regionale Vielfalt, namentlich in Franken und Altbayern (1098–1525)* (Münster, 2003).

Goldene Pracht (2012): *Goldene Pracht. Mittelalterliche Schatzkunst in Westfalen,* ed. Bistum Münster, Landschaftsverband Westfalen-Lippe and Westfälische Wilhelms-Universität, exh. cat., Münster, LWL-Landesmuseum für Kunst und Kulturgeschichte and Domkammer der Kathedrale St. Paulus, Münster (Munich, 2012).

Goldkuhle, 'Unbekannte Einzelblätter' (1958): Fritz Goldkuhle: 'Unbekannte Einzelblätter aus einer mittelalterlichen Miniaturhandschrift', *Neusser Jahrbuch für Kunst, Kulturgeschichte und Heimatpflege* (1958), 10–18.

González, 'Número' (2000): Javier Roberto González, 'El número como símbolo en la Edad Media latina', *Stylos: Revista del Instituto de Estudios Grecolatinos 'Francisco Novoa' (Universidad Católica Argentina)* 9 (2000), 89–118.

Goodich, 'Liturgy' (2004): Michael E. Goodich, 'Liturgy and the Foundation of Cults in the Thirteenth and Fourteenth Centuries', in: *Lives and Miracles of the Saints: Studies in Medieval Hagiography,* ed. Michael E. Goodich, Variorum Collected Studies Series 798 (Aldershot, 2004), 145–57.

Gosmann, 'Paradiese' (1994): Michael Gosmann, 'Paradiese. Dominikanerinnen', in: *Westfälisches Klosterbuch* (1994), vol. 2, 262–68.

Gosmann, 'Die Grafen von Arnsberg' (2009): Michael Gosmann, 'Die Grafen von Arnsberg und ihre Grafschaft. Auf dem Weg

zur Landesherrschaft (1180–1371)', in: *Das Herzogtum Westfalen* 1, ed. Harm Klueting (Münster, 2009), 171–202.

Gotische Buchmalerei (1997): *Gotische Buchmalerei aus Westfalen. Choralbücher der Frauenklöster Paradiese und Welver bei Soest,* ed. Ulrich Löer, Soester Beiträge 57 (Soest, 1997).

Gottlieb, *Window* (1981): Carla Gottlieb, *The Window in Art: From the Window of God to the Vanity of Man. A Survey of Window Symbolism in Western Painting* (New York, 1981).

Gottwald, *Musikhandschriften* (1988): Clytus Gottwald, *Die Musikhandschriften*, Die Handschriften des Germanischen Nationalmuseums Nürnberg 4 (Wiesbaden, 1988).

Grabar, 'Iconographie' (1956): André Grabar, 'Iconographie de la sagesse divine', *Cahiers archéologiques* 8 (1956), 254–61.

Grabmann, *Philosophia* (1918): Martin Grabmann, *Die Philosophia pauperum und ihr Verfasser Albert von Orlamünde. Ein Beitrag zur Geschichte des philosophischen Unterrichtes an den deutschen Universitäten des ausgehenden Mittelalters*, Beiträge zur Geschichte der Philosophie und Theologie des Mittelalters 20.2 (Münster, 1918).

Grade, 'Antiphonare' (1997): Jochen Grade, 'Buchmalerei in zwei Antiphonaren aus Paradiese (D 7, D 9)', in: *Gotische Buchmalerei aus Westfalen. Choralbücher der Frauenklöster Paradiese und Welver bei Soest*, ed. Ulrich Löer, Soester Beiträge 57 (Soest, 1997), 69–86.

Graduale von Sankt Katharinenthal (1983): *Das Graduale von Sankt Katharinenthal. Kommentar zur Faksimile-Ausgabe des Graduale von Sankt Katharinenthal, mit einer Einführung von A. A. Schmid und Beiträgen von E. J. Beer, A. Knoepfli, P. Ladner, M. Lütolf, D. Schwarz und L. Wüthrich* (Luzern, 1983).

Gräbke, 'Leinendecken' (1938): Hans Arnold Gräbke, 'Eine westfälische Gruppe gestickter Leinendecken des Mittelalters', *Westfalen* 23 (1938), 179–94.

Katrin Graf, *Bildnisse* (2002): Katrin Graf, *Bildnisse schreibender Frauen im Mittelalter (9. bis Anfang 13. Jahrhundert)* (Basel, 2002).

Klaus Graf, 'Retrospektive Tendenzen' (1996): Klaus Graf, 'Retrospektive Tendenzen in der bildenden Kunst vom 14. bis zum 16. Jahrhundert. Kritische Überlegungen aus der Perspektive des Historikers', in: *Mundus in imagine. Bildersprache und Lebenswelten im Mittelalter. Festgabe für Klaus Schreiner*, eds. Andrea Löther et al. (Munich, 1996), 389–420.

Grallet, *Le manuel du pélerin* (2010): Jean-Pierre Grallet, *Le manuel de pélerin: Jean Geiler de Kaysersberg* (Paris, 2010).

Graphische Symbole (1996): *Graphische Symbole in mittelalterlichen Urkunden. Beiträge zur diplomatischen Semiotik, Sigmaringen 1996*, ed. Peter Rück, Historische Hilfswissenschaften 3 (Sigmaringen, 1996).

Greber, *Textile Texte* (2002): Erika Grebe, *Textile Texte. Poetologische Metaphorik und Literaturtheorie. Studien zur Tradition des Wortflechtens und der Kombinatorik* (Cologne, 2002).

Green, 'Ivory' (1946): Rosalie B. Green, 'A Tenth-Century Ivory with the Response *Aspiciens a longe*', *Art Bulletin* 28 (1946), 112–14.

Greenhill, 'Child' (1954): Eleanor S. Greenhill, 'The Child in the Tree: A Study of the Cosmological Tree in Christian Tradition', *Traditio* 10 (1954), 323–71.

Grenz, *Named God* (2005): Stanley J. Grenz, *The Named God and the Question of Being: A Trinitarian Theo-Ontology* (Louisville, 2005), 241–46.

Grewe, *Wilhelm Schadow* (1998): Cordula A. Grewe, *Wilhelm Schadow (1788–1862). Monographie und catalogue raisonné* (Freiburg i. Br., 1998).

Grodecki, 'Vitreaux' (1961): Louis Grodecki, 'Les vitraux allégoriques de Saint-Denis', *Art de France* 1 (1961), 19–46.

Grosfillier, *Séquences* (2008): Jean Grosfillier, *Les Séquences d'Adam de Saint-Victor: Étude littéraire (poétique et rhétorique). Texts et traductions, commentaires*, Bibliotheca Victorina 20 (Turnhout, 2008).

Grubmüller, 'Übersetzungsliteratur' (1994): Klaus Grubmüller, 'Geistliche Übersetzungsliteratur im 15. Jahrhundert. Überlegungen zu ihrem literaturgeschichtlichen Ort', in: *Kirche und Gesellschaft im Heiligen Römischen Reich des 15. und 16. Jahrhunderts*, ed. Hartmut Boockmann, Abhandlungen der Akademie der Wissenschaften in Göttingen, Philologisch-historische Klasse 3/206 (Göttingen, 1994), 59–74.

Grünewald, 'Adventus' (2000): Thomas Grünewald, '*Adventus Augusti, adventus Christi*: Recherche sur l'exploitation idéologique et littéraire d'un cérémonial dans l'antiquité tardive', *Gnomon* 72 (2000) 426–29.

Grundmann, *Studien* (1927): Herbert Grundmann, *Studien über Joachim von Floris*, Beiträge zur Kulturgeschichte des Mittelalters und der Renaissance 32 (Leipzig, 1927).

Grundmann, *Bewegungen* (1935): Herbert Grundmann, *Religiöse Bewegungen im Mittelalter. Untersuchungen über die geschichtlichen Zusammenhänge zwischen der Ketzerei, den Bettelorden und der religiösen Frauenbewegung im 12. und 13. Jahrhundert*

und über die geschichtlichen Grundlagen der deutschen Mystik, Historische Studien 267 (Berlin, 1935; repr. 1977).

Grundmann, '"Litteratus-illitteratus"' (1958): Herbert Grundmann, '"Litteratus – illiteratus". Der Wandel einer Bildungsnorm vom Altertum zum Mittelalter', *Archiv für Kulturgeschichte* 40 (1958) 1–65.

Grundmann, 'Frauen und die Literatur' (1978): Herbert Grundmann, 'Die Frauen und die Literatur im Mittelalter. Ein Beitrag zur Frage nach der Entstehung des Schrifttums in der Volkssprache', in: *Grundmann, Ausgewählte Aufsätze* 3, Monumenta Germaniae Historica, Schriften 25, 3 (Stuttgart, 1978), 67–95.

Grundriss (1902): *Grundriss der romanischen Philologie* II/1, ed. Gustav Gröber (Strasbourg, 1902).

Grzybkowski, '*Dextrarum iunctio*' (1984): Andrzej Grzybkowski, 'Die *Dextrarum iunctio* auf dem Grabmal in Löwenberg', *Zeitschrift für Kunstgeschichte* 47 (1984), 59–69.

Guéranger, *L'année liturgique* (1871–1901): Prosper Guéranger, *L'année liturgique*, 15 vols. (Paris, 1871–1901).

Guéranger, *Liturgical Year* (1897–1910): Prosper Guéranger, *The Liturgical Year*, trans. Laurence Shepherd (London, 1897–1910).

Guerreau-Jalabert, 'L'arbre de Jessé' (1996): Anita Guerreau-Jalabert, 'L'arbre de Jessé et l'ordre chrétien de la parenté', in: *Marie* (1996), 137–70.

Guldan, *Eva und Maria* (1966): Ernst Guldan, *Eva und Maria. Eine Antithese als Bildmotiv* (Graz-Cologne, 1966).

Gumbrecht, *Production* (2004): Hans-Ulrich Gumbrecht, *Production of Presence: What Meaning Cannot Convey* (Stanford, 2004).

Gummlich, *Bildproduktion* (2003): Johanna Christine Gummlich, *Bildproduktion und Kontemplation. Ein Überblick über die Kölner Buchmalerei in der Gotik unter besonderer Berücksichtigung der Kreuzigungsdarstellung* (Weimar, 2003).

Gummlich-Wagner, 'Liturgische Bücher' (2000): Johanna Christine Gummlich-Wagner, 'Liturgische Bücher für den Kölner Dom. Domkanoniker als Stifter', in: *Kölnische Liturgie und ihre Geschichte. Studien zur interdisziplinären Erforschung des Gottesdienstes im Erzbistum Köln*, eds. Albert Gerhards & Andreas Odenthal, Liturgiewissenschaftliche Quellen und Forschungen 87 (Münster, 2000), 145–73.

Gummlich-Wagner, 'Zuschreibungen' (2000): Johanna Christine Gummlich-Wagner, 'Neue Zuschreibungen an das Kölner Klarissenskriptorium', *Wallraf-Richartz-Jahrbuch* 61 (2000), 23–40.

Gummlich-Wagner, 'Buchmalerei' (2005): Johanna Christine Gummlich-Wagner, 'Buchmalerei aus dem Kölner Minoriten-Skriptorium. Das Valkenburg-Graduale (Cod. 1001b der Diözesan- und Dombibliothek Köln) und sein Umfeld', in: *Mittelalterliche Handschriften der Kölner Dombibliothek. Erstes Symposion in der Erzbischöflichen Diözesan- und Dombibliothek Köln, 26. bis 27. November 2004*, ed. Heinz Finger, Libelli Rhenani 11 (Cologne, 2005), 286–338.

Gummlich-Wagner, 'Stilprägende Skriptorien' (2011): Johanna Gummlich-Wagner, 'Stilprägende Skriptorien in der gotischen Kölner Buchmalerei des 14. Jahrhunderts', in: *Glanz und Größe des Mittelalters. Kölner Meisterwerke aus den großen Sammlungen der Welt*, exh. cat. Cologne, Museum Schnütgen, eds. Dagmar Täube & Miriam Verena Fleck (Munich, 2011), 50–61.

Gummlich-Wagner, 'Memorialbilder' (2013): Johanna Christine Gummlich-Wagner, 'Memorialbilder und Kryptosignaturen in Handschriften aus dem Kölner Klarissenklöster St. Klara', in: *Wider das Vergessen und für das Seelenheil*, ed. Rainer Berndt, Erudiri Sapientia 9 (Münster, 2013), 251–69.

Gussone, 'Codex' (1995): Nikolaus Gussone, 'Der Codex auf dem Thron. Zur Ehrung des Evangelienbuches in Liturgie und Zeremoniell', in: *Wort und Buch in der Liturgie. Interdisziplinäre Beiträge zur Wirkmächtigkeit der Wortes und Zeichenhaftigkeit des Buches*, ed. Hanns Peter Neuhauser (St. Ottilien, 1995), 191–232.

Gy, 'L'office' (1985): Pierre-Marie Gy, 'L'office du Corpus Christi, oeuvre de S. Thomas d'Aquin', *Revue des Sciences philosophiques et théologiques* 69 (1985), 314–47.

Gy, *Liturgie* (1990): Pierre-Marie Gy, *La Liturgie dans l'histoire* (Paris, 1990), 223–45.

Gy, 'Ordinaire' (1992): Pierre-Marie Gy, 'L'ordinaire de Mende, une oeuvre inédite de Guillaume Durand l'ancien', in: *Liturgie et musique: IXe–XIVe s.*, Cahiers de Fanjeaux 17 (Toulouse, 1982), 239–249.

Haage, 'Gallus von Königssaal' (1980): Bernard D. Haage, 'Gallus von Königssaal', in: ²*VL* (Berlin, 1980), cols. 1063–65.

Haas, 'Gottesnamen' (2004): Alois M. Haas, 'Gottesnamen', in: *Mystik im Kontext* (Munich, 2004), 39–47.

Haefele, 'Inschriften' (1957): Hans F. Haefele, 'Die metrischen Inschriften auf der Altartafel Heinrichs II.', *Basler Zeitschrift für Geschichte und Alterstumkunde* 56 (1957), 25–34.

Härtel, *Gelehrte Bücher* (2006): Helmar Härtel, *Geschrieben und gemalt. Gelehrte Bücher aus Frauenhand. Eine Klosterbibliothek sächsischer Benediktinerinnen des 12. Jahrhunderts* (Wiesbaden, 2006).

Häußling, 'Messerklärungen' (1997): Angelus Albert Häußling, 'Messerklärungen (Expositiones missae)', in: *Christliche Identität aus der Liturgie. Theologische und historische Studien zum Gottesdienst der Kirche*, eds. Martin Klöckener et al. (Münster, 1997), 142–50.

Häußling, 'Witwenweihe' (1998): Angelus Albert Häußling, 'Witwenweihe', *LMA* 9 (1998), 281.

Hahn, *Strange Beauty* (2012): Cynthia Hahn, *Strange Beauty: Issues in the Meaning and Making of Reliquaries, 400–ca. 1204* (University Park, 2012).

Hale, 'Imitatio Mariae' (1989): Rosemary Drage Hale, 'Imitatio Mariae: Motherhood Motifs in Devotional Memoirs', in: *Medieval German Literature: Proceedings from the 23rd International Congress on Medieval Studies, Kalamazoo, Michigan, May 5–8, 1988*, ed. Albert Classen, Göppinger Arbeiten zur Germanistik (Göppingen, 1989), 129–46, repr. in *Mystics Quarterly* 16 (1990), 193–203.

Hale, 'Margaretha Ebner' (1999): Rosemary Drage Hale, 'Rocking the Cradle: Margaretha Ebner (Be)Holds the Divine', in: *Performance and Transformation: New Approaches to Late Medieval Spirituality*, eds. Mary A. Suydam & Joanna E. Ziegler (New York, 1999), 211–40.

B. Haller, 'Buchwesen Soest' (1996): Bertram Haller, 'Buchwesen, Literatur und Bildung in der Gesellschaft der Stadt Soest während des Spätmittelalters und der frühen Neuzeit', in: *Soest. Geschichte der Stadt* 2 (1996), 711–68.

B. Haller, 'Buchkunst' (2003): Bertram Haller, 'Buchkunst in westfälischen Klöstern — ein Überblick', in: *Westfälisches Klosterbuch* (2003), vol. 3, 625–82.

B. Haller, 'Westfälische Klosterbibliotheken' (2003): Bertram Haller, 'Westfälische Klosterbibliotheken nach der Säkularisation', in: *Klostersturm und Fürstenrevolution. Staat und Kirche zwischen Rhein und Weser, 1794–1803*, exh. cat., Museum für Kunst und Kulturgeschichte der Stadt Dortmund, ed. Ulrike Gärtner (Bönen, 2003), 242–53.

R. Haller, 'Mass Chants' (1986): Robert B. Haller, 'Early Dominican Mass Chants: A Witness to Thirteenth-Century Chant Style', Ph.D. dissertation, Catholic University of America (1986).

Halm, *Klosterleben* (2004): Cornelia Halm, *Klosterleben im Mittelalter. Die Dominikanerinnen in Lemgo. Von der Klostergründung bis zur Reformation*, Sonderveröffentlichungen des Naturwissenschaftlichen und Historischen Vereins für das Land Lippe 71 (Detmold, 2004).

Hamburger, 'Art' (1992): Jeffrey F. Hamburger, 'Art, Enclosure and the Cura Monialium: Prolegomena in the Guise of a Postscript', *Gesta* 31 (1992), 108–34.

Hamburger, 'Visual' (1989): Jeffrey F. Hamburger, 'The Visual and the Visionary: The Changing Role of the Image in Late Medieval Monastic Devotions', *Viator: Medieval and Renaissance Studies* 20 (1989), 161–82.

Hamburger, *Rothschild Canticles* (1990): Jeffrey F. Hamburger: *The Rothschild Canticles: Art and Mysticism in Flanders and the Rhineland ca. 1300* (New Haven, 1990).

Hamburger, *Nuns as Artists* (1997): Jeffrey F. Hamburger, *Nuns as Artists: The Visual Culture of a Medieval Convent* (Berkeley, 1997).

Hamburger, *Visual and Visionary* (1998): Jeffrey F. Hamburger, *Visual and the Visionary: Art and Female Spirituality in Late Medieval Germany* (New York, 1998).

Hamburger, 'Bibliothèque d'Unterlinden' (2000): Jeffrey F. Hamburger, 'La bibliothèque d'Unterlinden et l'art de la formation spirituelle', in: *Dominicaines* (2000), vol. 1, 110–59.

Hamburger, 'Speculations' (2000): Jeffrey F. Hamburger, 'Speculations on Speculation: Vision and Perception in the Theory and Practice of Mystical Devotions', in: *Deutsche Mystik im abendländischen Zusammenhang. Neu erschlossene Texte, neue methodische Ansätze, neue theoretische Konzepte*, Kolloquium Kloster Fischingen, eds. Walter Haug & Wolfram Schneider-Lastin (Tübingen, 2000), 353–408.

Hamburger, 'Women' (2001): Jeffrey F. Hamburger, 'Women and the Written Word in Medieval Switzerland/Frauen und Schriftlichkeit in der Schweiz im Mittelalter', in: *Bibliotheken Bauen—Tradition und Vision/Building for Books: Traditions and Visions*, eds. Susanne Bieri & Walther Fuchs (Bern, 2001), 71–164.

Hamburger, *St. John* (2002): Jeffrey F. Hamburger, *St. John the Divine: The Deified Evangelist in Medieval Art and Theology* (Berkeley, 2002).

Hamburger, '"Siegel"' (2002): Jeffrey F. Hamburger, '"Siegel der Ebenbildlichkeit, voll von Weisheit". Johannes der Evangelist und der Bildersprache der Vergöttlichung im Graduale von St. Katharinenthal', in: *Die Präsenz des Mittelalters in seinen Handschriften*, eds. Nigel F. Palmer & Hans-Jochen Schiewer (Tübingen, 2002), 115–37.

Hamburger, 'Eriugena' (2005): Jeffrey F. Hamburger, 'Johannes Scotus Eriugena deutsch redivivus: Translations of the *Vox spiritualis* in Relation to Art and Mysticism at the Time of Eckhart', in: *Meister Eckhart in Erfurt*, eds. Andreas Speer & Lydia Wegener, Miscellanea Mediaevalia 32 (Berlin, 2005), 473–537.

Hamburger, 'Work of Art' (2005): Jeffrey F. Hamburger, 'The Medieval Work of Art: Wherein the "Work"? Wherein the

"Art"?', in: *The Mind's Eye: Art and Theological Argument in the Middle Ages*, eds. Jeffrey F. Hamburger & Anne-Marie Bouché (Princeton, 2005), 374–412.

Hamburger, 'Rewriting History' (2005): Jeffrey F. Hamburger, 'Rewriting History: The Visual and the Vernacular in Late Medieval History Bibles', in: *Retextualisierung in der mittelalterlichen Literatur*, eds. Ursula Peters & Joachim Bumke, Zeitschrift für deutsche Philologie, Sonderheft 124 (Berlin, 2005), 259–307.

Hamburger, 'Overkill' (2007): Jeffrey F. Hamburger, 'Overkill, or History that Hurts', *Common Knowledge* 13 (2007), 404–28.

Hamburger, 'Visible' (2007): Jeffrey F. Hamburger, 'Visible, yet Secret: Images as Signs of Friendship in Seuse', in: *Amicitia— weltlich und geistlich. Festschrift for Nigel Palmer on the Occasion of his 60th Birthday*, eds. Annette Volfing & Hans-Jochen Schiewer, *Oxford German Studies* 36 (2007), 141–62.

Hamburger, 'Inscribing' (2008): Jeffrey F. Hamburger, 'Inscribing the Word—Illuminating the Sequence: Epithets in Honor of John the Evangelist in the Graduals from Paradies bei Soest', in: *Leaves from Paradise* (2008), 161–213.

Hamburger, 'Openings' (2009): Jeffrey F. Hamburger, 'Openings', in: *Imagination, Books and Community in Medieval Europe: Papers of a Conference held at the State Library of Victoria (Melbourne, Australia), 29–31 May, 2008*, ed. Gregory Kratzmann (Melbourne, 2009), 50–133.

Hamburger, 'Rahmenbedingungen' (2009): Jeffrey F. Hamburger, 'Rahmenbedingungen der Marienfrömmigkeit im Mittelalter', in: *Schöne Madonnen am Rhein. Rheinische Marienstatuen des schönen Stils*, exh. cat., LVR-LandesMuseum Bonn, ed. Robert Suckale (Bonn, 2009), 121–37.

Hamburger, 'Reading' (2009): Jeffrey F. Hamburger, 'Representations of Reading—Reading Representations: The Female Reader from the *Hedwig Codex* to Châtillon's *Léopoldine au Livre d'Heures*', in: *Die lesende Frau*, ed. Gabriela Signori, Wolfenbütteler Forschungen 121 (Wiesbaden, 2009), 177–239.

Hamburger, 'Magdalena Kremer' (2010): Jeffrey F. Hamburger, 'Magdalena Kremer, Scribe and Painter of the Dominican Convent of St. Johannes-Baptista in Kirchheim unter Teck', in: *The Medieval Book: Glosses from Friends & Colleagues of Christopher de Hamel*, eds. James Marrow et al. (London, 2010), 158–83.

Hamburger, '*Hrabanus redivivus*' (2014): Jeffrey F. Hamburger, '*Hrabanus redivivus*: Berthold of Nuremberg's Marian Supplement to *De laudibus sanctae crucis*', in: *Diagramm und Text. Diagrammatische Strukturen und die Dynamisierung von Wissen und Erfahrung. Überstorfer Colloquium 2012*, eds. Eckart Conrad Lutz et al., Scrinium Friburgense (Wiesbaden, 2014), 175–204.

Hamburger, *Script as Image* (2014): Jeffrey F. Hamburger, *Script as Image*, Corpus of Illuminated Manuscripts 21 (Louvain, 2014).

Jeffrey F. Hamburger, 'The Passion in Paradise: Liturgical Devotions for Holy Week in a Gradual from Paradies bei Soest and in Gertrude of Helfta's *Legatus divinae pietatis*', in: *Räume der Passion: Raumvisionen, Erinnerungsorte und Topographien des Leidens Christi in Mittelalter und Früher Neuzeit*, eds. Hans Aurenhammer & Daniela Bohde, Vestigia Bibliae 23–33 (Bern, 2015), 271–309.

Hamburger, 'Magdalena Kremerin' (2016): Jeffrey F. Hamburger, 'Magdalena Kremerin, Schreiberin und Malerin im Dominikanerinnenkloster St. Johannes des Täufers in Kirchheim unter Teck', in: *Chronik der Magdalena Kremerin* (2016), 162–82.

Hamburger, *Cross to Crucifix* (forthcoming): Jeffrey F. Hamburger, *From Cross to Crucifix: Sign, Symbol and Salvation History in Berthold of Nuremberg's Commentaries on Hrabanus Maurus and the Virgin Mary* (Chicago, forthcoming).

Hamburger et al., 'Medieval Hypertext' (2011): Jeffrey F. Hamburger, Susan Marti, & Drew Massey: 'Medieval Hypertext: The Illuminated Manuscript in the Age of Virtual Reproduction', in: *Bild und Text im Mittelalter*, eds. Barbara Schellewald & Karin Krause, Sensus. Studien zur mittelalterlichen Kunst 2 (Cologne, 2011), 365–408.

Hamburger & Palmer, *Prayer Book* (2015): Jeffrey F. Hamburger & Nigel F. Palmer, *The Prayer Book of Ursula Begerin*, 2 vols. (Dietikon, 2015).

Hamburger & Schlotheuber, 'Books' (2014): Jeffrey F. Hamburger & Eva Schlotheuber, 'Books in Women's Hands: Liturgy, Learning and the Libraries of Dominican Nuns in Westphalia', in: *Entre stabilité et itinérance: livres et culture des ordres mendiants (13e–15e siècles). 19-20 novembre 2010*, Colloque de clôture des travaux du groupe de recherche 'Les frères et les sœurs des ordres mendiants et leurs livres', eds. Nicole Bériou & Martin Morard (Turnhout, 2014), 129–57.

Hamburger & Signori, *Catherine of Siena* (2013): Jeffrey F. Hamburger & Gabriela Signori, *Catherine of Siena: The Creation of a Cult*, Medieval Women: Texts and Contexts 13 (Turnhout, 2013).

Hamel, *Glossed Books* (1984): Christopher de Hamel, *Glossed Books of the Bible and the Origins and the Paris Booktrade* (Woodbridge, Suffolk–Dover, N.H., 1984).

Hamel, *Cutting up Manuscripts* (1996): Christopher de Hamel, *Cutting up Manuscripts for Pleasure and Profit: The 1995 Sol. M. Malkin Lecture in Bibliography* (Charlottesville, 1996).

Hamel, 'Giant Bible' (2006): Christopher de Hamel, 'Dates in the Giant Bible of Mainz', in: *Tributes in Honor of James H. Marrow:*

Studies in Painting and Manuscript Illumination of the Late Middle Ages and Northern Renaissance, eds. Jeffrey F. Hamburger & Anne S. Korteweg (Turnhout, 2006), 173–83.

Hamm, *Frömmigkeitstheologie* (1982): Berndt Hamm, *Frömmigkeitstheologie am Anfang des 16. Jahrhunderts. Studien zu Johannes von Paltz und seinem Umkreis*, Beiträge zur historischen Theologie 65 (Tübingen, 1982).

Hamm, 'Normative Zentrierung' (1999): Berndt Hamm, 'Normative Zentrierung im 15. und 16. Jahrhundert. Beobachtungen zu Religiosität, Theologie und Ikonologie', *Zeitschrift für historische Forschung* 26 (1999), 163–202.

Hamm, *Reformation* (2004): Berndt Hamm, *The Reformation of Faith in the Context of Late Medieval Theology and Piety*, ed. Robert J. Bast, Studies in the History of Christian Thought 110 (Leiden-Boston, 2004).

Handbuch (1804): *Handbuch über den Königlich Preussischen Hof und Staat für das Jahr 1804* (Berlin, 1804).

Handschin, 'Apologetik' (1949): Jacques Handschin, 'Gesungene Apologetik', in: *Miscellanea Liturgica in honorem L. Cuniberti Mohlberg*, 2 vols., Bibliotheca 'Ephemerides Liturgicae' 23 (Rome, 1949), 75–106.

Handschriften Düsseldorf (2015): *Die mittelalterlichen Handschriften und Fragmente der Signaturengruppe D in der Universitäts- und Landesbibliothek Düsseldorf*, eds. Irmgard Siebert & Anne Liewert 2 vols. (Dusseldorf–Wiesbaden, 2015).

Handschriftenerbe (1989–1990): *Handschriftenerbe des deutschen Mittelalters*, ed. Sigrid Krämer, Mittelalterliche Bibliothekskataloge. Ergänzungsband I, 1–3 (Munich, 1989–1990).

Hardison, *Christian Rite* (1965): Osbourne Bennett Hardison, Jr., *Christian Rite and Christian Drama in the Middle Ages: Essays in the Origin and Early History of Modern Drama* (Baltimore, 1965).

Harrison, 'Liturgical Piety' (2009): Anna Harrison, '"I am Wholly Your Own": Liturgical Piety and Community among the Nuns of Helfta', *Church History* 78 (2009), 549–83.

Harissiadis, 'Trinité' (1984): Constantin Harissiadis, 'La Trinité dans les Offices de la Pentecôte', in: *Trinité det liturgie: Conférences Saint-Serge, XXXe semaine d'études liturgiques, Paris, 28 juin – 1er juillet 1983*, Bibliotheca 'Ephemerides Liturgicae': Subsidia 32 (Rome, 1984), 119–35.

Hartmann, *Königin* (2009): Martina Hartmann, *Die Königin im frühen Mittelalter* (Stuttgart, 2009).

Hascher-Burger, 'Handschriften' (2013): Ulrike Hascher-Burger, 'Handschriften mit Notation aus den niedersächsischen Au-gustiner-Chorfrauenstiften Steterburg, Heiningen und Dorstadt', in: *Rosenkränze und Seelengärten. Bildung und Frömmigkeit in niedersächsischen Frauenklöstern*, ed. Britta-Juliane Kruse, Ausstellungskataloge der Herzog August Bibliothek 96 (Wolfenbüttel, 2013), 108–15.

Hasebrink, 'Tischlesung' (1996): Burkhard Hasebrink, 'Tischlesung und Bildungskultur im Nürnberger Katharinenkloster. Ein Beitrag zu ihrer Rekonstruktion', in: *Schule und Schüler im Mittlalter*, eds. Martin Kintzinger et al., Beihefte zum Archiv für Kulturgeschichte 42 (Cologne et al., 1996), 187–216.

Hasebrink, 'Latinität' (2000): Burkhard Hasebrink, 'Latinität als Bildungsfundament: Spuren subsidiärer Grammatikunterweisung im Dominikanerorden', in: *Schulliteratur im späten Mittelalter*, ed. Klaus Grubmüller, Münstersche Mittelalter-Schriften 69 (Munich, 2000), 49–76.

Hasebrinck, 'Zersetzung' (2000): Burkhard Hasebrink, 'Zersetzung? Eine Neubewertung der Eckhartkompilation in Spamers Mosaiktrakten', in: *Literarische Formen des Mittelalters. Florilegien, Kompilationen, Kollektionen*, ed. Kaspar Elm, Wolfenbüttler Mittelalter-Studien 15 (Wiesbaden, 2000), 73–90.

Hathaway, '*Compilatio*' (1989): Neil Hathaway, '*Compilatio*: From Plagarism to Compiling', *Viator: Medieval and Renaissance Studies* 20 (1989), 19–44.

Hauréau, *Notices* (1892): Barthélemy Hauréau, *Notices et extraits de quelques manuscrits latins de la Bibliothèque Nationale*, vol. 5: *Fonds de la Sorbonne* (Paris, 1892).

Hausmann, *Handschriften* (1992): Regina Hausmann, *Die theologischen Handschriften der Hessischen Landesbibliothek Fulda bis zum Jahr 1600. Codices Bonifatiani 1–3 Aa, 1–1145a* (Wiesbaden, 1992).

Haverkamp, 'Tenxwind von Andernach' (1997): Alfred Haverkamp, 'Tenxwind von Andernach und Hildegard von Bingen. Zwei "Weltanschauungen" in der Mitte des 12. Jahrhunderts', in: *Verfassung, Kultur, Lebensform. Beiträge zur italienischen, deutschen und jüdischen Geschichte im europäischen Mittelalter. Dem Autor zur Vollendung des 60. Lebensjahres*, eds. Alfred Haverkamp et al. (Mainz, 1997), 321–60.

Heath, '"Nomina sacra"' (2010): Jane Heath, ' "Nomina sacra" and "sacra memoria" before the Monastic Age', *The Journal of Theological Studies* 61 (2010), 516–49.

Hecht, '*Imago pietatis*' (2006): Christian Hecht, 'Die *imago pietatis*. Überlegungen zur Entstehung eines mittelalterlichen Bildthemas', *Römisches Jahrbuch der Bibliotheca Hertziana* 36 (2006), 9–44.

Heck, 'Deux saints Jean' (1979): Christian Heck, 'Les deux saints Jean: étude de l'iconographie jumelée de Saint Jean-Baptiste et de Saint Jean-L'Évangeliste en Occident, des origines à la fin du moyen âge', Ph.D. dissertation, Université de Provence, Aix-en-Provence (1979).

Heck, 'Portail' (1989): Christian Heck, 'Le portail à l'agneau de la cathédrale de Fribourg-en-Brisgau', *Cahiers alsaciens d'archéologie, d'art et d'histoire* 32 (1989), 165–76 (Mélanges offerts à Robert Will).

Heck, 'Rapprochement' (1990): Christian Heck, 'Rapprochement, antagonisme, ou confusion dans le culte des saints: Art et dévotion à Katharinenthal au quatorzième siècle', *Viator: Medieval and Renaissance Studies* 21 (1990), 229–38.

Heiland-Justi, *Graduale* (2012): Werner Heiland-Justi, *Das Graduale des Klosters Wonnental bei Kenzingen* (Lindenberg in Allgäu, 2012).

Heilige Überlieferung (1938): *Heilige Überlieferung. Ausschnitte aus der Geschichte des Mönchtums und des heiligen Kultes. Ildefons Herwegen zum silbernen Abtsjubiläum dargeboten*, ed. Odo Casel (Münster, 1938), 263–84.

Heimann, 'Beobachtungen' (2002): Claudia Heimann, 'Beobachtungen zur Arbeitsweise von Johannes Meyer OP anhand seiner Aussagen über die Reform der Dominikanerkonvente der Teutonia', *Archivum Fratrum Praedicatorum* 72 (2002), 187–220.

Heinz, 'Schlussantiphonen' (1989): Andreas Heinz, 'Die Marianischen Schlussantiphonen der Tagzeitenliturgie. Alma redemptoris mater—Ave, regina caelorum—Regina caeli—Salve regina—Sub tuum praesidium', in: *Christus- und Marienlob in Liturgie und Volksgebet*, ed. Andreas Heinz (Trier, 1989), 114–35.

Heinz, 'Antijudaismus' (2010): Andreas Heinz, 'Antijudaismus in der römischen Liturgie?', in: Andreas Heinz, *Lebendiges Erbe. Beiträge zur abendländischen Liturgie- und Frömmigkeitsgeschichte* (Tübingen, 2010), 242–62.

Heinz, 'Erzengel Michael' (2010): Andreas Heinz, 'Der heilige Erzengel Michael—Schutzpatron der Deutschen? Geschichte—Kult—Liturgie', in: Andreas Heinz, *Lebendiges Erbe. Beiträge zur abendländischen Liturgie- und Frömmigkeitsgeschichte* (Tübingen, 2010), 263–79.

Heinzer, 'Kodifizierung' (2000): Felix Heinzer, 'Kodifizierung und Vereinheitlichung liturgischer Traditionen. Historisches Phänomen und Interpretationsschlüssel handschriftlicher Überlieferung', in: *Musik in Mecklenburg. Beiträge eines Kolloquiums zur mecklenburgischen Musikgeschichte veranstaltet vom Institut für Musikwissenschaft der Universität Rostock 24.–27. September 1997*, Studien und Materialien zur Musikwissenschaft 21 (Hildesheim, 2000), 85–106.

Heinzer, *Wörtliche Bilder* (2005): Felix Heinzer, *Wörtliche Bilder. Zur Funktion der Literal-Illustration im Stuttgarter Psalter (um 830)*, Wolfgang Stammler Gastprofessur 9 (Berlin, 2005).

Heinzer, '*Figura*' (2013): Felix Heinzer, '*Figura* zwischen Präsenz und Diskurs. Das Verhältnis des 'gregorianischen' Messgesangs zu seiner dichterischen Erweiterung (Tropus und Sequenz)', in: *Figura. Dynamiken der Zeiten und Zeichen im Mittelalter*, eds. Christian Kiening & Katharina Mertens Fleury, Philologie der Kultur 8 (Würzburg, 2013), 71–90.

Heinzer & Stamm, *Handschriften* (1984): Felix Heinzer & Gerhard Stamm, *Die Handschriften von St. Peter im Schwarzwald. Die Pergamenthandschriften*, Die Handschriten der Badischen Landesbibliothek in Karlsruhe 10/2 (Wiesbaden, 1984).

Heitmeyer-Löns, 'Lesepultdecke' (2009): Sabine Heitmeyer-Löns, 'Die Soester Lesepultdecke. Restauriert für die Zukunft?', *Soester Zeitschrift. Zeitschrift des Vereins für Geschichte und Heimatpflege Soest* (2009), 75–80.

Helas, 'Bildprogramme' (2011): Philine Helas, 'Bildprogramme karitativer Institutionen in Mittelalter und Renaissance', in: *Armut. Perspektiven in Kunst und Gesellschaft, 10. April 2011 – 31. Juli 2011. Eine Ausstellung des Sonderforschungsbereichs 600 'Fremdheit und Armut', Universität Trier*, eds. Herbert Uerlings et al. (Darmstadt, 2011), 186–95.

Hellgardt, *Zahlenkomposition* (1973): Ernst Hellgardt, *Zum Problem symbolbestimmter und formalästhetischer Zahlenkomposition in mittelalterlicher Literatur, mit Studien zum Quadrivium und zur Vorgeschichte des mittelalterlichen Zahlendenkens*, Münchener Texte und Untersuchungen 45 (Munich, 1973).

Hellgardt, 'Latin' (2014): Ernst Hellgardt, 'Latin and the Vernacular: Mechthild of Magdeburg—Mechthild of Hackeborn—Gertrude of Helfta', in: *A Companion to Mysticism and Devotion in Northern Germany* (2014), 131–55.

Helvétius, 'Virgo et virago' (1999): Anne-Marie Helvétius, 'Virgo et virago. Réflexions sur le pouvoir du voile consacré d'après les sources hagiographiques de la Gaule du Nord', in: *Femmes et pouvoirs des femmes à Byzance et en Occident (VIe–XIe siècle)*, eds. Stéphane Lebecq et al., Centre de Recherche sur l'Histoire de l'Europe du Nord-Ouest 19 (Lille, 1999), 189–203.

Helvétius, 'L'organisation des monastères féminins' (2011): Anne-Marie Helvétius, 'L'organisation des monastères féminins à l'époque mérovingienne', in: *Female "vita religiosa" between Late Antiquity and the High Middle Ages: Structures, Developments and Spatial Contexts*, eds. Gert Melville & Anne Müller, Vita regularis – Ordnungen und Deutungen religiösen Lebens im Mittelalter. Abhandlungen 47 (Vienna et al., 2011), 151–72.

Henkel, 'Bildtexte' (1989): Nikolaus Henkel, 'Bildtexte. Die Spruchbänder in der Berliner Handschrift von Heinrichs von Veldeke Eneasroman', in: *Poesis et pictura. Studien zum Verhältnis von Text und Bild in Handschriften und alten Drucken. Festschrift für Dieter Wuttke zum 60. Geburtstag*, eds. Stephan Füssel & Joachim Knape, Saecula Spiritualia (Baden-Baden, 1989), 49–76.

Henkel, 'Ecloga' (1991): Nikolaus Henkel, 'Die Ecloga Theodoli und ihre literarischen Gegenkonzeptionen', *Mittellateinisches Jahrbuch* 24–25 (1989–1990 [1991]), 151–62.

Henkel, 'Theodolus' (1995): Nikolaus Henkel, 'Theodolus', in: ²*VL* 9 (Berlin, 1995), cols. 760–64.

Henkel, 'Bild und Text' (2000): Nikolaus Henkel, 'Bild und Text. Die Spruchbänder der ehem. Berliner Handschrift von Priester Wernhers "Maria"', in: *Scrinium Berolinense. Tilo Brandis zum 65. Geburtstag*, ed. Peter Jörg Becker (Berlin, 2000), 246–75.

Henkel, 'Textüberlieferung' (2004): Nikolaus Henkel, 'Textüberlieferung und Performanz. Überlieferung zum Zeugniswert geistlicher Feiern und Spiele des frühen und hohen Mittelalters', in: *Das Theater des Mittelalters und der frühen Neuzeit als Ort und Medium sozialer und symbolischer Kommunikation*, eds. Christel Meier et al., Symbolische Kommunikation und gesellschaftliche Wertsysteme. Schriftenreihe des Sonderforschungsbereiche 496, vol. 4 (Münster, 2004), 23–43.

Hennessy, 'Blood Piety' (2007): Marlene Villalobos Hennessy, 'Aspects of Blood Piety in a Late Medieval English Manuscript', in: *History in the Comic Mode: Medieval Communities and the Matter of Person*, eds. Rachel Fulton & Bruce W. Holsinger (New York, 2007), 182–91.

Hennessy, 'Christ's Blood' (2011): Marlene Villalobos Hennessy, 'The Social Life of a Manuscript Metaphor: Christ's Blood as Ink' in: *The Social Life of Illumination: Manuscripts, Images, and Communities in the Late Middle Ages*, eds. Joyce Coleman et al., Medieval Texts and Cultures of Northern Europe 21 (Turnhout, 2013), 17–52.

J. Hennig, 'Abraham' (1966): John Hennig, 'Zur Stellung Abrahams in der Liturgie', *Archiv für Liturgiewissenschaft* 9 (1966), 349–66.

J. Hennig, 'David' (1967): John Hennig, 'Zur Stellung Davids in der Liturgie', *Archiv für Liturgiewissenschaft* 10 (1967), 157–64.

U. Hennig, '*Planctus*' (1992): Ursula Hennig, 'Die lateinische Sequenz Planctus ante nescia und die deutschen Marienklagen', in: *Latein und Volkssprache* (1992), 164–77.

Henri de Lubac (1966): *Henri de Lubac et le mystère de l'Église: actes du colloque du 12 octobre 1996 à l'Institut de France*, Études lubaciennes 1 (Paris, 1966).

Hermann, 'Bauinschrift' (2013): Sonja Hermann, 'Die Bauinschrift im Hauptchor der Wiesenkirche', in: *St. Maria zur Wiese, Soest*, ed. Jürgen Prigl (Munich, 2013), 74–80.

Hernad, *Handschriften* (2000): Béatrice Hernad with Andreas Weiner, *Die gotischen Handschriften deutscher Herkunft in der Bayerischen Staatsbibliothek, Teil I. Vom späten 13. bis zur Mitte des 14. Jahrhunderts*, Katalog der illuminierten Handschriften der Bayerischen Staatsbibliothek in München 5 (Wiesbaden, 2000).

Heusinger, *Johannes Mulberg* (2000): Sabine von Heusinger, *Johannes Mulberg OP (gest. 1414). Ein Leben im Spannungsfeld von Dominikanerobservanz und Beginenstreit*, Quellen und Forschungen zur Geschichte des Dominikanerordens, N.F. 9 (Berlin, 2000).

Hiley, *Plainchant* (1993): David Hiley, *Western Plainchant: A Handbook* (Oxford, 1993).

Hilg, *Handschriften* (1983): Hardo Hilg, *Die lateinischen mittelalterlichen Handschriften, Teil 1. Hs 17a–22921*, Die Handschriften des Germanischen Nationalmuseums Nürnberg 2/11 (Wiesbaden, 1983).

Hill, 'Scribe' (2003): Charles E. Hill, 'Did the Scribe of P52 Use the *Nomina Sacra*? Another Look', *Tyndale Bulletin* 54 (2003), 1–14.

Hillenbrand, 'Observantenbewegung' (1989): Eugen Hillenbrand, 'Die Observantenbewegung in der deutschen Ordensprovinz der Dominikaner', in: *Reformbemühungen und Observanzbestrebungen im spätmittelalterlichen Ordenswesen*, ed. Kaspar Elm, Berliner Historische Studien 14; Ordensstudien 6 (Berlin, 1989), 219–71.

Hilpisch, 'Chorgebet' (1938): Stephanus Hilpisch, 'Chorgebet und Frömmigkeit im Spätmittelalter', in: *Heilige Überlieferung. Ausschnitte aus der Geschichte des Mönchtums und des heiligen Kultes, Festgabe zum silbernen Abtsjubiläum von Ildefons Herwegen*, ed. Odo Casel (Münster, 1938), 263–84.

Hindman, 'Roles' (1983): Sandra Hindman, 'The Roles of the Author and the Artist in the Procedure of Illuminating Late Medieval Texts', in: *Text and Image*, ed. David W. Burchmore, Acta 10 (Binghamton, 1983), 27–62.

Hindsley, *Mystics* (1998): Leonard Patrick Hindsley, *The Mystics of Engelthal: Writings from a Medieval Monastery* (New York, 1998).

Hinnebusch, *Dominicans* (1985): William A. Hinnebusch, *The Dominicans: A Short History* (Dublin, 1985).

Hinnebusch, *History* (1973): William A. Hinnebusch, *The History of the Dominican Order*, 2 vols. (New York, 1966–1973).

Hirbodian, 'Töchter der Stadt' (2011): Sigrid Hirbodian, 'Töchter der Stadt oder Fremde? Geistliche Frauen im spätmittelalterlichen Straßburg zwischen Einbindung und Absonderung', in: *Das Markgräflerland. Kloster und Stadt am südlichen Oberrhein im späten Mittelalter und in der frühen Neuzeit* 2, ed. Geschichtsverein Markgräflerland (Schopfheim, 2011), 52–70.

Hirbodian, 'Dominikanerinnenreform' (2012): Sigrid Hirbodian, 'Dominikanerinnenreform und Familienpolitik. Die Einführung der Observanz im Kontext städtischer Sozialgeschichte', in: *Schreiben und Lesen* (2012), 1–16.

Hirbodian, 'Pastors and Seducers' (2014): Sigrid Hirbodian, 'Pastors and Seducers: The Practice of the Cura Monialium in Mendicant Convents in Strasbourg', in: *Partners in Spirit: Women, Men and Religious Life in Germany 1100–1500*, eds. Fiona J. Griffiths & Julie Hotchin, Medieval Women: Texts and Contexts 24 (Turnhout, 2014), 303–37.

Hlaváčková, 'Illumination' (2003): Hana Jana Hlaváčková, 'Die Illumination der liturgischen Handschriften des Arnestus von Pardubice', *Miscellanea Musicologica* 38 (2003), 47–62.

A. Hömberg, 'Geschichte' (1950): Albert K. Hömberg, 'Geschichte der Comitate des Werler Grafenhauses', *Westfälische Zeitschrift. Zeitschrift für vaterländische Geschichte und Altertumskunde* 100 (1950), 9–134.

M. Hömberg, *Wirtschafts(buch)führung* (2012–2013): Melanie Hömberg, *Wirtschafts(buch)führung im Kontext. Der Umgang mit Schriftlichkeit in reformierten Frauenklöstern in Süddeutschland*, Ph.D. dissertation, Ludwig-Maximilians Universität, Munich (2012–2013). Available online: https://edoc.ub.uni-muenchen.de/19134/1/Hoemberg_Melanie.pdf

Hömig, 'Lacomblet, Theodor Joseph' (1982): Herbert Hömig, 'Lacomblet, Theodor Joseph', in: *Neue Deutsche Biographie* 13 (1982), 380–81.

Holladay, 'Willehalm Master' (1995): Joan A. Holladay, 'The Willehalm Master and his Colleagues: Collaborative Manuscript Decoration in Early-Fourteenth-Century Cologne', in: *Making the Medieval Book: Techniques of Production: Proceedings of the Fourth Conference of The Seminar in the History of the Book to 1500*, ed. Linda L. Brownrigg (Los Altos Hills–London, 1995), 67–91.

Holladay, *Kassel Willehalm* (1996): Joan A. Holladay, *Illuminating the Epic: The Kassel Willehalm Codex and the Landgraves of Hesse in the Early Fourteenth Century*, College Art Association Monographs on the Fine Arts 54 (Seattle–London, 1996).

Holladay, 'Arguments' (1997): Joan A. Holladay, 'Some Arguments for a Wider View of Cologne Book Painting in the Early 14th Century', *Georges-Bloch-Jahrbuch des Kunstgeschichtlichen Seminars der Universität Zürich* 4 (1997), 5–21.

Hollander, 'Dante' (2000): John Hollander, 'Dante "Theologus-Poeta"', *Dante Studies* 118 (2000), 261–302.

Holsinger, 'Liturgy' (2007): Bruce Holsinger, 'Liturgy', in: *Oxford Twenty-First Century Approaches to Literature: Middle English*, ed. Paul Strohm, Oxford Twenty-First Century Appoaches to Literature (Oxford, 2007), 295–314.

Holy Face (1998): *The Holy Face and the Paradox of Representation: Papers from a Colloquium held at the Bibliotheca Herziana, Rome, and the Villa Spelman, Florence, 1996*, eds. Herbert L. Kessler & Gerhard Wolf (Bologna, 1998).

Honecker, 'Christus medicus' (1986): Martin Honecker, 'Christus medicus', in: *Der kranke Mensch in Mittelalter und Renaissance*, in: *Ringvorlesung im Wintersemester 1984/85*, ed. Peter Wunderli, Studia humaniora. Düsseldorfer Studien zu Mittelalter und Renaissance 5 (Dusseldorf, 1986), 27–43.

Honemann, Volker, 'Dominikanerinnen-Konstitutionen' (1980): Volker Honemann, 'Dominikanerinnen-Konstitutionen', in: ²*VL* 2 (Berlin, 1980), cols. 188–89.

Hood, 'Sacre Monte' (1984): William Hood, 'The Sacro Monte of Varallo: Renaissance Art and Popular Religion', in: *Monasticism and the Arts*, ed. Timothy Gregory Verdon, with the assistance of John Dally, Monasticism and the Arts 1 (Syracuse, 1984), 291–311.

Hopf, *Handschriften* (1994): Cornelia Hopf, *Die abendländischen Handschriften der Forschungs- und Landesbibliothek Gotha. Bestandverzeichnis 1. Großformatige Pergamenthandschriften Mem. I* (Gotha, 1994).

Horie, *Perceptions* (2006): Ruth Horie, *Perceptions of Ecclesia: Church and Soul in Medieval Dedication Sermons*, Sermo: Studies on Patristic, Medieval, and Reformation Sermons and Preaching 2 (Turnhout, 2006).

Horton, *Melchizedek* (1976): Fred L. Horton Jr., *The Melchizedek Tradition: A Critical Examination of the Sources to the Fifth Century A.D. and in the Epistle to the Hebrews* (Cambridge, 1976).

Houssiau, 'Liturgie' (1990): Fred L. Houssiau, 'La liturgie comme manifestation du temps de Dieu dans le temps des hommes', in: *Rituels: Mélanges offerts au Père Gy* (Paris, 1990), 327–37.

Howe, *Ceremonial Culture* (2007): Nicholas Howe, *Ceremonial Culture in Pre-Modern Europe* (Notre Dame, 2007).

Hubrath, *Schreiben* (1996): Margarete Hubrath, *Schreiben und Erinnern. Zur 'Memoria' im Liber Specialis Gratiae Mechthilds von Hakeborn* (Paderborn, 1996).

Hucker, 'Johann von Lunen' (1981–1982): Bernd Ulrich Hucker, 'Der Köln-Soester Fernhändler Johann von Lunen (1415–1443)

und die hansischen Gesellschaften Falbrecht & Co. und v. d. Hosen & Co.', in: *Soest. Stadt—Territorium—Reich. Festschrift zum 100 jährigen Bestehen des Vereins für Geschichte und Heimatpflege Soest*, ed. Gerhard Köhn, *Soester Zeitschrift* 92–93 (Soest, 1981–1982), 383–421.

Huebner & Plotzek-Wederhake, 'Antiphonar' (1999): Dietmar von Huebner & Gudrun Plotzek-Wederhake: 'Antiphonar, Antiphonarius', *LMA* 1 (1999), 722–24.

Hülsberg, *Untersuchungen* (2007): Jennifer Hülsberg, *Untersuchungen zum Valkenburg-Graduale. Codex 1001b der Diözesanbibliothek Köln*, Libelli Rhenani 22 (Cologne, 2007).

Hülsberg, 'Untersuchungen' (2008): Jennifer Hülsberg, 'Untersuchungen zum Valkenburg-Graduale', in: *Mittelalterliche Handschriften der Kölner Dombibliothek. Zweites Symposium der Diözesan- und Dombibliothek Köln zu den Dom-Manuskripten (1. bis 2. Dezember 2006)*, ed. Heinz Finger, Libelli Rhenani 24 (Cologne, 2008), 301–19.

A. Hughes, *Manuscripts* (1982): Andrew Hughes, *Medieval Manuscripts for Mass and Office: A Guide to Their Organization and Terminology* (Toronto–Buffalo–London, 1982).

A. Hughes, 'Late Medieval Plainchant' (2001): Andrew Hughes, 'Late Medieval Plainchant for the Divine Office', in: *Music as Concept and Practice in the Late Middle Ages,* eds. Reinhard Strohm & Bonnie Blackburn (Oxford, 2001), 31–96.

D. Hughes, 'Musical Text' (2007): David G. Hughes, 'The Musical Text of the Introit "Resurrexi"', in: *Music in Medieval Europe: Studies in Honour of Bryan Gillingham*, eds. Terence Bailey & Alma Colk Santosuosso (Burlington, Vt., 2007), 163–80.

Huglo, 'Poissy' (1990): Michel Huglo, 'Les processionnaux de Poissy', in: *Rituels: Mélanges offerts à Pierre-Marie Gy, O.P.*, eds. Paul de Clerc & Éric Palazzo (Paris, 1990), 339–46.

Huglo, 'Musica' (1994): Michel Huglo, 'La Musica du Fr. Prechêur Jérôme de Moray', in: *Max Lütolf zum 60. Geburtstag: Festschrift*, eds. Bernard Hangartner & Urs Fischer (Basel, 1994), 113–16.

Huglo, '"Prototype"' (2004): Michel Huglo, 'Comparison du "protoype" du couvent Saint-Jacques de Paris avec l'exemplaire personnel du maître de l'Ordre des prêcheurs (Londres, British Library, Add. Ms. 23935)', in: *Aux origines* (2004), 197–211.

Huglo, 'Processionnal' (2004): Michel Huglo, 'Les manuscrits du processionnal—premier bilan', in: *Die Erschließung der Quellen des mittelalterlichen Gesangs*, ed. David Hiley, Wolfenbütteler Mittelalter-Studien 18 (Wiesbaden, 2004), 155–60.

Huglo, 'Salve Festa Dies' (2006): Michel Huglo, 'Les versus Salve Festa Dies: leur dissémination dans les manuscrits du proces-

sionnal', in: *Papers read at the 12th Conference of the IMS Study Group Cantus Planus, Lillefüred (Hungary), 2004*, ed. László Dobszay (Budapest, 2006), 595–605.

Huglo, 'Books' (2011): Michel Huglo, 'Dominican and Franciscan Books: Similarities and Differences between their Notation', in: *The Calligraphy of Medieval Music*, ed. John Haines, Musicalia Medii Aevi 1 (Turnhout, 2011), 195–202.

Hurtado, 'Origin' (1998): Larry W. Hurtado, 'The Origin of the *nomina sacra*: A Proposal', *Journal of Biblical Literature* 117 (1998), 655–73.

Hurtado, 'P52' (2003): Larry W. Hurtado, 'P52 (P. Rylands Gk, 457) and the *Nomina Sacra*: Method and Probability', *Tyndale Bulletin* 54 (2003), 1–14.

Hurtado, *Artifacts* (2006): Larry W. Hurtado, *The Earliest Christian Artifacts: Manuscripts and Christian Origins* (Grand Rapids, 2006).

Hurtado, 'Staurogram' (2006): Larry W. Hurtado, 'The Staurogram in Early Christian Manuscripts: The Earliest Visual Reference to the Crucified Jesus?' in: *New Testament Manuscripts: Their Text and Their World*, eds. Thomas J. Kraus & Tobias Nicklas, Texts and Editions for New Testament Study 2 (Leiden, 2006), 207–26.

Hust, 'Bemerkungen' (2001): Christoph Hust, 'Bemerkungen zu einer Abrechnung über die Herstellung und Ausstattung eines Antiphonars des 14. Jahrhunderts', *Gutenberg-Jahrbuch* 76 (2001), 60–66.

Huygens, 'Commentaires' (2000): Robert B. C. Huygens, 'Commentaires sur la séquence "Ave, praeclara maris stella"', in: *Serta Mediaevalia: Textus varii saeculorum X–XIII in unum collecti*, ed. Robert B. C. Huygens, CCCM 171–171A (Turnhout, 2000), 409–90.

Iconicity of Script (2001): *The Iconicity of Script: Writing as Image in the Middle Ages,* ed. Jeffrey F. Hamburger, special issue of *Word & Image* 27 (2001).

Iconoclash (2002): *Iconoclash: Beyond the Image Wars in Science, Religion and Art*, eds. Bruno Latour & Peter Weibel (Karlsruhe, 2002).

Ilgen, *Die westfälischen Siegel 3* (1889): Theodor Ilgen, *Die westfälschen Siegel des Mittelalters*, Heft 3: Die Siegel der geistlichen Corporationen und der Stifts-, Kloster- und Pfarrgeistlichkeit, mit Unterstützung der Landstände der Provinz ed. vom Verein für Geschichte und Alterthumskunde Westfalens (Münster, 1889).

Ilisch, 'Agatha' (1986): Peter Ilisch, 'St. Agatha als Feuerbeschützerin', in: *Dokumentation zur Entwicklung des Feuerlöschwesens,*

ed. Schieferbergbau- und Heimatmuseum Schmallenberg-Holthausen (Schmallenberg-Holthausen, 1986), 386–91.

Ilisch & Kösters, *Patrozinien* (1992): Peter Ilisch & Christoph Kösters, *Die Patrozinien Westfalens von den Anfängen bis zum Ende des Alten Reiches*, Westfalia sacra. Quellen und Forschungen zur Kirchengeschichte Westfalens 11 (Münster, 1992).

Illich, *Vineyard* (1993): Ivan Illich, *In the Vineyard of the Text: A Commentary to Hugh's Didascalicon* (Chicago, 1993).

Illuminated Psalter (2004): *The Illuminated Psalter: Studies in the Content, Purpose and Placement of its Images*, ed. Frank O. Büttner (Turnhout, 2004).

Imagination (1993): *Imagination des Unsichtbaren. 1200 Jahre Bildende Kunst im Bistum Münster*, ed. Géza Jázai (Münster, 1993).

Inschriften der Stadt Lemgo (2004): *Die Inschriften der Stadt Lemgo. Nach der Sammlung und den Vorarbeiten von Hans Fuhrmann*, eds. Kristine Weber & Sabine Wehking, Die Deutschen Inschriften 59; Die Deutschen Inschriften. Düsseldorfer Reihe 6 (Wiesbaden, 2004).

Iversen, '*Pax et sapientia*' (1986): Gunilla Iversen, '*Pax et sapientia*: A Thematic Study on Tropes from Different Traditions (based primarily on Sanctus and Agnus dei Tropes)', in: *Pax et Sapientia: Studies in Text and Music of Liturgical Tropes and Sequences in Memory of Gordon Anderson*, ed. Ritva Jacobsson, Acta Universitatis Stockholmiensis: Studia Latina Stockholmiensia 28 (Stockholm, 1986), 23–58.

Iversen, '*Super agalmata*' (1996): Gunilla Iversen, '*Super agalmata*: Angels and the Celestial Hierarchy in Sequences and Tropes. Examples from Moissac', in: *Liturgy and the Arts in the Middle Ages: Studies in Honour of C. Clifford Flanigan*, eds. Eva Louise Lillie & Nils Holger Petersen (Copenhagen, 1996), 95–133.

Iversen, 'Biblical Interpretation' (2008): Gunilla Iversen, 'Biblical Interpretation in Tropes and Sequences', in: *Proceedings of the Fifth International Congress for Medieval Latin Studies, Journal of Medieval Latin 17* (2008), 210–25.

Iversen, *Laus angelica* (2010): Gunilla Iversen, *Laus angelica: Poetry in the Medieval Mass*, ed. Jane Flynn, trans. William Flynn, Medieval Church Studies 5 (Turnhout, 2010).

Iversen & Bell, *Sapientia* (2009): *Sapientia et Eloquentia: Meaning and Function in Liturgical Poetry, Music, Drama, and Biblical Commentary in the Middle Ages*, eds. Gunilla Iversen & Nicolas Bell, Disputatio 11 (Turnhout, 2009).

Iversen & Colette, *Parole Chantée* (2014): Marie-Noël Colette & Gunilla Iversen, *La parole chantée: invention poétique et musicale dans le Haut Moyen Âge occidental*, Témoins de notre histoire 18 (Turnhout, 2014).

Jacobi-Büsing, *Drüggelter Kapelle* (1964): Gunilla Jacobi-Büsing, *Die Drüggelter Kapelle. Versuch einer Deutung ihrer kultischen Bestimmung*, Soester wissenschaftliche Beiträge (Soest, 1964).

Jacobs & Ukert, *Beiträge* (1835–1843): Friedrich Jacobs & Friedrich A. Ukert, *Beiträge zur älteren Litteratur oder Merkwürdigkeiten der Herzogl. öffentlichen Bibliothek zu Gotha*, 3 vols. (Leipzig, 1835–1843).

Jacopo da Varagine (1987): *Jacopo da Varagine: Atti del I Convegno di Studi, Varazze, 13–14 aprile 1985*, eds. Giovanni Farris & Benedetto Tino Delfino, Atti e studi: Comune di Varazze, Centro studi Jacopo da Varagine 1 (Cogoleto, 1987).

Jäggi, *Frauenklöster* (2006): Carola Jäggi, *Frauenklöster im Spätmittelalter. Die Kirchen der Klarissen und Dominikanerinnen im 13. und 14. Jahrhundert*, Studien zur internationalen Architektur- und Kunstgeschichte 34 (Petersberg, 2006).

Jager, *Book* (2000): Eric Jager, *The Book of the Heart* (Chicago, 2000).

Jakob, 'St. Crux' (1983): Volker Jakob, 'St. Crux. Kirche und Kloster der Dominikaner zu Soest', *Soester Zeitschrift* 95 (1983), 57–64.

Jansen, 'Maria Magdalena' (1998): Katherine Ludwig Jansen, 'Maria Magdalena: *Apostolorum Apostola*', in: *Women Preachers and Prophets through Two Millennia of Christianity*, eds. Beverly Mayne Kienzle & Pamela J. Walker (Berkeley, 1998), 57–96.

Jansen, 'Crucifixes' (2005): Katherine Ludwig Jansen, 'Miraculous Crucifixes in Late Medieval Italy', in: *Signs, Wonders, Miracles: Representations of Divine Power in the Life of the Church. Papers read at the 2003 Summer Meeting and the 2004 Winter Meeting of the Ecclesiastical History Society*, eds. Kate Cooper & Jeremy Gregory (Woodbridge, 2005), 203–27.

Janson, 'Omega' (1973): Dora Jane Janson, 'Omega in Alpha: The Christ Child's Foreknowledge of his Fate: For Lise Lotte Moller on the Occasion of her Sixtieth Birthday', *Jahrbuch der Hamburger Kunstsammlungen* 18 (1973), 33–42.

Jeauneau, '*Vox spiritualis aquilae*' (1991): Édouard Jeauneau, '*Vox spiritualis aquilae*: Quelques épis oubliés', in: *From Augustine to Eriugena: Essays on Neoplatonism and Christianity in Honor of John O'Meara*, eds. Francis X. Martin & John A. Richmond (Washington, D.C., 1991), 107–16.

Jeauneau, 'Mystagogie' (1996): Édouard Jeauneau, 'De l'art comme mystagogie (le Jugement dernier vu par Érigène)', in: *De l'art comme mystagogie: Iconographie du Jugement dernier*

et des fins dernières à l'époque gothique. Actes du Colloque de la Fondation Hardt tenu à Genève du 13 au 16 février 1994, ed. Yves Christe (Poitiers, 1996), 1–8.

Jenny, 'Origin' (1915): Adeline M. Jenny, 'A Further Word as to the Origin of the Old Testament Plays', *Modern Philology* 13 (1915), 59–64.

Jensen, *'Beata Maria'* (1996): Brian Møller Jensen, *'Beata Maria semper virgo* in Piacenza, Biblioteca Capitolare c. 65', in: *Liturgy and the Arts in the Middle Ages: Studies in Honour of C. Clifford Flanigan*, eds. Eva Louise Lillie & Nils Holger Petersen (Copenhagen, 1996), 134–67.

Jessberger, *Graduale* (1986): Bettina Jessberger, *Ein dominikanisches Graduale aus dem Anfang des 14. Jahrhunderts: Cod. 173 der Diözesanbibliothek Köln*, Beiträge zur rheinischen Musikgeschichte 139 (Berlin, 1986).

Jørgensen, 'Cultic Vision' (2004): Hans Henrik Lohfert Jørgensen, 'Cultic Vision—Seeing as Ritual: Visual and Liturgical Experience in the Early Christian and Medieval Church', in: *The Appearances of Medieval Rituals: The Play of Construction and Modification*, eds. Nils Holger Petersen et al., Disputatio 3 (Turnhout, 2004), 173–99.

Johanek, 'Klosterlandschaft' (1998): Peter Johanek, 'Westfalens Klosterlandschaft um 1300', in: *Der "Codex Henrici". Lateinische Bibelhandschrift Westfalen, 1. Viertel des 14. Jahrhunderts*, ed. Universitäts- und Landesbibliothek Münster, Kulturstiftung der Länder – Patrimonia 144 (Löningen, 1998), 7–15.

Johanek, 'Karl IV.' (2009): Peter Johanek, 'Karl IV. und Heinrich von Herford', in: *Institution und Charisma. Festschrift für Gert Melville zum 65. Geburtstag*, eds. Franz J. Felten et al. (Cologne, 2009), 229–44.

Johnson, *Guéranger* (1984): Cuthbert Johnson, *Prosper Guéranger (1805–1875): A Liturgical Theologian. An Introduction to his Liturgical Writings and Work*, Studia Anselmiana 89; Analecta liturgica 9 (Rome, 1984).

Jones, 'Hymn Translation' (2012): Claire Taylor Jones, 'Rekindling the Light of Faith: Hymn Translation and Spiritual Renewal in the Fifteenth-Century Observant Reform', *Journal of Medieval and Early Modern Studies* 42 (2012), 567–96.

Jong, 'Brautsegen' (1962): Johannes Petrus de Jong, 'Brautsegen und Jungfrauenweihe. Eine Rekonstruktion des altrömischen Trauungsritus als Basis für theologische Besinnung', *Zeitschrift für katholische Theologie* 84 (1962), 300–22.

Jounel, 'Culte' (1963): Pierre Jounel, 'La Culte de la croix dans la liturgie romaine', *La Maison-Dieu* 75 (1963), 68–91.

Jülich, *Elfenbeinarbeiten* (2007): Theo Jülich, *Die mittelalterlichen Elfenbeinarbeiten des Hessischen Landesmuseums Darmstadt*, herausgegeben von Hessisches Landesmuseum Darmstadt (Regensburg, 2007).

Jugie, *Mort* (1944): Martin Jugie, *La Mort et l'assomption de la sainte vierge: Étude historico-doctrinale* (Vatican City, 1944).

Jungmann, 'Quadragesima' (1957): Josef A. Jungmann, 'Die Quadragesima in den Forschungen von Antoine Chavasse', *Archiv für Liturgiewissenschaft* 5 (1957), 84–95.

Jussen, 'Dolor' (1995): Bernhard Jussen, 'Dolor und Memoria. Trauerriten, gemalte Trauer und soziale Ordnung im späten Mittelalter', in: *Memoria als Kultur*, ed. Gerhard Otto Oexle, Veröffentlichungen des Max-Planck-Instituts für Geschichte 121 (Göttingen, 1995), 207–52.

Kaczynski 'Illustrations' (1973): Bernice M. Kaczynski, 'Illustrations of Tabernacle and Temple Implements in the *Postilla in Testamentum Vetus* of Nicolaus de Lyra', *Yale University Library Gazette* 48 (1973), 1–11.

Kaeppeli & Panella, *Scriptores* (1970–1993): Thomas Kaeppeli & Emilio Panella, *Scriptores ordinis Praedicatorum medii aevi*, 4 vols. (Rome, 1970–1993).

Kahsnitz, 'Allerheiligenbild' (1997): Rainer Kahsnitz, '*Coronas aureas in capite*. Zum Allerheiligenbild des Reichenauer Kollektars in Hildesheim', in: *Per assiduum studium scientiae adipisci margaritam. Festgabe für Ursula Nilgen zum 65. Geburtstag*, eds. Annelies Amberger et al. (St. Ottilien, 1997), 61–97.

Kantorowicz, 'Quinity' (1947): Ernst H. Kantorowicz, 'The Quinity of Winchester', *Art Bulletin* 29 (1947), 73–85.

Kantorowicz, 'Oriens Augusti' (1963): Ernst H. Kantorowicz, 'Oriens Augusti: Lever du Roi', *Dumbarton Oaks Papers* 17 (1963), 117–77.

Kaps, *Zweisprachigkeit* (2004): Gabriele Kaps, *Zweisprachigkeit im paraliturgischen Text des Mittelalters*, Studia Romanica et Linguistica 31 (Frankfurt a. M., 2004).

Karnau, 'Kloster Paradiese' (2004): Oliver Karnau, 'Kloster Paradiese bei Soest – Zum Umgang mit einer ehem. bedeutenden Klosteranlage im 19. und 20. Jahrhundert', *Westfalen. Hefte für Geschichte, Kunst und Volkskunde* 82 (2004), 211–22.

Karp, 'Sequences' (2008): Theodore Karp, 'Sequences of the 18th and 19th Centuries', in: *Dies est leticie: Essays on Chant in Honour of Janka Szendrei*, eds. David Hiley & Gábor Kiss, Wissenschaftliche Abhandlungen 90 (Ottawa, 2008), 333–48.

Karpp, 'Sammlung' (1991): Gerhard Karpp, 'Die Sammlung mittelalterlicher Handschriften in der Universitätsbibliothek Düsseldorf', in: *Westfälische Forschungen* 41 (1991) 360–78.

Kastner, *Historiae* (1974): Jörg Kastner, *Historiae fundationum monasteriorum. Frühformen monastischer Institutionsgeschichts-schreibung im Mittelalter*, Münchener Beiträge zur Mediävistik und Renaissance-Forschung 18 (Munich, 1974).

Katalog der deutschsprachigen illustrierten Handschriften des Mittelalters. Begonnen von Hella Frühmorgen-Voss †. Fortgeführt von Norbert H. Ott et al., vols. 1–2, 3,1–4, 4,1–2, 5,1/2, 6,3/4, 7,1/2 (Munich, 1991–2008).

H. Keller, *Secret* (2000): Hildegard Elisabeth Keller, *My Secret is Mine: Studies on Religion and Eros in the German Middle Ages*, Studies in Spirituality: Supplement 4 (Louvain, 2000).

H. Keller, 'Kolophon' (2002): Hildegard Elisabeth Keller, 'Kolophon im Herzen. Von beschrifteten Mönchen an den Rändern der Paläographie', in: *Der mittelalterliche Schreiber*, ed. Martin J. Schubert, Das Mittelalter. Perspektiven mediävistischer Forschung. Zeitschrift des Mediävistenverbandes, Jahresband 7 (2002), 165–93.

P. Keller, *Wiege* (1998): Peter Keller, *Die Wiege des Christuskindes. Ein Haushaltgerät in Kunst und Kult*, Manuskripte zur Kunst-wissenschaft 54 (Worms, 1998).

Kellner, *Heortology* (1908): Karl Adam Heinrich Kellner, *Heortology: A History of Christian Festivals from their Origin to the Present Day* (London, 1908).

Kelm, 'Buch' (1974): Elfriede Kelm, 'Das "Buch im Chore" der Priörin Anna von Buchwald im Klosterarchiv zu Preetz', *Jahrbuch für Heimatkunde im Kreis Plön* 4 (1974), 68–83.

Kemper, *Kreuzigung* (2006): Tobias A. Kemper, *Die Kreuzigung Christi. Motivgeschichtliche Studien zu lateinischen und deutschen Passionstraktaten des Spätmittelalters*, Münchener Texte und Untersuchungen 131 (Tübingen, 2006).

Kemperdick, *Avantgarde 1360* (2002): Stephan Kemperdick, *Avantgarde 1360. Ein rekonstruierte Baldachinaltar aus Nürnberg.* Kabinettstücke (Frankfurt a. M., 2002).

Kemperdick, 'Marienretabel' (2005): Stephan Kemperdick, 'Marienretabel aus dem Zisterzienserinnenkloster Fröndenberg', in: *Krone und Schleier. Kunst aus mittelalterlichen Frauenklöstern*, eds. Jan Gerchow et al. (Bonn–Essen, 2005), cat. no. 233a–d, 350–53.

Kemperdick, *Gemälde* (2010): Stephan Kemperdick, *Deutsche und böhmische Gemälde 1230–1430. Kritischer Bestandkatalog* (Petersberg, 2010).

Kemperdick & Lammertse, *Van Eyck* (2012): Stephan Kemperdick & Friso Lammertse, *The Road to Van Eyck* (Rotterdam, 2012).

Kendall, 'Gate of Heaven' (1993): Calvin B. Kendall, 'The Gate of Heaven and the Fountain of Life: Speech-Act Theory and Portal Inscriptions', in: *Essays in Medieval Studies* 10 (1993), 112–18.

Kendall, *Allegory* (1998): Calvin B. Kendall, *The Allegory of the Church: Romanesque Portals and their Verse Inscriptions* (Toronto, 1998).

L. Kendrick, *Letter* (1999): Laura Kendrick, *Animating the Letter: The Figurative Embodiment of Writing from Late Antiquity to the Renaissance* (Columbus, 1999).

R. Kendrick, *Sirens* (1996): Robert L. Kendrick, *Celestial Sirens: Nuns and their Music in Early Modern Milan* (Oxford, 1996).

Kessel, 'Antiphonar' (1992): Verena Kessel, 'Ein Antiphonar in Koblenz', *Wallraf-Richartz-Jahrbuch* 53 (1992), 323–33.

Kessel, *Balduin von Trier* (2012): Verena Kessel: *Erzbischof Balduin von Trier (1285–1354). Kunst, Herrschaft und Spiritualität im Mittelalter* (Trier, 2012).

C. Kessler, 'Gotische Buchmalerei' (1997): Cordula Kessler, 'Gotische Buchmalerei des Bodenseeraumes aus der Zeit von 1260 bis um 1340–50', in: *Buchmalerei im Bodenseeraum*, ed. Eva Moser (Friedrichshafen, 1997), 70–96.

C. Kessler, *Gotische Buchkultur* (2010): Cordula Kessler, *Gotische Buchkultur: Dominikanische Handschriften aus dem Bistum Konstanz*, Quellen und Forschungen zur Geschichte des Domini-kanerordens N.F. 17 (Berlin, 2010).

H. Kessler, 'Temple Veil' (1990–1991): Herbert L. Kessler, 'Through the Temple Veil: The Holy Image in Judaism and Christianity', *Kairos* N.S. 32–33 (1990–1991), 53–77.

H. Kessler, *Neither God nor Man* (2007): Herbert L. Kessler, *Neither God nor Man: Words, Images, and the Medieval Anxiety about Art* (Freiburg i. Br, 2007).

H. Kessler, '"License"' (2009): Herbert L. Kessler, ' "To Curb the License of Painters": The Functions of Some Captions in the Construction and Understanding of Pictured Narratives', in: *Figura e racconto: narrazione letteraria e narrazione figurativa in Italia dall' Antichità al primo Rinascimento; atti del convegno di studi, Losanna, 25–26 novembre 2005*, eds. Marco Praloran et al., Études lausanoises d'histoire de l'art 9 (Florence, 2009), 25–51.

H. Kessler, 'Silver' (2011): Herbert L. Kessler, 'The Eloquence of Silver', in: *L'allégorie dans l'art du Moyen Âge: formes et fonctions. Héritages, créations, mutations. Actes du colloque du RILMA,*

Institut Universitaire de France (Paris, INHA, 28–29 mai 2010), ed. Christian Heck (Turnhout, 2011), 49–64.

H. Kessler, 'Medietas / Mediator' (2015): Herbert L. Kessler, 'Medietas / Mediator and the Geometry of the Incarnation', in: *Image and the Incarnation: The Early Modern Doctrine of the Pictorial Image*, eds. Walter S. Melion & Lee Palmer Wandel (Leiden–Boston, 2015), 17–75.

Kesting, 'Maria' (1968): Peter Kesting, 'Maria als Buch', in: *Würzburger Prosastudien I. Wort-, begriffs- und textkundliche Untersuchungen*, Medium Aevum 13 (Munich, 1968), 122–47.

Kidd, 'Quinity' (1981–1982): Judith A. Kidd, 'The Quinity of Winchester Reconsidered', *Studies in Iconography* 7–8 (1981–1982), 21–33.

Kieckhefer, 'Christ Child' (2012): Richard Kieckhefer, '*Ihesus ist unser!*: The Christ Child in the German Sister Books', in: *Christ Child* (2012), 167–98.

Kiening, 'Prozessionalität' (2011): Christian Kiening, 'Prozessionalität der Passon', in: *Medialität der Prozession. Performanz ritueller Bewegung in Texten und Bildern der Vormoderne = Médialité de la procession: performance du mouvement rituel en textes et en images à l'époque pré-moderne*, eds. Katja Gvozdeva & Hans Rudolf Velten, Germanisch-romanische Monatsschrift: Beiheft 39 (Heidelberg, 2011), 177–97.

Kihlmann, *Expositiones* (2006): Erika Kihlman, *Expositiones sequentiarum: Medieval Sequence Commentaries and Prologues. Editions with Introductions*, Acta Universitatis Stockholmiensis: Studia Latina Stockholmiensia 53 (Stockholm, 2006).

Kihlman, 'Commentaries' (2007): Erika Kihlman, 'Medieval Sequence Commentaries', *Journal of Medieval Latin*, 17 (2007), 110–24.

Kihlman, '*Verbum dei*' (2008): Erika Kihlman, 'Commentaries on *Verbum dei deo natum* in Fourteenth- and Fifteenth-century Manuscripts', in: *Leaves from Paradise* (2008), 101–31.

Kihlman, 'Understanding' (2009): Erika Kihlman, 'Understanding a Text. Presentation and Edition of a Sequence Commentary in Oxford, Bodleian Library, MS Auct. F. 6. 8', in: *Sapientia et Eloquentia: Meaning and Function in Liturgical Poetry, Music, Drama and Biblical Commentary in the Middle Ages*, eds. Gunilla Iversen & Nicolas Bell, Disputatio 11 (Turnhout, 2009), 381–455, 472–76.

King, *Liturgies* (1955; repr. 2005): Archdale A. King, *Liturgies of the Religious Orders* (London–New York, 1955; repr. 2005).

Kirchenschätze (2005): *Kirchenschätze. 1200 Jahre Bistum Münster*, eds. Udo Grote & Reinhard Karrenbrock, 2 vols. (Münster, 2005).

Klamt, 'Letters' (2004): Christian Klamt, 'Letters van baksteen in een cistercienzerklooster: het Ave Maria te Zinna', in: *Meer dan muziek alleen. In memoriam Kees Vellekoop*, ed. René E. V. Stuip (Hilversum, 2004), 195–210.

Klapisch-Zuber, 'Holy Dolls' (1985): Christiane Klapisch-Zuber, 'Holy Dolls: Play and Piety in Florence in the Quattrocento', in: *Women, Family and Ritual in Renaissance Italy* (Chicago, 1985), 310–29.

Klapp, 'Schriftlichkeit' (2012): Sabine Klapp, 'Pragmatische Schriftlichkeit in Straßburger Frauenklöstern des späten Mittelalters', in: *Schreiben und Lesen* (2012), 207–32.

Klaus, *Ursprung* (1938): Adalbert Klaus, *Ursprung und Verbreitung der Dreifaltigkeitsmesse* (Werl, 1938).

Klauser, 'Ursprung' (1974): Theodor Klauser, 'Der Ursprung des Festes Petri Stuhlfeier am 22. Februar', in: *Gesammelte Arbeiten zur Liturgiegeschichte, Kirchengeschichte und christlichen Archäologie*, ed. Ernst Dassmann, Jahrbuch für Antike und Christentum. Ergängzungsband 3 (Münster, 1974), 97–113.

Kleinjung, *Frauenklöster* (2008): Christine Kleinjung, *Frauenklöster als Kommunikationszentren und soziale Räume. Das Beispiel Worms vom 13. bis zum Beginn des 15. Jahrhunderts*, Studien und Texte zur Geistes- und Sozialgeschichte des Mittelalters 1 (Korb am Neckar, 2008).

Klepper, *Insight* (2007): Deeana Copeland Kleeper, *The Insight of Unbelievers: Nicholas of Lyra and Christian Reading of Jewish Text in the Later Middle Ages* (Philadelphia, 2007).

Klesse, *Seidenstoff* (1967): Brigitte Klesse, *Seidenstoff in der italienischen Malerei des 14. Jahrhunderts*, Schriften der Abegg-Stiftung 1 (Bern, 1967).

Klöckener, '"Feier"' (1991): Martin Klöckener, 'Die "Feier vom Leiden und Sterben Jesu Christ" am Karfreitag. Gewordene Liturgie vor dem Anspruch der Gegenwart', *Liturgisches Jahrbuch* 41 (1991), 210–51.

Klöckener & Schouwink, 'Graduale' (2001–2002): Martin Klöckener & Wilfried Schouwink, 'Ein Graduale des 13. Jahrhunderts in der Stiftskirche St. Cornelius und Cyprianus in Metelen/Westfalen', *Archiv für Liturgiewissenschaft* 43–44 (2001–2002), 313–61.

Klocke, *Alt-Soester Bürgermeister* (1927): Friedrich von Klocke, *Alt-Soester Bürgermeister aus sechs Jahrhunderten, ihre Familien und ihre Standesverhältnisse*, Studien zur Soester Geschichte 2 (Soest, 1927).

Klocke, *Patriziat* (1927): Friedrich von Klocke, *Patriziat und Stadtadel im alten Soest*, Pfingstblätter des hansischen Geschichtsvereins 18 (Lübeck, 1927).

Klocke, *Studien* (1928): Friedrich von Klocke, *Studien zur Soester Geschichte 1: Aufsätze vornehmlich zur Sozialgeschichte* (Soest, 1928).

Kloster und Stift (1965): *Kloster und Stift St. Marien in Lemgo 1265–1965. Festschrift anläßlich des 700jährigen Bestehens*, ed. Erich Kittel, Sonderveröffentlichungen des Naturwissenschaftlichen und Historischen Vereins für das Land Lippe 16 (Detmold, 1965).

Kluge, *Gotische Wandmalerei* (1959): Dorothea Kluge, *Gotische Wandmalerei in Westfalen, 1290–1530*, Westfalen: Sonderheft 12 (Münster, 1959).

Knaus, 'Handschriften' (1972): Hermann Knaus, 'Gotische Hand-schriften mit romanischen Initialen', *Gutenberg-Jahrbuch* 47 (1972) 13–19.

Knaus, *Studien* (1992): Hermann Knaus, *Studien zur Handschriften-kunde. Ausgewählte Aufsätze*, ed. Gerhard Achten (Munich, 1992).

Knobloch, 'Status' (1990): Clemens Knobloch, 'Zum Status und zur Geschichte des Textbegriffs. Eine Skizze', *Zeitschrift für Literaturwissenschaft und Linguistik* 20 (1990), 66–87.

Knoepfli, *Kunstdenkmäler* (1989): Albert Knoepfli, *Die Kun-stdenkmäler des Kantons Thurgau, Bd. IV. Das Kloster St. Katharinenthal*, Die Kunstdenkmäler der Schweiz 83 (Basel, 1989).

Köhn, 'Soest 1543–1648' (1995): Gerhard Köhn, 'Soest und die Soester Börde in den kriegerischen Auseinandersetzungen 1543–1648, in: *Soest. Geschichte der Stadt* 3 (1995), 687–864.

Köln – Westfalen. 1180–1980. Landesgeschichte zwischen Rhein und Weser, 2 vols., exh. cat., Münster, Westfälisches Landesmuse-um and Cologne, Josef-Haubrich Kunsthalle (Lengerich, 1981).

Kölnische Liturgie (2000): *Kölnische Liturgie und ihre Geschichte. Studien zur interdisziplinären Erforschung des Gottesdienstes im Erzbistum Köln*, eds. Albert Gerhards & Andreas Odenthal, Liturgiewissenschaftliche Quellen und Forschungen 87 (Mün-ster, 2000).

König et al., *Defensorium* (2007): Eberhard König et al., *Von wundersamen Begebenheiten. Defensorium inviolatae virginitatis beatae Mariae. National Library of Ireland Ms 32, 513* (Simbach am Inn, 2007).

Kötzsche, 'Heiliges Grab' (1995): Lieselotte Kötzsche, 'Das hei-lige Grab in Jerusalem und seine Nachfolge', in: *Akten des XII. Internationalen Kongresses für christliche Archäologie, Bonn, 22.–28. September 1991*, eds. Ernst Dassmann & Josef Engemann, 2 vols., Studi di antichità cristiana 52; Jahrbuch für Antike und Christentum, Ergänzungsband 20/1 (Münster, 1995), 272–90.

Kohwagner-Nikolai, 'Funktion' (2001): Tanja Kohwagner-Nikolai, 'Zur Funktion des Heilsspiegelsteppichs im Kloster Wienhausen', *Die Diözese Hildesheim in Vergangenheit und Gegenwart* 69 (2001), 105–37.

Kohwagner-Nikolai, 'Gestickte Bildteppiche' (2006): Tanja Kohwagner-Nikolai, 'Gestickte Bildteppiche. Entstehungsbedin-gungen, Verwendung und ihre Funktion', in: *Kloster und Bildung im Mittelalter*, ed. Nathalie Kruppa, Veröffentlichungen des Max-Planck-Instituts für Geschichte 218; Studien zur Germania Sacra 28 (Göttingen, 2006), 177–96.

Kohwagner-Nikolai, *Bildstickereien* (2006): Tanja Kohwagner-Nikolai, *"Per manus sororum …". Niedersächsische Bildstickereien im Klosterstich (1300–1583)* (Munich, 2006).

Kolb, '"Huic oportet ut canamus"' (2015): Fabian Kolb, '"Huic oportet ut canamus cum angelis" – Musik, Liturgie und Spiri-tualität im Graduale der Gisela von Kerssenbrock', in: *Codex Gisle* (2015), 103–44.

Kolping, 'Textgeschichte' (1958): Adolf Kolping, 'Zur Frage der Textgeschichte, Herkunft und Entstehungszeit der anonymen 'Laus Virginis' (bisher 'Mariale Alberts des Grossen'), *Recherches de théologie ancienne et médiévale* 25 (1958), 285–329.

Kolping, 'Verhältnis' (1961): Adolf Kolping, 'Das Verhältnis des ps.-Bonaventurianischen Sermo VI de Assumtione BMV zu dem ps.-Albertinischen Mariale "Laus Virginis"', *Zeitschrift für katholische Theologie* 83 (1961), 190–207.

Kolve, *Play* (1966): Verdel A. Kolve, *The Play Called Corpus Christi* (Stanford, 1966).

Korn, *Romanische Farbverglasung* (1967): Ulf Dietrich Korn: *Die romanische Farbverglasung von St. Patrokli in Soest* (Münster, 1967).

Korn, 'Mittelalterliche Glasmalerei' (2010): Ulf Dietrich Korn: 'Mittelalterliche Glasmalerei in und um Soest', in: *Soest. Ge-schichte der Stadt* 1 (2010), 929–85.

Kosch, 'Auswahlbibliographie' (1998): Clemens Kosch, 'Auswahl-bibliographie zu Liturgie und Bildender Kunst/Architektur im Mittelalter', in: *Heiliger Raum. Architektur, Kunst und Liturgie in mittelalterlichen Kathedralen und Stiftskirchen*, eds. Franz Kohlschein & Peter Wünsche, Liturgiewissenschaftliche Quellen und Forschungen 82 (Münster, 1998), 243–360.

Koske, 'Paradiese' (1989): Marga Koske, 'Zur Geschichte des ehemaligen Klosters/Stifts Paradiese', *Soester Zeitschrift* 101 (1989), 127–68.

Koske, 'Dominikaner' (1994): Marga Koske, 'Soest. Dominika-ner', in: *Westfälisches Klosterbuch* (1994), vol. 2, 360–65.

Koudelka, '"Monasterium Tempuli"' (1961): Vladimir J. Koudelka, 'Le "Monasterium Tempuli" et la fondation dominicaine de San Sisto', *Archivum Fratrum Praedicatorum* 31 (1961), 5–81.

Kozachek, 'Repertory' (1995): Thomas Davies Kozachek, 'The Repertory of Chant for Dedicating Churches in the Middle Ages: Music, Liturgy & Ritual', Ph.D. dissertation, Harvard University, Cambridge, Ma. (1995).

Krafft, 'Brief' (2003): Otfried Krafft, 'Ein Brief des Mailänder Dominikanerpriors Lambert von S. Eustorgio zu Kanonisation, Elevation und Kultanfängen des Petrus Martyr (1253)', *Quellen und Forschungen aus italienischen Archiven und Bibliotheken* 83 (2003) 403–25.

Kraß, *Stabat mater* (1998): Andreas Kraß, *Stabat mater dolorosa. Lateinische Überlieferung und volkssprachliche Übertragungen im deutschen Mittelalter* (Munich, 1998).

Krautheimer, 'Introduction' (1942): Richard Krautheimer, 'Introduction to an Iconography of Medieval Architecture', *Journal of the Courtauld and Warburg Institutes* 5 (1942), 1–33.

Krauthheimer, *Studies* (1969): Richard Krautheimer, *Studies in Early Christian, Medieval and Renaissance Art* (New York, 1969).

Kriezels (1992): *Kriezels, aubergines en takkebossen: Randversierung in Noordnederlandse handschriften uit de viiftiende eeuw*, ed. Anne S. Korteweg (Zutphen, 1992).

Krings, *Arnstein* (1990): Bruno Krings, *Das Prämonstratenserstift Arnstein a.d. Lahn im Mittelalter (1139–1527)*, Veröffentlichungen der Historischen Kommission für Nassau 48 (Wiesbaden, 1990).

Krochalis & Matter, 'Manuscripts' (2001): Jeanne E. Krochalis & E. Ann Matter, 'Manuscripts of the Liturgy', in: *The Liturgy of the Medieval Church*, eds. Thomas J. Heffernan & E. Ann Matter (Kalamazoo, 2001), 433–72.

Krone und Schleier (2005): *Krone und Schleier. Kunst aus mittelalterlichen Frauenklöstern*, eds. Jan Gerchow et al. (Bonn–Essen, 2005).

Kroos, *Bildstickereien* (1970): Renate Kroos, *Niedersächsische Bildstickereien des Mittelalters* (Berlin, 1970).

Kroos, *Bilderhandschiften* (1976): Renate Kroos, *Drei niedersächsische Bilderhandschriften des 13. Jahrhunderts in Wien*, Abhandlungen der Akademie der Wissenschaften, Göttingen, Philologisch-historische Klasse 3/56 (Göttingen, 1976).

Kruckenberg, 'Sequence' (1997): Lori Kruckenberg, 'The Sequence from 1050–1150: Study of a Genre in Change', Ph.D. dissertation, University of Iowa (1997).

Kruckenberg, 'Making a Sequence Repertory' (2006): Lori Kruckenberg, 'Making a Sequence Repertory: The Tradition of the *Ordo Nidrosiensis Ecclesia*', in: *Sequences of Nidaros* (2006), 5–61.

Kruckenberg, 'Neumatizing' (2006): Lori Kruckenberg, 'Neumatizing the Sequence: Special Performances of Sequences in the Central Middle Ages', *Journal of the American Musicological Association* 59 (2006), 243–317.

Kruckenberg, 'Two "Sequentiae Novae"' (2006): Lori Kruckenberg, 'Two "Sequentiae Novae" at Nidaros', in: *Sequences of Nidaros* (2006), 387–411.

Kruckenberg, 'Music' (2008): Lori Kruckenberg, 'Music for John the Evangelist: Virtue and Virtuosity at Paradies', in: *Leaves from Paradise* (2008), 133–60.

Krüger, *Bild als Schleier* (2001): Klaus Krüger, *Das Bild als Schleier des Unsichtbaren. Ästhetische Illusion in der Kunst der frühen Neuzeit in Italien* (Munich, 2001).

Krüger, 'Bilder' (2003): Klaus Krüger, 'Bilder als Medien der Kommunikation. Zum Verhältnis von Sprache, Text und Visualität', in: *Medien der Kommunikation im Mittelalter*, ed. Karl-Heinz Spieß, Beiträge zur Kommunikationsgeschichte 15 (Wiesbaden, 2003), 155–204.

Kruse & Schnabel, 'Bücher' (2012): Britta-Juliane Kruse & Kerstin Schnabel: 'Bücher in Bewegung: Dynamisierung und Inventarisierung der Buchbestände im Augustiner-Chorfrauenstift Steterburg', in: *Die Bibliothek des Mittelalters als dynamischer Prozess*, eds. Michael Embach et al., Trierer Beiträge zu den historischen Kulturwissenschaften 3 (Wiesbaden, 2012), 147–76.

Kuder, 'Hiobbuch' (1997): Ulrich Kuder, 'Die dem Hiobbuch vorangestellten Bildseiten zu Beginn des 2. Bandes der Bibel von Floreffe', in: *Per assiduum studium scientiae adipisci margaritam. Festgabe für Ursula Nilgen zum 65. Geburtstag*, eds. Annelies Amberger et al. (St. Ottilien, 1997), 109–36.

Kuder, 'Psalter' (2011): Ulrich Kuder, 'Der Hiltegerus Psalter (sog. Würzburg-Ebracher Psalter) der Universitätsbibliothek München, 4° Cod. ms. 24 (Cim. 15)', in: *Studien zur Buchmalerei des 13. Jahrhunderts in Franken*, ed. Klaus Gereon Beuckers (Kiel, 2011), 15–159.

Küsters, 'Buchstabe' (2001): Urban Küsters, 'Der lebendige Buchstabe. Christliche Traditionen der Körperschrift im Mittelalter', in: *Audiovisualität vor und nach Gutenberg. Zur Kulturgeschichte der medialen Umbrüche*, Schriften des Kunsthistorischen Museum 6 (Vienna, 2001), 107–15.

Küsters, 'Second Blossoming' (2001): Urban Küsters, 'The Second Blossoming of a Text: The "Spieghel der Maechden" and the Modern Devotion', in: *Listen Daughter* (2001), 245–61.

Kuhdorfer, 'Säkularisation' (2003): Dieter Kuhdorfer, 'Die Säkularisation und das Bibliothekswesen – Traditionsbruch und Neuanfang für die Wissenschaft', in: *Lebendiges Büchererbe. Säkularisation, Mediatisierung und die Bayerische Staatsbibliothek,* eds. Cornelia Jahn & Dieter Kuhdorfer (Munich, 2003), 9–20.

Kulturtopographie (2009): *Kulturtopographie des deutschsprachigen Südwestens im späteren Mittelalter. Studien und Texte*, eds. Barbara Fleith & René Wetzel, Kulturtopographie des alemannischen Raums 1 (Berlin, 2009).

Kumler & Lakey, 'Things' (2012): Aden Kumler & Christopher R. Lakey: '*Res et significatio*: The Material Sense of Things in the Middle Ages', *Gesta* 51 (2012), 1–17.

Kuroiwa, 'L'iconographie (1)' (2012): Mie Kuroiwa, 'L'iconographie de saint Thomas d'Aquin dans les manuscrits parisiens enluminés (1): manuscrits des oeuvres de Thomas d'Aquin (c.1250–c.1510)', *Language, Culture and Communication: Journal of the College of Intercultural Communication, Rikkyo University, Tokyo, Japan* 4 (2012), 1–133.

Kuroiwa, 'L'iconographie (2)' (2013): Mie Kuroiwa, 'L'iconographie de saint Thomas d'Aquin dans les manuscrits enluminés parisiens (2): l'office de saint Thomas d'Aquin dans les livres liturgiques (c.1330–c.1510)', *Language, Culture and Communication: Journal of the College of Intercultural Communication, Rikkyo University, Tokyo, Japan* 5 (2013), 15–40.

Kurras, *Handschriften* (1974): Lotte Kurras, *Die deutschen mittelalterlichen Handschriften. Die literarischen und religiösen Handschriften. Anhang. Die Hardenbergischen Fragmente. Kataloge des Germanischen Nationalmuseums I/1* (Wiesbaden, 1974).

Kurz, *Überlieferung* (1976): Rainer Kurz, *Die handschriftliche Überlieferung der Werke des heiligen Augustinus 5/1*, Veröffentlichungen der Kommission zur Herausgabe des Corpus der lateinischen Kirchenväter 9 (Vienna, 1976).

Kuttner, 'Der Begriff *doli capax*' (1935): Stefan Kuttner, 'Der Begriff *doli capax*. Kanonistische Schuldlehre von Gratian bis auf die Dekretalen Gregors IX. Systematisch auf Grund der handschriftlichen Quellen dargestellt', *Studi e Testi* 64 (Vatican City, 1935), 125–29.

G. Ladner, *Idea* (1959): Gerhart B. Ladner, *The Idea of Reform: Its Impact on Christian Thought and Action in the Age of the Fathers* (Cambridge, Ma., 1959).

G. Ladner, 'Gestures' (1983): Gerhart B. Ladner, 'The gestures of prayer in papal inconography of the thirteenth and early fourteenth centuries', in: *Images and Ideas in the Middle Ages: Selected Studies in History and Art*, 2 vols, Storia e Letteratura. Raccolta di Studi e Testi 155 (Rome, 1983), 209–37.

G. Ladner, 'Vegetation' (1983): Gerhart B. Ladner, 'Vegetation Symbolism and the Concept of Renaissance', in: *Images and Ideas in the Middle Ages: Selected Studies in History and Art*, 2 vols, Storia e Letteratura. Raccolta di Studi e Testi 155 (Rome, 1983), 726–63.

P. Ladner, 'Beschreibung' (1983): Pascal Ladner, 'Codicologische und liturgische Beschreibung des Graduale von St. Katharinenthal', in: *Graduale von Sankt Katharinenthal* (1983), 295–326.

Lähnemann, 'Ikonographie' (2005): Henrike Lähnemann, '"An dessen bom wil ik stighen". Die Ikonographie des Wichmannsburger Antependiums im Kontext der Medinger Handschriften', *Oxford German Studies* 34 (2005), 19–46.

Lähnemann, 'Der Auferstandene' (2010): Henrike Lähnemann, 'Der Auferstandene im Dialog mit den Frauen. Die Erscheinungen Christi in den Andachtsübungen des Klosters Medingen', in: *Passion und Ostern in den Lüneburger Klöstern. Bericht des VIII. Ebstorfer Kolloquiums, Kloster Ebstorf, 25. bis 29. März 2009*, ed. Linda Maria Koldau (Ebstorf, 2010), 105–34.

Lähnemann, 'Devotion' (2014): Henrike Lähnemann, 'Bilingual Devotion in Northern Germany: Prayer Books from the Lüneburg Convents', in: *A Companion to Mysticism and Devotion* (2014), 317–41.

Lagueux, 'Sermons' (2009): Robert C. Lageux, 'Sermons, Exegesis, and Performance: The Laon *Ordo Prophetarum* and the Meaning of Advent', *Comparative Drama* 43 (2009), 197–220.

Lahaye-Geusen, *Opfer der Kinder* (1991): Maria Lahaye-Geusen, *Das Opfer der Kinder. Ein Beitrag zur Liturgie- und Sozialgeschichte des Mönchtums im Hohen Mittelalter*, Münsteraner Theologische Abhandlungen 13 (Münster, 1991).

Lahrkamp, '1585–1650' (1981): Helmut Lahrkamp, '1585–1650', in: *Köln – Westfalen. 1180–1980* (1981), vol. 1, 73–81.

Laienfrömmigkeit (1992): *Laienfrömmigkeit im späten Mittelalter. Formen, Funktionen, politisch-soziale Zusammenhänge*, ed. Klaus Schreiner, with Elisabeth Müller-Luckner, Schriften des Historischen Kollegs. Kolloquien 20 (Munich, 1992).

D. Lammers, 'Vorbericht' (1995): Dieter Lammers, 'Vorbericht über die Ausgrabungen auf dem Gelände des ehemaligen Dominikanerinnenklosters Paradiese', *Soester Zeitschrift* 107 (1995), 9–14.

J. Lammers, 'Buchmalerei' (1981): Joseph Lammers, 'Buchmalerei', in: *Köln – Westfalen* (1981), vol. 1, 402–07.

J. Lammers, *Buchmalerei* (1982): Joseph Lammers, *Buchmalerei aus Handschriften vom 12. bis zum 16. Jahrhundert*, Bildhefte des

Westfälischen Landesmuseums für Kunst und Kulturgeschichte Münster 18 (Münster, 1982).

Landolt-Wegener, *Glasmalereien* (1959): Elisabeth Landolt-Wegener: *Die Glasmalereien im Hauptchor der Soester Wiesenkirche*, Westfalen. Sonderheft 13 (Münster, 1959).

Lange, *Res publica* (2009): Cartsten Hjort Lange, *Res publica constituta: Actium, Apollo and the Accomplishment of the Triumviral Assignment*, Impact of Empire 10 (Leiden, 2009), 148–54.

Langemeyer, 'Tafelmalerei' (1981): Gerhard Langemeyer, '"Kölnisch" und "Westfälisch" in der Tafelmalerei der Spätgotik', in: *Köln – Westfalen. 1180–1980* (1981), vol. 1, 389–401.

Langer, *Mystische Erfahrung* (1987): Otto Langer, *Mystische Erfahrung und spirituelle Theologie. Zu Meister Eckharts Auseinandersetzung mit der Frauenfrömmigkeit seiner Zeit*, Münchener Texte und Untersuchungen zur deutschen Literatur des Mittelalters 91 (Munich, 1987).

Larchet, *Divinisation* (1996): Jean-Claude Larchet, *La Divinisation de l'homme selon Saint Maxime le Confesseur* (Paris, 1996).

Largier, 'Körper' (1999): Niklaus Largier, 'Der Körper der Schrift. Bild und Text am Beispiel einer Seuse-Handschrift des 15. Jahrhunderts', in: *Mittelalter. Neue Wege durch einen alten Kontinent*, eds. Jan-Dirk Müller & Horst Wenzel (Stuttgart–Leipzig, 1999), 241–71.

Latein und Volkssprache (1992): *Latein und Volkssprache im deutschen Mittelalter 1100–1500. Regensburger Colloquium 1988*, eds. Nikolaus Henkel & Nigel F. Palmer (Tübingen, 1992).

Leaves from Paradise (2008): *Leaves from Paradise: The Cult of John the Evangelist at the Dominican Convent of Paradies bei Soest*, ed. Jeffrey F. Hamburger, Houghton Library Studies 2 (Cambridge, Ma., 2008).

Leclercq, *Love of Learning* (1961): Jean Leclercq, *The Love of Learning and the Desire for God: A Study of Monastic Culture* (New York, 1961).

Leclercq, 'Culte' (1962): Jean Leclercq, 'Culte liturgique et prière intime dans le monachisme au Moyen Âge', *La Maison-Dieu* 69 (1962), 39–55.

Legenda aurea (1986): *Legenda aurea, sept siècles de diffusion: actes du colloque international sur la Legenda aurea, texte latin et branches vernaculaires à l'Université du Québec à Montréal, 11–12 mai 1983*, ed. Brenda Dunn-Lardeau (Montréal–Paris, 1986).

Le Goff, *Jacques de Voragine* (2011): Jacques Le Goff, *À la recherche du temps sacré: Jacques de Voragine et la 'Légende dorée'* (Paris, 2011).

Leidinger, 'Himmelpforten' (1992): Paul Leidinger, 'Himmelpforten – Zisterzienserinnen', in: *Westfälisches Klosterbuch* (1992), vol. 1, 447–51.

Leidinger, 'Grafen von Werl' (2009): Paul Leidinger, 'Die Grafen von Werl und Werl-Arnsberg (ca. 980–1124). Genealogie und Aspekte ihrer politischen Geschichte in ottonischer und salischer Zeit', in: *Das Herzogtum Westfalen* 1, ed. Harm Klueting, with Jens Foken (Münster, 2009), 119–70, repr. in: Paul Leidinger, *Von der karolingischen Mission zur Stauferzeit. Beiträge zur früh- und hochmittelalterlichen Geschichte Westfalens vom 8.–13. Jahrhundert*, Quellen und Forschungen zur Geschichte des Kreises Warendorf 50 (Warendorf, 2012), 191–242.

Leimbach, *Sedulius* (1879): Carl L. Leimbach, *Caelius Sedulius und sein Carmen paschale*, Patristische Studien I. Wissenschaftliche Beilage zu dem Jahresbericht der Realschule I.O. zu Goslar (Goslar, 1879).

Lemke, 'Äbtissenliste' (2008): Hilde Lemke, 'Eine Revision der Äbtissenliste des Klosters Fröndenberg im 14. und 15. Jahrhundert und die Roller der Katharina von der Mark im Zisterzienserkonvent des späten Mittelalters', *Märkisches Jahrbuch für Geschichte* 108 (2008), 107–50.

Lengeling, 'Agapefeier' (1973): Emil-Joseph Lengeling, 'Agapefeier beim "Mandatum" des Gründonnerstag in einer spätmittelalterlichen Agende aus dem Bistum Münster', *Studia Westfalica. Beiträge zur Kirchengeschichte und religiösen Volkskunde Westfalens. Festschrift für Alois Schröer*, ed. Max Bierbaum (Münster, 1973), 230–58.

Lengeling, *Missale* (1995): Emil-Joseph Lengling, *Missale Monasteriense 1300–1900. Katalog, Texte und vergleichende Studien*, eds. Benedikt Kranemann & Klemens Richter, Liturgiewissenschaftlichen Quellen und Forschungen 76 (Münster, 1995).

Lentes, 'Bild' (1994): Thomas Lentes, 'Bild, Reform und Cura Monialium. Bildverständnis und Bildgebrauch im Buch der Reformacio Predigerordens des Johannes Meyer († 1485)', in: *Dominicains et dominicaines en Alsace, XIIIe–XXe siècles. Actes du colloque de Guebwiller, 8–9 avril 1994*, ed. Jean-Luc Eichenlaub (Colmar, 1996), 177–95.

Lentes, '*Textus*' (2006): Thomas Lentes, '*Textus Evangelii*: Materialität und Inszenierung des *textus* in der Liturgie', in: '*Textus' im Mittelalter. Komponenten und Situationen des Wortgebrauchs im schriftsemantischen Feld*, eds. Ludolf Kuchenbuch & Uta Kleine (Göttingen, 2006), 133–48.

Lentes, 'Ereignis' (2010): Thomas Lentes, 'Ereignis und Repräsentation. Ein Diskussionsbeitrag zum Verhältnis von Liturgie und Bild im Mittelalter', in: *Die Bildlichkeit symbolischer Akte*, Symbolische Kommunikation und gesellschaftliche Wertesysteme.

Schriftenreihe des Sonderforschungsbereiches 496, 28 (Münster, 2010), 155–84.

Leroquais, *Bréviaires* (1934): Victor H. Leroquais, *Les bréviaires manuscrits des bibliothèques publiques de France*, 6 vols. (Paris, 1934).

Lesser, 'Bücherverbreitung' (2014): Bertram Lesser, 'Kaufen, Kopieren, Schenken. Wege der Bücherverbreitung in den monastischen Reformbewegungen des Spätmittelalters', in: *Schriftkultur* (2014), 327–54.

Lesser & Prinsen, 'Einbände' (2013): Bertram Lesser & Femke Prinsen, 'Gebunden, geheftet, vernäht. Vielfältige Einbände aus Frauenklöstern', in: *Rosenkränze und Seelengärten. Bildung und Frömmigkeit in niedersächsischen Frauenklöstern*, ed. Britta-Juliane Kruse, Ausstellungskataloge der Herzog August Bibliothek 96 (Wolfenbüttel, 2013), 71–78.

De Letouf, *Mémoires* (1693): Claude de Letouf, *Mémoires et la vie de Messire Claude de Letouf, chevalier, baron de Sirot, lieutenant général des camps et armées du Roy* (Paris, 1683).

Levy, 'Organum' (1974): Kenneth Levy, 'A Dominican Organum Duplum', *Journal of the American Musicological Society* 27 (1974), 183–211.

Levy, 'Orality' (1990): Kenneth Levy, 'On Gregorian Orality', *Journal of the American Musicological Society* 43 (1990), 185–227.

F. Lewis, 'Image' (1990): Flora Lewis, 'From Image to Illustration: The Place of Devotional Images in the Book of Hours', in: *Iconographie médiévale: Image, texte, contexte*, ed. G. Duchet-Suchaux (Paris, 1990), 29–48.

G. J. Lewis, *Bibliographie* (1989): Gertrud Jaron Lewis, *Bibliographie zur deutschen Frauenmystik des Mittelalters, mit einem Anhang zu Beatrijs van Nazareth und Hadewijch von Frank Willaert und Marie-José Govers*, Bibliographien zur deutschen Literatur des Mittelalters 10 (Berlin, 1989).

Lexicon Latinitatis (1977–2005): *Lexicon Latinitatis Nederlandicae Medii Aevi* = Woordenboek van het middeleeuws Latijn van de Noordelijke Nederlanden, eds. Johannes W. Fuchs et al., 8 vols., (Leiden, 1977–2005).

Lexikon der christlichen Ikonographie, eds. Engelbert Kirschbaum & Günter Bandmann, 8 vols. (Rome, 1968–1978).

Lexikon des Mittelalters, ed. Robert Auty et al., 10 vols. (Munich–Zurich, 1977–1999).

LeZotte, 'Power' (2011): Annette LeZotte, 'Cradling Power: Female Devotions and Early Netherlandish Jésueaux', in: *Push Me, Pull You: Physical and Spatial Interaction in Late Medieval and Renaissance Art*, eds. Sarah Blick & Laura D. Gelfand, 2 vols., Studies in Medieval and Reformation Traditions 156 (Leiden, 2011), vol. 2, 59–84.

Linden, 'Konvent' (2000): Sandra Linden, 'Vom irdischen zum himmlischen Konvent. Die Baumvision als Interpretationszugang zur Todesdarstellung im Engelthaler Schwesternbuch', in: *Oxford German Studies* 29 (2000), 31–76.

Linden, 'Buch' (2007): Sandra Linden, 'Das sprechende Buch. Fingierte Mündlichkeit in der Schrift', in: *Text—Bild—Schrift. Vermittlung von Information im Mittelalter*, eds. Andres Laubinger et al., Mittelalter-Studien 14 (Munich, 2007), 83–100.

Lindgren, *Sensual Encounters* (2009): Erika Lauren Lindgren. *Sensual Encounters: Monastic Women and Spirituality in Medieval Germany* (New York, 2009).

Linke, 'Survey' (1993): Hansjürgen Linke, 'A Survey of Medieval Drama and Theater in Germany', in: *Medieval Drama on the Continent of Europe*, eds. Clifford Davidson & John H. Stroupe (Kalamazoo, 1993), 17–53.

Lipinsky, '*Crux Gemmata*' (1960): Angelo Lipinsky, 'La *Crux Gemmata* e il culto della Santa Croce nei monumenti superstiti e nelle raffigurazioni monumentali', in: *Corso di Cultura sull' Arte Ravennate e Bizantina* 7 (1960), 139–89.

Lipsius, *Apostelgeschichten* (1883–1890): Richard Adelbert Lipsius, *Die apokryphen Apostelgeschichten und Apostellegenden. Ein Beitrag zur altchristlichen Literaturgeschichte und zu einer zusammenfassenden Darstellung der neutestamentlichen Apokryphen*, 2 vols. (Braunschweig, 1883–1890; repr. Amsterdam, 1976).

Listen Daughter (2001): *Listen Daughter: The Speculum Virginum and the Formation of Religious Women in the Middle Ages*, ed. Constant J. Mews (Basingstoke, 2001).

Literary History (1996): *Literary History and the Challenge of Philology: The Legacy of Erich Auerbach*, ed. Seth Lerer (Stanford, 1996).

Liturgie und Frauenfrage (1990): *Liturgie und Frauenfrage: Ein Beitrag zur Frauenforschung aus liturgiewissenschaftlicher Sicht*, eds. Teresa Berger & Albert Gerhards, Pietas Liturgica 7 (St. Ottilien, 1990).

Lobrichon, 'Femme' (1996): Guy Lobrichon, 'La Femme d'Apocalypse 12 dans l'exégèse du haut Moyen Âge latin (760–1200)', in: *Marie* (1996), 407–28.

Loe & Reichert, *Statistisches* (1907): Paulus von Loe & Benedikt Maria Reichert, *Statistisches über die Ordensprovinz Teutonia*, Quellen und Forschungen zur Geschichte des Dominikanerordens 1 (Leipzig, 1907).

Löer, 'Buchmalerei' (1997): Ulrich Löer, 'Buchmalerei in einem Graduale aus Dortmund (B 6) und Paradiese (D 11)', in: *Gotische Buchmalerei aus Westfalen. Choralbücher der Frauenklöster Paradiese und Welver bei Soest*, ed. Ulrich Löer, Soester Beiträge 57 (Soest, 1997), 101–15.

Löer, 'Handschriftenfragmente' (1997): Ulrich Löer, 'Illuminierte Handschriftenfragmente aus dem Kloster Welver', in: *Gotische Buchmalerei aus Westfalen. Choralbücher der Frauenklöster Paradiese und Welver bei Soest*, ed. Ulrich Löer, Soester Beiträge 57 (Soest, 1997), 55–68.

Löer, 'Eher für Schul- und Kirchenfondsals' (2001): Ulrich Löer, 'Eher für Schul- und Kirchenfonds für die Bezahlung von Sing- und Lesemessen – Zur Säkularisation des Dominikaner- und Minoritenklosters zu Soest 1814', *Soester Zeitschrift* 113 (2001), 65–81.

Löer, 'Preussische Beamte' (2013): Ulrich Löer, 'Preußische Beamte als "Retter in der Not" – kulturstaatliche Initiativen für sakrale Kunstwerke aus Soest. Ein Beitrag zur preußischen Denkmalpflege und Museumspolitik im 19. Jahrhundert', *Forschungen zur Brandenburgischen und Preußischen Geschichte* 23.1 (2013) 19–59.

Löser, 'Predigen' (2009): Freimut Löser, 'Predigen in dominikanischen Konventen. "Kölner Klosterpredigten" und "Paradisus anime intelligentis"', in: *'Paradisus anime intelligentis'. Studien zu einer dominikanischen Predigtsammlung aus dem Umkreis Meister Eckharts*, eds. Burkhard Hasebrink et al. (Tubingen, 2009), 227–64.

Loewen, *Early Franciscan Thought* (2013): Peter Victor Loewen, *Music in Early Franciscan Thought*, Medieval Franciscans 9 (Leiden, 2013).

Lohrum, 'Johannes Teutonicus' (1992): Meinolf Lohrum, 'Johannes Teutonicus', Biographisch-Bibliographisches Kirchenlexikon 3 (1992), col. 595.

Lohrum, 'Dominikaner' (1989): M. Lohrum, 'Dominikaner', in: *Marienlexikon*, eds. Remigius Bäumer & Leo Scheffczyk, 6 vols. (St. Ottilien, 1989), vol. 2, 207–09.

Lohrum, 'Minden – Dominikaner' (1992): Meinolf Lohrum, 'Minden. Dominikaner', in: *Westfälisches Klosterbuch* (1992), vol. 1, 629–32.

Lokaj, 'Stupor mundi' (2009): Rodney John Lokaj, 'Stupor mundi re-addressed', *Critica del testo* 2–3 (2009), 113–21.

Lomnitzer, 'Dietrich von Apolda' (1980/2004): Helmut Lomnitzer, 'Dietrich von Apolda', in: ²*VL* 2 (Berlin, 1980), cols. 103–10 and ²*VL* 11 (Berlin, 2004), col. 353.

Lorenz-Leber, *Kloster Lüne* (1991): Angela Lorenz-Leber, *Kloster Lüne* (Königstein im Taunus, 1991).

Lot-Borodine, *Déification* (1970): Myrrha Lot-Borodine, *La déification de l'homme selon la doctrine des Pères grecs* (Paris, 1970).

Lowden, 'Beginnings' (1999): John Lowden, 'The Beginnings of Biblical Illustration', in: *Imaging the Early Medieval Bible*, ed. John W. Williams (University Park, PA, 1999), 9–59.

Lowden, 'Illuminated Books' (2003): John Lowden, 'Illuminated Books and the Liturgy: Some Observations', in: *Objects, Images, and the Word: Art in the Service of the Liturgy*, ed. Colum Hourihane (Princeton, 2003), 17–53.

Lubac, *Exégèse* (1959): Henri de Lubac, *Exégèse médiévale: les quatre sens de l'écriture* (Paris, 1959), translated as *Medieval Exegesis: The Four Senses of Scripture*, trans. Mark Sebanc & E. M. Macierowski, 3 vols. (Grand Rapids, 1998–2009).

Luchtenberg, *Johannes Löh* (2013): Paul Luchtenberg, *Johannes Löh und die Aufklärung im Bergischen* (Berlin, 2013).

Lütolf, 'Anmerkungen' (1983): Max Lütolf, 'Anmerkungen zum liturgischen Gesang im mittelalterlichen St. Katherinenthal', in: *Graduale von Sankt Katharinenthal* (1983), 235–94.

Lukas, *St. Maria zur Wiese* (2004): Viktoria Lukas, *St. Maria zur Wiese. Ein Meisterwerk gotischer Baukunst in Soest* (Berlin, 2004).

Lumma, 'Beispiel' (2014): Liborius Olaf Lumma, 'Ecce nova facio omnia – Ein Beispiel für die liturgische Verwendung der Apokalypse in der Kirchweihliturgie', in: *Tot sacramenta quot verba. Zur Kommentierung der Apokalypse des Johannes von den Anfängen bis ins 12. Jahrhundert*, eds. Konrad Huber et al. (Münster, 2014), 379–92.

Luneau, *L'histoire* (1964): Auguste Luneau, *L'histoire du salut chez les Pères de l'Église: la doctrine des âges du monde* (Paris, 1964).

Lurker, 'Quadrat' (1978): Manfred Lurker, 'Quadrat und Vierzahl im Weltbild früher Kulturen', *Mannus* 44 (1978), 121–32.

Lutter, 'Klausur' (2005): Christina Lutter, 'Klausur zwischen realen Begrenzungen und spirituellen Entwürfen. Handlungsspielräume und Identifikationsmodelle der Admonter Nonnen im 12. Jahrhundert', in: *Virtuelle Räume. Raumwahrnehmung und Raumvorstellung im Mittelalter. Akten des 10. Symposiums des Mediävistenverbandes. Krems, 24.–26. März 2003*, ed. Elisabeth Vavra (Berlin, 2005), 305–24.

Lutz, *Identität* (2010): Eckart Conrad Lutz, *Arbeiten an der Identität. Zur Medialität der cura monialium im Kompendium des Rektors eines reformierten Chorfrauenstifts. Mit Edition und Ab-*

bildung einer Windesheimer 'Forma investiendi sanctimonialium' und ihrer Notationen, Scrinium Friburgense 27 (Berlin, 2010).

Lutze, 'Antiphonar' (1937): Eberhard Lutze, 'Antiphonar', *RDK* 1 (1937), 729–32.

Maasewerd, 'Parusiegedanke' (1962): Theodor Maasewerd, 'Der Parusiegedanke in der Liturgie des Advents', *Bibel und Liturgie* 36 (1962), 62–77.

McAodha, 'Holy Name' (1969): Loman McAodha, 'The Holy Name of Jesus in the Preaching of St. Bernardine of Siena', *Franciscan Studies* 29 (1969), 37–65.

McCaffery, 'Maundy' (1980): Hugh McCaffery, 'The Meaning of the Maundy according to Saint Bernard', in: *The Chimaera of his Age: Studies on Bernard of Clairvaux*, eds. E. Rozanne Elder & John R. Sommerfeldt (Kalamazoo, 1980), 140–46.

McCormack, '*Adventus*' (1972): Sabine G. McCormack, 'Change and Continuity in Late Antiquity: The Ceremony of *Adventus*', *Historia: Zeitschrift für Alte Geschichte* 21 (1972), 721–52.

McGinn, *Mysticism* (1994): Bernard McGinn, *The Growth of Mysticism* (New York, 1994).

McGrade, 'Gottschalk' (1996): Michael McGrade, 'Gottschalk of Aachen, the Investiture Controversy, and Music for the Feast of the *Divisio apostolorum*', *Journal of the American Musicological Society* 49 (1996), 351–408.

Maciejewski, 'Research' (2010): Jacek Maciejewski, '"*Nudo pede intrat urbem*"': Research on the "Adventus" of a Medieval Bishop through the First Half of the Twelfth Century', *Viator: Medieval and Renaissance Studies* 41 (2010) 89–100.

MacInerney, *Virgins* (2003): Maud Burnett MacInerney, *Eloquent Virgins from Thecla to Joan of Arc* (New York, 2003).

McKinnon, *Advent Project* (2000): James W. McKinnon, *The Advent Project: The Later-Seventh-Century Creation of the Roman Mass Proper* (Berkeley, 2000), 238–39.

McNamee, *Vested Angels* (1998): Maurice B. McNamee, *Vested Angels: Eucharistic Allusions in Early Netherlandish Paintings*, Liturgia condenda 6 (Louvain, 1998).

Mäder, *Streit* (1971): Eduard Johann Mäder, *Der Streit der 'Töchter Gottes'. Zur Geschichte eines allegorischen Motivs* (Bern, 1971).

Magali, 'Séquences' (2001): Javelaud Magali, 'Les séquences du Graduel de Fontevraud', 2 vols., Mémoire de maîtrise, Centre d'Études Supérieures de Civilisation Médiévale, Poitiers (2001).

Maggioni, *Richerche* (1995): Giovanni Paolo Maggioni, *Richerche sulla composizione e sulla transmissione della 'legenda aurea'*, Biblioteca di Medioevo Latino 8 (Spoleto, 1995).

Magister Raimundus (2002): *Magister Raimundus: Atti del convegno per il IV cenenario della canonizzazione di San Raimondo de Penyafort (1601–2001)*, ed. Carlo Longo, Dissertationes historicae 28 (Rome, 2002).

Maguire, 'Validation' (2011): Henry Maguire, 'Validation and Disruption: The Binding and Severing of Text and Image in Byzantium', in: *Bild und Text im Mittelalter*, eds. Karin Krause & Barbara Schellewald, Sensus 2 (Cologne, 2011), 267–81.

Maier, *Wienhausen* (1970): Konrad Maier, with Helmut Engel, *Die Kunstdenkmale des Landkreises Celle. Im Regierungsbezirk Lüneburg, Teil II: Wienhausen. Kloster und Gemeinde*, Die Kunstdenkmale des Landes Niedersachsen 34/2 (Hannover, 1970).

Maître, 'Quelques Tropes' (1993): Claire Maître, 'À propos de quelques tropes dans un manuscrit cistercien', in: *Recherches nouvelles sur les tropes liturgiques*, eds. Wulf Arlt & Gunilla Björkvall, Studia Latina Stockholmiensia 36, Corpus Troporum: Supplement (Stockholm, 1993), 343–59.

Maler, 'Studien' (1939): Johannes Maler, 'Studien zur Geschichte der Marienantiphon "Salve regina"', Ph.D. dissertation, Albert Ludwig Universität, Freiburg i. Br. (1939).

Mambelli, '"Gemma Animae"' (2004): Francesca Mambelli, 'Il problema dell'immagine nei commentari allegorici sulla liturgia. Dalla "Gemma Animae" di Onorio d'Autun (1120 ca.) al "Rationale divinorum officiorum" di Durando di Mende (1286–1292)', *Studi medievali*, 3rd series 45 (2004), 121–58.

Mane, 'Le travail au moyen âge' (1992): Perrine Mane, 'Le travail au moyen âge: comparaison entre le texte de l'Ancien Testament et les enluminures d'une Bible moralisée', in: *L'image au moyen âge: actes du Colloque, Amiens, 19–23 mars 1986*, eds. Danielle Buschinger & Wolfgang Spiewok, WODAN: Recherches en Littérature Médiévale 15 (Amiens, 1992), 193–206.

Manion, 'Assumption' (1998): Margaret M. Manion, 'An Unusual Image of the Assumption in a Fourteenth-Century Dominican Choir-Book', in: *The Art of the Book: Its Place in Medieval Worship*, eds. Margaret M. Manion & Bernard J. Muir (Exeter, 1998), 153–61.

S. Manning, 'Typology' (1970): Stephen Manning, 'Typology and the Literary Critic', *Early American Literature* 5 (1970), 51–73.

W. Manning, 'Miniatures' (1968): Warren F. Manning: 'Three Curious Miniatures of Saint Dominic', *Archivum Fratrum Praedicatorum* 38 (1968), 43–46.

Manuscript Illumination (2001): *Manuscript Illumination in the Modern Age: Recovery and Reconstruction*, ed. Sandra Hindman et al. (Evanston, 2001).

Manuwald, 'Wortillustration' (2010): Henrike Manuwald, '"Eine blühende Nachkommenschaft und ein hürdenehmender Steuerberater". Zur medialen Struktur und Funktion von Wortillustration', *Archiv für Kulturgeschichte* 92 (2010), 1–45.

Marco & Craddock, 'Peter Martyr' (2005): Barbara de Marco & Jerry R. Craddock, 'St. Peter Martyr and the Development of Early Dominican Hagiography', in: *Études de langue et de littérature médiévales offertes à Peter T. Ricketts à l'occasion de son 70ème anniversaire*, eds. Dominique Billy & Ann Buckley (Turnhout, 2005), 141–52.

Mariaux, 'Claricia' (2013): Pierre Alain Mariaux, 'Qui a peur de Claricia?', in: *L'image en questions. Pour Jean Wirth*, eds. Frédéric Elsig et al., Ars Longa 4 (Geneva, 2013), 138–45.

Marie (1966): *Marie: Le culte de la Vierge dans la société médiévale*, eds. Dominique Iogna–Prat et al. (Paris, 1996)

Marrow, 'Morgan Infancy Cycle' (1968): James H. Marrow, 'Dutch Manuscript Illumination before the Master of Catherine of Cleves: The Master of the Morgan Infancy Cycle', *Nederlands Kunsthistorisch Jaarboek* 19 (1968), 51–113.

Marrow, 'John the Baptist' (1968): James H. Marrow, 'John the Baptist, Lantern for the Lord: New Attributes for the Baptist from the Northern Netherlands', *Oud Holland* 83 (1968), 3–12.

Marrow, 'Supplement' (1970): James H. Marrow, 'John the Baptist, Lantern for the Lord: A Supplement', *Oud Holland* 85 (1970), 188–93.

Marrow, 'Tormentors' (1977): James H. Marrow, '*Circumdederunt me canes multi*: Christ's Tormentors in Northern European Art of the Late Middle Ages and Early Renaissance', *Art Bulletin* 59 (1977), 167–81.

Marrow, *Passion Iconography* (1979): James H. Marrow, *Passion Iconography in Northern European Art of the Late Middle Ages and Early Renaissance: A Study of the Transformation of Sacred Metaphor into Descriptive Narrative*, Ars Neerlandica 1 (Courtrai, 1979).

Marti, *Engelberg* (2002): Susan Marti, *Malen, Schreiben und Beten: die spätmittelalterliche Handschriftenproduktion im Doppelkloster Engelberg*, Zürcher Schriften zur Kunst-, Architektur- und Kulturgeschichte 3 (Zurich, 2002).

Marti, 'Schwester Elisabeth' (2006): Susan Marti, 'Schwester Elisabeth schreibt für ihre Brüder in Dortmund. Das Graduale für das Dortmunder Dominikanerkloster', in: *Die Dortmunder Dominikaner* (2006), 277–94.

Marti, 'Sisters' (2008): Susan Marti, 'Sisters in the Margin? Scribes and Illuminators in the Scriptorium of Paradies bei Soest', in: *Leaves from Paradise* (2008), 5–54.

Marti, 'Geflecht' (2009): Susan Marti, 'Ein Geflecht aus Text und Bild. Vorläufige Überlegungnen zu einer Leinenstickerei aus der Soester Wiesenkirche', *Soester Zeitschrift. Zeitschrift des Vereins für Geschichte und Heimatpflege Soest* (2009), 59–67.

Marti, 'Memorialbildnisse' (2013): Susan Marti, 'Memorialbildnisse in spätmittelalterlichen Chorhandschriften aus dem Dominikanerinnenkloster Paradies bei Soest', in: *Netzwerke der Memoria*, eds. Jens Lieven et al. (Essen, 2013), 157–72.

Marti, 'Micrographic Prayers' (2016): Susan Marti, 'Micrographic Prayers for Monks and Colorful Images for Nuns: Evidence for Gender-Specific Decorations in Liturgical Manuscripts from Late Medieval Germany', in: *Les Femmes, la culture et les arts en Europe, entre Moyen Âge et Renaissance. Colloque Lille, mars, 2012*, eds. Anne-Marie Legaré & Cynthia Brown (Turnhout, 2016), 177–95.

Maschke, 'Fragmentfunde' (2013): Eva M. Maschke, 'Neue Fragmentfunde in der Universitäts- und Landesbibliothek Münster. Zur Rekonstruktion einer Notre-Dame-Handschrift aus dem Soester Dominikanerkonvent', *Die Musikforschung* 66 (2013), 277–80.

Masciadri, 'Pange lingua' (2006): Virgilio Masciadri, 'Pange lingua. Überlegungen zu Text und Kontext', *Millennium-Jahrbuch* 3 (2006), 185–224.

Materialität (2002): *Materialität und Medialität von Schrift*, eds. Erika Greber et al., Schrift und Bild in Bewegung 1 (Bielefeld, 2002).

Mathiesen, '"Office"' (1983): Thomas J. Mathiesen, '"The Office of the New Feast of Corpus Christi" in the *Regimen animarum* at Brigham Young University', *Journal of Musicology* 2 (1983), 13–44.

Mattern, *Literatur* (2011): Tanja Mattern, *Literatur der Zisterzienserinnen. Edition und Untersuchung einer Wienhäuser Legendenhandschrift*, Bibliotheca Germanica 56 (Tübingen–Basel, 2011).

Mattick, 'Chorbücher' (1998): Renate Mattick, 'Drei Chorbücher aus dem Kölner Klarissenkloster im Besitz von Sulpiz Boisserée', *Wallraf-Richartz-Jahrbuch* 59 (1998), 59–101.

Mauss, 'Benedictus Füger' (1994): Detlev Mauss, 'Benedictus Füger und die Clarissen zu Runcada bei Brixen', *Gutenberg Jahrbuch* 69 (1994), 292–301.

Mayr-Harting, 'Assumption' (2004): Henry Mayr-Harting, 'The Idea of the Assumption of Mary in the West, 800–1200', *Studies in Church History* 39 (2004), 86–111.

Mecham, 'Northern Jerusalem' (2005): June Mecham, 'A Northern Jerusalem: Transforming the Spatial Geography of the Convent of Wienhausen', in: *Defining the Holy: Sacred Space in Medieval and Early Modern Europe*, eds. Sarah Hamilton & Andrew Spicer (Aldershot, 2005), 139–60.

Mecham, 'Cooperative Piety' (2008): June Mecham, 'Cooperative Piety among Monastic and Secular Women in Late Medieval Germany', *Church History and Religious Culture* 88 (2008), 581–611.

Mecham, *Sacred Communities* (2014): June L. Mecham, *Sacred Communities, Shared Devotions: Gender, Material Culture, and Monasticism in Late Medieval Germany*, eds. Alison I. Beach et al., Medieval Women: Texts and Contexts 29 (Turnhout, 2014).

Meersseman, *Akathistos* (1958–1960): Gilles Gérard Meersseman, *Der Hymnos Akathistos im Abendland*, 2 vols., Spicilegium Friburgense 2–3 (Fribourg, 1958–1960).

Meersseman, *Dossier* (1982): Gilles Gérard Meersseman, *Dossier de l'Ordre de la Pénitence au XIIIe siècle*, Spicilegium Friburgense 7, 2nd edn. (Fribourg, 1982).

Meeuws, '"Ora et labora"' (1992): Marie-Benoît Meeuws, '"Ora et labora": devise Bénédictine?' *Collectanea cisterciensia* 54 (1992), 193–219.

C. Meier, '*Scientia*' (1987): Christel Meier, '*Scientia divinorum operum*. Zu Hildegards von Bingen visionär-künstlerischer Rezeption Eriugenas', in: *Eriugena Redivivus. Zur Wirkungsgeschichte seines Denkens im Mittelalter und im Übergang zur Neuzeit, Vorträge des V. Internationalen Eriugena-Colloquiums Werner-Reimers-Stiftung Bad Homburg, 26.–30. August 1985*, ed. Werner Beierwaltes (Heidelberg, 1987), 89–141.

C. Meier, 'Malerei' (1990): Christel Meier, 'Malerei des Unsichtbaren: Über den Zusammenhang von Erkenntnistheorie und Bildstruktur im Mittelalter', in: *Text und Bild, Bild und Text. DFG-Symposion 1988*, ed. Wolfgang Harms, Germanistische Symposien. Berichtsbände 11 (Stuttgart, 1990), 35–65.

C. Meier, '"Labor improbus" oder "opus nobile?"' (1996): Christel Meier, '"Labor improbus" oder "opus nobile"? Zur Neubewertung der Arbeit in philosophisch-theologischen Texten des 12. Jahrhunderts', *Frühmittelalterliche Studien* 30 (1996), 315–42.

C. Meier, 'Quadratur' (2003): Christel Meier, 'Die Quadratur des Kreises. Die Diagrammatik des 12. Jahrhunderts als symbolische Denk- und Darstellungsform', in: *Die Bildwelt der Diagramme Joachims von Fiore. Zur Medialität religiös-politischer Programme im Mittelalter*, ed. Alexander Patschovsky (Ostfildern, 2003), 23–53.

C. Meier, 'Autorschaft' (2004): Christel Meier, 'Autorschaft im 12. Jahrhundert. Persönliche Identität und Rollenkonstrukt', in: *Unverwechselbarkeit. Persönliche Identität und Identifikation in der vormodernen Gesellschaft*, ed. Peter von Moos, Norm und Struktur 23 (Cologne et al., 2004), 207–66.

T. Meier, *Gestalt Marias* (1959): Theo Meier, *Die Gestalt Marias im geistlichen Schauspiel des deutschen Mittelalters* (Berlin, 1959).

Meinardus, '"Strickenden Madonna"' (1988): Otto F. A. Meinardus, 'Zur "strickenden Madonna" oder "die Darbringung der Leidenswerkzeuge" des Meister Bertram', *Idea. Jahrbuch der Hamburger Kunsthalle* 7 (1988), 15–22.

Meister, *Fragmente* (1901): Aloys Meister, *Die Fragmente der Libri VIII Miraculorum des Caesarius von Heisterbach*, Römische Quartalschrift für christliche Alterthumskunde und für Kirchengeschichte. Supplementheft 13 (Rome, 1901).

Meli, 'Virginitas et Auctoritas' (2004): Beatriz Meli, 'Virginitas et Auctoritas: Two Threads in the Fabric of Hildegard of Bingen's "Symphonia armonie celestium revelationum"', in: *The Voice of Silence: Women's Literacy in a Men's Church*, eds. Thérèse de Hemptinne & María Eugenia Gongora, Medieval Church Studies 9 (Turnhout, 2004), 47–56.

Mellinkoff, *Moses* (1970): Ruth Mellinkoff, *The Horned Moses in Medieval Art and Thought*, California Studies in the History of Art 14 (Berkeley, 1970).

Mellinkoff, 'Red Hair' (1982): Ruth Mellinkoff, 'Judas's Red Hair and the Jews', *Journal of Jewish Art* 9 (1982), 31–46.

Mellinkoff, *Outcasts* (1993): Ruth Mellinkoff, *Outcasts: Signs of Otherness in Northern European Art of the Late Middle Ages*, 2 vols. (Berkeley, 1993).

Melzer, 'Ausgrabungen' (1996): Walter Melzer, 'Neue Ausgrabungen zu den Anfängen des Klosters Paradiese und an den Quellen der Stadt Soest', *Soester Zeitschrift* 108 (1996), 15–20.

Melzer, 'Paradiese' (2000): Walter Melzer, 'Das ehemalige Dominikanerinnenkloster Paradiese', in: *Die Stadt Soest: Archäologie und Baukunst*, eds. Gabriele Isenberg et al., Führer zu archäologischen Denkmälern in Deutschland 38 (Stuttgart, 2000), 162–72.

Melzer & Lammers, 'Ausgrabungen' (2000): Walter Melzer & Dieter Lammers, 'Ausgrabungen im ehemaligen Dominikanerinnenkloster Paradiese bei Soest', in: *Fundort Nordrhein-Westfalen, Millionen Jahre Geschichte*, exh. cat., Römisch-Germanisches Museum Cologne, Westfälisches Museum für Archäologie Münster and Museum het Valkenhof Nijmegen, eds. Heinz Günter Horn et al. (Mainz, 2000), 428–30.

Mengis, *Schreibende Frauen* (2013): Simone Mengis, *Schreibende Frauen um 1500. Scriptorium und Bibliothek des Dominikanerinnenklosters St. Katharina St. Gallen*, Scrinium Friburgense 28 (Berlin, 2013).

Menzel, *Predigt und Geschichte* (1998): Michael Menzel, *Predigt und Geschichte. Historische Exempel in der geistlichen Rhetorik des Mittelalters*, Archiv für Kulturgeschichte. Beiheft 45 (Cologne et al., 1998).

Mercuri, *Corona* (2004): Chiara Mercuri, *Corona di Cristo, corona di re: La monarchia francese e la Coronoa di Spine nel medioevo*, Centro alti studi in scienze religiose 2 (Rome, 2004).

Mersch, *Vallis Dei* (2007): Margit Mersch, *Das ehemalige Zisterzienserinnenkloster Vallis Dei in Brenkhausen im 13. und 14. Jahrhundert*, Denkmalpflege und Forschung in Westfalen 45 (Mainz, 2007).

Mertens, 'Reformbewegungen' (1996): Dieter Mertens, 'Monastische Reformbewegungen des 15. Jahrhunderts. Ideen – Ziele – Resultate', in: *Reform von Kirche und Reich zur Zeit der Konzilien von Konstanz (1414–18) und Basel (1431–49). Konstanz-Prager Historisches Kolloquium (11.–17. Oktober 1993)*, eds. Ivan Hlaváček & Alexander Patschovsky (Konstanz, 1996), 157–81.

Mertens, 'Klosterreform' (2001): Dieter Mertens, 'Klosterreform als Kommunikationsereignis', in: *Formen und Funktionen öffentlicher Kommunikation im Mittelalter*, ed. Gerd Althoff, Vorträge und Forschungen 51 (Stuttgart, 2001), 397–420.

Meschede, *Fröndenberger Altar* (1996): Petra Meschede, *Der Fröndenberger Altar*, Kunst in Westfalen 2 (Paderborn, 1996).

Messerer, 'Darstellungsprinzipien' (1962): Wilhelm Messerer, 'Einige Darstellungsprinzipien der Kunst im Mittelalter', *Deutsche Vierteljahrschrift für Literaturwissenschaft und Geistesgeschichte* 36 (1962), 157–78.

Meßner 'Hermeneutik' (1993): Reinhard Meßner, 'Zur Hermeneutik allegorischer Liturgieerklärung in Ost und West', *Zeitschrift für Katholische Theologie* 115 (1993), 284–319, 415–34.

Metz, *La consécration* (1954): René Metz, *La consécration des vierges dans l'Église romaine: étude d'histoire de la liturgie*, Bibliothèque de l'Institut de droit canonique de l'Université de Strasbourg 4 (Paris, 1954).

Metz, 'La couronne' (1985): René Metz, 'La couronne et l'anneau dans la consécration des vierges. Origine et évolution des deux rites dans la liturgie latine', in: *La femme et l'enfant dans le droit canonique médiéval*, Variorum Reprints: Collected Studies Series 222 (London, 1985), 113–32.

Mews, 'Holy Theft' (2009): Constant J. Mews, 'Celebrating a Holy Theft: The Translation of the Relics of St. Thomas Aquinas from Italy to France and the "Poissy Antiphonal"', in: *Imagination, Books and Community in Medieval Europe: Papers of a Conference held at the State Library of Victoria, Melbourne, Australia, 29 – 31 May, 2008, in conjunction with an Exhibition, 'The Medieval Imagination', 28 March – 15 June 2008*, ed. Gregory C. Kratzmann (South Yarra, 2009), 241–45.

Mews, 'St. Thomas' (2009): Constant J. Mews, 'Remembering St. Thomas in the Fourteenth Century: Between Theory and Practice', *Przegląd Tomistyczny* 15 (2009), 77–91.

Meyendorff, 'Iconographie' (1959): John Meyendorff, 'L'iconographie de la sagesse divine dans la tradition byzantine', *Cahiers archéologiques* 10 (1959), 259–77.

C. Meyer, *Catalogue* (2006): Christian Meyer, *Catalogue des manuscrits notés du Moyen Âge: Collections d'Alsace, de Franche-Comté et de Lorraine. I, Colmar, Bibliothèque municipale*, Catalogue des manuscrits notés du Moyen Âge conservés dans les bibliothèques publiques de France (Turnhout, 2006).

R. Meyer, 'Miniaturen' (1967): Ruth Meyer, 'Die Miniaturen im Sakramentar des Bischofs Sigebert von Minden', in: *Studien zur Buchmalerei und Goldschmiedekunst des Mittelalters. Festschrift für Hermann Karl Usener* (Marburg an der Lahn, 1967), 181–200.

W. Meyer, *Geschichte* (1882): Wilhelm Meyer, *Geschichte des Kreuzholzes vor Christus*, Abhandlungen der philosophischen Classe der königlich bayerischen Akademie der Wissenschaften 16/2 (Munich, 1882).

Meyer & Suntrup, *Lexikon* (1987): Heinz Meyer & Rudolf Suntrup, *Lexikon der mittelalterlichen Zahlenbedeutungen*, Münstersche Mittelalter-Schriften 56 (Munich, 1987).

Meyer-Barkhausen, 'Netze' (1954): Werner Meyer-Barkhausen, 'Die Kirche des ehemaligen Zisterzienserklosters in Netze', *Hessische Heimat* 4 (1954), 2–6.

Meyvaert & Davril, 'Théodulfe' (2003): Paul Meyvaert & Anselme Davril, 'Théodulfe et Bède au sujet des blessures du Christ', *Revue Bénédicine* 113 (2003), 71–79.

B. Michael, 'Bibliothek' (1990): Bernd Michael, 'Die Bibliothek der Soester Dominikaner. Ein Verzeichnis ihrer erhaltenen Handschriften', *Soester Zeitschrift* 102 (1990), 8–30.

B. Michael, *Bibliothek* (1990): Bernd Michael, with Tilo Brandis, *Die mittelalterlichen Handschriften der Wissenschaftlichen Bibliothek Soest* (Wiesbaden, 1990).

E. Michael, *Inschriften* (1984): Eckhard Michael, *Die Inschriften des Lüneburger St. Michaelisklosters und des Klosters Lüne*, Die deutschen Inschriften 24 (Wiesbaden, 1984).

E. Michael, 'Bildstickereien' (1985): Eckhard Michael, 'Bildstickereien aus Kloster Lüne als Ausdruck der Reform des 15. Jahrhunderts', *Die Diözese Hildesheim in Vergangenheit und Gegenwart* 53 (1985), 633–78.

Michel, 'Oelinghausen' (1994): Wilfried Michel, 'Oelinghausen—Prämonstratenserinnen', in: *Westfälisches Klosterbuch* (1994), vol. 2, 164–72.

Michels, *Genealogien* (1955): Franz Goswin von Michels, *Genealogien Soester Geschlechter*, Soester Beiträge 11 (Soest, 1955).

Michelson, 'Bernardino of Siena' (2004): Emily Michelson, 'Bernardino of Siena Visualizes the Name of God', in: *Speculum Sermonis: Interdisciplinary Reflections on the Medieval Sermon*, eds. Georgiana Donavin et al., Disputatio 1 (Turnhout, 2004), 157–79.

Miedema, *'Mirabilia Romae'* (1996): Nine Robijntje Miedema, *Die 'Mirabilia Romae'. Untersuchungen zu ihrer Überlieferung mit Edition der deutschen und niederländischen Texte*, Münchener Texte und Untersuchungen 108 (Tübingen, 1996).

Miglio, *Alfabeto* (2008): Luisa Miglio, *Governare l'alfabeto: Donne, scrittura e libri nel Medioevo*, Scritture e libri del medioevo 6 (Rome, 2008).

Millet & Rabel, *Vierge* (2011): Hélène Millet & Claudia Rabel, with Bruno Mottin: *La Vierge au Manteau du Puy-en-Velay: Un chef-d'œuvre du gotique international (vers 1400–1410)* (Paris, 2011).

Milner, 'Lignum vitae' (1996): Christine Milner, 'Lignum vitae or *crux gemmata*? The Cross of Golgotha in the Early Byzantine Period', *Byzantine and Modern Greek Studies* 20 (1996), 77–99.

Mimouni, *Dormition* (1995): Simon Claude Mimouni, *Dormition et assomption de Marie: histoire des traditions anciennes*, Théologie historique 98 (Paris, 1995).

Miner, 'Sketches' (1972): Dorothy Miner, 'Preparatory Sketches by the Master of Bodleian Douce Ms. 185', in: *Kunsthistorische Forschungen Otto Pächt zu seinem 70. Geburtstag*, eds. Artur Rosenauer et al. (Salzburg, 1972), 118–28.

Minnis, '"Compilatio"' (1979): Alistair J. Minnis, 'Late-Medieval Discussions of *Compilatio* and the Role of the *Compilator*', *Beiträge zur Geschichte der deutschen Sprache und Literatur* 101 (1979), 385–421.

Minnis, 'Quadruplex sensus' (2000): Alistair J. Minnis, '*Quadruplex sensus, Multiplex modus*: Scriptural Sense and Mode in Medieval Scholastic Exegesis', in: *Interpretation and Allegory: Antiquity to the Modern Period*, ed. Jon Whitman, Brill's Studies in Intellectual History 101 (Leiden, 2000), 231–56.

Mise en page (1990): *Mise en page et mise en texte du livre manuscrit*, eds. Henri-Jean Martin & Jean Vezin (Paris, 1990).

Mitchell, *Iconology* (1986): William J. T. Mitchell, *Iconology: Text, Image, Ideology* (Chicago, 1986).

Mittelalter (2007): *Mittelalter. Kunst und Kultur von der Spätantike bis zum 15. Jahrhundert*, eds. Jutta Zander-Seidel et al., Die Schausammlungen des Germanischen Nationalmuseums 2 (Nuremberg, 2007).

Mittelalterliche Buchmalerei (1954): *Mittelalterliche Buchmalerei aus Westfalen, Städtisches Gustav-Lübcke-Museum* (Hamm, 1954).

Möler, 'Nährmutter' (1950): Liselotte Möler, 'Nährmutter Weisheit. Eine Untersuchung über einen spätmittelalterlichen Bildtypus', *Deutsche Vierteljahrschrift für Literaturwissenschaft und Geistesgeschichte* 24 (1950), 347–59.

Moessner, 'Medieval Embroideries' (1982): Victoria J. Moessner, 'The Medieval Embroideries of Convent Wienhausen', in: *Studies in Cistercian Art and Architecture* 3, ed. Meredith P. Lillich, Cisterican Studies Series 89 (Kalamazoo, 1987), 161–77.

Mohn, *Klosteranlagen* (2006): Claudia Mohn, *Mittelalterliche Klosteranlagen der Zisterzienserinnen. Architektur der Frauenklöster im mitteldeutschen Raum*, Berliner Beiträge zur Bauforschung und Denkmalpflege 4 (Petersberg, 2006).

Mollwo, *Wettinger Graduale* (1944): Marie Mollwo, *Das Wettinger Graduale. Eine geistliche Bilderfolge vom Meister des Kasseler Willehalmcodex und seinem Nachfolger* (Bern-Bümpliz, 1944).

Monnas, *Merchants* (2008): Lisa Monnas, *Merchants, Princes and Painters: Silk Fabrics in Italian and Northern Paintings, 1300–1550* (New Haven, 2008).

More, 'Performance' (1965–1966): Mother Thomas More, 'The Performance of Plainsong in the Later Middle Ages and the Sixteenth Century', *Proceedings of the Royal Musical Association* 92 (1965–1966), 121–34.

Morenzoni, 'Sermons' (1996): Franco Morenzoni, 'Les sermons de Jourdain de Saxe, successeur de Saint Dominique', *Archivum Fratrum Praedicatorum* 66 (1996), 201–44.

Morenzoni, 'Exempla' (1998): Franco Morenzoni, 'Exempla et prédication: l'exemple de Jourdain de Saxe', in: *Les Exempla médiévaux: Nouvelles perspectives*, eds. Jacques Berlioz & Marie Anne Polo de Beaulieu (Paris, 1998), 269–91.

Mormando, *Preacher's Demons* (1999): Franco Mormando, *The Preacher's Demons: Bernardino of Siena and the Social Underworld of Early Renaissance Italy* (Chicago, 1999).

Morris, 'Holy Sepulchre' (1997): Colin Morris, 'Bringing the Holy Sepulchre to the West: S. Stefano Bologna from the Fifth to the Twentieth Century', *Studies in Church History* 33 (1997) 31–59.

Mortier, *Histoire* (1907): Daniel Antonin Mortier, *Histoire des maitres généraux de l'ordre des frères prêcheurs 3: (1324–1400)* (Paris, 1907).

Mossman, 'Kritik' (2010): Stephen Mossman, 'Kritik der Tradition. Bildlichkeit und Vorbildlichkeit in den deutschen Predigten Marquards von Lindau und die Umdeutung der *mater dolorosa*', in: *Die Predigt im Mittelalter zwischen Mündlichkeit, Bildlichkeit und Schriftlichkeit*, eds. René Wetzel & Fabrice Flückinger, Medienwandel—Medienwechsel—Medienwissen 13 (Zurich, 2010), 305–27.

Mossman, *Marquard von Lindau* (2010): Stephen Mossman, *Marquard von Lindau and the Challenges of Religious Life in Late Medieval Germany: The Passion, the Eucharist, the Virgin Mary* (Oxford, 2010).

Moxey, 'Visual Studies' (2008): Keith Moxey, 'Visual Studies and the Iconic Turn', *Journal of Visual Culture* 7 (2008), 131–46.

Müllenhoff, 'Marienklage' (1867): Karl Müllenhoff, 'Bordesholmer Marienklage', *Zeitschrift für deutsches Altertum und deutsche Literatur* 13 (1867), 288–319.

Müller, 'Untersuchungen' (1998): Markus Müller, 'Untersuchungen zum Bildschmuck des "Codex Henrici"', in: *Der "Codex Henrici". Lateinische Bibelhandschrift Westfalen, 1. Viertel des 14. Jahrhunderts*, ed. Universitäts- und Landesbibliothek Münster, Kulturstiftung der Länder – Patrimonia 144 (Löningen, 1998), 65–90.

Münz-Vierboom, *Klostermauern* (2007): Birgit Münz-Vierboom, *Von Klostermauern und frommen Frauen. Die Ergebnisse der Ausgrabungen im ehemaligen Zisterzienserinnenkloster Gravenhorst*, ed. Birgit Münz-Vierboom (Münster, 2007).

Muff & Benz, 'Textiles Arbeiten' (2000): Guido Muff & Ursula Benz, '"Lasst uns das Kindelein kleiden… lasst uns das Kindelein zieren". Textiles Arbeiten im Kloster St. Andreas', in: *Bewegung in der Beständigkeit. Zu Geschichte und Wirken der Benediktinerinnen von St. Andreas/Sarnen Obwalden*, ed. Rolf de Kegel (Alpnach, 2000), 141–56.

Muir, 'Love' (2009): Carolyn Diskant Muir, 'Love and Courtship in the Convent: St. Agnes and the Adult Christ in Two Upper Rhine Manuscripts', *Gesta* 47 (2009), 123–45.

Mulchahey, *Education* (1998): M. Michèle Mulchahey, '*First the Bow is Bent in Study ….*': Dominican Education before 1350, Studies and Texts 132 (Toronto, 1998).

Muratova, 'Adam' (1977): Xenia Muratova, 'Adam donne leurs noms aux animaux', *Studi Medievali* 18 (1977), 367–94.

Murdoch, 'Adambuch' (1975): Brian O. Murdoch, 'Das deutsche Adambuch und die Adam Legenden des Mittelalters', in: *Deutsche Literatur des späten Mittelalters. Hamburger Kolloquium 1973*, eds. Wolfgang Harms & L. Peter Johnson, Publications of the Institute of Germanic Studies, University of London 22 (Berlin, 1975), 209–24.

Muschiol, 'Liturgie und Klausur' (2001): Gisela Muschiol, 'Liturgie und Klausur: zu den liturgischen Voraussetzungen von Nonnenemporen', in: *Studien zum Kanonissenstift*, ed. Irene Crusius, Veröffentlichungen des Max-Planck-Instituts für Geschichte 167; Studien zur Germania sacra 24 (Göttingen, 2001), 129–48.

Musikort Kloster (2009): *Musikort Kloster. Kulturelles Handeln von Frauen in der Frühen Neuzeit*, ed. Susanne Rode-Breymann, Musik-Kultur-Gender 6 (Vienna, 2009).

Mystik der Frauen (1998): '*Vor mir steht die leere Schale meiner Sehnsucht*'. *Die Mystik der Frauen von Helfta*, eds. Hildegund Keul & Michael Bangert (Leipzig, 1998).

Naughton, 'Manuscripts' (1995): Joan Naughton, 'Manuscripts from the Dominican Monastery of Saint-Louis de Poissy', Ph.D. dissertation, University of Melbourne (1995), available at: https://minerva-access.unimelb.edu.au/handle/11343/39437 (last accessed on July 21, 2016).

Naughton, 'Books' (1998): Joan Naughton, 'Books for a Dominican Nuns' Choir: Illustrated Liturgical Manuscripts at Saint-Louis de Poissy, c. 1330–1350', in: *The Art of the Book: Its Place in Medieval Worship*, eds. Margaret M. Manion & Bernard J. Muir (Exeter, 1998), 67–110.

Naughton, 'Friars' (1998): Joan Naughton, 'Friars and their Books at Saint-Louis de Poissy, a Dominican Foundation for Nuns', *Scriptorium* 52 (1998), 83–102.

Naumburger Domschatz (2006): *Der Naumburger Domschatz. Sakrale Kostbarkeiten im Domschatzgewölbe*, ed. Holger Kunde (Petersberg, 2006).

Nebbiai, *Discours des livres* (2013): Donatella Nebbiai, *Le discours des livres: Bibliothèques et manuscrits en Europe IXe–XVe siècle* (Rennes, 2013).

Neidiger, 'Armutsbegriff' (1977): Bernhard Neidiger, 'Der Armutsbegriff der Dominikanerobservanten. Zur Diskussion in

den Konventen der Provinz Teutonia (1389–1513)', *Zeitschrift für die Geschichte des Oberrheins* 145 (1977), 117–58.

Nemes, '"Geistlichen Übungen"' (2004): Balázs J. Nemes, 'Die "Geistlichen Übungen" Gertruds von Helfta. Ein vergessenes Zeugnis mittelalterlicher Mystik', www.iaslonline.de (last accessed on July 21, 2016).

Nemes, 'Handschriften' (2009): Balázs J. Nemes, '*Dis buch ist iohannes schedelin*. Die Handschriften eines Colmarer Bürgers aus der Mitte des 15. Jahrhunderts und ihre Verflechtungen mit der Literatur der Dominikanerobservanz', in: *Kulturtopographie* (2009), 157–214.

Nemes, 'Der "entstellte" Eckhart' (2012): Balázs J. Nemes, 'Der "entstellte" Eckhart. Eckhart-Handschriften im Straßburger Dominikanerinnenkloster St. Nikolaus', in: *Schreiben und Lesen* (2012), 39–98.

Nemes, 'Text Production' (2014): Balázs J. Nemes, 'Text Production and Authorship: Gertrude of Helfta's *Legatus divinae pietatis*', in: *Companion to Mysticism and Devotion* (2014), 103–30.

Neumüllers-Klauser, 'Inschriften' (1992): Renate Neumüllers-Klauser, 'Frühe deutschsprachige Inschriften', in: *Latein und Volkssprache* (1992), 178–98.

Neunhauser, 'Guéranger' (1991): Burkhard Neunhauser, 'Prosper Guéranger (1805–1875). Werk und Bedeutung nach der Studie von Cuthbert Johnson OSB', *Archiv für Liturgiewissenschaft* 33 (1991), 77–86.

Newman, 'Love's Arrows' (2005): Barbara Newman, 'Love's Arrows: Christ as Cupid in Late Medieval Art and Devotion', in: *The Mind's Eye: Art and Theological Argument in the Middle Ages*, eds. Jeffrey F. Hamburger & Anne-Marie Bouché (Princeton, 2005), 263–86.

Nichols, *Romanesque Signs* (1983): Stephen G. Nichols, *Romanesque Signs: Early Medieval Narrative and Iconography* (New Haven, 1983), 1–65.

Sequences of Nidaros (2006): *The Sequences of Nidaros: A Nordic Repertory and Its European Context*, eds. Lori Kruckenberg-Goldenstein & Andreas Haug (Trondheim, 2006)

Niederkorn-Bruck, 'Musik' (2011): Meta Niederkorn-Bruck, 'Musik in der Liturgie des Klosters (rezipieren und reproduzieren)', in: *Funktionsräume, Wahrnehmungsräume, Gefühlsräume. Mittelalterliche Lebensformen zwischen Kloster und Hof*, ed. Christina Lutter, Veröffentlichungen des Institutes für Österreichische Geschichtsforschung 59 (Vienna–Munich, 2011), 59–80.

Niehoff, 'Graduale' (2008): Franz Niehoff, 'Das Londoner Graduale', in: *seligental.de: anders leben seit 1232*, Schriften aus den Museen der Stadt Landshut 24 (Landshut, 2008), 86–87.

Niffle-Ancieaux, *Repos* (1890): Edmond Niffle-Ancieaux, *Les repos de Jésus et les berceaux reliquaries* (Namur, 1890).

Noble, *Images* (2009): Thomas Noble, *Images, Iconoclasm, and the Carolingians* (Philadelphia, 2009).

Nold, 'John XXII' (2009): Patrick Nold, 'Two Views of John XXII as a Heretical Pope', in: *Defenders and Critics of Franciscan Life: Essays in Honor of John V. Fleming*, ed. Michael F. Cusato, Medieval Franciscans 6 (Leiden, 2009), 139–58.

Kanonissen und Mystikerinnen (2008): *Nonnen, Kanonissen und Mystikerinnen. Religiöse Frauengemeinschaften in Süddeutschland. Beiträge zur interdisziplinären Tagung vom 21. bis 23. September 2005 in Frauenchiemsee*, eds. Eva Schlotheuber et al., Veröffentlichungen des Max-Planck-Instituts für Geschichte 235; Studien zur Germania Sacra 31 (Göttingen, 2008).

Norberg, *Introduction* (2004): Dag Norberg, *An Introduction to the Study of Medieval Latin Versification*, translated by Grant C. Roti & Jacqueline de La Chapelle Skubly; introduction by Jan Ziolkowski (Washington, D.C., 2004).

Nuns' Literacies: Hull (2012): *Nuns' Literacies in Medieval Europe: The Hull Dialogue*, eds. Virginia Blanton et al., Medieval Women: Texts and Contexts 26 (Turnhout, 2013).

Nuns' Literacies: Kansas City (2015): *Nuns' Literacies in Medieval Europe: The Kansas City Dialogue*, eds. Virginia Blanton et al., Medieval Women: Texts and Contexts 27 (Turnhout, 2015).

Nußbaum, 'Bewertung' (1962): Otto Nußbaum, 'Die Bewertung von rechts und links in der römischen Liturgie', *Jahrbuch für Antike und Christentum* 5 (1962), 158–71.

Nußbaum, 'Altarplatten' (1996): Otto Nußbaum, 'Zum Problem der runden und sigmaförmigen Altarplatten', in: *Geschichte und Reform des Gottesdienstes. Liturgiewissenschaftliche Untersuchungen* (Paderborn, 1996), 292–323.

O'Brien, 'Illustration' (1992): Cecilia O'Brien, 'The Illustration of the First Sunday in Advent in Fourteenth- and Fifteenth-Century Italian Breviaries', in: *Il Codice miniato: rapporti tra codice, testo e figurazione. Atti del III Congresso di storia della miniatura con una nota sul restauro dei codici della Biblioteca comunale e dell' Accademia etrusca esposti in occasione del Convegna*, eds. Melania Ceccanti & Maria Cristina Castelli, Storia della miniatura 7 (Florence, 1992), 147–57.

Oakes, *Ora pro nobis* (2008): Catherine Oakes, *Ora pro nobis: The Virgin as Intercessor in Medieval Art and Devotion* (London, 2008).

O'Carroll, 'Friars' (1995): Maura O'Carroll, 'The Friars and the Liturgy in the Thirteenth Century', in: *La Predicazione dei frati dalla metà del '200 alla fine del '300. Atti del XXII Convegno internazionale, Assisi, 13–15 ottobre 1994* (Spoleto, 1995), 191–227.

O'Carroll, 'Cult' (2005): Maura O'Carroll, 'The Cult and Liturgy of St. Dominic', in: *Domenica di Caleruega e la Nascita dell' Ordine dei Frati Predicatori: Atti del XLI Convegno storico internazionale, Todi, 10–12 ottobre 2004*, Atti dei Convegni del Centro italiano di studi sul basso medioevo—Accademia Tudertina e del Centro di studi sulla spiritualità medievale 18 (Spoleto, 2005), 567–611.

Ochsenbein, 'Latein und Deutsch' (1992): Peter Ochsenbein, 'Latein und Deutsch im Alltag oberrheinischer Dominikanerinnenklöster des Spätmittelalters', in: *Latein und Volkssprache* (1992), 42–51.

Ocker, 'Exegesis' (1999): Christopher Ocker, 'Medieval Exegesis and the Origin of Hermaneutics', *Scottish Journal of Theology* 65 (1999), 328–45.

Odenthal, '"Hodie scietis"' (2010): Andreas Odenthal, 'Ausstehende Gegenwart. Der Gregorianische Introitus "Hodie scietis" der Vigilmesse von Weihnachten und seine liturgietheologische Funktion', *Liturgisches Jahrbuch* 60 (2010) 3–20.

Odenthal, 'Osterfeiern' (2011): Andreas Odenthal, '*Surrexit dominus vere*. Osterfeiern um das Heilige Grab als Ausdruck eines veränderten religiösen Empfindens im Mittelalter', in: *Liturgie vom Frühen Mittelalter zum Zeitalter der Konfessionalisierung. Studien zur Geschichte des Gottesdienstes*, Spätmittelalter, Humanismus, Reformation 61 (Tübingen, 2011), 125–42.

Ohly, *Gesetz* (1985): Friedrich Ohly, *Gesetz und Evangelium. Zur Typologie bei Luther und Lucas Cranach. Zum Blutstrahl der Gnade in der Kunst*, Schriftenreihe der Westfälischen Wilhelms-Universität Münster, N.F. 1 (Münster, 1985).

Oliver, 'Mosan Origins' (1978): Judith H. Oliver, 'The Mosan Origins of Johannes von Valke', *Wallraf-Richartz-Jahrbuch* 40 (1978), 23–37.

Oliver, *Manuscript Illumination* (1988): Judith H. Oliver, *Gothic Manuscript Illumination in the Diocese of Liege (c. 1250–c. 1330)*, 2 vols., Corpus of Illuminated Manuscripts from the Low Countries 2–3 (Leuven, 1988).

Oliver, 'Walters Homiliary' (1996): Judith H. Oliver, 'The Walters Homilary and Westphalian Manuscripts', *Journal of the Walters Art Gallery* 54 (1996), 69–85.

Oliver, *Singing with Angels* (2007): Judith Oliver, *Singing with Angels: Liturgy, Music, and Art in the Gradual of Gisela von Kerssenbrock* (Turnhout, 2007).

O'Malley, 'Survey' (1974): Jerome F. O'Malley, 'A Survey of Medieval Johannine Hymns', *Annuale Mediaevale* 15 (1974), 46–73.

O'Meara, *Eriugena* (1988): John J. O'Meara, *Eriugena* (Oxford, 1988).

Ommundsen, 'Books, Scribes, and Sequences' (2007): Åslaug Ommundsen, 'Books, Scribes, and Sequences in Medieval Norway', Ph.D. dissertation, University of Bergen (2007). Available online: https://bora.uib.no/handle/1956/2252 (last accessed on January 27, 2016).

Onomastique (2000): *Onomastique et parenté dans l'Occident médiéval*, eds. K. S. B. Keats-Rohan & Christian Settipani (Oxford, 2000).

Opiz, 'Erziehung und Bildung' (1996): Claudia Opitz, 'Erziehung und Bildung in Frauenklöstern des hohen und späten Mittelalters (12.–15. Jahrhundert)', in: *Geschichte der Mädchen- und Frauenbildung. Vom Mittelalter bis zur Aufklärung*, ed. Elke Kleinau, 2 vols. (Frankfurt a. M., 1996), vol. 1, 63–78.

O'Reilly, 'St. John' (1992): Jennifer O'Reilly, 'St. John as a Figure of the Contemplative Life: Text and Image in the Art of the Anglo-Saxon Benedictine Reform', in: *St. Dunstan: His Life, Times and Cult*, eds. Nigel Ramsey et al. (Woodbridge, 1992), 165–85.

Ortroy, 'Pierre Ferrand' (1911): François van Ortroy, 'Pierre Ferrand O. P. et les premiers biographes de S. Dominique, fondateur de l'ordre des Frères Precheurs', *Analecta Bollandiana* 30 (1911), 27–88.

Ostrowitzki, 'Lebenswelt' (2013): Anja Ostrowitzki, 'Klösterliche Lebenswelt im Spiegel von Briefen des 16. Jahrhunderts aus dem Benediktinerinnenkloster Oberwerth bei Koblenz', *Studien und Mitteilungen zur Geschichte des Benediktinerinnenordens und seiner Zweige* 124 (2013), 167–206.

Otto, *Tauler-Rezeption* (2003): Henrik Otto, *Vor- und frühreformatorische Tauler-Rezeption. Annotationen in Drucken des späten 15. und frühen 16. Jahrhunderts*, Quellen und Forschungen zur Reformationsgeschichte 75 (Gütersloh, 2003).

Ousterhout, 'Geography' (1998): Robert Ousterhout, 'Flexible Geography and Transportable Topography', in: *The Real and Ideal Jerusalem in Jewish, Christian and Islamic Art: Studies in Honor of Bezalel Narkiss on the Occasion of his Seventieth Birthday*, ed. Bianca Kühnel, *Jewish Art* 23–24 (1998) 393–404.

Ouy, 'Jean Gerson' (1962): Gilbert Ouy, 'La plus ancienne oeuvre retrouvé de Jean Gerson: Le brouillon inachevé d'un traité contre Juan de Monzon (1389–90)', *Romania* 83 (1962), 433–92.

Overgaauw, 'Handschriften' (1997): Eef A. Overgaauw, 'Spätmittelalterliche Handschriften aus Westfalen in ihrem Verhältnis

zu Handschriften aus den Niederlanden', in: *Humanistische Buchkultur. Deutsch-niederländische Kontakte im Spätmittelalter (1450–1520)*, eds. Joseph M. M. Hermans & Robert Peters, Niederlande-Studien 14 (Münster, 1997), 65–97.

Overgaauw, 'Der "Codex Henrici"' (1998): Eef A. Overgaauw, 'Der "Codex Henrici". Paläographische und kodikologische Aspekte einer westdeutschen Bibelhandschrift des frühen 14. Jahrhunderts', in: *Der "Codex Henrici". Lateinische Bibelhandschrift Westfalen, 1. Viertel des 14. Jahrhunderts*, ed. Universitäts- und Landesbibliothek Münster, Kulturstiftung der Länder – Patrimonia 144 (Löningen, 1998), 16–44.

Overgaauw, 'Autographen' (2006): Eef A. Overgaauw: 'Die Autographen des Dominikanertheologen Jakob von Soest (c. 1360 bis c. 1440)', *Scriptorium* 60 (2006), 60–79.

Ozimic, *Sermo CLX* (1979): Dolores Ozimic, *Der pseudoaugustinische Sermo CLX. Hieronymus als sein vermutlicher Verfasser, seine dogmengeschichtliche Einordnung und seine Bedeutung für das österliche Canticum triumphale 'Cum rex gloriae'*, Dissertationen der Universität Graz 47 (1979).

Paap, *Nomina Sacra* (1959): Anton H.R.E. Paap, *Nomina Sacra in the Greek Papyri of the First Five Centuries A.D.: The Sources and Some Deductions*, Papyrologica Lugduno-Batava 8 (Leiden, 1959).

Padberg, 'St. Peter Oelinghausen' (1986): Magdalena Padberg, 'St. Peter Oelinghausen; Pfarr-Kloster-Wallfahrtskirche', in: *Kloster Oelinghausen. St. Peter: Pfarr-Kloster-Wallfahrtskirche*, ed. Magdalena Padberg (Arnsberg, 1986), 77–103.

Pächt, *Practice* (1977): Otto Pächt, *The Practice of Art History: Reflections on Method*, intro. by Christopher S. Wood, trans. David Britt; originally published as *Methodisches zur kunst-historischen Praxis. Ausgewählte Schriften*, eds. Jörg Oberhaidacher et al. (Munich, 1977).

Pächt & Alexander, *Illuminated Manuscripts* (1966): Otto Pächt & Jonathan J. G. Alexander, *Illuminated Manuscripts in the Bodleian Library Oxford*, 3 vols., vol.1: *German, Dutch, Flemish, French and Spanish Schools* (Oxford, 1966).

Page, *Christian West* (2010): Christopher Page, *The Christian West and its Singers: The First Thousand Years* (New Haven, 2010).

A. Palazzo, 'Philosophy' (2012): Alessandro Palazzo, 'Philosophy and Theology in the German Dominican *Scholae* in the Late Middle Ages: The Cases of Ulrich of Strasbourg and Berthold of Wimpfen', in: *Philosophy and Theology in the Studia of the Religious Orders and at Papal and Royal Courts. Acts of the XVth Annual Colloquium of the Société Internationale pour l'Étude de la Philosophie Médiévale*, University of Notre Dame, 8–10 October 2008, eds. Kent Emery et al. (Turnhout, 2012), 75–105.

É. Palazzo, 'Pratiques' (1992): Éric Palazzo, 'Les pratiques liturgiques et dévotionelles et le décor monumental dans les églises du Moyen Âge', in: *L'emplacement et la fonction des images dans la peinture murale du Moyen Âge: Actes du 5ème séminaire international d'art mural, 16–18 septembre, Saint-Savin*, ed. Peter Klein, Cahiers 2 (Saint-Savin-sur-Gartempe, 1992), 45–56.

É. Palazzo, *L'évêque* (1999): Éric Palazzo, *L'évêque et son image: l'illustration du Pontifical au Moyen Âge* (Turnhout, 1999).

É. Palazzo, *Liturgie* (2000): Éric Palazzo, *Liturgie et société au Moyen Âge* (Paris, 2000).

É. Palazzo, 'Exégèse' (2004): Éric Palazzo, 'Exégèse, liturgie et politique dans l'iconographie du cloître de Saint-Aubin d'Angers', in: *Der mittelalterliche Kreuzgang. Architektur, Funktion und Programm = The Medieval Cloister = Le cloître au Moyen Âge*, ed. Peter Klein (Regensburg, 2004), 220–40.

É. Palazzo, 'Art and Liturgy' (2006): Éric Palazzo, 'Art and Liturgy in the Middle Ages: Survey of Research (1980–2003) and some Reflections on Method', *Journal of English and Germanic Philology* 105 (2006), 170–84.

É. Palazzo, 'L'avenir' (2009): Éric Palazzo, 'L'avenir des recherches sur les livres liturgiques du Moyen Âge occidental', in: *Études Grégoriennes* 36 (2009) = *Lingua mea calamus scribae: Mélanges offerts à Madame Marie-Noël Colette*, eds. Susan Rankin et al. (Solesmes, 2009), 295–304.

É. Palazzo, 'Liturgie' (2009): Éric Palazzo, 'La liturgie carolingienne', in: *Le monde carolingien: Bilan, perspectives, champs de recherches. Actes du colloque international de Poitiers, Centre d'études supérieures de civilisation médiévale, 18–20 novembre 2004*, eds. Wojciech Fałkowski & Yves Sassier, Culture et société médiévales 8 (Turnhout, 2009), 219–41.

É. Palazzo, 'Art et liturgie' (2010): Éric Palazzo, 'Art et liturgie au Moyen Âge: Nouvelles approches anthropologique et epistémologique', *Annales de Historia del Arte: Volumen Extraordinario* (2010), 31–74.

É. Palazzo, 'Five Senses' (2010): Éric Palazzo, 'Art, Liturgy, and the Five Senses in the Early Middle Ages', *Viator: Medieval and Renaissance Studies* 41 (2010), 25–56.

É. Palazzo, '"Livre-Corps"' (2010): Éric Palazzo, 'Le "Livre-Corps" à l'époque carolingienne et son rôle dans la liturgie de la messe et sa théologie', *Quaestiones medii aevi novae* (2010), 31–63.

É. Palazzo, 'Visions' (2010): Éric Palazzo, 'Visions and Liturgical Experience in the Early Middle Ages', in: *Looking Beyond: Visions, Dreams, and Insights in Medieval Art and History*, ed. Colum P. Hourihane, Index of Christian Art 11 (Princeton, 2010), 15–29.

É. Palazzo, *Cinq sens* (2014): Éric Palazzo, *L'invention chrétienne des cinq sens dans la liturgie et l'art au Moyen Âge* (Paris, 2014).

Palazzo & Johansson, 'Jalons' (1996): Éric Palazzo & Ann-Katrin Johansson, 'Jalons liturgiques pour une histoire du culte de la Vierge dans l'Occident latin (Ve–XIe siècle)', in: *Marie* (1996), 15–43.

Palmer, 'Kapitel' (1989): Nigel F. Palmer, 'Kapitel und Buch. Zu den Gliederungsprinzipien mittelalterlicher Bücher', *Frühmittelalterliche Studien* 23 (1989), 43–88.

Palmer, 'Quaternities' (1998): Nigel F. Palmer, 'Cosmic Quaternities in the "Roman de Fauvel"', in: *Fauvel Studies: Allegory, Chronicle, Music and Image in Paris, BnF ms. fr. 146*, eds. Margaret Bent & Andrew Wathey (Oxford, 1998), 395–420.

Palmer, '"Righteousness"' (2009): Nigel F. Palmer, '"Turning Many to Righteousness": Religious Didacticism in the *Speculum humanae salvationis* and the Similitude of the Oak Tree', in: *Dichtung und Didaxe. Lehrhaftes Sprechen in der deutschen Literatur des Mittelalters*, eds. Henrike Lähnemann & Sandra Linden (Berlin, 2009), 345–66.

Palmer, 'Authorship' (2010): Nigel F. Palmer, 'The Authorship of *De doctrina cordis*', in: *A Companion to 'The Doctrine of the Hert': The Middle English Translation and its Latin and European Contexts*, eds. Denis Renevey et al. (Exeter, 2010), 19–56.

Palmer, 'Vorwort' (2013): Nigel F. Palmer, 'Vorwort', in: Simone Mengis, *Schreibende Frauen um 1500. Scriptorium und Bibliothek des Dominikanerinnenklosters St. Katharina St. Gallen*, Scrinium Friburgense 28 (Berlin, 2013).

Paravicini Bagliani, 'Gregory X' (2000): Agostino Paravicini Bagliani, 'Gregory X, Pope (c. 1210–1276), in: *Encyclopedia of the Middle Ages*, eds. André Vauchez with Barrie Dobson & Michael Lapidge, 2 vols. (Cambridge, 2000), vol. 1, 640.

Paravicini Bagliani, 'Félix V' (2009): Agostino Paravicini Bagliani, 'Félix V et le cérémonial pontifical de l'adventus', in: Paravicini Bagliani, *Il potere del papa: corporeità, autorappresentazione, simboli*, Milllennio medievale: Strumenti et studi N.F. 21 [78] (Florence, 2009), 335–46.

Pardun, *Edelherren von Rüdenberg* (1980): Heinz Pardun, *Die Edelherren von Rüdenberg und die Alte Burg bei Arnsberg*, Städtekundliche Schriftenreihe über die Stadt Arnsberg 13 (Arnsberg, 1980).

Parker & Little, *Cloisters Cross* (1994): Elizabeth C. Parker & Charles T. Little, *The Cloisters Cross: Its Art and Meaning* (New York, 1994).

Parkes, 'Influence' (1976): Malcolm B. Parkes, 'The Influence of the Concepts of *ordinatio* and *compilatio* on the Development of the Book', in: *Medieval Learning and Literature: Essays Presented to Richard William Hunt*, eds. Jonathan J. G. Alexander & Margaret T. Gibson (Oxford, 1976), 115–41.

Parkes, *Keble College* (1979): Malcolm B. Parkes, *The Medieval Manuscripts of Keble College, Oxford: A Descriptive Catalogue with Summary Descriptions of the Greek and Oriental Manuscripts* (London, 1979).

Parkes, 'Archaizing Hands' (1997): Malcolm B. Parkes, 'Archaizing Hands in English Manuscripts', in: *Books and Collectors 1200–1700: Essays Presented to Andrew Watson*, eds. James P. Carley & Colin G. C. Tite (London, 1997), 101–41.

Parkes, 'Compilation' (2000): Malcolm B. Parkes, 'The Compilation of the Dominican Lectionary', in: *Literarische Formen des Mittelalters. Florilegien, Kompilationen, Kollektionen*, ed. Kaspar Elm, Wolfenbütteler Mittelalter-Studien 15 (Wiesbaden, 2000), 9–106.

Pascher, *Liturgisches Jahr* (1963): Joseph Pascher, *Das Liturgische Jahr* (Munich, 1963).

Passion Story (2008): *The Passion Story: From Visual Representation to Social Drama*, ed. Marcia Kupfer (University Park, 2008).

Passion und Ostern (2010): *Passion und Ostern in den Lüneburger Klöstern. Bericht des VIII. Ebstorfer Kolloquiums, Klöster Ebstorf, 25. bis 29. März*, ed. Linda Maria Koldau (Ebstorf, 2010).

Patze, 'Klostergründung' (1977): Hans Patze, 'Klostergründung und Klosterchronik', *Blätter für deutsche Landesgeschichte* 113 (1977), 89–121.

Paulus, *Geschichte* (2000): Nikolaus Paulus, *Geschichte des Ablasses im Mittelalter. Vom Ursprunge bis zur Mitte des 14. Jahrhunderts. Zweiter Band*, 2nd edn. (Paderborn, 1922; repr. Darmstadt, 2000).

Pearce, 'Liturgy' (1991): Judith Pearce, 'Liturgy and Image: The Advent Miniature in the Salisbury Breviary', in: *Medieval Texts and Images: Studies of Manuscripts from the Middle Ages*, ed. Margaret M. Manion (Chur, 1991), 25–42.

Pensée (1993): *Pensée, image & communication en Europe médiévale: à propos des stalles de Saint-Claude*, eds. Pierre Lacroix & Andrée Renon (Besançon, 1993).

Perdrizet, *Vierge* (1908): Paul Perdrizet, *La Vierge de miséricorde: étude d'un thème iconographique*, Bibliothèque des Écoles Françaises d'Athènes et de Rome 101 (Paris, 1908).

Performance (1999): *Performance and Transformation: New Approaches to Late Medieval Spirituality*, eds. Mary A. Suydam & Joanna E. Ziegler (New York, 1999).

Perillo, 'Contemplazione' (2015): Graziano Perillo, 'La contemplazione, principale caratteristica dell' Evangelista Giovanni secondo Alberto Magno', *Quaestio* 15 (2015), 15–24.

Perl, 'Central Themes' (1998): Eric D. Perl, '"That Man Might Become God": Central Themes in Byzantine Theology', in: *Heaven on Earth: Art and the Church in Byzantium*, ed. Linda Safran (University Park, 1998), 39–57.

Personal Names (2002): *Personal Names Studies of Medieval Europe: Social Identity and Familial Structures*, eds. George T. Beech et al., Studies in Medieval Culture 43 (Kalamazoo, 2002).

R. Peters, 'Marienklage' (2003): Robert Peters, 'Zur Sprache der Bordesholmer Marienklage', in: *Literatur-Geschichte-Literaturgeschichte. Beiträge zur mediävistischen Literaturwissenschaft. Festschrift für Volker Honemann zum 60. Geburtstag*, eds. Nine Miedema & Rudolf Suntrup (Frankfurt a. M., 2003), 810–24.

U. Peters, *Religiöse Erfahrung* (1988): Ursula Peters, *Religiöse Erfahrung als literarisches Faktum. Zur Vorgeschichte und Genese frauenmystischer Texte des 13. und 14. Jahrhunderts* (Tübingen, 1988).

C. Petersen, *Ritual* (2004): Christoph Petersen, *Ritual und Theater. Messallegorese, Osterfeier und Osterspiel im Mittelalter*, Münchener Texte und Untersuchungen 125 (Tübingen, 2004).

N. Petersen, 'Liturgical Drama' (2004): Nils Holger Petersen, 'Liturgical Drama: New Approaches', in: *Bilan et perspectives des études médiévales (1993–1998): actes du 2ème congrès européen d'études médiévales*, ed. Jacqueline Hamesse (Turnhout, 2004), 625–44.

N. Petersen, 'Reception' (2009): Nils Holger Petersen, 'Biblical Reception, Representational Ritual, and the Question of "Liturgical Drama"', in: *Sapientia et Eloquentia: Meaning and Function in Liturgical Poetry, Music, Drama and Biblical Commentary in the Middle Ages*, eds. Gunilla Iversen & Nicolas Bell, Disputatio 11 (Turnhout, 2009), 163–201.

Petzold, 'Colours' (1999): Andreas Petzold, '"Of the Significance of Colours": The Iconography of Colour in Romanesque and Early Gothic Book Illumination', in: *Image and Belief: Studies in Celebration of the Eightieth Anniversary of the Index of Christian Art*, ed. Colum Hourihane, Occasional Papers 3 (Princeton, 1999), 125–34.

Peytavie, *Prouille* (1997): Charles Peytavie, *Le monastère de Prouille au Moyen Âge: Éléments pour une enquête* (Toulouse, 1997).

Pfaff, 'Bild' (2003): Carl Pfaff, 'Bild und Exempel. Die observante Dominikanerin in der Sicht des Johannes Meyer O.P.', in: *Personen in der Geschichte. Geschichte der Personen. Studien zur Kreuzzugs-, Sozial- und Bildungsgeschichte. Festschrift für Rainer Christoph Schwinges*, eds. Christian Hesse et al. (Basel, 2003), 221–335.

G. Pfeiffer, *Malerei* (2009): Götz J. Pfeiffer, *Die Malerei am Niederrhein und in Westfalen um 1400. Der Meister des Berswordt-Retables und der Stilwandel der Zeit*, Studien zur internationalen Architektur- und Kunstgeschichte 73 (Petersberg, 2009).

G. Pfeiffer, 'Barfüßer-Meister' (2015): Götz Pfeiffer, 'Im Blick gen Westen – Die Stellung des Barfüßer-Meisters zur Malerei in Köln und Westfalen um 1400', in: *Das Göttinger Barfüßerretabel von 1424. Akten des wissenschaftlichen Kolloquiums, Landesmuseum Hannover, 28.–30. September 2006. Ergebnisband des Restaurierungs- und Forschungsprojektes*, eds. Cornelia Aman & Babette Hartwieg (Petersberg, 2015), 262–74.

H. Pfeiffer, 'Skulpturen' (1983): Heinrich Pfeiffer, 'Die Skulpturen des Abraham und Melchisedek in der Stiftskirche zu Wechselburg. Regnum et sacerdotium im alttestamentlichen Vorbild', in: *Aus Kirche und Reich. Studien zu Theologie, Politik und Recht im Mittelalter. Festschrift für Friedrich Kempf zu seinem 75. Geburtstag und fünfzigjährigen Doktorjubiläum*, ed. Hubert Mordek (Sigmaringen, 1983), 329–53.

Piano, 'Porte close' (2009): Natacha Piano, 'De la porte close du temple de Salomon à la porte ouverte du Paradis: Histoire d'une image mariale dans l'éxegèse et la liturgie médiévales (IVe–XIIIe siècles)', *Studi Medievali* 50 (2009), 133–57.

Pickering, *Literature* (1966): Frederick P. Pickering, *Literature and Art in the Middle Ages* (Coral Gables, 1970); trans. of *Literatur und darstellende Kunst im Mittelalter*, Grundlagen der Germanistik 4 (Berlin, 1966).

Pickering, 'Ikonographie' (1981): Frederick P. Pickering, 'Zur Ikonographie der Kindheit von Johannes dem Täufer', *Anzeiger des Germanischen Nationalmuseums* (1981), 21–27.

P. Pieper, 'Miniaturen' (1980): Paul Pieper, 'Die Miniaturen des Nequambuches', in: *Das Soester Nequambuch. Neuausgabe des Acht- und Schwurbuchs der Stadt Soest*, ed. Wilhelm Kohl (Wiesbaden, 1980), 17–79.

R. Pieper, *Kirchen* (1993): Roland Pieper, *Die Kirchen der Bettelorden in Westfalen. Baukunst im Spannungsfeld zwischen Landespolitik, Stadt und Orden im 13. und frühen 14. Jahrhundert*, Franziskanische Forschungen 39 (Werl, 1993).

R. Pieper, 'Uneinheit' (2006): Roland Pieper, 'Von der Uneinheit des einheitlichen Raumes. Die Architektur der Dortmunder

Dominikanerkirche zwischen Funktion, Repräsentation und Symbolismus', in: *Die Dortmunder Dominikaner* (2006), 123–38.

Pino, 'Culto' (2001): Franco Andrea dal Pino, 'Culto e pietà mariana presso i Frati Minori nel Medioevo', in: *Gli studi di mariologia medievale: bilancio storiografico. Atti del I Convegno mariologico della Fondazione Ezio Franceschini con la collaborazione della Biblioteca palatina e del Dipartimento di storia dell'Università di Parma, Parma, 7-8 novembre 1997*, ed. Clelia Maria Piastra (Tavarnuzze, 2001), 159–92.

Piper, 'Maria' (1873): Ferdinand Piper, 'Maria als Thron Salomos und ihre Tugenden bei der Verkündigung', *Jahrbücher für Kunstwissenschaft* 5 (1873), 97–137.

Pippal, 'Similitudo' (1987): Martina Pippal, 'Von der gewußten zur geschauten Similitudo. Ein Beitrag zur Entwicklung der typologischen Darstellungen bis 1181', *Kunsthistoriker* 4 (1987), 53–61.

Places, 'Divinization' (1957): Édouard des Places, 'Divinization', *DSAM* 3 (1957), 1370–1459.

Planchart, 'Proses in the Sources' (2001): Alejandro Enrique Planchart, 'Proses in the Sources of Roman Chant, and Their Alleluias', in: *The Study of Medieval Chant: Paths and Bridges, East and West, in Honor of Kenneth Levy*, ed. Peter Jeffery (Woodbridge, Suffolk, 2001), 313–39.

Plessow, *Schachzabelbücher* (2007): Oliver Plessow, with Volker Honemann and Mareike Temmen, *Mittelalterliche Schachzabelbücher zwischen Spielsymbolik und Wertevermittlung. Der Schachtraktat des Jacobus de Cessolis im Kontext seiner spätmittelalterlichen Rezeption*, Symbolische Kommunikation und Gesellschaftliche Wertesysteme 12 (Münster, 2007).

Potthoff, 'Scheda' (1994): Marie-Theres Potthoff, 'Scheda. Prämonstratenser', in: *Westfälisches Klosterbuch* (1994), vol. 2, 324–29.

Powitz, *Handschriften* (1968): Gerhard Powitz, *Die Handschriften des Dominikanerklosters und des Leonhardstifts in Frankfurt am Main*, Katalog der Stadt- und Universitätsbibliothek Frankfurt a. M. 2, ed. Clemens Köttelwesch (Frankfurt a. M., 1968).

Pragmatik und Performanz (2011): *Zwischen Pragmatik und Performanz. Dimensionen mittelalterlicher Schriftkultur*, eds. Christoph Dartmann et al., Utrecht Studies in Medieval Literary 18 (Turnhout, 2011).

Prangsma-Hajenius *Légende* (1995): Angelique M. L. Prangsma-Hajenius, *La Légende du Bois de la Croix dans la littérature française médievale* (Assen, 1995).

Praßl, '"Psallat ecclesia mater"' (1987): Franz Karl Praßl, '"Psallat ecclesia mater". Studien zu Repertoire und Verwendung von Sequenzen in der Liturgie österreichischer Augustinerchorherren vom 12. bis zum 16. Jahrhundert', Ph.D. dissertation, University of Graz (1987).

Praßl, 'Liber Ordinarius' (1998): Franz Karl Praßl, 'Der älteste Salzburger Liber Ordinarius (Codex M II 6 der Universitätsbibliothek Salzburg)', in: *Musica Sacra Medievalis. Geistliche Musik Salzburgs im Mittelalter. Salzburg, 6.–9. Juni 1996. Kongressbericht*, eds. Stefan Engels & Gerhard Walterskirchen, Studien und Mitteilungen zur Geschichte des Benediktinerordens und seiner Zweige. Ergängzungsband 40 (St. Ottilien, 1998), 31–47.

Pratiques (2009): *Pratiques de l'eucharistie dans les Églises d'Orient et d'Occident (Antiquité et Moyen Âge): actes du séminaire tenu à Paris, Institut catholique (1997–2004)*, eds. Nicole Bériou et al., Collection des études augustiniennes: Série Moyen Âge et temps modernes 45–46 (Paris, 2009).

Prieur, *St. Gertrud* (1983): Jutta Prieur, *Das Kölner Dominikanerinnenkloster St. Gertrud am Neumarkt*, Kölner Schriften zu Geschichte und Kultur 3 (Cologne, 1983).

Prieur, 'Dominikanerinnenklöster' (2003): Jutta Prieur, 'Von der Gründung bis zur Aufhebung. Das Schicksal der Dominikanerinnenklöster in Köln, Soest und Lemgo', in: *Klostersturm und Fürstenrevolution. Staat und Kirche zwischen Rhein und Weser 1794/1803*, exh. cat., Dortmund, Museum für Kunst und Kulturgeschichte, Veröffentlichungen der Staatlichen Archive des Landes Nordrhein-Westfalen, Ausstellungskataloge 31 (Bönen, 2003), 38–48.

Prieur, 'Lemgo' (2006): Jutta Prieur, 'Happy-End in Lemgo. Zur Vorgeschichte des Lemgoer Marienklosters in Lahde', in: *Wie Engel Gottes. 700 Jahre St. Marien Lemgo*, ed. Jutta Prieur, Schriften des Städtischen Museum Lemgo 6 (Bielefeld, 2006).

Pringle, *Churches* (2007): Denys Pringle, *The Churches of the Crusader Kingdom of Jerusalem: A Corpus*, 4 vols., vol. 3: *The City of Jerusalem* (Cambridge, 2007).

Programme (2011): *Le programme: Une notion pertinente en histoire de l'art médiéval?*, eds. Jean-Marie Guilloüet & Claudia Rabel, Cahiers du Léopard d'or 12 (Paris, 2011).

Proksch, *Klosterreform* (1994): Constance Proksch, *Klosterreform und Geschichtsschreibung im Spätmittelalter*, Kollektive Einstellungen und sozialer Wandel im Mittelalter N.F. 2 (Cologne, 1994).

Prophetie und Autorschaft (2014): *Prophetie und Autorschaft. Charisma, Heilsversprechen und Gefährdung*, eds. Christel Meier & Martina Wagner-Egelhaaf (Berlin, 2014).

Quak, 'Passionsspiel' (1995): Arend Quak, 'Zwischen zwei Sprachen: zum Maastrichter Passionsspiel', in: *So wold ich in fröiden singen. Festgabe für Anthonius H. Touber zum 65. Geburtstag*, eds. Carla Dauven-van Knippenberg & Helmut Birkhan, Amsterdamer Beiträge zur älteren Germanistik (Amsterdam, 1995), 399–408.

Qu'est-ce que nommer? L'image légendée (2010): *Qu'est-ce que nommer? L'image légendée entre monde monastique et pensée scolastique. Actes du colloque du RILMA, Institut Universitaire de France (Paris, INHA, 17–18 octobre 2008)*, ed. Christian Heck (Turnhout, 2010).

Quinn, *Quest* (1962): Esther Casier Quinn, *The Quest of Seth for the Oil of Life* (Chicago, 1962).

Quinto, 'Stefano Langton' (1989): Riccardo Quinto, 'Stefano Langton e i quattro sensi della Scrittura', *Medioevo: Rivista di storia della filosofia medievale* 15 (1989) 67–109.

Räsänen, *Corpse* (2013): Marika Räsänen, *The Restless Corpse: Thomas Aquinas' Remains as the Centre of Conflict and Cult in Late Medieval Southern Italy* (Turku: Painosalama Oy, 2013).

Ragusa, 'Throne of Solomon' (1977): Isa Ragusa, 'Terror daemonum and terror inimicorum: The Two Lions of the Throne of Solomon and the Open Door of Paradise', *Zeitschrift für Kunstgeschichte* 40 (1977), 93–114.

Ragusa, 'Esztergom' (1980): '"Porta patet vitae sponsus vocat intro venite" and the Inscriptions of the Lost Portal of the Cathedral of Esztergom', *Zeitschrift für Kunstgeschichte* 43 (1980), 345–51.

Rahner, 'De dominici pectoris fonte' (1931): Hans Rahner, 'De dominici pectoris fonte potavit', *Zeitschrift für katholische Theologie* 55 (1931), 103–08.

Rahner, 'Flumina' (1941): Hans Rahner, 'Flumina de ventre Christi. Die patristische Auslegung von Joh. 7:37,38', *Biblia* 22 (1941), 269–302, 367–401.

Randall, *Images in the Margins* (1966): Lilian M. C. Randall, *Images in the Margins of Gothic Manuscripts* (Berkeley, 1966).

Randall, *Manuscripts Walters Art Gallery* (1997): Lilian M. C. Randall, *Medieval and Renaissance Manuscripts in the Walters Art Gallery*, 3 vols., vol. 3: *Belgium, 1250–1530* (Baltimore–London, 1997).

Randall, 'Fragmentation' (2000): Lilian M. C. Randall, 'The Fragmentation of a Double Antiphonal from Beaupré', in: *Interpreting and Collecting Fragments of Medieval Books. Proceedings of The Seminar in the History of the Book to 1500, Oxford 1998*, eds. Linda L. Brownrigg et al. (London–Los Altos Hills, 2000), 210–29.

Ranson, 'Innovation' (2002): Lyne Ranson, 'Innovation and Identity: A Franciscan Program of Illustration in the *Verger de soulas* (Paris, Bibliothèque Nationale de France, Ms. fr. 9220)', in: *Insights and Interpretations: Studies in Celebration of the Eighty-Fifth Anniversary of the Index of Christian Art*, ed. Colum Hourihane (Princeton, 2002), 85–105.

Raw, 'Source' (1992): Barbara Raw, 'What Do We Mean by the Source of a Picture?' in: *England in the Eleventh Century: Proceedings of the 1990 Harlaxton Symposium*, ed. Carola Hicks (Stamford, 1992), 285–300.

Raw, *Trinity* (1997): Barbara Raw, *Trinity and Incarnation in Anglo-Saxon Art and Thought* (Cambridge, 1997).

Raw, 'Advent' (2003): Barbara Raw, 'Two Versions of Advent: The Benedictional of Æthelwold and *The Advent Lyrics*', *Leeds Studies in English* 34 (2003), 1–28.

Reallexikon zur deutschen Kunstgeschichte, eds. Otto Schmitt et al., 9 vols. (Stuttgart–Munich, 1937–2006).

Redzich, *Apocalypsis* (2010): Carola Redzich, *Apocalypsis Joannis tot habet sacramenta quot verba. Studien zu Sprache, Überlieferung und Rezeption hochdeutscher Apokalypseübersetzungen des späten Mittelalters*, Münchener Texte und Untersuchungen 137 (Berlin, 2010).

Regensburger Buchmalerei (1987): *Regensburger Buchmalerei von der frühkarolingischen Zeit bis zum Ausgang des Mittelalters*, exh. cat., Munich, Bayrische Staatsbibliothek and Regensburg, Museen der Stadt, ed. Florentine Mütherich (Munich, 1987).

S. Rehm, *Spiegel* (1999): Sabine Rehm, *Spiegel der Heilsgeschichte. Typologische Bildzyklen in der Glasmalerei des 14. bis 16. Jahrhunderts im deutschsprachigen Raum*, Reihe XXVIII. Kunstgeschichte 349 (Frankfurt a.M, 1999).

U. Rehm, 'Sherborne Missal' (1994): Ulrich Rehm, '*Accende lumen sensibus*: Illustrations of the Sherborne Missal interpreting Pentecost', *Word & Image* 10 (1994), 230–59.

U. Rehm, *Vaterunser-Erklärungen* (1994): Ulrich Rehm, *Bebilderte Vaterunser-Erklärungen des Mittelalters*, Saecula spiritualia 28 (Baden-Baden, 1994).

Reichert, 'Geschichte' (1900–1901): Benedictus M. Reichert, 'Zur Geschichte der deutschen Dominikaner am Ausgange des XIV. Jahrhunderts', *Römische Quartalschrift für christliche Altertumskunde und Kirchengeschichte* 14 (1900), 79–101, and 15 (1901), 124–52.

Reimann, 'Dortmund' (1992): Norbert Reimann, 'Dortmund—Dominikaner', in: *Westfälisches Klosterbuch* (1992), vol. 1, 261–68.

Reinecke, *Buchmalereien* (1937): Helmut Reinecke, *Lüneburger Buchmalereien um 1400 und der Maler der Goldenen Tafel* (Bonn, 1937).

Reisner, 'Instrumentalisierung' (2003): Sonja Reisner, 'Sub tuum praesidium confugimus. Zur Instrumentalisierung von Visionen und Wunderberichten in der dominikanischen Ordenshistoriographie am Beispiel der Schutzmantelmadonna', in: *Acta Antiqua Academiae Scientarum Hungaricae* 43 (2003), 393–406.

Reliquiare (2011): *Reliquiare im Mittelalter*, eds. Bruno Reudenbach & Gia Toussaint (Berlin, 2011).

Renevey, 'Name' (1996): Denis Renevey, 'The Name Poured Out: Margins, Illuminations and Miniatures as Evidence for the Practice of Devotions to the Name of Jesus in Late Medieval England', in: *The Mystical Tradition and the Carthusians*, ed. James Lester Hogg, Analecta Cartusiana 130 (1996), 127–48.

Renevey, 'Name of Jesus' (1999): Denis Renevey, 'Name Above Names: The Devotion to the Name of Jesus from Richard Rolle to Walter Hilton's *Scale of Perfection* I', in: *The Medieval Mystical Tradition: England, Ireland and Wales. Exeter Symposium VI*, ed. Marion Glasscoe (Woodbridge, 1999), 103–21.

Repertorium hymnologicum: Catalogue des chants, hymnes, proses, s.quences, tropes en usage dans l'église latine depuis les origines jusqu'à nos jours, ed. Ulysse Chevalier, 6 vols. (Brussels, 1892–1920).

Repsher, *Church Dedication* (1998): Brian Vincent Repscher, '*Locus est terribilis*': *The Rite of Church Dedication in Medieval Christendom* (Lewiston, 1998).

Repsher, 'Abecedarium' (2003): Brian Vincent Repscher, 'The Abecedarium: Catechetical Symbolism in the Rite of Church Dedication', *Mediaevalia* 24 (2003), 1–18.

Reudenbach, 'Bild' (2004): Bruno Reudenbach, 'Bild—Schrift—Ton. Bildfunktionen und Kommunikationsformen im *Speculum virginum*', *Frühmittelalterliche Studien* 37 (2004), 25–45.

Reynolds, 'Sacred Mathematics' (1979): Roger E. Reynolds, '"At Sixes and Sevens"—and Eights and Nines: The Sacred Mathematics of Sacred Orders in the Early Middle Ages', *Speculum* 54 (1979), 669–84.

Reynolds, 'Liturgy' (1986): Roger E. Reynolds, 'Liturgy, Treatises on', in: *Dictionary of the Middle Ages*, ed. Joseph R. Strayer, 13 vols. (New York, 1986), vol. 7, 624–33.

Reynolds, *Clerics* (1999): Roger E. Reynolds, *Clerics in the Early Middle Ages: Hierarchy and Image*, Variorum Collected Studies Series 669 (Aldershot, 1999), 669–84.

Reynolds, 'Adoration' (2013): Roger E. Reynolds, 'Eucharistic Adoration in the Carolingian Era? Exposition of Christ in the Host', *Peregrinations: Journal of Medieval Art & Architecture* 4/2 (2013), 70–153.

B. Richter, *Sammlung* (2008): Burkhard Richter, *Die Sammlung der angewandten Kunst des Gustav-Lübcke-Museums Hamm, fotografiert von Heinz Feußner* (Hamm, 2008).

D. Richter, 'Allegorie' (1968): Dieter Richter, 'Die Allegorie der Pergamentbearbeitung. Beziehungen zwischen handwerklichen Vorgängen und der geistlichen Bildersprache des Mittelalters', in: *Fachliteratur des Mittelalters. Festschrift für Gerhard Eis*, eds. Gundolf Keil et al. (Stuttgart, 1968), 83–92.

Rieger, *Altarsetzung* (1885): Fritz Rieger, *Die Altarsetzung der deutschen Könige nach der Wahl* (Berlin, 1885).

Ries, 'Judenvertreibungen' (1999): Rotraud Ries, '"De joden to verwisen". Judenvertreibungen in Nordwestdeutschland im 15. und 16. Jahrhunderts', in: *Judenvertreibungen in Mittelalter und früher Neuzeit*, eds. Friedhelm Burgard et al., Forschungen zur Geschichte der Juden. Schriftenreihe der Gesellschaft zur Erforschung der Geschichte der Juden e.V. und des Aryre Maimon-Institutes für Geschichte der Juden A/9 (Hannover, 1999), 189–223.

Ringler, *Viten* (1980): Siegfried Ringler, *Viten- und Offenbarungsliteratur in Frauenklöstern des Mittelalters. Quellen und Studien*, Münchener Texte und Untersuchungen 72 (Munich, 1980).

Risse, *Niedermünster* (2014): Alexandra Risse, *Niedermünster in Regensburg. Eine Frauenkommunität in Mittelalter und Früher Neuzeit*, Beiträge zur Geschichte des Bistums Regensburg. Beiband 24 (Regensburg, 2014).

Ritchey, 'Arborescence' (2008): Sara Ritchey, 'Spiritual Arborescence: Trees in the Medieval Christian Imagination', *Spiritus* 8 (2008), 64–82.

Ritzinger, 'Hermann de Minden' (1906): Edmund Ritzinger, 'Hermann de Minden et la province Dominicaine de Teutonie à la fin du XIIIe siècle', Dissertation théologique, Freiburg i. Ü. (1906).

Roberg, 'Konzilsort' (1988): Burkhard Roberg, 'Auf der Suche nach einem Konzilsort. Gregor X. und die Vorbereitung der Generalsynode von 1274', in: *Ecclesia militans. Studien zu Konzilien- und Reformationsgeschichte. Remigius Bäumer zum 70. Geburtstag gewidmet*, eds. Walter Brandmüller et al., 2 vols. (Paderborn, 1988), vol. 1, 97–110.

Röckelein, 'Heilige Schrift' (2008): Hedwig Röckelein, 'Die Heilige Schrift in Frauenhand', in: *Präsenz und Verwendung der Heiligen Schrift im christlichen Frühmittelalter. Exegetische Litera-*

tur und liturgische Texte, ed. Patrizia Carmassi, Wolfenbütteler Mittelalter-Studien 20 (Wiesbaden, 2008), 139–209.

Röckelein, 'Schriftlandschaften' (2014): Hedwig Röckelein, 'Schriftlandschaften—Bildungslandschaften—religiöse Landschaften in Norddeutschland', in: *Schriftkultur* (2014), 19–140.

Roeder, *Gebärde* (1974): Anke Roeder, *Die Gebärde im Drama des Mittelalters*, Münchener Texte und Untersuchungen 49 (Munich, 1974).

Roest, *History of Franciscan Education* (2000): Bert Roest, *A History of Franciscan Education (c. 1210–1517)*, Education and Society in the Middle Ages and Renaissance 11 (Leiden–Boston, 2000).

Romano, 'Gaudete Sunday' (2010): John F. Romano, 'Joy in Waiting? The History of Gaudete Sunday', *Mediaeval Studies* 72 (2010), 75–124.

Rommel, 'Passionsspiel' (2002): Florian Rommel, '*ob mann jm vnrehtt thutt, so wollenn wir doch habenn sein blutt*'. Judenfeindliche Vorstellungen im Passionsspiel des Mittelalters', in: *Juden in der deutschen Literatur des Mittelalters. Religiöse Konzepte-Feindbilder-Rechtfertigungen*, ed. Ursula Schulze (Tübingen, 2002), 183–207.

Ronig, 'Bilder' (1956): Franz Ronig, 'Zwei Bilder der stillenden Muttergottes in einer Handschrift des Trierer Bistumsarchivs', *Archiv für Mittelrheinische Kirchengeschichte* 8 (1956), 362–70.

A. Rose, 'Antiennes' (1957–1958): A. Rose, 'Les antiennes et les psaume de communion', *Revue diocésaine de Namur* 11 (1957), 280–86, 289–305, 420–32, 539–548, 698–708; 12 (1958), 52–58.

V. Rose, *Verzeichnis* (1901): Valentin Rose, *Verzeichnis der lateinischen Handschriften II. 1*, Die Handschriften-Verzeichnisse der königlichen Bibliothek zu Berlin 13 (Berlin, 1901).

Rosenau, 'Architecture' (1974): Helen Rosenau, 'The Architecture of Nicolaus de Lyra's Temple Illustrations and the Jewish Tradition', *Journal of Jewish Studies* 25 (1974), 294–304.

Rothenberg, 'Symbolism' (2006): David J. Rothenberg, 'The Marian Symbolism of Spring, ca. 1200–ca. 1500: Two Case Studies', *Journal of the American Musicological Society* 59 (2006), 319–98.

Rouse & Rouse, '*Distinctiones*' (1974): Mary A. Rouse & Richard H. Rouse, 'Biblical *Distinctiones* in the Thirteenth Century', *Archives d'histoire doctrinale et littéraire du moyen âge* 41 (1974), 27–37.

Rouse & Rouse, '*Statim invenire*' (1982): Mary A. Rouse & Richard H. Rouse, '*Statim invenire*: Schools, Preaches, and New Attitudes to the Page', in: *Renaissance and Renewal in the Twelfth Century*, eds. Robert L. Benson & Giles Constable (Cambridge, Ma., 1982), 201–25.

Rouse & Rouse, *Authentic Witnesses* (1991): Mary A. Rouse & Richard H. Rouse, *Authentic Witnesses: Approaches to Medieval Texts and Manuscripts*, Publications in Medieval Studies 17 (Notre Dame, 1991).

Rouse & Rouse '*Ordinatio*' (1992): Mary A. Rouse & Richard H. Rouse, '*Ordinatio* and *Compilatio* Revisited', in: *Ad Litteram: Authoritative Texts and Their Medieval Readers*, eds. Mark D. Jordan & Kent Emery, Jr., Notre Dame Conferences in Medieval Studies 3 (Notre Dame, 1992), 113–34.

Rouse & Rouse, *Manuscripts* (2000): Mary A. Rouse & Richard H. Rouse, *Manuscripts and their Makers: Commercial Book Producers in Medieval Paris, 1200–1500*, 2 vols. (Turnhout, 2000).

Rouwhorst, 'Origins' (2001): Gerard A. M. Rouwhorst, 'The Origins and Evolution of Early Christian Pentecost', *Studia patristica* 35 (2001), 309–22.

Roux, 'Graduels' (1962): Raymond Le Roux, 'Les Graduels des dimanches après la Pentecôte', *Études Grégoriennes* 5 (1962), 119–30.

Rubin, *Corpus Christi* (1991): Miri Rubin, *Corpus Christi: The Eucharist in Late Medieval Culture* (Cambridge, 1991).

Rublack, 'Female Spirituality' (1994): Ulinka Rublack, 'Female Spirituality and the Infant Jesus in Late Medieval Dominican Convents', *Gender and History* 6 (1994), 37–57.

Rudy, 'Words' (2007): Kathryn M. Rudy, 'Words as Devotional Objects', *Simulacrum* (May 2007), 29–33.

Rudy, *Virtual Pilgrimages* (2011): Kathryn M. Rudy, *Virtual Pilgrimages in the Convent: Imagining Jerusalem in the Late Middle Ages*, Disciplina Monastica 8 (Turnhout, 2011).

M.-M. Rückert, 'Schenkungen, Stiftungen, Kaufgeschäfte' (2016): Maria-Magdalena Rückert, 'Schenkungen, Stiftungen, Kaufgeschäfte – zum Wirtschaftsgebaren der Dominikanerinnen von Kirchheim und Gottes', in: *Chronik der Magdalena Kremerin* (2016), 53–71.

P. Rückert, 'Legitimation' (2009): Peter Rückert, 'Legitimation – Tradition – Repräsentation. Pragmatische Schriftkultur bei den Zisterziensern im deutschsprachigen Südwesten', *Kulturtopographie* (2009), 99–120.

Rüther, 'Schreibbetrieb' (1999): Andreas Rüther, 'Schreibbetrieb, Bücheraustausch und Briefwechsel. Der Konvent St. Katharina in St. Gallen während der Reform', in: *Vita religiosa im Mittelalter. Festschrift für Kaspar Elm zum 70. Geburtstag*, eds. Franz-Josef Felten et al., Berliner historische Studien 31; Ordensstudien 13 (Berlin, 1999), 653–77.

Rüther & Schiewer, 'Predigthandschriften' (1992): Andreas Rüther & Hans-Jochen Schiewer, 'Die Predigthandschriften des Straßburger Dominikanerinnenklosters St. Nikolaus in undis. Historischer Bestand, Geschichte, Vergleich', in: *Die deutsche Predigt im Mittelalter* (1992), 169–93.

Ruh, *Geschichte* (1990–1999): Kurt Ruh, *Geschichte der abendländischen Mystik*, 4 vols. (Munich, 1990–1999).

Ruh, 'Gertrud von Helfta' (1992): Kurt Ruh, 'Gertrud von Helfta. Ein neues Gertrud-Bild', *Zeitschrift für deutsches Altertum und deutsche Philologie* 121 (1992), 1–20.

Rumphorst, 'Rorate caeli' (1980): Heinrich Rumphorst, 'Der semiologische Befund der Introitus "Rorate caeli" und "Viri Galilaei" nach den Hss Einsiedeln 121 und Laon 239', in: *Ut mens concordet voci. Festschrift Eugène Cardine zum 75. Geburtstag*, ed. Johannes Berchmans Göschl (St. Ottilien, 1980), 238–56.

Russakoff, 'Jean Pucelle' (2013): Anna D. Russakoff, 'Collaborative Illumination: Jean Pucelle and the Visual Program of Gautier de Coinci's Les Miracles de Nostre Dame (Paris, BnF, nouv. acq. fr. 24541)', *Jean Pucelle: Innovation and Collaboration in Manuscript Painting*, eds. Kyunghee Pyun & Anna D. Russakoff (Turnhout, 2013), 65–89.

Russo, 'Compilation' (1992): Daniel Russo, 'Compilation iconographique et légitimation de l'ordre dominicain: les fresques de Tomaso da Modena à San Niccolò de Trévise (1352)', *Revue de l'art* 97 (1992), 76–84.

Russo, 'Prêcheurs' (2001): Daniel Russo, 'L'ordre des Prêcheurs dans l'iconographie méridionale et ses modes de représentation', *Cahiers de Fanjeaux* 36 (2001), 345–82.

Ryle, 'Sequence' (1977): Stephen F. Ryle, 'The Sequence: Reflections on Literature and Liturgy', in: *Papers of the Liverpool Latin Seminar 1976*, ed. Francis Cairns, ARCA Classical and Medieval Texts Papers and Monographs 2 (Liverpool, 1977), 171–82.

Sacri Monti (2007): *Sacri Monti: Varallo, Sesia, Crea*, eds. Claudio Argentiero et al. (Ferno, 2007).

Saenger, 'Impact' (1996): Paul Saenger, 'The Impact of the Early Printed Page on the History of Reading', *Bulletin du bibliophile* 2 (1996), 237–301.

Sainteté (2001): *De la sainteté à l'hagiographie: genèse et usage de la Légende dorée*, eds. Barbara Fleith & Franco Morenzoni (Geneva, 2001).

Salzer, *Sinnbilder* (1893): Anselm Salzer, *Die Sinnbilder und Beiworte Mariens in der deutschen Literatur und lateinischen Hymnpoesie des Mittelalters. Mit Berücksichtigung der patristischen Literatur. Eine literar-historische Studie* (Linz, 1893).

Sandler, 'Handclasp' (1984): Lucy Freeman Sandler, 'The Handclasp in the Arnolfini Wedding: A Manuscript Precedent', *Art Bulletin* 66 (1984), 488–91.

Sandler, 'Omne bonum' (1990): Lucy Freeman Sandler, '*Omne bonum*: Compilatio and Ordinatio in an English Illustrated Encyclopaedia of the Fourteenth Century', in: *Medieval Book Production: Assessing the Evidence. Proceedings of the Second Conference of the Seminar in the History of the Book to 1500, Oxford, July 1988*, ed. Linda L. Brownrigg (Los Altos Hills, 1990) 183–200.

Sandler, 'Marginal Imagery' (1997): Lucy Freeman Sandler, 'The Study of Marginal Imagery: Past, Present, and Future', *Studies in Iconography* 18 (1997), 1–50.

Sandler, 'Images' (2000): Lucy Freeman Sandler, 'The Images of Words in English Gothic Psalters (The Saunders Lecture 1997)', in: *Studies in the Illustration of the Psalter*, eds. Bredan Cassidy & Rosemary Muir Wright, St. Andrews Studies in the History of Art (Stamford, 2000), 67–86.

Sansterre, 'Vénération' (2006): Jean-Marie Sansterre, '*Omnes qui coram hac imagine genua flexerint … La vénération d'images de saints et de la Vierge d'après les textes écrits en Angleterre du milieu du XIe aux premières décennies du XIIIe siècles', *Cahiers de civilisation médiévale* 49 (2006), 257–94.

Sansterre, 'Sacralité' (2011): Jean-Marie Sansterre, 'Sacralité et pouvoir thaumaturgique des statues mariales (Xe siècle–première moitié du XIIIe siècle)', *Revue Mabillon* N.S. 22 (2011), 53–77.

Sattler, *Geschichte* (1769–1783): Christian Friedrich Sattler, *Geschichte des Herzogthums Würtenberg unter der Regierung der Herzogen. Theil II–XIII*, 5 vols. (Tübingen, 1769–1783).

C. Sauer, 'Allerheiligenbilder' (1996): Christine Sauer, 'Allerheiligenbilder in der Buchmalerei Fuldas', in: *Kloster Fulda in der Welt der Karolinger und Ottonen*, Fuldaer Studien 7 (Frankfurt a. M., 1996), 365–402.

J. Sauer, *Symbolik* (1924): Joseph Sauer, *Symbolik des Kirchengebäudes und seiner Ausstattung in der Auffassung des Mittelalters, mit Berücksichtigung von Honorius Augustodunensis, Sicardus und Durandus*, 2nd enlarged edn. (Freiburg i. Br., 1924).

Saurma-Jeltsch, 'Wandmalerei' (2002): Lieselotte E. Saurma-Jeltsch, 'Profan oder sakral? Zur Interpretation mittelalterlicher Wandmalerei im städtischen Kontext', in: *Literatur und Wandmalerei I. Erscheinungsformen höfischer Kultur und ihre Träger im Mittelalter. Freiburger Colloquium 1998*, eds. Eckart Conrad Lutz et al. (Tübingen, 2002), 283–327.

Von Sava, *Siegel* (1859): Karl von Sava, *Die mittelalterlichen Siegel der Abteien und Regularstifte im Erzherzogthume Österreich und unter der Enns* (Wien, 1859).

Schäfer, *Fusswaschung* (1956): Thomas Schäfer, *Die Fusswaschung im monastischen Brauchtum und in der lateinischen Liturgie. Liturgiegeschichtliche Untersuchung*, Texte und Arbeiten: 1 Abt. 47 (Beuron, 1956).

Schäferdiek, '*Passio Johannis*' (1985): Knut Schäferdiek, 'Die *Passio Johannis* des Melito von Laodikeia und die *Virtutes Johannis*', *Analecta Bollandiana* 103 (1985), 367–82.

Schaffer, *Koimesis* (1985): Christa Schaffer, *Koimesis, Der Heimgang Mariens. Das Entschlafungsbild in seiner Abhängigkeit von Legende und Theologie*, Studia Patristica et Liturgica 15 (Regensburg, 1985).

Schapiro, 'Drawings' (1954): Meyer Schapiro, 'Two Romanesque Drawings in Auxerre and Some Iconographic Problems', in: *Studies in Art and Literature for Belle Da Costa Greene*, ed. Dorothy Miner (Princeton, 1954), 331–49.

Schapiro, 'Relief' (1963): Meyer Schapiro, 'A Relief in Rodez and the Beginnings of Romanesque Sculpture in Southern France', in: *Romanesque and Gothic Art: Studies in Western Art*, Acts of the Twentieth International Congress of the History of Art 1 (Princeton, 1963), 40–66.

Schapiro, *Romanesque Art* (1993): Meyer Schapiro, *Romanesque Art: Selected Papers* (London, 1993).

Scheeben, *Albert der Große* (1931): Heribert Christian Scheeben, *Albert der Große. Zur Chronologie seines Lebens*, Quellen und Forschungen zur Geschichte des Dominikanerordens in Deutschland 27 (Leipzig, 1931).

Scheeben, 'Geschichte' (1938): Heribert Christian Scheeben, 'Zur Geschichte der Verehrung des Hl. Thomas von Aquino', *Angelicum* 15 (1938), 286–94.

Scheingorn, 'Reshapings' (2012): Pamela Scheingorn, 'Reshapings of the Childhood Miracles of Jesus', in: *Christ Child* (2012), 254–92.

Scherner '"Text"' (1996): Maximilian Scherner, '"Text". Untersuchungen zur Begriffsgeschichte', *Archiv für Begriffsgeschichte* 39 (1996), 103–60.

H.-J. Schiewer, 'Sankt Johannsen' (1993): Hans-Jochen Schiewer, 'Die beiden Sankt Johannsen, ein dominikanischer Johannes-Libellus und das literarische Leben im Bodenseeraum um 1300', *Oxford German Studies* 32 (1993), 21–54.

H.-J. Schiewer, '*Uslesen*' (2000): Hans-Jochen Schiewer, '*Uslesen*. Das Weiterwirken mystischen Gedankenguts im Kontext dominikanischer Frauengemeinschaften', in: *Deutsche Mystik im abendländischen Zusammenhang. Neu erschlossene Texte, neue methodische Anstäze, neue theoretischen Konzepte*, eds. Walter Haug & Wolfram Schneider-Lastin (Tübingen, 2000), 581–603.

R. Schiewer, 'Sermons' (1998): Regina D. Schiewer, 'Sermons for Nuns of the Dominican Observance Movement', in: *Medieval Monastic Preaching*, ed. Carolyn Muessig, Brill's Studies in Intellectual History 90 (Leiden, 1998), 75–92.

R. Schiewer, 'Worte' (2013): Regina D. Schiewer, 'Worte über einen ungeliebten Heiligen? Die einzige deutschsprachige Petrus Martyr-Predigt', in: *Grundlagen. Forschungen, Editionen und Materialien zur deutschen Literatur und Sprache des Mittelalters und der Frühen Neuzeit*, eds. Rudolf Bentzinger et al., Zeitschrift für deutsches Altertum und deutsche Literatur. Beihefte 18 (Stuttgart, 2013), 285–99.

Schilp, 'Propsteikirche' (2006): Thomas Schilp, 'Propsteikirche St. Johann der Täufer—die Kirche des ehemaligen Dominikanerklosters', in: *Stadtführer. Dortmund im Mittelalter*, eds. Thomas Schilp & Barbara Welzel, 2nd rev. edn. (Bielefeld, 2006), 83–97.

Schilp, 'Seelenheil' (2006): Thomas Schilp, 'Seelenheil und Stadtkultur. Das Dortmunder Predigerkloster in der spätmittelalterlichen Stadt', in: *Die Dortmunder Dominikaner* (2006), 57–69.

Schimmelpfennig, 'Geburt' (1999): Bernhard Schimmelpfennig, 'Die Geburt Jesu, Der Kaiser Augustus und die Sibylle von Tivoli', in: … *The Man of Many Devices Who Wandered Full Many Ways … Festschrift in Honor of János M. Bak*, eds. Balázs Nagy & Marcell Sebők (Budapest, 1999), 139–47.

Schinagl-Peitz, 'Naturkundliches Wissen' (1992): Elisabeth Schinagl-Peitz, 'Naturkundliches Wissen in lateinischen und deutschen Predigten des Spätmittelalters', in: *Die deutsche Predigt im Mittelalter* (1992), 285–300.

Schlechter & Stamm, *Provenienzen* (2000): Armin Schlechter & Gerhard Stamm: *Die kleinen Provenienzen*, Die Handschriften der Badischen Landesbibliothek in Karlsruhe 13 (Wiesbaden, 2000).

Schleif, 'Hands' (1993): Corinne Schleif, 'Hands that Appoint, Anoint, and Ally: Late Medieval Donor Strategies for Approbation through Painting', *Art History* 16 (1993), 1–33.

Schlie, *Kunst-Denkmäler* (1896): Friedrich Schlie, *Die Kunst- und Geschichts-Denkmäler des Grossherzogthums Mecklenburg-Schwerin, I. Die Amtsgerichte Rostock, Ribnitz, Sülze-Marlow, Tessin, Laage, Gnoien, Dargun, Nekalen*, 2nd edn. (Schwerin, 1896).

Schlotheuber, 'Bildungswesen' (1994): Eva Schlotheuber, 'Bildungswesen und Bibliotheken der Bettelorden', in: *700 Jahre Paulinerkirche. Vom Kloster zur Bibliothek*, ed. Elmar Mittler (Göttingen, 1994), 21–24, 54–56.

Schlotheuber, *Franziskaner* (1996): Eva Schlotheuber, *Die Franziskaner in Göttingen. Die Geschichte des Klosters und seiner Bibliothek*, Saxonia Franciscana 8 (Werl, 1996).

Schlotheuber, 'Ebstorf' (2004): Eva Schlotheuber, 'Ebstorf und seine Schülerinnen in der zweiten Hälfte des 15. Jahrhunderts', in: *Studien und Texte* (2004), 169–221.

Schlotheuber, *Klostereintritt* (2004): Eva Schlotheuber, *Klostereintritt und Bildung. Die Lebenswelt der Nonnen im späten Mittelalter. Mit einer Edition des 'Konventstagebuchs' einer Zisterzienserin von Heilig-Kreuz bei Braunschweig (1484–1507)*, Spätmittelalter und Reformation. Neue Reihe 24 (Tübingen, 2004).

Schlotheuber, 'Wahl' (2005): Eva Schlotheuber, 'Die Wahl der Priorin', in: *Frömmigkeit – Theologie – Frömmigkeitstheologie. Contributions to European Church History. Festschrift Berndt Hamm*, eds. Gudrun Litz et al., Studies in the History of Christian Traditions 124 (Leiden–Boston, 2005), 145–58.

Schlotheuber, 'Humanistisches Wissen' (2006): Eva Schlotheuber, 'Humanistisches Wissen und geistliches Leben. Caritas Pirckheimer und die Geschichtsschreibung im Nürnberger Klarissenkonvent', *Pirckheimer Jahrbuch* 21 (2006), 89–118.

Schlotheuber, 'Sprachkompetenzen' (2006): Eva Schlotheuber, 'Sprachkompetenzen und Lateinvermittlung. Die intellektuelle Ausbildung der Nonnen im Spätmittelalter', in: *Kloster und Bildung im Mittelalter*, eds. Nathalie Kruppa & Jürgen Wilke, Veröffentlichungen des Max-Planck-Instituts für Geschichte 218; Studien zur Germania Sacra 28 (Göttingen, 2006), 61–87.

Schlotheuber, 'Bräute Christi' (2008): Eva Schlotheuber, 'Die gelehrten Bräute Christi. Geistesleben und Bücher der Nonnen im Hochmittelalter', in: *Die gelehrten Bräute Christi* (2008).

Schlotheuber, 'Bücher' (2008): Eva Schlotheuber, 'Bücher und Bildung in den Frauengemeinschaften der Bettelorden', in: *Nonnen, Kanonissen und Mystikerinnen* (2008), 242–62.

Schlotheuber 'Familienpolitik' (2009): Eva Schlotheuber, 'Familienpolitik und geistliche Aufgaben', in: *Die Familie in der Gesellschaft des Mittelalters*, ed. Karl-Heinz Spieß, Vorträge und Forschungen 71 (Ostfildern, 2009), 223–49.

Schlotheuber, 'Zisterzienserinnengemeinschaften' (2009): Eva Schlotheuber, 'Die Zisterzienserinnengemeinschaften im Spätmittelalter', in: *Norm und Realität. Kontinuität und Wandel der Zisterzienser im Mittelalter*, eds. Franz J. Felten & Werner Rösener, (Berlin, 2009), 287–324.

Schlotheuber, 'Best Clothes' (2010): Eva Schlotheuber, 'Best Clothes and Everyday Attire of Late Medieval Nuns', in: *Fashion and Clothing in Late Medieval Europe/Mode und Kleidung im Europa des späten Mittelalters*, eds. Regula Schorta & Rainer C. Schwinges (Basel, 2010), 139–54.

Schlotheuber, '"Per vim et metum"' (2010): Eva Schlotheuber, '"Per vim et metum": Die bitteren Klagen der Mädchen und Frauen an der römischen Kurie über ein erzwungenes Professgelübde', in: *Kirchlicher und religiöser Alltag im Spätmittelalter: Akten der internationalen Tagung in Weingarten, 4.–7. Oktober 2007*, eds. Andreas Meyer et al., Schriften zur südwestdeutschen Landeskunde 69 (Ostfildern, 2010), 165–76.

Schlotheuber, 'Armut' (2011): Eva Schlotheuber, 'Armut, Demut und Klausur – Zur Geschichte des weiblichen Ordenszweiges', in: *Franziskus. Licht aus Assisi*, Ausstellung 9. Dezember 2011–6. Mai 2012, Erzbischöflichen Diözesanmuseum & Franziskanerkloster Paderborn, eds. Christoph Stiegemann et al. (Munich, 2011), 81–88.

Schlotheuber, 'Klara von Assisi und Agnes von Prag' (2013): Eva Schlotheuber, 'Klara von Assisi und Agnes von Prag. Die Besitzlosigkeit als besondere Herausforderung für Frauengemeinschaften', in: *Svatá Anežka Česká a velké ženy její doby. Die heilige Agnes von Böhmen und die großen Frauengestalten ihrer Zeit*, eds. Miroslav Šmied & František Záruba, Opera Facultatis theologiae catholicae Universitatis Carolinae Pragensis Historia et historia artium 14 (Prague, 2013), 56–73.

Schlotheuber, 'Educación y Formación' (2014): Eva Schlotheuber, 'Educación y Formación, Saber Práctico y Saber Erudito en los Monasterios Femeninos en la Baja Edad Media [Education and Training, Practical and Scholarly Knowledge in Late Medieval Female Convents]', *Anuario Estudios Medievales* 44.1 (2014), 309–48.

Schlotheuber, '"Freedom"' (2014): Eva Schlotheuber, 'The "Freedom of their Own Rule" and the Role of the Provost in Women's Monasteries of the Twelfth and Thirteenth Centuries', in: *Partners in Spirit: Women, Men, and Religious Life in Germany, 1100–1500*, eds. Fiona J. Griffiths & Julie Hotchin, Medieval Women: Texts and Contexts 24 (Turnhout, 2014), 109–44.

Schlotheuber, 'Intellectual Horizons' (2014): Eva Schlotheuber, 'Intellectual Horizons: Letters from a Northern German Convent (with a Textual Appendix)', in: *Companion to Mysticism and Devotion* (2014), 343–83.

Schlotheuber, 'Neue Grenzen' (2014): Eva Schlotheuber, 'Neue Grenzen und neue Möglichkeiten – religiöse Lebensentwürfe geistlicher Frauen in der Umbruchzeit des 12. und 13. Jahrhunderts', in: *Als Mann und Frau schuf er sie. Religion und Geschlecht*, ed. Barbara Stollberg-Rilinger, Schriftenreihe des Exzellenzclusters Religion und Politik 7 (Würzburg, 2014), 87–107.

Schlotheuber, 'Willibald' (2014): Eva Schlotheuber, 'Willibald und die Klosterfrauen von Sankt Klara – eine wechselhafte Beziehung', *Pirckheimer Jahrbuch für Renaissance- und Humanismusforschung* 28 (2014), 57–75.

Schlotheuber, 'Hildegard von Bingen' (2015): Eva Schlotheuber, 'Hildegard von Bingen und die konkurrierenden spirituellen Lebensentwürfe der mulieres religiosae im 12. und 13. Jahrhundert', in: *Hildegard von Bingen – unversehrt und unverletzt. Symposium Mainz 27. Februar bis 3. März 2013*, ed. Rainer Berndt (Münster, 2015), 323–65.

Schlotheuber et al., 'Einleitung' (2014): Eva Schlotheuber et al., 'Einleitung', in: *Schriftkultur* (2014), 7–18.

Schmale, 'Hermann von Reichenau' (1981): Franz-Josef Schmale, 'Hermann von Reichenau (Herimannus Augiensis, Contractus, der Lahme)', in: ²*VL* 3 (Berlin, 1981), cols. 1082–90.

G. Schmidt, *Armenbibeln* (1959): Gerhard Schmidt, *Die Armenbibeln des XIV. Jahrhunderts* (Graz, 1959).

H.-J. Schmidt, 'Allegorie und Empirie' (1992): Hans-Joachim Schmidt, 'Allegorie und Empirie. Interpretation und Normung sozialer Realität in den Predigten des 13. Jahrhunderts', in: *Die deutsche Predigt im Mittelalter* (1992), 301–32.

P. Schmidt, 'Finger in der Handschrift' (2009): Peter Schmidt, 'Der Finger in der Handschrift. Vom Öffnen, Blättern und Schließen von Codices auf spätmittelalterlichen Bildern', in: *Codex und Raum*, eds. Stephan Müller et al., Wolfenbüttler Mittelalter Studien 21 (Wiesbaden, 2009), 85–126.

R. Schmidt, '*Aetates mundi*' (2004): Roderich Schmidt, '*Aetates mundi*. Die Weltalter als Gliederungsprinzip der Geschichte', in: *Weltordnung—Herrschaftsordnung*, ed. Roderich Schmidt, Bibliotheca eruditorum 14 (Goldbach, 2004), 1–30.

V. Schmidt, 'Illusionisme' (1996): Victor M. Schmidt, 'Illusionisme rond 1300: Enige opmerkingen bij de Madonna Stoclet van Duccio di Buonisegna', in: *Onverwacht bijeengebracht: Opstellen voor Ed Taverne en Lyckle de Vries ter gelegenheid van hun 25-jarig jubileum in dienst van de Rijksuniversiteit Groningen*, eds. Jan L. de Jong & Elwin A. Koster (Groningen, 1996), 119–24.

J.-C. Schmitt, 'Images classificatrices' (1989): Jean-Claude Schmitt, 'Les images classificatrices', *Bibliothèque de l'École de Chartres* 147 (1989), 311–41.

J.-C. Schmitt, 'L'exception' (2006): Jean-Claude Schmitt, 'L'exception corporelle: à propos de l'Assomption de Marie', in: *The Mind's Eye: Art and Theological Argument in the Middle Ages*, eds. Jeffrey F. Hamburger & Anne-Marie Bouché (Princeton, 2006), 151–85.

J.-C. Schmitt, 'Mort' (2009): Jean-Claude Schmitt, 'La mort, les morts et le portrait', in: *Le portrait individuel: refléxions autour d'une forme de représentation XIIe–XVe siècles*, ed. Dominic Olariu (Bern, 2009), 55–33.

J.-C. Schmitt, 'Images' (2010): Jean-Claude Schmitt, 'Les images et le sacré', in: *La performance des images*, eds. Alain Dierkens et al., *Problèmes d'histoire des religions* 19 [2009] (Brussels, 2010), 29–46.

S. Schmitt, 'Herrschaft' (2004): Sigrid Schmitt, 'Die Herrschaft der geistlichen Fürstin. Handlungsmöglichkeiten von Äbtissinnen im Spätmittelalter', in: *Fürstin und Fürst. Familienbeziehungen und Handlungsmöglichkeiten von hochadeligen Frauen im Mittelalter*, ed. Jörg Rogge, Mittelalterforschungen 15 (Ostfildern, 2004), 187–202.

F. Schneider, *Advents-Diptychon* (1889): Friedrich Schneider, *Das Advents-Diptychon aus der Sammlung Honolez-Hüpsch* (Mainz, 1889).

H. Schneider, 'Aqua benedicta' (1987): Herbert Schneider, 'Aqua benedicta: Das mit Salz gemischte Weihwasser', in: *Segni e riti nelle chiesa altomedievale occidentale, 11–17 aprile 1985*, 2 vols. (Spoleto, 1987), vol. 1, 337–67.

K. Schneider, 'Bibliothek' (1983): Karin Schneider, 'Die Bibliothek des Katharinenklosters und die städtische Gesellschaft', in: *Studien zum städtischen Bildungswesen des späten Mittelalters und der frühen Neuzeit*, Bericht über Kolloquien der Kommission zur Erforschung der Kultur des Spätmittelalters 1978 bis 1981, eds. Bernd Moeller et al. (Göttingen, 1983), 70–83.

N. Schneider, *Portrait* (1994): Norbert Schneider, *The Art of the Portrait: Masterpieces of European Portrait-painting, 1420–1670* (Cologne, 1994).

R. Schneider, 'Thronsetzungen' (1995): Reinhard Schneider, 'Bischöfliche Thron- und Altarsetzungen', in: *Papstgeschichte und Landesgeschichte. Festschrift für Hermann Jakobs zum 65. Geburtstag*, Beihefte zum Archiv für Kulturgeschichte 39 (Cologne, 1995), 1–6.

Schneider-Lastin, 'Zürich, Oetenbach' (1999): Wolfram Schneider-Lastin, 'Zürich, Oetenbach. Literaturproduktion und Bibliothek', in: *Helvetia Sacra* IV/5. *Die Dominikaner und Dominikanerinnen in der Schweiz* (Basel, 1999), 1029–35.

Schneyer, 'Augsburger Predigtzyklus' (1969): Johannes Baptist Schneyer, 'Alberts des Großen Augsburger Predigtzyklus über den hl. Augustinus', *Recherches de Théologie ancienne et médiévale* 36 (1969), 100–48.

Schneyer, *Repertorium* (1969–1990): Johannes Baptist Schneyer, *Repertorium der lateinischen Sermones des Mittelalters für die Zeit von 1150–1350*, 11 vols., Beiträge zur Geschichte der Philosophie und Theologie des Mittelalters 43 (Münster, 1969–1990).

Schnusenberg, *Verhältnis* (1981): Christine Schnusenberg, *Das Verhältnis von Kirche und Theater. Dargestellt an ausgewählten*

Schriften der Kirchenväter und liturgischen Texte bis auf Amalarius von Metz (a.d. 775–852), Europäische Hochschulschriften Reihe XXIII. Theologie 141 (Bern, 1981).

Schramm, 'Bügelkrone' (1959): Percy Ernst Schramm, 'Die Bügelkrone, ein karolingisches Herrschaftszeichen mit einem Anhang. Die Lobwörter *decus imperii* und *spes imperii*', in: *Festschrift für Karl Gottfried Hugelmann zum 80. Geburtstag am 26. September 1959 dargebracht von Freunden, Kollegen und Schülern* (Aalen, 1959), 561–78.

Schreiben und Lesen (2012): *Schreiben und Lesen in der Stadt. Literaturbetrieb im spätmittelalterlichen Straßburg*, eds. Stephen Mossman et al., Kulturtopographie des alemannischen Raums 4 (Berlin-Boston, 2012).

Schreiner, 'Laienfrömmigkeit' (1992): Klaus Schreiner, 'Laienfrömmigkeit – Frömmigkeit von Eliten oder Frömmigkeit des Volkes? Zur sozialen Verfasstheit laikaler Frömmigkeitspraxis im späten Mittelalter', in: *Laienfrömmigkeit im späten Mittelalter. Formen, Funktionen, politisch-soziale Zusammenhänge*, eds. Klaus Schreiner & Elisabeth Müller-Luckner, Schriften des Historischen Kollegs 20 (Munich–Vienna 1992), 1–78.

Schreiner, 'Verschriftlichung' (1992): Klaus Schreiner, 'Verschriftlichung als Faktor der monastischen Reform. Funktionen von Schriftlichkeit im Ordenswesen des hohen und späten Mittelalters', in: *Pragmatische Schriftlichkeit im Mittelalter. Erscheinungsformen und Entwicklungsstufen*, eds. Hagen Keller et al., Münstersche Mittelalter-Schriften 65 (Munich, 1992) 37–75.

Schreiner, 'Tod Marias' (1993): Klaus Schreiner, 'Der Tod Marias als Inbegriff christlichen Sterbens. Sterbekunst im Spiegel mittelalterlicher Legendenbildung', in: *Tod im Mittelalter*, eds. Arno Borst et al., Konstanzer Bibliothek 20 (Constance, 1993), 261–312.

Schreiner, 'Antijudaismus' (1998): Klaus Schreiner, 'Antijudaismus in Bildern des späten Mittelalters', in: *Das Medium Bild in historischen Ausstellungen. Beiträge … zur Sektion 6 des 41. Deutschen Historikertags in München 1996*, Materialien zur Bayerischen Geschichte und Kultur 5/98 (Munich, 1998), 9–34.

Schreiner, 'Buchstabensymbolik' (2000): Klaus Schreiner, 'Buchstabensymbolik, Bibelorakel, Schriftmagie. Religiöse Bedeutung und lebensweltliche Funktion heiliger Schriften im Mittelalter und in der Frühen Neuzeit', in: *Die Verschriftlichung der Welt. Bild, Text und Zahl in der Kultur des Mittelalters und der Frühen Neuzeit*, eds. Horst Wenzel et al., Schriften des Kunsthistorischen Museums 5 (Vienna, 2000), 59–103.

Schreiner, 'Buch im Nacken' (2001): Klaus Schreiner, 'Das Buch im Nacken. Bücher und Buchstaben als zeichenhafte Kommunikationsmedien in rituellen Handlungen der mittelalterlichen Kirche', in: *Audiovisualität vor und nach Gutenberg. Zur Kulturge-* *schichte der medialen Umbrüche*, Schriften des Kunsthistorischen Museums 6 (Vienna, 2001), 73–95.

Schreiner, 'Symbolik' (2006): Klaus Schreiner, 'Die Symbolik des Alphabets in der Liturgie der mittelalterlichen und frühneuzeitlichen Kirchweihe', in: *Das Haus Gottes, das seid ihr selbst. Mittelalterliches und barockes Kirchenverständnis im Spiegel der Kirchweihe*, eds. Ralf M. W. Stammberger & Claudia Sticher, with Annekatrin Warnke (Berlin, 2006), 143–87.

Schreiner, 'Maria' (2009): Klaus Schreiner, 'Die lesende und schreibende Maria als Symbolgestalt religiöser Frauenbildung', in: *Die lesende Frau. Tagung zum Thema 'Die lesende Frau', Herzog August Bibliothek Wolfenbüttel*, ed. Gabriela Signori, Wolfenbütteler Forschungen 121 (Wiesbaden, 2009), 113–54.

Schreiner, *Rituale* (2011): Klaus Schreiner, *Rituale, Zeichen, Bilder. Formen und Funktionen symbolischer Kommunikation im Mittelalter*, eds. Ulrich Meier et al., Norm und Struktur. Studien zum sozialen Wandel in Mittelalter und Früher Neuzeit 40 (Cologne, 2011).

Schrift als Bild (2010): *Schrift als Bild, für das Küpferstichkabinett – Staatliche Museen zu Berlin*, exh. cat., ed. Michael Roth, with Nadine Rottau (Petersberg, 2010).

Schriftkultur (2014): *Schriftkultur und religiöse Zentren im norddeutschen Raum*, eds. Patricia Carmassi et al., Wolfenbütteler Mittelalter-Studien 24 (Wiesbaden, 2014).

Schrifträume (2008): *Schrifträume. Dimensionen von Schrift zwischen Mittelalter und Moderne*, eds. Christian Kiening & Martina Stercken (Zurich, 2008).

Schüppel, *Monumentalkruzifixe* (2005): Katharina Christa Schüppel, *Silberne und goldene Monumentalkruzifixe. Ein Beitrag zur mittelalterlichen Liturgie- und Kulturgeschichte* (Weimar, 2005).

Schürer, *Exemplum* (2005): Markus Schürer, *Das Exemplum oder die erzählte Institution. Studien zum Beispielgebrauch bei den Dominikanern und Franziskanern des 13. Jahrhunderts*, Vita regularis 23 (Münster, 2005).

Schulte, *Hymnen* (1925): Adalbert Schulte: *Die Hymnen des Breviers nebst den Sequenzen des Missale*, Wissenschaftliche Handbibliothek Reihe 1: Theologische Lehrbücher 17, 5th rev. edn. (Paderborn, 1925).

Schulze Kalthoff, 'Dominikanerkloster' (2005): Norbert Schulze Kalthoff, 'Vom Dominikanerkloster zum medizinischen Zentrum—das "Kloster Paradiese"', *Kreis Soest. Landschaft und Natur, Freizeit und Kultur, Wirtschaft und Soziales* 3 (2005), 110–11.

Schumacher, *Sündenschmutz* (1996): Meinolf Schumacher, *Sündenschmutz und Herzenreinheit. Studien zur Metaphorik der Sünde in lateinischer und deutscher Literatur des Mittelalters,* Münstersche-Mittelalterschriften 73 (Munich, 1996).

Schumann, *Heinrich von Herford* (1996): Klaus Peter Schumann, *Heinrich von Herford. Enzyklopädische Gelehrsamkeit und universalhistorische Konzeption in Dienste dominikanischer Studienbedürfnisse,* Veröffentlichungen der Historischen Kommission für Westfalen, Reihe 44.4 (Münster, 1996).

Schumann, 'Petrus Comestor' (2000): Klaus Peter Schumann, 'Petrus Comestor und Petrus Lombardus in Minden? Prolegomena zu einer Geschichte der dominikanischen Partikularstudien im spätmittelalterlichen Westfalen', in: *Manipulus florum. Festschrift für Peter Johanek zum 60. Geburtstag,* eds. Ellen Widder et al. (Münster, 2000), 151–70.

Schwartz, *Kirchen* (1961): Hubertus Schwartz, *Soest in seinen Denkmälern,* 6 vols., vol. 5: *Die Kirchen der Soester Börde,* Soester wissenschaftliche Beiträge 20 (Soest, 1961).

Schwartz, *Soest* (1979): Hubertus Schwartz, *Soest in seinen Denkmälern,* 6 vols., vol. 3: *Gotische Kirchen, Ergänzungen,* Soester wissenschaftliche Beiträge 16, 2nd edn. (Soest, 1979).

Sciacca, 'Curtain' (2007): Christiane Sciacca, 'Raising the Curtain on the Use of Textiles in Manuscripts', in: *Weaving, Veiling, and Dressing: Textiles and their Metaphors in the Late Middle Ages,* eds. Kathryn M. Rudy & Barbara Baert (Turnhout, 2007), 161–90.

Sciacca, 'Stiches' (2010): Christiane Sciacca, 'Stitches, Sutures, and Seams: "Embroidered" Parchment Repairs in Medieval Manuscripts', in: *Medieval Clothing and Textiles,* eds. Robin Netherton & Gale R. Owen-Crocker (Woodbridge, 2010), 57–92.

Scott, *Gothic Manuscripts* (1996): Kathleen Scott, *Later Gothic Manuscripts, 1390–1490,* 2 vols., A Survey of Manuscripts Illuminated in the British Isles 6 (London, 1996).

Sears, *Ages of Man* (1986): Elizabeth Sears, *The Ages of Man: Medieval Interpretations of the Life Cycle* (Princeton, 1986).

Sears, 'Afterlife' (2006): Elizabeth Sears, 'The Afterlife of Scribes: Swicher's Prayer in the Prüfening Isidore', in: *Pen in Hand: Medieval Scribal Portraits, Colophons and Tools,* ed. Michael Gullick (Walkern, 2006), 75–96.

Seebas, *Musikdarstellung* (1973): Tilman Seebas, *Musikdarstellung und Psalterillustration im früheren Mittelalter. Studien angehend von einer Ikonologie der Handschrift Paris, BN, fons latin, 1118* (Bern, 1973).

Seeberg, *Textile Bildwerke* (2014): Stefanie Seeberg, *Textile Bildwerke im Kirchenraum. Leinenstickereien im Kontext mit-telalterlicher Raumausstattungen aus dem Kloster Altenberg/Lahn* (Peterberg, 2014).

Seidel, 'Kolophone' (2002): Kurt Otto Seidel, '*Tres digiti scribunt totum corpusque laborat.* Kolophone als Quelle für das Selbstverständnis mittelalterlicher Schreiber', in: *Der Schreiber im Mittelalter,* ed. Martin J. Schubert, Das Mittelalter: Perspektiven mediävistischer Forschung 7/2 (Berlin, 2002), 146–56.

Seifert, 'Choralhandschriften' (1956): Gotthard Seifert, 'Die Choralhandschriften des Predigerklosters zu Freiburg im Breisgau um 1500', Inaugural-Dissertation, Albert-Ludwigs-Universität, Freiburg i. Br. (1956).

Selle, *Service* (1995): Xavier de la Selle, *Le Service des âmes à la cour: confesseurs et aumôniers des rois de France de XIIIe au XVe siècle* (Paris, 1995).

Sennhauser et al., *Zisterzienserbauten* (1990): Hans Rudolf Sennhauser et al., *Zisterzienserbauten in der Schweiz. Neue Forschungsergebnisse zur Archäologie und Kunstgeschichte,* 2 vols.: vol. 1: *Frauenklöster,* Veröffentlichungen des Instituts für Denkmalpflege an der Eidgenössischen Technischen Hochschule Zürich 10/1 (Zurich, 1990).

Shailor, 'New Manuscript' (1983): Barbara Shailor, 'A New Manuscript of Nicholaus de Lyra, 1270–1349', *Yale University Library Gazette* 58 (1983), 9–16.

Shalev-Eyni, 'Humor' (2008): Sarit Shalev-Eyni, 'Humor and Criticism: Christian-Secular and Jewish Art of the Fourteenth Century', *Zeitschrift für Kunstgeschichte* 71 (2008), 188–206.

Shalev-Eyni, *Jews* (2010): Sarit Shalev-Eyni, *Jews among Christians: Hebrew Book Illumination from Lake Constance* (London–Turnhout, 2010).

Sheerin, 'St. John the Baptist' (1976): Daniel Sheerin, 'St. John the Baptist in the Lower World', *Vigiliae Christinae* 20 (1976), 1–22.

Siart, 'Heilsspiegel' (2008): Olaf Siart, 'Heilsspiegel und Liturgie. Der Glasfensterzyklus im Ebstorfer Kreuzgang und der Friedhof der Nonnen', in: *Gebaute Klausur. Funktion und Architektur mittelalterliche Klosterräume,* ed. Renate Oldermann, Veröffentlichungen des Instituts für Historische Landesforschung der Universität Göttingen 52 (Bielefeld, 2008), 219–34.

Signori, 'Leere Seiten' (2000): Gabriela Signori, 'Leere Seiten. Zur Memorialkultur eines nicht regulierten Augustiner-Chorfrauenstifts im ausgehenden 15. Jahrhundert', in: *Lesen, Schreiben, Sticken und Erinnern. Beiträge zur Kultur- und Sozialgeschichte mittelalterlicher Frauenklöster,* ed. Gabriele Signori, Religion in der Geschichte 7 (Bielfeld, 2000), 149–84.

Signori, 'Memorialpraktiken' (2004): Gabriela Signori, 'Hoch-mittelalterliche Memorialpraktiken in spätmittelalterlichen Reformklöstern', *Deutsches Archiv für Erforschung des Mittelalters* 60 (2004), 517–48.

Simon, *L'Ordre des Pénitentes* (1918): André Simon, *L'Ordre des Pénitentes de Ste Marie-Madeleine en Allemagne au XIIIe siècle* (Fribourg, 1918).

Simpson, *Iconoclasm* (2010): James Simpson, *Under the Hammer: Iconoclasm in the Anglo-American Tradition* (Oxford, 2010).

Skemer, *Amulets* (2006): Don C. Skemer, *Binding Words: Textual Amulets in the Middle Ages* (University Park, 2006).

Skubiszewski, '"Roi de gloire"' (1996): Piotr Skubiszewski, 'Le titre "Roi de gloire" et les images du Christ: un concept théologique, l'iconographie et les inscriptions', in: *Épigraphie et iconographie: Actes du Colloque tenu à Poitiers les 5–8 octobre 1995, Civilisation Médiévale* 2 (Poitiers, 1996), 229–58.

Smeyers, *Flämische Buchmalerei* (1999): Maurits Smeyers, *Flämische Buchmalerei. Vom 8. Jahrhundert bis zur Mitte des 16. Jahrhunderts. Die Welt des Mittelalters auf Pergament* (Leuven–Stuttgart, 1999).

I. Smith, 'Hymns' (2008): Innocent Smith (Philip Carl Smith), 'The Hymns of the Medieval Dominican Liturgy, 1250–1369', B.A. Thesis, University of Notre Dame (2008).

J. Smith, 'Prouille' (2009): Julie Ann Smith, 'Prouille, Madrid, Rome. The Evolution of the Earliest Dominican *Instituta* for Nuns', *Journal of Medieval History* 35 (2009), 340–52.

J. Smith, 'Clausura Districta' (2010): Julie Ann Smith, 'Clausura Districta: Conceiving Space and Community for Dominican Nuns in the Thirteenth Century', *Parergon* 27 (2010), 13–36.

K. Smith, 'Bodies' (2006): Katherine Allen Smith, 'Bodies of Unsurpassed Beauty: "Living" Images of the Virgin in the High Middle Ages', *Viator: Medieval and Renaissance Studies* 37 (2006), 167–87.

L. Smith, *Masters* (2001): Lesley J. Smith, *Masters of the Sacred Page: Manuscripts of Theology in the Latin West to 1274* (Notre Dame, 2001).

L. Smith, 'Jerusalem' (2012): Lesley J. Smith, 'The Imaginary Jerusalem of Nicholas of Lyra', in: *Imagining Jerusalem in the Medieval West*, eds. Lucy Donkin & Hanna Vorholt, Proceedings of the British Academy 175 (Oxford, 2012), 77–96.

Smolinsky, 'Kirchenreform' (1994): Heribert Smolinsky, 'Kirchenreform als Bildungsreform im Spätmittelalter und in der frühen Neuzeit', in: *Bildungs- und schulgeschichtliche Studien zu Spätmittelalter, Reformation und konfessionellem Zeitalter*, ed. Harald Dickerhof, Wissensliteratur im Mittelalter 19 (Wiesbaden, 1994), 35–51.

Social Life (2013): *The Social Life of Illumination: Manuscripts, Images, and Communities in the Late Middle Ages*, eds. Joyce Coleman et al., Medieval Texts and Cultures of Northern Europe 21 (Turnhout, 2013).

Sölch, 'Eigentümlichkeiten' (1931–1932): Gisbert M. Sölch, 'Zwei Eigentümlichkeiten in der Weihnachtsliturgie des Dominikanermissale', *Liturgische Zeitschrift* 4 (1931–1932), 87–92.

Sölch, *Eigenliturgie* (1957): Gisbert M. Sölch, *Die Eigenliturgie der Dominikaner: Eine Gesamtdarstellung*, Für Glauben und Leben 7 (Dusseldorf, 1957).

Soest. Geschichte der Stadt 1: Der Weg ins städtische Mittelalter. Topographie, Herrschaft, Gesellschaft, ed. Wilfried Ehbrecht, Soester Beiträge 52 (Soest, 2010).

Soest. Geschichte der Stadt 2: Die Welt der Bürger. Politik, Gesellschaft und Kultur im spätmittelalterlichen Soest, ed. Heinz-Dieter Heimann (Soest, 1996).

Soest. Geschichte der Stadt 3: Zwischen Bürgerstolz und Fürstenstaat. Soest in der frühen Neuzeit, ed. Ellen Widder, Soester Beiträge 54 (Soest, 1995)

Soester Antependium (2005): *Das Soester Antependium und die frühe mittelalterliche Tafelmalerei. Kunsttechnische und kunsthistorische Beiträge, Akten des Wissenschaftlichen Kolloquiums vom 5.–7. Dezember 2002*, eds. Joachim Poeschke et al. (=*Westfalen* 80, 2002) (Münster, 2005).

Sophia (1999): *Sophia: la sapienza di Dio*, eds. Giuseppina Cardillo Azzaro & Pierluca Azzaro (Milan, 1999).

Spalding, 'Charters' (1914): Mary Caroline Spalding, 'The Middle English Charters of Christ', Ph.D. dissertation, Bryn Mawr (1914).

Spieß, *Familie und Verwandtschaft* (1993): Karl-Heinz Spieß, *Familie und Verwandtschaft im deutschen Hochadel des Spätmittelalters. 13. bis Anfang des 16. Jahrhunderts*, Vierteljahrschrift für Sozial- und Wirtschaftsgeschichte. Beihefte 111 (Stuttgart, 1993).

Spieß, 'Memoria' (2000): Karl-Heinz Spieß, 'Liturgische Memoria und Herrschaftsrepräsentation im nichtfürstlichen Hochadel des Spätmittelalters', in: *Adelige und bürgerliche Erinnerungskulturen Formen der Erinnerung*, ed. Werner Rösener, Formen der Erinnerung 8 (Göttingen, 2000) 97–123.

Spitz, *Metaphorik* (1972): Hans-Jörg Spitz, *Die Metaphorik des geistigen Schriftsinns. Ein Beitrag zur allegorischen Bibelauslegung*

des ersten christlichen Jahrtausends, Münstersche Mittelalter-Schriften 12 (Munich, 1972), 23–40.

Spitzlei, *Erfahrungsraum* (1991): Sabine B. Spitzlei, *Erfahrungsraum Herz. Zur Mystik des Zisterzienserinnenklosters Helfta im 13. Jahrhundert*, Mystik in Geschichte und Gegenwart. Texte und Untersuchungen, Abteilung I. Christliche Mystik 9 (Stuttgart–Bad Cannstatt, 1991).

Springer, *Gospel* (1988): Carl P. E. Springer, *The Gospel as Epic in Late Antiquity: The Paschale carmen of Sedulius*, Supplements to Vigiliae Christianae 2 (Leiden, 1988).

Stadt im Wandel (1985): *Stadt im Wandel: Kunst und Kultur des Bürgertums in Norddeutschland 1150–1650*, ed. Cord Meckseper, exh. cat., Braunschweigisches Landesmuseum (Vieweghaus), Herzog Anton Ulrich-Museum (Burg Dankwarderode) und Dom am Burgplatz, 4 vols. (Braunschweig–Stuttgart–Bad Cannstadt, 1985).

Staehelin, 'Musik' (1998): Martin Staehelin, 'Spätmittelalterliche Musik und Musikübung im Kloster Helfta', in: *Bete und arbeite! Zisterzienser in der Grafschaft Mansfeld. Begleitband zur Ausstellung im Sterbehaus Martin Luthers in Eisleben, 24.10.1998 – 24.6.1999*, ed. Esther Pia Wipfler (Halle a. d. Saale, 1998), 193–97.

Staender, *Catalogus* (1889): Joseph Staender, *Chirographorum in regia bibliotheca Paulina Monasteriensis catalogus* (Breslau, 1889).

Stamm, 'Klosterreform' (1995): Gerhard Stamm, 'Klosterreform und Buchproduktion. Das Werk der Schreib- und Lesemeisterin Regula', in: *750 Jahre Zisterzienserinnen-Abtei Lichtenthal*, ed. Harald Siebenmorgen (Sigmaringen, 1995), 63–71.

Stammler, 'Studien' (1922, repr. 1964): Wolfgang Stammler, 'Studien zur Geschichte der Mystik in Norddeutschland', *Archiv für Religionswissenschaft* 21 (1922), 122–62; repr. as 'Mystic in Norddeutschland', in: *Altdeutsche und Altniederländische Mystik*, ed. Kurt Ruh (Darmstadt, 1964), 386–436.

Staubach, 'Pragmatische Schriftlichkeit' (1991): Nikolaus Staubach, 'Pragmatische Schriftlichkeit im Bereich der Devotio moderna', *Frühmittelalterliche Studien* 25 (1991), 418–61.

Stauffer, 'Muster' (2002): Annemarie Stauffer, 'Exotische Muster. Die Gewebedarstellungen auf dem Berswordt-Altar', in: *Der Berswordt-Meister und die Dortmunder Malerei um 1400. Stadtkultur im Spätmittelalter*, eds. Andrea Zupancic & Thomas Schilp, Veröffentlichungen des Stadtarchivs Dortmund 18 (Bielefeld, 2002), 135–37.

Stauffer, 'Überlegungen' (2004): Annemarie Stauffer, 'Neue Überlegungen zu den Gewebedarstellungen des Conrad von Soest', in: *Conrad von Soest. Neue Forschungen über den Maler*

und die Kulturgeschichte der Zeit um 1400, ed. Brigitte Buberl, Dortmunder Mittelalter-Forschungen 1 (Bielefeld, 2004), 145–65.

Stegmüller, *Repertorium* (1940–1961): Friedrich Stegmüller, *Repertorium Biblicum medii aevi*, 11 vols. (Madrid, 1940–1961).

Steiner, *Documentary Culture* (2003): Emily Steiner, *Documentary Culture and the Making of Medieval English Literature* (New York, 2003).

Steinhardt, 'Gradual' (1993): Milton Steinhardt, 'A Recently Discovered Dominican Gradual of Humbert's Time', *Archivum Fratrum Praedicatorum* 63 (1993), 43–50.

Stejskal, 'Historismus' (1972): Karel Stejskal, 'Der Historismus in der Kunst am Hofe Karls IV', in: *Evolution générale et développements régionaux en histoire de l'art. Actes du XXIIe congrès international d'histoire de l'art, Budapest 1969*, 3 vols. (Budapest, 1972), vol. 2, 585–89.

Stevens, *Words* (1986): John Stevens, *Words and Music in the Middle Ages: Song, Narrative, Dance and Drama, 1050–1350* (Cambridge, 1986).

Stinson, 'Assumption' (1998): John Stinson, 'The Dominican Liturgy of the Assumption: Texts and Music for the Divine Office', in: *The Art of the Book*, eds. Margaret M. Manion & Bernard J. Muir (Exeter, 1998), 163–93.

Stirnemann, 'Fils de la vierge' (1990): Patricia Stirnemann, 'Fils de la vierge: l'initiale à filigranes parisienne, 1140–1314', *Revue de l'art* 90 (1990), 58–73.

Stock, 'Dies irae' (2002): Alex Stock, 'Dies irae. Zu einer mittelalterlichen Sequenz', in: *Ende und Vollendung. Eschatologische Perspectiven im Mittelalter*, eds. Jan A. Aertsen & Martin Pickavé, Miscellanea mediaevalia 29 (Berlin, 2002), 279–91.

Stöllinger-Löser & Haage, 'Privatbesitz im Ordensleben' (1989): Christine Stöllinger-Löser & Dietrich Haage, 'Privatbesitz im Ordensleben', in: ²*VL* 7 (Berlin, 1989), cols. 845–50.

Stones, *Gothic Manuscripts* (2013): Alison Stones, *Gothic Manuscripts, 1260–1320: Part I*, A Survey of Manuscripts Illuminated in France, 2 vols. (London–Turnhout, 2013–2014).

Streider, *Tafelmalerei* (1993): Peter Streider, *Tafelmalerei in Nürnberg, 1350–1550* (Königstein im Taunus, 1993).

Studien und Texte (2004): *Studien und Texte zur literarischen und materiellen Kultur der Frauenklöster im späten Mittelalter. Ergebnisse eines Arbeitsgesprächs in der Herzog August Bibliothek Wolfenbüttel, 24.–26. Febr. 1999*, eds. Falk Eisermann et al., Studies in Medieval and Reformation Thought 99 (Leiden, 2004).

Stüwer, *Patrozinien* (1938): Wilhelm Stüwer, *Die Patrozinien im Kölner Großarchidiakonat Xanten. Beiträge zur Kultgeschichte des Niederrheins* (Bonn, 1938).

Sturlese, 'Soester Lektor' (1983): Loris Sturlese, 'Der Soester Lektor Reiner von Cappel O.P. und zwei Wolfenbütteler Fragmente aus Kapitelsakten der Dominikanerprovinz Saxonia (1358, ca. 1370)', *Wolfenbütteler Beiträge* 6 (1983), 186–201.

Suckale, 'Arma Christi' (1977): Robert Suckale, 'Arma Christi. Überlegungen zur Zeichenhaftigkeit mittelalterlicher Andachtsbilder', *Städel-Jahrbuch* N.F. 6 (1977), 177–208.

Suckale, 'Löwenmadonna' (1999): Robert Suckale, 'Die Löwenmadonna, ein politischer Bildtyp aus der Frühzeit Karls IV.?', *Iconographica: mélanges offers à Piotr Skubiszewski par ses amis, ses collègues, ses élèves*, eds. Robert Favreau & Marie-Hélène Debiès, Civilization médiévale 7 (Poitiers, 1999), 221–29.

Suckale, *Bild als Zeitzeuge* (2002): Robert Suckale, *Das mittelalterliche Bild als Zeitzeuge* (Berlin, 2002).

Suckale, 'Madonnentafel' (2003): Robert Suckale, 'Die Glatzer Madonnentafel des Prager Erzbischofs Ernst von Pardubitz als gemalter Marienhymnus. Zur Frühzeit der böhmischen Tafelmalerei, mit einem Beitrag zur Einordnung der Kaufmannschen Kreuzigung', in: *Stil und Funktion. Ausgewählte Schriften zur Kunst des Mittelalters*, eds. Peter Schmidt & Gregor Wedekind (Munich, 2003), 119–50.

Suckale, '"Sweet Style"' (2011): Robert Suckale, 'The "Sweet Style" in Regensburg: An Addition to the Leaves from the Early Fourteenth-Century Antiphonary from the Dominican Convent of the Holy Cross', *Harvard Library Bulletin* 21 (2011), 45–52.

Suntrup, *Bedeutung* (1978): Rudolf Suntrup, *Die Bedeutung der liturgischen Gebärden und Bewegungen in lateinischen und deutschen Auslegungen des 9. bis 13. Jahrhunderts*, Münstersche Mittelalter–Schriften 37 (Munich, 1978), 342–50.

Suntrup, 'Te igitur' (1980): Rudolf Suntrup, 'Te igitur–Initialen und Kanonbilder in mittelalterlichen Sakramentarhandschriften', in: *Text und Bild. Aspekte des Zusammenwirkens zweier Künste in Mittelalter und früher Neuzeit*, eds. Christel Meier & Uwe Ruberg (Wiesbaden, 1980), 278–382.

Surmann, *Christus* (1991): Ullrike Surmann: *Christus in der Rast*, Liebighaus Monographie 13 (Frankfurt a. M., 1991).

Swanson, 'Childhood and Childrearing' (1990): Jenny Hughes Swanson, 'Childhood and Childrearing in "ad status" Sermons by Later Thirteenth-century Friars', *Journal of Medieval History* 16 (1990), 309–31.

Swarzenski, *Handschriften* (1936): Hanns Swarzenski, *Die lateinischen illuminierten Handschriften des XIII. Jahrhunderts am Rhein, Main und Donau*, 2 vols. (Berlin, 1936).

Syring, 'Compilatio' (1998): Andrea Syring, 'Compilatio as a Method of Middle High German Literature Production: An Anonymous Sermon about St. John the Evangelist and its Appearance in other Sermons', in: *Medieval Sermons and Society: Cloister, City, University*, eds. Jacqueline Hamesse et al., Textes et études du Moyen Âge 9 (Louvain-la-Neuve, 1998), 117–43.

Szövérffy, 'Kultgeschichte' (1973): Joseph Szövérffy, 'Kultgeschichte und Politik. Die Anfänge des Magdalenenkultes in Vézelay, Burgunds Angliederung unter Konrad II. und die Sequenz Victimae paschali', *Archiv für Kulturgeschichte* 55 (1973), 305–11.

Szövérffy, *Hymns* (1976): Joseph Szövérffy, *Hymns of the Holy Cross: An Annotated Edition with Introduction*, Medieval Classics: Texts and Studies 7 (Brookline–Leiden, 1976).

Szövérffy, 'Streifzüge' (1983): Joseph Szövérffy, 'Hymnologische Streifzüge', in: *Psallat chorus caelestium: Religious Lyrics of the Middle Ages. Hymnological Studies and Collected Essays* (Berlin, 1983), 478–504.

Szövérffy, 'Randbemerkungen' (1983): Joseph Szövérffy, 'Kreislauf von Ideen und Bildern. Randbemerkungen zum mittelalterlichen Drama, zur Hymnendichtung und Ikonographie', in: *Psallat chorus caelestium: Religious Lyrics of the Middle Ages. Hymnological Studies and Collected Essays* (Berlin, 1983), 366–75.

Szövérffy, *Concise History* (1985): Joseph Szövérffy, *A Concise History of Medieval Latin Hymnody: Religious Lyrics between Antiquity and Humanism*, Medieval Classics: Texts and Studies 19 (Leiden, 1985).

Tacconi, *Cathedral and Civic Ritual* (2005): Marika Tacconi, *Cathedral and Civic Ritual in Late Medieval and Renaissance Florence: The Service Books of Santa Maria del Fiore* (Cambridge, 2005).

Tångeberg, *Holzskulptur* (1989): Peter Tångeberg, *Holzskulptur und Altarschrein. Studien zu Form, Material und Technik mittelalterliche Plastik in Schweden* (Munich, 1989).

Tångeberg, *Retabel und Altarschreine* (2005): Peter Tångeberg, *Retabel und Altarschreine des 14. Jahrhunderts: schwedische Altarausstattungen in ihrem europäischen Kontext* (Stockholm, 2005).

Tanneberger, *Basistexte* (2014): Tobias Tanneberger, '...usz latin in tutsch gebracht...'. Normative Basistexte religiöser Gemeinschaften in volkssprachlichen Übertragungen. Katalog – Untersuchung – Fallstudie*, Vita Regularis. Abhandlungen 59 (Berlin–Münster 2014).

Tarruell, '"Dedicatio ecclesiae"' (1989): Jorge Gilbert Tarruell, 'La "dedicatio ecclesiae": il rito liturgico e i suoi principi ideologici', in: *L'Amiata nel medioevo: Atti del convegno internazionale di studi storici, Abbadia San Salvatore, 29 maggio–1 giugno 1986*, eds. Mario Ascheri & Wilhelm Kurze (Rome, 1989), 19–32.

Tax, 'Verfasserschaft' (2006): Petrus W. Tax, 'Zur Verfasserschaft und Entstehungszeit der Pfingstsequenz, *Veni, Sancte Spiritus*', *Zeitschrift für deutsches Altertum* 135 (2006), 13–20.

Telesko, 'Antiphonar' (1998): Werner Telesko, 'Das Antiphonar von St. Peter und seine Bedeutung für die Buchmalerei des 12. Jahrhunderts', *Mitteilungen der Gesellschaft für Salzburger Landeskunde* 139 (1998), 297–327.

Terrien, *Iconography* (1996): Samuel Terrien, *The Iconography of Job through the Centuries: Artists as Biblical Interpreters* (University Park, 1996).

Terza, 'Charles S. Singleton' (1986): Dante della Terza, 'Charles S. Singleton: An Appraisal', *Dante Studies* 104 (1986), 9–25.

Teviotdale, 'Inscriptions' (1996): Elizabeth C. Teviotdale, 'Latin Verse Inscriptions in Late Anglo-Saxon Art', *Gesta* 35 (1996), 99–110.

Teviotdale, 'Antiphonals' (2000): Elizabeth C. Teviotdale, 'A Pair of Franco-Flemish Cistercian Antiphonals of the Thirteenth Century and Their Programs of Illumination', in: *Interpreting and Collecting Fragments of Medieval Books: Proceedings of The Seminar in the History of the Book to 1500*, Oxford 1998, eds. Linda L. Brownrigg & Margaret M. Smith (London–Los Altos Hills, 2000), 230–58.

Teviotdale, *Stammheim Missal* (2001): Elizabeth C. Teviotdale, *The Stammheim Missal* (Los Angeles, 2001).

'Textus' (2006): *'Textus' im Mittelalter. Komponenten und Situationen des Wortgebrauchs im schriftsemantischen Feld*, eds. Ludolf Kuchenbuch & Uta Kleine (Göttingen, 2006).

Thali, *Beten* (2003): Johanna Thali, *Beten, Schreiben, Lesen. Literarisches Leben und Marienspiritualität im Kloster Engelthal*, Bibliotheca Germanica 42 (Tübingen, 2003).

Théry, 'Livres choraux' (1932): Gabriel Théry, 'À propos des livres choraux des Dominicains de Gubbio', *Archivum Fratrum Praedicatorum* 2 (1932), 252–83.

Thesaurus Austriacus (1996): *Thesaurus Austriacus. Europas Glanz im Spiegel der Buchkunst. Handschriften und Kunstalben von 800 bis 1600*, ed. Eva Irblich (Vienna, 1996).

Thibodeau, 'William Durand' (1992): Timothy M. Thibodeau, 'William Durand: Compilator *Rationalis*', *Ecclesia Orans* 9 (1992), 97–113.

Thibodeau, 'Enigmata Figurarum' (1993): Timothy M. Thibodeau, 'Enigmata Figurarum: Biblical Exegesis and Liturgical Exposition in Durand's *Rationale*', *Harvard Theological Review* 86 (1993), 65–79.

Thiel, 'Elements' (1990–1991): Pieter J. J. van Thiel, 'Catholic Elements in Seventeenth-Century Dutch Painting, apropos of a Children's Portrait by Thomas de Keyser', *Simiolus* 20 (1990–1991), 39–62.

Thiemann, 'Klöster' (2003): Bernhard Thiemann, 'Die Klöster der Stadt Soest', in: *Klöster und monastische Kultur in Hansestädten. Beiträge des 4. wissenschaftlichen Kolloquiums Stralsund 12. bis 15. Dezember 2001*, eds. Claudia Kimminus-Schneider & Manfred Schneider, Stralsunder Beiträge zur Archäologie, Geschichte, Kunst und Volkskunde in Vorpommern 4 (Rahden/Westf., 2003).

Thoma, 'Ökonomie und Verwaltung' (2008): Gertrud Thoma, 'Ökonomie und Verwaltung in mittelalterlichen Frauenkonventen Süddeutschlands', in: *Nonnen, Kanonissen und Mystikerinnen* (2008), 297–313.

Thomas, 'Profession' (1969): Antoninus Hendrik Thomas, 'La profession religieuse des Dominicains: formule, cérémonies, histoire', *Archivum Fratrum Praedicatorum* 39 (1969), 5–52.

Thorndike, *Catalogue* (1963): Lynn Thorndike & Kibre Pearl, *A Catalogue of Incipits of Medieval Scientific Writings in Latin*, The Mediaeval Academy of America Publications 29 (London, 1963).

Thunberg, 'Human Person' (1987): Lars Thunberg, 'The Human Person as Image of God: I. Eastern Christianity', in: *Christian Spirituality: Origins to the Twelfth Century*, eds. Bernard McGinn et al. (New York, 1987), 291–312.

Timmermann, *Studien* (1982): Waltraud Timmermann, *Studien zur allegorischen Bildlichkeit in den Parabolae Bernhards von Clairvaux. Mit der Erstedition einer mittelniederdeutschen Übersetzung der Parabolae 'Vom geistlichen Streit' und 'Vom Streit der vier Töchter Gottes'*, Mikrokosmos 10 (Frankfurt a. M., 1982).

Todorov, 'Symbolism' (1974): Tzvetan Todorov, 'On Linguistic Symbolism', *New Literary History* 6 (1974), 111–34.

Tóth & Falvay, 'New Light' (2014): Peter Tóth & Dávid Falvay, 'New Light on the Date and Authorship of the Meditationes vitae Christi', in: *Devotional Culture in Late Medieval England and Europe: Diverse Imaginations of Christ's Life*, eds. Stephen Kelly & Ryan Perry, Medieval Church Studies 31 (Turnhout, 2014), 17–105.

Toubert, 'Représentations' (1990): Hélène Toubert, 'Les représentations de l'*Ecclesia* dans l'art des Xe–XIIe siècles', in: *Atti del XIII Convegno di Studi, sul tema Musica e Arte figurativa nei secoli X–XII, 15–18 ottobre 1972*, Convegni del Centro di studi

sulla spiritualità medievale 13 (Todi, 1973), 67–101, repr. in: *Un art dirigé: réforme grégorienne et iconographie* (Paris, 1990), 37–63.

Toussaint, *Reliquien* (2011): Gia Toussaint, *Kreuz und Knochen. Reliquien zur Zeit der Kreuzzüge* (Berlin, 2011).

Transformations (1977): *Transformations of the Court Style: Gothic Art in Europe 1270 to 1330* (Providence, 1977).

Traube, *Nomina sacra* (1907): Ludwig Traube, *Nomina sacra. Versuch einer Geschichte der christlichen Kürzung*, Quellen und Untersuchungen zur lateinischen Philologie des Mittelalters 2 (Munich, 1907).

Travail et travailleurs (1991): *Travail et travailleurs en Europe au moyen âge et au début des temps modernes*, ed. Claire Dolan, Papers in Mediaeval Studies 13 (Toronto, 1991).

Traver, *Four Daughters* (1907): Hope Traver, *The Four Daughters of God: A Study of the Versions of This Allegory, with Special Reference to Those in Latin, French, and England*, Bryn Mawr College Monographs: Monograph Series 5–6 (Bryn Mawr, 1907).

Traver, 'Four Daughters' (1925): Hope Traver, 'The Four Daughters of God: A Mirror of Changing Doctrine', *PMLA* 40 (1925), 44–92.

Treffort, 'Inscrire' (2003): Cécile Treffort, 'Inscrire son nom dans l'espace liturgique à l'époque romane', *Cahiers de Saint-Michel-de-Cuxa* 34 (2003), 147–60.

Treffort, 'Consécration' (2008): Cécile Treffort, 'Une consécration "à la lettre": place, rôle et autorité des textes inscrits dans la sacralisation de l'église', in: *Mises en scène et mémoires et de la consécration de l'église dans l'Occident médiéval*, ed. Didier Méhu, Collection d'études médiévales de Nice 7 (Turnhout, 2008), 219–51.

Treitler, 'Speaking of Jesus' (1985): Leo Treitler, 'Speaking of Jesus', in: *Liturgische Tropen. Referate zweier Colloquien des Corpus Troporum in München (1983) und Canterbury (1984)*, Münchener Beiträge zur Mediävistik und Renaissance-Forschung 36 (Munich, 1985), 125–30.

Tripps, *Bildwerk* (2000): Johannes Tripps, *Das handelnde Bildwerk in der Gotik. Forschungen zu den Bedeutungsschichten und der Funktion des Kirchengebäudes und seiner Ausstattung in der Hoch- und Spätgotik*, 2nd edn. (Berlin, 2000).

Tristam, *Weltzeitalter* (1985): Hildegard L. C. Tristam, *Sex aetates mundi. Die Weltzeitalter bei den Angelsachsen und den Iren*, Untersuchungen und Texte. Anglistische Forschungen (Heidelberg, 1985).

Trost, *Goldtinten* (1991): Vera Trost, *Gold- und Silbertinten. Technologische Untersuchungen zur abendländischen Chrysographie und Argyrographie von der Spätantike bis zum hohen Mittelalter*, Beiträge zum Buch- und Bibliothekswesen 28 (Wiesbaden, 1991).

Trottmann, *Vision béatifique* (1995): Christian Trottmann: *La vision béatifique: des disputes scolastiques à sa définition par Benoît XII*, Bibliothèque des écoles françaises d'Athènes et de Rome 289 (Rome, 1995).

Trudi, *Immagine* (2001): Fabio Trudi: *'Haec ades mysterium adumbrat ecclesiae': Immagine simboliche dell' Ecclesia nel rito di dedicazione della chiesa*, Bibliotheca 'Ephemerides Liturgicae': Subsidia 112 (Rome, 2001).

Tuckett, 'P52' (2001): Christopher M. Tuckett, 'P52 and the Nomina Sacra', *New Testament Studies* 47 (2001), 544–48.

Tuckett, 'Nomina Sacra' (2003): Christopher M. Tuckett, '*Nomina Sacra*: Yes and No?' in: *The Biblical Canons*, eds. Jean-Marie Auwers & Henk Jan de Jonge, Bibliotheca Ephemeridum theologicarum Lovanienisum 163 (Louvain, 2003), 432–58.

Tuckett, 'Codex E' (2006): Christopher M. Tuckett: '*Nomina Sacra* in Codex E', *Journal of Theological Studies* 57 (2006), 487–99.

Tugwell, 'Profession' (1983): Simon Tugwell, 'Dominican Profession in the Thirteenth Century', *Archivum Fratrum Praedicatorum* 53 (1983), 5–52.

Tugwell, 'Humbert of Romans, "Compilator"' (1997): Simon Tugwell, 'Humbert of Romans, "Compilator"', in: *Lector et compilator: Vincent de Beauvais, frère prêcheur. Un intellectuel et son milieu au XIIIe siècle*, eds. Serge Lusignan & Monique Paulmier-Foucart (Grâne, 1997), 47–76.

Tugwell, 'Evolution' (2000): Simon Tugwell, 'The Evolution of Dominican Structures of Government, II: The First Dominican Provinces', *Archivum Fratrum Praedicatorum* 70 (2000), 100–109.

Tugwell, 'L'évolution' (2001): Simon Tugwell, 'L'évolution des "Vitae fratrum": Résumé des conclusions provisoires', in: *L'ordre des Prêcheurs et son histoire en France méridionale (Cahiers de Fanjeaux* 36) (Fanjeaux, 2001), 415–18.

Tugwell, 'Prouille' (2004): Simon Tugwell, 'For whom was Prouille Founded?', *Archivum Fratrum Praedicatorum* 74 (2004), 5–125.

Tugwell, 'Magdalen Nuns' (2006): Simon Tugwell, 'Were the Magdalen Nuns Really Turned into Dominicans in 1287?', *Archivum Fratrum Praedicatorum* 76 (2006), 39–77.

Uffmann, 'Inside and Outside' (2001): Heike Uffmann, 'Inside and Outside the Convent Walls: The Norm and Practice of Enclosure in the Reformed Nunneries of Late Medieval Germany', *Medieval History Journal* 4 (2001), 83–108.

Uffmann, *Rosengarten* (2008): Heike Uffmann, *Wie in einem Rosengarten. Monastische Reformen des späten Mittelalters in den Vorstellungen von Klosterfrauen*, Religion in der Geschichte 14 (Bielefeld, 2008).

Uhrle, *Weiler* (1969): Susann Uhrle, *Das Dominikanerinnenkloster Weiler bei Esslingen*, Veröffentlichungen der Kommission für geschichtliche Landeskunde in Baden-Württemberg. Reihe B/49 (Stuttgart, 1969).

Urfels-Capot, *Sanctoral* (2007): Anne-Élisabeth Urfels-Capot, *Le Sanctoral du lectionnaire de l'office dominicain (1245–1256): édition et étude d'après le ms. Rome, Sainte-Sabine XIV L1. Ecclesiasticum officium secundum ordinem fratrum praedicatorum*, Mémoires et documents de l'École des Chartes 84 (Paris, 2007).

Väth, *Handschriften* (2001): Paula Väth, *Die illuminierten lateinischen Handschriften deutscher Provenienz der Staatsbibliothek zu Berlin, Preussischer Kulturbesitz, 1200–1350, Teil 1: Text, Teil 2: Abbildungen*, 2 vols., Kataloge der Handschriftenabteilung, 3/3 (Wiesbaden, 2001).

Vargas, 'Change' (2012): Michael Vargas, 'Administrative Change in the Fourteenth-century Dominican Order: A Case Study in Partial Reforms and Incomplete Theories', in: *Reassessing Reform: A Historical Investigation into Church Renewal*, eds. Christopher M. Bellitto & David Zachariah Flanagin (Washington, D.C., 2012), 84–104.

Vauchez, 'Canonisations' (1977): André Vauchez, 'Les Canonisations de S. Thomas et de S. Bonaventure: pourquoi deux siècles d'écart?', in: *1274, année charnière: mutations et continuités: Lyon–Paris 30 septembre–5 octobre 1974*, Colloques internationaux du Centre National de la Recherche Scientifique 558 (Paris, 1977), 91–107.

Velu, *Visitation* (2012): Anne Marie Velu, *La Visitation dans l'art: Orient et Occident Ve–XVIe siècle* (Paris, 2012).

Venchi, *Catalogus* (2001): *Catalogus hagiographicus ordinis Praedicatorum*, ed. Franciscus Maria Ricci (Rome, 2001).

Venturi, 'Augusto' (1906): Lionello Venturi, 'Una rappresentazione trecentesca della leggenda di Augusto e della sibilla tiburtina', *Ausonia* 1 (1906), 93–95.

Verborgene Pracht (2002): *Verborgene Pracht. Mittelalterliche Buchkunst aus acht Jahrhunderten in Freiburger Sammlungen*, eds. Detlef Zinke et al. (Lindenberg, 2002).

Verdier, 'Ara coeli' (1982): Philippe Verdier, 'La naissance à Rome de la vision de l'ara coeli: un aspect de l'utopie de la paix perpétuelle à travers un thème iconographique', *Mélanges de l'École française de Rome* 94 (1982), 85–119.

Verdier, 'Saint-Denis' (1982): Philippe Verdier, 'Saint-Denis et la tradition carolingienne des tituli: le *De rebus in administratione sua gestis* de Suger', in: *La chanson de geste et le mythe carolingien: Mélanges René Louis* (Saint-Père-sous-Vézelay, 1982), 341–59.

Verzár, 'Victory' (1984): Christine Verzar, 'Victory over Evil: Variations on the Image of Psalm 90:13 in the Art of Nicolaus', in: *Scritti di storia dell'Arte in onore di Roberto Salvini*, ed. Cristina De Benedictis (Florence, 1984), 45–51.

Vetter, '*Mulier amicta sole*' (1958–1959): Ewald M. Vetter, 'Mulier amicta sole und Mater salvatoris', *Münchner Jahrbuch der bildenden Kunst*, 3. Folge, 9–10 (1958–1959), 32–71.

Vetter, 'Virgo in sole' (1962–1963): Ewald M. Vetter, 'Virgo in sole', in: *Homenaje a Johannes Vincke para el 11 de mayo, 1962* (Madrid, 1962–1963), 367–418.

Vetter, *Kupferstiche* (1972): Ewald M. Vetter, *Die Kupferstiche zur Psalmodia Eucaristica des Melchor Prieto von 1622*, Spanische Forschungen der Görresgesellschaft, 2nd series 15 (Münster, 1972).

Vidal, 'Between the City' (2015): Mercedes Pérez-Vidal, 'Between the City and the Cloister: Saints, Liturgy and Devotions in the Dominican Nunneries in Late Medieval Castile', in: *Saints and the City. Beiträge zum Verständnis urbaner Sakralität in christlichen Gemeinschaften (5.–17. Jh.)*, ed. Michele Ferrari (Erlangen, 2015), 233–67.

Vila-Abadal, 'Salmo 33 [34]' (1953): Plàcid M. Vila-Abadal, 'El salmo 33 [34] como canto de comunión', in: *XXXV Congresso Eucaristico Internacional 1952: Sesiones de estudio* 1 (Barcelona, 1953), 725–31.

Virgilian Tradition (2008): *The Virgilian Tradition*, eds. Jan M. Ziolkowski & Michael C. J. Putnam (New Haven, 2008).

Vision and Visuality (1999): *Vision and Visuality*, ed. Hal Forster (New York, 1999).

Visuality (2000): *Visuality Before and Beyond the Renaissance: Seeing as Others Saw*, ed. Robert S. Nelson (Cambridge, 2000).

Vlhová-Wörner, '"Fama crescit eundo"' (2002): Hana Vlhová-Wörner, '"Fama crescit eundo"—Der Fall: Domazlaus predicator, der älteste böhmische Sequenzendichter', *Hudební věda* 39 (2002), 311–30.

Vlhová, 'Sequentiar' (2003): Hana Vlhová, 'Das Sequentiar des Arnestus von Pardubice. Das Repertoire und sein Verhältnis zum "Prager Ritus"', *Miscellanea Musicologica* 38 (2003), 69–88.

Voaden, 'Mechtild of Hackeborn' (2010): Rosalynn Voaden, 'Mechtild of Hackeborn', in: *Medieval Holy Women in the Christian Tradition, c. 1100–c. 1500*, eds. Rosalynn Voaden & Alastair Minnis (Turnhout, 2010), 431–51.

Voelkle & Wieck, *Breslauer Collection* (1992): William M. Voelkle & Roger S. Wieck, *The Bernard H. Breslauer Collection of Manuscript Illuminations* (New York, 1992).

Vogeler, 'Einfälle' (1891): Eduard Vogeler, 'Verwüstende Einfälle staatischer (niederländischer) Truppen in die Börde', *Zeitschrift des Vereins für die Geschichte von Soest und der Börde* 9 (1891), 78–87.

Voit, *Engelthal* (1977): Gustav Voigt, *Engelthal. Geschichte eines Dominikanerinnenklosters im Nürnberger Raum*, 2 vols., Schriftenreihe der altnürnberger Landschaft 26 (Nuremberg, 1977).

Volfing, *John the Evangelist* (2001): Annette Volfing, *John the Evangelist and Medieval German Writing: Imitating the Inimitable* (Oxford, 2001).

Volfing, 'Johannes und Maria' (2013): Annette Volfing, 'Johannes und Maria in den Johannes-Kompendien (Bamberg, Karlsruhe, Pommersfelden)', in: *Predigt im Kontext* (Berlin, 2013), eds. Volker Mertens et al. (Berlin, 2013), 333–46.

Voltmer, 'Political Preaching' (2013): Rita Voltmer, 'Political Preaching and the Design of Urban Reform: Joahnnes Geiler of Kayersberg and Strasbourg', *Franciscan Studies* 71 (2013), 71–88.

Vosding, 'Gifts' (forthcoming): Lena Vosding, 'Gifts from the Abbey: The Letters of the Lüne Benedictine Nuns as Materialisation of Spiritual Care', in: *What is a Letter? An Interdisciplinary Approach*, eds. Marie Isabelle Matthews-Schlinzig et al. (Oxford, forthcoming).

Wachinger, ' "Salve mater salvatoris" ' (1992): Burkhart Wachinger, ' "Salve mater salvatoris" (deutsch)', in: ²*VL* 8 (Berlin, 1992), cols. 551–52.

Wachinger, 'Hymnenmeditation' (2007): Burkhart Wachinger, 'Hymnenmeditation im Gespräch mit Gott', in: *Impulse und Resonanzen: Tübinger mediävistische Beiträge zum 80. Geburtstag von Walter Haug*, eds. Gisela Vollmann-Profe et al. (Tübingen, 2007), 323–64.

Wachtel, *Musikpflege* (1938): Hildegard Wachtel, *Die liturgische Musikpflege im Kloster Adelhausen seit Gründung des Klosters 1234 bis um 1500*, Freiburger Diözesan-Archiv N.F. 39 (1938).

B. Wagner, 'Prämonstratenserkloster' (2009): Bettina Wagner, 'Das Prämonstratenserkloster Windberg und seine Bibliothek im Spiegel der Ausgabenbücher des 15. Jahrhunderts', in: *Zur Erforschung mittelalterlicher Bibliotheken. Chancen – Entwicklungen – Perspektiven*, ed. Andrea Rapp, Zeitschrift für Bibliothekswesen und Bibliographie. Sonderbände 97 (Frankfurt a. M., 2009), 421–35.

G. Wagner, *Kreuzverehrung* (1960): Georg Wagner, *Volksfromme Kreuzverehrung in Westfalen von den Anfängen bis zum Bruch der mittelalterlichen Glaubenseinheit*, Schriften der volkskundlichen Kommission des Landschaftsverbandes Westfalen-Lippe 11 (Münster, 1960).

Wailes, *Parables* (1987): Stephen L. Wailes, *Medieval Allegories of Jesus' Parables*, Publications of the UCLA Center for Medieval and Renaissance Studies 23 (Berkeley, 1987).

Walberg, 'Benninghausen' (1992): Hartwig Walberg, 'Benninghausen—Zisterzienserinnen', in: *Westfälisches Klosterbuch* (1992), vol. 1, 447–51.

Waller, 'Painted Glass' (1853): J. Green Waller, 'On Ancient Painted Glass in Morley Church', *Journal of the British Archaeological Association* 8 (1853), 28–34.

Walters et al., *Corpus Christi* (2006): Barbara R. Walters, Vincent Corrigan, & Peter T. Ricketts, *The Feast of Corpus Christi* (University Park, 2006).

Walther, 'Ordensstudium' (2005): Helmut G. Walther, 'Ordensstudium und theologische Profilbildung. Die 'Studia generalia' in Erfurt und Paris an der Wende vom 13. zum 14. Jahrhundert', in: *Meister Eckhart in Erfurt*, eds. Andreas Speer & Lydia Wegener, Miscellanea mediaevalia 32 (Berlin–New York, 2005), 75–94.

Walz, *Compendium* (1930): Angelus Walz, *Compendium historiae ordinis Praedicatorum* (Rome, 1930).

Walzel, 'Dichtung' (1932): Oskar F. Walzel, 'Der Dichtung Schleier aus der Hand der Wahrheit', *Euphorion. Zeitschrift für Literaturgeschichte* 33 (1932), 83–105.

Warr, 'Habits' (2002): Cordelia Warr, 'Religious Habits and Visual Propaganda: The Vision of the Blessed Reginald of Orléans', *Medieval History* 28 (2002), 43–72.

A. Watson, *Iconography* (1934): Arthur Watson, *The Early Iconography of the Tree of Jesse* (Oxford, 1934).

A. G. Watson, *Catalogue* (1979): Andrew G. Watson, *Catalogue of Dated and Datable Manuscripts c.700–1600 in the Department of Manuscripts, The British Library* (London, 1979).

Weakland, *John XXII* (1968): John E. Weakland, *Pope John XXII and the Beatific Vision Controversy* (Atlantic Highlands, 1968).

Wehking & Wulf, 'Die Inschriften' (1990): Sabine Wehking & Christine Wulf, 'Die Inschriften des Stifts Fischbeck bis zur Mitte des 17. Jahrhunderts', in: *'Ja muz ich sunder riuwe sin'. Festschrift für Karl Stackmann zum 15. Februar 1990*, eds. Wolfgang Dinkelacker et al. (Göttingen, 1990), 51–82.

Wehlt, 'Lemgo-Dominikanerinnen' (1992): Hans-Peter Wehlt, 'Lemgo. Dominikanerinnen, bis 1305 in Lahde', in: *Westfälisches Klosterbuch* (1992), vol. 1, 499–505.

Wehrli-Johns, 'Graduale' (1995): Martina Wehrli-Johns, 'Das Selbstverständnis des Predigerordens im Graduale von Katharinental', in: *Contemplata aliis tradere. Studien zum Verhältnis von Literatur und Spiritualität*, eds. Claudia Brinker et al. (Bern, 1995), 241–72.

Wehrli-Johns, 'Bildexegese' (2010): Martina Wehrli-Johns, 'Bildexegese und Sprachreflexion im Dienste der Kirchenreform. Predigten zum Fest Mariä Heimsuchung aus dem Umfeld des Prager Reformkreises und der dominikanischen Frühobservanz', in: *Die Predigt im Mittelalter zwischen Mündlichkeit, Bildlichkeit und Schriftlichkeit*, eds. René Wetzel & Fabrice Flückiger (Zurich, 2010), 109–31.

Weisheipl, *Thomas d'Aquino* (1974): James A. Weisheipl, *Friar Thomas d'Aquino: His Life, Thought, and Work* (Garden City, N.J., 1974).

Weiß, 'Altarsetzung' (2004): Dieter J. Weiß, 'Altarsetzung und Inthronisation. Das Zeremoniell bei der Einsetzung der Bischöfe von Bamberg', in: *Hortulus floridus Bambergensis. Studien zur fränkischen Kunst- und Kulturgeschichte. Renate Baumgärtel-Fleischmann zum 4. Mai 2002*, ed. Werner Taegert (Petersberg, 2004), 99–108.

Welker, 'Jenarer Liederhandschrift' (2010): Lorenz Welker, 'Die "Jenaer Liederhandschrift" im Kontext großformatiger liturgischer Bücher des 14. Jahrhunderts aus dem deutschen Sprachraum', in: *Die 'Jenaer Liederhandschrift'. Codex—Geschichte—Umfeld*, eds. Jens Haustein & Franz Körndle (Berlin–New York, 2010), 137–47.

Wenger, *Palmesel* (2000): Alfons Wenger, *Der Palmesel. Geschichte, Kult und Kunst, eine Ausstellung im Museum für Natur & Stadtkultur Schwäbisch Gmünd*, exh. cat., Museumskatalog Schwäbisch Gmünd 6, eds. Alfons Wenger et al. (Schwäbisch Gmünd, 2000).

Wenzel, *Spiegelungen* (2009): Horst Wenzel, *Spiegelungen. Zur Kultur der Visualität im Mittelalter*, Philologische Studien und Quellen 216 (Berlin, 2009).

Wesjohann, *Gründungserzählungen* (2012): Achim Wesjohann, *Mendikantische Gründungserzählungen im 13. und 14. Jahrhundert. Mythen als Element institutioneller Eigengeschichtsschreibung der mittelalterlichen Franziskaner, Dominikaner und Augustiner-Eremiten*, Vita regularis. Abhandlungen 49 (Berlin, 2012).

Westfalia picta (1989): *Westfalia picta, Bd. IV: Kreis Soest, Kreis Unna/Stadt Hamm*, eds. Jochen Luckhardt et al. (Bielefeld, 1989).

Westfälisches Klosterbuch, ed. Hengst (1993–2003): *Westfälisches Klosterbuch. Lexikon der vor 1815 errichteten Stifte und Klöster von ihrer Gründung bis zur Aufhebung*, ed. Karl Hengst, 3 vols., Veröffentlichungen der Historischen Kommission für Westfalen 44; Quellen und Forschungen zur Kirchen- und Religionsgeschichte 2 (Münster, 1993–2003).

Westfälische Malerei (1964): *Westfälische Malerei des 14. Jahrhunderts*, ed. Paul Pieper (Münster, 1964).

Wetter, *Textilien* (2012): Evelin Wetter, *Mittelalterliche Textilien III. Stickerei bis um 1500 und figürlich gewebte Borten*, Die Textilsammlung der Abegg-Stiftung 6 (Riggisberg, 2012).

Wetter, 'Von Bräuten und Vikaren' (2012): Evelin Wetter, 'Von Bräuten und Vikaren Christi. Zur Konstruktion von Ähnlichkeit im sakralen Initiationsakt', in: *Similitudo. Konzepte der Ähnlichkeit in Mittelalter und Früher Neuzeit*, eds. Martin Gaier et al. (Munich, 2012), 129–46.

Whitehead, 'Columnae' (2003): Christiania Whitehead, 'Columnae … sunt episcopi. Pavimentum … est vulgus: The Symbolic Translation of Ecclesiastical Architecture in Latin Liturgical Handbooks of the Twelfth and Thirteenth Centuries', in: *The Theory and Practice of Translation in the Middle Ages*, The Medieval Translator/Traduire au Moyen Âge 8, eds. Rosalynn Voaden et al. (Turnhout, 2003), 29–38.

Wiederkehr, *Hermetschwiler Gebetbuch* (2013): Ruth Wiederkehr, *Das Hermetschwiler Gebetbuch. Studien zu deutschsprachiger Gebetbuchliteratur der Nord- und Zentralschweiz im Spätmittelalter. Mit einer Edition*, Kulturtopographie des alemannischen Raums 5 (Berlin, 2013).

Wielockx, 'Poetry' (1998): Robert Wielockx, 'Poetry and Theology in the *Adoro te deuote*: Thomas Aquinas on the Eucharist and Christ's Uniqueness', in: *Christ among the Medieval Dominicans: Representations of Christ in the Texts and Images of the Order of Preachers*, eds. Kent Emery, Jr. & Joseph Wawrykow (Notre Dame, 1998), 157–74.

Wiethaus, 'Collaborative Literacy' (2015): Ulrike Wiethaus, 'Collaborative Literacy and the Spiritual Education of Nuns at Helfta', in: *Nuns' Literacies: Kansas City* (2015), 27–46.

Wilckens, 'Kanonbilder' (1963): Leonie von Wilckens, 'Zwei Kanonbilder in Missalebänden der Nürnberger Katharinenklosters', *Anzeiger des Germanischen Nationalmuseums* (1963), 62–66.

Wilckens, *Textilen Künste* (1991): Leonie von Wilckens, *Die textilen Künste: Von der Spätantike bis um 1500* (Munich, 1991).

Williams & Hoffmann, 'Vitaspatrum' (1999): Ulla Williams & Werner J. Hoffmann, 'Vitaspatrum', in: ²VL 10 (Berlin, 1999), cols. 449–66.

Williams-Krapp, *Legendare* (1986): Werner Williams-Krapp, *Die deutschen und niederländischen Legendare des Mittelalters. Studien zu ihrer Überlieferungs-, Text- und Wirkungsgeschichte*, Texte und Textgeschichte 20 (Tübingen, 1986).

Williams-Krapp, 'Frauenmystik' (1993): Werner Williams-Krapp, 'Frauenmystik und Ordensreform in 15. Jahrhundert', in: *Literarische Interessenbildung im Mittelalter. DFG-Symposium 1991*, ed. Joachim Heinzle, Germanistische Symposien. Berichtsbände 14 (Stuttgart, 1993), 301–13, repr. in: *Geistliche Literatur des späten Mittelalters. Kleine Schriften*, eds. Kristina Freienhagen-Baumgardt & Katrin Stegherr, Spätmittelalter, Humanismus, Reformation 64 (Tübingen, 2012), 159–72.

Williams-Krapp, 'Kultpflege' (1998): Werner Williams-Krapp, 'Kultpflege und literarische Überlieferung. Zur deutschen Hagiographie der Dominikaner im 14. und 15. Jahrhundert', in: *Ist mir getroumet mîn leben? Vom Träumen und vom Anderssein. Festschrift für Karl-Ernst Geith zum 65. Geburtstag*, eds. André Schnyder et al., Göppinger Arbeiten zur Germanistik 632 (Göppingen, 1998), 147–73.

Williams-Krapp, 'Schrifttum' (2011): Werner Williams-Krapp, 'Das geistliche Schrifttum des Spätmittelalters vom Anfang des 14. bis zum Ende des 15. Jahrhunderts, Veränderungen nach der Mitte des 14. Jahrhunderts', in: *Deutsches Literatur-Lexikon. Das Mittelalter, Autoren und Werke nach Themenkreisen und Gattungen 2: Das geistliche Schrifttum des Spätmittelalters*, ed. Wolfgang Achnitz (Berlin–Boston 2011), xi–xx.

Williams-Krapp, 'Bedeutung' (2012): Werner Williams-Krapp, 'Die Bedeutung der reformierten Klöster des Predigerordens für das literarische Leben in Nürnberg im 15. Jahrhundert', in: *Geistliche Literatur* (2012), 189–208.

Williams-Krapp, 'Literaturlandschaften' (2012): Werner Williams-Krapp, 'Literaturlandschaften im späten Mittelalter', in: *Geistliche Literatur* (2012), 29–34.

Williams-Krapp, 'Wir lesent daz vil' (2012): Werner Williams-Krapp, 'Wir lesent daz vil in sölichen sachen swerlich betrogen werdent. Zur monastischen Rezeption von mystischer Literatur im 14. und 15. Jahrhundert', in: *Geistliche Literatur* (2012), 141–56.

B. Williamson, 'Sensory Experience' (2013): Beth Williamson, 'Sensory Experience in Medieval Devotion: Sound and Vision, Invisibility and Silence', *Speculum* 88 (2013), 1–43.

M. Williamson, 'Pictura' (2000): Magnus Williamson, 'Pictura et scriptura: The Eton Choirbook in its Iconographical Context', *Early Music* 28 (2000), 359–80.

M. Williamson, *Eton Choirbook* (2010): Magnus Williamson, *The Eton Choirbook: Facsimile and Introductory Study* (Oxford, 2010).

Willing, *Literatur* (2004): Antje Willing, *Literatur und Ordensreform im 15. Jahrhundert. Deutsche Abendmahlsschriften im Nürnberger Katharinenkloster*, Studien und Texte zum Mittelalter und zur frühen Neuzeit 4 (Münster, 2004).

Willing, *Bibliothek* (2012): Antje Willing, *Die Bibliothek des Klosters St. Katharina zu Nürnberg. Synoptische Darstellung der Bücherverzeichnisse* (Berlin, 2012).

Wilmart, 'Tradition' (1929): André Wilmart, 'La tradition littéraire et textuelle de l' *Adoro te devote*', *Recherches de théologie ancienne et médiévale* 1 (1929), 21–40, 149–76.

Wilmart, *Auteurs spirituels* (1932): André Wilmart, *Auteurs spirituels et textes dévots du Moyen Âge latin: Études d'histoire littéraire* (Paris, 1932).

Wilmart, 'Poème' (1935): André Wilmart, 'Le grand poème bonaventurien sur les sept paroles du Christ en croix', *Revue bénédictine* 47 (1935), 274–77.

Wilmart, 'Poèmes' (1937): André Wilmart, 'Poèmes de Gautier de Châtillon dans un manuscrit de Charleville', *Révue Bénédictine* 49 (1937), 121–69.

Wilms, *Geschichte* (1920): Hieronymus Wilms, *Geschichte der deutschen Dominikanerinnen 1206–1916* (Dülmen, 1920).

Wimmer, *Deutsch und Latein* (1974): Rupprecht Wimmer, *Deutsch und Latein im Osterspiel. Untersuchungen zu den volksprachlichen Entsprechungstexten der lateinischen Strophenlieder*, Münchener Texte und Untersuchungen zur deutschen Literatur des Mittelalters 48 (Munich, 1974).

Winkler, 'Beobachtungen' (2003): Gabriele Winkler, 'Beobachtungen zu den im "ante Sanctus" angeführten Engeln und ihrer Bedeutung', *Theologische Quartalschrift* 183 (2003), 213–38.

Winzeler, *St. Marienstern* (2011): Marius Winzeler, *St. Marienstern. Der Stifter, sein Kloster und die Kunst Mitteleuropas im 13. Jahrhundert* (Wettin-Löbejün, 2011).

J. Wirth, *Les marges à drôleries* (2008): Jean Wirth et al., *Les marges à drôleries des manuscrits gothiques, 1250–1350*, Matériaux pour l'histoire (Geneva, 2008).

J. Wirth, 'Performativité' (2010): Jean Wirth, 'Performativité de l'image?' in: *La performance des images*, eds. Alain Dierkens, Gil Bartholeyns, & Thomas Golsenne, Problèmes d'histoire des religions 19 [2009] (Brussels, 2010), 125–35.

K.-A. Wirth, 'Lehrfiguren' (1983): Karl-August Wirth, 'Von mittelalterlichen Bildern und Lehrfiguren im Dienste der Schule', in: *Studien zum städtischen Bildungswesen des späten Mittelalters*, eds. Bernd Moeller et al., Abhandlungen der Akademie der Wissenschaften in Göttingen, Philologisch-Historische Klasse, 3. Folge 137 (Göttingen, 1983), 256–370.

Wittekind, 'Schriftband' (1995): Susanne Wittekind, 'Vom Schriftband zum Spruchband. Zum Funktionswandel von Spruchbändern in Illustrationen biblischer Stoffe', *Frühmittelalterliche Studien* 29 (1995), 343–67.

Wolf: 'Kirchen' (1996): Manfred Wolf, 'Kirchen, Klöster, Frömmigkeit', in: *Soest. Geschichte der Stadt* 2 (1996), 771–898.

Wolter-von dem Knesebeck, 'Beobachtungen' (1993–1994): Harald Wolter-von dem Knesebeck, 'Beobachtungen zum Blankenburger Psalter', *Wolfenbütteler Notizen zur Geschichte des Buchwesens* 18–19 (1993–1994), 61–72.

Wolter-von dem Knesebeck, 'Codex Gisle' (2015): Harald Wolter-von dem Knesebeck: 'Zur Entstehung und kunsthistorischen Einordnung des Codex Gisle', in: *Codex Gisle* (2015), 93–101.

Women and Experience (2009): *Women and Experience in Later Medieval Writing: Reading the Book of Life*, eds. Anneke Mulder-Bakker & Liz Herbert McAvoy (New York, 2009).

Women and Gender (2006): *Women and Gender in Medieval Europe: An Encyclopedia*, ed. Margaret Schaus (New York, 2006).

Wood, 'Utrecht Psalter' (1987): C. Gibson Wood, 'The Utrecht Psalter and the Art of Memory', *Revue d'art Canadiennes* 14 (1987), 9–15.

Worm, 'Steine' (2003): Andrea Worm, 'Steine und Fußspuren Christi auf dem Ölberg. Zu zwei ungewöhnlichen Motiven bei Darstellungen der Himmelfahrt Christi', *Zeitschrift für Kunstgeschichte* 66 (2003), 297–320.

Worstbrock, 'Magister Adam' (1978): Franz Worstbrock, 'Magister Adam', in: ²*VL* 1 (Berlin, 1978), cols. 47–50.

C. Wright, 'Dufay' (1994): Craig Wright, 'Dufay's *Nuper rosarum flores*, King Solomon's Temple, and the Veneration of the Virgin', *Journal of the American Musicological Society* 47 (1994), 395–427, 429–41.

R. M. Wright, 'Sound' (1991): Rosemary Muir Wright, 'Sound in Pictured Silence: The Significance of Writing in the Illustration of the Douce Apocalpyse', *Word & Image* 7 (1991), 239–74.

Writing Religious Women (2000): *Writing Religious Women: Female Spiritual and Textual Practices in Late Medieval England*, eds. Denis Renevey & Christina Whitehead (Cardiff, 2000).

C. Wulf, 'Bild und Text' (1996): Christine Wulf, 'Bild und Text auf den niedersächsischen Textilien des Mittelalters', in: *Épigraphie et iconographie: Actes du Colloque tenue à Poitiers les 5–8 octobre 1995*, ed. Robert Favreau, Civilisation médiévale 2 (Poitiers, 1996), 259–72.

C. Wulf, 'Inschriften' (1996): Christine Wulf, 'Die Inschriften auf dem großen Goldkelch im Domschatz', in: *Der grosse Goldkelch Bischof Gerhards*, ed. Michael Wolfson, Der Hildesheimer Dom. Studien und Quellen 1 (Hildesheim, 1996), 68–69.

F. Wulf, '*Sancti Spiritus*' (1983): Friedrich Wulf, '*Sancti Spiritus assit nobis gratia*. Eine frühmittelalterliche Pfingstsequenz aus dem liber hymnorum des Notker Balbulus', in: *Liturgie und Dichtung: Ein interdisziplinäres Kompendium*, eds. Hansjakob Becker & Reiner Kaczynski, 2 vols., Pietas Liturgica 1 (St. Ottilien, 1983), vol. 1: Historische Präsentation, 547–72.

Yardley, *Performing Piety* (2006): Anne Bagnall Yardley, *Performing Piety: Musical Culture in Medieval English Nunneries* (New York, 2006).

Young, *Drama* (1933): Karl Young, *The Drama of the Medieval Church*, 2 vols. (Oxford, 1933).

Zacher, 'Osterspiel' (1842): Julius Zacher, 'Mittelniederländisches Osterspiel', *Zeitschrift für deutsches Altertum und Philologie* 2 (1842), 302–50.

Załuska, 'Évangéliare' (2004): Yolanta Załuska, 'Évangéliare du "prototype" dominicain et évangéliare du "prototype" cistercien', in: *Aux origines* (2004), 127–57.

Zanichelli '"Sogetti"' (2006): Giuseppa Z. Zanichelli, 'I "Soggetti" dei libri liturgici miniati (VI–VIII secolo)', in: *L'arte medievale nel contesto, 300–1300: funzioni, iconografia, tecniche*, ed. Palo Piva (Milan, 2006), 245–74.

Zieman, 'Reading' (2003): Katherine Zieman, 'Reading, Singing and Understanding: Constructions of the Literacy of Women Religious in Late Medieval England', in: *Learning and Literacy in Medieval England and Abroad*, ed. Sarah Rees Jones (2003), 97–120.

Zieman, *New Song* (2008): Katherine Zieman, *Singing the New Song: Literacy and Liturgy in Late Medieval England* (Philadelphia, 2008).

Zimmermann, 'Jesus Christus' (1997): Andrea Zimmermann, 'Jesus Christus als "Schmerzensmann" in hoch- und spätmittelalterlichen Darstellungen der bildenden Kunst. Eine Analyse ihres Sinngehalts', Ph.D. dissertation, Martin-Luther-Universität Halle-Wittenberg (1997).

Zunker, *Adel* (2003): Diana Zunker, *Adel in Westfalen. Strukturen und Konzepte von Herrschaft (1106–1235)*, Historische Studien 472 (Husum, 2003).

Index of Manuscripts

Aarau, Kantonsbibliothek
Cod. Wett. f. max. 1–3: 697, *697*

Aberdeen, University Library
MS 25: 426n61

Altena, Museum Burg Altena
B 1267a–c, B 1269: 143

Altenhohenau, Bibliothek des Metropolitankapitels
Altenhohenau
Chorbuch 2: 88

Baltimore, Walters Art Museum
MS. W. 148: 134, *138*, 139–42, *141*, 144n155

Bamberg, Staatsbibliothek
Msc. Hist. 139: 442
Msc. Hist. 153: 602

Basel, Universitätsbibliothek
Cod. A VI 38: 593n65, 602
Cod. B.XI.11: 536

Berlin, Staatsbibliothek zu Berlin – Preussischer
Kulturbesitz
Ms. germ. 40 192: 602
Ms. theol. lat. f. 8: 143
Ms. theol. lat. IV 11: 471
Ms. theol. fol. 178 (Pigmentum cordis): 81, App. B: 23
Ms. germ. fol. 19: 52n67

Besançon, Bibliothèque municipale
ms. 54: *534*, 536

Bloomington, Indiana University, Lilly Library
MS. Ricketts 198: 76n232, 174–5

Cambridge, Fitzwilliam Museum
MS 288: 112
MS 289: 195

Cambridge, Massachusetts, Harvard University,
Houghton Library

MS Typ 584: *485*
MS Typ 1095: 1, 93, 95, 102, 170, 179, 247, 289, 292,
298, 633, 744, 749, 779
John the Evangelist, cult of: 122n29, 262,
568–9, *571–2*, 573, 580, 582, 584–5, *587*,
589–90, 600–1, *603*, 609–11, 637, 775

Cleveland, Museum of Art
on loan from the collection of Otto Ege, 346.1991:
329, 330–1

Coblenz, Landeshauptarchiv
Best. 701, no. 1003 (formerly Hs. 2): 134n89, 145,
145n158
Best. 701, no. 1004 (formerly Hs. 3): 134n89,
145n158
Best. 701, no. 1005 (formerly Hs. 4): 145n158

Colmar, Bibliothèque municipale
ms. 136: 289
ms. 137: 286, 289
ms. 308: 96n26, 159n45
ms. 309: 96n26
ms. 312: 159n45
ms. 317: 214, 220–1, 242, 272, 286

Cologne, Dom- und Diözesanbibliothek
Cod. 260: 112
Cod. 263: 115n5
Cod. 1001b: 112n118, 115n5, 319, *727*, 728
Cod. 1073: 112n118, 115n5, 159, 287
Cod. 1149: 115n5
Cod. 1150: 115n5, 219–20
Cod. 1173: 219, 657, *657*

Darmstadt, Universitäts- und Landesbibliothek
Hs. 837: 583, 586, *586*
Hs. 2505: 357, 523, *523*

Detmold, Staatsarchiv
L 110 B, Nr. 18 *see* Lemgo, St Mary's, library
catalogue *in general index*
L 110 B, Nr. 19: 81n282, 82n283, App. B: 30n6
L 110 B, Nr. 20: 84n307–8, App. B: 31n20

General Index

Burchard de Monte Sion: App. B: 25, 27
Busche (*de Bosco*), Johannes von dem, prior of
 Minden, Provincial of Saxonia: 2, 78–80,
 App. B: 31n13
Busche, Wilburg von dem, nun at Lemgo: 83,
 App. B: 26, 31

Cain, biblical figure: 377, 381–2
Cambrai: 111
Canterbury: 757
Carina of Balsamo: 507
Carl Theodor, electoral prince: 107
Carmina Burana: 253
Cassiodorus: App. H: 91
Catherine of Alexandria, saint: 41–2, 94, 116, 128,
 130–1, 511, 704
 and Common of Saints: *720, 721*
 sequences: 218–19, 221
Catherine of Siena, saint: 4, 71, 109, 124, 617, *617*, 724
Cecilia, nun of San Sixto: 17–18, 20
Cecilia (Caecilia), saint: 41, 71, 130, 319, 510–11, 701
Celsus, saint: 683
Charles the Bald, Frankish emperor: 756
Charles IV, Holy Roman Emperor: 2
Christ, Jesus: 161–2, 165, 175, 177, 180, *196, 197, 198,*
 205, 242, 263, 266–9, *199,* 300, 301, 303, *305,*
 308, 311, 377, 440, 584, 593–4, 662, 677, 683,
 691, 694, 698, 700, 729, 731, 750, 757, 766, 777
 Adam as type of: 265, 380
 Advent: 317–41, *332, 334*
 and Agnes, saint: *645*
 as *Agnus dei*: 315, *315,* 323, 329, 438–9, *439–40,* 481,
 542, 543, 564, 565, 588, 590, 598 604, 624, *624,*
 630, 631, 667, 710, *713*
 Ascension: 178, *179,* 181, 232–42, 307, *457,* 460, 465,
 455–64, *457, 633*
 Baptism: 120–1, 135–6, 366–7, 369
 as Bridegroom: 70, 329–31, 573, 579
 and Caiphas: 129
 Cana, wedding at: 366–7, 369
 Christmas and Nativity: 131, 136, *140–41, 186,*
 343–75, *546*
 and Common of Apostles: 243
 and Common of Saints: 703–7, *705, 711–12, 716,*
 717, 718, 719, 720, *721–2*
 Crown of Thorns: 661–3
 Crucifixion: 129, *182,* 307, 316, *316* 338, 379, 412,
 416, 418–25, 536, 589, 657–61, *658,* 689, *758*
 and dedication of churches: 723–4, 726, 728–32,
 752
 Deposition and Entombment: *129,* 132, 135–6,
 424–5, *425,* 428, *429*
 as *Deus medicus*: 488
 Eastertide: 435–66, *436–44,* 446–50, 452–4,
 457–60, 462–3, 465, 739

 Feeding of Five Thousand: 366–7, 397–8, *398*
 Flagellation: 129, *422,* 423, 657, *658*
 as gardener: 445–6
 Gethsemane: 409–10, 416, *416*
 Harrowing of Hell: 240, 426, *428,* 430, 431, 440,
 441, 633
 and John the Baptist: 621–2, *622,* 626, 628, *628,*
 630–1, *633,* 633–5, *634,* 667
 as Man of Sorrows: 380, *380,* 407, 409, 427, 433,
 480, 482, 584–5, *587–8,* 589–91, 613, 657, *659*
 and numerology: 752–3
 Pentecost: 468–77, *470, 474, 476*
 Presentation in Temple: *519, 521, 522*
 and Proper of Saints: 640–2, 644, 649–51, 655,
 636–63, 665, 668, 669, 671–2, 676, 678, *678,*
 683–5, 688, *693, 694,* 696, 698–9, *699,* 701
 Resurrection: 111, 155, *179,* 307, 427, 657; *see also*
 Eastertide
 Septuagesima and Lent: 378–82, *384, 386–8, 390–5,*
 398, 401, 435–40, *436–9,* 443, 446–7
 as shepherd: 202, *204,* 449, 450, 452
 and Simeon: 520
 treatise on: App. B: 27
 Trinity Sunday: 480–3
 see also Corpus Christi; Holy Week
Christina von Dortmund: 21, App. A: 8n28
Christmas
 Christmas Day, Major Mass: 351–60
 Christmas Day, Morning Mass: 349–51
 Christmas Eve: 343–5
 Circumcision/Holy Name: 362–6
 Midnight Mass: 345–9
 Sunday within Octave: 361
chrysography: 758
Cîteaux: 501
Clairvaux: 501
Clare (Clara), saint: 41, *53,* 63
Clarenberg, Poor Clares: 357, 523
Clement I, pope, saint: *700,* 701
Clement IV, pope: 148
Clement V, pope: 479
 Clementinae: 89
Clement VI, pope: 80
Clement VII, pope: 516
Cleophas, saint, apostle: 443
Clot (Clotinge), Everhard (Eberhard), Soest
 Dominican: 16, App. A: 6, 11, 16
 Conrad, App. A: 5
 Borchard, App. A: 5
Codex Aureus: 756
Codex Egberti: 756
Codex Gisle (Rulle Gradual): 171, *186, 187, 190,* 286,
 321, *322,* 337, *337,* 423n42, 437, *438,* 738
Codex Henrici: 142–4
Codex Rutensis miscellaneus: 25

Colmar: 15, 65
Cologne: 2, 16, 21, 34, 41–2, 97, 130, 205, 287, 319, 774
 Augustinian canonesses of Agatha: 133
 cathedral: 128
 Heilig Kreuz (Holy Cross): 159, 219–20
 illuminated manuscripts: 112, 121–2, 128, 138–40, 142
 St. Clara: 184, 190
 St. Gertrud(e): 24, 34, 41–2, 98, 201, 219–20
 Sta. Maria in Kapitol: 403
 university: 4, 292, 769
Cologne Bible Master: 128
Common of Apostles: 178, *180*, 199, 242–52
Common of Saints (*Commune sanctorum*): 94, 116, 148, 294, 297, 516, 617–18, 703–22
Commune sanctorum see Common of Saints
Computus: 83, App. B. 26
Concordantiae caritatis: 759
confession, treatise on: App. B: 27
Conrad, archbishop of Cologne: App. A: 3, 12
Conradus de Asti, Dominican General: 74
Constance: 160
Constantine, Roman emperor: 217, 263, 412
Constantine of Orvieto, *Constantini legenda sancti Dominici*: 302–3
contrafactum technique
 importance for late sequence repertories, 216-7
 examples from Paradies, 252, 254–7, 263–7, 269–72, 273–80, App. E
conversio: 18, 20, 22, 57–9, 62, 70, 75, 772
Corpus Christi: 42, 219, 260–1, 275–8, 294, 298, 309, 749, 483–93, *484*, 488, 492–3, 741
 and dedication of churches: 730
 'Lauda Sion': 214–18, 220, 222, 261, 492
 origin: 148–9, 213, 479
Cosmas, saint: 693
Cross, feasts of, 216, 219, 263–267, 656–61
cura animarum: 17, 23–4, 26
cura monialium: 3, 11, 13–15, 23, 25, 292
cura temporalium: 23–4, 26, App. A: 10

Damian, saint: 693
Daniel, biblical prophet: 337, 607, 614
Dante Alighieri: 736
David, biblical king: 181, *194*, 235, 237, 275, 288, 305, 307, 311–13, 314, 316, 318–19, *318–19*, 324, 331, 333, 335–6, 506, 508, 513, *527*, *547*, 548–50, 552, *698*, *729*, 750, 761, 777
 and Annunciation: 524, 527, 529
 and Assumption: 530, 533, 547
 and Christmas and Epiphany: 349–51, 361–2, 375
 and Common of Saints: 703–5, *713*, 710, 715, 717, 719, 721–2
 and Corpus Christi: 483–4, 491
 and dedication of churches: 726, 729

 and Eastertide: 435, 437–8, 441–2, 445–6, 450–3, 455–6, 461
 and Holy Week: 405, 426
 and John the Evangelist: 267, 269, 593, 597, 608, 612, 614–15
 and Pentecost: 468, 471
 and Proper of Saints: 642, 644, 648, 651, 656, 668–9, 672, 698–9, 701
 and Purification of Virgin: 520, 522
 and Septuagesima and Lent: 378, 381, 383, 386–9, 400
 and Seven Ages: 377–8
 and the Temple: *521*
 Tower of: 523, *525*, 526, *527*, *536*, *539*
 and Trinity Sunday: 479
 and typology: 738–9
De animalibus: 83
De institutione Paradisi et humili ingressu sororum: 15, App. A: 3, 6
De perfectione virtutum: 81
De preparatione cordis (*De doctrina cordis*): 81, App. B: 24
De terra sancta: 83, App. B: 25, 27
Dedication of the Church: 7, 723–32, 752, 776, App. A: 15
Denis, saint: 218, 694
Denzel, Michael: 70
Diessenhoffen *see* Katharinenthal
Dietrich of Apolda: 303, 747, App. H: 91
 Acta ampliora: 509–12
Dietrich of Frieburg: 2
Dietrich von Recklinghausen: App. A: 8n27
Dionysius the Areopagite: 532–3, 600, *601*, 608
Divinization: 559, 593, 595–7, 601, 603–5, 770
Dohm, von, *Justitz-Assessor*: 99, 101
Dominic, saint: 304, 632, 748
 and Augustinian Rule: 117
 on consecration of nuns: 61–2
 and *cura monialium*: 3, 11, 13, 17–18, 772
 feast day: 41–2, 120, 27, 148, 508–14, 661, 685
 as founder of Order: 7
 and Holy Week: 428
 illustrations of: 128, 130–1, *300*, 302, 501, 504, *504*, *506*, 507–8, *507*, 510, *510*, *511*, 579, 583, *655*
 life of: 302–4
 and Proper of Saints: 685
 sequences: 217, 220, 232, 263, 269, 272–9
Dorothea (Dorothy), saint: 219, 132
Dortmund: 17, 21, 39, 42, 83, 97, 144, 149, App. A: 14
 Paradies bei Soest, connection with: 150–2, 157, 261, 769, 776, 779–80; *see also* Dortmund, Archiv der Propsteigemeinde, Propsteikirche Cod. B 6
 Counts of: App. A: 7
Dortmund, Christina von: 21, 34, App. A: 8, 14

Bela von (daughter): App. A: 8
Johann von: App. A: 8
Dortmund, Herbord von: 19, App. A: 7, 10, 16
Dortmund, Margareta von: 21, App. A: 14
Drüggelte *see* Möhnesee-Drüggelte
Durandus (of Mende), William: 327
 on dedication of churches: 723–4
 on Eastertide: 448–50, 456
 on exegesis: 737–8
 Rationale Divinorum Officiorum: 5, 291–2, 325,
 368, 371, 378, 383–6, 389, 397, 427, 735, 736–8,
 777–8
Dusseldorf: 99–101
 court library: 103–9
Duzborg, Jacobus von: 97

Eastertide
 Easter Day: 435–41
 Easter Monday: 441–3
 Easter Week: 443–8
 First Octave: 448–51
 Minor Rogations: 455
 Sunday within Octave of Ascension Day: 464–6
 Sundays following Octave: 451–5
 Vigil of the Ascension: 455–64
Ebner, Christina: 67
Ebner, Margaretha, *Offenbarungen*: 340–1
Ebstorf: 48
 corporal case: 488, *488*
Echternach, St. Willibrord: 563n16
Eckhart, Meister: 2, 11, 85, 778
 and Lahde/Lemgo: 79
 on Mary and Martha: 69–70, 84, 771
Edmont, Wilhelm: 97
Edward the Confessor, king of England: 109, 695
Egisheim, Benedicta von: 66
Ehrenschwendtner, MarieLuise: 48, 74–5, 85, 88
Ehrenwalten, August Klein von: 108
Einecke: App. A: 4, 6
Eineckerholsen: App. A: 4
Einhorn, Jürgen: 205
Eleven Thousand Virgins: 41–2
Elfenhusen, Druda (Gertrud): 97
Elias, biblical prophet: 391
Eligius, saint: 83, App. B: 27
Elijah, biblical prophet: 239
Elisabeth, saint, mother of John the Baptist: 274, 547,
 553, 626, *626*, 628–9, 635–6, *665*, 666–8, *668*
Elisabeth de Wirenborne *see* Wierborn, Elisabeth
Elisabeth of Hungary, saint: 510, 635
Elisabeth of Schönau: 537
 Liber viarum dei: 51–2
Elisabeth of Thuringia, saint: 221, 700–1, *700*
Elisabeth von Batenhorst: App. B: 31n19
embroidery: 162–3, 202, 204–7, *205*, 763

whitework: 161, *161–2*, 205–6
Engelthal: 11, 67, 423, 731
 library: 85–6
Enkesen: 29
entrance into convents and profession: 20, 55–67,
 772–3
Epimachus, saint: 663
Epiphany: 366–9
 First Sunday following Octave: 371–3
 Second Sunday following Octave: 373–5
 Sunday within Octave: 369–71
Erasmus, Desiderius: 206
Erfurt: 2
 Neuwerkskloster: 320, 480–1
Eriugena, John Scotus: 597, 600–2, 748, 764
 homily on John the Evangelist: 747, 778
 Vox aquilae spiritualis: 559, 608, App. H: 91
Esau, biblical figure: 727
eschatology: 427, 598, 707, 730, 735, 738–9
Eve, biblical figure: 22, 50, 266, 377, 379–80, 426, 431,
 440
excision of initials and illuminations: 98, 116, 120–3,
 617, *618*
exempla: App. B: 25
Ezechiel, biblical prophet: 315–16, 593–4, 608, 611,
 613–14

Fabian, saint: 644
Fall (Adam and Eve): 22
Falkenberg, Kuno von, archbishop of Trier: 756
Faustinus, saint: 683
Felician, saint: 663
Felicity, saint: 674–5, *675*
Felix, saint: 683
Felix of Nola, saint: 643
Ferner, Robert: 20, App. A: 10, 16
 Gottschalk: App. A: 10
Flasch, Kurt: 69–70
Flecto genua: 81, App. B: 22
Floreffe Bible: 486–7, *488*, *754–5*, 756
Fontevrault: 392, 414, 417, 431, 583, *583*; *see also*
 Limoges, Bibliothèque francophone
 multimedia de Limoges, ms. 2
Francis, saint: 41, 694
Frater Ambrosius: 82, App. B: 23
Frauenhofer, Katharina: 88
Frauenstiftskirche Neuenheerse: 133
Frederick II, Holy Roman Emperor: 569
Freiburg in Breisgau
 Adelhausen: 11, 44n8), 46n19, 55
 (*Schwesternbuch*), 61, 69
 St. Maria Magdalena zu den Reuerinnen: 504
Fröndenberg Altar, Master of: 178–9, 191–3, 195, 197,
 199, 202, 353, *354*, 586, 775
Fröndenberg bei Unna: 178–9, 191–3

Hildbrandt of Blomenberghe: App. B: 26
Hildegard of Bingen: 63, 90
Hildeger de Foro: 19, App. A: 7, 14
Hildesheim
 chalice of bishop Gerhard: *489–90*, 491
 TrinitatisHospital: 763
Hinnebusch, Wilhelm A.: 46
Hippolytus, saint: 42, 554, 687
Hochstaden, Konrad von, archbishop of
 Cologne: 19–21, 32, App. A: 12n52
Hohenholte, chalice: 160, *160*
Holladay, Joan: 138, 142
HolsteinSchauenburg, Mechthild von: 19
Holthausen: 18, 72
Holy Innocents: 42, 642–3, *643*
Holy Week: 403–5, 410–34
 Palm Sunday: 407–10
 Passiontide Sunday: 405–6
 Passiontide Weekdays: 406
Holzer, Jenny: 757
Honorius III, pope: 13, 17
Honorius Augustodunensis, *Gemma animae*: 375
Honrode, Dietrich (Theodericus) von: 19, App. A: 6,
 7, 13
Horace: 85
Horburg, Heilrad von: 67
Hortus deliciarum: 302
Hours of the Virgin: App. B: 25
Hoya, Otto von: 76–7
Huckenhusen, Gertrud (Drude) von: 83, App. B: 25,
 31n15
 Johann von, mayor of Lemgo: App. B: 31n15
 Family of: App. B 31n15
 Oda von: App. B: 31n.15
Hugh of SaintCher (Hugo de S. Caro),
 cardinallegate: 13, 15,
 De doctrina cordis: 82, App. B. 24, 25
 Expositio missae: App. B 25
Hugh of Saint Victor
 De quinque septenis: 485
 De sacramentis christianae fidei: 82, App. B: 21, 26,
 30n2, 31n11
 Expositio in regulam beati Augustini: 81, App. B: 21
Hughes, Andrew: 127
Humbert of (de) Romans, Master of Dominican
 Order: 14, 23, 56, 63, 73, 80–1, 773, App. B: 21,
 App. H: 91
 Constitutions of: 58–61, 67–8, 70
 De eruditione praedicatorum: 55
 Exhortatio: 51
 Expositio regulae: App. B: 21
 Legenda maior: 303–4
 Liber de instructione officialium: 75, 174
 liturgy, codification of: 127, 148, 157, 242, 286–7,
 293

sequences: 213–14, 216–21, 259–60, 264, 267, 272,
 513
'To Girls or Adolescents in the World': 71
Hurtado, Larry: 363

Ida von Essen: App. A: 11
Ignatius sicut Blasius, saint: 651, 714–15, *714*
illumination workshops: 138–44
Imhof, Appolonia: 88
imitatio Christi: 51
indulgences: 33–4, 39, 41–2, 133
Innocent III, pope (Lothar of Segni): 5, *588–9*, 590–1,
 615
 Liber Extra: 25
Innocent IV, pope: 58
inscriptions, unidentified: App. H, 91–2
International Gothic Style: 95, 170, 197
Investiture Controversy: 49
Irimbert of Admont: 356–7
Isaiah, biblical prophet: 321, 323, 547, 573, 593, 608,
 614, 693
 and Annunciation: 524–5, *524, 527*, 529
Isidore of Seville: 601, App. H: 91
 De natura rerum: 188
 De ortu et obitu partum: 615
 Etymologiae: 188

Jacob, biblical patriarch: 240, 350, 457, 461, 727, *727*
Jacobus, Dominican friar at Soest: App. A: 11n50
Jacobus de Cessolis, *Schachzabelbuch* (*Ludus
 scacorum*): 82, App. B: 23
Jacobus de Voragine, *Legenda aurea*: 231, 344, 355,
 386, 403, 411–12, 455, 459, 474, 508, 588, 605,
 723, App. B: 20, 22, App. H: 91
 on Advent: 317, 338
 on Agatha, saint: 132
 on Agnes, saint: 644
 on All Saints: 696
 on Ascension: 237
 on Assumption: 532–3
 on Christmas and Epiphany: 351, 366–7
 on Dominic, saint: 302–3
 on Holy Week: 403, 411–12
 on John the Baptist: 268–9
 on John the Evangelist: 268–9
 on Joseph, saint: 325
 on Septuagesima: 379
 on Trinity Sunday: 479
 on True Cross: 265, 660
James, son of Alphaeus, saint, apostle: 250, 569
James the Greater, saint, apostle: 227–8, 250, *304*, 391,
 488, 635
 and Common of Saints: 714
 and Proper of Saints: 655–6, *656–7*, 682
 sequence: 305–6

Jean II le Bon, king of France: 179
Jeremiah, biblical prophet: 608, 614
Jerome (Hieronymus), saint: 82, 87, 601, 614, 694, 710
 Epistolae: 83, 84, 347, App. B: 23, 28
Jerome (Hieronymus) of Moravia, *Tractatus de Musica*: 116
Jerusalem, Holy Sepulcher: 657
Job, biblical figure: 614–15
Johann von Huckenhusen *see* Huckenhusen, Johann von
Johanna, prioress of Lahde: 76–8
Johannes Balbus, *Catholicon*: 89
Johannes de Sacro Bosco, *Computus*: 83
Johannes Teutonicus (von Wildeshausen), Master of Dominican Order: 13, 16, 18, App. A: 6, 13
John XXII, pope: 479, 519
John XXIII, pope: 362
John Cassian, *Collationes patrum*: 81
John Chrysostom: 609–10, 615
John of Sterngassen: 2
John the Baptist: 7, 121, 130–1, 135–6, 151, 157, 170, 314–15, *315*, 329, 331, *332i*, *333*–4, 394, 569, 573, 579, 587, *667*, 759–60, App. F: 69–72
 birth (Nativity) of: *620*, 622, *628*, *629*, *630*, 631, 666–9, *666*
 and Christmas: 343–6
 circumcision of: 629, *629*
 Decollation of: 178, 688–9, *688*–9, 742
 Office of: 5, 95, 152, 154–5, 166, 197, 199, 200, 260–2, 617–37, 622, 724
 and Pentecost: *470*, 471
 and Proper of Saints: 665–9, 688–9
 as *Schutzmantelfigur*: 635
 sequences: 218–20, 227, 273–5, 280
 and Virgin Mary: 267–8, 273–5
John the Evangelist: 3, 7, 41, 130–2, 151, *181*, *183*, 197–8, 302, 305–7, 314, *318*, 332, 355, 397, 504, *507*, 508, 513, *532*, 544, *661*, *670*, 672, *677*, *681*, 692, 738–9, 747–8, 758, 761, 770, 775, 777
 and Advent: 322, 324, 326, 328–9, 331, 335, 338
 as alter Christus: 595–8, 601
 and Annunciation: 523–5, 528–9
 and Ascension: 235–7, 239
 and Assumption of Mary: 530, 533–9, 541–3, 547
 and Christmas and Epiphany: 343–7, 349–50, 352, 357, 359, 361–2, 364, 371, 375
 and Common of Saints: 703–4, 707, *707*, 711–12, 715–15, *714–16*, 717, 719, 721
 and Corpus Christi: 483–4, 488, 492, *493*
 cult of: 559–616, *560–1*, *563–5*, *570–2*, *574–8*, *580*–3, *586–95*, *597*, *599–601*, 603–5, 636–7
 and David: 267, 269
 and dedication of churches: 726–7, 729–31
 as eagle: *305*, 307, *308*, 315, *315*, 329, 396, *429*, 447, 454, 458, 510, 562, 584–6, 592–8, *600*, 605,

610–11, 616, 642, 655, 669, 704, 707, 753, 763–4
 and Eastertide: 435–9, 442, 445, 447–8, *448*, 450, *451*, 452–8, *454*, 461, 464–51
 epithets: 563–72, *566*
 feast: 120, 149, 191–2, 268, 294, 340, 607–16, 738
 and Holy Week: 400, 410, 412, 418–20, *419*, 423, 425–8, *430*, 431, 433, *434*
 images and inscriptions for feast: 607–16
 inscription of names: 605–7, 759
 at the Latin Gate: 663, 724
 libelli: 1, 95, 102, 286, 292, 298, 748, 448
 as lion: 305, 534–6, 565
 Office: 5, 94, 260–1, 596, 607, 617–18
 and Pentecost: 468–9, *470*, 471, 473, *474*, *475*, 477
 and Proper of Saints: 642–3, 648–51, 653, 655, 658–9, 663, 666, 669–72, 683–4, 693, 696, 698–9, 742
 and Purification of the Virgin: 520–1
 as recipient of liturgical books: 750
 and Septuagesima and Lent: 378, 380–2, 384–400, *386–7*, 391, 394–7, 409
 sequences: 219, 227–8, 232, 249–50, 298–9, 308–9, 724, 726
 as *sponsa Christi*: 329, *563*, 598
 and Trinity Sunday: 479, 481–3
 ‘Verbum dei’: 268, 740, 748, 764
 ‘Victime paschali laudes’: 253–5, 257
 and Virgin Mary: 15, 252–7, 259–60, 263–82, 311, 316, 409, 418–20, *419*, 423, 427, *430*, 433, 519, 529, 533–9, 541–3, *542*, 550–1, 553, 584, 587, 589–91, 595–7, 615, *636*, 658–9, 661, *748–9*
Jordan of Saxony: 508, *512*, 513, 519
 Libellus de principiis ordinis praedicatorum: 302
Joseph, saint: 140, 276, 318, 322, 324–5, 482
 Christmas and Bethlehem: 344, 349, 361
Judas, apostle: *337*, 338, 414–15, *416*
Jude, saint: 250, 695–6
Juliana of Mt. Cornillon (Juliana of Liège): 479
Jungholz, Elisabeth von: 66
Jutta von Arnsberg, nun at Paradies: App. A: 10n42

Kamenz, Bernhard III von: 112
Kamp: 133
Katharinenthal (St. Katharinenthal): 127–8, 160, *183*, 184, 331, 741–2, 760, 778
 John the Evangelist, cult of: 219, 559–61, *580*–2, 581–2, 584–5, 587–8, 592–5, 602, 606
 sequentiary: 217–21, 229, 272
 see also Zurich, Schweizerisches Landesmuseum, inv. no. LM 26117
Kemperdick, Stephan: 353
Kempf, Elisabeth, prioress of Unterlinden: 73–4
Kippenheim, Dorothea von: 73
Kirchberg: 185

micrographic text: 154–7, 159–63, 165, 167–8, 170
as scribe: 1, 39–41, 95–6, 144, 147, 149–51, *147*,
 154–7, 159, 167–8, 187, 220, 562, 775–6
sequences, choice of: 259–61, 267, 272–3
sources and models used: 155, 157–63, 167
Lyons, Council of (1274): 364

Maastricht Passion Play: 325
Madrid
 Santo Domingo el Real: 3, 11, 15
Magdeburg: 21
Magdeburg, Mechthild von, *Das fließende Licht der
 Gottheit*: 85
Marbod of Rennes, *Liber de gemmis*: 83, App. B: 27
Marcellinus, saint: 663, *664*
Marcellus, saint: 644
Margaret(a), saint: 41, 109, 219, 221, 294, 681, 760
Margareta, nun of Lahde: 77
Maria Medingen *see* Medingen
Marienklagen: 423
Mark, Katharina von der, abbess of Fröndenberg bei
 Unna: 193, 353
Mark, pope, saint: 694
Mark the Evangelist, saint: 250, 322, 324
 as lion: 307, *308*, 483, 592
Marner, Der: 132
Martha of Bethany, biblical figure: 68–70, 84, 109,
 294, 409–10, 771
Marti, Susan: 205
Martial, bishop of Limoges: 149
Martin, saint: 42, 699–700, *699*
Mary, Virgin: 41, 128, 135, 149, 165, *178*, 285, 298–9,
 303, *305*, *421*, *538*, *543*, *554*, 660, 766, 777
 Annunciation: 62–3, *62*, 65, 93–4, 116, 120, 131, 133,
 135–6, 161, *187*, 188, 195, *195*, 205, 295, 299–301,
 300, 318, *318*, 320, 322, 323–5, 331, 339, 357, 440,
 501, 504, 506, 523–9, *523–4*, *526*, 529, *533*, 553,
 554, 569, 624, 653, 742, 757
 as Apocalyptic Woman: 534, 537, 550–2, *551*, *552*,
 707, 762, 763
 Ara coeli: 353, 355, 357
 Ascension: 233, 238, 241, 253
 Assumption: 111, 128, 131, 152, 198, *199*, 221, 260–1,
 275–80, 305, 529–50, *539*, 687
 'Ave virgo gloriosa celi iubar': 272–4
 'Ave virgo gratiosa': 249–50
 Bethlehem, journey to: 343–4, 361
 Birth/Nativity of: 130–1, *184*, 256, 268–75, 547–9,
 548, 690, 742, *758*
 as bride of Song of Songs: 3, 269
 chastity, as role model for: 50, 62
 Christmas/Nativity of Jesus and Epiphany: *140*,
 141, *186*, 268, 344–75, 352, 354, 358, 527, 583
 as Church, type of: 3, 259–60, 730
 as City of God: 527, 539

Coronation: 62, 63, *64*, 130, 161–2, 204–5, *205*, 331,
 504, *531*, 532, 536–7, 541, 545–6, *546*, 552, 697,
 697, *718*
Death and Ascension: 111, *531*, *540*, 541, 565
as Dominican patron: 3, 7, 272, 519–57
and Eastertide: *438*, *441*, 455, 458–9, *458*, 465
Flight into Egypt: 344, 407
and Holy Week: 409, 418–20, *419*, 421, 423, 425–8,
 430, 431, 433
Immaculate Conception: 221
and John the Baptist: *624*, *626*, 628–9, 634–5, 668
and John the Evangelist: 15, 252–7, 259–60, 263–82,
 311, 316, 409, 418–20, *419*, 423, 427, *430*, 433,
 519, 529, 533–9, 541–3, *542*, 550–1, 553, 584, 587,
 589–91, 595–7 615, *636*, 658–9, 661, *748–9*
as Madonna of Mercy: 3, 280, *507*, 508, *510*, 512,
 519, 697, 698, 407
in Majesty: *544*
as morning star (*stella maris*): *547*, *548*, 549
'Nativitas Marie virginis': 268
and numerology: 752
and Pentecost: 467, 469, 471, *471*
Purification of: 520–3, 651
Regina coeli: 371
'Salvatoris mater pia': 264
'Salve regina': 519–20, 546
'Salve salutare lignum': 261, 263–6, *266*
and Septuagesima and Lent: 381, 386–7, 400
sequences: 213, 217–21, 232, 249–51, 741
'Sub tuum praesidium': 519
as *Theotokos*: 538
and Trinity Sunday: 481
'Victime paschali laudes': 252–5, 257
'Virgine Iohanne laudes': 255–7, 267
as Window of Heaven: 710, *712*
Mary Magdalene, saint: 41, 128, 131, 148–52, 155, 157,
 161–2, 205, *395*, 591, 766, App. B: 31n8
 as apostle of the apostles: 554
 Ascension of: *681*
 and Eastertide: *438*, *438*, 441, 444–6
 and Holy Week: 412, 414–15, *414–15*, 423, 425, 428,
 431, 433
 and Proper of Saints: 681–2, *683*
 sequences: 218, 220–1, 250, 253, 261
 'Victime paschali laudes': 253–4
Mary of Bethany, biblical figure: 69–70, 84, 409–10,
 771
Mathey, Jacobus: 160
Matthew, saint, apostle: 199–200, *200*, 250, 408, 447,
 477, 479, *564*, 616
 and Common of Saints: *713*, *714*
 and Proper of Saints: *691*, *692*
 as winged man/angel: 307, 482, 592
Matthias, saint: 250, *467*, 468, 652, *652*
Maurice, saint: 693

Paccaronio, Tommaso (Thomas of Firmo), Dominican Master General: 516
Paderborn, Johannes von: 82, App. B: 25, 31n14
Padua, St. Anna: 61
Palazzo, Éric: 292
Palmer, Nigel: 142
Pancras, saint: *662, 663*
Pantaleon, saint: *683*
Paradies bei Soest, as institution: 769–81, App. A: (passim)
 agricultural and domestic buildings: 28–9, 31
 antiphonary, lost: 134–6
 archaeology: 27–33, 35, 769, 779
 Augustine, rule of: 21
 cartulary: 96, 779
 cemetery: 32, 40
 church
 altars: 40–2
 building and plan: 27–31, 33–40, *36–8*, 93, 772, 774
 stained glass: 130
 claustration (enclosure): 19, 23, 28, 31–2, 40, 78, 98, 771
 cloister: 29, 31
 conversio: 65
 dissolution: 27, 98–102, 109, 774
 Dominican rite, following of: 501–17
 Dortmund, connection with: 150–2, 157, 261, 769, 776, 779–80
 education: 74, 770, 772
 foundation and legend: 3, 15–16, 18–26, 32–3, 76, 79–80, 771–2
 gate complex: 28–30
 iconographic program: 126–34
 incorporation into Dominican Order: 1, 25–6
 infirmary: 28–9, 34–5
 layout: 6, 772, 774
 library: 93–6, 223, 286, 779
 dissolution inventories: 99–109, 774
 and Dusseldorf court library: 103–9, *104–6*
 early modern period: 97–8
 sale of: 107–9, 774
 living quarters: 29, 31–2
 model of: *34*
 murals: 130
 and personal property: 46–7
 plans: 27–8, *27–30*, 35–6, *35–7*, 40–1
 reform, avoidance of: 2–3, 48
 and Reformation: 97–8, 774
 repairs of manuscripts: 119–26
 scribes, nuns as: 95, 96–7, 147, 231, 286, 770, 774; *see also* Lünen, Elisabeth von; Rathus (Rothus), Elisabeth
 scriptorium: 95, 144–5, 231, 286, 756–, 769–70, 776

 manuscript commissions: 96–7, 150–2, 157, 189, 779
 micrographic tradition: 163–8, 170
 seal of: 22, *22*
 stylistic relationships: 137–45
 textiles: 780
 written sources, early: 32–5
 see also Cambridge, Massachusetts, Harvard University, Houghton Library, MS Typ 1095; Dortmund, Archiv der Propsteigemeinde, Propsteikirche Cod. B 6; Dusseldorf, Universitäts und Landesbibliothek, Cod. D 7, Cod. D 9, Cod. D 10a, Cod. D 11, Cod. D 12; Munich, Staatliche Graphische Sammlung, inv. no. 18703
Paris
 Notre Dame: 212, 215
 St. Victor: 212–13, 232
 Ste.Chapelle: 661
 sequences: 212–13
 university: 4, 213
Passiones et vitae sanctorum: 442
patrocinia: 40–1
Paul, saint: 41–2, 50, 53, 131, 136, 148, 151, 197, *198*, 315–16, 327, *504*, 515, *515*, 517, *550*, *552*, *564*, *650*, *670*, 673–4 , *678*
 and Annunciation: 526
 and Christmas: 345, 362
 Conversion of: 120, 261, 331, *648–9*, *649–50*, 674
 and Corpus Christi: 484, 492
 and Dionysius the Areopagite: 532
 and Eastertide: 458
 and Holy Week: 410–11
 martyrdom of: 673–4, *674*
 and Pentecost: 477
 and Proper of Saints: *648–9*, *649–50*, 669–74
 sequences: 218, 220, 250
 and Trinity Sunday: 479, 483
Pentecost: 468–77
Pertz, Georg Heinrich: 103, 108
Peter, saint, apostle: 41–2, 131, 135, 148, 177, 315, 336, 391, *504*
 and Ascension: 238
 Chair at Rome: 651–2, *652*
 and Christmas: 345 347
 and Eastertide: 443–4, *443*, 447–8, *448*, 456, 461
 and Holy Week: 433, *434*
 martyrdom of: 197–8, *198*, 670–2, *671*, *673*
 as pastor: *204*
 and Pentecost: 467–9, *473*, *474*, 475, 477
 and Proper of Saints: 640, 651–2, *651–2*, 663, *664*, 669–73, *670*, *672–3*, 683–5, *684–5*
 sequences: 218, 220, 250, 261
 as shepherd: 202, *204*
Peter Chrysologus, *Collectio sermonum*: App. H, 91

De divinis officiis: 339, 367, 378, 384
De Trinitate et operibus eius libri XLII: 612

St. Denis: 307, *308*
St. Gall(en): 31
 St. Katharine: 43, 86
St. Katharinenthal *see* Katharinenthal
St. Marienstern: 112
Salzburg, St. Peter's Abbey: 126–7
Samson, biblical figure: 438, *439*, 513
Sand Veit im Bonogew, Hainerich: 222
Sapiens, Johannes *see* Weise, Johannes
Scheda, Premonstratensian monastery: 12 (map), 19,
 App. A: 7, 7n18, 14
Schwefe: App. A: 4, 11n47
Schilling (Solidus), Elisabeth: 47, 95, 191, 357, 775
Schmidl, Augustin: 90
Schmidt, HansJoachim: 83
Schönensteinbach: 47, 72
Schramm, Josef: 99–100, 102–3
Schwarz, Hubertus: 33
Schwefe: 29, 42, App. A: 4, 7n15, 10n39, 11n47, 17
Scorel, Jan van: 206
Sebastian, saint: 42, 644
Sedes sapientiae: 370–2, 534, 553
Sedulius, Caelius, *Carmen Paschale*: 83, 367,
 App. B: 27
Seligenthal: 760
Sennen, saint 683
Septuagesima and Lent: 377–401
Sermones quadragesimales. Viridarius de tempore: 86
Seth, biblical figure: 379–80, 660
sequences, see also Catherine of Alexandria;
 contrafactum technique; Dominic; Humbert
 of Romans; James the Greater; John the
 Baptist; John the Evangelist; Lünen, Elisabeth
 of; Mary, Virgin; Mary Magdalene; Paris; Paul;
 Peter
 in library at Lemgo: 83, App. B, 27
 place within liturgy and liturgical manuscripts,
 210–11
 formal characteristics, 212–3, 216–7
 importance as evidence for medieval religious
 history, 231–2, 263, 273
 layers within D 11, 260–3, 270–2, 274–80, App. D
 probably unique to Paradies bei Soest, 262, App. D
Seuse, Heinrich: 2, 51, 85, 404–5
 Horologium sapientie: 85
Seven Ages of the World: 377–8, 383–4
Severin of Cologne, saint: 42
Severinus, saint: 695
Sherborne Missal: 759
Sicardus of Cremona: 5, 291, 345, 427, 435
 Mitrale: 327, 367, 382–3
Siegfried, archbishop of Cologne: App. A: 4

Sigebert of Gembloux: 573
Simeon, biblical figure: 520
Simon, saint: 250, 695–6
Simon of Cyrene: 420, *421*
Simplicius, saint: 683
Slagghert, Lambrecht: 194
Smaragdus, *Diadema monachorum*: 537, App. H.: 91
Smith, Julie: 18
Soest: 769, App. A: 6n3, 6n6
 Damenstift: 27, *27*, 30
 Holy Cross (zum HeiligKreuz): 16, 42, 80, 109, 114
 manuscript workshops in: 138–9, 143–4
 and Reformation: 97
 St. Patrokoli: 200
 St. Petri (Petrikirche): 133–4, 197
 St. Walburgis (Walpurga): 16, 149, 194
 town of: 16, 19–20, 29, 32, 133
 Wiesenkirche: 161, *161–2*, 205–6
 see also Paradies bei Soest
Soest, Conrad von: 192–3, 199–200, *202*, 204, 586,
 775
Soest, Jacob von: 516
Solesme: 289
Solidus, Elisabeth *see* Schilling, Elisabeth
Solomon, biblical king: 305, 315–16, 614–15, 731
 and Assumption: 530, 533–4
 throne of: *535*, 537
 see also Temple of Solomon
songs: 56, 85, App. B, 27
Song of Songs, glossed: 62, 84, App. B: 25, 27
Speculum humanae salvationis: 357, 523, 525, 527–8,
 539, 759, App. H: 91
Speculum virginum: 81, 302, 582, 747, 751–2, 759,
 App. B: 21, App. H: 91
Spiegel, Loppa von: 190
sponsa Christi: 50–1, 60, 329, *563*, 598
Stammheim Missal: 756
Ständer, Joseph: 97
Steinbach, Hedwig von: 66, *72*
Stephania de Phirreto: 66
Stephen I, pope, saint: 685
Stephen, saint, protomartyr: 131, 641–2, *641*, 643
Stephen Langton: 517
Stetten im Gnadental bei Hechingen: 185
Straßburg, St. Nikolaus in undis: 86, 602
studium generale: 2, 82, 114

Suso, Henry: 364
Sylvester I, pope, saint: 643
Symphosius, Caelius Firmanus, *Enigmata
 Symphosii*: 84, App. B: 27

Tabula exemplorum: 83, App. B: 25
Tauler, Johannes: 2, 89, App. B: 22
 Christo confixus sum cruci: 81, App. B: 22

Addendum to Appendix E

'Exortum lumen lux' for John the Evangelist (See Chapter 11.3)

3.2 O - cu - la - tum se - dis cir - cu - i - tum a - ni - man - tum can - tum et a - di - tum

quod vin - cen - tem men - tem ab - scon - di - tum man - na pa - - vit.

4.1 A - vis al - ta vo - la - tu ne - sci - ens me - tam fe - tam pre - dam

re - ci - pi - ens ap - tam rap - tam di - vi - sit nu - tri - ens Chri - sto gra - tos;

4.2 Gran - dis a - lis per - lu - strat a - sy - am que - rit se - rit pa - cem

et gra - ti - am te - git re - git pen - nis ec - cle - si - am et re - na - tos.

5.1 Fla - gel - la - tur cor - pus vir - gi - ne - um cru - ce du - ce fert fer - vens

o - le - um in - qui - na - tum la - tum ve - ne - ne - um po - tum vi - cit;

5.2 Pre - ser - va - tum cul - pe con - ta - gi - o sic man - su - rum pu - rum dat ra - ti - o

fra - trum a - mans fa - mans te - sta - ci - o hoc pre - di - cit.

6.1 Qui ce - lo - rum thro - nis con - iun - ge - ris ag - ni bys - so sto - la - tus

u - te - ris ce - nam ag - ni con - fer qua fru - e - ris pre - gu - sta - ta - tam;

6.2 Vir - go vi - sa se - cre - ta re - ser - a ad cu - bi - le cum spon - sa pro - per - a

spon - sam spon - so tra - duc con - fe - de - ra co - pu - la - tam. A - men.